IN TRUST
FOR THE NATION

Paintings from
National Trust Houses

Sponsored by

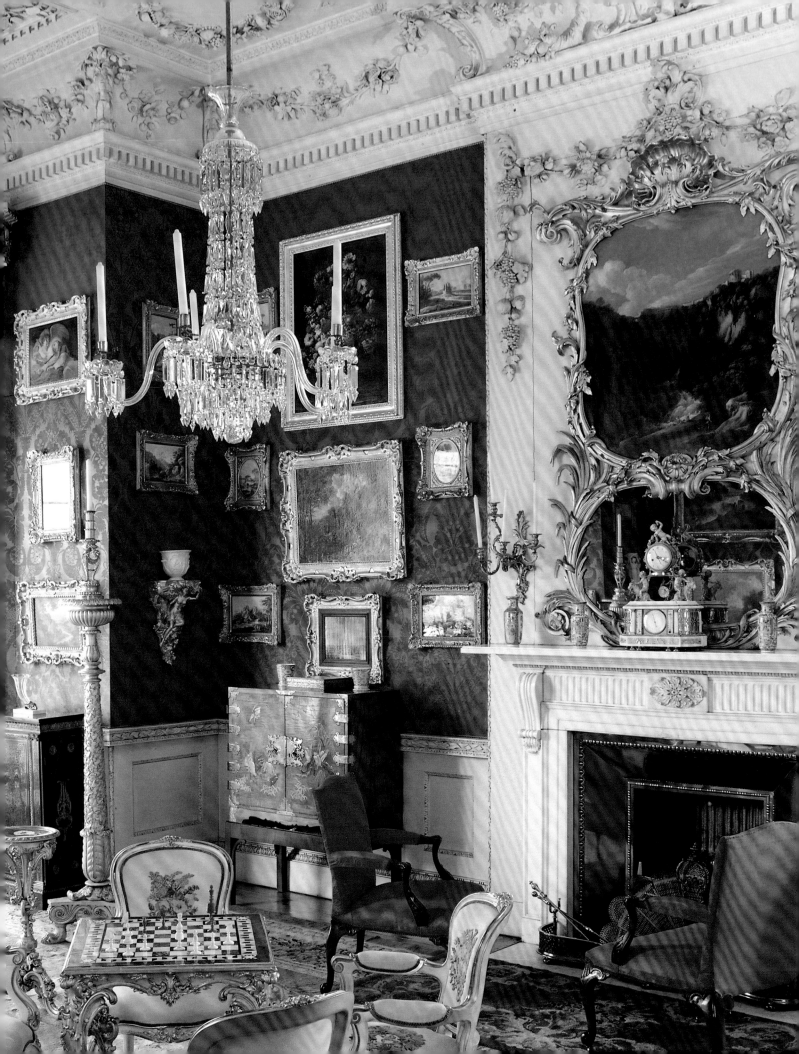

IN TRUST
FOR THE NATION

Paintings from
National Trust Houses

Alastair Laing

THE NATIONAL TRUST
in association with
National Gallery Publications, London

To
St John Gore
Adviser on Paintings to the National Trust,
1956–86

Bernard of Chartres used to say that we are like
dwarfs on the shoulders of giants, so that, if we
can see more than they … it is not by virtue of any
sharpness of sight on our part … but because we
are carried high and raised up by their giant size.

John of Salisbury, *Metalogicon* (1159), book III, ch.4

and
In Memoriam
† Gervase Jackson-Stops
Architectural Adviser, 1975–95

First published in Great Britain in 1995 by National Trust
(Enterprises) Ltd, 36 Queen Anne's Gate, London SW1H 9AS
in association with National Gallery Publications Ltd
to accompany the exhibition *In Trust for the Nation* held at
the National Gallery, 22 November 1995 – 10 March 1996

British Library Cataloguing-in-Publication Data
A catalogue record for this book is available from the British Library

ISBN 0 7078 0260 1 hardback
ISBN 0 7078 0195 8 paperback

Edited by Oliver Garnett, with Ruth Thackeray
Designed by Newton Engert Partnership
Production by Lorna Simmonds
Phototypeset in Monotype Sabon Series 669-673 by
Southern Positives and Negatives (SPAN), Lingfield, Surrey
Printed in Great Britain by Balding + Mansell

Photographs: Governor and Company of the Bank of England p.76;
Trustees of the British Museum pp.70, 122; Clwyd Record Office
p.73 (bottom left); Courtauld Institute pp.96, 138; Mansell
Collection p.183; National Gallery, London p.133; National Gallery
of Scotland p.86; National Trust Photographic Library pp.10, 52;
NTPL/Prudence Cuming pp.92, 101; NTPL/Andreas von Einsiedel
p.50; NTPL/Angelo Hornak pp.19, 51, 83; NTPL/John Hammond
front cover, pp.7, 15, 16–17, 21, 23, 24, 25, 27, 29, 31, 33, 35,
37, 39, 41, 43, 45, 47, 48–9, 53, 55, 57, 59, 61, 63, 65, 67, 69, 71,
73 (top and bottom right), 75, 77, 79, 80–81, 84–5, 87, 89, 93, 95,
97, 98–9, 103, 105, 107, 109, 111, 113, 115 (all), 116–17, 121,
123, 125, 127, 128 (top and bottom), 131, 135, 139, 141, 142, 145,
147 (all), 149 (top and bottom), 150, 151, 152, 153, 154–5, 159,
161, 163 (left and right), 164 (all), 165 (all), 167 (top and bottom),
169 (all), 171, 173, 175, 177, 179, 180, 181, 182, 185, 187, 189,
191, 193, 195, back cover; NTPL/Nadia MacKenzie p.2; NTPL/
Derrick E. Witty p.66; Museo del Prado pp.134, 138; Tate Gallery
p.91; Board of Trustees of the Victoria & Albert Museum p.28.

Frontispiece: The Cabinet at Felbrigg Hall

CONTENTS

AUTHOR'S ACKNOWLEDGEMENTS

This exhibition, and its catalogue, could never have come into being without the encouragement, help and co-operation of an enormous number of people, not all of whom can be mentioned by name. I owe the greatest debt, as the dedication of this catalogue indicates, to the work of my predecessor, Bobby Gore. I owe as much, but in a different way, to my secretary, Sarah Jameson, who has not only unerringly deciphered my labyrinthine manuscripts and reduced them to intelligible form on the word-processor, but has tenaciously pursued a vast miscellany of enquiries on my behalf, while preserving her patience and calm, even in the face of my occasional lack of either. I am grateful to all the Historic Buildings Representatives and their Assistants and secretaries, and to all the Property Managers, Administrators and their assistants, who have answered so many of the enquiries. I have had the greatest co-operation from Sarah Staniforth and Tina Sitwell, the Adviser and Assistant Adviser on Paintings Conservation, in ensuring that the pictures and their frames will be in a fit state to be exhibited, and in organising the necessary work to achieve this. From among those who have restored paintings and frames for the exhibition, I have had particularly illuminating discussions with Keith Laing (no relation!) and Zahira Veliz. Oliver Garnett provided drafts of the gazetteer entries, has been the patient editor of a laborious but copious author, and has shown a great capacity for taking pains. Lorna Simmonds has overseen the production of this catalogue with sensitivity and an eagle eye, and Cerys Byrne has organised the complex business of photographing the paintings for it.

The catalogue could never have been written without the use of a number of libraries, and the helpfulness of their staff: above all of the London Library, but also of the National Art Library in the Victoria & Albert Museum, the Witt Photographic Library, the British Library and the Print Room of the British Museum, and the National Gallery Library (to which its Director, Neil MacGregor, kindly gave me access).

Among those who have answered scholarly enquiries, I have a particular debt to the staff of the Rijksbureau voor Kunsthistorische Documentatie in The Hague, and to Gosem Dullaart in particular, who has not only looked up numerous questions relating to provenance, but has supplied me with photocopies of otherwise unconsultable sale catalogues. I have also had much useful information from Karen Schaffers-Bodenhausen, the Director of the Stichting Iconographisch Bureau in The Hague. I am enormously grateful to Chris Masters for shouldering a considerable burden of checking and locating references; it is only fair to him to say that any errors are my responsibility, not his. I am also particularly indebted for help in pursuing matters of provenance to Charles Sebag-Montefiore, whose library and whose memory are each mines of information; to Michael Hall, who has generously responded to repeated requests for information about pictures that have belonged to the English Rothschilds, in anticipation of his own book on them as collectors; to Jeremy Rex-Parkes, for giving me the run of Christie's priced and named catalogues; and to Burton F. Fredericksen, who has personally deployed the mighty resources of the Getty Provenance Index, to pursue particularly elusive points of ownership.

Individuals to whom I am grateful for answering – often rather rushed – scholarly inquiries (and I beg forgiveness from any whom, through oversight in the rush of writing entries, I have omitted) are: David Alexander; Brian Allen; Jaynie Anderson; Alessandra Anselmi; P. Bede Bailey, OP; Malcolm Baker; Carol Blackett-Ord; Sarah Bridges; Christopher Brown; David Carter; David Cross; Karl-Heinz Dräger; Judy Egerton; Mark Evans; Marion Fawlk; Gabriele Finaldi; Geoffrey Fisher; Clare Ford-Wille; Francis Greenacre; Antony Griffiths; David Hancock; Enriqueta Harris; Leslie Harris; Peter Hecht; Charles Hind; John Ingamells; Lady de l'Isle; Susan Jenkins; Evelyn Joll; Ronda Kasl; John Kenworthy-Browne; Sir Denis Mahon; Paolo Messina; Alison McCann; Sir Oliver and Lady Millar; Patrick Noon; Peregrine Palmer; Bruno Pons(†); Monica Preti Hamard; Aileen Ribeiro; William Robinson; Malcolm Rogers; Anne Rowell; Stella Rudolph; Julie Schofield; Libby Sheldon; Jacob Simon; Peter Sutton; Nicholas Turner; Marianne de Voogd; Clive Wainwright; Reinhard Wegner; Selby Whittingham; Catherine Wills; John Human Wilson; Marieke de Winkel; Karin Wolfe-Grifoni; Jeremy Wood; Lucy Wood.

Finally, ten years ago, when I made my acknowledgements for help and support in writing the catalogue of the *Boucher* exhibition, I ended with thanks to my wife for her patience and forbearance with a husband whose mind and body were so constantly elsewhere. The work on this catalogue has been, if possible, even more absorbing; all the less excusably, since it is now both she and our son whom it has taken me away from. I hope that it will not have left them with cause to think permanently of me as Aubrey related that William Oughtred's son Benjamin remembered him:

> He told me that his father ... studied late at night, went not to bed till eleven o'clock, had his tinder box by him, and on the top of his bed-staff he had his inkhorn fixed. He slept but little. Sometimes he went not to bed in two or three nights, and would not come down to meals till he had found out the *quaesitum*!

Alastair Laing

SPONSOR'S PREFACE

This exhibition offers a wonderful opportunity to view some of the treasures from National Trust houses. These paintings are never normally seen together, and here in the National Gallery you have a unique chance to make interesting comparisons both within the exhibition and also with the National Gallery's own collections, a few yards away. For myself, I am particularly fascinated to see the world of mid-Victorian banking recalled in George Elgar Hicks's sketch for *Dividend Day at the Bank of England*.

The Bank's sponsorship of *In Trust for the Nation* is the high point of a long relationship with the National Trust, which dates from 1923, when we were appointed the Trust's bankers. Recently, we have enjoyed sponsoring the Young National Trust Theatre, which will be staging *Very Big Thing!*, the first ever pantomime at the National Gallery, over this Christmas. This specially commissioned work brings to life not only the pictures in the exhibition, but also the issues surrounding the foundation of the Trust in 1895. Barclays' commitment to encouraging young people to enjoy the National Trust also includes support for *Trust Tracks*, the Trust's new newsletter for young members.

Barclays Bank is delighted to be helping the National Trust to celebrate its Centenary by sponsoring this fascinating exhibition. We hope you enjoy *In Trust for the Nation* and congratulate the National Trust on reaching its Centenary.

Andrew Buxton
Group Chairman, Barclays Bank PLC

Detail of Hicks, *Dividend Day at the Bank of England* (27)

FOREWORD FROM
THE NATIONAL GALLERY

A fortnight before the outbreak of the Second World War, part of the National Gallery's collection was evacuated to Penrhyn Castle, one of the few houses in Wales with doors high enough to take Van Dyck's huge equestrian portrait of Charles I. In the National Trust's Centenary year, and 50 years after the end of the war, we are delighted to be able to return the compliment by welcoming masterpieces from Penrhyn and 28 other National Trust houses to the Sainsbury Wing.

The National Gallery and the National Trust share an adjective, but are in many ways very different organisations: the one a metropolitan body funded by government to collect paintings of the highest quality from all over the world; the other an independent private charity with its heart in the British countryside, which, as Alastair Laing explains in his introduction, began acquiring important works of art almost by accident. Yet a strong common thread unites them. Both came into existence only thanks to the determination of a small group of enthusiasts. They are both deeply indebted to the generosity of private donors and to the financial support of such bodies as the National Art-Collections Fund and the National Heritage Memorial Fund. Throughout their histories they have owed much to many of the same public-spirited individuals, from Lords Crawford, Curzon and Bearsted, to Lord Rothschild, Sir Brinsley Ford, Nicholas Baring and Simon Sainsbury. Above all, they are united by a shared determination to provide the widest possible access to what they look after. This exhibition grows out of that commitment, offering visitors a chance to see some of the finest, but often least familiar, pictures in Britain during the winter months, when they are not normally on show.

Our principal debt of gratitude is to those who have given or loaned to the National Trust their pictures, from which this exhibition has been selected. The burden of making that choice and of writing the catalogue has fallen on the shoulders of the Trust's Adviser on Pictures and Sculpture, Alastair Laing, patiently assisted by his secretary, Sarah Jameson. We are also most grateful to Sarah Staniforth, Tina Sitwell, Margaret Reid and their assistants, who have prepared the pictures for exhibition and transport, working closely with the Gallery's own Conservation Department and Registrar.

During the war years, the Penrhyn estate provided a refuge for another national institution, Tommy Handley and the cast of *ITMA*. So it is perhaps appropriate that we should also offer a stage during the exhibition to the Young National Trust Theatre, which does so much to bring the Trust's properties alive for young visitors. The YNTT has flourished thanks to the generous and wholehearted support of Barclays Bank PLC, to which we are immensely grateful for sponsoring this exhibition. Without such financial backing, it would have been impossible.

Neil MacGregor
Director

FOREWORD FROM
THE NATIONAL TRUST

The National Trust's first provisional Council contained no fewer than five artists, including the renowned Victorian painter and sculptor G.F. Watts. It is good to see him represented here, and particularly by his portrait of Mrs 'Jeanie' Nassau Senior. For she was not only a close friend of Octavia Hill, one of the Trust's three founders, but also actively involved in her campaigns for better housing and education for all. In its Centenary year, the Trust is re-affirming its original social purpose, and at the same time looking forward through its growing educational programme, of which this exhibition forms part.

The National Trust's primary duty remains to maintain the countryside, coastline and buildings in its care. When the Trust took over Erddig in the early 1970s, the famous Servants' Portraits were in a pitiful state of decay. Two have been selected for this exhibition, and their present condition is a tribute to the patient efforts of the Trust's conservators. None of this vital conservation work can be done without funds, and that is just one of the many reasons why the Trust has launched a Centenary campaign to raise £20 million.

The Centenary is also a celebration of 100 years of achievement by the National Trust. I am sure that visitors will find the exhibition a thoroughly enjoyable experience and a worthy climax to the programme of Centenary events throughout England, Wales and Northern Ireland. I hope that it will also encourage you to seek out these and other pictures in the houses from which they have been borrowed.

In Trust for the Nation records not only four centuries of patronage and collecting in Britain, but also the Trust's continuing debt to those who have given it their houses, estates and collections. We are also particularly indebted to the Marquess of Anglesey, Lady Janet Douglas Pennant, the Earl of Powis and the Powis Estate Trustees, who have kindly agreed to loan paintings to the exhibition, and to those donor families who are foregoing the usual pleasure of living with pictures from their homes while they are closed. We are obliged to Cheshire and Staffordshire County Councils, who run Tatton Park and Shugborough, for agreeing to loan pictures from these houses.

The Trust is grateful to Neil MacGregor, who first suggested that this exhibition be held at the National Gallery, and to his colleagues at the National Gallery who have brought it to fruition. Van Dyck's *Stoning of St Stephen* from Tatton Park has been conserved and catalogued by members of the National Gallery's staff. Alastair Laing and many others at the National Trust have worked long and hard to make the exhibition a success.

The National Trust has enjoyed a happy relationship with Barclays Bank PLC for many years, particularly as the sponsor of the Young National Trust Theatre, and I am pleased to join Neil MacGregor in thanking Barclays most warmly for its generous sponsorship of this exhibition.

Sir Angus Stirling
Director-General

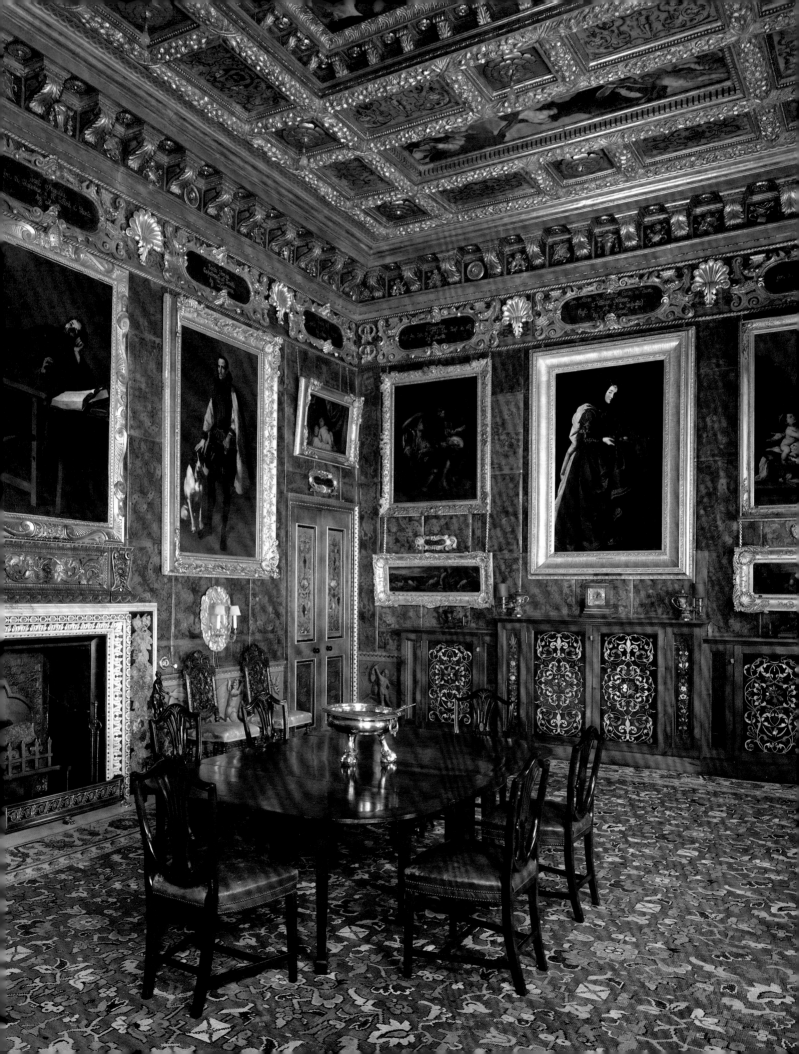

INTRODUCTION

'We are really establishing a great National Gallery of natural pictures,' proclaimed Canon Hardwicke Rawnsley at the meeting that formally proposed the establishment of a National Trust for Places of Historic Interest or Natural Beauty on 16 July 1894.[1] Another of the Trust's founders, Octavia Hill, often referred to the same idea in her speeches.[2] Yet nothing could have been further from their minds, than that the National Trust should actually own or show paintings.

The largest kind of inhabited building that the founders of the National Trust then thought it might need to rescue was the manor house; and manor houses did not, in general, have *collections* of pictures.[3] In any case, when it was first incorporated, the National Trust was neither concerned nor empowered to hold chattels of any sort.

A Country Houses Scheme was mooted only in the 1930s, when a few perceptive figures, notably the Liberal politician Philip Kerr, 11th Marquess of Lothian, saw that more than half a century of depressed agricultural rents, aggravated by over a generation of death-duties and progressive taxation, and – in some cases – the failure of heirs after the slaughter of the First World War, had already led to the destruction and dismemberment of numerous country houses, and threatened many more. A change in the National Trust's legal status was promoted, so as to make it possible for it to rescue and endow such houses with their chattels still intact. The National Trust Act of 1937 that extended its purposes in this way included a clause promoting 'the preservation of furniture, pictures and chattels of any description having national or historic or artistic interest'.[4] This particular clause appears to have gone through without debate.[5]

The National Art-Collections Fund had also been established, in 1903, but in its first 70 years, it saw its real business as preventing single masterpieces from going abroad, by raising the funds to acquire them for museums and public galleries in this country. Only in 1977 was the National Trust added to its list of potential beneficiaries, so that works of art might remain in the historic collections in the Trust's care. This came about thanks, above all, to the efforts of the NACF's then Chairman, Sir Brinsley Ford.[6]

The National Trust itself was perhaps slow to realise that it was becoming a significant owner and curator of paintings. Indeed, it sometimes seems – as Seeley said of Britain's acquisition of an Empire – as if it had done so 'in a fit of absence of mind'. When Lord Lothian himself bequeathed Blickling Hall to the Trust in 1940, he simply transferred with

Fig. 1 The Spanish, or Golden, Room at Kingston Lacy

it such pictures as happened to be there, a number of which belonged to – and still bear the numbers of – the historic collection of his chief Scottish seat, Newbattle Abbey.

In 1931 Montacute had been rescued, and presented to the National Trust, by Ernest Cook, grandson – appropriately enough – of the pioneer of the guided tour. But, though Cook himself formed an excellent collection of pictures and furniture, which he was to bequeath to the NACF to distribute on his death in 1955,[7] he did not buy any of the contents of the house offered by the widow of its last tenant, Lord Curzon, nor did he find other pictures to replace those sold in 1895 by its original owners, the Phelips family. Ironically, Cook's will, which directed that his own collection should just be distributed amongst the 'Public Galleries, Libraries, and Museums in England', took effect ten years after the National Trust had launched its appeal for furnishings for Montacute when it reopened after the war, and only four years after the industrialist Sir Malcolm Stewart had bequeathed his collection of pictures, furniture and tapestries to the National Trust 'for the adornment of Montacute House, in order that it may re-assume its former character as the stately home of an English gentleman, as distinct from the aspect of a museum'.

During the Second World War, Mrs Greville's surprising legacy of Polesden Lacey had come to the National Trust, and with it all her collections there and at her London house in Charles Street. They were to form a memorial to her father, William McEwan, who, with Scotch acumen, had laid the sound Dutch foundations of the collection (see cat. no.64). She had stipulated:

> That all my pictures and objects [*sic*] d'art in my house, No. 16 Charles Street, or elsewhere . . . shall be taken to Polesden Lacey and added to those already there . . . so as to form a Picture and Art Gallery in a suitable part or parts of the house.

It is hard to know what precedent can have been in her mind. It seems extraordinary that, in the dark days of 1942, she could have envisaged the kind of growth, whether in the membership of the National Trust, or of overall mobility, that would make such an aspiration a workable reality.

This bequest was followed by the comparable gifts of the Bearsted collections at Upton (see cat. nos.9, 19, 24, 65, 69) in 1948 and the Anthony de Rothschild collections at Ascott (see cat. nos.29, 39, 40, 41, 43, 62, 63) in 1949. In both cases, it was the quality of the collections rather than of the house (though the gardens were also an important factor) that determined both gift and acceptance. Yet the National Trust was still slow to recognise that it had acquired a new curatorial role. Advice on the pictures came originally, above all, from its Chairman,

Lord Crawford, a scion of one of the most remarkable kin-groups of connoisseurs in Britain.[8] He was Chairman of the NACF (of which his father had been one of the founders) between 1945 and 1970, and of the National Trust (1945–65), as well as Chairman of the Trustees of the National Gallery (1938–9, 1946–8), and he had originally lent a selection from his own inherited collection of pictures to Montacute, when he had been forced to give up Haigh Hall in 1946. Further counsel came from Ellis Waterhouse, Anthony Blunt, Ben Nicolson and the restorer Horace Buttery. Then, in 1948, Blunt, the Surveyor of the King's Pictures and Director of the Courtauld Institute, was appointed to the Trust's Historic Buildings Committee as Honorary Adviser on Pictures, with the intention that he (aided by his deputy, Oliver Millar, for English portraiture) would deal with questions concerning pictures.[9]

Only in 1956 did the National Trust appoint a salaried Technical Adviser on Paintings (the 'Technical' was later quietly dropped; the word 'Adviser' had been deliberately chosen, in that the day-to-day curatorial responsibility for the paintings – then as now – rested with the Historic Buildings Representatives in each region). This was St John ('Bobby') Gore,[10] who undertook the herculean task, of systematically cataloguing every picture in the houses that had come to the National Trust, and of instituting campaigns of conservation and restoration to cope with the great backlog of necessary work – always with the most slender financial resources. He also published a series of succinct but authoritative catalogues of five major collections in the astonishingly short period of as many years: of the Ascott Collection in 1963; the Bearsted Collection at Upton House, the Faringdon Collection at Buscot Park, and the Greville Collection at Polesden Lacey – all three in 1964, which represents an *annus mirabilis* of achievement – and the Saltram Collection in 1967. That catalogues of other major collections, such as those of Petworth, Stourhead and Knole, were not published, was not because he had not catalogued them, but because the Trust had by then come to take a more narrowly commercial view of the slender sales of the catalogues that had already been published. In addition, Gore wrote regularly on collections in the Trust's care for *Country Life*, and published a check-list of the major pictures in all National Trust houses in a special supplement to the April 1969 issue of the *Burlington Magazine*. He also organised exhibitions, or made contributions to exhibitions, of pictures from Trust houses: all in the endeavour – shared by the present exhibition – to make them more widely known. The most memorable of these was *The Art of Painting in Florence and Siena from 1250 to 1500*, not least because, in the number of pictures that came from private collections, and in the provenances of those from public collections, it was something of a valedictory to the distinguished British tradition of collecting in this field. Held at Wildenstein's in 1965, it was organised by Denys Sutton, but Gore wrote all the catalogue entries – only a year after his three catalogues of National Trust collections. To speak personally, for a moment, it was this exhibition, more than anything else, that determined me to become an art historian.

This remarkable bout of activity was slowed – but not

ended – when Gore was additionally appointed Historic Buildings Representative for the South-East, and then in 1973 promoted to be Historic Buildings Secretary, with overall responsibility for all the historic buildings, their contents and gardens in the care of the National Trust. He continued to be the Adviser on Paintings, but in 1974 appointed Hermione Sandwith (later co-author of the influential *Manual of Housekeeping*) to undertake the more detailed work of surveying the condition of the oil paintings in the Trust's care, and of organising campaigns of conservation, particularly *in situ*. She was succeeded in 1985 by Sarah Staniforth, who came from the National Gallery specifically as Adviser on Paintings Conservation (assisted since 1990 by Christine Sitwell). When he retired as Historic Buildings Secretary in 1981, Gore continued to act as Adviser on Paintings on a part-time basis.

Collections of paintings had continued inexorably to come to the National Trust: Attingham in 1953, Ickworth in 1956, Waddesdon in 1957 (though this has always been self-governing, pioneering regular conservation, and commissioning an exemplary series of catalogues from outside scholars), Tatton Park in 1960, Anglesey Abbey in 1966, Felbrigg in 1969, Knightshayes (though sadly shorn of its major pictures, which were left separately to the NACF, for allocation to national museums) in 1973, and Wimpole and Dunham Massey in 1976. Numerous houses were also given or left to the Trust with a complement of pictures, even if these did not exactly comprise a 'collection'. Then, after a pause, and the shock of the break-up of Mentmore in 1977, which led to the creation of the National Heritage Memorial Fund, came the remarkable legacy of Kingston Lacy with all its estates and collections (1982), followed by the NHMF- and NACF-aided acquisitions of Belton House (1984), Calke Abbey (1985) and Kedleston (1987), and their chattels. In the case of Belton, very sadly, the difficulty of raising the sums of money necessary to endow the house, garden and parkland was such that only a portion of its contents could be acquired, and the rest went to auction; but Calke came virtually lock, stock and barrel; and at Kedleston most of the historic contents of the State Rooms were secured. After this hectic round of acquisition, and with Gore's retirement from his part-time post in 1986, the National Trust once more appointed a full-time Adviser on Pictures (& Sculpture).

So much for the historic background to how the National Trust became, without really willing or intending it, second only to the Royal Collections in the number (some 8,500 oil paintings alone) and quality of the pictures that it looks after. Why, though, this exhibition?

From time to time, regret is uttered that National Trust houses are shut over the winter, and the suggestion is made that selections from their collections could helpfully be lent to museums during that period.[11] The same reasons that govern the shutting of the houses in winter militate against any such practice of seasonal loans on a regular basis. British country houses tend to have a higher degree of humidity than the accepted norm for museums and galleries. If they were to be kept open over the winter, they would have to be heated, for the comfort of visitors and of the devoted band of volunteer

room-stewards, without whom we could not open our houses at all. Heating would dry out the atmosphere, with deleterious effects on oils on canvas, and even worse effects on those on wood: causing paint to flake and panels to dry out and crack – only to expand again, and cause further flaking, when spring arrives, the heating is turned off, and the humidity rises. Similarly, the 'ideal' environment achieved by a museum is less than ideal for objects that have adjusted to the atmospheric fluctuations of a quite different environment, so that regular junketing between the two would only do them harm.

Despite this, the National Trust does try to respond positively to all reasonable requests to borrow pictures when its houses are closed, for exhibitions where only the real presence of that picture – and not simply some illustration of it – can represent a particular artist or visual point. So it does not seem unreasonable, just once in a hundred years, to mount our own exhibition of some of the finest pictures in our houses. Partly because there will be very few people who are able to visit all the properties from which they come; partly because – we must reluctantly admit – individual pictures in certain houses cannot always be seen properly across rooms, or under illumination lowered to protect even more light-sensitive textiles, drawings and watercolours (although, given due notice, arrangements can always be made for particular pictures to be seen more closely); and finally because – as even I did not fully appreciate until making the selection for this exhibition – it is almost impossible to form any idea of the wealth and variety of the collections in National Trust houses as a whole. It may be said that there is no need for any such idea to be formed or represented: that what matters, and what it is significant to see, is each collection in its own historic context. That is true, but it is only part of the truth. Any picture exists in a whole variety of actual or imagined contexts, so that our appreciation and enjoyment of it can change and be enhanced in each of those in which we actually see it – above all, through its juxtaposition with related pictures.

The attempt has therefore been made in this exhibition, rather than choosing each picture singly, on its own absolute merits, to select only those that could hang harmoniously together, in a set of freshly created contexts. Each room thus focuses upon a particular kind, or kinds, of painting; and each is intended to exemplify one strand of the patronage and collecting of art in Britain. Since such patronage and collecting provides the explanation for a picture being in a particular house, and is the *raison d'être* for its remaining there, the catalogue entries devote especial attention to the various collections through which the painting may previously have passed, and to the taste and character of the individual who was responsible for its presence there. Some attempt has also been made in these entries to allude to similar or related paintings in other National Trust houses, both to set the wider context, and to draw attention to the many pictures that there was no room to borrow. The gazetteer offers summary histories of the collections in the 29 houses represented in the exhibition.

The themes of the various rooms can be seen by glancing through the catalogue, where each has its own introductory section. Broadly speaking, the first two rooms, and half of the third, are devoted to the patronage or collecting of native artists, or of foreign artists working in Britain. The second half of the third room, and the other three rooms, are dedicated to the kinds of Old Master painting that were collected here, suiting the size and character of each picture to its particular room and companions.

We have excluded Early Italian or Netherlandish paintings. This is for conservation reasons above all, as most are on panels (which are particularly sensitive to changes of atmosphere), but also because there are only six exhibition rooms, and it would have been a little confusing to place somewhere in these, pictures that would have been the earliest to have been painted, yet which would generally have been among the last to have been collected. Similarly, we have again regarded it as of overriding importance that what is shown should hang together harmoniously, and so have made no attempt to be fair as between regions: Northern Ireland, Cornwall, the North-West and South Wales have no collection of pictures, properly so designated, in Trust care, nor any single picture that, within the constraints of the exhibition, seemed to cry out for inclusion. Nor have we tried to be purely representative in what is on show. Some four-fifths of the pictures in National Trust houses are native portraits, so, rather than show a representative – and consequently over-large – selection from these, the decision was taken to focus exclusively on two of the especial strengths of British portraiture as seen in country houses: the whole-length portrait and the conversation-piece.

That there is very little save portraiture dating from after the early 19th century is partly a reflection of the strengths of the particular collections that have come into the Trust's care, and partly because of the difficulty of hanging later with earlier pictures: this was the one constraint observed in many of the otherwise utterly eclectic hangs of the 19th century. Even the little Lagrenées from Stourhead ultimately fell by the wayside for this reason. Other pictures – such as the magnificent pair of Genoese portraits by Rubens at Kingston Lacy, or Stubbs's 'Hambletonian' from Mount Stewart – could not be hung at sufficient height and distance in the exhibition rooms of the Sainsbury Wing to do them justice. Another outstanding picture from Kingston Lacy, Sebastiano del Piombo's unfinished *Judgement of Solomon*, would have lacked a proper context, and has anyway already been lent to London, Cambridge and Paris in the last ten years. Without in any way seeking to exclude obvious choices, the preference has been given, wherever possible, to showing less familiar pictures, or those that have not been seen in London within recent memory.

It is to be hoped that this exhibition will be a revelation to everybody – both of the accumulated wealth of pictures in the houses of the National Trust, and of individual pictures within their manifold collections. Anybody who misses a cherished favourite has only to seek it out once our houses reopen. If the exhibition encourages visitors to make a point of going to our houses to look at the paintings in them, or to look at them with more attention when they do go, it will have done its work. And perhaps it will be seen that there is indeed another national gallery, of pictures as well as of landscape, within the care of the National Trust.

1 Thomas BARBER (Nottingham c.1768–1843)

Mrs Garnett

Oil on canvas. 89·5 × 69 cm (36 × 26 in)
Inscribed on stretcher twice: *By Barber/About 1800/No.32*
Kedleston Hall, Derbyshire

Mrs Garnett was housekeeper at Kedleston between 1766 and 1809. This is a surprising length of time for one who must have risen to this post from other duties, which perhaps accounted for her already seeming old in 1777. In that year she took Samuel Johnson and James Boswell around the house:

> Our names were sent up, and a well-drest elderly housekeeper, a most distinct articulator, shewed us the house. . . . We saw a good many fine pictures. . . . There is a printed catalogue of them which the housekeeper put into my hand; I should like to view them at leisure.[1]

Two years earlier, Mrs Garnett had made an equally favourable impression on William Bray: 'The uncommon politeness and attention of the housekeeper, who shewed it, added not a little to the entertainment.'[2] James Plumptre's ecstatic account in 1793 implies how different Mrs Garnett was from most of her kind:

> We entered the House at the Servant's Hall, by a door under the Portico, put down our names, and were then shewn up into the Grand Hall, where the Housekeeper joined us. Of all the Housekeeper[s] I ever met with at a Noblemans Houses [*sic*], this was the most obliging and intelligent I ever saw. There was a pleasing civility in her manner which was very ingratiating, she seem'd to take a delight in her business, was willing to answer any questions which were ask'd her, and was studious to shew the best lights for viewing the pictures and setting off the furniture.[3]

Recent cleaning has revealed that Mrs Garnett is standing where she greeted Plumptre – beside a fluted column of the Marble Hall designed by Robert Adam.

It was an important part of the business of house servants – and generally of the housekeeper – to show respectable visitors around notable houses. There are records of a party going to view Helmingham in Suffolk as early as 1657, and of perfect strangers being shown round Claydon in Buckinghamshire in 1681.[4] What was unusual was for the housekeeper herself to be painted – the portrait-shower portrayed.[5] (It was the identities of sitters in portraits, and the stories associated with them, that interested 18th-century visitors, not matters of attribution or iconography.)

The fallibility of such guides is obvious, and Horace Walpole, who was particularly interested in portraits, has many a cautionary tale about them. At Petworth in 1764 the 'Proud' 6th Duke of Somerset, 'having survived all the servants that were possessed of accurate lists of the paintings, . . . refused to grant new lists, or copies, to the new servants, so that when he died, half the portraits were unknown by the family.' It descended to low comedy at Wrest Park, Bedfordshire, in 1736: 'On the great staircase is a picture of the Duchess's [of Kent]; I said 'twas very like: "Oh dear, Sir", said Mrs. Housekeeper, "it's too handsome for my Lady Duchess; her Grace's chin is much longer than that."'[6]

The remedies against such ignorance were two-fold: to inscribe the identities of portraits on the pictures themselves (labels on frames are a 19th-century invention), as the most passionate portrait collectors did;[7] or to have a regular catalogue printed. At Kedleston from 1769 onwards there was such a guide,[8] which went through at least two more editions in the same format up until about 1790, to take account of the successive expansions of the collections. Mrs Garnett holds a copy of this catalogue, ready to 'put it into the hand' of the next enquiring visitor.

Although based in Nottingham, Thomas Barber had a considerable practice among the local aristocracy, and one by no means restricted to portraits of servants (though one of his finest performances is *Two Park Keepers at Wollaton*, painted for Lord Middleton). There are a number of portraits by him at Hardwick Hall in Derbyshire and Shugborough in Staffordshire, as well as at Kedleston, but it is *Mrs Garnett* who perhaps best exemplifies both his provincial honesty, and his sympathy with such a sitter.

HIST: presumably at Kedleston from the time that it was painted, c.1800; first recorded in the Wardrobe in 1849; among the contents of Kedleston purchased by the National Trust with the aid of a grant from the National Heritage Memorial Fund in 1987, when the house and park were given to the Trust by the present (3rd) Viscount Scarsdale.

LIT: *Kedleston* 1849, p.20 (also successive edns, and later gbks); *Kedleston* 1988, p.43, no.17, and fig. on p.42; Tinniswood 1989, pp.102–5, illus. p.105.

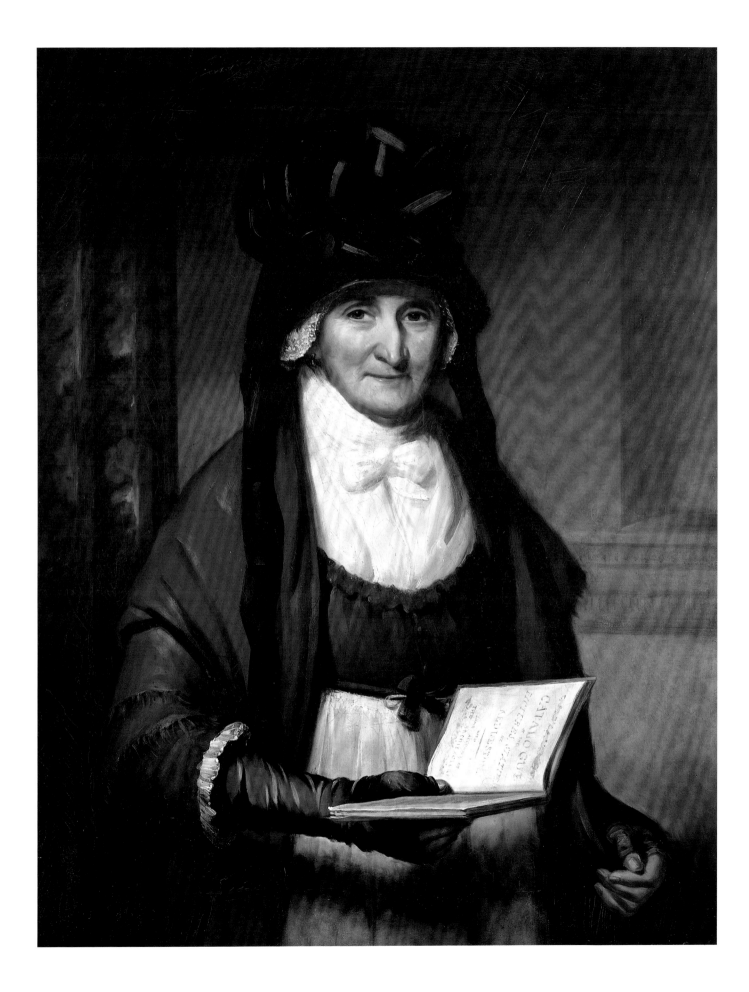

I
THE PORTRAIT GALLERY

It is appropriate that this exhibition should begin with a room of whole-length portraits. Halls and entrance halls were one of the three main traditional locations for portraits. As Sir Richard Colt Hoare said, justifying his gathering of all but the portraits in pastel at Stourhead into the Entrance Hall:

> Family portraits [are] a very appropriate decoration for the first entrance into a house. . . . They remind us of the genealogy of our families, and recall to our minds the hospitality, &c. of its former inhabitants, and on the first entrance of the friend, or stranger, seem to greet them with a *SALVE*, or welcome.[1]

The other traditional locations were dining-rooms (in which, again, ancestry was associated with hospitality, and where Colt Hoare gathered his pastels) and long galleries. Splendid arrays primarily of whole-lengths survive in the Ballroom (previously 'yᵉ great Dining Roome') at Knole, and in the Music Room at Plas Newydd, which was created as a dining-room in the guise of a medieval hall.[2] In the case of long galleries, however, it was not so much that portraits were seen as a particularly appropriate form of picture for such a location; rather, as the transference in the meaning of the word 'gallery' indicates,[3] long galleries were simply regarded as the most suitable part of a house or palace in which to display any paintings and sculpture. And, in England at least, painting was at first virtually synonymous with portraiture.

Nor were portraits in long galleries by any means exclusively, or even largely, full-lengths. At Hardwick, for instance, the long wall opposite the windows was originally reserved for tapestries, and there seems to have been room only for smaller portraits in the bays.[4] The present arrangement, of hanging portraits in three or four tiers on the tapestries, only goes back to the 5th Duke of Devonshire (1748–1811), who began the antiquarianising of the house in the latter part of the 18th century.[5] Yet, while Mytens painted *Thomas Howard, Earl of Arundel* around 1618, seated in front of one long gallery at Arundel House in London exclusively adorned with whole figures of Antique marble sculpture, he shows his *Countess* seated in front of the other, primarily calibrated by a succession of whole-length portraits.[6]

The proportions of full-length portraits were obviously particularly suited to those of such Elizabethan and Jacobean galleries. So too, when Philip, 4th Lord Wharton (1613–96)

Detail of Gainsborough, *Commodore Hervey* (8)

created one of the very first purpose-built picture galleries recorded in England, at Wooburn after 1658, he clearly intended it primarily to house a magnificent array of whole-lengths: ladies (in particular) by Van Dyck, and subsequently Garter Knights by Lely.[7] Generally, by the 1660s, however, three-quarter-lengths (in the standard 50 × 40 inch canvas size popularised by Lely) had become the regular adornment of galleries whose proportions were also broader and less elongated than those of Elizabethan and Jacobean times. Who can forget the effect of the array of three-quarter-length portraits in the galleries of Ham House, Chirk Castle or Althorp?

Whole-lengths alone have been chosen to adorn this first room, partly for effect, but partly because only such a self-denying ordinance could prevent the exhibition being swamped by portraiture. Probably about four-fifths of the pictures in houses in the care of the National Trust are portraits. That is partly a reflection of the original historical reality: not every gentry house had a picture collection (though, by the mid-19th century, few such houses were without at least a token collection of Old Masters), whereas every house had an accumulation of portraits. As the abbé Le Blanc observed in 1745, after more than a century of already vigorous portrait painting: 'Portrait-painters are more and worse in London today than they have ever been. . . . It is amazing how fond the English are of having their pictures drawn.'[8] When, in later years, money had to be raised to keep a family or an estate going, it was subject-pictures rather than portraits that – along with libraries and plate – were among the first things to be sold. So it is in this somewhat depleted state, with an over-preponderance of portraiture, that most collections have come into the care of the National Trust.

Nor were portraits themselves always exempt from such a fate: it was unfortunate for old collections that, first of all, dealers such as Charles and Asher Wertheimer saw that fine portraits by artists such as Van Dyck, Reynolds, Gainsborough and Romney (which had to some degree been created in conscious or unconscious flattery of the élite of the day, or of those who sought to emulate it) could be deftly transferred from old landed families in difficulty to members of a burgeoning plutocracy anxious, not merely to surround themselves with fine things, but with portraits that would somehow, by association, perform the same function for their new owners. And it was particularly unfortunate for British collections that the astute Joseph Duveen realised that the 18th-century French boiseries and furniture that he was selling to the 'squillionaires' of the United States could be perfectly complemented, by Reynoldses, Gainsboroughs, Romneys, Hoppners, Beecheys and Lawrences, which combined the stylishness that his clients craved with a rendition of personality that made their sitters seem approachable. Even so, however, glamour seems to have won out over character, at least for the buyers, who were readier to pay large sums for beautiful women by Gainsborough, masterful men by Reynolds, or swagger portraits of either sex by Lawrence, than for the staider but often more penetrating portraits of the other sex, or by other artists, that families hung on to.

It may have been such reasons, or just accidents of history,

that account for the fact that there seemed to be no Lawrence whole-length in any National Trust house that cried out for inclusion in this gallery.[9] Nor has any whole-length female portrait by Gainsborough been chosen, since neither that of *Caroline Conolly, Countess of Buckinghamshire* (1784; Blickling), nor the supposed portrait of *Lady Mary Bruce, Duchess of Richmond* (Ascott) seem outstanding of their kind, although the latter was an example of just such a transfer from the new wealth of the 18th century (Conolly) to the new wealth of the 19th century (Rothschild). All would have been very different had it been possible to borrow from the greatest Rothschild house of all – and the finest collection of 18th-century English whole-length portraits in the country – Waddesdon Manor: but the terms of the Rothschild bequest to the National Trust preclude any outward loans.

The greater scale of houses and rooms in the 19th century meant a continuing demand for whole-length portraits, but the insistence upon respectability may also have made these less striking. Perhaps for this reason, there was something of a dip in the recent *Swagger Portrait* exhibition at the Tate Gallery, where the mid-19th century was represented. Regrettably, there is no full-length in a National Trust house by either of the two artists chosen and best qualified to bridge it: the showy foreigner, Franz Xaver Winterhalter, and the Scottish PRA, Sir Francis Grant, who always had an un-English facility in his sheer manipulation of the brush. The artist who represents the mid-century here, G. F. Watts (cat. no.14), was always (until virtually canonised in his old age) something of an outsider, just as his sitter, *Mrs Nassau Senior*, was no conventional society figure – any more than was *Mrs Ronald Greville* (cat. no.15), whose portrait (again, tellingly, by a foreign artist) closes the century. There are two oil portraits by J. S. Sargent in National Trust houses, *Nancy, Lady Astor* (Cliveden) and *Ethel, Lady Knaresborough* (Lyme Park), but neither is a full-length and the latter is uncharacteristically dull.

For the 20th century, sadly, a virtual blank. Although portraiture continues to flourish in Britain to a degree unknown on the Continent, the clients are more often institutions than individuals, particularly for portraits on any scale. The swagger tradition of the whole-length, in particular, has been disrupted. And perhaps those whose altruism, or fears for the future, persuaded them to give their estates or houses to the National Trust were less likely than most to have themselves so portrayed.[10] The balance of power between artist and sitter has also shifted decisively in favour of the former, for whom the taking of a likeness has been only a pretext. Sickert's portraits of two donors to the National Trust, a whole-length of *Gavin, 2nd Lord Faringdon* (Faringdon Collection Trust) and a three-quarter-length of *Teresa, Lady Berwick* (Attingham Park), both relied on photographs for that aspect. Despite this, the sitter in the latter always maintained that it was not a good likeness, and that anyway: 'No one could call it a portrait, it is a fantasia in a characteristic subdued colour scheme' – as the artist's title for it, *Lady in Blue*, indeed confirms.[11]

Fig. 2 David Cox, *The Long Gallery at Hardwick Hall*

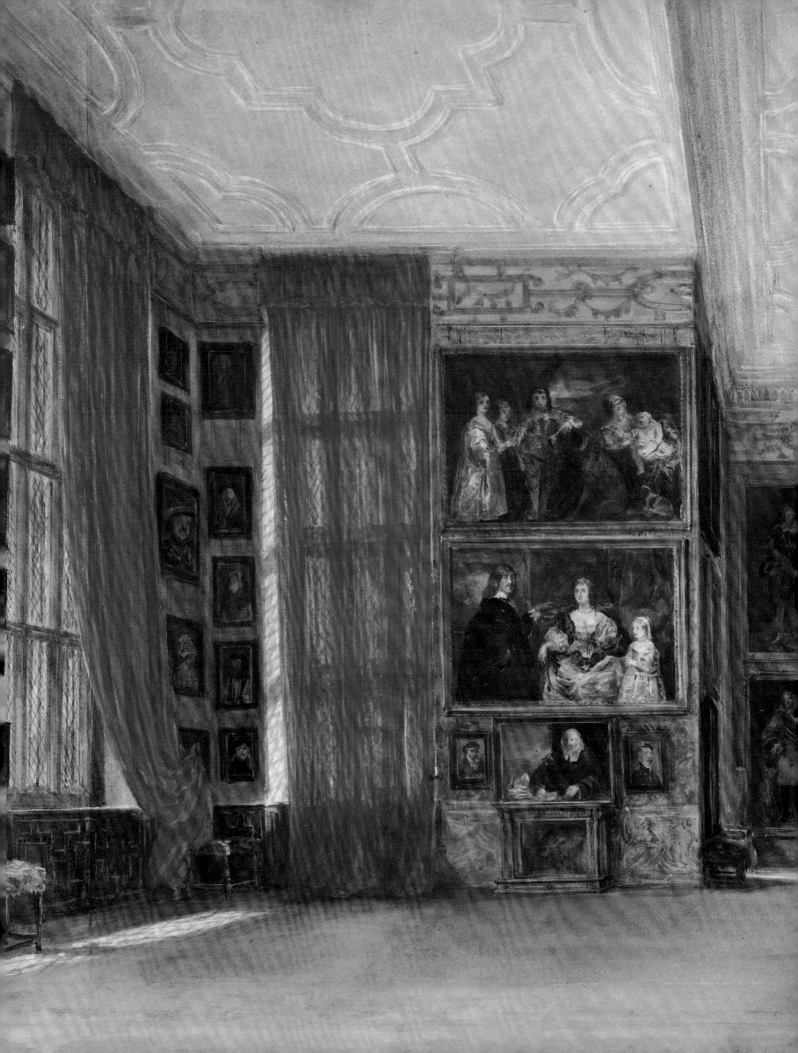

2 Sir Anthony VAN DYCK (Antwerp 1599 – Blackfriars 1641)

Sir Robert Shirley (c.1581–1628)

Oil on canvas. 210 × 133.5 cm (79 × 52½ in)
Inscribed in yellow, bottom left: S*. Robert Shirley*
Petworth House, West Sussex

Robert Shirley was one of the more exotic of the adventurers who carved out a career for themselves in the disturbed world of the early 17th century. He was the third son of Sir Thomas Sherley or Shirley (1542–1612), Treasurer-at-War in the Low Countries, and builder of the great mansion at Wiston, West Sussex. Sir Thomas's financial débâcle in the 1590s forced all three of his sons to seek their fortunes abroad. In 1598/9 Robert accompanied the second, Sir Anthony (1565–1635), on a mission on behalf of the Earl of Essex to Ferrara, and then to Persia, where he remained behind and married a Circassian Christian noblewoman, Teresia Khan.[1] In 1607/8 he left Persia to negotiate alliances with European princes against Turkey on behalf of Shah Abbas the Great. He was well received by Sigismund III of Poland and Pope Paul V, and was first knighted, then created a count palatine, by the Emperor Rudolph II.

Shirley was in England from 1611 to 1612/13, but found his mission opposed by the Levant merchants. He began a second series of missions at the end of 1615, and spent from 1617 to the summer of 1622 in Spain; on 22 July he arrived in Rome, where he was received as Persian Ambassador by Pope Gregory XV.[2] While in Rome he encountered Van Dyck, whose 'Italian' sketchbook contains a whole set of quick pen sketches of Shirley, his wife and his suite.[3] That of the envoy himself, showing him full figure but in profile, is inscribed '*Ambasciatore di Persia in Roma*', with the colour notes '*drapo doro*' and '*le figure et gli foliagi de colori differenti de veluto*'. That of his seated wife, inscribed '*habito et maniera di Persia*', seems more consciously a sketch for her portrait (also at Petworth), as its landscape setting is also included. Nevertheless, the sketches tend to suggest that Van Dyck was originally just struck by the Shirleys and their suite as exotic phenomena, and that the portraits of Sir Robert and his wife were not commissioned until later. His training with Rubens had sharpened his eye for the enriching effect that colourful oriental dress could offer. He may even have known Rubens's *Nicolas de Respaigne* (Wilhelmshöhe, Kassel), which used exotic colour in this way. He had also recently begun to absorb the lessons of Titian and the other great Venetian colourists.

By 1607 Shirley was already sporting Persian dress 'with a great turban', and, as Thomas Fuller later said: 'He much affected to appear in foreign vests, and as if his clothes were his limbs, accounted himself never ready till he had something of the Persian habit about him.'[4] He is shown here wearing a tunic embroidered with gold and silver thread, and a cloak of cloth of gold, richly embroidered with oriental figures and flowers. The bow and arrow may be a Persian token of gentry status, akin to the European sword.

But who commissioned these portraits, when, and what became of them? It seems most likely that Shirley himself had them painted before his departure from Rome on 29 August 1622, but it is not clear whether the pictures accompanied him to his next post as Persian Ambassador to the Court of James I in London. While in England, he was painted, again in Persian costume, for another whole-length (Berkeley Castle, Glos), which might suggest that the Van Dyck was not available for copying. On the other hand, it may have been its presence in England that stimulated the East India Company in 1626 to commission Richard Greenbury to paint the rival Persian envoy, Nakd Ali Beg, in a similar cloak.

Shirley quarrelled with Beg to such an extent that the King sent both of them packing in 1626. He died back in Persia two years later, under the mistaken belief that he had lost the Shah's favour. The portraits seem to have remained with Shirley's widow, who retired to the convent attached to S. Maria della Scala in Rome, where she died in 1668.[5] They may have been seen in Rome by G.P. Bellori around this time. The description in his life of the artist (1672) – '*nell' habito persiano, accrescendo con la vaghezza de gli habiti peregrini la bellezza de' ritratti*' – could suggest that he knew them from personal inspection.[6] They were very possibly imported to England from Italy in the 18th century, and bought by the 2nd Earl of Egremont (1710–63), as one of his numerous acquisitions of pictures on the art market.

HIST: first recorded in the Green Drawing Room at Petworth in 1764, and there in successive inventories and catalogues (and visible in Turner's gouache of what was by then called the Red Room: Turner Bequest CCXLIV–21) until 1856 and probably after, but found in a bedroom by Blunt (1980, p.125) in 1952; thence by descent; transferred in lieu of death-duties in 1956 (the first ever such arrangement) to HM Treasury, by which conveyed to the National Trust.

ENGR: by O. Birrell after a drawing by W. Gardiner, 1799, for Adolphus's *British Cabinet*, i, no.6; the head-and-shoulders (probably via the foregoing), by R. Cooper, for *The Three Brothers*, 1825.

EXH: *Artists in 17th Century Rome*, Wildenstein, London, 1955, no.38 (seminal entry by Denys Sutton); *Van Dyck*, Agnew's, 1968, no.17; *Van Dyck in England*, National Portrait Gallery, 1982–3, no.4; *Anthony Van Dyck*, National Gallery of Art, Washington, 1990–91, no.28.

LIT: Bellori 1672, p.255; Dallaway 1819, p.321, no.8; Smith 1831, iii, p.154, no.545; Waagen 1854, iii, p.40, no.10 (where considered 'too feeble in drawing and too heavy in colour for van Dyck'); Cust 1900, p.243, no.117; Cust 1902, pp.17–18, pl.xxii; Collins Baker 1920, p.28, no.96; Vaes 1924, pp.202–3, 223–30; Glück 1931, p.577, no.510 (there reproduced for the first time); Adriani 1940, pp.56–7; van Puyvelde 1950, p.162; for subsequent literature, see exh. cat., 1990–91, nos.28, 29.

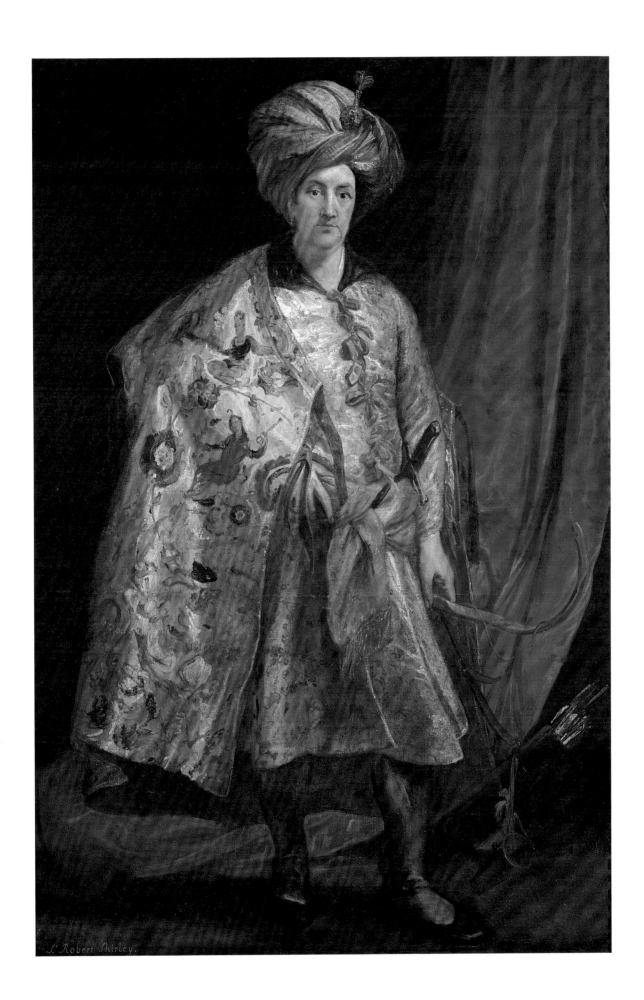

Sr. Robert Shirley.

3 Sir Anthony VAN DYCK (Antwerp 1599 – Blackfriars 1641)

Lady Frances Cranfield, Countess of Dorset (c.1623–87)

Oil on canvas. 187 × 128 cm (73½ × 50½ in)
Knole, Kent

This is one of the loveliest of Van Dyck's portraits of young women, even though from midway in his English career, when some of its elements were derived from stock, and their execution may have been partly delegated to his studio assistants. What is particularly effective is the way in which this attractive and marriageable young daughter of a fallen minister and nobleman is shown in all her finery, her hair fashionably dressed, but in a 'wilderness' setting, with nothing but her gauzy veil to bridge the gulf of unreality between the costume and the context. It all suggests the 'careless Romance' of dress that William Sanderson was later to single out as one of Van Dyck's most distinctive contributions to English female portraiture.[1] The rocks not only set off the sitter's softness and delicacy with their rough hardness, but provide the perfect isolating foil for her bust. It is not exactly an Arcadian portrait[2] – there are none of the traditional appurtenances of the shepherdess – but the setting effectively removes the sitter from the real world to place her in the context of the pastoral poetry of the day:

> Farewell
> Sweet Groves to you;
> You Hills, that highest dwell;
> And all you humble Vales, adieu;
> You wanton Brookes, and solitary Rockes.[3]

Van Dyck may indeed have intended to imply that she was taking leave of the natural life of a girl for that of a woman, caught up in the artifice of the Court, since it seems most likely that it was painted just before her marriage (probably in early 1637)[4] to Richard Sackville, Lord Buckhurst, later 5th Earl of Dorset (1622–77). It certainly appears to have been painted close in time to Van Dyck's portrait of her niece, *Lady Anne Carey, Viscountess Clandeboye, later Countess of Clanbrassil* (Frick Collection, New York). The latter bears a later inscription dating it to 1636, but may in fact have been painted just before Lady Anne's marriage to James Hamilton, Viscount Clandeboye, in November 1635. A bill from the painter-dealer George Geldorp to Lady Frances's father, Lionel Cranfield, 1st Earl of Middlesex, includes the sum of £6: '*pour une bordure fort Riche pour le Portraict de Madame ffransis Coppie*'.[5] This style also strongly implies that Lady Frances was not yet married.

The marriage was to be particularly significant for Knole and the Sackvilles. For, on the death of her brother in 1674, Frances inherited the estates of their father, which included Copt Hall in Essex. From here in 1701 came the Cranfield family portraits, much important furniture and the copies of the Raphael Cartoons in the Cartoon Gallery at Knole.

The setting was evidently thought so apt or evocative that Van Dyck used it for a third female sitter, *Lady Isabella Rich*, who married Sir James Thynne.[6] Yet he also employed it for a male sitter, *James Hamilton, 3rd Marquess and later 1st Duke of Hamilton*,[7] which is thought to have been painted as late as 1640. In that, the rocks instead reinforce the adamantine message conveyed by the full suit of armour worn by the sitter, donned because of the Scottish Wars.

It is always perilous to make assumptions about picture frames, but this seems to be the original. That makes Geldorp's bill of particular interest, since it probably denotes this too as a closely datable example of what might be called a 'pre-Sunderland' type of frame. Other examples, more scrolly and probably slightly later, are found on some of the portraits at Ham House.[8] They are distinguished from true 'Sunderland' frames by the lack of auricular ornament, and by the corner ornaments, which are a cross between pomegranates and fleurs-de-lis. To have a Van Dyck still in the frame originally made for it is a phenomenon of enormous rarity.

At least eight copies of this portrait are known, including one in the Royal Collection, first recorded in the inventory of James II,[9] in addition to miniatures done from it. Lely's very interesting adaptation of it to the portrait of a '*Miss Ingram*' (Temple Newsam, Yorks) includes a leaping King Charles spaniel borrowed from Van Dyck's *Lady in Blue (?Lady Penelope Wriothesley, Lady Spencer)* (Tate Gallery).

HIST: by descent at ?Copt Hall until ?1701, and then by descent at Knole, until accepted by HM Treasury in lieu of tax, and conveyed to the National Trust in 1992.

EXH: *Fair Women*, Grafton Galleries, 1895, no.84; *Exhibition of Works by Van Dyck*, RA, winter 1900–1, no.64; Averell House, New York, 1932 (cf. *Art News*, xxx, 1932, p.6); *Twenty Masterpieces*, Knoedler, London, 1935, no.20; *Van Dyck tentoonstelling*, Koninklijk Museum, Antwerp, 1949, no.68.

LIT: Vertue ii, p.50; Smith 1831, iii, pp.107–8, no.378; Waagen 1857, p.339; Cust 1900, pp.125, 274, no.78; Schaeffer 1909, p.408; Phillips 1929, i, p.434; ii, pp.406, 416; Glück 1931, p.409; van den Wijngaert 1943, pp.161–2, pl.58; Larsen 1980, ii, no.874 (and under 873): '*Si tratta di un opera autentica, e non … di un imitatore … E da presumere che lo scenario di fondo fosse di proprietà della bottega, dato che fu spesso ripetuto. … Databile al 1636*'; Larsen 1988, no.816, i, p.385, fig.432, ii, pp.321–2, as the autograph original datable to c.1636 (5 copies are listed as A207/1– 207/5, ii, p.481).

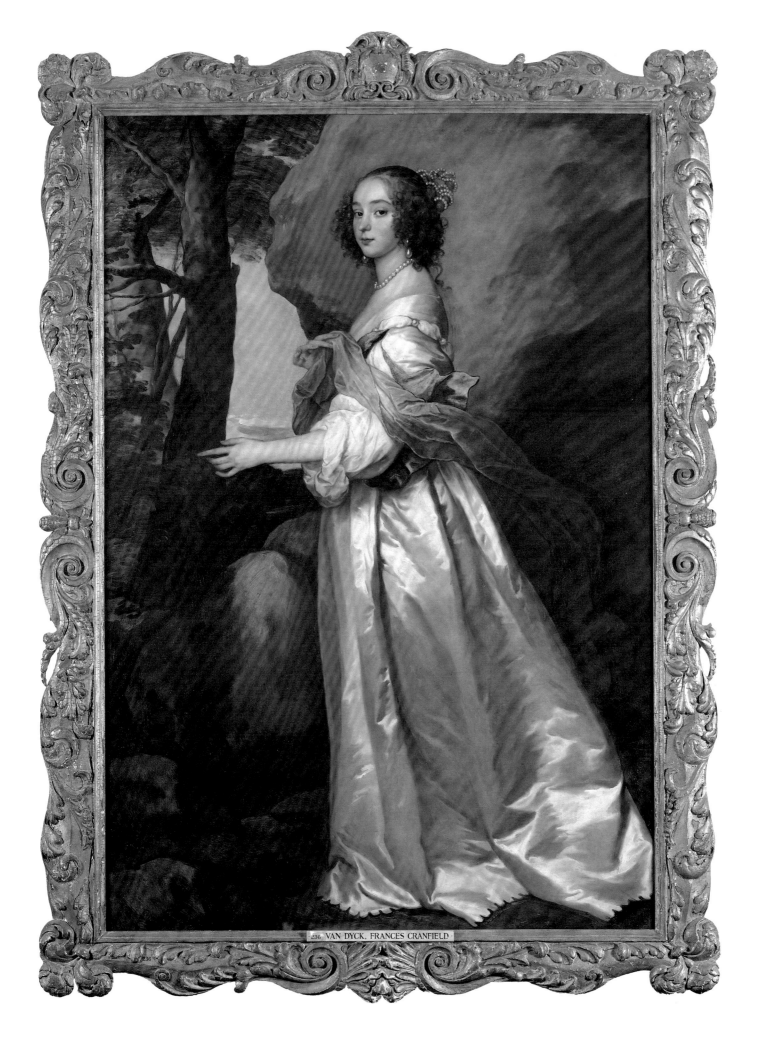

236 VAN DYCK, FRANCES CRANFIELD

4 Jacob HUYSMANS (Antwerp c.1633 – London c.1696)

Lady Elizabeth Somerset, Countess and later Marchioness/Duchess of Powis (c.1633–91)

Oil on canvas. 238 × 147 cm (93¾ × 58 in)
Powis Castle, Powys

This picture represents the *ne plus ultra* of Baroque portraiture in Britain. As such, it is highly appropriate for a woman whose Catholic marcher lord of a husband, William, 1st Earl of Powis (c.1626–96), was successively to be created Marquess, Knight of the Garter, and Duke (in exile), by James II. Her even mightier brother, Henry, 3rd Marquess of Worcester and 1st Duke of Beaufort (1629–99), manifested at Badminton 'a princely way of living . . . above any other, except crowned heads, that I have had notice of in Europe, and in some respects greater than most of them'.[1]

Lady Elizabeth was the younger of two daughters of the magnate, inventor and ardently Catholic Royalist, Edward, 2nd Marquess of Worcester (1601–67), and his first wife, Elizabeth Dormer. When she was younger, she was painted by John Michael Wright, who included a countess's coronet on a table, probably to celebrate the conferral of an earldom on her husband in 1674.[2] Contrary to what is usually stated, the present portrait is appreciably later in date, as emerges both from the greater age of the sitter, and from Huysmans's extraordinarily free handling of paint. Tempting though it is to suggest that it marks her elevation to Marchioness in March 1687, the absence of any coronet in celebration of so new and so rare an honour makes this unlikely. The Cupid bearing a dish of fruit that includes a conspicuous pomegranate (emblem of fertility) might have been taken as a symbolic reference to the birth of James, Prince of Wales, on 10 June 1688, when she was appointed Governess to the Royal Children. The picture was certainly painted before that, but, in view of other pregnancies of James II's consort, Mary of Modena, that did not reach their term, may have anticipated such an event.

The Roman Catholic Huysmans had absorbed the Baroque style in Antwerp and arrived in England in 1662, where he became established in royal circles as Lely's chief rival. He was much patronised by Charles II's queen, Catherine of Braganza,[3] but Mary of Modena generally preferred another Catholic artist, Benedetto Gennari.[4] When Catherine retired to her house and convent in Hammersmith after Charles II's death in 1685, Huysmans was free to look for other clients. His Catholic faith and royal service must have both been recommendations. Indeed, the leaping dog may allude to Lady Powis's fidelity to her mistress, Mary of Modena, whom she was to follow into exile at St Germains, with the overthrow of James II in 1688. The animal's pose is borrowed from Van Dyck's *Lady in Blue (?Lady Penelope Wriothesley, Lady Spencer)* (Tate Gallery). Mary of Modena

is also shown holding just such a dog in two of Lely's portraits of her.

It is probably the fact that this portrait is a celebration of Lady Powis's status in relation to the Queen that accounts for there being no portrait of comparable scale or grandeur of her husband at Powis. Or else, if any such was painted, it may have been lost through the neglect of George, 2nd Earl of Powis of the 2nd creation (1755–1801).[5]

HIST: by descent at Powis.

EXH: *The Age of Charles II*, RA, 1960–61, no.55, p.24, pl. vol., p.17 (rectifying the previous misidentification of the sitter as Catherine of Braganza); *The Swagger Portrait*, Tate Gallery, 1992–3, no.14.

LIT: Steegman 1957, i, p.263, no.22 (as 'called *Catherine of Braganza*' and 'perhaps by P. Mignard'); *Powis Castle* 1987 (*Catalogue of Pictures*, supplement), p.13, no.80 (as painted c.1665–70); 1989 (integrated), p.76, no.80.

Fig. 3 John Michael Wright, *Lady Elizabeth Somerset, Countess of Powis* (c.1674; Powis Castle)

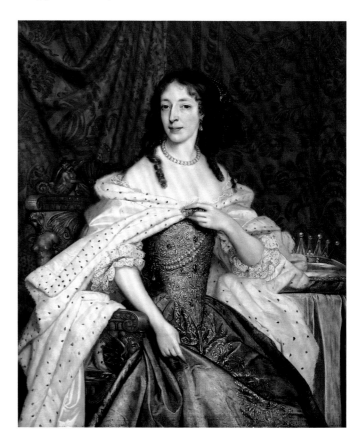

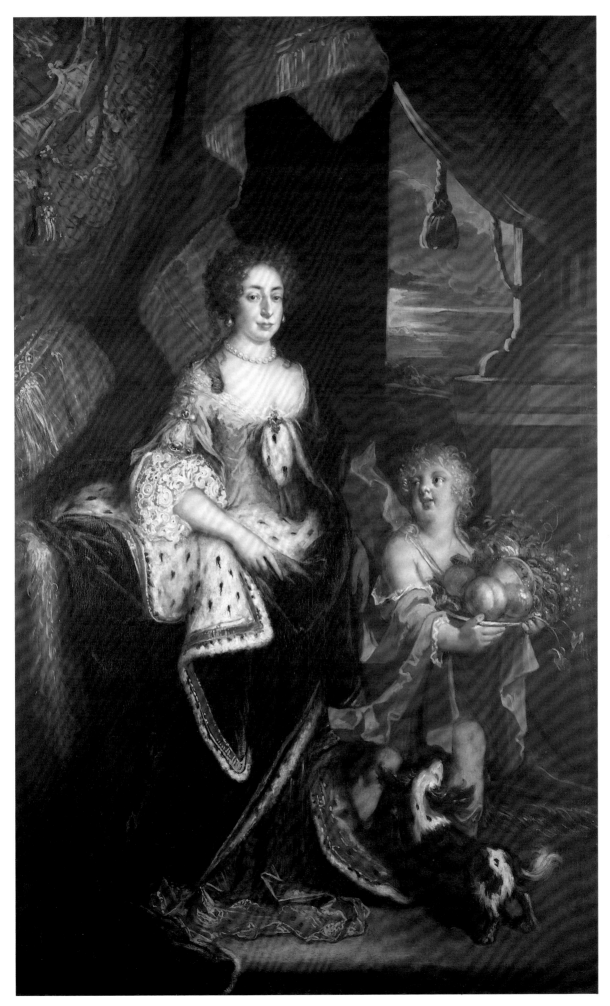

(Before restoration)

5 Attributed to Sebastiano BOMBELLI (Udine 1635–1719)

Roger Palmer, Earl of Castlemaine (1634–1705), and his Secretary

Oil on canvas. 194 × 147 cm (76½ × 57½ in)
Inscribed bottom right: *An: Do/1664/Venetia*; on folded
letter: *To/the Hon.^{ble}/William Herbert/[Earl of Powis* added
in a later hand]; and on back of 19th-century [?] lining-
canvas: *Roger/EARL OF CASTLEMAINE*
Powis Castle, Powys

History is rarely kind to cuckolds, particularly when they
appear to have connived at their own cuckoldry. Roger
Palmer was – by some accounts – a short, unprepossessing
man of slender fortune, despite which, Barbara Villiers
(*c.*1641–1709), only daughter of William, 2nd Viscount
Grandison, agreed to marry him in 1659, because already
compromised by a previous liaison. Palmer's 'gay wife' soon
became the mistress of Charles II, who created him Earl of
Castlemaine in 1661 in order that she should have a title.
Shortly afterwards Castlemaine declared himself a Roman
Catholic, and, following a dispute with his wife and the King
over the Anglican re-baptism of their first male bastard,
Charles Fitzroy (later Duke of Southampton), he went
abroad in 1662 or 1663. From 15 April to 20 October 1664 he
accompanied Generalissimo Andrea Cornaro's expedition to
the Levant, but saw no action, publishing *An Account of the
Present War between the Venetians & Turk; with the State
of Candie: (in a Letter to the King from Venice)* in 1666.
From the place and date inscribed on the picture, and from
the background scene, it would appear to be that expedition
that is alluded to, and it may even be his very letter to the
King that he is seen dictating.

To determine the actual artist of the picture is not entirely
straightforward. In Venice in 1664 the ageing Nicolò Renieri
(Regnier), Gerolamo Forabosco and Daniele van den Dyck
were all capable of turning their hand to portraiture, while
Giulio Cirello was producing portraits in nearby Padua.
Sandrart reveals that 'there was scarcely any great man
living within reach, or who visited Venice from abroad,
whose likeness was not painted by Bombelli'.[1] Sebastiano
Bombelli was to achieve such fame as a portrait painter in
Venice that he was also to be invited to courts elsewhere in
Italy and north of the Alps. However, he did not arrive in
the city until around 1660, and was certainly absent from it
in 1663, and possibly for some time afterwards.[2] His first
datable portrait, of *Benedetto Mangilli* (1665), is more
modest.[3] That which appears to have the most in common
with the present portrait in both handling and approach –
The Avogadori Pietro Garzoni and Francesco Benzon[4] –
was apparently not painted until 1683–4. None the less, of
all the artists above, only Bombelli would seem to have been
capable of painting this.

In its somewhat gauche interweaving of so many different
strands, this is very much a young man's picture. The

inclusion of the secretary was clearly suggested by Titian's
Georges d'Armagnac with Guillaume Philandrier,[5] which
Bombelli presumably knew from a copy, since the original
had been in England since 1624. The dramatic treatment
owes much to the portraits that G.B. Carbone must have
painted during his sojourn in Venice in the 1650s. The
standing pose is indebted to the portraits by Sustermans that
Bombelli is believed to have studied in Florence. Finally, the
virtuoso rendition of the heap of glinting armour, of the
brocades of the tablecloth and vest, and of the distant view,
all reveal a youthful desire to show his varied skills.

The Earl of Castlemaine will have been the more alert to
the virtuosity of the artist, in that his father, Sir James
Palmer of Dorney Court, Bucks, had been an amateur
limner, collector, adviser to Charles I on his collection, and
a governor of the Mortlake tapestry works. Castlemaine
himself is said to have been given the *Wilton Diptych*
(National Gallery) by James II, in reward for his lavish, but
futile embassy to Rome in 1685/6–7,[6] though it too seems
more likely to have been acquired by his father in some
exchange with Charles I. His mother was a daughter of the
1st Baron Powis, grandfather of the addressee of the letter on
the table; and he spent some of his latter years as part of the
household of these fellow-recusants. He had no offspring,
so it is probable that he either bequeathed or (in view of the
inscription on the letter) had already given this picture to
his cousins.

HIST: either given by the sitter to his cousin, William Herbert, 3rd Lord
Powis, 1st Earl, Marquess and Duke of Powis (*c.*1626–96), or
bequeathed to the latter's son, William Herbert, 2nd Marquess of
Powis (*c.*1665–1745); by descent at Powis (apparently first recorded in
1886); accepted in lieu of tax by HM Treasury in 1961; conveyed to the
National Trust in 1991.

EXH: 1st National Portrait Exhibition, 1866, no.1015 (as 'dictating to
his secretary, *Nicholas* Wright'[7]); *British-born Artists of the 17th
Century*, Burlington Fine Arts Club, 1938, no.23; *Age of Charles II*,
RA, winter 1960, no.77 (as 'Venetian School', but with a suggestion
that Bombelli might have been the artist).

LIT: Lionel Cust, 'Palmer, Roger', *DNB* (as 'in a red cloak and large
wig'); Collins Baker 1912, i, p.194 (as painted by J.M. Wright in Italy);
Steegman 1957, i, p.264, no.24 (as 'Venetian 166–', and saying that the
date had recently been discovered by Oliver Millar, the picture having
been previously thought to have been painted in 1686) *Powis Castle*
1987 (*Catalogue of Pictures*, supplement), p.5, no.31, and fig.
(as 'Venetian, 17th century', and dated 1665); 1989 (integrated), p.68,
no.31, and fig. (as 'Attributed to Sebastiano Bombelli', giving
inscription in full).

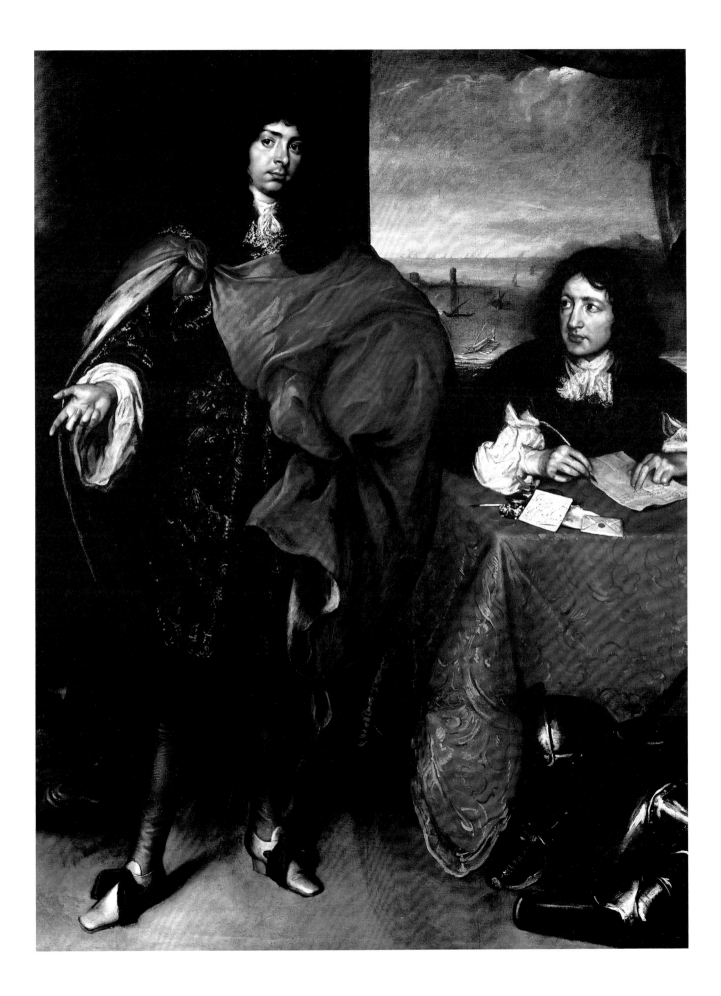

6 Sir Godfrey KNELLER, Bt (Lübeck 1646/9 – London 1723)

Dorothy Mason, Lady Brownlow (1664/5 or 1666/7–1699/1700)

Oil on canvas. 239 × 142 cm (88 × 45 in)
Inscribed in gold bottom right: *LADY BROWNLOWE WIFE
TO Sᴿ Wᴹ/& MOTHER TO LORD TYRCONNEL./
G KNELLER FECᵀ.*
Belton House, Lincolnshire

It is in his full-length portraits that Kneller excels, as this and
his set of Hampton Court 'Beauties' amply demonstrate. On
this scale he is able to deploy the lessons of his long training
and travel on the Continent: to manipulate the human form
and swathes of drapery in space, with ancillary contributions
from architecture, landscape, steps and urns, thus ennobling
even the least remarkable of sitters.

Dorothy Mason, Lady Brownlow has no especial claim
to fame; this portrait might persuade one otherwise.
A daughter[1] of Sir Richard Mason,[2] of Bishop's Castle, MP
(c.1619–1684/5), and Anna Margaretta Long, she was
married to William Brownlow (1665–1700/1) in the summer
of 1688, as his first wife. This picture was, no doubt, painted
in that year, or soon after. The same year William's elder
brother, 'Young' Sir John Brownlow, finished building his
new country house at Belton. William and Dorothy seem
chiefly to have resided at the house in Arlington Street in
London that they had bought from Lady Frescheville. Even
after William succeeded as the 4th Baronet of Humby, on
Sir John's suicide in 1697, the latter's widow, Alice, held
Belton until her death in 1721, and it then passed to William
and Dorothy's son, John, later Viscount Tyrconnel (see cat.
no.17).

Otherwise they often lodged with Dorothy's mother at
Worcester Park, near Sutton, Surrey. It was from Arlington
Street that the immense funeral procession organised by her
husband – which somehow seems consonant with the
ambitions of this portrait – wound its way to St Nicholas,
Sutton.[3] It was also for Sutton church that he had a great
monument erected to her[4] (since the turn of this century
disgracefully concealed by the organ), which a tourist from
Camberwell in 1831 described as 'a dish of hasty pudding
garnished with slices of gilt gingerbread'.[5] All that we know
of Dorothy Mason herself is that she was amiable –
described as 'really deserving everybody's love'. It is her
sister Anne who is remembered by history, as the Countess
of Macclesfield who was – in defiance of the truth – seized
on and excoriated as the mother who had abandoned him,
by the bohemian poet Richard Savage and his biographer,
Samuel Johnson.[6]

Kneller painted a pendant to this portrait, of *Sir William
Brownlow*, which is also at Belton, as is another pair of
whole-lengths of them both, by Riley and Closterman.
A further three-quarter-length of *Lady Brownlow* alone,
signed and dated 1687 by Wissing and Van der Vaart, and

another by Dahl, are at Belton too. The full-length of her by
Wissing that was scraped in mezzotint by J. Smith is at
Grimsthorpe in the same county – no doubt by descent from
her niece Jane, Duchess of Ancaster.

HIST: by descent to the sitter's son, Sir John Brownlow, 5th Bt, cr.
Viscount Tyrconnel (1690–1754), and, on his death without issue, to
his sister, Anne (1694–1779), widow of Sir Richard Cust, 2nd Bt, of
Pinchbeck; thence, by direct descent at Belton, to the Cust Barons (and,
for a period, Earls) Brownlow, until 1984, when Edward, 7th Baron
Brownlow (b.1936) gave the house, its garden and some of its contents,
to the National Trust, to which the National Heritage Memorial Fund
gave £8 million to acquire further contents and the park, and to
establish an endowment.

LIT: Stewart 1983, p.95, no.111 (as c.1685); *Belton* 1992, p.62, no.77.

Fig. 4 Design for Lady Brownlow's tomb in St Nicholas, Sutton,
attributed to Thomas Stayner (Victoria & Albert Museum)

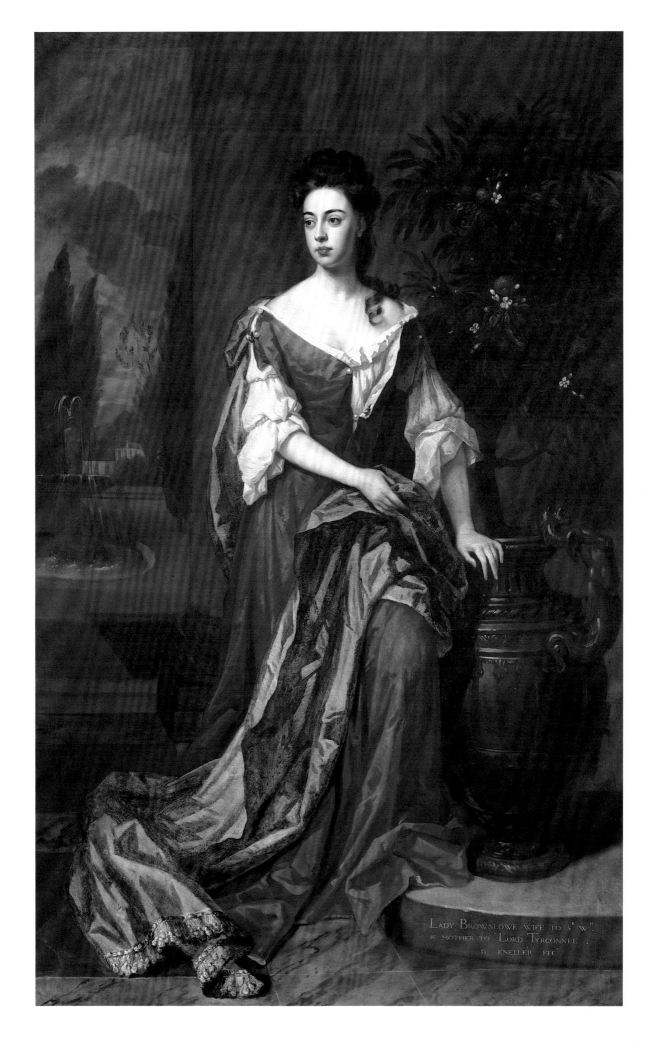

LADY BROWNLOWE WIFE TO Sʳ Wᵐ
& MOTHER TO LORD TYRCONNEL.
G. KNELLER FEC

7 Sir Joshua REYNOLDS, PRA (Plympton 1723 – London 1792)

The Hon. Theresa Robinson, Mrs John Parker (1744/5–75)

Oil on canvas. 234 × 142 cm (92 × 56 in)
Inscribed bottom left: *Theresa Dr. of Ld. Grantham/& Wife of Jno. Ld. Boringdon.*
Saltram, Devon

Reynolds was born only four miles from Saltram. His mother was befriended by Lady Catherine (Poulett) Parker, who is reported to have given Reynolds and his sisters their very first pencil.[1] Lady Catherine's eldest son, John Parker, MP (1734/5–88), created Baron Boringdon in 1784, was Reynolds's lifelong friend: 'the man whose name occurs oftenest in his list of engagements, his entertainer often two or three times a week in town, and his frequent host in his visits to Devonshire'.[2] Reynolds painted him twice, once in a small whole-length almost unique in his oeuvre, the other time half-length, in the dress of the Woburn Hunt.[3] He also painted Parker's brother,[4] this, his second wife (twice),[5] their two children,[6] and a number of his friends,[7] and – apparently for him – the engraver *Francesco Bartolozzi*.[8] He also advised Parker on his collection, selling him a reputed Guercino of the *Madonna and Child with the Infant John*[9] and probably the Lubin Baugin (then attributed to 'Baroccio') that is framed and hung as a pendant to it.

Angelica Kauffman apparently formed a third in this friendship, painting both a portrait of Reynolds and seven subject pictures that were acquired by Parker. She had already painted Parker himself in 1764 in Rome or Naples, where his first wife, Frances Hort, had died in that year.[10]

In May 1769 Parker married his second wife, the subject of this, one of the tenderest of Reynolds's adult portraits. The second daughter of the diplomat and minister Thomas Robinson (1695–1770), created Baron Grantham in 1761, by Frances Worsley of Hovingham, Theresa contributed much to the embellishment of Saltram and its grounds, both through what Reynolds praised as her own 'skill and exact judgement ... [and] ... propriety of taste and right thinking', and through the advice and procurement of her connoisseur brothers.[11] Her first sittings for this portrait were in April 1770, but the next was not recorded until February 1772, when she was heavily pregnant with her son John. On 3 March her sister Anne wrote to their brother Frederick: 'Perhaps you may think that her situation may make this an improper time, but I assure you she never looked better ... and as for the figure, Sir J says it need not be done quite exact at now.'[12] On 12 March Theresa herself wrote to Frederick:

> I am going to Sir Joshua's this morning, the last sitting for a full length. ... Sir Thomas Parker [full-length by Gheeraerts] wants a companion so much in the Great Room at Saltram, that it could not be delayed another year.[13]

Robert Adam's new Saloon, in which the portrait was to hang, had been carpeted in 1770 and supplied with its remaining furniture in 1771. Yet the picture had still not been sent down by the autumn. Having missed that year's exhibition at the Royal Academy, Reynolds was no doubt determined both that it should be in the next year's showing, and that it should be engraved. On 20 October Theresa wrote to her eldest brother, Thomas, Lord Grantham, then Ambassador in Madrid:

> My picture is not actually at Saltram. Sir Joshua is very lazy. When it comes I will endeavour by some means or other to give you a little notion of it. Mr. Parker says I am drawn feeling my pulse: it may not be the less like for that, as I am apt to do so.[14]

There is a terrible poignancy in these last words, for in showing her thus, Reynolds prefigured her early death in November 1775 from a recurrence of the fever which had brought on the premature birth of her daughter Theresa in September.[15] Despite her mild exasperation over his dilatoriness, Reynolds evidently came to treasure her as much as he did her husband; he is credited with the anonymous obituary in the *Gentleman's Magazine*:

> Her amiable disposition, her softness and gentleness of manners, endeared her to every one that had the happiness of knowing her. ... The gentleness and benevolence of her disposition were so naturally impressed on every look and motion, that, without any affected effort or assumed courtesy, she was sure to make every one her friend that had ever spoke to her, or even seen her.[16]

It is one of this portrait's singular virtues that it manages to convey some notion of this sweetness of character while showing the sitter in profile, which is not only one of the austerest forms of presentation, but also one frequently used for funerary images.[17]

HIST: by descent from the sitter's husband, until Saltram was acquired by the National Trust in 1957, when this was one of the star chattels accepted by HM Treasury from the Executors of the 4th Earl of Morley in part payment of death-duties, and subsequently transferred to the Trust.

ENGR: mezzotints by Thos. Watson, 1773 (CS 28); and by S.W. Reynolds, 1824.

EXH: RA, 1773, no.234 or 282; British Institution, 1813, no.20; Grosvenor Galleries, 1884, no.138; *Europalia*, Brussels, 1973, no.51.

LIT: Graves and Cronin 1899–1901, ii, pp.728–9; Waterhouse 1941, p.63; *Saltram* 1967, p.32, no.62; Waterhouse 1973, p.63; Lummis and Marsh 1990, pp.71–2, and pl. between pp.84 and 85.

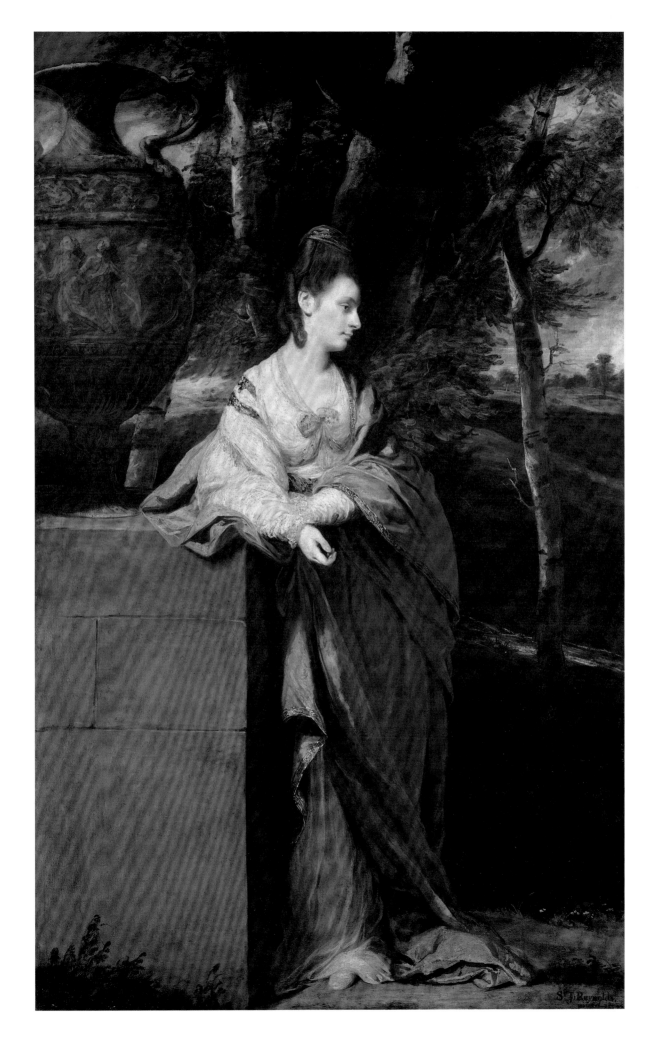

8 Thomas GAINSBOROUGH, RA (Sudbury 1727 – London 1788)

Commodore the Hon. Augustus John Hervey (1724–79)

Oil on canvas. 232 × 152 cm (91½ × 60 in)
Ickworth, Suffolk

Gainsborough is less frequently associated with military or naval portraits than Reynolds, and this picture perhaps enables one to see why. Despite uniform, setting and props, the sitter remains first and foremost the gentleman, as easy on the seashore leaning upon the fluke of an anchor as he would have been with his elbow on a chair in the Assembly Rooms at Bath. It was in this city that he was probably painted, around 1767: Hervey was there for his gout that year, and Gainsborough had his studio in Bath at the time. The nonchalance of Hervey's pose is, however, deceptive. Around this period, he wrote in his *Journal* (about an earlier period): 'I cared very little about anything but my pleasures in these days, till I got to sea, and then my profession was all my pleasure'.[1]

In his portraits Gainsborough aimed at naturalness above all else, but invested little effort in devising new postures. Here he uses the standard crossed-leg pose favoured by every portrait painter of the day. He had employed a variant of it for the portrait he had painted about three years earlier of another naval hero (and a rival of Hervey), *Commodore (later Earl) Howe* (Trustees of the Howe Settled Estates), who also went to Bath for the gout, around 1763–4.[2] The casual way in which Hervey rests his elbow on the anchor may owe something to Van Dyck's *Algernon, 10th Earl of Northumberland* (c.1636; Duke of Northumberland).

When this portrait was painted, Hervey's active life at sea had in fact ended. As a younger son, he had had to make a career, and he had been an assiduous naval officer, entering the Navy in 1735 as 'Captain's servant' to his uncle William Hervey, and ending his sea-faring as Captain of the *Centurion* in 1763. From 1771 to 1775, when he resigned on succeeding his brother as Earl of Bristol, he was a Lord of the Admiralty, and in 1778 he was promoted Vice-Admiral of the Blue. His naval and amorous activities are breezily recounted in his diaries for 1746–59.[3]

The present picture, which was exhibited in 1768, is thus retrospective. It alludes to what the future Lord Bristol must have regarded as the most distinguished action of his career: his part in the taking of the Moro Castle in 1762, commanding the entrance to the Havannah (Havana), capital of the then Spanish-owned Cuba, during the Seven Years War.[4] Hervey was given the honour of bringing the news back to England, and on the way captured a large French frigate laden with military stores. The ship must be his command, the *Dragon*, a new one of 74 guns;[5] the Spanish ensign cast down on the anchor commemorates the defeated navy.

The 3rd Earl of Bristol's amorous and matrimonial career ran less smoothly than his naval one, which helps to account for the somewhat irregular descent of this picture. In 1744 he entered upon a clandestine marriage with the already notorious Elizabeth Chudleigh. Seven years later he had to flee from an entanglement with the wife of M. de Caze in Paris.[6] From about 1763 to 1765 he had a liaison with Kitty Hunter, the former mistress of the 10th Earl of Pembroke.[7] Gainsborough is credited with an octagonal miniature painting (also at Ickworth) of their illegitimate son, Augustus Hervey (c.1765–82), executed in about 1780. It seems to have been Lord Bristol's desire to marry a Miss Moysey, a daughter of Gainsborough's physician at Bath, that led him in 1768, first to attempt to gain a divorce from Elizabeth Chudleigh, and then, when she refused, to collude with her in denying that the marriage had ever existed, so that she could marry the Duke of Kingston. Lord Bristol's final liaison, which began around 1771, was with Mary Davis[8] (c.1735–1825), wife of the banker Alexander Nesbitt. On his death from 'gout in the stomach', he bequeathed her this portrait and a number of other pictures, which she in turn seems to have given or left to the descendants of the sitter's sister, Lady Lepell Hervey, Lady Mulgrave (d.1780).

HIST: commissioned by the sitter, and seen in his house in St James's Square by Horace Walpole, who singled it out as 'very good. one of the best modern portraits I have seen';[9] Mary Davis, Mrs Nesbitt (d.1825), Norwood House, Streatham; the Hon. Anne Phipps, Lady Murray (d.1848), the only child of the 2nd Baron Mulgrave, by whom apparently inserted, with 41 other pictures, drawings and prints, into the second half of a sale held by Robins, 17 May 1827, lot 111; apparently left on the auctioneer's hands, so in sale of Joseph Robins, Christie's, 21–2 Feb 1834, lot 83 (bt in); again, in a sale held by Hoard, Travellers' Club, 9 May 1835, lot 106 (bt in); and at Deacon's, 9 May 1838 (bt Lockyer for 65 gns); offered by Lockyer to Earl Jermyn (later 2nd Marquess of Bristol), who refused it but referred the offer to his father, the 1st Marquess (1769–1859), the sitter's nephew, who evidently bt it; first recorded as in the possession of the Marquess of Bristol by G.F. Fulcher in 1856;[10] thence by descent, until accepted with the house and a significant part of its contents, in lieu of death-duties, by HM Treasury in 1956, and transferred to the National Trust.

ENGR: mezzotints by James Watson, 1773 (CS 574), and C. Tomkins.

EXH: Society of Artists, 1768, no.60 (as 'A sea officer; whole length ditto' [= Gainsborough]); New Galleries, 1891, no.165; *Naval Exhibition*, 1891, no.360; RA, winter 1912, no.122; *British Art*, RA, 1934, no.264; *British Painting in the 18th Century*, British Council (Canada and America), 1957, no.10; National Gallery, after cleaning in 1957; *Europalia*, Brussels, 1973, no.17; *English Pictures from Suffolk Collections*, Agnew's, 1980, no.15; *The Treasure Houses of Britain*, National Gallery of Art, Washington, 1985–6, no.483; *The Swagger Portrait*, Tate Gallery, 1992–3, no.40.

LIT: Fulcher 1856, p.211; Armstrong 1898, pp.116, 192; Whitley 1915, p.59; 1928, ii, p.369; Walpole 1939, p.66; Waterhouse 1953, p.11; Waterhouse 1958, no.82, p.56, pl.105; French 1988, no.A29, pp.68–9.

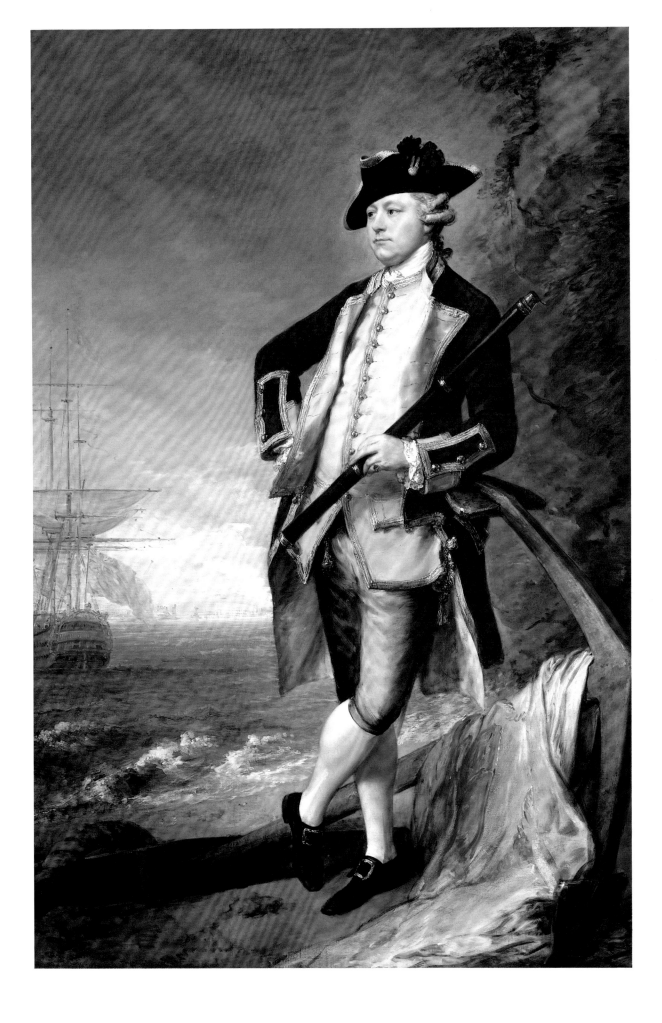

9 George ROMNEY (Beckside 1734 – Kendal 1802)

William Beckford (1760–1844)

Oil on canvas. 236 × 145 cm (93 × 57 in)
Upton House, Warwickshire

Sittings for this portrait are recorded in Romney's diary from June 1781 to March 1782,[1] just before and after Beckford had attained his majority and in between his extensive tours on the Continent. Out of these travels came his *Biographical Memoirs of Extraordinary Painters* (1780), a satirical squib written at the age of seventeen, and the anonymously published *Dreams, Waking Thoughts, and Incidents; in a Series of Letters, from Various Parts of Europe* (1783).[2]

Although the portrait conveys all the arrogance of a rich, handsome and precociously published youth, its conventionality suggests that it may in fact have been painted at the wish of his Methodistical but dangerously possessive mother, Maria. She had possibly intended originally to unveil it at the lavish coming-of-age festivities that she organised for him at Fonthill Splendens in Wiltshire at the end of September 1781. It was begun after the inception of his notorious liaison with the Hon. William ('Kitty') Courtenay, and completed not long before he had finished writing *Vathek*, the feverish, pseudo-oriental, semi-autobiographical romance that became his chief title to originality and fame, despite being published anonymously.[3] Little given to self-knowledge of the deeper sort, he none the less wrote to Sir William Hamilton's first wife just before the portrait was begun, with a remarkably accurate prophecy of his future existence: 'I fear I shall never be half so sapient nor good for anything in this world, but composing airs, building towers, forming gardens, collecting old Japan, and writing a journey to China or the moon.'[4]

Beckford collected pictures with equal zeal. He was a pupil and friend of Alexander Cozens, and a patron of his son, John Robert Cozens. Joseph Vernet wrote to him when he was only twenty, saying: 'I would prefer to work for you than for any other person, because, if I am fortunate enough to produce something good, you will recognise it.' He commissioned Philippe de Loutherbourg to paint sets for his coming-of-age party. He also owned such masterpieces as Giovanni Bellini's *Doge Loredan* and *The Agony in the Garden*, Raphael's *St Catherine* (all in the National Gallery), and, albeit only briefly, the Altieri Claudes (now Anglesey Abbey, Cambs, NT). Despite all this, he tends to be regarded as primarily a collector of *virtù*,[5] and as the capricious builder of the pseudo-medieval folly that he himself outlived, Fonthill Abbey.

For this, Hazlitt's notorious denunciation of him in *Sketches of the Principal Picture-Galleries in England* is mainly responsible. In an exhibition celebrating collectors and collecting, it is impossible not to quote from this tirade:

It is on this account that we are compelled to find fault with the Collection at Fonthill Abbey, because it exhibits no picture of remarkable eminence that can be ranked as an heir-loom of the imagination. . . . What shall we say to a Collection, which uniformly and deliberately rejects every great work, and every great name in art, to make room for idle rarities and curiosities of mechanical skill? It was hardly necessary to build a cathedral to set up a toy-shop! . . . This huge pile (capable of better things) is cut up into a parcel of little rooms, and those little rooms are stuck full of little pictures, and *bijouterie*. Mr. Beckford may talk of his *Diamond Berchem*, and so on: this is but the language of a *petit-maitre* in art; but the author of VATHEK (with his leave) is not a *petit-maitre*. His genius, as a writer, 'hath a devil': his taste in pictures is the quintessence and rectified spirit of *still-life*. He seems not to be susceptible of the poetry of painting, or else to set his face against it. It is obviously a first principle with him to exclude whatever has feeling or imagination – to polish the surface, and suppress the soul of art . . . and to reduce all nature and art, as far as possible, to the texture and level of a China dish – smooth, glittering, cold, and unfeeling![6]

The subject of the oval relief on the plinth on which Beckford leans has not so far been identified, but it appears to show an old man, bent double with grief, and clutching a bundle of sticks, contemplated by a younger figure in strange, slightly oriental, headgear. They may be King Lear and his Fool, or Job and a Comforter, although neither has any obvious connection with Beckford. Even the teazle in front of it seems to have some significance, but until the subject of the relief is identified, it is impossible to say what.[7]

HIST: by descent from the sitter's younger daughter, Susannah, wife of Alexander, 10th Duke of Hamilton (1767–1852), until sold at Christie's, 7 Nov 1919, lot 55, as *Alderman Beckford* by Romney; bt by [? Charles] Davis, on behalf of Marcus Samuel, 1st Viscount Bearsted (1853–1927); given with Upton House to the National Trust by Walter, 2nd Viscount Bearsted (1882–1948), in 1948, shortly before his death.

EXH: *Works of Old Masters & Scottish National Portraits*, Royal Scottish Academy Building, Edinburgh, 1883, no.16; *Loan Exhibition of Old Masters and Scottish National Portraits*, Edinburgh, 1886, no.1470; *International Exhibition*, Glasgow, 1888, no.128; *The Bearsted Collection*, Whitechapel Art Gallery, 1955, no.13 (pl.II in catalogue); *English Pictures*, Agnew's, 1965, no.21; *Beckford*, Holburne Museum, Bath, 1966; *La peinture romantique anglaise*, Petit Palais, Paris, 1972, no.216; *Europalia*, Brussels, 1973, no.55; *Portugal e o Reino Unido: A aliança revisitada*, Calouste Gulbenkian Museum, Lisbon, 1994–5, no.150.

LIT: Ward and Roberts 1904, ii, p.9; Melville 1910, p.294, pl. opp. p.174; Tipping 1919, pp.515–16, fig.2; Chapman 1930, pp.116–17; *Upton* 1950, p.19, no.68; *Upton* 1964, no.68, pp.25–6, pl.Ia.

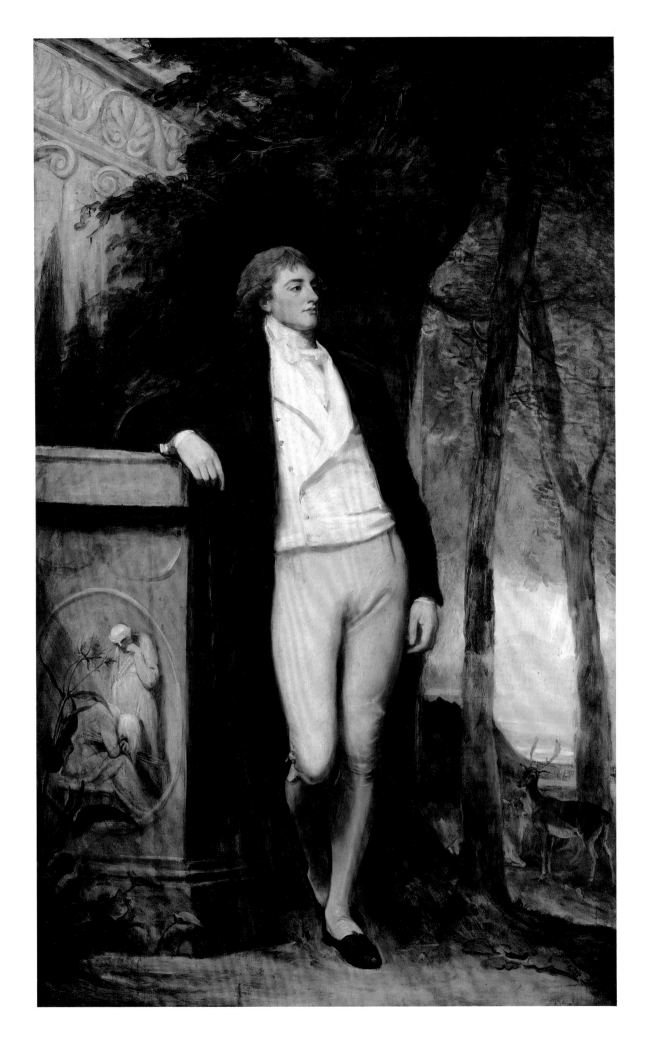

10 John HOPPNER, RA (London 1758–1810)

Lady Caroline Capel (1773–1847) *holding her Daughter Harriet* (1793–1819)

Oil on canvas. 236 × 145 cm (98½ × 69 in)
Plas Newydd, Isle of Anglesey

Hoppner elicited one of the more splendidly dyspeptic passages in Ellis Waterhouse's idiosyncratic *Painting in Britain: 1530–1790* in 1953:

> [He] admittedly had a large name in his own day, but the recent fashion for him is due chiefly to assiduous puffing by the art-trade half a century ago, and to the childlike desire of the very rich in that far-off age of collecting to fill their houses with portraits of beautiful women and lovely children. . . . he is for ever reminding us of the work of one or other of his greater contemporaries: at first of Reynolds and Romney, and later of Lawrence and Raeburn. . . . He is best in half-lengths, for his full-length ladies are little more than torrents of white muslin without form or shape. . . . Every one of Hoppner's borrowings and combinations is contrived, because it was calculated to please the flashy taste of those circles whose centre was the Prince of Wales. . . . Happily death carried him off in time for the Prince, whose taste had matured, not to be too late to give his patronage to Lawrence.[1]

This dazzling but perverse excoriation might almost have been directed at the present picture. Indeed both the family from which the sitter sprang, and the one into which she married, belonged to 'those circles whose centre was the Prince of Wales', even if it would be unfair to describe either of them as manifesting 'flashy taste'. Lady Caroline Paget was the eldest daughter of the 1st Earl of Uxbridge. Her eldest brother, Henry, Lord Paget, later 2nd Earl of Uxbridge and 1st Marquess of Anglesey (1768–1854), had a distinguished military career, commanding the cavalry at the Retreat to Corunna (1808) and at the Battle of Waterloo (1815), in which he lost a celebrated leg. The Prince Regent promptly made him a Marquess, declaring: 'that he *loved* him . . . that he was his best officer and his best subject'.[2]

The Marquess's private life also had a distinctly Regency flavour. In 1809/10, as Lord Paget, he abandoned and was divorced by his first wife, Lady Caroline ('Car') Villiers, daughter of a favourite of the Prince of Wales, the Countess of Jersey; she then married the 6th Duke of Argyll. Lord Paget had eloped with Lady Charlotte ('Char') Cadogan, the wife of Wellington's brother, Henry Wellesley, later Earl Cowley, and, after their two divorces, married her.

The present picture, by contrast, almost proclaims itself as a manifesto of domestic virtue. Lady Caroline had been married in 1792 to the Hon. John Capel (1769–1819), the first son of the 4th Earl of Essex by his second wife. She is shown holding their sleeping first child, Harriet, with her cradle beside her. (Their eldest son, later 6th Earl of Essex,

who would more usually have been the first to have his birth celebrated, was not born until 1803.) The implication is clearly that, in accordance with the by then fashionable practice, Lady Caroline was nursing the child herself.[3]

The piquancy of Hoppner's portrayal resides in the contrast between the apparent domestic intimacy of Lady Caroline's occupation (which is underscored by the Reynoldsian naturalism of his treatment of the vegetation and landscape), and the rhetorical grandeur of the setting. The full panoply of paired columns, balustrade and looped curtain with tassels all derive ultimately from the grand aristocratic portraits painted by Rubens and Van Dyck in Genoa in the early 17th century.

This discrepancy seems, however, to have arisen by accident. When the portrait was exhibited at the Royal Academy in 1794, simply as the *Portrait of a Lady of Quality*, 'Anthony Pasquin' wrote of it: 'This is a spirited likeness of Lady Caroline Capel: the drapery is fancifully displayed; the dog in the foreground is ill-drawn, the child incorrect, and the whole assemblage seem frightened!' Hoppner was very sensitive to criticism, so he may well have yielded to a suggestion from the sitter or her family that the dog should be painted out. No sign of the dog or other *pentimenti* have ever been noticed in the picture, but it has also never been subjected to bright light or scientific examination. If no trace of dog or other alterations is to be found, the only conclusion would have to be that Hoppner painted the portrait again from scratch – an expenditure of time that he would have been ill able to afford. In any case, by the time that it was painted, Lady Caroline had had another daughter, Caroline, who died in infancy; possibly Harriet's being shown asleep also hinted at that loss.

Harriet Capel was to have a short, troubled life. In 1815 she fell in love with Jonkheer Ernst Trip, ADC to the Prince of Orange, but her love was not returned. Two years later in Lausanne she married David Parry-Okeden, and eighteen months afterwards died in childbirth at the age of only 26.[4]

This portrait is one of four by Hoppner that have graced the Plas Newydd Music Room almost since they were painted.

HIST: presumably painted for the sitter's father, Henry, 1st Earl of Uxbridge of the 2nd creation (1744–1812); thence by descent, and since 1976, when Plas Newydd was given to the National Trust by Henry, 7th Marquess of Anglesey, on long-term loan to the Trust.

EXH: RA, 1794, no.36; Grosvenor Gallery, 1913–14, no.20.

LIT: Pasquin 1794, pp.30–31; Neale 1822, 1st series, v, no.61 (as in the Music Room – then Dining Hall – at Plas Newydd); Skipton 1905, pp.64–5, 169; McKay and Roberts 1909, p.42, 2/1914, *Supplement*, p.9; Anglesey 1955, frontispiece; Steegman 1957, i, p.29, no.22; Wilson 1992, i, p.181; *Plas Newydd* 1992, p.20.

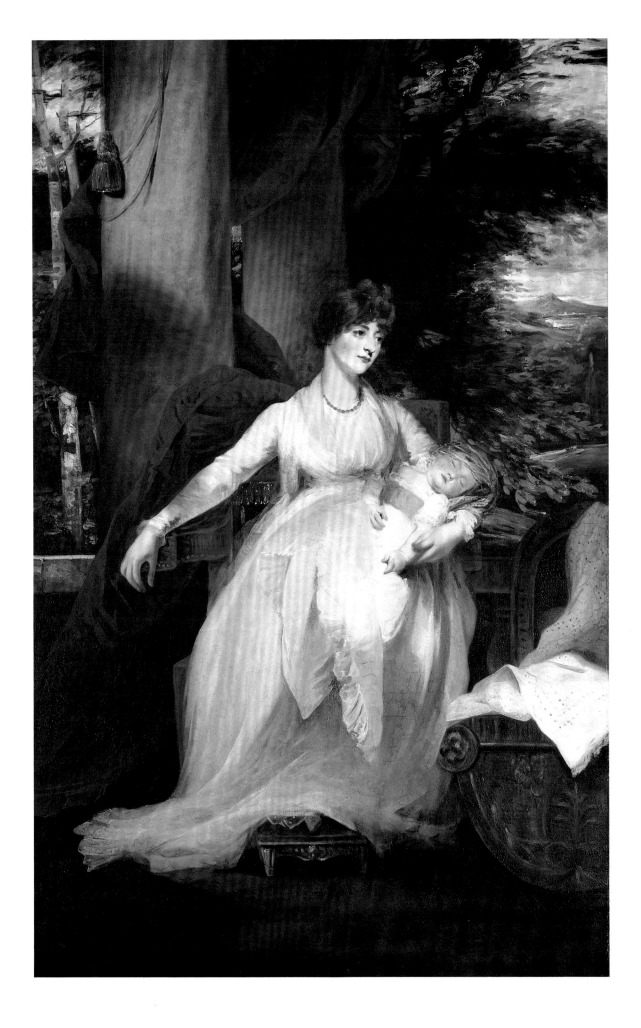

11 Samuel WOODFORDE, RA (Ansford 1763 – Ferrara 1817)

Sir Richard Colt Hoare, 2nd Bt (1758–1838), *with his Son Henry* (1784–1836)

Oil on canvas. 254 × 168 cm (100 × 66 in)
Inscribed on plinth of vase: *R.C. HOARE Bart. AETAT.*
XXXVII/H.R. HOARE AETAT. XI
Stourhead, Wiltshire

There could have been no more appropriate way of depicting Colt Hoare, as the sitter is familiarly known. He stands in an Italian landscape, holding a print of the classicising model to which he would like it to conform in one hand, and a portfolio of his sketches of it in the other. The son who attempts to distract him from his inner reverie almost seems to be an intrusion upon the scene. Indeed, since Henry was not actually present in Italy, he must be understood as urging his father in spirit, not in person, to return home.[1]

The portrayal must be very much as it was willed by the sitter. For Woodforde was virtually a Hoare house artist. As the diarist Joseph Farington was told by him in 1807:

> When between 16 & 17 years old . . . the late Mr. [Henry II] Hoare of *Stourhead* . . . immediately offered him encouragement; allowed him to draw from pictures at Stourhead & then sent him to study at the Royal Academy. Mr. Hoare died in a few years, but the Father of the present Sir Richard Hoare . . . the first Baronet of that name . . . offered to send Woodforde to Italy and to allow him £100 a year for 3 years. . . . He went to Italy, and in 2 years His Patron died; but his son, the present Sir Richard Hoare, coming to Rome abt. that period, promised to continue the allowance so long as He, Sir Richard, should remain in Italy, which he did till Woodforde had been absent from England abt. 6 years. He then returned with Sir Richard through Germany to England, and for sometime after the allowance was continued to Him . . . until he told Sir Richard that he found himself getting some money.[2]

The picture was painted in 1795,[3] four years after the sitter's return from Italy, to which he had gone partly to distract himself after the death of his wife and the boy's mother, Hester Lyttelton, in 1785. While abroad, chiefly in Italy and Sicily, he had taken an artist, Carlo Labruzzi (*c.*1765–1818), with him, but he had himself sketched and drawn prodigiously, having taken lessons from John 'Warwick' Smith before he left.

J.B. Nichols's *Catalogue of the Hoare Library at Stourhead* (1840) records some 900 drawings made on the Continent by Hoare himself, with another 200 by Labruzzi, and 21 worked up from Hoare's by Francis Nicholson, all bound in twenty volumes. Sadly, these were sold in the Heirlooms sale of 30 July–8 August 1883, and only seven volumes were bought back, so as to be once again in the Library that Colt Hoare had himself added to Stourhead in 1794–1804. The surviving albums, however, make a fascinating collection, since they range from free sketches, generally in black chalk, made on the spot; through ink drawings, often superimposed on these, and evidently worked up from them the same evening; to full wash or watercolour drawings, made back in England. These finished drawings were all later bound in sequence, in topographically divided volumes, each supplied with a neatly written introduction, and a commentary on the individual plates. The dry, impersonal nature of the texts suggests that these volumes were intended as preparations for publication. But, in the event, Colt Hoare's *Recollections abroad: during the year 1790. Sicily and Malta* (1817), and *during the year 1790, 1791 [Italy, the Tyrol, &c.]* (1818) were published without illustrations. It was only when Napoleon's confinement on Elba in 1814 suddenly aroused interest in that remote island that Colt Hoare rushed out his own account of the place, with engravings by John Smith after the drawings he had made some 25 years before.

In some ways, this picture marks the ending of a chapter in Colt Hoare's life, and the beginning of his real career, as artist, archaeologist, historian and topographer of Wales and Wiltshire. Two years before it was painted, he began the first of his meticulously prepared and recorded itineraries through Wales, which he was to make almost every year thereafter until 1810.[4] His first tour was primarily in search of the conventionally Picturesque, but as he extended and deepened his knowledge of Wales in successive tours, his interests became increasingly archaeological, and then turned to his native Wiltshire. Colt Hoare published first his annotated edition (1804), and then his translation (1806), of Giraldus Cambrensis's *Itinerary of Archbishop Baldwin through Wales in 1188*, followed by his greatest monuments, *The Ancient History of Wiltshire* (1812–21) and *The History of Modern Wiltshire* (1822–44).[5]

Nowhere in all this is there any indication of Colt Hoare the collector and connoisseur. Yet his travel diaries show him to have been keenly interested in the character and quality of his fellow-landowners' collections, and he himself added a number of distinguished pictures to the collection formed at Stourhead by his grandfather, Henry II Hoare 'the Magnificent' (1705–85) – most notably Cigoli's *Adoration of the Magi*.[6] At the same time he was an earnest encourager of contemporary artists, including Woodforde himself.[7]

HIST: commissioned by the sitter, and thence by descent, until 1946, when it was given to the National Trust with the house, its grounds and the rest of the contents, by Sir Henry Hoare, 6th Bt (1865–1947).

LIT: *Stourhead* 1818, p.6; Colt Hoare 1822, p.71; Woodbridge 1970, p.153, pl.24b; Colt Hoare 1983, colour frontispiece.

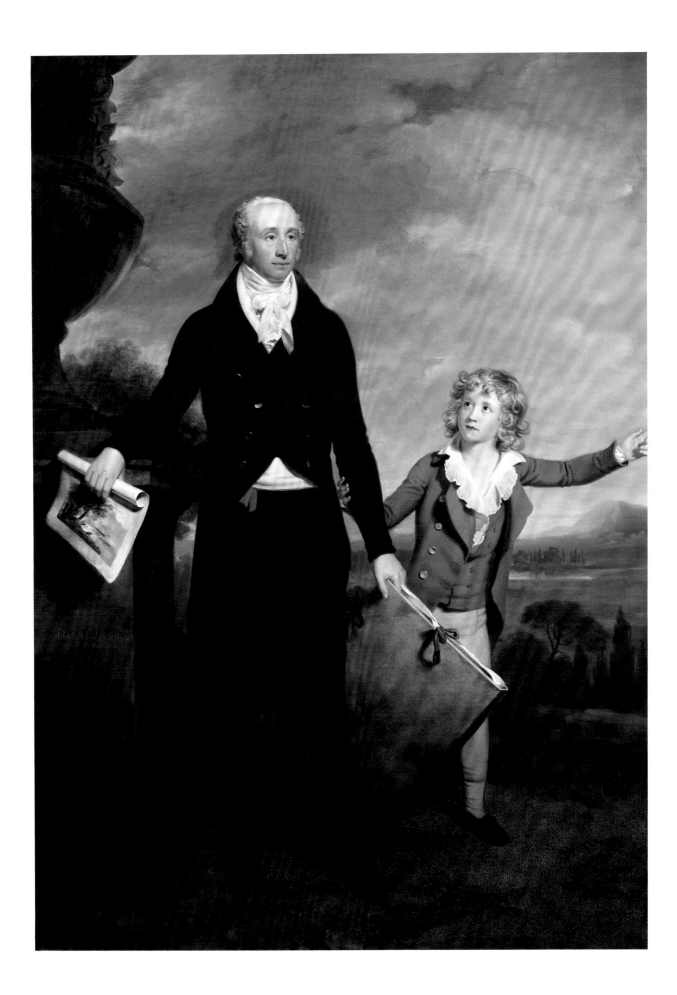

12 William OWEN, RA (Ludlow 1769 – London 1825)

Mrs Robinson

Oil on canvas. 200 × 175 cm (98½ × 69 in)
Petworth House, West Sussex

William Owen has yet to receive his due as a portrait painter. His portraits, when one encounters them, are distinctive and have considerable power: a good example of a male portrait is *Sir Thomas Dyke Acland* (1818; Killerton, Devon). What they lack is the ingratiating quality that might have helped them to the revived fame of those British portrait painters promoted in America by Joseph Duveen. Richard and Samuel Redgrave thought his real talent lay in landscape.[1] R.E. Graves in the *Dictionary of National Biography* considered his portraits 'truthful and characteristic', but 'somewhat weak in drawing'. After giving a list of distinguished male sitters, he concludes, 'His portraits of ladies were not equally successful'.[2] This is contradicted, not only by the present picture, but, for instance, by *Lady Leicester* (Tabley House, Cheshire). In more recent times, he has been accorded a cool entry (without illustration) in Robin Simon's *The Portrait in Britain and America*,[3] but not even a mention in John Wilson's essay on 'The Romantics 1790–1830' in *The British Portrait*.[4]

Yet Owen himself was not only very successful, earning £3,000 a year in his heyday, but keenly appreciated by such connoisseurs as Sir John Leicester,[5] Sir George Beaumont and George IV, who, as Prince of Wales, appointed him his official portrait painter on the death of Hoppner in 1810, and, as Prince Regent, appointed him principal portrait painter in 1813. In our own time, the rediscovery and attribution to Owen of the *Hon. Henrietta Monckton, Mrs Robert Pemberton Milnes* (private collection) was one of the sensations of the recent exhibition of *Masterpieces from Yorkshire Houses*.[6]

The portrait of *Mrs Robinson* has always made a considerable impact, even in the crowded hang of the North Gallery at Petworth, where it was hung in a conspicuous position beside Flaxman's *St Michael crushing Satan* (1819–26).[7] Yet, curiously, despite this and despite the picture's being no.1 (with this title) in the 1803 exhibition of the Royal Academy, no one ever seems to have recorded who the sitter was, or to have explained why the 3rd Earl of Egremont should have bought or commissioned her portrait.

In view of the 3rd Earl of Egremont's reputation – and in particular of Thomas Creevey's account of his visit to Petworth in 1828, when he drew the conclusion that one portrait after another was of a former member of 'my Lord's Seraglio'[8] – the suspicion inevitably arises that this picture depicts one of his mistresses. Because of the name, she has often been assumed to be Mary Darby, Mrs Robinson, the Prince Regent's 'Perdita' (1758–1800), celebrated through portraits of her by Gainsborough, Romney and Reynolds in

the Wallace Collection and at Waddesdon. Indeed Owen had come to Reynolds's notice by copying one of his portraits of 'Perdita', and was given encouragement by him. But she had died three years before the present picture was exhibited, and there is nothing posthumous about this portrait, nor any resemblance to those of her.

There are three other Mrs Robinsons who may be potential candidates for the sitter. In 1808 a mysterious 'Mrs. Robinson' appears to have been keeping late hours in appropriately *louche* company, that of the Princess of Wales.[9] However, Lord Egremont is unlikely to have acquired a portrait of a companion of the Princess, as she had been separated from his friend, the Prince of Wales, since 1796.

More promising is the wife of Sir Christopher Robinson (not knighted until 1809), who was to be, as King's Advocate, one of George IV's advisers in the trial of Queen Caroline in 1820.[10] Although of modest origins, he became rich as an Admiralty lawyer, and he married in 1799 a wealthy wife, Catherine (1776/7–1830), daughter of the Rev. Ralph Nicholson, Rector of Didcot. She bore him three sons and two daughters, but nothing else is known of her.

Another candidate who seems worth considering is Miss Waring (d.1817). She was the wife of a Col. Robinson (d. c.1815) and the eldest sister of Fanny Waring, a friend of Joseph Farington, who was in turn friendly with Owen. This is little enough to go on, but at least the couple's dates of death allow of the possibility that the Earl of Egremont bought her portrait at a posthumous sale.

That this portrait was exhibited under the sitter's name as early as 1803 might suggest that she was an actress, but there is none whose dates would permit her to be the woman – probably in her twenties – depicted here.[11] In sad truth, we must conclude with Lord Egremont's answer to Creevey's too persistent questioning about the identity of the sitter in a Reynolds portrait at Petworth: '"Oh!" he said, "it was a lady not much known in the world".'[12]

HIST: bought or commissioned by the 3rd Earl of Egremont; thence by descent, until the death in 1952 of the 3rd Lord Leconfield, who had given Petworth to the National Trust in 1947, and whose nephew and heir, John Wyndham, 6th Lord Leconfield and 1st Lord Egremont (1920–72), arranged for the acceptance of the major portion of the collections at Petworth in lieu of death-duties (the first ever such arrangement) in 1956 by HM Treasury, which subsequently conveyed all save the Turners to the Trust.

EXH: RA, 1803, no.1.

LIT: *Petworth* 1856, p.4, no.13; Collins Baker 1920, p.91, no.13 and pl.

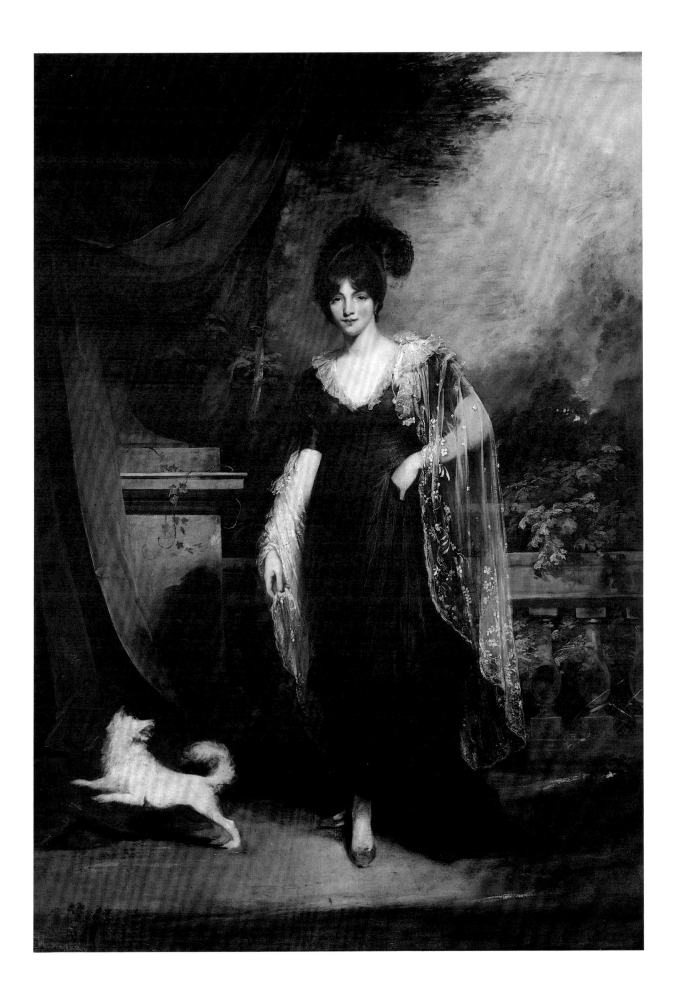

13 Thomas PHILLIPS, RA (Dudley 1770 – London 1845)

George O'Brien Wyndham, 3rd Earl of Egremont (1751–1837)

Oil on canvas. 187 × 155 cm (73½ × 61 in)
Petworth House, West Sussex

The 3rd Earl of Egremont is depicted 'when about sixty years old', according to the artist's sitter-book and the catalogue of the RA exhibition in 1839. Behind him is the north bay of the North Gallery at Petworth, which he built in 1826 to accommodate further additions to his famous collection of modern British paintings and sculpture. It is only very recently that this picture has been identified as painted in 1839 and therefore posthumous.[1] It thus assumes a new interest, as not simply a portrait of a collector in the actual surroundings of his collection (rare though that is), but as a retrospective summation of a patron of art, seen through the eyes of the chief beneficiaries of his will and of his patronage.

The chief beneficiary of the 3rd Earl's will was his eldest illegitimate son, Col. George Wyndham (created Lord Leconfield in 1859). He must not only have commissioned the picture, when there was already no dearth of portraits of his father in the house,[2] but also have taken care to place it in a cardinal position, over the chimneypiece of the Square Dining Room.[3] He probably also suggested including over the 3rd Earl a portrait of his most distinguished relative, his cousin, the politician *William Wyndham Grenville, 1st Baron Grenville* (1759–1834), head of the 'Ministry of all the Talents' in 1806–7.[4]

After the 3rd Earl's death, Phillips wrote to Col. Wyndham, describing him as 'my best friend and benefactor, who for forty-one years has never ceased to shew his favour and kindness to me and mine, and whom I and my family have learn't to honour and love as a Father'.[5] He must have had most say over the other works included. The most prominent of the pictures is *The Birth of Venus*[6] by his friend William Hilton (1786–1839), with whom he and David Wilkie had toured Italy in 1825. Significantly, it was not even a painting that had been commissioned by Lord Egremont, but had been sold by the artist to Sir John Leicester (see cat. no.32), at whose posthumous sale in 1827 it had been bought by Phillips on behalf of Lord Egremont. Even more curiously, not only is it placed off-centre, in a way that would have been impossible in the actual hang of the north bay of the North Gallery, but a *pentimento* shows that it replaced an – unfortunately unidentifiable – upright painting that was more logically centred over the door.

Immediately below this, but quite out of scale with it, is the earliest and still in certain respects the greatest of the Turners bought by the 3rd Earl, the so-called 'Egremont Seapiece'.[7] The 3rd Earl's collecting and patronage of Turner surpassed that of any other artist in its scope (see cat. no.32), but even so this picture may have been inserted by Phillips

because of his good fellowship with Turner: not only was each an *habitué* at Petworth, but both were close friends of the sculptor Francis Chantrey, and were, with him, among the founders of the Artists' General Benevolent Institution.

In the bottom register is *Sancho Panza and the Duchess*[8] by C.R. Leslie (1794–1859), one of a pair of literary subjects painted by him for Lord Egremont, in 1824 and 1835, and called by Creevey 'the cleverest and prettiest thing I ever saw'.[9] He too was often at Petworth, and again there is a particular association with Phillips, who had introduced him to the 3rd Earl, when he proposed Leslie instead of himself to make a sketch of a dying grandchild for the peer.[10]

The sculpture, by contrast, seems to have been more carefully chosen to exemplify the patronage of the 3rd Earl, but also perhaps to reflect its actual or intended placement in the north bay of the North Gallery. Flaxman's *St Michael crushing Satan* (1819–26) occupied the centre of that room, then as now.[11] The other marble is *Venus visiting Vulcan at his Forge*[12] (1827) by J.E. Carew (?1785–1868). Carew was an Irish-born sculptor almost exclusively employed on commissions for Lord Egremont from 1823 onwards, who built a studio at Brighton to carve them and was given Grove House, Petworth, to live in from 1835, and for whose works the 3rd Earl ultimately intended to create a special gallery. Finding himself not mentioned in Egremont's will, however, Carew brought a suit against the estate, for the astonishing sum of £50,000 that he claimed was owing to him. The court ruled that, if anything, he was the debtor, so that he was declared bankrupt. The case was in progress while Phillips was painting his picture, and *pentimenti* show that the artist had originally intended to give the group a much more prominent position this side of the arch to the north bay.[13]

Another *pentimento* concerns the 3rd Earl's famous love of animals. Not only is there a bronze of a horse on the table beside him, but the same animal, 'Cricketer', was represented – as is still the case in actuality – as a finial on top of the gold cup that he won at Goodwood in 1825. This was painted out, and a knop of vegetable ornament substituted. At the Earl's feet sits a spaniel, one of the many dogs that accompanied him everywhere.[14]

HIST: substituted for Reynolds's *Death of Cardinal Beaufort* as the overmantel in the Square Dining Room at Petworth after 1839; sent to Cockermouth in 1861;[15] returned to Petworth early in the 20th century; thence by descent, until accepted in lieu of death-duties in 1956 by HM Treasury, by which subsequently conveyed to the National Trust.

EXH: RA, 1839, no.98.

LIT: *Petworth* 1856, p.34, no.309*; Collins Baker 1920, p.98, no.695; Hussey 1925, p.971, fig.11; Gore 1977, p.356, fig.21 on p.354; Blunt 1980, pp.121–2, fig.1 on p.120; Bucklow 1993.

14 George Frederic WATTS, OM, RA (London 1817–1904)

Jane Elizabeth ('Jeanie') Hughes, Mrs Nassau Senior (1828–77)

Oil on canvas. 176·5 × 103 cm (69½ × 40½ in)
Wightwick Manor, Staffordshire

Watts is not thought of primarily as a portrait painter, and when he is, it is for the high seriousness and painful honesty of the head-and-shoulders portraits that comprise his 'Hall of Fame' (from 1846; National Portrait Gallery; now in part in a memorable installation at Bodelwyddan Castle, Clwyd). He himself set a low estimate on portraiture by comparison with the rendition of abstract and morally uplifting conceptions. Certainly, his most famous portrait, 'Choosing' (c.1864; National Portrait Gallery), contained an unmistakable symbolism intended to elevate it above the humbler concerns of the genre: his child-bride, the actress Ellen Terry, making the choice between showy but scentless camellias and a humble clutch of sweet-smelling violets held to her heart.

There was clearly some special significance for Watts in the association of women with flowers, for it is in the unusual action of watering lilies of the valley in a pot that he chose to paint Mrs Nassau Senior, in 1858. She was the daughter of the author and artist John Hughes[1] (1790–1857) of Donnington Priory in Berkshire, and thus the younger sister of Thomas Hughes (1822–96), Christian Socialist, founder of the Working Men's College and author of *Tom Brown's Schooldays* (1857). In 1848 she married Nassau John Senior[2] (1822–91), who should perhaps be known as Nassau Senior Junior, since he was the son of the celebrated economist and creator of the 1834 Poor Law, Nassau William Senior (1790–1864). With such family connections, it was natural that she too devoted herself to social causes, becoming the first female Inspector of Workhouses and Pauper Schools (1874) and the founder of the Association for Befriending Young Servants. She also helped Octavia Hill, co-founder of the National Trust, with the accounts of her housing schemes.[3]

Watts's friendship with Jeanie Senior began around 1855, when he was living as a house-guest of the Prinseps at Little Holland House in Kensington. Rather surprisingly, Watts's second wife, Mary Fraser-Tytler, claimed that it was 'her naturally bright and spontaneous out-of-door nature' that appealed to him.[4] In fact, it seems more likely that it was their joint concern to do good – he through his art, she by practical action – combined with her physical attractiveness, that drew him to her.

Jeanie Senior's chief physical attraction was her 'rippling golden hair'[5] – the self-same enchantment that was to help draw him to Ellen Terry, who was once memorably observed as she 'loosened the pins from her hair, which tumbled about her shoulders like a cloak of shining gold'.[6] When painting his frescoes for Lord Somers in Carlton House Terrace in 1856, the painter even wrote to Jeanie Senior, asking her 'to lend me your hair . . . and a hand or an arm occasionally'.[7] The outstretched, yearning attitude of Ellen Terry and Jeanie Senior is also strikingly similar, showing off – as Mrs Russell Barrington says of 'Choosing' – 'a beautiful fair girl's head and a perfect throat stretching forward'.[8] Significantly, Watts appears to have accentuated Mrs Senior's throat and its stretching action in the painting, by comparison with his pencil study of her head.[9]

Watts's portrait of Mrs Senior, like that of Ellen Terry, is a moral allegory expressed through the language of flowers. The lilies of the valley, which symbolised 'the return of happiness' to the Victorians, are growing in a rich pot on a fantastically ornate plinth. Scattered in the foreground, as if rejected, lie cut flowers – including an arum lily, orchid and rose. Watts appears to be setting up a deliberate contrast between the natural simplicity of the growing lilies, and the richness, profusion and artifice with which they are surrounded. The glass carafe with which she waters the lilies, and the clear crystal jug of water in the foreground, suggest both purity and temperance. Watts himself subsequently told Mrs Barrington that, by showing Jeanie Senior in the act of 'watering and bending over her flowers with loving care, . . . he had tried to suggest . . . her beneficent gracious nature'.[10]

Although never a Pre-Raphaelite (and indeed, repudiated for a time by Ruskin for that reason), Watts was influenced by the members of the PRB – at no time more, perhaps, than when he was painting the present portrait. The composition has curious premonitions of Holman Hunt's *Isabella and the Pot of Basil* (1867; Laing Art Gallery, Newcastle-upon-Tyne).[11] Watts was further influenced at this period by Pre-Raphaelite techniques of oil painting, having discussions with Rossetti, Millais and perhaps Ruskin on the respective advantages of various paint mediums; for some years, under Rossetti's influence, he painted his pictures, including this one, with copal varnish.[12] The result of these influences was, as his widow says, that this portrait is 'brilliant in colour, and as delicate in handling as a miniature'[13] – two of the distinguishing characteristics of Pre-Raphaelite painting.

HIST: by descent from the sitter to Oliver Nassau Senior, by whom lent to Wightwick from 1947, and from whom bought by the National Trust with the encouragement of Lady Mander in 1955.

EXH: RA, 1858, no.142 (under pseudonym of F.W. George: 'owing to a sort of curiosity to see whether his manner was recognisable or not'[14] – it was); Grosvenor Galleries, 1882, no.82; ?RA, 1886, no.1493; New Galleries, 1892, no.87; *Watts*, Tate Gallery, 1954, no.21.

LIT: Sketchley 1904, p.177; West and Pantini 1904, pl.54; Barrington 1905, pp.2, 7, pl. opp. p.6; Bell 1905, p.44, illus. p.50; Watts 1912, i, pp.174–5; Hare, p.47; Blunt 1975, p.102, pl.14.

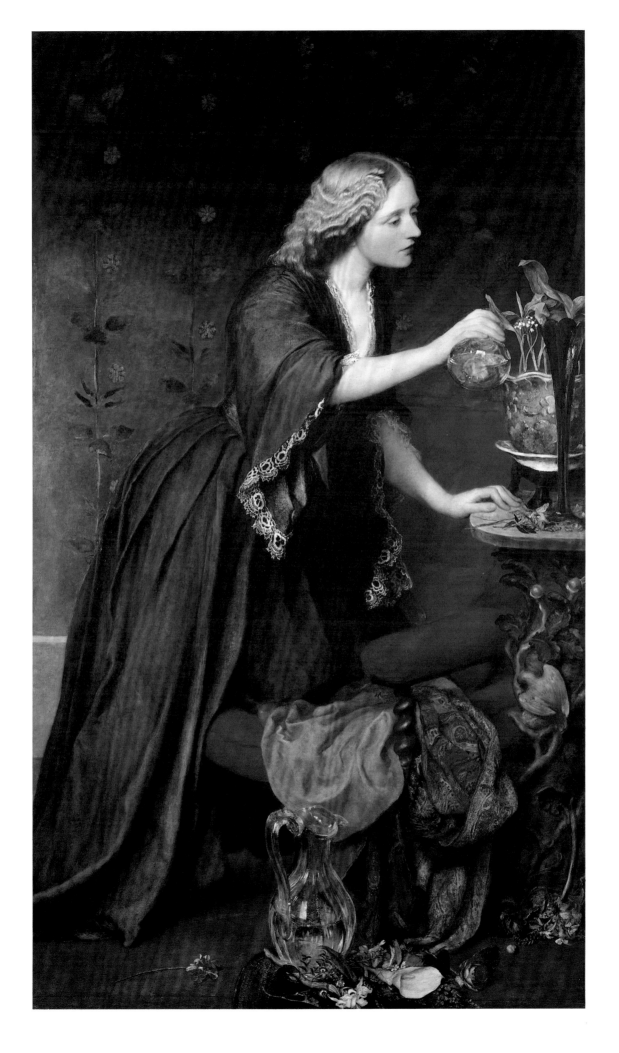

15 Charles-Auguste-Emile Durand, known as CAROLUS-DURAN
(Lille 1837 – Paris 1917)

Margaret Anderson, Mrs the Hon. Ronald Greville (d.1942)

Oil on canvas. 206 × 99 cm (81 × 39 in)
Signed bottom left: *Carolus-Duran/Paris 1891*
Polesden Lacey, Surrey

It was typical of Mrs Greville's unconventionality that, though her social ambitions were immense, she should have had herself painted in 1891, the year of her marriage, not only by a foreign artist, but by one whose reputation had been somewhat racy. Carolus-Duran's first major full-length portrait, of his wife, the pastellist 'Croizette', as *Lady with a Glove* (Musée d'Orsay, Paris), had caused a sensation at the Salon of 1869. He had followed it with a series of bold portraits of ladies from French society and the *demi-monde*.

Carolus-Duran's former pupil, John Singer Sargent, had also set a precedent, with his *'Madame X' (Virginie Avegno, Mme Pierre Gautreau)* (1882–4, exh. Salon, 1884; Metropolitan Museum, New York). This notorious portrait of the promiscuous American wife of a French banker was in marked contrast to that with which Sargent restored his reputation in Britain and America, of *Mrs Henry White* (1883; Corcoran Gallery of Art, Washington), which was exhibited at the Royal Academy in 1884. Carolus-Duran himself had been represented by portraits at the RA since his *Countess of Dalhousie* in 1883. He exhibited only six more portraits there in the 1880s, however, mostly of foreigners, and between then and 1902, only four more, although one of them was of a woman from the same racy 'Marlborough House set' as Mrs Greville, *Daisy, Countess of Warwick*. Yet it is interesting that Mrs Greville, having had herself painted with such directness by Carolus-Duran, does not appear to have let him exhibit it anywhere: the sensation was to be for the initiates of her *salon* alone.

That *salon*, and her biting wit, were to become Mrs Greville's chief claim to fame.[1] Her social ascent, from illegitimate daughter of a self-made Scottish brewer, to friend of the King and Queen of Spain, of King Farouk of Egypt, and of George VI and Queen Elizabeth – who spent part of their honeymoon at Polesden Lacey – was astonishing. Her father, William McEwan, MP (1827–1913), founded the brewery that bears his name, which flourished on the back of sales to the British army and the colonies.[2] He had no children by his first wife, and consoled himself after her death with one Helen Anderson, a woman variously described as his housekeeper, his cook, or as wife of the day-porter at his brewery, whom, according to Margaret, Marchioness of Crewe, McEwan put on night duty 'for convenience'.[3] Whether he subsequently married her or not is unclear; neither their marriage certificate, nor any birth certificate for their daughter, Margaret, or

'Maggie', has been found. Father and daughter remained remarkably close: she always sat with a portrait of him behind her chair in the dining-rooms at Polesden Lacey and her London house.[4]

Margaret McEwan was catapulted, not just into society, but into royal circles, by her marriage in 1891 to Capt. the Hon. Ronald Greville, MP (1864–1908), eldest son of the 2nd Baron Greville and Lady Violet Graham.[5] Lord Greville was a groom-in-waiting to Queen Victoria; but, more importantly, 'Ronnie' Greville was not only one of the closest friends of the Prince of Wales, the future Edward VII, but also since childhood the closest male friend of George Keppel, complaisant husband of the Prince's mistress, Alice Keppel. Of her Mrs Greville was memorably to remark after the fall of France in 1940: 'To hear Alice talk about her escape from France, one would think she had swum the Channel, with her maid between her teeth.'[6] Keppel was best man at their wedding in 1891, and the Keppels and the Grevilles thereafter not only occupied nearby houses in Charles Street, but demolished the house between so as to create an Italian garden linking the two. By the time that her husband died, Mrs Greville was thoroughly launched – through her wealth, connections, wit, and prowess as a hostess – into an impregnable position in society, needing no further cachet: 'I'd rather be a beeress than a peeress', she said.

In 1906 her father had bought Polesden Lacey for them as a country residence, and Mewès & Davis, the architects of the London Ritz, remodelled the interior with much panelling and gold leaf.[7] There and in Charles Street she gave her celebrated dinner parties for royalty, politicians, ambassadors and celebrities, served by a brace of butlers – the conventional Boles and the communist Bacon.[8] At these she demolished rival hostesses with such splendid put-downs as that of the over-made-up Emerald Cunard: 'You mustn't think that I dislike little Lady Cunard, I'm always telling Queen Mary that she isn't half as bad as she is painted.'[9] She was buried in the rose garden at Polesden Lacey, 'next to the dog cemetery, in accordance with female country-house-owner tradition', according to James Lees-Milne; with a gravestone designed by Prof. Albert Richardson, which 'looks like the top of an old-fashioned servant's trunk'.[10]

HIST: at Polesden Lacey, with which bequeathed by the sitter, together with her 'pictures and objects [sic] d'art', to the National Trust in 1942, in memory of her father, William McEwan, with the express stipulation that it, another portrait of her and Constant's portrait of her father 'be accorded suitable positions in the proposed Gallery'.

EXH: *Daily Mail Ideal Home Exhibition*, Olympia, 1957.

LIT: *Polesden Lacey* 1964, p.13, no.1, pl.1.

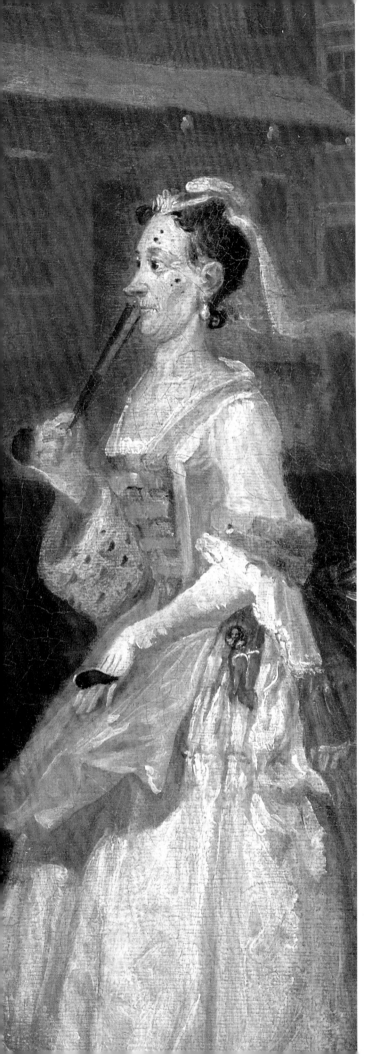

2

CONVERSATION-PIECES, NARRATIVE PAINTING AND SPORTING ART

'I had rather see the portrait of a dog that I know, than all the allegorical paintings they can shew me in the world.'[1] Nikolaus Pevsner, who quoted this remark of Samuel Johnson's in *The Englishness of English Art*, went on to assert: 'This irritating remark, as so much of what the irritating Doctor said, is massively English.'[2] He then quoted with approval the remark of another immigrant who, like himself, had blossomed in unexpected ways in this apparently uncongenial environment, the Swiss painter Johann Heinrich Füssli (1741–1825). Henry Fuseli, as he became, exclaimed that there was 'little hope of *Poetical* painting finding encouragement in England. The People are not prepared for it. Portrait with them is everything. Their taste & feelings all go to *realities*. The Ideal does not operate on their minds.'[3]

What is unusual about the English love of portraiture is not so much that the English loved to have themselves depicted, as that they extended this love of the painted record to their houses, their gardens, their horses, their dogs, their servants – and even to their pigs and cattle. (There are fine sets of cattle-pictures at Attingham, Shugborough, and in the private apartments of Petworth, by W.H. Davis and John Boultbee, and some sheep at Townend, but curiously, only one fat pig, at Calke Abbey.) One can, of course, find individual instances of all these kinds of picture on the Continent, but it is only in England that each evolved into a genre of painting all of its own. Indeed, while the etymological derivation of the term 'portrait' (Fr. *portrait*, It. *ritratto*, Sp. *retrato*, but Ger. *Bildnis*), from *pour* + *traire*, carries with it the connotation not just of drawing, but of drawing *out* (i.e. of reaching towards some spiritual essence of the thing portrayed), it is doubtful whether the term is so readily transferable from humans to the animal world anywhere other than in England. But the same sensibility that could provide in a will for dogs, those 'dumb sensible sincere creatures' (see cat. no.16), and even put up tombstones to them (see cat. nos.15 and 16),[4] would find nothing unnatural in having them painted.

It might seem to conflict with this idea that, whereas

Detail of Hogarth, *Morning* (19a)

49

small-scale horse painting did become a genre of its own from John Wootton (1678/82–1764) and James Seymour (c.1702–52) onwards,[5] dog painting never quite achieved the same autonomous status. But that was because of the very propinquity of dogs to humans, which meant that they were less likely to be shown on their own than with their master or mistress, as in the portraits of the *Marchioness of Powis* (cat. no.4) or the *3rd Earl of Egremont* (cat. no.13) – and even with *Lady Caroline Capel*, before being painted over (cat. no.10). Unusually perhaps in that world, dogs were more cherished for themselves than for their lineage, so that accumulations of portraits of them, as a record of ancestry, were unnecessary, unlike with horses or even cattle. A witty canine commentary upon this aspect of portrait painting is provided by Wootton's preposterous picture of *The Countess of Oxford's Harlequin Bitch 'Casey'* (on loan to Wimpole Hall from Lady Anne Cavendish-Bentinck), in which the pampered creature lies on a cushion, while a portrait of two other dogs takes the place of an ancestral portrait in the overmantel behind her. Cats fared even more poorly, probably because they were the companions more of women than of men, who were generally the ones commissioning pictures. Perhaps also,

because lacking visible musculature on account of their fur, they eluded the skills of artists brought up on the study of anatomy. (There is, however, a charming Francis Sartorius of a cat called *Psyche* at Fenton House in London.)

The genre of painting that combined most of these separate forms of portrayal into one was the conversation-piece. This has come to be regarded as quintessentially English, in part because of the brilliant propaganda for the English examples made by Sir Philip Sassoon and Mrs David Gubbay with their pioneering exhibition at the former's town house, 25 Park Lane, in 1930, which led to G. C. Williamson's *English Conversation Pictures* (1931) and Sacheverell Sitwell's *Conversation Pieces* (1936).[6] In fact, the conversation-piece, whether in the form of the portrait of a family or of a 'conversation' of virtuosi, was well established in the Netherlands and in France in the 17th century. Three fine, but frustratingly anonymous, examples of the former are in National Trust houses: two Dutch, of c.1640–50, at Peckover House, Wisbech, and on Derwent Island; the other more probably Flemish, of c.1670, at Attingham. The last two both lack the reduction to puppet scale that often seems an essential characteristic of the genre, while the Attingham picture adds an allegorical dimension by

Fig. 5 The South Drawing Room at Wimpole Hall

providing each of the children with an emblem of one of the Cardinal Virtues.

It was also a Frenchman – albeit a Huguenot born in Berlin – Philippe Mercier, who did most to introduce the conversation-piece to England (see cat. nos.17, 18). It is thanks, perhaps, to these immediate French rather than to remoter Dutch origins that the one thing that the English conversation-piece is *not*, is bourgeois or middle-class,[7] as the examples shown here amply testify. Sometimes, perhaps, the distinction between a small-scale group or family portrait and a conversation-piece is not properly made. Smallness of scale is surely one of the true defining characteristics of the latter, but what distinguishes it above all is the introduction of some activity to link the *dramatis personae* together. That is what is done here by Mercier, Hogarth (cat. no.20) and Zoffany (cat. no.22), three of the most successful practitioners of the genre. Hogarth went on from such depictions to his 'modern moral Subjects' (see cat. no.19), of which he said: 'I have endeavoured to treat my subjects as a dramatic writer: my picture is my stage, and men and women my players, who by means of certain actions and gestures are to exhibit a dumb show.'[8] Zoffany made actual theatrical representations a major branch of his art from the 1760s onwards: a good example, *Mrs Abington in 'The Way to Keep Him'* (1768), is at Petworth.

Hogarth provides the natural link between the conversation-piece and narrative painting, just as Sacheverell Sitwell went on to write *Narrative Pictures* (1937) the year after *Conversation Pieces*. As Pevsner saw it, Hogarth's decision to turn to painting his 'modern moral Subjects' combined two quintessentially English traits: the urge to observe and record, together with the desire to use art to preach and reform. The latter was similar to the motivation behind the creation of so many museums and galleries in the 19th century, and one of the things that sets them off from once private collections such as those from which the pictures in this exhibition are drawn. The history painting against which Hogarth was reacting of course also tells a story; but, in general, the tale was already oft-told, and the point of the exercise for each artist was his particular interpretation of it, measured explicitly or implicitly against the paragons of the past. The point of narrative painting, exactly as with the novel, is the novelty of the tale. Implicit in this is the further charge, that to Hogarth, as in narrative painting as a whole, 'the story mattered more than the art'.[9] It was certainly this that undid so much of British narrative painting in its heyday, the 19th century. And with artists such as G.E. Hicks, it is often more in the private sketches with which they prepared their compositions (e.g. cat. no.27), rather than in the over-finished pictures they exhibited, that their art is shown.

As the century wore on, the narrative pretext tended to grow weaker, and pictures simply became vehicles for ingratiating arrangements of healthy, happy and attractive people – and more particularly of their impeccable costumes – in lovingly detailed interiors, florid gardens or sanitised urban settings. The two most successful practitioners of this genre in Britain were the Frenchman James Tissot (1836–1902) and the Dutchman Sir Lawrence Alma-Tadema (1836–1912).

Fig. 6 Robert West, *Thomas Smith and his Family* (1733; Upton House)

From around 1876 Tissot increasingly tended to portray his mistress, Kathleen Newton, in enigmatic situations that derived such meaning as they had from the inexplicit titles given to them.[10] Alma-Tadema translated the small-change of Victorian daily life into a saponaceous never-never land of Antiquity.[11] Yet it is precisely the fact that the narrative pretext generally meant so little to either of them that made their most successful pictures aesthetically pleasing groupings of forms and colour. There is no painting by Alma-Tadema in any National Trust house, but Tissot's *The Crack Shot* (cat. no.28), painted before he had encountered Kathleen Newton, is a case in which apparently casual observation of the real has produced an arresting and effective image.

Conversation-pieces, and pictures of animals, horses or servants, were not, by and large, being consciously 'collected' at the time that they were commissioned, although by the time that the second set of Erddig servant portraits (see cat. no.25) was painted in 1830, these were clearly seen as continuing a tradition. Narrative pictures more often were, but for 19th-century collections that have perhaps since been more ruthlessly broken up and dispersed than those of the previous century.[12] *The Crack Shot* originally belonged to just such a vanished collection of modern British and foreign art, that of the Murrietas, spread between great mansions in Kensington Palace Gardens, Carlton House Terrace and Wadhurst Park in East Sussex.

It is instead to two of the pioneering 20th-century collectors of such pictures that the National Trust owes its finest examples: the 2nd Viscount Bearsted (1882–1948), whose interest was essentially in 18th-century English conversation-pieces, and developed out of his interest in English sporting painting; and Captain George Bambridge (1892–1943), whose collection grew out of his original taste for coaching prints, but – perhaps because of his extensive sojourns in foreign capitals as a diplomat – extended to embrace a catholic and original collection containing both Continental and English narrative pictures.[13]

16 Jan WYCK (Haarlem 1645 – Mortlake 1700)

A Dutch Mastiff ('Old Vertue'?) with Dunham Massey in the Background

Oil on canvas. 89·5 × 69 cm (24 × 29½ in)
Dunham Massey, Cheshire

'A brindled mastiff of bulldog type' is probably the best technical description of this dog.[1] Although canine nomenclature was far from exact around 1700, when this picture was painted, it does seem possible tentatively to relate it to a particular breed that was cultivated at Dunham Massey, a house where the cult of the dog was unusually strong.[2] In general, country gentlemen and the nobility had their horses painted, but not their dogs. Fond though they might be of the latter, these did not represent the same kind of financial investment as horses, and their blood-lines were not as yet so developed. Nor were they the chief occasion for the same kind of social gathering, in the form of hunts and races. At Dunham, however, the dogs were commemorated not only by a whole variety of portraits (beginning with this one), but also by tombstones, the earliest surviving of which, dated 1702, is to 'Pugg, alias Old Vertue'. 'Pugg' was clearly the dog's name rather than breed, as the word was only then changing from an affectionate insult (meaning imp or dwarf) into the designation of a particular dwarf breed of dog.[3]

That such dogs were bred at Dunham is also suggested by the fact that in 1690/1 Katherine Booth (1672–1765) wrote: 'My cousin Booth [Vere Booth or his elder brother] yesterday gave me a little Dutch Masty ... the prettiest chubbiest face that ever you saw, he is now on my lap.'[4]

Sadly, only a year or so later this particular animal ran out into the streets in her absence and disappeared. Katherine, however, remained devoted to dogs to the end of her days, adding codicils to her will about them. The first went:

> I cannot satisfie myself without taking care of my sensible loveing Dutch Mastive Poppet if I die before her, so I write this; to charge my Estate real & personal, with twelve pence a week to maintain her in meat as long as she lives, that is, the person who takes care of her is to have it for that purpose & to have the little table with a drawer to put her meat or combs or Trencher in, (which I call hers) and she shall have her mug for water and a bottle allways full in the room she lies in; & shall lie on the Bed or go into it if she pleases, & the first thing carried out to some safe place in a morning to doe her occasions. Then at Breakfast a little Bread crumbled on her Trencher or Plate & a Tea or Coffee Cup of Milk put toe it & stired together, any Butchers meat cut on her Trencher at noon & a bone to please her all times & to be carried out again after Dinner as before: the same at night before she goes to Bed, & not suffered to run out in Street or lane alone; & to stay in my House at Boughton as long as possible after my Death.

But in 1756 she had to add another: 'Since Poppet is dead all is at an end with what I have writ above & in this Paper but my concern now is for Prity Prince & Bender, Dum sensible sincere creatures.'[5] It is pleasant to think that these 'Dum, sensible sincere creatures' may have been the descendants of the dog shown here.

The attribution of this picture has hovered between Wyck and Leendert Knyff (1650–1722) ever since it became the object of scholarly attention in 1976, with the revelation of the treasures of Dunham Massey bequeathed to the National Trust by the 10th and last Earl of Stamford. This uncertainty is understandable, since such a combination of a dog portrait with a view of a house is almost unique, and both artists are credited by George Vertue with making paintings of dogs for the gentry. That so few works of the kind by either artist have been identified does not help matters.

Jan Wyck was the son of Thomas, or 'Old', Wyck (*c*.1616–77), who painted italianate scenes of harbours and alchemists' laboratories. Of Jan Vertue says, 'His Hunting Pieces are also in grate Esteem among our Country-Gentry, for whom he often drew Horses & Dogs by the Life, in which he imitated the manner of Woverman [Philips Wouwerman].'[6] At least two signed examples of such works are known: *Huntsman with a dead Hare and a Pack of Hounds above Berkhamsted* (Sotheby's, 12 March 1986, lot 111), and *Portrait of a Löwchen in the Grounds of a Country House* (Christie's, 17 July 1987, lot 26A).

Fig.7 Detail of Johannes Kip's 1697 engraving of Dunham Massey, after a painting by Leendert Knyff

Leendert, or Leonard, Knyff is best known as a painter of bird's-eye views of houses, many of which were later engraved by his fellow-countryman Johannes Kip. These include a *View of Dunham Massey from the South-west* engraved by Kip in 1697. The view of the house shown here is from the south-east and depicts the idiosyncratic entrance front of open arcades and paired pilasters which was built in the 1660s by the younger Sir George Booth to join the turrets of his grandfather's early 17th-century house, but which disappeared when the house was remodelled by John Norris between 1732 and 1740.

Vertue calls Knyff 'a dutch painter – chiefly fowls, dogs, &c.', and records 'some dogs painted by him, freely enough' at William Sotheby's house, Sewardstone in Essex.[7] There is a whole group of portraits of, or including, dogs, painted by Knyff in 1699 and 1700, at Temple Newsam in Yorkshire, from the collection of the Earls of Halifax, but none is very similar to the present picture.[8] Closer in many respects is the signed example in the Yale Center for British Art.[9] But,

despite these affinities, an attribution to Wyck seems preferable, above all because of the refinement of its handling, and the painterly quality of the background scene – of the hero of the picture chasing sheep! Moreover, the picture has been ascribed to Wyck since it was first recorded in 1769, in an inventory generally reliable in its ascriptions.

HIST: recorded in the first MS 'Catalogue of Pictures &c at Dunham, 1769' (taken a year after the death of the 4th Earl of Stamford, husband of the heiress of Dunham Massey, Lady Mary Booth), p.19 (as 'a Dutch Mastiff . . . Wyke', in the Yellow Bedchamber); 1776 inventory, p.20 (ibid., as the same); 1787 inventory, p.29 (in the Stairfoot-Room, as the same); 1811 inventory, p.26 (ibid., as the same); undated inventory of 1830–45, p.20 (ibid., as the same); by descent to Roger, 10th Earl of Stamford, who bequeathed the house and estate of Dunham Massey, and all its contents, to the National Trust on his death in 1976.

LIT: *Dunham Massey* 1986, p.56, no.74 (as by Knyff); Laing 1990, pp.63–4, fig.1 (as by Knyff).

17 Philippe MERCIER (Berlin 1689 – London 1760)

The Belton Conversation-piece

Oil on canvas. 61 × 74 cm (24 × 29 in)
Signed bottom left: *Ph. Mercier Pinxit*
Belton House, Lincolnshire

If any picture can be said to epitomise the charms of country-house life in England in the 18th century, it is this. It is Mercier's masterpiece, the picture in which he successfully fused the Watteauesque *fête galante* with the Netherlandish family portrait, to create the English conversation-piece. So it is appropriate that he should have included an apparently idealised portrait of himself sketching the scene in the bottom left-hand corner.[1] The picture was painted in 1725–6, some ten years after his arrival in England, but is one of his earliest surviving works.

On the left is the man who commissioned the painting: Sir John Brownlow, Viscount Tyrconnel (1690–1754), eldest son of Sir William Brownlow and Dorothy Mason (see cat. no.6). He wears the ribbon and star of the recently revived Order of the Bath, of which he was one of the first new knights.[2] Behind him is the south front of Belton, which had passed to him in 1721 on the death of his aunt, Alice, Lady Brownlow (née Sherard). His first wife, Alice's daughter, Eleanor Brownlow (1691–1730), sits in a 'chariot' pushed by her blackamoor page. No doubt she was already suffering from the illness that would carry her off five years later; to alleviate it, her husband was to take her out of London to the purer air of Greenwich in 1729. Mercier made one of his loveliest drawings, *aux trois crayons*, of her down to the waist in the very same coroneted chariot, as a preparation for this picture.[3]

Seated in the swing – a little surprisingly, perhaps, the effective focus of the picture – is Elizabeth Dayrell (1700/1–68), daughter of Peter Whitcombe and Lady Brownlow's sister, Mary Sherard, and thus first cousin to Viscountess Tyrconnel. Looking at her, and standing behind Lady Tyrconnel, is her husband, Francis Dayrell (d.1760) of Shudy Camps, Cambridgeshire. Holding the rope of the swing is Savile Cockayne Cust (1698–1772), later of Cockayne Hatley, Bedfordshire. He was a remoter cousin, but by the marriage of Sir Richard Cust, 2nd Bt, of Pinchbeck, Lincolnshire, to Lord Tyrconnel's only sister Anne, Belton was subsequently to pass from the Brownlows to the Cust family. Though known as 'Cavil Cust' on account of his litigious nature, he was a constant and welcome guest at Belton.

Finally, looking out at the right, a little detached from the scene, is William Brownlow (1699–1726), Lord Tyrconnel's only brother. He was something of a sportsman, and no doubt enjoyed Belton for that reason. But he had also lost money in the 'South Sea Bubble' of 1720, and was to leave just £607 net when he died on 28 July 1726. The painting must have been completed by then, since there is nothing in it premonitory of his death. Indeed, the two brothers act as *repoussoirs* within the picture, focusing attention on the carefree scene at its centre.

Lord Tyrconnel's early patronage of Mercier was particularly significant, because the peer was to become a member of the circle of Frederick, Prince of Wales after the latter's arrival in England in December 1728. Mercier was appointed Principal Painter to the Prince in February 1729, and almost immediately started on a whole-length state portrait. He went on to paint a series of much less formal images of the Prince (see cat. no.18). Mercier had apparently painted the Prince in Hanover in 1716, but this would have been highly unlikely to have given him the *entrée* to Frederick, so Tyrconnel (if not the Prince's sisters) may have been responsible for the reintroduction.[4] In 1730 Mercier painted another portrait of the Prince, who later gave it to Tyrconnel.[5] Tyrconnel also obtained from Mercier a '*Prospect of Belton*' that was recorded in his house in Arlington Street in 1738.[6] If, as seems likely, this is the picture that now hangs in the Breakfast Room at Belton, then Mercier – who never seems to have painted pure landscapes – probably restricted his role to inserting the figures. Yet the setting of the present painting forms an undeniable part of its charm.

HIST: presumably commissioned by Viscount Tyrconnel, but not apparently recorded either at Belton in 1737 or in his house in Arlington Street in 1738, nor in the posthumous inventory taken at the latter on 2 April 1754;[7] Frances Bankes, Lady Brownlow (1756–1847), Hill St; given by her to John, 2nd Baron and 1st Earl Brownlow some time after the death of her husband, the 1st Baron, in 1807 (recorded as one of the pictures forming her gift, by an addition to the Hon. Elizabeth Cust's MS catalogue of the pictures at Belton, as: '*Lady Tyrconnel & a Family Party in the Belton Gardens*', without attribution); thence by descent, until bought by the National Trust from the 7th Lord Brownlow in 1984, at the same time as he gave Belton, its garden and many of its other contents to the Trust.

EXH: *British Country Life throughout the Centuries*, Grosvenor Sq., 1937, no.281; *European Masters of the 18th Century*, RA, 1954–5, no.443; *The Conversation Piece in Georgian England*, Kenwood, 1965, no.30; *Philip Mercier*, City Art Gallery, and York, and Kenwood, 1969, no.12, illus.; *Zwei Jahrhunderte Englische Malerei*, Haus der Kunst, Munich, 1979–80, no.12; *Rococo: Art and Design in Hogarth's England*, Victoria & Albert Museum, 1984, no.C2; *The Treasure Houses of Britain*, National Gallery of Art, Washington, 1985–6, no.166; *Patronage Preserved*, Christie's, 1991, no.28, pp.54–5, pl. p.55.

LIT: Cust 1909, pp.191–2; Waterhouse 1953, p.141, pl.115 (1978 repr., pp.188–9, pl.149); Edwards 1954, no.80, pp.58, 166, illus. p.121; Hayes 1969, pp.116, 118, fig.4; Ingamells and Raines 1976–8, no.16, p.17; Allen 1991, p.136, pl.121; *Belton* 1992, p.73, no.124 and col. fig. on back cover.

18 Philippe MERCIER (Berlin 1689 – London 1760)

Frederick, Prince of Wales (1707–51) and his Sisters making Music at Kew

Oil on canvas. 77·5 × 57 cm (30½ × 22½ in)
Cliveden, Buckinghamshire

This is one of the most delightfully informal portraits of a royal prince to have been painted anywhere in the 18th century. Mercier had been appointed successively Principal Painter (6 February 1729), Gentleman Page of the Bedchamber (6 March 1729) and Library Keeper (26 January 1730) – which also meant picture-buyer[1] – to Frederick, Prince of Wales. He also taught Frederick's sisters to draw and paint.[2]

What is probably the prime version of this picture, in the National Portrait Gallery, signed and dated 1733, is identical in composition, but unfortunately has lost about a foot at the top of the canvas and an inch beneath, and is not in perfect condition.[3] The third version, in the Royal Collection, was first recorded in 1767 as 'a picture of His Late Royal Highness Prince of Wales, & 3 Sisters in a Concerto'. In it Mercier placed the same group of figures in an apartment of the Prince of Wales's – almost certainly at Kensington Palace[4] – and added a listening dog. The germ of the whole composition seems to have been a group at the centre of a drawing by Mercier of a *fête galante* (British Museum), still strongly indebted to Watteau.[5]

Frederick had begun to learn the bass-viol only around 1733,[6] but by the summer of 1734 he was regularly to be seen at Kensington Palace 'with his violoncello [the instrument shown in all three versions] between his legs, singing French and Italian songs to his own playing for an hour or two together, while his audience was composed of all the underling servants and rabble of the Palace'.[7] His sisters depicted must be the Princess Royal, Princess Anne (1709–59), Princess Amelia (1711–86) and Princess Caroline (1713–57), since the fourth, Princess Mary (1723–71), was only about ten at the time. However, it is not immediately clear which is which, as their likenesses are scarcely differentiated enough to tell, either here or in the wholelengths of the three sisters painted by Mercier in 1726 (Shire Hall, Hereford).[8]

There is also a slight doubt about the precise setting. It is always said to be the garden (i.e. the north, Thames side) of the Dutch House, which appears in the background and was the Princesses' home at that time. However, the group seem actually to be outside the railing boundary of that garden, and in the grounds of Kew House, which stood opposite it to the south-east. Frederick leased Kew House from 1729, partly no doubt to lure visitors from the court of his mother, Queen Caroline, at nearby Richmond Lodge. Between 1731 and 1735 he had William Kent rebuild it in Portland stone as the White House (now gone; the site is marked by a sundial).

This scene of family harmony seems to conflict with Lord Egmont's comment in his diary for 2 December 1733: 'The breach between him [the Prince] and the King being so great that he has not spoken this twelvemonth to his sister the Princess Royal, which must be supposed the Order of the King.'[9] Moreover, the Prince and Princess took opposite sides in the dispute of 1733–4 over Handel's merits that divided music-lovers (and the politically inclined, since it became another form of proclaiming allegiance either to the King or to the Prince).

The breach between the Prince and Princess cannot have endured, however, or the Prince would not have permitted Mercier to paint his sister and her husband in 1733/4. Lord Hervey claimed in his *Memoirs* that 'the Prince, in the beginning of his enmity to his sister, set himself at the head of the other opera [i.e. to the Royal Opera in the Haymarket: the 'Opera of the Nobility' in Lincoln's Inn Fields] to irritate her'.[10] But Hervey, as the devoted supporter of Frederick's estranged mother, is not a reliable witness, and recent research by Carole Taylor has shown that the Prince was supporting Handel too in the very season of 1733–4, as well as in subsequent seasons.[11] By 1734 at least (and it should not be forgotten that, under the Old Style calendar, 1733 continued until 25 March 1734, New Style), there must have been an element of sheer teasing in the supposed musical quarrel between the Prince and the Princess Royal.[12]

And it is indeed perhaps that friendly difference in musical tastes that this picture was designed to express. Although the Princess Royal is usually identified as the Princess playing the harpsichord,[13] the evidence is far from conclusive. Is it not more likely that the Princess Royal is actually the figure shown looking up from reading Milton with an amused expression on her face, and that her ostentatious refusal to join in the music-making is intended to proclaim her difference with Frederick over the matter of their musical tastes?

HIST: Schutz family;[14] Shotover House sale, 26 Oct 1855, lot 632; W. E. Biscoe, Holton Park; his sale, Christie's, 20 June 1896, lot 9, bt Charles Davis; ?William Waldorf, 1st Viscount Astor (1848–1919; who had bought Cliveden, which had once belonged to Frederick, Prince of Wales, in 1893); presented to the National Trust, with the house and grounds, by Waldorf, 2nd Viscount Astor (1879–1952) in 1942.

EXH: *Philip Mercier*, City Art Gallery, York, and Kenwood, 1969, no.25; *Europalia*, Brussels, 1973, no.39; *Pittura inglese 1660–1840*, Palazzo Reale, Milan, 1975, no.23; *Frederick Prince of Wales and his Circle*, Gainsborough's House, Sudbury, Suffolk, 1981, no.3.

LIT (not always strictly about this version): Turner 1942, p.32, illus.; Edwards 1948, pp.308–12; Ingamells 1974, p.257, fig.4; Ingamells 1976, p.512, n.7; Kerslake 1977, i, pp.338–9, ii, pl.949; Ingamells and Raines 1976–8, pp.20–21, no.38; Rorschach 1989–90, pp.7–8, 56, no.99, fig.7; *Cliveden* 1994, pp.89–90 and col. pl. on p.17.

19 William HOGARTH (London 1697–1764)

The Four Times of Day

a *Morning*

b *Night*

Oil on canvas. Each 74 × 61 cm (29 × 24 in)
Upton House, Warwickshire

Hogarth painted *The Four Times of Day* in and around 1736, about two years before *The Hervey Conversation-piece* (cat. no.20; *Noon* and *Evening* belong to the Grimsthorpe and Drummond Castle Trustees). The same amused – but, in this case, more overtly satirical – observation of human foibles, and the same sheer delight in manipulating the brush, obtain in each. But whereas many of the symbolic allusions of *The Hervey Conversation-piece* now escape us, the moral and topical ones of *The Four Times of Day* are mostly more obvious, or have been spelt out for us by 18th-century commentators. Yet because the pictures were intended to be the models for engravings, they contain an accumulation of detail that makes them in some ways easier to read in the form of prints. Of the four, only *Morning* has a unity of action and of composition that enables us to appreciate the picture even without any particular knowledge of its individual allusions. That may also be because *Morning* is the picture most securely anchored in the French tradition of showing the Four Times of Day through the daily round of ladies or gentlemen of fashion.[1]

Because the traditional way of showing *Morning* was by *La Toilette*,[2] Hogarth has chosen as his chief protagonist a spinster, 'the exhausted representative of involuntary female celibacy'.[3] She is bound for church at five minutes to seven on a snowy winter morning, but is dressed up to the nines. Significantly, it is her freezing foot-boy who carries her prayer book, while she manipulates a fan, somehow impervious to the cold in all but her nose, despite her half-bared bosom and lack of mantle. In the left foreground, a woman warms her hands at a fire, while two couples are more naturally kindled by animal passion. The attention of the old maid is riveted by one of these couples, so that she entirely ignores the woman begging for alms beneath her. She is so vividly drawn as to seem a portrait; indeed Hogarth's first biographer, John Nichols, thought that she was a friend or relative of the artist, and that he was struck out of her will in consequence of the portrayal, but that story was probably inspired by the picture. This certainly influenced Henry Fielding when he avoided describing the appearance of Bridget Allworthy in *Tom Jones* (1749), by saying: 'that is done already by a more able Master, Mr. *Hogarth* himself, to whom she sat many Years ago, and hath been lately exhibited by that Gentleman in his print of a Winter's Morning, of which she was no improper Emblem'.[4]

The scene is set in front of the pseudo-portico of St Paul's church in the Piazza of Covent Garden, a once-fashionable square that only a decade before had also been 'inhabited by Painters. (A credit to live there)'.[5] Hogarth had himself been an inhabitant, at first in lodgings, and then in the house of his father-in-law, Sir James Thornhill, just before and after his marriage in 1730. But in 1733 he had moved to Leicester Fields (now Square), which George II as Prince of Wales was soon to make even more fashionable by taking Leicester House. Bagnios (often brothels), taverns and coffee houses were inexorably dragging the character of the area down, and St Paul's itself was said to be a place for finding partners or making assignations. Hogarth actually inscribed the name of one of these taverns, ironically, as Tom King's *Coffee House*, over the door of the shack in front of St Paul's. Roisterers with drawn swords and canes can be seen through the doorway. The notoriety which the print brought this establishment is said finally to have prompted the authorities to arrest Moll King, the widow of the Old Etonian Tom King, for keeping a disorderly house, to fine her, and to make her pull the shack down.[6] In the right background Dr Miller (Dr Rock in the engraving) is seen setting up his stand for the sale of the pills supposed to cure the venereal disorders engendered in such places.

Night is a more confused scene, replete with Masonic (see cat. no.20) and crypto-Jacobite allusions. The setting is Charing Cross: on one side is the Rummer Tavern, and on the other (somewhat misplaced) the Cardigan's Head (both of which served as early Masonic lodges);[7] at the end of the street are the lights of the Golden Cross Inn. In front of the first, a Mason in apron and full regalia, Col. Sir Thomas De Veil,[8] is so drunk and knocked about that he has to be supported home by his Tyler colleague. Although De Veil was a known tippler, he enforced the Hanoverian acts against the illegal sale of spirituous liquors so severely that there were riots against him and his informers, which were suppressed by the application of the equally Hanoverian Riot Act. Hogarth attacked the evil effects of spirits in his later engraving, *Gin Lane*, and was also a Freemason. So it was clearly the hypocrisy of the magistrate, rather than his severity, that he was attacking. Hubert Le Sueur's equestrian statue of Charles I, King and Martyr, visible at the end of the street, underlines the anti-Hanoverian and crypto-Jacobite message. This message is reinforced by the fact that the scene is shown as taking place on Oak-Apple Day (29 May), when, to commemorate Charles II's birthday and his escape in the Boscobel Oak after the Battle of Worcester on 3 September 1651, oak branches were displayed, bonfires were lit, fireworks let off, and candles put in windows.

a

In utter contrast to the calm centre of *Morning*, there is a general impression of topsy-turviness and of a world in disorder. It is full moon, when lunatics were supposed to be most out of their wits. The Salisbury Flying Coach has been overturned. A man is being shaved in the middle of the night, his apron implicitly mocking those of the Freemasons. A link-boy blows his torch into flame, rather than extinguishing it.[9] A chamber-pot is being emptied out of a window, and ricochets on to De Veil, who also wears oak leaves in his hat, even though a supporter of the Hanoverians. Under cover of darkness, a distant cart performs a moonlight flit, and a publican waters his beer.

Hogarth advertised his engravings of *The Four Times of Day* in May 1737, and called for subscriptions. The engravings were ready for delivery to subscribers on 1 May 1738. The paintings had been made expressly to be engraved, and in the absence of any sort of market for contemporary subject-paintings, there was no very obvious means of selling them. On 25 January 1744/5 he therefore advertised an auction of his own sets of 'comic-history-paintings': *The Harlot's Progress*, *The Rake's Progress* and *The Four Times of Day*. A month later he issued an engraving, *The Battle of the Pictures*, as an admission ticket for the sale. The 'battle' was between a whole covey of Old Master paintings and some of Hogarth's: the mock-pious old maid in *Morning* is shown speared by a corner of the canvas of a genuinely penitential *St Francis*.[10]

Hogarth had originally intended to sell the sets as such, but subsequently agreed that they might also be bought: 'Singly (each Picture being an entire Subject of itself)'. In the event, the *Times of Day* were split up into two pairs: *Morning* and *Night* went to the retired merchant Sir William Heathcote, 1st Bt, for 46 guineas, and *Noon* and *Evening* to the 3rd Duke of Ancaster for 75 guineas. The whole sale, of some twenty pictures, realised around £450, which Vertue thought a surprisingly successful result for such 'impudence'. ('No painters nor Artists to be admitted to his sale', he noted, as a mark of Hogarth's pretensions.)[11] But then, not only were these 'comic-history-paintings' unique, and examples of Hogarth at the top of his form, they were still highly topical. They may no longer be so for us, but we can still relish them as marvels of both paint and psychology.

HIST: the artist's sale, his house, Leicester Fields, 28 Feb 1744/5, sold, for 26 gns (*Night*) and 20 gns (*Morning*), to Sir William Heathcote, 1st Bt; thence by descent (included in an illustrated MS inventory of the pictures at Hursley Park, Hants, of 1843, in Dept. of Special Collections, Getty Center, Malibu) as nos.11 and 12 in the South Drawing Room, with a note that they featured in a Catalogue of Pictures in the Heathcote house in St James's Square of 1748); Heathcote Heirlooms sale, Christie's, 27 May 1938, lot 29; bt by Sir Alec Martin on behalf of 2nd Viscount Bearsted for 2,400 gns (outbidding the Earl of Ancaster, who had commendably wished to reunite the set).

EXH: BI, 1814, no.181 (*Morning*), no.191 (*Night*); RA, winter 1885, no.44 (*Morning*), no.48 (*Night*); *Two Hundred Years of British Painting*, Public Library and Art Gallery, Huddersfield, 1946, no.86 (*Morning* only); *Five Centuries of European Painting*, Whitechapel Gallery, 1948, no.23 (*Morning* and *Night*); *William Hogarth*, Tate Gallery, 1951, no.38, pl.XII (*Morning*), no.39 (*Night*); *The Bearsted Collection*, Whitechapel Gallery, 1955, no.2 (*Morning*), no.3 (*Night*); *English Pictures*, Agnew, 1965, no.4 (*Morning*), no.5 (*Night*); *Hogarth*, Tate Gallery, 1971–2, no.77 (*Morning*), no.80 (*Night*); *British Painting 1600–1800*, British Council, Art Gallery of New South Wales, Sydney, and National Gallery of Victoria, Melbourne, 1977–8, no.23 (*Morning*), no.24 (*Night*); *Manners and Morals: Hogarth and British Painting*, Tate Gallery, 1987–8 [when reunited with *Noon* and *Evening* for the first time since 1745], no.91 (*Morning*), no.94 (*Night*).

LIT (selective): Nichols 1781, pp.99–100; 1782, pp.208–11; 1785, pp.248–51; Felton 1785, pp.27–33; Nichols and Steevens 1808, i, pp.102–3, 116–18; 1810, ii, pp.147–50; 1817, iii, p.174; *Upton* 1964, pp.18–19, nos.43, 44 and pl. Id (*Morning*); Paulson 1965, i, pp.178–9, 181–2; 1970, i, pp.178–9, 181–2; 1971, i, pp.394–404, col. pl.151a (*Morning*); Shesgreen 1983; Paulson 1989, pp.103–5, 106–8; 1992, ii, pp.127–51, esp. pp.149–50, pp.411–14 nn.1–27.

20 William HOGARTH (London 1697–1764)

The Hervey Conversation-piece

Oil on canvas. 102 × 127 cm (40 × 50 in)
Signed (on flowerpot, bottom right): *W. Hogarth Pinx^t*
Ickworth, Suffolk

The protagonists of this lively and enchanting picture were enumerated by Horace Walpole: 'Charles Duke of Marlborough, Lord Hervey, M^r Winnington, M^r Fox and Lord Ilchester, and Desaguliers, in one piece'.[1] It may have been inspired by a 'Conversation Picture' painted in 1732 by Hogarth's older rival, Bartholomew Dandridge (1691–c.1755), showing the Architect-Earl of Burlington and his cronies 'playing Monkish tricks, to divert them in their studious amusements of y^e Belles Lettres, designs of Architecture, &c.'.[2]

In the centre stands John, Baron Hervey of Ickworth (1696–1743), who commissioned the picture. He was the eldest grandson of the 1st Earl of Bristol, author of the lapidary *Memoirs of the Reign of George II*, husband of the 'pretty, witty Molly Lepell', friend of Lady Mary Wortley Montagu and thus the rival and enemy of Pope, who attacked him in verse as 'Bathos', 'Lord Fanny' and 'Sporus'.[3] He wears a dove-grey-coloured coat, and his key as Vice-Chamberlain of the King's Household. Robert Walpole nominated him in 1730 for this post, which gave him the access that enabled him to govern Queen Caroline, and, through her, George II; he gave it up when promoted Lord Privy Seal in 1740. He is indicating what now appear as the elevation and plan of a banqueting-house (see below).

The paper is held by Henry Fox (1705–74), created 1st Baron Holland of Foxley in 1763, and father of Charles James Fox. Like his father, Sir Stephen Fox, he made an immense profit from the office of Paymaster-General. Macaulay called him 'the most unpopular of the statesmen of his time, not because he sinned more than any of them, but because he canted less'.[4] At Hervey's urging, George II had appointed Henry Fox Surveyor-General of the King's Works in June 1737, so his action of holding out plans for approval is entirely appropriate.

His country-loving elder brother, Stephen Fox (1704–76), created Baron Ilchester in 1741 and 1st Earl of Ilchester in 1756, is seated at the table behind him, surreptitiously using his cane to topple the chair on which the clergyman stands. He owed his peerage to Hervey, who was his boon companion – possibly even lover – from 1727 until their breach in 1742. He was also the original owner of the only known copy of this picture, which hung in his house at Redlynch.

Seated in the chair on the right is Charles Spencer, 3rd Duke of Marlborough, in civilian dress, but of a military red, probably to signify the colonelcy of the 38th Foot, which he acquired in March 1738. The picture is therefore likely to have been painted after that date, but before 1741/2,

when he received the Garter, the sash and star of which appear on the Redlynch copy, but not here.[5] The 3rd Duke seems to have first come into contact with Hervey and his circle in 1737, while negotiating with Henry Fox on behalf of Frederick, Prince of Wales. At Fox's clandestine marriage to Lady Caroline Lennox in 1744, he gave away the bride.

Thomas Winnington (1696–1746), at the far right in black breeches and a dark brown coat, was a friend and ally of both Hervey and the Foxes. From 1736 to 1741 he was a Lord of the Treasury. In 1743 Hervey left him a considerable legacy, which their former crony, Sir Charles Hanbury-Williams, hinted was for sexual reasons.[6] The same year he was made Paymaster-General.

The identity of the parson, teetering on the chair as he studies a distant village and church with the aid of a telescope, has been almost universally misconstrued, thanks to a later tradition in the Fox-Strangways family that identified him with Peter Lewis Villemin, Willemin, or Wilman (d.1762). This cleric had performed the double marriage ceremony for Stephen Fox and Elizabeth Strangways-Horner in 1735/6, and been rewarded with the incumbency of 'Issy', or Eisey, near Cricklade in Wiltshire. However, Villemin was a younger man, and although evidently the butt of Fox family jokes, already had the living for which Hogarth's parson is still so precariously on the look-out.[7] There seems no reason to doubt Walpole's clear statement about the Redlynch copy that the clergyman was the Huguenot physicist John Theophilus Desaguliers (1683–1744).[8] Indeed the telescope is an evident allusion to one of Desaguliers's main scientific interests: optics. Hysing's 1725 portrait of him, scraped in mezzotint by Peter Pelham, which provides a perfectly compatible likeness, shows him holding a magnifying glass, and with a Newtonian prism beside him.

Desaguliers is not otherwise recorded as a member of the Hervey-Fox circle. Why, then, was he included? The reason seems to be Freemasonry. Desaguliers has been called 'the Father of Modern Speculative Masonry'. He was originally a member of the Rummer & Grapes, or 'Old' Lodge, Channel Row, Grand Master of the Order in 1719–20, and Deputy Grand Master from 1722 to 1726.[9] Hogarth was originally a member of the Hand & Appletree, and later of the Bear & Harrow Lodge. As Grand Steward of that Lodge in 1734–5, he became one of the first twelve members of the Stewards' Lodge in 1735, and thus a member of the Grand Lodge.[10] Stephen Fox and the future 3rd Duke of Marlborough were admitted as Masons together on 23 January 1729/30.[11]

Masonry may also explain the plans on the paper held by Henry Fox. For, originally, these were not simply painted upon the canvas, but upon a little piece of paper pasted down onto it. Unfortunately, by this century, the plans themselves were virtually illegible. Horace Buttery therefore

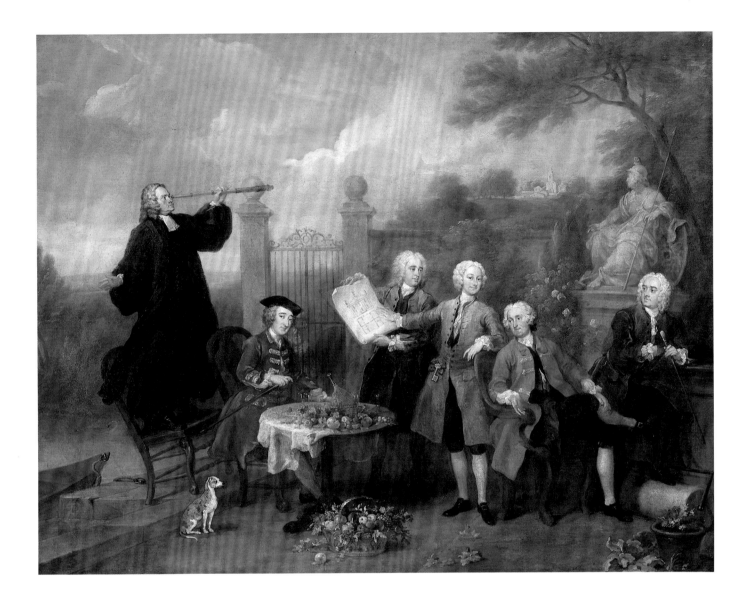

took those in the Redlynch copy (which appeared to him to correspond) as his model, when he restored the picture in 1960 (but this time directly onto the canvas). Were there originally diagrams of a more overtly Masonic kind upon it? The Masonic elements may have been introduced through complicity between the artist and Desaguliers,[12] but his inclusion here at all must have been at Hervey's behest.

Not that the picture should be read simplistically, in terms of one set of symbols alone. It also seems unlikely to represent an actual gathering at any particular place – least of all at Stephen Fox's shooting-box at Maddington in Wiltshire,[13] since that was set in the bleak landscape of Salisbury Plain, whereas the setting here is fertile, but clearly imaginary. The fruit and flowers (rather than bottles and glasses) suggest symbolic intent, as do the moored boat, the gates so oddly placed athwart the river bank, the garden roller and the statue of Britannia: but what they signify eludes our grasp.[14] What should not be overlooked is that this is one of the most successfully integrated and purely painterly of all Hogarth's outdoor conversation-pieces.

HIST: presumably by descent from Lord Hervey to his sons, the 2nd, 3rd and 4th Earls of Bristol, and thus to successive Marquesses of Bristol (first mentioned in a list of *c*.1837, as '*Assemblage of Political persons of the Day*, by Hogarth') until surrendered with Ickworth and the contents of the state rooms to HM Treasury in 1956, in lieu of the death-duty payable on the estate of the 4th Marquess (1863–1951), and handed over to the National Trust.

EXH (selective): *William Hogarth*, Tate Gallery, 1951, no.41; *Portrait Groups from National Trust Collections*, Arts Council, 1960, no.7; *Hogarth*, Tate Gallery, 1971, no.98; *The Treasure Houses of Britain*, National Gallery of Art, Washington, 1985–6, no.164.

LIT (selective): Gage 1838, p.308 (as 'Cabinet minister[s] in King George the Second's reign, – Hogarth'); Hervey 1894, Appendix II: 'List of all Hervey portraits', p.271 (as 'a political group in 1738, by Hogarth'); Beckett 1949, p.44, pl.95; Ilchester 1950, pp.20, 228 (saying that the original was painted in 1736; that his own version at Melbury – the frontispiece – is a copy by Ranelagh Barrett; and that the parson represented is Willemin); Antal 1962, pp.33, 223 n.97, pl.73b; Paulson 1971, i, pp.455–8, pl.177; Halsband 1973, pp.239, 343 n.37, pl.14; Campbell 1990, pp.281–97; Paulson 1992, ii, pp.174–6, 418–19 nn.54–7, fig.79.

21 Arthur DEVIS (Preston 1712 – Brighton 1787)

(Sir) Nathaniel (1726–1804) and Lady Caroline (1733–1812) Curzon

Oil on canvas. 89·5 × 69 cm (36 × 27 in)
Signed and dated (now very faint) bottom left:
Art: Devis/fec. 1754
Kedleston Hall, Derbyshire

Sir Nathaniel Curzon and his wife are shown here as simple country gentlefolk, painted around 1754 by an artist much favoured at this epoch by their kind. They are elegantly dressed, but in a garden setting, the husband gazing dotingly at his wife as she demonstrates her ladylike accomplishments on the mandolin.

By 1754 Devis had been based in London for a dozen years, and his clientele covered the country. Nevertheless, the core of his commissions came from an interrelated group of High Tory gentry families, many with estates or connections in his native Lancashire, and often with a Jacobite history or leanings.[1] Nathaniel Curzon and his younger brother, Assheton (who was also painted by Devis, but to all appearances a little earlier, with his tutor Robert Mather[2]), were just such figures. Through their father, Sir Nathaniel Curzon, 4th Bt, they belonged to the leading Tory family in Derbyshire, albeit one that had declared for George III in the critical moment of the '45, when Bonnie Prince Charlie virtually reached Kedleston. Through their mother, Mary Assheton of Middleton, they were connected with most of the leading Lancashire Tory gentry. Through their maternal family's influence, they also sat as MPs for Clitheroe in Lancashire: Nathaniel from 1748 to 1754, when he was succeeded by Assheton (1754–80, 1792–4). In 1754 Nathaniel took over his father's Derbyshire seat, and also some of the responsibility for running the family estates. This picture seems to have been painted to mark those events.

By his marriage to Lady Caroline Colyear in 1750, Curzon had linked himself to a family with both Williamite and Jacobite connections: his wife's grandfather, General Sir David Colyear, 1st Earl of Portmore, was a Scotch-Dutch soldier of fortune, who had come over to England in the train of William III; but her grandmother was Catherine Sedley, Countess of Dorchester, the most influential mistress of James II while he was Duke of York. The marriage of Nathaniel and Lady Caroline was evidently an affectionate one, as the two were painted again together only seven years later, by Nathaniel Hone (State Dressing Room, Kedleston). The contrast in scale and character between the two pictures is remarkable. Hone's is a lifesize portrayal, showing the couple taking a walk, anticipating by a quarter of a century Gainsborough's portrait of the Halletts called *The Morning Walk* (1785/6; National Gallery).

The differences between the two pictures reflect the revolution in Curzon's taste and horizons that took place over those seven years. There is evidence that he had gone abroad in 1749, the year before his marriage, but he made only a brief tour of a month, of northern France, Belgium and Holland, and spent only £300 there, including purchases.[3] There is no evidence that he ever went to Italy. He had already begun buying pictures from the dealer John Barnard in 1751, and at the London auction rooms in 1753, but it seems to have been around 1756–7 that the sea-change in his taste occurred. In April 1756 he commissioned a large-scale picture of *Venus ushering Helen to Paris* (now at the top of the main staircase at Kedleston) from the pioneering Scottish Neo-classical painter in Rome, Gavin Hamilton, who was returning there from London. In February 1757 he purchased three huge Italian pictures at a sale (evidently of pictures recently brought over from Italy) held by the dealer William Kent (no relation of the architect): Luca Giordano's *Triumph of Bacchus and Ariadne* (Music Room, Kedleston) and Benedetto Luti's *Cain and Abel* and *Christ in the House of Simon Levi* (Drawing Room).[4] Such pictures could not have been bought without potential locations for them in mind. Indeed, all three were included in the designs for a Great Room that James 'Athenian' Stuart must have drawn up immediately after their purchase.[5] Stuart's designs also seem to have suggested the idea for Hone's double-portrait.

Stuart had been a friend in Rome of Gavin Hamilton: he had walked with him to Naples and back in 1748, accompanied by his archaeological collaborator, Nicholas Revett, and the architect who was to supply casts of Antique sculpture to Kedleston, Matthew Brettingham the Younger. All four were originally to have gone to Athens together in 1750. It therefore seems highly likely that it was Stuart who began to give a new, classical and italianate turn to Curzon's taste. But neither Stuart nor any of his associates received the rewards they expected. Hamilton got no more commissions either as painter or dealer;[6] Brettingham failed to fill all the niches in the Marble Hall with his casts,[7] and his father was displaced as architect by Paine, and he by Robert Adam. It was left to Adam alone to enjoy the patronage of 'a man resolved to spare no Expence, with £10,000 a Year, Good-Temper'd, & having taste himself for the Arts and little for Game'.[8] A very different figure from the one that we see represented here.

HIST: by descent from the sitters, until bought with part of the contents of Kedleston with the aid of the National Heritage Memorial Fund in 1987, when the house and park were given to the National Trust by the 3rd Viscount Scarsdale.

LIT: Harris 1978, pp.208, 217, fig.9; D'Oench 1980, pp.20 n.49, 82 no.44; *Kedleston Hall* 1988, p.23, illus. p.75 (detail).

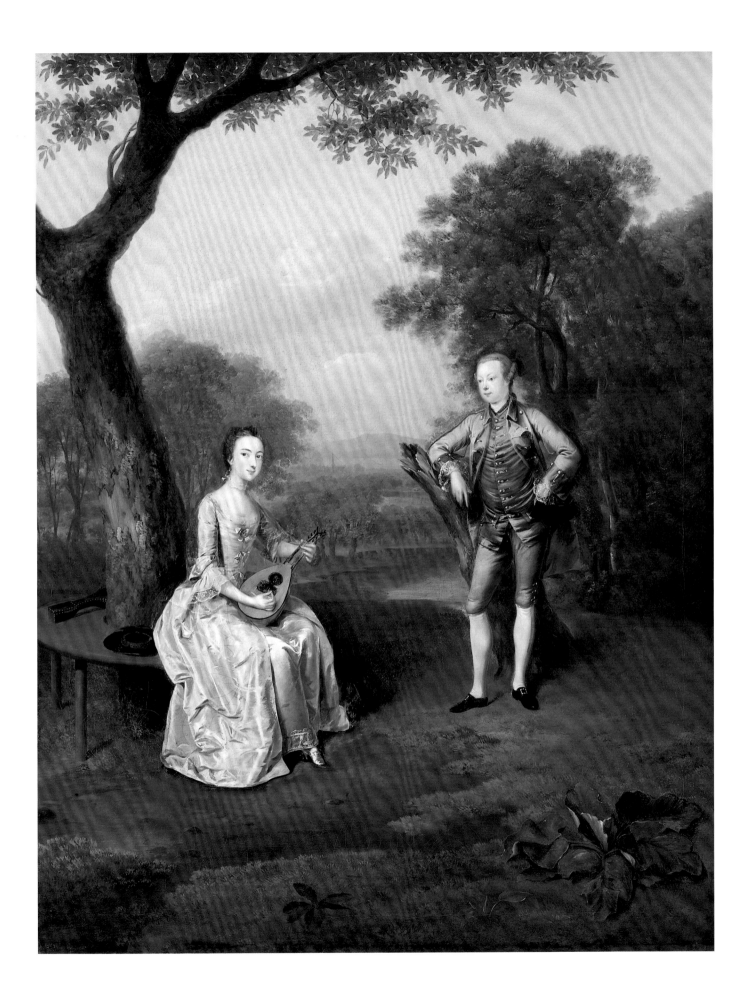

22 Johann ZOFFANY, RA (Frankfurt am Main 1733 – Kew 1810)
The Woodley Family

Oil on canvas. 120 × 165 cm (44 × 65 in)
Kingston Lacy, Dorset

It is tempting to see, in the motif of a greyhound coursing a hare, a slightly laborious German pun. For the German for greyhound is *Windhund* (literally 'wind-dog'); and it would appear, not only from the number of children shown and their ages, but also on stylistic grounds,[1] that this picture was painted around 1766, when William Woodley, MP (1728–93) was appointed Governor of the Leeward Islands, a post that he was to hold until 1771 (and again from 1792 until his death).[2] The Leeward Islands and the Windward

Fig. 8 George Romney, *Frances Woodley, Mrs Bankes* (1780–81; Kingston Lacy)

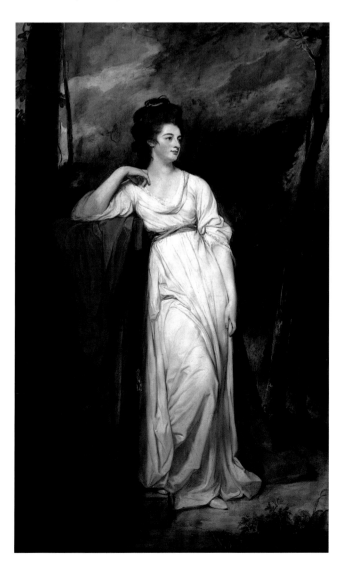

Islands form the Lesser Antilles in the West Indies, and are so called because they are respectively less and more exposed to the prevailing north-east trade wind. Just as the wind-dog races away, so William Woodley is about to go, with his family, to take up his post on the islands less dogged by the wind. Perhaps this is all somewhat fanciful, but the motif is an unusual one, not to my knowledge otherwise employed by Zoffany as the pretext for a conversation-piece.[3]

In setting out for the Leeward Islands, both William Woodley and his wife were returning to their colonial roots. For he was the eldest son and heir of William Woodley of St Christopher, alias St Kitt's, and Ann Payne. His wife Frances (1737/8–1813), whom he had married in 1758, was his cousin, the daughter of Abraham Payne Jr, also of St Kitt's.[4] He was a Whig MP for Great Bedwyn in Wiltshire in Lord Bruce, later the Earl of Ailesbury's, interest from 1761 to 1766 (and again for Marlborough, 1780–84), and he owed his governorship to the Whig Prime Minister, Lord Rockingham.[5] Presumably because he wished to set up as a gentleman in England, he sold his paternal plantation on St Kitt's, called 'Profit', in 1767. He evidently held on to other estates there, since he later gave them as a reason for wanting to recover the Governorship.

Woodley and his wife had two sons and three daughters, all but one of whom are shown here. The eldest boy, another William (d. 1810), shown chasing some insect with his hat, followed his father's career as a colonial administrator in Antigua, becoming President of St Kitt's in 1807, and Lieutenant-Governor of Berbice in 1808. His younger brother, John (b. 1766), the recently born child held by his mother, became Attorney-General of St Kitt's in 1826.

The eldest girl, Frances (1760–1823), shown handing John a rose, is the reason this picture is at Kingston Lacy. For she became a celebrated beauty, and in 1784 married Henry Bankes the Younger, MP (1757–1834). They were the parents of the second great collector of the family, William Bankes (see cat. no.45), on whom she doted. She is the subject of a fine whole-length by Romney at Kingston Lacy. The child seated on the ground is Hariot, or Harriett, who married Thomas Pickard of Bloxworth in 1788. Something of an amateur artist, she not only herself made pastel copies of works by Hoare, Reynolds and Greuze, which are now at Kingston Lacy, but seems to have taught her sister-in-law, Anne Bankes, to do the same.

The child as yet unborn, Maria (1772–1808), was to be more celebrated than any of those shown here. A poet and author, in 1790 she married Lt. Walter Riddell, who took her to his ancestral home in Scotland, where she encountered Robert Burns, who addressed both flattering and satirical poems to her.[6] A half-length portrait of her by Lawrence is also at Kingston Lacy.[7]

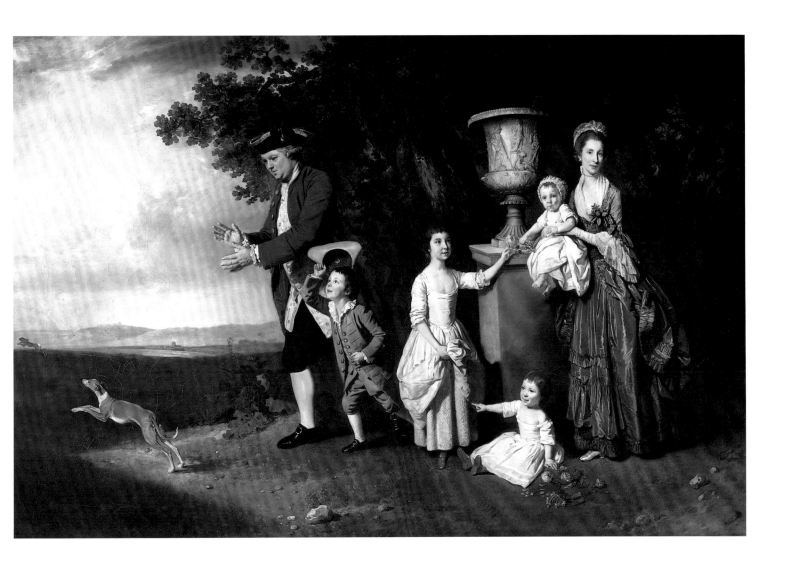

Behind John Woodley is a reduced version of the Medici Vase (Uffizi), one of the two most admired Antique marble vases. At this time it was still in the Villa Medici in Rome, but was widely disseminated through prints and numerous copies.[8] This may be included here as a purely conventional prop, but it is – at the very least – suggestive that its relief frieze was in those days thought to represent *The Sacrifice of Iphigenia*: the Greek fleet was windbound at Aulis until that was performed.

HIST: first recorded at Kingston Lacy in a partial and undated inventory of between 1815 and 1834, presumably there by family descent to Frances Woodley, Mrs Henry II Bankes (1760–1823), but possibly, since there was a direct male heir, as a deliberate acquisition by Henry II Bankes (1757–1834); by descent, until bequeathed to the National Trust, with the whole estates and contents of Kingston Lacy and Corfe Castle, by Ralph Bankes (1902–81).

LIT: Manners and Williamson 1920, p.177 (as 'Picture believed to represent a Mr. Bankes with his wife and family, and to have been painted at Kingston Lacy');[9] *Kingston Lacy* 1994, pp.39, 75, no.118, with col. fig.

23 Sawrey GILPIN, RA (Scalesby Castle 1733 – Brompton 1807)

'Furiband' with his Owner, Sir Harry Harpur, and a Groom

Oil on canvas. 61·5 × 74·5 cm (24¼ × 29¼ in)
Signed bottom right: *S. Gilpin/1774*
Inscribed on the stretcher: *N° 1 Furiband by Squirrel*
Sir Harry Harpur
Calke Abbey, Derbyshire

'Furiband' was foaled in 1767, by 'Squirrel' out of 'Lady-thigh'.[1] Bred by the Duke of Ancaster, he was sold three times before being bought by Sir Harry Harpur, 6th Bt (1739–89), of Calke, in 1772. Unusual in his day for running when only a three-year-old, he won most of his races in 1770 and 1771, chiefly at Newmarket. By the time that this picture was painted, he had won for Sir Harry at Nottingham and Spalding in 1772, at Burford in 1773, and at Stamford, Stratford and Warwick, in 1774. He was to win again at Warwick, and at Maidenhead, in 1775, but by 1777 he had been sold to a Mr Moody. It must therefore have been his successes, rather than a particular fondness, that prompted Sir Harry to have himself portrayed with him.

The picture is one of four racehorses painted by Gilpin for Sir Harry in 1774 that are in the Library at Calke, a room hung – unusually for such a room in England – exclusively with horseflesh.[2] This may reflect the historic importance of horses for Calke. There had been a stud here since the 17th century, to which one of the founders of British bloodstock, 'the Harpur Arabian', had been brought by Sir John Harpur, 4th Bt (1680–1741), at the beginning of the century. The payments for both the pictures and their frames are recorded in the Calke Account Book under 1775: 'Pᵈ. Mʳ. Gilpin for painting 4 houses [*sic*] £68.5s' and 'Pᵈ. Mʳ. Vials for 4 frames for the hourse [*sic*] painted by Mʳ. Gilpin £7.7s.'. Interestingly, 'Mr. Vial's, Leicester Fields' was the contact address in London that Gilpin gave in the catalogue of the Society of Artists for 1765, when he was living at Windsor, painting the Duke of Cumberland's horses. Thomas Vial or Vialls (active 1756–d.1779/80), was one of the most distinguished framemakers of his day, furnishing frames to numerous great houses and – his swan-song – to the Dilettanti Society for its pair of Reynolds portraits of its members.[3]

Gilpin had trained in the studio of the marine painter Samuel Scott in Covent Garden from 1749, but preferred drawing horses in the market. Soon after setting up on his own around 1758, he became a protégé of the Duke of Cumberland, working in his stables at Windsor and Newmarket. Today he is totally overshadowed by his slightly older contemporary, George Stubbs (1724–1806). Yet in the 1770s both were elected President, and then Director, of the Incorporated Society of Artists, and were rated as equally matched rivals. Indeed Gilpin was sometimes assessed more highly, because, when they depicted 'historical' subjects that included horses, in an effort to be accepted as more than

mere horse-painters, Gilpin was prepared, as Stubbs was not, to imbue the horses themselves with those expressions of sentiment and emotion in which, when exemplified in humans, the superiority of history-painting was thought to reside. As an intelligent fellow-artist, Prince Hoare, commented:

> Gilpin, less anatomically learned than Stubbs, gave to inferiour animals of every description, not only the forms of simplicity and truth, but added a grace and sentiment, which seemed to rank them in a higher class of intellect.[4]

We, by contrast, value more highly works such as this, which is devoid of the sometimes inappropriate ambitions that the traditional hierarchy of categories of painting encouraged. It also comes nearest to what we now see as one of the great strengths of Stubbs, his observation of the human companions of his horses. In particular, he gave to hunt-servants, grooms and stable-lads a dignity usually denied to them or their equivalents in paintings that were overtly of rustic life.

In the present picture, while the horse grazes in the centre of the composition, almost as if it were conscious that it is the cynosure of every eye, the snub-nosed groom unselfconsciously places a trusting hand upon its neck, while its owner contemplates it, totally absorbed, and leaning on his stick in an attitude that curiously mirrors that of the horse's rump and hind legs. Yet even here Gilpin betrays his exalted ambitions: for this apparently natural pose is in fact reminiscent of the pose of one of the figures on the Medici Vase.

HIST: commissioned in 1774, and thence by descent, until Calke Abbey was given to the National Trust by Henry Harpur-Crewe (1921–91), and its contents were acquired with the aid of a grant from the National Heritage Memorial Fund, thanks to a special allocation of money from the Government, in 1984.

EXH: Society of Artists, 1775, no.95, as *A Portrait of Furybon* (with the other three horses in the set being nos.92–4).

LIT: Wills 1989, p.148, fig.1 (as '*Jason*'); *Calke Abbey* 1989, p.56, no.184 (as '*Jason*').

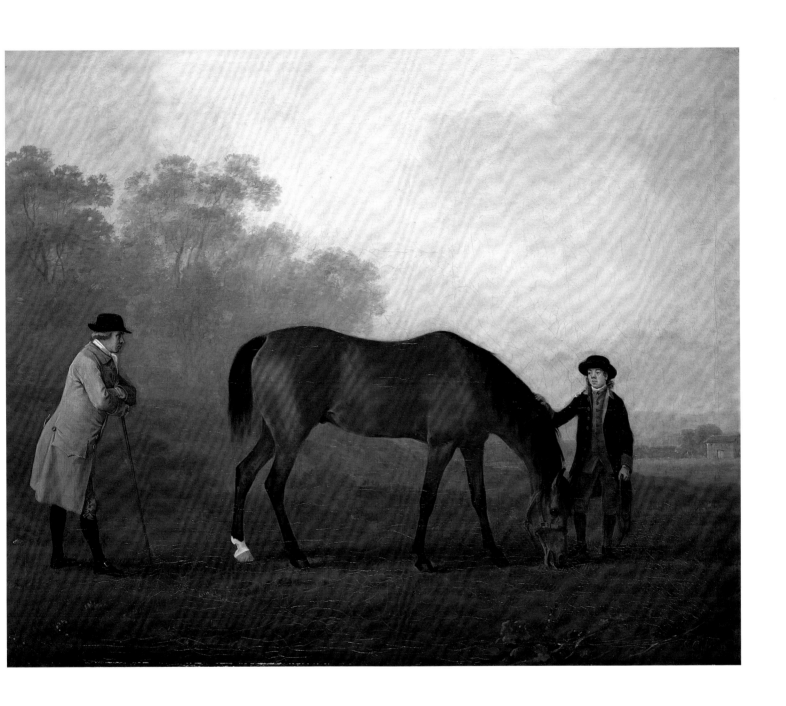

24 Richard Morton PAYE (Botley, Hants 1750 – London 1821)[1]
Self-portrait of the Artist engraving

Oil on canvas. 73·5 × 60·5 cm ($28\frac{7}{8}$ × $23\frac{3}{4}$ in)
Upton House, Warwickshire

Paye exhibited this picture at the Society of Artists in 1783 under the title simply of *An Engraver at Work*. Such images are rare at any time[2] and even more so when the painter is himself the engraver. The details of the engraver's craft are fascinating: the reduced version of the original portrait to engrave from; the mirror to produce a reversed image that he can copy directly on to his plate, which will then print in the same direction as the original; the use of the block to steady his hand; and the screen to diffuse light from the window in daytime. But the picture possesses an additional source of interest, in that Paye was not only both painter and engraver, but also a modeller and chaser. So the picture includes sculpture – both reduced plaster casts of such celebrated Antiques as the Apollo Belvedere, and (discreetly tucked under the table on the right) what are apparently examples of his own work.

The portrait that he is engraving is not, however, one painted by himself, but a reduced version of a lost picture by Nathaniel Dance (1735–1811).[3] It depicts Percival Pott, FRS (1714–88), the philanthropic Bart's surgeon and eponymous victim of 'Pott's fracture' of the leg, which he cured without amputation. The portrait shows Pott at an advanced age, and must therefore have been one of the last painted by Dance before he retired from professional practice in 1782.

The engraving was also published by Paye himself, on 21 October 1783, from 26 Swallow Street, off Piccadilly.[4] The most plausible reason for this is that he had begun it as some form of return to the sitter's third, but second surviving, son, Joseph Holden Pott (1759–1847), who had then just taken his MA at Cambridge, and subsequently rose to become Vicar of Kensington and Archdeacon of London. Pott Junior is recorded as having been Paye's first patron, and as buying his earliest works,[5] although it seems odd for a younger son to have been dispensing patronage at the age of 23 and before the death of his father. We know, however, that Pott had already manifested an interest in art, since in 1782 he had published (anonymously) *An Essay on Landscape Painting*.

Paye's second patron is said by the same sources to have been the satirist and art critic (and interestingly, previously also a physician) 'Peter Pindar', alias Dr John Wolcot (1738–1819). Wolcot's patronage of Paye can be fairly narrowly dated: it began after he fell out with his original artistic protégé, 'the Cornish Wonder', John Opie (1761–1807), in 1782, and ended around 1785, when Paye exhibited at the RA a *Portrait of a Sulky Boy*[6] (reputedly an illegitimate son of Wolcot's), and then painted a satirical image of Wolcot himself. All in all, therefore, there are good reasons for

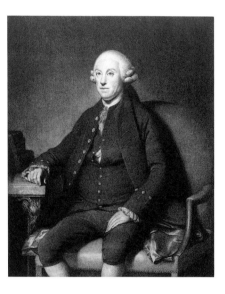

Fig.9 Richard Morton Paye after Nathaniel Dance, *Percival Pott* (engraving, 1783; British Museum)

dating the younger Pott's patronage of Paye to a period extending until at least 1783. The fact, however, that the engraving of Pott Senior was not dedicated either to him or to his son, may indicate that the farouche Paye had broken with both of them by the time that he came to publish it,[7] or have just been another example of his unworldliness.

At this period Paye seems to have made a speciality of pictures displaying light effects, for which his inspiration, at least in general terms, was evidently Joseph Wright of Derby (1734–97).[8] A life-size version of one of the Antique casts shown in this painting, the *Nymph with a Shell*, was used by Wright as the focal point of his *Academy by Lamplight* (exh. Society of Artists, 1769; Yale Center for British Art).[9] However, there does not seem to be any trace of a direct connection between Wright and Paye, and the vein was not one that the latter continued to explore. He was compelled by the demands of the market to concentrate increasingly upon sentimentalised fancy pictures and portraits of children, virtually from the year this picture was exhibited.

HIST: bought between 1827 and 1832 by Joseph Neeld,[10] MP (1789–1856), of Grittleton House, near Chippenham, Wilts (as by Wright of Derby); thence by descent to L.W. Neeld; his sale, Christie's, 13 July 1945, lot 141 (as 'A Portrait of the Artist seated, sketching'); bt by Peter Chance for the 2nd Viscount Bearsted (1882–1948), by whom given, with the majority of his collection, to the National Trust in 1948.

EXH: Society of Artists, 1783, no.203; Grosvenor Galleries, 1889, no.131, lent by Sir John Neeld, 1st Bt (as *The Student*).

LIT: Anon. 1832, p.98; Lionel Cust, *DNB*, xliv, 1895, pp.105–6 (as 'a portrait of the artist engraving a portrait'); Clayton 1913, p.236 (calling it *The Student*); Upton 1964, p.23, no.57; Waterhouse 1981, p.270, with illus. (as displaying knowledge of Wright of Derby).

25 BRITISH SCHOOL, 1830

a *Thomas Rogers, Carpenter* (1781–1875)

Oil on canvas. 110·5 × 94 cm (45 × 36 in)

b *Edward Barnes, Woodman* (b.1761/2)

Oil on canvas. 111·5 × 94 cm (46 × 36 in)

Each inscribed with identity, age, date and biographical doggerel, in scrolled compartments beneath
Erddig, Clwyd

Portraits of faithful servants are less of a rarity than one might think (cf. cat. no.1). And just as horses (cf. cat. no.23) were more frequently portrayed than dogs (cf. cat. no.16), so outdoor staff, and particularly those connected with the rearing, protection and pursuit of game, were more commonly depicted than indoor servants.[1]

The portraits of servants at Erddig are, however, a case apart. What makes them exceptional is not simply that two whole sets of servants were painted at different times, each memorialised by doggerel written by their employer, but that this then became a continuing tradition, extending from the first set, painted by a Wrexham artist, John Walters, in the 1790s,[2] right up into the 20th century, with photography taking over from painting.[3]

The first set of doggerel was composed by Philip I Yorke (1743–1804), who published all of it for a local audience in his *Crude-Ditties* (Wrexham, 1802). This idiosyncratic man began the tradition of portraying the house and estate staff and suppliers at Erddig. He was evidently imbued from an early age with an unusual degree of devotion towards his family's seat and its contents, writing in 1771 to his agent, John Caesar the Elder: 'I would not have, upon Recollection, any Rummage *yet* made in the Lumber Room; among the many old, and strange things there.'[4] The servants that he chose to commemorate, with his doggerel and portraits of them by John Walters, were: 'That best of beaters – *Jack Henshaw*' (1791); *Jack Nicholas*, kitchen porter (1791); '*Edward Prince*, our old Carpenter' (1792); *Jane Ebrell* (1793), originally 'spider-brusher [i.e. housemaid] to the Master', but latterly coachman's wife. There were also two who were outside suppliers: *William Williams* (1793), blacksmith; and *Thomas Jones* (1796), publican and butcher.[5]

It was not until almost 40 years later that the next set of portraits was painted, and then just three of them: the two shown here, together with *Thomas Pritchard*: 'Our Gardener, old, and run to seed'. They were commissioned by Philip I Yorke's eldest son and successor, Simon II (1771–1834), who composed similar doggerel for them. It is singular that he should have waited so long before commissioning these additions to the set of servant portraits begun by his father; and even more so that, when he did so, the

pictures should have been of such high quality. The answer to each puzzle may be one and the same: for, unlike the previous set, these pictures cannot be by a local man like Walters (who would have left some trace of his activities in nearby houses), but must be the work of an itinerant artist, or of an artist for some reason briefly resident in the area. Simon Yorke must have seized the opportunity to get these three servant portraits out of him, but did not commission others of himself and his family. This may just have been characteristic self-effacement, or because the artist was not regarded as belonging to the appropriate grade to paint portraits of the gentry.[6]

In the present state of knowledge, it is very difficult to say who he might have been. In the directness of his approach, and in the way in which the figure is made to stand out in relief against a thin and sketchy background, he is reminiscent of Ben Marshall (1768–1835), but the technique is not Marshall's. The discrepancy between the confident handling of the main human figures, and that of the subsidiary ones – and even of the dog – in the picture of *Edward Barnes*, is such that these last almost have the appearance of having been inserted by another, less competent, hand.

Of the two servants represented here, more is known about *Thomas Rogers*, because he came of a family that supplied a number of servants to Erddig.[7] We do not know whether or not he was a forebear, but the first recorded carpenter to work at Erddig was one Philip Rogers, from Eyton, who in March 1685/6 contracted with Joshua Edisbury, the builder of Erddig, 'to doe all yᵉ Carpenter's work for two banqueting housses to be erected at Erthigg',[8] and also put up much of the panelling still in the house. Thomas Rogers began his remarkable 73 years of service at Erddig in 1798, working first as pig-boy, and then as thatcher's assistant and slater. He was next apprenticed to a wheelwright, where he would have learnt how to handle wood:

> But soon he did out-strip his Trade
> And next our Carpenter was made.
> To all our jobs he gives his Fiat
> To prove himself a second *Wyatt*.[9]

In 1815 he was almost lost to Erddig, when he was press-ganged; fortunately, he was allowed to appeal to his employer, who paid the necessary ransom. He survived into the age of photography, so that he is to be seen in his Sunday best, but holding a saw as emblem of his office, in a

daguerreotype taken in 1852 of all the staff on the steps of Erddig, with his son and successor, James Rogers, standing beside him. His tools, stamped with his initials, are still at Erddig.[10] Only in 1871, at the age of 90, did he retire and receive a pension. Four years later he died, and Simon III Yorke paid for the death notices, coffin and funeral, for which the Erddig carriages were used.

The little that we know of *Edward Barnes* is gleaned from the doggerel underneath his portrait. He was once a soldier in the Denbighshire Militia, one of the swords of which (supplied by the Yorkes, and kept in the Servants' Hall) he holds in his right hand. He then became lodge-keeper at Erddig, before being made woodman – betokened by the axe held over his left shoulder – with occasional duties in the garden. He was also known as a fisherman and an amateur brewer, with a taste for finer tipples:

> He knows full well to draw a Cork,
> And toast in Port 'The House of Yorke'.

So important did Simon II Yorke think it that all these multifarious activities should be alluded to, that he provided the artist with a crude sketch, to show him how he wanted it done.[11] Despite the *naïveté* of these aspects of the picture, the man himself is presented with a straightforwardness and dignity rare in early 19th-century portrayals of his class.

HIST: Cust (1914) lumps both sets of servant portraits together, calling them 'the work of an unknown local artist', and saying that 'Two guineas a piece was the price paid for them' (both statements seem more likely to refer to the original set by John Walters); in any case, by descent at Erddig, until 1973, when the last squire, Philip III Yorke (1905–78), gave estate, house and contents to the National Trust.

EXH: (25a) *The Destruction of the Country House*, Victoria & Albert Museum, 1974, no.30; *Pride of Possession*, Welsh Arts Council, National Museum of Wales, Cardiff, etc., 1975, no.30.

LIT: Cust 1914, ii, pp.258–9, pls. opp. pp.256–8 (showing the pictures in a state of extreme – but, for Erddig, characteristic – dilapidation in the Servants' Hall); Steegman 1957, p.98, nos.42 (25a), 41 (25b); Waterson 1976, pp.412–13, fig.2 (25a); Waterson 1978[2], p.1036, fig.5 (25b); Waterson 1980, pp.59–60, fig.37 (25a), pp.142–5, fig.86 (25b); *Erddig* 1995, pp.21, 41 and col. pl. on p.21 (*Thomas Rogers*).

Fig. 10 Simon Yorke's sketch for *Edward Barnes* (Clwyd Record Office)

a

b

26 Sir Edwin LANDSEER, RA (London 1803–73)

Lady Louisa Russell, Marchioness (and later Duchess) of Abercorn (1812–1905) *holding her Daughter, Lady Harriet Hamilton, later Countess of Lichfield* (?1834–1913)

Oil on panel. 35.5 × 25.5 cm (14 × 10 in)
Signed bottom right: *The Doune 1834 EL*
Shugborough, Staffordshire

Landseer seems to have snatched up a panel and to have made this spontaneous sketch upon it, without calculating whether or not he would be able to get all of the mother's head in. (The panel is too slight to have admitted of enlargement;[1] the artist instead began another painting on copper, which is now in the Tate Gallery.)

The informality of this picture takes us straight to the heart of Landseer's remarkable relationship with the highest echelons of the Whig aristocracy. The son of a deaf and eccentric engraver, he became the intimate friend of 'dooks and doochesses'.[2] J.G. Lockhart describes a dinner that Landseer gave for his aristocratic men friends in 1851:

> The dinner was good, but very queer and conceited, a mixture of finery and *the fast* school. . . . The only plebeian was Swinton. We had Lords Abercorn, Ossulstone, Mandeville and Ed. Russell, and they all called the knight 'Lanny', and he called them 'Ossy', 'Many', 'Ned', Abercorn only 'Marquis' – I suppose he being the only one that pays. All dog, and horse, stag, and Queen for talk . . . and when I left them at half-past ten, they were all starting for some place where a new American game of rackets is played by gaslight, Lanny and all.[3]

Landseer was an equal favourite with their womenfolk, and even – for a time – with the Queen herself. This was partly a reflection of Landseer's brilliant and entertaining (if ultimately unstable) personality, and partly because his subject-matter – dogs, game, hunting and children – was a familiar and favourite part of their daily lives. What is more, the painter and his patrons had recently discovered the Scottish Highlands, where all these things could be enjoyed in conditions of relative simplicity, away from the formal constraints of Court and country house life.

Whole albums of ink drawings of society figures, ranging from quick sketches to caricatures, give us a glimpse of the way he observed such people. Yet for all this intimacy, he neither curbed his difficult temperament nor compromised his art. He could not tolerate being watched when painting, nor would he let anyone see his pictures until they were finished.[4]

Among the greatest of these figures, and the closest of Landseer's friends, were John, 6th Duke of Bedford (1766–1839) and his much younger second wife, Georgiana (1781–1853), daughter of the 4th Duke of Gordon, whom the Duke had married in 1803. Landseer was a frequent visitor, not just to Woburn Abbey in Bedfordshire, but to Endsleigh in Devon, and to The Doune (where this picture was painted) and Glenfeshie in the Highlands. Among the pictures that they bought or commissioned from Landseer were portraits of their two youngest sons, *Lord Cosmo Russell on his Pony 'Fingall', or The Young Mountaineer* (1824; Duke of Abercorn) and *Lord Alexander Russell on his Pony 'Emerald', or The First Leap* (1829; Guildhall Art Gallery); and his great exercise in Border history in the Rubens–Snyders vein, *The Hunting of Chevy Chase* (1825–6; Birmingham Museum and Art Gallery); as well as a number of fancy pictures of their two youngest daughters, Louisa and Rachel.[5]

Gossip accused Landseer of being the Duchess's lover, and of fathering her youngest child, Lady Rachel Russell (1826–98), later Lady James Butler, who was indeed born five years after her closest sibling.[6] Landseer's mental breakdown in 1840 was also attributed by some to the widowed Duchess's refusal to marry him. But, whereas the Duke, as an 18th-century survival, might perhaps have turned a blind eye to the relationship, because of his own pleasure in the artist's company, it seems less probable that the Duchess's eldest children, who were Landseer's contemporaries, would have tolerated it.[7] Rather does the artist always seem to have had the gift of getting on with older women.[8]

Landseer may, however, have felt some attraction to the Duchess's daughters, and particularly to Lady Louisa, who married Lord James Hamilton, later 1st Duke of Abercorn, in 1832: he painted two versions of this tender maternal study of her,[9] as well as a similar one of 'Loo', Louisa Stuart Mackenzie, Lady Ashburton, with whom he undoubtedly was in love.[10] Moreover, the dark-haired Highland woman suckling her child in Landseer's *A Highland Breakfast* (exh. 1834; Sheepshanks collection, Victoria & Albert Museum)[11] is curiously reminiscent of the Marchioness. Between the chalk study[12] and the final painting, she is made finer-featured, and if anything more like her. So much so, that one is strongly tempted to wonder whether there was not some transference between the present decorous representation, and the earthier, more natural one in *A Highland Breakfast*, in Landseer's mind, and whether he did not portray the Highland woman as he would like to have portrayed the Marchioness, but could not for reasons of decorum.

An ink drawing of *Lord Hamilton and Lady Harriet Hamilton with a Fortune-teller* (1843), and a coloured chalk drawing of *Lady Harriet Hamilton*, both by Landseer, are also at Shugborough.

27 George Elgar HICKS (Lymington 1824 – Odiham 1914)

Dividend Day at the Bank of England

Oil on millboard. 28 × 38 cm (11 × 15 in)
Signed bottom right: *G E Hicks 1859* [the capitals in monogram]
Wimpole Hall, Cambridgeshire

This is Hicks's preliminary study for his *Dividend Day at the Bank of England* (1859; Bank of England), which stands with his *The General Post Office: One Minute to Six* (1860; Museum of London), and with W.P. Frith's *Ramsgate Sands* (1854; Royal Collection), *Derby Day* (1858; Tate Gallery), and *The Railway Station* (1862; Royal Holloway College), as among the best-known and most popular tableaux of mid-Victorian life in England. Yet whereas Frith (1819–1909) gained fame and fortune, became a Royal Academician, and had his badge as CVO pinned to him by Edward VII himself the year before he died, Hicks received no honours of any kind. In his lifetime, he was the object of only one study, and that was as the 104th of James Dafforne's articles on contemporary British artists, in *The Art-Journal* in 1872;[1] even there, according to Dafforne, the space taken up by the steel-engravings of three untypical examples of Hicks's paintings prevented him from saying much. He remained virtually unknown in this century until Christopher Wood illustrated *The General Post Office* on the jacket of his *Victorian Panorama* in 1976. Two years earlier the late Jeffrey Daniels had bought *Changing Homes* (1860) for the Geffrye Museum, which inspired an exhibition devoted to Hicks there in 1982.

The reason for this neglect appears to have been that Hicks, though loved by visitors to the RA, was generally disapproved of by the critics. Why this should have been the case, when Frith was so lauded, is not immediately obvious. It may partly have been because Frith, when he took up these subjects, was an established Academician, a friend of such writers as Dickens, and had already made his name with comparable pictures, but set in a golden past. Hicks, by contrast, had previously made only a modest name for himself, first as a book illustrator (notably of Thomas Campbell's *Gertrude of Wyoming*, 1846) and then primarily as a painter of rural and sentimental subjects. Something of the stigma of the semi-amateur may also have dogged him. Besides, Frith was the pioneer, and Hicks an imitator, whose *Dividend Day* was quite clearly cashing in on the success of *Derby Day* the year before. When Hicks took a subject from F.B. Barwell's *Parting Words – A Crowded Scene at a Railway Station* (exh. RA, 1859) for his *Railway Waiting Room* in 1861, he was trumped by the success of Frith's *The Railway Station* the following year. Beyond that, however, it seems to have been felt that Hicks, but not Frith, had overstepped the fine line between vivid observation and caricature: it was perhaps no accident that *Punch* was among his more favourable critics.

Hicks was sensitive to accusations of vulgarity: in the present sketch a flâneur leaning on the wheelchair is ogling the girl in the centre; in the finished version he has become an attendant pushing it. The young clerk with a quill between his teeth seated on the left was turned into a venerable, be-whiskered and top-hatted one; and the group in the right foreground was made more sombre and decorous. But it made no difference. When the picture was exhibited at the RA in 1859, he was criticised for aspiring to ape Hogarth, but without his moral message. *The Times* thundered that Hicks's picture was 'degenerating into that excessive characterization which borders on caricature . . . these subjects bring out whatever vulgarity is in a man'.[2] *The Athenaeum's* critic, F.G. Stephens, as a former member of the Pre-Raphaelite Brotherhood, was in the opposite camp to both Hicks and Frith, and mounted a full-frontal assault on the two of them:

> Mr. Hicks, exquisite in drawing-room idylls, must now forsooth attempt Frithisms and the humours of London life. *Dividend Day at the Bank* is an unreal, laboured piece of unsuccessful humour, with here and there a pretty face. The subject is too much for Mr. Hicks. Let him get back to his violet banks and silk gowns – there he is at home.[3]

None of these criticisms affected the crowds surging round the picture at the exhibition, however; so that Hicks was encouraged to go on and paint the equally popular *General Post Office* the next year, of which *Punch* aptly wrote: 'the crush represented in Mr. Hicks's picture gives

Fig. 11 George Elgar Hicks, *Dividend Day at the Bank of England* (1859; Bank of England)

only a faint idea of the crowd around it. The glimpses which you catch of it between hats, over shoulders, and under arms, increase the reality of the scene.'[4] He followed this up with *Billingsgate Fish Market* (1861; Fishmongers' Hall), *An Infant Orphan Election at the London Tavern – Polling* (1865; private collection; sketch, Aske Hall sale, 21 Sept 1994, lot 760) and *Before the Magistrates* (1866; private collection). But by then the novelty had worn off, whereas criticism had not abated, so he reverted to his sentimental subjects, dabbling too with oriental, biblical and historical scenes, into the next and unsympathetic century (when his notebooks increasingly read 'refused' or 'rejected'). From the later 1870s, however, most of his paintings were portraits, including the huge and extraordinary *Adelaide, Countess of Iveagh* (1884–5; Elveden Hall sale, 21–4 May 1984).

Hicks was clever in his choice of subject for the present picture. 'Dividend day' was the quarter-day when dividends on Bank Stock and Government Securities were paid to personal applicants. In the handsome vaulted room built by Soane, the clerks on the left handed out dividend warrants, which were cashed in another part of the building. 'Consols', as the Consolidated Government Annuities yielding an unvarying (from their consolidation in 1751 until 1889) interest of 3 per cent per annum were known, were the only investment permitted to the trustees of widows, orphans and the like, and Hicks saw the touching dramatic possibilities they offered. Because of their security, almost anyone with any savings held some of these stocks. As Disraeli has Vivian Grey say in his novel of that name:

> There is nothing like a fall in Consols to bring the blood of our good people of England into cool order. ... If the Consols were again at 60 [instead of at par, 100] we should be again bellowing, God save the King! eating roast beef, and damning the French.[5]

Hicks's picture was thus not merely anecdotal, but implied a subtle reassurance to visitors to the RA of the peace and stability of mid-Victorian England: that Consols stood at 100, and all was well with the world.

HIST: sold for £30 to G. Simms of Bathwick Hill, Bath (who had bt *Osier Whitening* two years previously);[6] bt from the Leicester Galleries in 1937 by Capt. George Bambridge; thence to his widow, Elsie Kipling, Mrs Bambridge, by whom left to the National Trust with Wimpole Hall and all its contents on her death in 1976.

EXH: *Victorian Life*, Leicester Galleries, 1937, no.57.

LIT: Sitwell 1937, pp.82 (calling Hicks 'an unknown man'), 100, pl.23; exh. cat. *George Elgar Hicks*, Geffrye Museum, 1982, under no.21, illus. as fig.21a; *Wimpole Hall* 1991, p.73.

28 Jacques-Joseph, called James, TISSOT

(Nantes 1836 – château de Buillon, Doubs 1902)

The Crack Shot

Oil on canvas. 67·5 × 46·5 cm (26½ × 18¼ in)
Signed bottom left (on trellis): *Tissot*[1]
Wimpole Hall, Cambridgeshire

The Crack Shot is exceptional among Tissot's paintings
in showing an active, independent woman, in command of
the situation; one who is, for once, more absorbed by her
activity than just conscious of, or responsive to, being
observed. As Sir Michael Levey has said, generally in
Tissot's paintings:

> Elegantly rather than ostentatiously dressed, though very
> much *dressed*, costumed, encased in clothes that seem at
> once plumage and armour, women occupy a prominent
> yet uncertain place – disturbing, even perhaps provoking,
> men more than, apparently, feeling much themselves . . .
> [they] not only cast a potent spell over men, but seem
> often to do so half against their will. How bored they are
> with their role! To escape from the burden of being
> attractive, of causing emotional stress, might be supposed
> the chief feeling with which, in painting after painting,
> they gaze beyond the spectator.[2]

That *The Crack Shot* has this – for Tissot – unusual
character seems to be connected with the moment at which
it was painted. Tissot began his second visit to London in
1869, when, having conquered Paris, he appears to have
wanted to open a fresh campaign in life's battle (which is
what he told Edmond de Goncourt he enjoyed London for).[3]
Other works painted in 1869–70 show a similar desire to
give a new direction to his art. From 1870 dates his
memorable portrait of the nonchalant adventurer *Colonel
Frederick Gustavus Burnaby* (National Portrait Gallery),[4]
the first and most striking of a mere handful of portraits of
men, which are restricted to his first years in London. And
between 1869 and 1870, under the sobriquet 'Coïdé', he
supplied sixteen caricatures of foreign royalty and politicians
to the newly founded magazine *Vanity Fair*.[5]

The figure linking all these activities, perhaps even in-
cluding the present picture, was that lively character Thomas
Gibson Bowles (?1841–1922).[6] He had founded *Vanity Fair*
in 1868, commissioning – or buying *en bloc* – Tissot's
caricatures the next year. One of his two collaborators was
Colonel Burnaby, who also put up half the £200 with which
the magazine was reputedly founded. When Tissot returned
to Paris in the autumn of 1870, playing a courageous part as
a sniper in the defence of the city against the Prussians, he
shared a billet with Bowles, who was there as war corres-
pondent for the *Morning Post*. Bowles's book on the siege,
The Defence of Paris, was illustrated with sketches made on

the spot by Tissot. These the latter worked up into illus-
trations when staying subsequently at Bowles's London
house, Cleeve Lodge, Hyde Park Gate, where the publisher
gave him refuge when he had to flee Paris in 1871 after
siding with the failed Commune.

It has even been suggested that the present painting is set
in the garden of Cleeve Lodge. There is no evidence for this,
nor even of Tissot's staying with Bowles on his first visit to
London: he is more likely to have stayed with a fellow-artist,
to give him access to a studio. But it certainly looks like the
garden of a London house, and the title latterly given to it,
At the Rifle Range, is clearly inappropriate. There is no
range: a Pembroke table and a rug have been brought out of
doors to make a temporary stand under a garden trellis, and
the young woman appears to be testing a variety of rifles and
pistols. She is watched by a man who looks not unlike
Bowles when war correspondent, and by a woman who
protects her ears against the noise of the gunshots.

None the less, one wonders whether the key to the locale –
and perhaps even to the subject – may not be Adriano de
Murrieta, Marquis de Santurce, who attempted to sell this
and another picture by Tissot, *On the Thames: The Fright-
ened Heron* (Minneapolis Institute of Art), at Christie's in
1883. He and his father, José de Murrieta,[7] were among the
earliest recorded owners of the artist's work in England, and
had vast – and perhaps somewhat indiscriminate – collec-
tions of modern British and Continental paintings. José de
Murrieta, a Spanish born merchant and banker, and his sons
also employed Alfred Stevens to decorate their great
mansion, 11 Kensington Palace Gardens, from about 1854,
and subsequently got Walter Crane to paint a frieze in the
ballroom added in 1873.[8] This picture may not only have
been painted for them, but also in the purlieus of Kensington
Palace. The identity of Tissot's markswoman remains a
mystery, but the picture itself is a rather satisfying one-off in
Tissot's oeuvre.[9]

HIST: sale of the collection of [Adriano de Murrieta,] Marqués de
Santurce, Christie's, 7 April 1883, lot 151 (bt in at 210 gns); sale of a
portion of the collection of Joseph Beausire (1833–1907) of Wethers-
field, Christie's, 13 April 1934, lot 76, bt by Tooth for 50 gns; with the
Leicester Galleries, 1936–7, when bt by Capt. George Bambridge;
thence to his widow, Elsie Kipling, Mrs Bambridge, by whom left to the
National Trust with Wimpole Hall and all its contents on her death in
1976.

EXH: *Tissot*, Leicester Galleries, 1937, no.3; *James Tissot*, Barbican Art
Gallery, 1984, no.24 (both wrongly titled *At the Rifle Range*).

LIT: Laver 1936, pp.73, 75, pl.V (dated to *c*.1872); *Lilliput*, Sept 1942,
col. pl.; Wentworth 1984, p.111, n.83, pl.96; *Wimpole Hall* 1991, p.73.

3

TOPOGRAPHICAL LANDSCAPE

Landscape is so ordinary a word, and one so naturally used when we talk of the countryside, that it can come as a surprise to realise that it was originally a term of art. It derives from the Dutch *landschap*, in which '*schap*' comes from the old Teutonic word meaning 'to shape' or 'to create', and was first used by painters. The earliest recorded use of the term in English – in the older form, 'Landskip' – was in 1598, in Richard Haydocke's translation of Lomazzo's *Trattato dell'arte delle pittura, scultura et architettura* (1584),[1] where the Italian had used *paesi* ('countrysides').

The idea of creation implies making something out of nothing, or out of the void, with the aid of the creative spirit or the imagination. This suggests that landscape was in origin a mental construct. However, the earliest mentions of it as a branch of painting show that it was rooted in depicting the specific, even if in combinations that may have been imaginary rather than actual views.

These mentions go back to Antiquity, to the time that we think of as that of the absolute primacy of the figure – of the naked human form – in art. What is more, the first of them, in Vitruvius's famous chapter on the decadence of mural painting, specifically attaches landscape painting to the adornment of particular rooms in houses. Having stated that any form of superior painting should be avoided in winter dining-rooms, because of the inevitable damage from the smoke of fires and the soot from lamps, Vitruvius goes on to say:

> For the other apartments, that is, those intended to be used in Spring, Autumn, and Summer, as well as for atria and peristyles, the Ancients required realistic pictures of real things. . . . their covered walks, on account of the great length, they decorated with a variety of landscapes [*varietatibus topiorum*], copying the characteristics of definite spots. In these paintings there are harbours, promontories, seashores, rivers, springs, canals, temples, groves, mountains, flocks, shepherds.[2]

Pliny the Elder mentions one Spurius Tadius, who in the time of the Emperor Augustus 'first introduced the most attractive fashion of painting walls with pictures of country houses and porticoes and ornamental gardens [*topiaria opera*], groves, woods, hills, fish-ponds, canals, rivers, coasts, and whatever anybody could desire'.[3]

These descriptions by Pliny and Vitruvius encouraged the taste for landscape that already existed in Renaissance Italy.

Detail of Hawkins, *Penrhyn Slate Quarry* (34)

Landscape, however, then still appeared primarily as a subordinate element in other kinds of painting.[4] It also remained at the bottom of the hierarchy of the genres, categorised dismissively as *parerga*, meaning 'by-works'. As Paolo Giovio, the great Humanist and portrait collector, wrote about Dosso Dossi (*c*.1489/90–1542):

> The gentle manner of Dosso of Ferrara is esteemed in his proper works, but most of all in those which are called *parerga*. For, devoting himself with relish to the pleasant diversions of painting, he used to depict jagged rocks, green groves, the firm banks of traversing rivers, the flourishing work of the countryside, the gay and hard toil of the peasants, and also the far distant prospects of land and sea, fleets, fowling, hunting, and all that genus [of painting] so pleasing to the eyes, in a lavish and festive style.[5]

The 'jagged rocks' remind us that these early landscapes, though based on the real, were works of the imagination, taking their inspiration from the backgrounds of pictures by Leonardo da Vinci and Titian, or from memory. Even the 'landscape of fact',[6] which was first practised in northern Europe, had its origins in similar feats of memory and re-combination upon the canvas. Karel van Mander reports that Pieter Bruegel the Elder (active 1551–d.1569) had drawn the Alps so exactly *nae t' leven* ('from the life') on his journey to Italy, that when people saw the pictures that he painted after his return, they said that he had swallowed up the Alps and had spat them out onto his canvases and panels;[7] but they were works of the imagination, none the less.

The same use of fantasy characterises what is perhaps the earliest English discussion of landscape painting, the little fable told by Edward Norgate in 1648–50, to account for the development of landscape as an autonomous branch of art:

> To reduce this part of painting to an absolute and intire Art, and to confine a man's industry for the tearme of Life to this onely, is, as I conceave, an Invencon of these later times, and though a Noveltie, yet a good one, that to the Inventors and Professors hath brought both honour and profitt. The first occasion, as I have been told abroad, was thus. A Gentle-man of Antwerpe, being a great *Liefhebber* (Virtuoso, or Lover of Art), returning from a long Journey he had made about the Countery of Liege and Forrest of Ardenna [a significant location, in view of what follows, and of what we know of the Valckenborchs: see cat. no.57], comes to visit his old friend, an ingenious painter of that Citie, whose House and Company he useually frequented. The Painter he finds at his Easill – at worke which he very dilligently intends, while his newcome freind, walking by, recountes the adventures of his long Journey, and with all what Cities he saw, what beautifill prospects he beheld in a Country of a strange scitiation, full of Alpine Rocks, old Castles, and extrordinary buildings &c. With which relation (growing long) the prompt and ready Painter was soe delighted as, unregarded by his walking freind, he layes by his worke, and on a new Table begins to paint what the other spake, describing his description in a more legible and lasting

Character then the others words. In short, by that time the Gentleman had ended his long discourse, the Painter had brought his worke to that perfecton, as the Gentleman at parting, by chance casting his eye that way, was astonisht with wonder to see those places and that Countery soe lively exprest by the Painter as if hee had seene with his eyes or bene his Companion in the Journey.

> This first Esay at Lanscape it seemes got the Painter Crownes and Credit. This began others to imitate, and now the Art is growne to that perfection, that it is as much as 20 or 30 yeares practice can doe, to produce a good painter, at this one species of painting onely.[8]

Norgate refers to landscape painting as 'an Art soe new in England, and soe lately come a shore, as all the Language within our fower Seas cannot find it a Name, but a borrowed one, and that from a people that are noe great Lenders but upon good Securitie, the Duch.'[9] When he names actual artists, he mentions only the most celebrated – Bruegel, Coninxloo, Momper, Bril, Elsheimer and Rubens – but no native prac-titioners, although landscapes were being painted by English-men. The earliest to survive is probably the miniature of Bril-like character by the amateur Sir Nathaniel Bacon (1585–1627), from the Museum Tradescantium (now the Ashmolean Museum, Oxford). The collection of Charles I contained '*A Landshape w*[th] *greenewich Castle in it*' by [George] Portman' (active 1626–37), who also painted landscape overmantels.[10]

It was a significant pointer to the future that in the mid-17th century foreign conjurors of 'ideal landscape' who operated here, such as Cornelis van Poelenburgh (*c*.1586–1667), were outnumbered by delineators of the 'landscape of fact': Alexan-der Keirincx (1600–52), with his London prospects and his ten views of the 'Kings houses & townes in Scotland … after y[e] life'; Claude de Jongh (*c*.1605–63), with his views of the Thames and London Bridge; Wenceslaus Hollar (1607–77), with his poetic rural etchings of Albury; and George Geldorp's unknown assistant, with his 'landshape of London'.[11] Even painters of imaginary scenes, such as Adriaen van Stalbemt (1580–1662), were pressed into recording reality.[12]

The mysterious George Portman's 'landskip' overmantels were painted in 1633 for Sir William Paston's sadly long-vanished treasure house, Oxnead Hall. This is an early – perhaps the earliest – recorded instance of such a use of landscape in England, for what was to be a classic location. As William Sanderson says, in the chapter entitled 'To place the Pictures within Doors', in his *Graphice* in 1658: '*Landskips* become Chimney-pieces'. He also includes the recommenda-tion that 'Pictures becomes [*sic*] the sides of your *Staire-case*; when the grace of a Painting invites your guest to breathe, and stop at the ease-pace; and to delight him, with some *Ruine* or *Building* which may at a view, as he passes up, be observed.'[13] Foreign academic theorists, by contrast, disapproved of land-scape overmantels, recommending figural subjects instead.[14]

Overmantels became the stock-in-trade of English land-scape and marine painters. The landscape itself might be actual or ideal, but there seems to have been – in keeping, perhaps, with the tectonic character of the chimneypiece itself

Fig. 12 John Harris, *Dunham Massey from the South-east* (*c.*1750; Dunham Massey)

– a preference for including buildings in either case: views of the houses themselves in the case of 'landscapes of fact', and ruins, in particular, in the case of ideal landscapes. Landscapes of both kinds were considered suitable for most rooms in a house. The cruder – but to us, marvellously informative – kind of bird's-eye view popularised by Leonard Knyff (1650–1721/2) is only rarely described in inventories, suggesting that comparatively little value was put upon them. To the minds of their possessors, they rated perhaps as much as maps as they did as works of art.[15]

Endearing though so many of the English examples are, it is doubtful how many of them can reasonably be categorised as art; they have therefore, with some reluctance, been excluded from this exhibition. Also absent is the landscape water-colour, so central to the English topographical tradition and so loved by such collectors as Sir Richard Colt Hoare (see cat. no. 11). Instead, within the small compass of this room, we have chosen seven pictures – four British, three Continental (is it chance that these last are all, in a manner of speaking, townscapes?) – not only as superb works of art, but also, in the case of three of the British examples, to show how the topo-graphical impulse was linked to the territorial imperative.

Although the link between landscape painting and land ownership has been badly overstated in recent years,[16] a link there undoubtedly was. Similar motivations to those that impelled a gentleman to have himself, his wife and children, his horses, and even his dogs, portrayed, impelled him to have not only his house and estate recorded, but also – admittedly on much rarer occasions – the source of the wealth that helped underpin his very act of patronage.

It is sad that no British sovereign had the imagination to commission from Turner, as Louis XV of France did from Vernet, and Ferdinando IV of the Two Sicilies did from Hackert, a series of 'Views of the Ports of the Realm', through which so much of the wealth sustaining Britain passed. How-ever, the 3rd Earl of Egremont commissioned a view of *The Chain Pier, Brighton* and the *Chichester Canal*, in both of which he was an investor, along with two views of *Petworth Park* and *Lake*, for the Carved Room at Petworth in 1827–8.

In 1774 William Beckford of Somerley had taken George Robertson (1749–88) with him to Jamaica to make a series of drawings and watercolours of views on his estates. The originals of these are now at Penrhyn, where Hawkins's *Penrhyn Slate Quarry* (cat. no. 34) also hangs. It is fascinating to compare these with the engravings made after Beckford's and Robertson's return, by Vivares and Lerpinière. The originals are pure topography, and give some idea of the lush and exotic vegetation of the island; the prints, by engravers who had never seen the sites themselves, and whose publisher wanted to make them more appealing to a public without Beckford's proprietorial interest in Jamaica, are prettified into conventional picturesque views that might be of almost anywhere. And yet the same publisher, Boydell, was also to publish six engravings of the industries at Colebrookdale (1788) after paintings by Robertson, three of which show 'the horrors of the Dale' with great candour, and no attempt at prettification. Such portrayals of the industrial landscape, however, remained rare.[17]

The *Manchester Ship Canal* (cat. no. 35) will come as a surprise to those who know B. W. Leader only as the painter of *February Fill Dyke*, but it owes its genesis to the painter's origins in a family of engineers, and to its owner's pivotal place in the promotion of the canal. The painting still works power-fully as landscape, however. Thomas Hemy's *Elswick Works* (1886; Cragside) was commissioned by the 1st Lord Arm-strong to record an actual industrial landscape – his vast range of factories on the banks of the Tyne. When Aran Watson visited Elswick, he was reduced to comparisons with the Old Testament: 'The smoke rises up from Tophet, the furnaces vomit forth their flames and there is a mighty clang of labour.'[18] A reminder, if one were needed, of how closely the landscapes of fact and the imagination are intertwined.

29 Aelbert CUYP (Dordrecht 1620–91)

View of Dordrecht

Oil on canvas. 68·3 × 192·8 cm (27 × 76 in)
Ascott, Buckinghamshire

Dordrecht – or Dort, as it was often known – was the artist's native city. It is seen from the north-east, from the Papendrecht, at the point at which the Oude Maas, or Old Meuse, becomes the Beneden Merwede, whence one channel, the Noord, goes northward to the Nieuwe Maas and Rotterdam, and another, the Dortse Kil, goes south to the Hollands Diep, and so towards Antwerp. The city thus lies on one of the busiest waterways in the country, one always filled with a wealth of shipping. Here, a two-masted merchant ship flying Dutch flags is anchored in mid-stream, while smaller transport ships called *kaags* cluster round the entrance to the Wolwevershaven, with the massive shape of the Grote Kerk behind, and the Groothoofdspoort (with the spire that preceded the present dome, which was not constructed until 1692) to the left. The distant windmill to the right, the 'Standaard-Molen', marks the junction of the Oude Maas and the Dortse Kil. Further right still, more

small boats sail in the evening calm, and two rafts link up with a sloop.

The quayside is shown as rebuilt in 1647, but the picture itself is generally dated later than this, to the 1650s. Following the end of the Thirty Years War in 1648, Holland was at peace, so that there is none of the wealth of warships shown in Cuyp's earlier views of shipping on the Maas. Instead, the raft is an allusion to the hardwoods shipped down from Germany, on which much of Dordrecht's prosperity had been based.[1] A precedent for this was Adam Willaerts's huge *View of Dordrecht* (1629; Dordrechts Museum), which then hung in the Town Hall, and whose elongated format may have been at the back of Cuyp's mind when he composed the present picture.

Willaerts's picture had a public function, and was a kind of panorama of Dordrecht. It is not clear why Cuyp should have adopted such a format for this essentially private statement, in which the city was pushed to one side of the picture, or what kind of location it was painted for. (It is the wrong shape and size for a Dutch overmantel.) Very oddly

for a picture of this consequence, we have no record of who owned it in Holland,[2] before it appeared sundered into two pictures serving as pendants in Sir George Colebrooke's sale in London in 1774. (Scientific examination kindly undertaken by the National Gallery in 1993 has confirmed that it was indeed originally one picture, and that it was so deftly severed and spliced that virtually nothing has been lost from the centre of it.) It is also singular that it bears no trace of any signature, yet has not been cut down. This, the idiosyncratic format, and the lack of any record of early ownership, may all indicate that Cuyp painted it for his own pleasure and use – very possibly around the time of his marriage in 1658 to the wealthy Cornelia Bosman, after which he painted less and less.

Cuyp made a number of pictures of Dordrecht at different points in his career. The *View of Dordrecht* (Iveagh Bequest, Kenwood) shows essentially the same scene, but more compressed, and in a more conventional format. There is no certainty as to which version came first: both paintings contain *pentimenti*, and the preparatory drawings in the Rijksprentenkabinet and the British Museum could be for either. Fine though the Kenwood *View of Dordrecht* undoubtedly is, it does not approach the beauty of this picture, which Anthony Blunt described as embodying 'one of the most romantic renderings of light effects in the whole of Dutch painting'.[3]

HIST: though painted as one, it seems first to be recorded as two pictures, in the sale of Sir George Colebrooke, 2nd Bt, MP (1729–1809),[4] at Christie's, 23 April 1774, lots 22 ('A View of Dort with a variety of shipping, etc.') and 23 ('Boats with a raft floating, its companion'), bt E. Bathall for 50 gns each; then possibly in the collection of John, 3rd Earl of Bute (1713–92);[5] in the collection of his widowed daughter-in-law, Louisa, Lady Stuart, by 1815; her sale, Christie's, 15 May 1841, lots 74–5, the view of Dordrecht as '*Morning*' and the river scene on the right as '*Evening*'; bt by the London dealer Thomas B. Brown, who reunited the two halves and sold the picture to Robert Stayner Holford (1808–92),[6] in whose collection noted by Smith in 1842; Sir George Holford sale, Christie's, 17 May 1928, lot 10; bt by Agnew's for 20,000 gns for Anthony de Rothschild (1887–1961);[7] by whom given to the National Trust, along with the house, grounds and most of the ground-floor collections at Ascott, in 1949.

EXH: BI, 1815, nos.133, 134; 1843, no.115; 1852, no.68; 1862, no.4; RA, winter 1887, no.75; BFAC, 1900, no.31; *Exposition hollandaise*, Louvre, 1921, no.5; *Dutch Art*, RA, winter 1929, no.265 (*Commemorative Catalogue*, p.28); BFAC, 1936, no.68; *Aelbert Cuyp in British Collections*, National Gallery, 1973, no.13; *Art in Seventeenth Century Holland*, ibid., 1976, no.27; *De zichtbaere Werelt*, Dordrechts Museum, 1992–3, no.22 (entry by Alan Chong).

LIT: Fawkes 1815, p.54; Smith 1834, v, nos.187, 188; and 1842, ix, no.52; Waagen 1854, ii, p.202; Blanc 1861, p.10; Hofstede de Groot 1909, ii, no.164; Holford 1927, ii, no.152, pl.cxxxvii (frontispiece); *Ascott* 1963, no.10, pp.9–10, pl. (entry by F. St John Gore); Reiss 1975, no.98, p.137 (dating it to the early 1650s); exh. cat. *Aelbert Cuyp en zijn familie*, Dordrechts Museum, 1977–8, p.88; Haak 1984, pp.416–17, fig.908; Russell 1984, p.228; Russell 1990, p.41, fig.24.

30 Bernardo BELLOTTO (Venice 1720/21 – Warsaw 1780)

View of Verona from the Ponte Nuovo

Oil on canvas. 132·5 × 231 cm (52¼ × 91 in)
Powis Castle, Powys

Although Bellotto early on took the name of his teacher and maternal uncle, Canaletto, to help sell his view-paintings, his strengths and weaknesses were very different.[1] In his early Venetian, Florentine and Roman views, Bellotto mostly seems to have been inhibited by the way in which Canaletto and previous view-painters had set their stamp upon the sites portrayed. Paradoxically, it was only when he had broken free from townscape, to paint views of villas and villages around Milan in 1744, that a new and individual tonality and a love of texture entered his work. From then on he also showed his special talent for creating striking and un-expected urban and other architectural compositions by his choice of viewpoint rather than by the careful elaboration of perspective on which his uncle relied. With works such as this, painted between 1745 and his departure for Dresden in 1747, Bellotto emerged from his uncle's shadow, as an artist whose happiest effects were achieved on a large scale. As J. G. Links has written: 'From now on, seven feet was to be Bellotto's minimum width for his important townscapes, in itself, surely a mark of self-confidence in a man not yet thirty years old.'[2]

This view from over the River Adige is upstream and to the north, towards the Visconti fortress of Castel S. Pietro, which then dominated the city, but was destroyed by the French in 1801. To the left, on the west bank, is the unfinished brick façade and tower of S. Anastasia. At the extreme right edge of the picture, on the east bank, is the Palazzo Fiorio della Seta, decorated with 16th-century frescoes. The wooden shacks anchored out in the current are floating mills for grinding corn. Around the same time Bellotto painted the view in the opposite direction, *The Adige at Verona with the Ponte delle Navi* (on loan to the National Gallery of Scotland), as a pendant.[3]

Filled with self-confidence Bellotto may have been, but pictures of this size were not generally painted on spec.[4] The drawing with which Bellotto recorded the present picture (now in the Hessisches Landesmuseum, Darmstadt)[5] is in-scribed '*copia del quadro dela Vista stando sun il ponte novo verso il castelo di Verona a Verona di Bernard. Belotto de:ᵗᵗᵒ il Canaletto per ingiltera*', which indicates an English buyer. Indeed, it was almost only English *milordi*, or sovereign princes of the Holy Roman Empire, who were capable of patronage of pictures on such a scale. Regrettably, we have no idea who this travelling Englishman might have been.[6] Nor do we know how it came on the market less than a generation later. The first record of the picture is as *A View in Verona* by 'Cannalletti', in a list of the 1st Lord Clive's pictures taken at his house in Berkeley Square between 1771 and 1774. The 1775 inventory puts a price against it of £147, which translates into 140 guineas, strongly suggesting a purchase in the salerooms, where guineas were the usual unit of bidding, but no such auction has come to light.

Bellotto also made same-sized virtual replicas of the two

Fig. 13 Bernardo Bellotto, *The Adige at Verona with the Ponte delle Navi* (on loan to the National Gallery of Scotland)

views, which he seems to have presented in 1747/8 to the Royal Collection in Dresden, where he had been appointed Court Painter.[7] As could be seen at the Venetian exhibition at the Royal Academy (1994–5), there is little diminution in quality between the present picture and the Dresden version, and only slight differences of detail (the main one being the addition of an extra boat, drawn up alongside the foremost of the floating mills).[8]

There is also another excellent version of the present picture in the Lee Collection of the Courtauld Institute, by William Marlow (1740–1813).[9] This has plausibly been identified with one of a pair of *Views of Verona* in a sale of pictures, purportedly 'lately consigned from abroad', at Christie's on 30 March 1771, which fetched the great price of 516 guineas. Yet, less than a month later, Horace Walpole was reporting to Horace Mann that it had come out that they were by Marlow.[10] More plausibly, since no copy by Marlow of the *View of the Ponte delle Navi* has ever been recorded, while the purchaser of one of the *Views of Verona* in the 1771 sale was able to resell it for 205 guineas only six years later, the vendor at Christie's had attempted to swell his profits by pairing Marlow's copy of the present picture at auction with the original of its pendant, having sold the other original – the present picture – to Lord Clive privately.

HIST: Robert, 1st Baron Clive of Plassey (1725–74), by 1774; by descent to his son, Edward, 2nd Lord Clive, 1st Earl of Powis of the 3rd creation (1754–1839), who married the Powis heiress, Lady Henrietta Herbert, in 1784; thence by descent;[11] when Powis and the majority of its contents were transferred to the National Trust in 1952, the Bellotto remained in the ownership of the family; when offered for sale in 1981, its acquisition by the Trust was made possible by grants from the National Heritage Memorial Fund and the National Art-Collections Fund, and Grant-in-Aid administered by the Victoria & Albert Museum.

EXH: RA, winter 1904, no.68 (as Canaletto); Magnasco Society, 1925, no.21; *Italian Art*, RA, winter 1930, no.768 (*Commemorative Catalogue*, no.541, pl.CXCVII, reproducing in error the Courtauld picture); *Works of Art from Private Collections*, City Art Gallery, Manchester, 1960, no.113; *Souvenirs of the Grand Tour*, Wildenstein, 1982, no.6; *The Treasure Houses of Britain*, National Gallery of Art, Washington, 1985–6, no.193; *Treasures for the Nation*, British Museum, 1988–9, no.90.

LIT: von Hadeln 1930, pp.20, 24; Fritzsche 1936, pp.27–8, 106, VG 26 (provenance confused with that of the Courtauld picture); Kozakiewicz 1972, i, p.45, ii, no.98, pp.79–80, illus. p.77; *Powis Castle* 1987 (*Catalogue of Pictures*, supplement), pp.5–6, no.32. detail fig.; 1989 (integrated), p.69, no.32, detail fig.; exh. cat. *Bernardo Bellotto: Verona e le città europee*, Museo di Castelvecchio, Verona, 1990, pp.124–7; exh. cat. *The Glory of Venice: Art in the Eighteenth Century*, RA, National Gallery of Art, Washington, 1994–5, pp.362–5, 429.

31 Jakob Philipp HACKERT (Prenzlau 1737 – San Piero di Careggi 1807)

The Excavations of Pompeii

Oil on canvas. 118 × 164 cm (46½ × 64½ in)
Signed bottom right: *Filippo Hackert dipinse 1799*
Attingham Park, Shropshire

The view, looking towards Castellamare and the Sorrentine Peninsula, encompasses the excavated area of Pompeii as it appeared at the end of the 18th century. The large, open space in the centre is the Theatre, to the left is the triangular Forum, and adjacent to it are the Barracks of the Gladiators and the Quadriporticus. At the extreme left is the Odeum or small theatre, and on the right, behind its screening wall, is the worst plundered, but still best preserved, of the shrines of Pompeii, the Temple of Isis.

Today Pompeii is the most famous of the sites engulfed by the eruption of Vesuvius in AD 79, and its excavated remains have become the archaeological site *par excellence*, of which everyone has heard. Yet in the 18th century, when it was rediscovered, it was overshadowed by its sister-city, Herculaneum. This was partly because Herculaneum had been discovered first: systematic excavations began in 1738 and continued vigorously until 1765, when the focus shifted to Pompeii and Stabia. But it was also because the early excavators were interested only in carrying off Antique sculpture, wall-paintings, papyri, bronzes and the like; and the most spectacular finds of this type were made at Herculaneum.[1] Herculaneum also had the aura of forbidden fruit, thanks to Carlos III (1716–88), King of the Two Sicilies and controller of both sites, who restricted access to the excavations and would not allow notes or sketches to be taken in the museum of excavated antiquities at Portici.

It was only later in the 18th century that interest in Pompeii began to equal that in Herculaneum. Because Pompeii had been destroyed by ash rather than lava, much more had survived. Because it had not been buried deep under lava and later constructions, it could be laid bare by proper excavation, instead of being simply bored through by tunnels, as Herculaneum was. The extraordinary completeness of Pompeii's survival provoked a new fascination with how the Romans had actually lived, which gradually replaced the earlier, spoliatory interest exclusively in works of art. Bulwer Lytton's *The Last Days of Pompeii* (1834) invested the site with human drama, and in 1863 Fiorelli discovered how to make plaster casts from the voids left by the trapped and fleeing figures, giving the place a ghoulish fascination that has never left it.[2]

In his *Voyage pittoresque, ou description des Royaumes de Naples et de Sicile* (1781–6), the abbé de Saint-Non had included celebrated imaginary plates of the *Discovery of Herculaneum* and of the *Transfer of the Antiquities of Herculaneum from the Museum of Portici to the Palazzo dei Vecchi Studi in Naples*, along with a dozen or so plates of

the sites of Pompeii.[3] But these views of the sites, complete with elegant visitors, are of more picturesque than archaeological merit, in keeping with the slant of the whole publication. To paint actual excavations – as distinct from ruins – for their own sake was something novel, and in this – as in so many things – the pioneer would appear to have been Thomas Jones (1742–1803), in his oil-on-paper sketch of *An Antique Building discovered in a Cava in the Villa Negroni at Rome in y^e Year 1779* (Tate Gallery).[4] He had, however, to some extent been anticipated by Giovanni Battista Piranesi (1720–78), who had made a number of visits to Herculaneum and Pompeii in the 1770s. Piranesi recorded his impressions of the sinister desolation of Pompeii in particular, in a series of powerful drawings, some of which were etched and eventually published by his son Francesco in *Les antiquités de la Grande Grèce* (1804–7).[5] Francesco had previously engraved seven detailed and more conventional drawings of Pompeii by Louis-Jean Desprez, which he published with a plan of the site in 1788–9.

Hackert's panoramic view in oils is something very different. He was the most successful German landscape painter of the late 18th century, and his precise views and capriccios of Italy were keenly sought after by foreigners, from the Earl-Bishop of Bristol to Catherine the Great. He had settled there in 1768, and was first invited to Naples by Sir William Hamilton in 1770. Successive and ever longer stays resulted in his appointment as Court Painter to King Ferdinando IV (1751–1825) in 1786.

When Goethe visited Naples in 1787, Hackert obtained permission for his pupil in drawing and future biographer to visit the museum at Portici. In 1789 Hackert accompanied Goethe's patron, Duchess Anna Amalia of Saxe-Weimar, on her visit to the excavations. He may have been encouraged by such visits, or – more probably – by the example of Francesco Piranesi's publication, to paint a set of six gouaches of sites in Pompeii, and to have them engraved by his brother Georg. He announced them to a friend, Heinrich, Baron von Offenberg, in December 1792 as '*was Curioses Neues fürs Publicum von Europa*'. Hackert recognised that, in the new order thrown up by the French Revolution, such excavations had become a matter of public interest, rather than simply the property of an individual ruler. However, it was still only with the permission of the King that he could either paint them or have them engraved, finally publishing them in 1794–6.[6]

In 1788–92 Hackert had painted a set of *Views of the Ports of the Kingdom of the Two Sicilies* (on the model of Joseph Vernet's *Ports of France*) for Ferdinando IV. It seems possible that he began the present picture and its pendant, *Lake Avernus with the Bay of Naples in the Distance* (also at Attingham), as part of another royal commission; all the

more so, in that in 1796 he had painted both sites for the King of Prussia.[7] But in December 1798 the Neapolitan court fled to Palermo to escape the French Revolutionary forces, who occupied Naples early the following year. In March 1799 the Hackert brothers, whose house had already been plundered by the Neapolitan *lazzaroni*, were also forced to leave the city, when the French troops, who had at least been guaranteeing law and order, threatened to withdraw. Taking the probably still unfinished pictures and their engraving plates, the brothers fled first to Pisa, where the present picture, which is signed in Italian rather than French, was probably completed. In May 1800 they moved to Florence, where the pendant, dated 1800, was probably finished.[8]

When the pair was put up for sale in 1827 by Thomas Noel Hill, 2nd Baron Berwick (1770–1832), the auction catalogue said: 'These Pictures were painted by order of the noble Proprietor.' Lord Berwick had, however, made his Grand Tour of Italy in 1792–4, some years before the pictures were painted. He might in theory have commissioned them after his return, perhaps through an intermediary, but no other case is known of his doing so, and the troubled state of Europe would have made such a commission foolhardy. Besides, by this time he was

beginning his career as a profligate buyer of the Old Master paintings that the French Revolution had released on to the market. He is more likely to have obtained them from Hackert after the Peace of Amiens (1802), when regular communication with Italy was re-established, and when the painter would have been glad to find a buyer for them, since Ferdinando IV – if it was indeed he who had originally commissioned them – was still in exile in Sicily.

HIST: bought or commissioned by Thomas Noel Hill, 2nd Lord Berwick; his sale, Robins, Attingham, 30 July ff. 1827, 6th day (6 Aug), lot 55, bt in at 52 gns by Tennant, acting on behalf of Lord Berwick; retained by the Hon. William Noel-Hill, later 3rd Lord Berwick (1773–1842), as one of the pair, together valued at £100; thence by descent to Thomas, 8th Lord Berwick (1877–1947), by whom bequeathed to the National Trust, with Attingham, its estate and contents, in 1947.

EXH: *Italian Art and Britain*, RA, 1960–61, no.243; *German Art*, Manchester City Art Gallery, 1961, no.193; *Souvenirs of the Grand Tour*, Wildenstein, 1982, no.31; *The Treasure Houses of Britain*, National Gallery of Art, Washington, 1985–6, no.185; *Travels in Italy*, Whitworth Art Gallery, Manchester, 1988, no.89.

LIT: Wegner 1992, pp.71, 72, 87–8, fig.18; Wegner and Krönig 1994, pp.158–9; Nordhoff and Reimer 1994, no.286, i, fig.141; ii, pp.138–9.

32 Joseph Mallord William TURNER, RA (London 1775–1851)

Tabley, Cheshire, the Seat of Sir J. F. Leicester, Bart.: Calm Morning

Oil on canvas. 91·5 × 117 cm (36 × 46 in)
Signed bottom right: *J M W TURNER RA*
Petworth House, West Sussex

There might seem to be a certain perversity in exhibiting, as the representative of the twenty paintings by Turner at Petworth, one which is neither of the house or its grounds; nor one of those directly commissioned by the artist's great patron and host, George, 3rd Earl of Egremont (1751–1837) (see cat. no.13). Only six of the Turners at Petworth, however, fall into one or other of these two categories. This picture also underlines how much the man who commissioned it stimulated the 3rd Earl to promote and collect modern British painting and sculpture, and how greatly the sale of part of his collection was to enrich the 3rd Earl's at Petworth.[1]

Tabley: Calm Morning was conceived with another subject, *Tabley: Windy Day*[2] (Tabley House Joint Committee, Tabley House), in the summer of 1808, when Turner was staying at the house, which was the country seat of Sir John Fleming Leicester, 5th Bt (1762–1827), created Baron de Tabley in 1826. Both views show, from slightly different angles, the round tower designed by Leicester himself to stand on the edge of the mere at Tabley, with, in the background, Tabley House. The latter had been built in 1761–7 by John Carr of York for Sir John's father, Sir Peter Byrne Leicester, 4th Bt, to replace Tabley Old Hall, which then still stood on the opposite side of the mere.

Turner was determined to be received at Tabley as a guest rather than as an employee. Henry Thomson (1773–1843), who was invited to stay and to make a painting of the mere and tower from a similar viewpoint at the same time (Tabley House), said of him to their fellow-artist, A.W. Callcott: 'His time was occupied in *fishing* rather than painting.'[3] Turner's oil sketch – which curiously omits both pictures' main motif, the round tower – was cut out of the so-called 'Tabley' sketchbook and folded in four, as if for sending by post to Sir John Leicester for his approval;[4] and *Tabley: Windy Day* (which was actually sent up to Tabley) has his London address inscribed on the stretcher.[5] It seems clear, therefore, that the artist did not embark upon the paintings until he returned to London.

The present picture was one of ten Turner oils bought or commissioned by Leicester, largely between 1806 and 1809, a period when Egremont was also buying vigorously. Leicester's first attempted acquisition directly from the artist, *The Festival upon the Opening of the Vintage of Macon* (exh. RA, 1803; Sheffield City Art Galleries), was sold instead to the 1st Lord Yarborough, but he succeeded in buying *The Shipwreck* (exh. Turner Gallery, 1805; Tate Gallery) in 1806. A year later, however, he relinquished it

to the artist in a part-exchange for the *Fall of the Rhine at Schaffhausen* (exh. RA, 1806; Museum of Fine Arts, Boston). His earliest painting by Turner, *Kilgarran Castle on the Twyvey, Hazy Sunrise, previous to a Sultry Day* (exh. RA, 1799; Wordsworth House, Cockermouth, NT, Lady Mildred Fitzgerald bequest), was not acquired from the artist, but from what was already its second owner possibly as early as 1803, or even before. The last of his acquisitions was *Sun rising through Vapour: Fishermen cleaning and selling Fish* (National Gallery), which he bought in 1818, though it had been exhibited at the Royal Academy in 1807. This preference for Turner's earlier works was shared by Lord Egremont and helps to account for his purchase of the present picture. Yet although Leicester acquired only half the number of Turners that Egremont did, their range of style and subject was wider.

The 3rd Earl of Egremont's first acquisition from Turner was *Ships bearing up for Anchorage*, known subsequently as 'The Egremont Sea-piece'.[6] Turner exhibited this at the RA in 1802, but it is far from certain that it was acquired then, or even much before 1805. Egremont's subsequent acquisitions extended between that year and 1831, chiefly from Turner's exhibitions at his own Gallery, but mostly fell between 1807 and 1812. It was only in 1809 – the date strongly suggesting that he was inspired by Leicester's example – that he commissioned paintings of his two chief seats, *Petworth from the Lake: Dewy Morning* and *Cockermouth Castle*. There was subsequently a curious and unexplained hiatus between his acquisition of two pictures exhibited by Turner at his Gallery in 1812, and his commissioning of four more pictures in 1828–9: two of Petworth, and two of constructions in which he had had an interest, *The Chain Pier, Brighton* and *Chichester Canal*.

Lord Egremont and Turner probably encountered one another again as fellow-bidders at the sale of the pictures from Lord de Tabley's London house in 1827. Egremont purchased the present Turner and three pictures by other artists, including the *Europa* by Hilton that was to be made the central picture in Phillips's posthumous portrait of him (cat. no.13). Turner bought back his own *The Blacksmith's Forge* (Tate Gallery), and *Sun Rising through Vapour*. It seems to have been only after the Tabley sale that Turner became a regular houseguest at Petworth – given the Old Library to use as a studio, and humoured in every particular.[7] By that time patron and artist matched one another in eccentricity, and the one was as impatient with the formalities of deference as the other was determined not to accord it.

In addition to Turner, Sir John Leicester and Lord Egremont patronised many of the same contemporary British artists. The only major painter they both ignored was

Constable, although he stayed once at Petworth. Leicester appears to have started collecting even before he had taken 24 Hill Street as his London house in 1805 and had had the library remodelled as a top-lit picture gallery in 1805/6. He bought paintings by Gainsborough in 1789 and 1797, and commissioned the first of a number of subject-pictures from Northcote in 1798/9. By the summer of 1808 he had had the picture gallery at Tabley constructed by Thomas Harrison. Egremont likewise seems to have begun by collecting Hogarths, Gainsboroughs and Reynoldses, and also commissioned pictures from Northcote, but he did not build his top-lit addition to the picture and sculpture gallery at Petworth until 1824.

Leicester was always the more active propagandist for his collection and for modern British art. In 1818 he opened his London picture gallery to the public, and the following year published a catalogue by William Carey of his British pictures at both Hill Street and Tabley. By contrast, Egremont abandoned his inherited London mansion in 1794, and did not create or open a gallery in his new house there. Nor was any catalogue of his collection published in his lifetime. The North Gallery at Petworth is instead his memorial.

HIST: commissioned by Sir John Fleming Leicester, 5th Bt (1762–1827), later Lord de Tabley, in 1808; sale of pictures by Christie's at his London house, 24 Hill Street, 7 July 1827, lot 34; bt by the 3rd Earl of Egremont (1751–1837) for 165 gns; thence by descent, until the death in 1952 of the 3rd Lord Leconfield, who had given Petworth to the National Trust in 1947, and whose nephew and heir, John Wyndham, 6th Lord Leconfield and 1st Lord Egremont (1920–72), arranged for the acceptance by HM Treasury of the major portion of the collections in lieu of death-duties (the first ever such arrangement); the ownership of the Turners was transferred by the Treasury to the Tate Gallery in 1984.

EXH: RA, 1809, no.146; ?Liverpool Academy, 1811, no.9 (more probably *Tabley: Windy Day*); *The Turner Collection from Petworth*, Tate Gallery, 1951, no.3; *English Pictures from National Trust Houses*, Agnew's, 1965, no.31; *Bicentenary Exhibition*, RA, 1968, no.154; *Turner 1775–1851*, Tate Gallery, 1974–5, no.151.

LIT: Carey 1819¹, no.43; Carey 1819², no.42; Young 1821, no.43; *Petworth* 1856, p.3, no.8 (as *Scene at Tabley, the Tower in the Lake*, in the North Gallery); Collins Baker 1920, p.123, no.8; Farington 1982, ix, pp.3397–8 (11 Feb 1809), 3442 (30 April 1809); 1982, x, p.3520 (2 Aug 1809); Butlin and Joll 1984, no.99, i, pp.70–71, ii, pl.107 (with previous literature); Whittingham 1986, p.28, fig.31; Butlin et al. 1989, pp.25, 30–31, 53, 133, col. fig.34.

33 Richard Parkes BONINGTON
(Arnold, nr Nottingham 1802 – London 1828)
Coastal Scene of Northern France

Oil on canvas. 80 × 121 cm (31½ × 47½ in)
Anglesey Abbey, Cambridgeshire

There were three British painters in the earlier part of the 19th century whom the French particularly admired: Constable, Bonington and John Martin. All three exhibited at the Paris Salons, and Bonington actually lived in France, even sharing a studio at one point with Delacroix, and had many clients who were French or lived in France. It is surprising therefore to find no major work by any of them in a French public collection.[1]

This painting was perhaps one of the greatest missed opportunities. Its first owner, Bonington's close friend Charles, baron Rivet,[2] offered it to the Louvre shortly after the artist's death, but it was refused by the director, the comte de Forbin, on the grounds that the artist's 'successes with the public and among collectors do not constitute a sufficient title to admission into the galleries of the Louvre'.[3] Rivet retorted that he would instead bequeath the picture to his family, with the proviso that it was never to be given or sold to the Louvre or any other French museum.

Forbin may also have been influenced by the fact that the painting is not quite finished: the white horse, for instance, has no forelegs. According to Dubuisson and Hughes, Bonington had indicated them, 'but being dissatisfied he painted them over with a light tint matching that of the ground. Then he did no more to it, and the picture remains thus incomplete.'[4] Nor were the face and headgear of the woman crouching on the sand completed. There are also a number of visible *pentimenti*, including a building painted out at the left, the original positioning of a figure similar to the central fishermen with something at his feet painted out to the right of him, and a more substantial figure than the girl now seated on the bay horse also painted out. All these things indicate that the picture must have given the artist a certain difficulty. Yet the final result seems effortless, and he must evidently have considered that he was in danger of disturbing this effect by continuing to work at it. As his friend Delacroix later noted:

> He altered his pictures because he had such facility that everything he put on canvas was charming. Yet the details did not always hold together, and his tentative efforts to get back the general effect sometimes caused him to abandon a picture after he had begun it.[5]

There is some uncertainty as to the setting, and consequently also as to the date, of this picture. Contrary to what was stated in the catalogue of the 1991–2 Bonington exhibition, the title *Near the Bay of the Somme* is far from traditional, and does not originate with Rivet or his heirs.[6] Telling his story of its rejection by the Louvre, René-Paul Huet called it '*une Plage normande*'. Since his father, the painter Paul Huet, had gone sketching along the Seine (which debouches in Normandy) in 1825, and planned a trip to Normandy with Bonington in 1828, which was aborted by the latter's terminal illness, he could have been speaking from first-hand information. This was also the title used by Dubuisson, who first related René-Paul Huet's story, in 1909.[7]

The grounds for instead called the painting *Near the Bay of the Somme* – or, more specifically, *Near St-Valéry-sur-Somme* – rest on supposed similarities (invisible to the writer) with the site shown in a watercolour whose identification seems equally tenuous.[8] There are, however, certain admissible similarities with other oil paintings of broad beaches with uncluttered horizons, all of which are said to show the coast of Picardy.[9] One of these, the picture in the Ferens Art Gallery, Hull, has a teamed pair of dark and white horses with paniers, similar to those in the present painting.[10] In two other respects, however, our picture differs from the coast scenes supposed to represent Picardy: the buildings are thatched, not tiled, and the headgear does not resemble traditional Picard types, as shown in Bonington's own paintings and drawings. Bonington depicted similar headgear in the stylistically comparable *A Fishmarket near Boulogne*[11] (Yale Center for British Art) and similar thatched cottages in *Shipping on the Canal at Calais: Morning Effect*[12] (Knightshayes, Devon; NT). Both suggest a link with Artois, rather than with Picardy or Normandy.

Fig. 14 Detail of R.P. Bonington, *Shipping on the Canal at Calais: Morning Effect* (Knightshayes)

Bonington visited Artois twice: in 1823, as part of an extensive exploration of the Channel coast from Bruges down to Normandy, in connection with a commission from J.F. d'Ostervald, for views to be published as aquatints in his *Excursions sur les côtes et dans les ports de France*; and in 1824, when he spent most of what he called 'the happiest year of my life' in Mme Perrier's boarding-house in Dunkerque, much of it with his bosom friend and fellow-artist, Alexandre Colin (1798–1873). Removed from the distractions of Paris, he was evidently able to get a lot of work done, and there is no indication that he travelled much. If this picture was painted then, it was no doubt the synthesis of many sketches, and of impressions in his mind, rather than a view of a particular location – as the *pentimento* of a building would also suggest. That also accords better with the very general titles that Bonington himself gave to most of the coastal scenes that he exhibited: *Marine*; *Une plage sablonneuse*; *French Coast Scenery*; *French Coast, with Fishermen*. It is only the topographical mania of the British that has insisted on investing them with the titles of specific locations long after the event.

HIST: given to, or bought by, baron Charles Rivet (1800–72); thence to his daughter, Mme de Catheu; Marie de Catheu, Mme Paul Tiersonnier; Galerie Drouin, Paris; Mr Spector; acquired before 1962 by Huttleston Broughton, 1st Lord Fairhaven (1896–1966); bequeathed by him with Anglesey Abbey and all its contents to the National Trust in 1966.

ENGR: soft-ground etching by Charles Damour, 1852.

EXH: [?Galerie Drouin], Paris, 1936; *Pictures and Drawings by Richard Parkes Bonington and his Circle*, BFAC, 1937, no.29 (as *Coast Scene*, lent by Mme Paul Tiersonnier, née Marie de Catheu); *Pictures, Watercolours and Drawings by R.P. Bonington*, Agnew's, 1962, no.2, cover illus. (as *Normandy Coast Scene: The Mouth of the Somme*, painted in 1826, and with Mme de Salvandy substituted for Mme de Catheu in the provenance); *Treasures from Country Houses: Europalia 1973*, Palais des Beaux-Arts, Brussels, 1973, no.7, p.53, colour pl.; *Richard Parkes Bonington: 'On the Pleasure of Painting'*, Yale Center for British Art, New Haven, and Petit Palais, Paris, 1991–2, no.35, pp.126–7, colour pl. and detail (as *Near St-Valéry-sur-Somme*).

LIT: Dubuisson 1909, pp.384–6, with fig. (as *Plage normande* of c.1823, in the collection of Mme de Catheu); Dubuisson and Hughes 1924, p.118 (as *Coast Scene*); review of Shirley 1940 by Paul Oppé, *Burlington Magazine*, lxxix, Sept 1941, p.100, pl.A (as *Coast Scene, Normandy*); Sutton 1962, p.61, fig.3; Cornforth 1962, p.448, fig.1.

34 Henry HAWKINS, RBA (exh. 1822–81)

Penrhyn Slate Quarry

Oil on canvas. 132 × 188 cm (52 × 74 in)
Signed bottom right on a stone: *Hv Hawkins 1832*
Penrhyn Castle, Gwynedd

The slate quarries of Penrhyn and Dinorwic were once the largest in the world.[1] The scale and grandeur of their workings had impressed travellers ever since the later 18th century: in 1771 Richard Pennant, later 1st Baron Penrhyn (1739–1808), had inherited the workings at the north end of the Nant Ffrancon valley through his marriage to Anne, daughter of General Hugh Warburton, and in 1782 he took the only recently granted leases back in hand, consolidating them into one large quarry. From this he built a new road to the mouth of the River Cegin, and at the mouth of the river created Port Penrhyn in 1786. The market for slate collapsed with the outbreak of the war against France in 1793. When Pitt imposed a crippling tax on sea-borne slate the same year, the surviving workforce was given employment by the creation of a much more efficient iron tramway, six miles long, falling through 500 feet down to the port. This enabled only twelve men with sixteen horses to bring down more slate than 140 men with 400 horses had done before. By the mid-19th century, it was producing a net income of £100,000 per annum for its owner.

Slate had two main uses: for buildings, as roofing, cladding, shelves, cisterns, etc.; and in schools, as black-boards and writing-slates. The spread of education greatly increased the latter use, and Pennant ensured that the business went to his quarry by establishing a manufactory for the finishing and framing of writing-slates on the wharf at Port Penrhyn. Some time before his death in 1798, the traveller Thomas Pennant (only distantly related) waxed lyrical about the transformations wrought by Lord Penrhyn, and about this manufactory: 'Previously, we were entirely supplied from *Switzerland*: that trade has now ceased; the Swiss manufacturers are become bankrupt.'[2]

The architectural use of slate was greatly promoted by the symbiotic relationship between the Pennants and the Wyatts. James Wyatt had added a wing to Richard Pennant's Cheshire house, Winnington Hall, in 1776. His brother Samuel reconstructed Penrhyn Castle, where he built an entrance lodge, stables and estate cottages from 1782 onwards. In 1785 yet another brother, Benjamin, was appointed general agent to the estate, responsible for the running of the quarry and port. His brothers – but particularly Samuel, who became the leading purveyor of Welsh slate in London – thus had a direct incentive to encourage their clients to make every possible use of Penrhyn slate. When Samuel rebuilt Shugborough in Staffordshire for the 1st Viscount Anson from 1790, he faced the whole exterior with slate, even down to the columns of the portico.

By around 1800, the scale of the Penrhyn quarries had made them into something of a tourist attraction. In that innocent period, the more spectacular processes of the Industrial Revolution seemed like new wonders of Nature developed by man – marvels of the sublime more than of the picturesque.[3] The Rev. William Bingley was one of the first to record such reactions: 'Here I found several immense openings . . . as rude as imagination can paint, that had been formed in getting the slate. On first surveying them, a degree of surprise is excited, how such yawning chasms could have been formed by any but the immediate operations of Nature.'[4] Few commented on the quarrymen's grim working conditions.

By the time that Prince Pückler-Muskau saw the quarry, just four years before this picture was painted, its immensity was truly staggering:

> Five or six high terraces of great extent rise one above another on the side of the mountain; along these swarm men, machines, trains of an hundred waggons attached together and rolling rapidly along the iron railways, cranes drawing up heavy loads, water-courses, &c. It took me a considerable time to give even a hasty glance at this busy and complicated scene. . . . I reached the fearfully magnificent scene of operations. It was like a subterranean world! Above the blasted walls of slate, smooth as a mirror and several hundred feet high, scarcely enough of the blue heaven was visible to enable me to distinguish mid-day from twilight. . . . The perpendicular sides were hung with men, who looked like dark birds, striking the rock with their long picks, and throwing down masses of slate which fell with a sharp and clattering sound.

He then describes one of the regular springings of a mine, alluding to the darker side of all this activity: 'According to the statement of the overseer himself, they calculate on an average of an hundred and fifty men wounded, and seven or eight killed in a year. An hospital exclusively devoted to the workmen on this property, receives the wounded.'[5]

1832, the year in which this picture was painted, was doubly propitious for Penrhyn Quarry. In 1831 Pitt's duty on slate was finally repealed, and on 8 September 1832 the thirteen-year-old Princess – later Queen – Victoria visited it, recording the event in her journal, in a way that almost describes the various activities visible in this picture:

> It was very curious to see the men split the slate, and others cut it while others hung suspended by ropes and cut the slate; others again drove wedges into a piece of rock and in that manner would split off a block. Then little carts about a dozen at a time rolled down a railway by themselves.[6]

Hawkins would be unlikely to have missed the opportunity of depicting the royal visitor. He almost certainly, therefore, painted it before her visit, and more probably on commission than as a speculation. By this time the owner of Penrhyn was the rebuilder of the castle in its present, remarkable neo-Norman form: George Hay Dawkins-Pennant (1764–1840), nephew of the discoverer of Palmyra, and first cousin once removed of Richard Pennant, Lord Penrhyn, whose family name he had added to his own after inheriting this princely legacy in 1816.

George Dawkins-Pennant devoted his energy to building rather than to collecting paintings.[7] But, in addition to acquiring a certain number of historical portraits, he seems to have commissioned from George Fennel Robson (1790–1833) a set of eight appropriately large watercolours of views of or from his Caernarfonshire estates. The present picture, commissioned from a more local artist than Robson, in keeping with its 'inferior' subject-matter, represents the economic underpinning of these views and the castle itself.

In 1842 the Penrhyn slate quarries were again depicted, in a dramatic lithograph by W. Crane of Chester for his *Picturesque Scenery in North Wales*.[8] In keeping with the title and scope of the publication, the human figures in that view are but few, on the scale of ants, and are solely intended to point up, by their minuteness, the vastness of the quarry. Here, by contrast, they are active constituents of the scene, and a number of them are clearly portraits. Regrettably, we lack a key, but the artist does appear to have shown himself sketching the scene in the bottom right-hand corner, while a boy points out to him the pinnacle of Talcen Mawr ('Gibraltar Rock') in the middle distance. In the centre foreground, in a rather surprising artistic allusion, another gesticulating boy adopts the pose of Reynolds's *Infant John the Baptist*.[9] Since he points heavenward, rather than to any feature of the scene, it is possible that he is intended as a deliberate reminder that all this mighty endeavour is but human, and is subject to the mightier hand of God; just as the settlement next to the quarry, where the workers lived, was called Bethesda, the name of the sacred pool at Jerusalem, after the chapel built there in 1820.

HIST: presumably commissioned or bought by George Hay Dawkins-Pennant; thence by descent to Hugh, 4th Baron Penrhyn (1894–1949), who left Penrhyn and its estates to his niece, Lady Janet Harpur, née Pelham, who, with her husband, John Harpur, thereupon assumed the name of Douglas Pennant, and in 1951 made over the castle and part of its contents in lieu of death-duties to HM Treasury, which transferred them to the National Trust.

LIT: *Penrhyn* 1991, p.70, col. fig. p.83.

35 Benjamin Williams LEADER, RA (Worcester 1831 – Gomshall 1923)

The Excavation of the Manchester Ship Canal: Eastham Cutting, with Mount Manisty in the Distance

Oil on canvas. 124·5 × 212 cm (49 × 83½ in)
Signed bottom right: *B.W. LEADER 1891*
Tatton Park, Cheshire

A curiously intricate web links together canal-building in Britain, this particular canal, those who built it, and the families of the painter and commissioner of this picture. At the same time, it is an austerely impressive aesthetic celebration of the Industrial Revolution, by an artist better known for romanticised Worcestershire landscapes such as *February Fill Dyke* (1881; Birmingham City Art Gallery)[1] than for half-flooded massive mechanical excavations.

Cheap and reliable bulk transport was one of the essential preconditions of the Industrial Revolution. Before the advent of the railways, canals were the key to ensuring this; their first great promoter was Francis Egerton, 3rd Duke of Bridgewater (1736–1803). In 1887, after N.M. Rothschild & Sons had met with an initial setback in raising the necessary capital to construct the Manchester Ship Canal, Wilbraham Egerton, 2nd Baron and 1st Earl Egerton of Tatton (1832–1909), head of a cadet line of the same family, was appointed chairman of the company, to restore confidence.[2] This he did, in part by himself becoming the single largest investor, remaining as chairman until the canal was opened in 1894. He also sold the land on which Manchester Docks were built. It was he who commissioned this picture of the site where construction began, where he had cut the first sod (with a spade preserved at Tatton) on 11 November 1887.

Fig. 15 Benjamin Williams Leader, first sketch for *The Excavation of the Manchester Ship Canal* (Tatton Park)

Benjamin Williams Leader was born Benjamin Leader Williams, the second son of Edward Leader Williams, Chief Engineer to the Severn Navigation Commission and Hon. Sec. of the Worcester Literary & Scientific Institution. His younger brother was Sir Edward Leader Williams, the engineer of Shoreham harbour and Dover docks, and Engineer successively to the River Weaver Trust, the Bridgewater Navigation Company and the Manchester Ship Canal. He thus had inland waterways, so to speak, in his blood. He changed his name in 1857: to avoid confusion, as he said, with a dozen other regular exhibitors at the Royal Academy who had the same surname, including a whole family in his speciality – landscape.

Leader was too young to have absorbed anything from Constable's stay with his father on his visit to Worcester in 1835, but he knew the copy that his father had made at this time of Constable's *A Water-mill at Gillingham, Dorset* (1827; Victoria & Albert Museum).[3] His own earliest landscapes fell under the very different influence of the Pre-Raphaelites. He achieved considerable early success, with his pictures being bought by such fellow-artists as Thomas Creswick, Alfred Elmore and David Roberts, and *The Old Church at Bettws-y-Coed* being acquired by Gladstone.[4] But his move to Whittington, near Worcester, in 1862, brought two decades of provincial eclipse that was broken only in 1881 with the astonishing response that *February Fill Dyke*[5] evoked among visitors to the Royal Academy. The following year the very similar *In the Evening there shall be Light* (1897 version; Manchester City Art Gallery) was even more successful. In 1889 he could afford to buy the late Frank Holl's Surrey retreat, Burrows Cross, and get Holl's architect, Norman Shaw, to add a bigger studio.[6]

By 1891, when the present picture was painted, Leader's brother could therefore recommend him with confidence to Lord Egerton for this commission.[7] Who better to portray the seemingly unpromising subject of a half-flooded, half-built canal than an artist specialising in 'rain-filled rutty roads', who 'loves a flooded country in late November, with the dark land and the leafless trees defined against a golden sky'?[8]

Leader's response to the scene also shows that he could be much more than the mere veristic but elegiac recorder of a vanishing countryside whom his detractors dismissed. It reveals instead some of the qualities that brought him honours and distinction in France, and that encouraged two Frenchmen, Chauvel and Brunet-Debaines, to etch his work: 'As it was often said, then and afterwards, Leader's pictures seem to have been made for the etcher; all their strength and charm of design was seen at its best, and their crudity of

colour disappeared.'[9] The half-size version of this picture (also at Tatton) is, indeed, virtually monochrome, as well as reducing the human figures and machinery to insignificance.[10] It lays bare, as it were, the musculature that underlies Leader's seemingly artless composition.

The machinery that occupies a conspicuous position in the foreground looks rudimentary, but was singularly effective. As Sir Bosdin Leech described the Eastham section of the workings: 'Steam navvies of the Ruston & Proctor type (commonly but incorrectly called American devils) were driving their sharp teeth into the hillside and removing tons of soil into long strings of waggons, which as soon as possible were drawn away to a tip by small engines.' The record performance of one of these machines was the removal of 640 wagons (or 2,900 cubic yards) of soil, in twelve hours.[11]

Eastham may have been chosen not merely because it was where the excavations for the canal began, but also because it had previously been a beauty spot, known as the 'Richmond of the Mersey', with woods and foliage – visible on the right (and made more of in the initial sketch) – extending down to the estuary, which sweeps here in a noble curve, beside the future canal. However, the mound in the background, 'Mount Manisty', is no natural formation, but a heap of soil from the workings, which was named after the

contractor's agent for this first section of the canal. It is part of Leader's achievement that, without in any way glamorising the raw process of excavation, he has managed to fuse it with the beauty of the sky and of the estuary, to produce an image with its own sort of power and beauty.

HIST: commissioned by Wilbraham Egerton, Earl Egerton of Tatton for £600; thence by descent to Maurice Egerton, 4th Baron Egerton of Tatton (1874–1958), by whom bequeathed with the house, gardens and contents of Tatton Park to the National Trust.

EXH: *International Fine Arts Exhibition (British Section)*, Rome, 1911.

LIT: Lusk 1901, pp.6, 23, fig. on p.7; Leech 1907, i, p.134, facing pl.; Gore 1964, p.693.

4

IDEAL LANDSCAPE

It was the noble owner of a house now belonging to the National Trust – Wimpole Hall – who received one of the most magisterial put-downs from artist to would-be patron on the subject of landscape:

> Mr Gainsborough presents his Humble respects to Lord Hardwicke; and shall always think it an honor to be employ'd in anything for his Lordship; but with respect to *real views* from Nature in this Country, he has never seen any Place that affords a Subject equal to the poorest imitations of Gaspar or Claude. Paul San[d]by is the only Man of Genius, he believes, who has employ'd his Pencil that way – Mr. G. hopes Lord Hardwicke will not mistake his meaning, but if his Lordship wishes to have anything tolerable of the name of G, the subject altogether, as well as figures etc., must be of his own Brain; otherwise Lord Hardwicke will only pay for Encouraging a Man out of his way, and had much better buy a picture of some of the good Old Masters.[1]

Fuseli was even more trenchant in his Fourth Lecture, referring to 'the last branch of uninteresting subjects, that kind of landscape which is entirely occupied with the tame delineation of a given spot; an enumeration of hill and dale, clumps of trees, shrubs, water, meadows, cottages and houses, what is commonly called Views'.[2]

How Gainsborough set out composing his cherished landscapes, by contrast, we know from Reynolds's account in his 14th Discourse:

> From the fields he brought into his painting-room stumps of trees, weeds, and animals of various kinds; and designed them, not from memory, but immediately from the objects. He even framed a kind of model of landskips, on his table; composed of broken stones, dried herbs, and pieces of looking glass, which he magnified and improved into rocks, trees, and water.[3]

A later 'Amateur of Painting' had a more precise description of how 'he would place cork or coal for his foregrounds; make middle grounds of sand and clay; bushes of mosses and lichens; and set up distant woods of broccoli'.[4] There is a touch of the model-train enthusiast's improvisation of settings in all of this, which provides a certain justification for Richard Wilson's dismissal of Gainsborough's landscapes as '*Fried Parsley*'.[5]

Detail of Claude, *Landscape with Jacob and Laban and his Daughters* (37)

Gainsborough's techniques of landscape composition were a half-way stage between landscape as the pure creation of fantasy or chance, and landscape as inventive combination. Alexander Cozens's 'blot sketches' exemplify the former approach, which derived ultimately from the famous passages in Leonardo's *Treatise on Painting* that describe the inspiration to be gained by staring at damp-stained walls or irregular stones.[6] Ancient Roman and 17th-century Dutch painters perfected the latter method, that of juggling and recomposing studies of particular sites and features, made either on the spot, from memory, or from the works of other artists.

In the cumulative way in which Leonardo enumerates the components of his method, he is surely in turn echoing Vitruvius's and Pliny's descriptions of Antique landscape murals (cf. p.81). This illustrates how similar were the purely imaginative and the combinatory approaches to landscape, both in their raw material and in their final results: 'If you have to invent some scene, you can see there [in these stains on walls and in variegated stones] resemblances to a number of landscapes, adorned in various ways with mountains, rivers, rocks, trees, great plains, valleys and hills.'[7]

As Gainsborough's mention of Paul Sandby and the addressees of Cozens's book indicate, the English at first tended to see landscape primarily in terms of gouaches and watercolour drawings, and those mostly topographical. If they wanted imaginary landscape painting, they favoured examples by its classic exemplars in 17th-century Italy – Claude, Poussin (by which they understood both Nicolas and his nephew by marriage, Gaspard Dughet) and Salvator Rosa.[8] Copies of these were a second option, and original works by native artists a poor third. Even these last were initially modelled upon such Italian originals – whether they were the pioneering pictures of John Wootton, or those painted by Richard Wilson shortly after his return from Italy in 1757.[9] It was not until Gainsborough, and then Turner, that major practitioners of ideal or imaginary landscape appeared in Britain.

Regrettably, such pictures are not strongly represented in National Trust houses. Gainsborough's *Rocky Coastal Scene with Ruined Castle, and Fishermen dragging Nets* (exh. RA, 1781; Anglesey Abbey)[10] is not one of his most successful efforts, nor is the now darkened *Woody Lane* at Penrhyn.[11] It is also difficult to share Constable's ecstatic enthusiasm for the *Pastoral Landscape* at Petworth, at least in its present state: 'I now, even now, think of it with tears in my eyes. No feeling of landscape ever equalled it. With particulars he had nothing to do, his object was to deliver a fine sentiment – & he has fully accomplished it.'[12]

It is true that what is thought to be Gainsborough's earliest surviving finished landscape painting, *Crossing the Ford* – still essentially Dutch in character – is in the Bearsted Collection at Upton.[13] But the one undoubted masterpiece among Gainsborough's landscape paintings acquired for a National Trust house, *Peasants going to Market: Early Morning* – by Henry II Hoare 'the Magnificent' in 1773 – was lost to Stourhead in the Heirlooms sale of 1883, just as it has unforgivably been sold from Royal Holloway College since.[14]

Turner's *Lake Avernus: Aeneas and the Cumaean Sibyl* (1814–15; Yale Center for British Art)[15] is imaginary, both to the extent that it was a historical landscape, and because he had not yet seen the site when he painted it for Sir Richard Colt Hoare from the latter's drawing, as a pendant to a Richard Wilson of another classic lake, *Lake Nemi, with Diana and Callisto*, already at Stourhead. Turner's painting also went in the Heirlooms sale, along with its Wilson pendant (though the latter has been generously lent back to the house by the descendants of the buyer). And magnificent though the collection of Turners at Petworth is, not one of the landscapes there is a work of his pure, glorious fantasy; the only non-topographical landscape painting is *Narcissus and Echo* (1804),[16] which is more like an essay in picture-making in the style of Gaspard Poussin. The 3rd Earl of Egremont's taste ran almost entirely towards the portrayal of places that had some particular association for him.

This room of ideal landscape is, then, exclusively one of Continental Old Masters. Not inaptly, in some respects, since it was the very profusion of such pictures that British wealth was able to command (particularly after the breakup of the old, European collections brought about by the French Revolution) that rendered it difficult for native practitioners to thrive. Nor were most British artists in a position to conjure up idealised prospects of the Italy that their potential patrons saw through the eyes of the Latin poets, and where many had enjoyed their first real taste of freedom as young men. Those that could, such as Jacob More (1740–93), received an adulation that is hard to comprehend today.[17]

If Italy was the country of which Englishmen dreamed, then Claude was its poet. Even though only one pair of this artist's pictures had been painted for an English client, by the mid-18th century enthusiasm for him was such, and acquisition of his works had been so extensive, that Thomas Coke, Earl of Leicester (1697–1759) could create a cabinet almost exclusively devoted to them, carefully graduated according to the times of day represented.[18] Of the 195 paintings by Claude recorded in his *Liber Veritatis*,[19] at least 125 have been at some time or other in a British collection.[20] The influence exerted by these paintings on the English landscape garden has become a commonplace, although in fact they had more echoes in the character and placing of garden buildings (as at Stourhead), than on the planting of the gardens themselves.[21]

What is probably the first Claude to have initiated this great influx is the centre-piece of this room (cat. no.37). Remarkably, it is still in the house for which it was originally bought – Petworth. A pair of paintings of almost equal stature, the two 'Altieri Claudes' at Anglesey Abbey, were imported by William Beckford (cat. no.9) in 1799, and are typical of the more celebrated kind of picture whose acquisition the upheavals of the Revolution made possible. They might also have been borrowed for this exhibition, had they not only just been shown at the National Gallery.[22] Instead, it seemed more appropriate to flank the *Landscape with Jacob and Laban* with an arrangement of the kind of more decorative landscape that would have been hung with Claudes and Dughets in both British collections and their Roman models.

Facing it on one wall is a transmutation of Claude's imagery

into a more hedonistic, golden key, attributed to 'the Claude Lorrain of France', Pierre Patel the Elder (cat. no.38). On another wall, two italianate Dutch landscapes illustrate the hold that an imagined South had for a substantial number of artists and patrons in the United Provinces – a country commonly (but erroneously) seen as obsessed with the direct transcription of the everyday scene. It is sometimes maintained that the Italy portrayed by such artists – particularly Asselijn (cat. no.39) – was one mediated to them through the paintings of Claude, but their preoccupations were different from his – more essentially pastoral and descriptive of the Roman Campagna. As the Bril (cat. no.36) also reminds us, they drew on an already long tradition of Netherlandish artists responding to the Roman scene. Such Dutch italianate pictures as the Asselijn and the Berchem (cat. no.40) were highly valued by the more foreign-oriented Dutch ruling classes, who were probably familiar either by personal experience or through pastoral literature with the idealised vision of Italy that they represented.[23]

Looked at another way, however, the italianate Dutch tradition was just another of the manifestations of the extreme specialisation that characterised the Dutch School. For Italian artists, landscape stood so low in the hierarchy of painting that it was left almost entirely to foreigners to satisfy, despite the considerable demand for it even among Italian collectors. As Gérard de Lairesse observed towards the end of the golden age of Dutch landscape painting: 'It is not unusual that each landscape painter has a special inclination . . . the one to wild and desolate views, the other to still and calm; still a third to nordic and cold, [and others variously to] sun or moonshine, waterfalls and dunes, waters and woody views.'[24]

'Woody views' were precisely one of the two chief specialities of Hobbema (cat. no.41). He lived on into (but did not practise in) the 18th century, when the best Dutch pictures of the previous era were already beginning to find their admirers abroad – at first in France, with such pioneers as the comtesse de Verrue, and later in the century in Britain. None the less, certain artists, of whom Hobbema was one, and Cuyp, even more strikingly, another, were more (or even first) sought after in Britain, to the extent that British collections at one point enjoyed almost a monopoly of their finest works.[25] Cuyp in particular, whose topographical landscapes are so idealised, and whose ideal landscapes seem so real, perfectly assuaged the British longing for both kinds of depiction.

Fig. 16 Detail of Aelbert Cuyp, *Evening Landscape* (before conservation; Kedleston Hall)

36 Paul BRIL (Antwerp 1554 – Rome 1626)
Landscape with Troglodyte Goatherds

Oil on canvas. 112 × 142 cm (44 × 56 in)
Transferred inscription on lining-canvas : *PAUL BRILLE./ DUC DE VALENTINOIS./1730.*
Petworth House, West Sussex

The Bril brothers, Matthaeus (*c*.1550–83) and Paul, arrived in Rome from Flanders, one after the other, in the 1570s, at a time when the hitherto subordinate genre of landscape painting was about to become an autonomous branch of art. The trend was set by a Brescian steeped in Venetian painting, Girolamo Muziano (1532–92). Landscape played an extensive part in the organisation and mood of his religious easel paintings and drawings, many of the latter being intended for, and widely diffused by, engravings. Muziano's way of delineating landscape was taken up in Rome by Matteo da Siena (1553–88) and turned into a special variety of fresco painting – as Sydney Freedberg puts it, 'part fantasy, part ornament, and part wallpaper'.[1]

The Flemings had always been celebrated for landscape. Hence Michelangelo's dismissive words:

> In Flanders . . . they paint stuff and masonry, the green grass of the fields, the shadow of trees, and rivers and bridges, which they call – 'landscapes', with many figures on this side and many figures on that. And all this, though it pleases some persons, is done without reason or art, without symmetry or proportion, without skilful choice or boldness and, finally, without substance or vigour.[2]

Flemish artists naturally gravitated to this speciality when they went to Rome to study Antiquity and perfect their art. Matthaeus Bril, who was in Rome by 1570, was one of the first to do so, and he seems to have been joined around 1575 by his younger brother Paul, though the latter's presence is not attested until 1582.

Paul Bril's frescoes of the 1580s in the Vatican and the Lateran Palaces show him already open to a freer, more Italian way of painting.[3] However, his early Roman easel paintings – mostly small cabinet pictures on copper or panel – are quite different in character: intricate, precious, highly Mannerist compositions, still heavily indebted to the Flemish tradition. It was only, according to Baglione, when he received a fresh stimulus from the Italian tradition, under the influence of Annibale Carracci's approach to landscape, that his easel pictures took on a different character: 'he renewed his *prima maniera Fiamenga* . . . by a greater rapprochement with nature, and with the *buona maniera Italiana*.'[4] The result was an explosion in demand for his landscapes, and in the prices that he asked for them – Flemish merchants being the greatest takers. That is, no doubt, why most of his easel pictures have, historically, been found in northern Europe. Around the same time he seems to have expanded the size of

pictures; to do this, and to facilitate an Italian painterliness, he took more to using canvas.

The present picture, though not signed or dated, appears to be a particularly fine (albeit somewhat damaged) example of the transitional phase from one manner to the other, of around 1610–15, but before he had recourse to other, particularly Italian, artists for his figures, or was himself influenced by them. (It is significant that when this picture was auctioned in 1754, the figures were said – wrongly – to be by Annibale Carracci.) Bril's development has still not been the object of comprehensive study,[5] but, among dated examples of his work, one can see particular affinities between this painting and the *Landscape with the Penitent St Jerome* (1609; Musée Granet, Aix, on loan from the Louvre),[6] and with the *Landscape with Hebe and the Eagle of Jove*, which has figures by Rubens (1610; Prado).[7] The *Landscape with Ruins and Herdsfolk* (1620; Louvre), the undated *Landscape with the Vision of St Eustace* (Wellington Museum, Apsley House), the *Landscape with River Valley and Fishermen* (1624; Louvre) and the *Landscape with the Temptation of Christ in the Wilderness* (1626; Birmingham Museum and Art Gallery)[8] show the evolution of the final, even looser, phase of his more italianate style.

A painting on canvas of roughly the same dimensions, with a virtually identical landscape, a similar group by the cave, but somewhat different figures and animals elsewhere, was in the collection of Graham Baron Ash, at Wingfield Castle in Suffolk.[9] Another, narrower, canvas, with a similar, but more naturalistically treated, landscape (indicating a later dating), the same cave group, but again different figures elsewhere, is in the Pitti Palace, Florence.[10] These strongly suggest that once Bril had established a satisfying landscape composition, he went on to paint copies with slight variations, possibly leaving others to add different sets of figures. The present picture shows *pentimenti* in both the landscape (a tower cancelled on the right) and the figures (a change in the position of the head of the woman milking a goat) and animals (another goat painted out to the right of her).

The superb early 18th-century French frame must have been put on this picture in 1730 by its first owner, Jacques-François-Léonor de Goyon-Matignon, duc de Valentinois (1689–1751), who seems to have made a practice of inscribing his pictures with his name and (presumably) their date of acquisition.[11] After his death, five of his paintings were imported into England and sold at auction in 1754 by 'Dr' Bragge. Charles, 2nd Earl of Egremont (1710–63), who bought this one, was a politician, gourmand and voracious collector. Shortly before his death he was heard to say: 'Well, I have but three turtle dinners to come, and if I survive them, I shall be immortal.' He didn't – they did for him

instead. He was an active buyer in the salerooms, which were becoming the chief vehicle for the market in pictures in London, Paris and Amsterdam at this very period.[12] The dealer 'Dr' Robert Bragge imported whole batches of pictures from abroad, including from the better-organised auction market in Paris. The 2nd Earl kept almost all his Old Masters at Egremont House, Piccadilly (now the Naval & Military Club). When his son, the 3rd Earl of Egremont, decided to give this up and move to a more modest house in Grosvenor Place in 1794, he simply sold off the bulk of the Old Masters there, in an anonymous two-day sale held at Christie's on 7 and 8 March.[13] None the less, the present picture, Sébastien Bourdon's *Joseph Sold by his Brethren*[14] and David Teniers's wonderfully apt *The Archduke Leopold Wilhelm's Picture Gallery*[15] still survive at Petworth, to commemorate the 2nd Earl's enthusiasm as a collector.

HIST: acquired in 1730 by Jacques-François-Léonor de Goyon-Matignon, duc de Valentinois (1689–1751), hôtel de Matignon, Paris; sold privately; 'Dr' Robert Bragge's sale, Prestage's, 24–5 Jan 1754, 2nd day, lot 63 (as 'P[aul] Brill. A landscape, Fig: An. Carracci. From the Duke of Valentinois Collection'); bt for £126 by 'Anderson' on behalf of Charles, 2nd Earl of Egremont (1710–63); his posthumous inventory, 5–10 Dec 1764, Egremont House, Piccadilly, in the Front Dressing Room; his son, George, 3rd Earl of Egremont (1751–1837); inventory taken at Petworth by Henry Wyndham Phillips in 1835, listed (without attribution) in the North Gallery; thence by descent, until accepted in lieu of death-duties in 1956 by HM Treasury, by which subsequently conveyed to the National Trust.

LIT: *Petworth* 1856, p.10, no.83; [inadvertently omitted from Collins Baker 1920]; exh. cat. *Fine Paintings from East Anglia*, Norwich, 1964, under no.8; Gore 1977, p.346, fig.3; Gore 1989, p.129 and fig.11; Pears 1988, pp.166, 261 n.29, pl.50; Berger 1993, p.202 (as unseen, but one of the '*Eigenhändige Gemälde*').

37 Claude Gellée, known as CLAUDE (LORRAIN)
(Chamagne 1600 – Rome 1682)

Landscape with Jacob and Laban and his Daughters

Oil on canvas. 143.5 × 252 cm (56½ × 99 in)
Signed bottom right: *CL/AUDIO/ ROMA 1654*(?)
Petworth House, West Sussex

And Laban had two daughters: the name of the elder was
Leah, and the name of the younger was Rachel. Leah was
tender eyed; but Rachel was beautiful and well favoured.
And Jacob loved Rachel; and said, I will serve thee seven
years for Rachel thy younger daughter. ... And Jacob
served seven years for Rachel; and they seemed unto him
but a few days, for the love he had to her.[1]

But – as so often in the Old Testament – Jacob was made the
victim of a trick: Leah was surreptitiously substituted by
Laban for Rachel in the marriage-bed, on the grounds that it
was not the custom of the country for the younger daughter
to be married before the first-born; and Jacob had to serve
another seven years before he could marry Rachel too.

Familiar though the Bible story is, depictions of it are
curiously rare. Claude is not only one of the first artists to
have painted it, he is almost the only major artist to have
done so in the 17th century.[2] Indeed he went on to produce a
reduced variant of the core elements in 1659 (*Liber Veritatis*
147; Norton Simon Museum, Pasadena) and another
depiction in 1676 (*LV* 188; Dulwich College Art Gallery).
What is more, he made an exceptional pen-and-wash
drawing on parchment of the figure group in the present
picture (Wildenstein).

All this suggests that the subject had a particular
resonance for Claude, but quite why is less easy to establish.
Apropos the Dulwich version, Humphrey Wine has noted
that Leah and Rachel were seen as personifications of the
active and the contemplative life, and that Jacob's choice of
Rachel was seen as prefiguring Christ's selection of Mary.[3]
That may indeed have been the case in medieval herme-
neutics, but it is scarcely applicable to this Claude. For one
thing, the two women are presented as if vying with one
another in the attempt to dazzle Jacob with their charms,
rather than as embodiments of different ways of life, as
Mary and Martha were. In some ways, indeed, the figures
appear almost to be enacting a biblical variant of the
Judgement of Paris. Intriguingly, when Claude painted the
much commoner *Jacob at the Well* (*LV* 169; Hermitage) in
1667, he introduced Leah, with no sanction from the Bible;
furthermore, he eliminated any other shepherds from the
scene, in defiance of the Bible story, so as to reduce the scene
to these three figures, with Jacob again seeming to
contemplate the respective charms of the two sisters.[4]

Claude's intentions are obscured still further by the
apparent absence of any thematic link between the present
picture and its pendant, the *Landscape with the Worship of
the Golden Calf* (1653; *LV* 129; Staatliche Kunsthalle,
Karlsruhe). It is impossible to accept the contrast recently
drawn[5] between the faithlessness to God of the Jews
worshipping the Golden Calf, and the faithfulness with
which Jacob carries out his bargain with Laban: Jacob, after
all, had little choice, if he wished to win Rachel's hand![6] For
the moment, we must simply confess our ignorance. While it
is a healthy development to have focused attention upon the
subject-matter of Claude's paintings and drawings, it is
dangerous to attempt exegesis by referring to extraneous
traditions of interpretation. All that it seems possible to
say with certainty is that, for Claude, the fact that a picture
told a story, and how it told that story, were important;
the choice of the story itself appears to have been much
less so.

The *Jacob and Laban* and *Worship of the Golden Calf*
were two of three pictures recorded in the *Liber Veritatis* as
having been commissioned by the Roman patrician Carlo
Cardelli (1626–62).[7] Cardelli was a considerable collector –
145 pictures were listed in his posthumous inventory – with
a fondness for landscape in particular. He bought landscapes
and marines by Dughet, whom he also got to fresco some
since-vanished rooms in his palace on what is now the Piazza
Cardelli, where a fountain-niche with a statue of *Apollo*
stood in the internal courtyard. Another team of artists was
commissioned to paint landscapes with mythological
pretexts on the *piano nobile*.[8]

Cardelli's heirs seem, however, to have had little interest
in preserving the collection, and all three Claudes (very
possibly with other pictures from it) were imported into
England by an intriguing syndicate, apparently consisting of
Sir Robert Gayer (at the Italian end), Grinling Gibbons and
Parry Walton,[9] for what would have been one of the first-
known auctions exclusively of pictures (bar six ivory reliefs
by Bossuit) to be held in this country, at the Banqueting
House, Whitehall, on Tuesday, 11 May 1686. The auction,
or 'sale by way of public out-cry', was advertised, and a
catalogue printed, but for some reason (very possibly the
opposition of the upholsterers, in whose hands auctions then
lay) it did not take place,[10] but was converted into an
ordinary sale 'out of hand'. These Claudes may have been
the first paintings by the artist to have been imported into
England since the *Landscape with Narcissus and Echo*
(National Gallery) and the *Pastoral Landscape* (1644;
National Gallery of Canada, Ottawa) – the only two that
the *Liber Veritatis* (nos.77, 78) records as having been
specifically painted '*per Angleterre*'.[11]

HIST: acquired, with the *Worship of the Golden Calf* and a *Sunrise* [= *Embarkation of St Paul*, LV 132], in 1654 by Carlo Cardelli (1626–62); his posthumous inventory, 26 Feb 1663, as one of two *Landscapes* 12 *palmi* [long], with 'a *Moses led home by Rachel and daughters*' [sic!]; sold by his heirs to Sir Robert Gayer[12] (c.1636–1702), perhaps acting in a syndicate with Grinling Gibbons and Parry Walton, by whom advertised for auction at the Banqueting House, Whitehall, 11 May 1686; auction turned into a 'sale out of hand', when bought by Charles Seymour, 6th Duke of Somerset (1662–1748) for £200 and sent down to Petworth (cf. Vertue and Walpole);[13] thence by descent through his daughter's son, Charles Wyndham, 2nd Earl of Egremont (1710–63); recorded in the posthumous inventory of the chattels of Egremont House, Piccadilly, 5–10 Dec 1764, in the Red Damask Drawing Room (as 'A Great Landscape by Claude Lorrain'); by the time of the next list, that made by Henry Wyndham Phillips in 1835, in the Square Dining Room at Petworth (no.321), where it remained until removed by Blunt to the Somerset Room; by descent, until the death in 1952 of the 3rd Lord Leconfield, who had given Petworth to the National Trust in 1947, and whose nephew and heir, John Wyndham, 6th Lord Leconfield and 1st Lord Egremont (1920–72), arranged for the acceptance of the major portion of the collections at Petworth in lieu of death-duties (the first ever such arrangement) in 1956 by HM Treasury, which subsequently conveyed all save the Turners to the Trust.

ENGR: by William Woollett, after a drawing by Joseph Farington, published by Boydell, 1783; aquatint by J.-P.-M. Jazet: both in reverse.

EXH: BI, 1816, no.83; BI, 1823, no.143; *Pictures from Petworth House*, Wildenstein, 1954, no.6; *The Art of Claude Lorrain*, Arts Council, Hayward Gallery, 1969, no.28; *Claude Lorrain*, National Gallery of Art, Washington, and Grand Palais, Paris, 1982–3, no.43.

LIT: Vertue 1932, ii, p.81 (written c.1730); Walpole 1941, ix, p.98, letter to George Montagu of 26 Aug 1749; Smith 1837, viii, p.264, no.134; Waagen 1854, iii, p.33; *Petworth* 1856, p.36, no.329; Collins Baker 1920, pp.14–15, no.329 and facing pl.; Hussey 1925, p.903 (wrongly stating that owned by Woollett when engraved in 1783) and fig. on p.903; Röthlisberger 1961, i, pp.312–13, 314 and 322–3; ii, fig.227; Röthlisberger 1968, pp.286–7; Röthlisberger 1977, no.202; Kitson 1978, pp.135–6 (LV 134); exh. cat. by Humphrey Wine, *Claude: The Poetic Landscape*, National Gallery, 1994, pp.18, 19 (fig.5), 81.

38 Attributed to Pierre PATEL the Elder (Chauny *c*.1605 – Paris 1676)

Landscape with Antique Ruins and Figures

Oil on canvas. 102 × 127 cm (40 × 50 in)
Wallington, Northumberland

Wallington has some of the finest Rococo plasterwork in the country, by Pietro Lafranchini.[1] Even so, visiting a house otherwise given over to proconsular and Ruskinian high-mindedness for a century and a half, and thus to a certain sobriety, it is something of a surprise that almost the first thing that one should come upon is this picture, as an overmantel in the Entrance Hall: a purely hedonistic landscape in a sportive Rococo giltwood frame.

It was one of only five pictures to strike Arthur Young when he visited Wallington in 1768, when it was in the Drawing Room (now the Library): 'The chimney-piece of polished white marble, with festoons of grapes, &c. Over it a landscape, architecture, and trees, in a light, glowing, brilliant stile; extremely pleasing, though not perfectly natural.'[2] Where the picture was acquired remains a mystery. Little is known about any early collection of pictures that there may have been at Wallington, but it must have been installed as an overmantel in its present frame in the then Drawing Room not long after that was stuccoed by Lafranchini in 1741 for Sir Walter Calverley Blackett, 2nd Bt, MP (1707–77).

Patel the Elder was known as '*le Claude Lorrain de la France*'.[3] Unlike Claude, who spent his entire working life in Rome, he never made the journey to Italy, and indeed he evolved a specifically French and more artificial way of painting landscape. In his pictures, ruins – which are often, as here, dramatically foreshortened and cropped, and bathed in a crepuscular glow – evoke a vision of the past tinged with romantic melancholy. Arthur Young's rider, 'not perfectly natural', acknowledges that his enjoyment of the picture was a departure from the Claudean standards by which he and his contemporaries generally judged landscape, whether painted or real. In England the artist was known as 'Old Patel' so as to distinguish him from his son, Antoine-Pierre Patel (1646–1707), whose oeuvre has still not been clearly differentiated from his father's. It is for this reason that, although Natalie Coural has accepted this picture as an autograph work by Patel the Elder on the basis of a photograph,[4] a little caution still seems in order.

For it is clear that there is a difference in execution and quality between this picture and some of the paintings with which it is most comparable in its elements and composition, such as the *Landscape with Ruins and Cowherds* (Louvre),[5] the three signed and dated *Landscapes* of 1652 with religious pretexts – *Christ and the Centurion* (Hermitage), *The Journey to Emmaus* (Chrysler Museum, Norfolk, VA); and *The Rest on the Flight into Egypt* (recently acquired by the National Gallery)[6] – or two other *Landscapes with the Rest on the Flight into Egypt*, which was evidently a favourite subject (1658; Musée de Tours; and 1673; Louvre).[7]

All these are – sometimes appreciably – smaller than the present picture, which was perhaps conceived from the first with some decorative use in mind. The three signed and dated pictures of 1652 were painted with 24 years active career still before the artist. Most of his few other datable or dated pictures fall within a decade either side of these: the oval *Landscape* painted for the Cabinet de l'Amour of the Hôtel Lambert around 1646,[8] *The Rest on the Flight into Egypt* (1658; Musée de Tours) and the two pictures of *Moses* painted for Anne of Austria in 1660 (Louvre). Only the little copper of *The Rest on the Flight into Egypt* (Louvre) is dated as late as 1673. We therefore do not know the extent to which Patel the Elder's manner may have broadened, and even coarsened (as seems the case in the present picture), and particularly in larger-scale decorative pictures, as time wore on, and he perhaps grew a little stale from continual self-repetition.

The younger Patel's signed and dated oils, by contrast, all seem to bear dates in the 1690s and 1700s, by which time he had evolved a different, more northern and more congested, but less idyllic, way of presenting landscape, which is prefigured in some gouaches dated in the 1680s.[9] This seems to leave the period of between about 1665 and 1685, when it is almost impossible to know whether we are dealing with a late phase of Patel the Elder's work, with a period of collaboration with his son, or with the point at which the latter had become an independent practitioner through the death of his father. Already in the mid-18th century the great collector and connoisseur Pierre-Jean Mariette could say: 'Sometimes a painting is attributed to the father that, in fact, belongs to the son.'[10]

There are certain other pictures that are comparable to the present painting, whose attribution seems, significantly, to have oscillated in just this way between father and son. Foremost among them, perhaps, is the *Landscape with Antiochus precipitated from his Chariot* (wrongly called the *Fall of Phaethon*): now in the Musée de Picardie, Amiens, as by Patel the Elder, it was previously twice exhibited at the Finch College Museum of Art, New York, and sold,[11] as by Patel the Younger.[12] Of all Antoine-Pierre's signed pictures, on the other hand, the *Landscape with the Exposition of the Infant Moses* (1705; Hermitage)[13] comes closest in compositional character to his father's works, yet seems appreciably different in execution from the present picture. Perhaps the first metropolitan airing of the Wallington painting will enable its exact status between father and son to be better assessed.

Patel's paintings, though always scarcer than Claude's, seem to have been quite eagerly collected in England in the

18th century. They appear with some regularity in English sales, and the nickname 'Old Patel' shows that he was an accepted and cherished figure. Many of the fine examples now in America or back in France were sold from Britain in this century, so it is good both that the National Gallery should have recently imported such a fine example, and that this picture should have remained where it was first admired in the 18th century.[14]

HIST: first recorded at Wallington, in the possession of Sir Walter Calverley Blackett, 2nd Bt, MP (1707–77); thence by descent from his sister's son, Sir John Trevelyan, 4th Bt, of Nettlecombe (1734–1828), to Sir Charles Trevelyan, 3rd Bt, of Wallington (1870–1958); by whom deeded to the National Trust with the estate and house of Wallington and its contents in 1941, taking effect at his death in 1958.

LIT: Gore 1969, p.258 (as attributed to Patel the Elder); Wright 1985[1], p.240 (as by Patel the Elder); Wright 1985[2], p.128 (as attributed to Patel [the Elder]); *Wallington* 1994, p.43, illus. p.44 (as Patel the Younger).

39 Jan ASSELIJN, known as 'Crabbetje'
(Dieppe? *c.*1615 – Amsterdam 1652)

Landscape with Herdsmen fording a River

Oil on canvas. 56·5 × 64 cm (22¼ × 25¼ in)
Signed bottom centre: *JA* (in ligature)
Ascott, Buckinghamshire

Nicknamed 'Crabbetje' ('little crab') because of his misformed hand, Asselijn was, with Jan Both and Thomas Wijk, one of the second generation of specifically Dutch artists in Italy, and a pioneer of the idealised italianate Dutch landscape. Despite the shortness of his career, he had a formative influence on such later practitioners of this genre as Nicolaes Berchem (see cat. no.40), Aelbert Cuyp (see cat. no.29), Willem Schellinks (?1627–78), who also made a topographical tour of England, Carel Dujardin (1622–78) and Adam Pijnacker (1621–73).[1] In addition to introducing an idealised version of the sunlit landscape of the South into Dutch painting, Asselijn opened that landscape up, as here, and dispensed with the conventional framing devices on either side.

Although the present picture was at one point attributed to the Haarlem painter Willem Romeyn (*c.*1624–*c.*1694),[2] apparently in ignorance of the signature, that attribution has subsequently been corrected back to Asselijn, and there seems little doubt that the latter ascription is the right one. Romeyn was essentially a *petit-maître*, primarily interested in sheep, goats and cattle (which is probably what led to the misattribution), and rarely lifted his head to take a wider view.[3] His touch is more tentative and pettifogging than here, and his figures more timid.

The figures in this picture are one of the strongest indications of Asselijn's authorship. The woman with her spindle, in particular, belongs to that phase of his work in which he included boldly lit, comparatively prominent figures, painted in a way that recalls those of J.B. Weenix (1621–63), with whom he actually collaborated on the *Naval Harbour* (Akademie der bildenden Künste, Vienna). The motif of herds strung out across a river winding through a rocky landscape is also one for which Asselijn seems to have had a particular fondness.[4] The only element that is lacking is some fragment of an Antique ruin, often strikingly arched or vaulted, such as Asselijn was particularly partial to using, to give more character to his settings.[5] These reflect the drawings of such ruins that he had made in Italy *c.*1640–*c.*1644, three series of which were engraved by G. Perelle when he was in Paris, *c.*1646/7.

The vivid lighting and the strong muscular forms of the cattle can also be found in Asselijn's *Landscape with Herdsmen driving Cattle and Sheep towards Ruins* (Akademie, Vienna);[6] the *Bullock with its Feet in the Water and Herd-boy* (Staatliche Gemäldegalerie, Dresden),[7] in which the bullock resembles the left-hand one here; and the *Herdsman with Bullock and Dog amidst the Ruins of the Temple of Jupiter Stator* (Dresden),[8] in which the bullock appears to have been painted from the same drawing as that used here, but with a more upraised head.

There is a second painting by Asselijn at Ascott, a *Cavalry Skirmish among Trees and Rocks*,[9] which is very close in character to his last-known treatment of this subject (Statens Museum, Copenhagen),[10] with which he began his career before going to Italy. It is an indication of Asselijn's great receptivity as an artist that, in the space of his short career, he could progress from such formulaic battle-pieces, through idealised evocations of Italian landscape and ruins, to topographical reportage of the kind embodied in his *Breach of the St Anthony Dyke in 1651* (Staatliche Gemäldegalerie, Schwerin) and *Reconstruction of the St Anthony Dyke in 1652* (Gemäldegalerie, Staatliche Museen, Berlin).[11] None of his fellow italianate Dutch artists who had actually made the journey to Italy had the versatility to record his native country in this way too.

HIST: Baron Lionel de Rothschild (1808–79), recorded as in the billiard room, Gunnersbury Park, London, in 1878/9;[12] Leopold de Rothschild (1845–1917), Ascott; Anthony de Rothschild (1887–1961), Ascott; by whom given to the National Trust in 1949, with the house, grounds and most of the contents of the showrooms.

LIT: *Ascott* 1963, no.25, p.16 (entry by F. St. John Gore), rev. 1974.

40 Claes Pietersz., called Nicolaes, BERCHEM
(Haarlem 1620 – Amsterdam 1683)

Herdsfolk retiring from a Watering-place at Eventide

Oil on canvas. 39.5 × 52 cm ($15\frac{1}{2}$ × $20\frac{1}{2}$ in)
Signed bottom left: *Berchem*
Ascott, Buckinghamshire

If any single artist can be taken as typifying the italianate Dutch school of landscape painting, it is Berchem. Thanks to his productivity, versatility and longevity; thanks to the number and calibre of his pupils; thanks to his own etchings of figures and animals, and to the numerous 18th-century engravings after his pictures; and thanks to the figures that he painted in the landscapes of others; he was the most influential of all the italianate Dutch artists. Somewhat surprisingly, this consummate landscape and small-figure painter was the son of an equally distinguished artist in a quite different speciality, the still-life painter Pieter Claesz. (1596/7–1661). It is even more disconcerting to find that Berchem was confidently producing real-seeming scenes of Italy for several years before he actually went there, which was probably some time between 1653 and 1656. His art appears to be based upon close observation of the everyday, but was actually a product of the mind and of lessons absorbed from fellow-artists.

Berchem's prolific output has perhaps discouraged anyone since Hofstede de Groot from drawing up a catalogue raisonné of his work.[1] Berchem also reused motifs, sometimes borrowed from other artists, in pictures painted several years apart. For both reasons, it is difficult to date his many undated pictures precisely, although attempts have been made.[2] None the less, the present painting would appear to have been produced between 1655 and 1665, a little after Berchem's return from his putative visit to Italy, when he had begun to filter the italianate Dutch mode of landscape painting through his own experience and strong sensibility, into formulae of his own.

A close parallel in handling, despite the difference of support, is supplied by the signed and dated panel of *Cattle and Sheep in a Landscape* (1655; Ascott).[3] More comparable, both in subject-matter and in its powerful back-lighting, albeit in a much broader landscape setting, is the painting on canvas customarily called *The Three Droves* (1656; Rijksmuseum, Amsterdam)[4] and the *Shepherdess carrying a Kid across a Ford* (1658; Royal Collection).[5] There are also powerful affinities with the *Ford between Ruins* (1658; Rijksmuseum).[6] In all these pictures, however, there is perhaps less generalisation than in the present one. It was also only after the 1650s that Berchem seems virtually to have abandoned dating his landscapes,[7] which may indicate that this painting should be dated more closely to the early or mid-1660s.[8]

Such a dating would also agree with the fact that the main figure in the painting, the drover seen from behind, appears to be an adaptation of a more gentlemanly figure studied in a beautiful drawing formerly in the collections of the Earls of Warwick and I. Q. van Regteren Altena.[9] This was originally made for, or used in, a painting of *Hunters relaxing in an Italian Courtyard* (private collection), commonly dated to around 1660. The pose makes more sense in that picture, in which he is shown leaning on a ledge, with drinking-pot and glasses at his elbow.[10]

Like almost all the finest Dutch pictures at Ascott save the Cuyp (cat. no.29), this painting belonged to the individual only recently given his due as the greatest collector among the 'English' Rothschilds, Baron Lionel de Rothschild (1808–79), the eldest son of the founder of that branch of the great banking family, Nathan Mayer (1777–1836).[11] His collection was chiefly kept at 148 Piccadilly, where it was seen by Gustav Waagen, who called it 'a small but very choice collection of paintings, chiefly of the Flemish and Dutch schools'.[12] It was only with the acquisition of the major portion of two collections *en bloc* – that of Charles Heusch, by Baron Lionel on his own, in 1862, and that of the Jonkheer Willem van Loon (see cat. no.62), with his French cousin, baron Edmond de Rothschild, just before his death – that Baron Lionel's collection attained real extent and quality, particularly so far as the Dutch School was concerned.

In this case, there may have been a pleasing circularity in Baron Lionel's purchase. The picture had previously been in two distinguished Norfolk collections of Dutch and Flemish pictures, those of Horatio, 3rd Earl of Orford (1783–1858)[13] at Wolterton, and the Norwich merchant and brewer, John Patteson (1755–1833).[14] According to the catalogue of the latter's sacrificial sale in 1819: 'The greater number were purchased by the Proprietor at the commencement of the French Revolution, at Frankfurt and elsewhere on the Continent.' In Frankfurt the upheavals of the Revolution would have enabled Patteson to pick up good pictures belonging to aristocratic French *émigrés* congregated at nearby Coblenz, or from panic sales by well-to-do local citizens, whose taste had been precisely for such precious Dutch cabinet pictures.[15] But Frankfurt was also the cradle of the Rothschilds, the city from which the five sons of Mayer Amschel (1743/4–1812) were to fan out and create a banking network covering the whole of Europe. At that stage they were still confined to the walled ghetto, but another of the consequences of the French Revolution was to emancipate them; no longer confined to Frankfurt, their combined wealth and shared passion for collecting were such that the *goût Rothschild* became a byword.[16]

HIST: John Patteson (1755–1833) sale, at his former house, Surrey St, Norwich, by Christie, 2nd day, 29 May 1819, lot 82, as 'one of the most pure and lovely pictures of this great master', bt Horatio, Lord Walpole, later 3rd Earl of Orford of the 2nd creation (1783–1858), for 375 gns; drawing room, Wolterton Hall; his sale, Christie's, 3rd day, 28 June 1856, lot 264, bt Pennel for 470 gns; J.E. Fordham sale, Christie's, 4 July 1863, lot 78, bt Thorpe for 520 gns; Baron Lionel de Rothschild (1808–79), Gunnersbury; thence by descent to Anthony de Rothschild (1887–1961), Ascott; by whom given to the National Trust in 1949, with the house, grounds and most of the contents of the showrooms.

EXH: BI, 1829, no.113; BI (British Gallery), 1842, no.156; *Origin of Landscape Painting in England*, Kenwood, 1967, no.2.

LIT: Chambers 1829, i, p.217; Smith 1842, ix, p.814, no.156; Waagen 1854, iii, p.434; Hofstede de Groot 1928, ix, no.717; *Ascott* 1963, no.9, p.9 (entry by F. St John Gore), rev. 1974; Moore 1988, p.65.

41 Meindert HOBBEMA (Amsterdam 1638–1709)

Cottages beside a Track through a Wood

Oil on panel. 60·5 × 84 cm (23¾ × 33¼ in)
Signed bottom mid-right: *M. hobbima*
Ascott, Buckinghamshire

In the first part of this century, before the Impressionists had swept the board, Hobbema's *The Avenue, Middelharnis* (1689; National Gallery) was probably the most celebrated landscape by a Continental artist in Britain; reproductions of it were to be found in half the homes and schoolrooms of the land. Popular opinion chimed with Hofstede de Groot's judgement that it was 'the finest picture, next to Rembrandt's *Syndics*, which has been painted in Holland'.[1] From the late 18th century on, Hobbema was the Dutch landscapist whose works were most sought after or cherished by British collectors, with the possible exception of Cuyp. And not only by collectors: John Crome's reputed last words were 'Oh Hobbima, my dear Hobbima, how I have loved you!', uttered with his eyes fixed on the *Roadside Inn* (Bührle Collection, Zurich), then in the collection of their reporter, Dawson Turner. The present picture is a superb example of one of the two types of painting by Hobbema that such connoisseurs valued most of all, those of 'cottages in a wood' or 'a watermill in a wooded landscape'. It is thus also more typical than *The Avenue, Middelharnis*, which is rare both in being late and in showing an actual place.

Most of Hobbema's characteristic dated or datable pictures were painted between 1662, when he began to manifest a personal style evolved from his long apprenticeship to Jacob van Ruisdael (*c.*1628/9–82), and 1668, when he became a wine-gauger at the Amsterdam tollhouse, and his output was consequently much diminished.

This picture is unusual for a Hobbema of its size in being on panel, suggesting an especial urge towards refinement, for a particular, but so far unidentified, collector. In terms of motif and handling, it is perhaps most clearly comparable with the four variants of another composition of *Cottages in a Wood*: the canvas in the Widener Collection in the National Gallery of Art in Washington;[2] the ex-Heywood-Lonsdale little panel now in the Mauritshuis in The Hague;[3] the large canvas in the National Gallery;[4] and the larger canvas still, in the Robarts collection.[5] None of these is dated (though Christopher Brown dates the National Gallery's picture to around 1665, with the other pictures, in the sequence just given, on either side of it). For dated pictures, one must turn to the canvases of 1662 from the Arthur de Rothschild Collection now in the Louvre, and in the Elkins Collection of the Philadelphia Museum of Art;[6] the ex-Westminster canvas of 1665 in the Mellon Collection in the National Gallery of Art in Washington,[7] and the panel also of 1665 formerly in the Blathwayt collection at Dyrham Park, Glos (NT), and now in the Frick Collection in New York;[8] the canvas of 1667 in the Fitzwilliam Museum, Cambridge;[9] and the panel of 1668 in the Royal Collection.[10]

These pictures were all produced within the remarkably short period of Hobbema's full activity as a mature artist, between 1662 and 1668. Their perfection and necessarily restricted number help to explain why they have been so consistently sought after. They also convey the illusion of being transcriptions of particular spots, yet the way in which they share and juggle the same elements shows that this cannot have been so.

HIST: unknown collection in Holland, from which bought for £400 in about 1817 by Alexander Baring, later 1st Baron Ashburton (1774–1848);[11] sold privately, probably by Alexander, 4th Baron Ashburton (1835–89; succeeded 1868), to Baron Lionel de Rothschild (1808–79); drawing-room, Gunnersbury Park, London; thence by descent to Anthony de Rothschild (1887–1961), Ascott; by whom given to the National Trust in 1949, with the house, grounds and most of the contents of the showrooms.

LIT: Smith 1835, vi, no.115; Waagen 1854, ii, p.111; Hofstede de Groot 1912, iv, no.220; *Ascott* 1963, no.47, p.30, pl. (entry by F. St John Gore), rev. 1974.

42 Jan Frans VAN BLOEMEN, known as L'ORIZZONTE
(Antwerp 1662 – Rome 1749)

CLASSICAL LANDSCAPES

a *Classical Landscape with Five Figures conversing by a Fountain topped by a Figured Urn*
b *Classical Landscape with a Traveller and Two Women conversing, and Three Goats gambolling*
c *Classical Landscape with a Man and Two Women conversing, a Villa in the Distance*
d *Classical Landscape with a Traveller and Two Women conversing, a Town in the Distance*

Oil on canvas. Uprights, $73 \times 60 \cdot 5$ cm ($28\frac{3}{4} \times 23\frac{3}{4}$ in)
Ovals, $73 \cdot 5 \times 54 \cdot 5$ cm ($29 \times 21\frac{1}{2}$ in)
Attingham Hall, Shropshire

In his life of the painter, Nicola Pio describes Orizzonte's output in words that might be applied to these paintings:

> Beautiful pictures done in such beautiful sites, with verdant foliage, limpid silver water, and with an agreeableness of colour; accompanied by small figures of the utmost gracefulness, with rural dwellings and urns: all so well assembled, that his pictures were welcomed into all the galleries of Italy.[1]

The price of such success in Orizzonte's lifetime has been subsequent neglect, not least because the arcadian vision conveyed by his paintings is one that has largely lost its meaning, in a Europe no longer impregnated with the classical culture that gave them their universal resonance. The impersonality and smooth perfection of his pictures are also less congenial to an age that prefers evidence of self and of struggle. Hence even a sympathetic observer such as the late Anthony Clark could find much warmer words to say about Orizzonte's imitator Andrea Locatelli (1693/5–1741), who died young and poor, than about the latter's long-lived, rich and successful model. None the less, his characterisation of Orizzonte has not been bettered:

> There is a gentle development in the artist's work, with few surprises in the voluminous production. He began as a careful imitator of Gaspard Poussin under more shining rococo (or Bacicciesque) skies and with intentions more charmingly intelligent than grand and noble. His palette is strong and rich, becoming more radiant with age; the brush emboldens each year towards a final sparkling pointillism. The aged Orizzonte is perhaps the greatest appreciator of the rich atmosphere and wet but very encouraging light of the Roman spring. . . . Only country folk (his seem at the same time biblical, classical, and contemporary) inhabit his landscapes, which are all of the same season of the year, and all both Arcadian and park-like. . . . Each of Orizzonte's landscapes were constructed and brought to life by a delicate observer, who might be called the Canaletto of the *idea* of the Roman Campagna.[2]

The four pictures shown here, though alike at first blush, and hung with four others in the Picture Gallery at Attingham as a set, actually seem to exemplify something of the almost imperceptible development of which Clark speaks. The upright pair, which has its own history, seems the more strongly indebted to Gaspard Dughet (1615–75), but with a piling-up of effects and motifs that distances the two pictures from their models, and leads to a slight lack of repose. The two ovals, on the other hand, which come from a set of six, have achieved a smoothness and serenity that reveal a more practised hand, as does the way in which they are effortlessly composed to fit their upright oval shapes. And though the figures are smoother and firmer, the distances have a shimmering quality that prefigures a little of that greatest poet of the Roman Campagna, Camille Corot.

That both sets of pictures rank among Orizzonte's better productions can be gauged from the fact that each has links with the only two pictures he dated (a feature generally denoting especial pride in a work), before he did so more frequently in the last decade of his career. Both the urn over the fountain and the distant Romanesque church in cat. no.42a recur in one of a pair of ovals in the Palazzo Ruspoli in Rome,[3] which is in turn closely related to a set of three ovals in another private collection in the city, one of which is dated 1714.[4] The same urn occurs in one of an exceptionally fine pair of ovals in the Accademia di S. Luca in Rome, the other being dated 1726.[5] These have almost identical frames to the Attingham ovals – a format Orizzonte seems to have reserved for special commissions, because of the greater cost of such frames.

HIST: the two ovals probably from the set of six pictures listed in the undated bill of lading in the papers from William Noel-Hill, 3rd Baron Berwick, PC, FSA (1773–1842), which is that of his final return from Naples to England in 1833;[6] the source of the rectangular pair is unrecorded; thence by descent, until bequeathed to the National Trust in 1953 with the estate, house and contents of Attingham by Thomas, 8th Baron Berwick (1877–1947).

LIT: *Attingham*, p.3 (?the two ovals, in the Satin Bed Room, among 'Six Landscapes, By Orizonti')', pp.17, 18 (?the two uprights, in the Large Drawing Room, each just described as 'Landscapes, By Orizonti'); Anon. 1886, in the Picture Gallery: 'fine landscapes by . . . Orizonti'; Cockelberghs 1976, p.55, figs.24, 27 (the two ovals).

a

b

c

d

5

THE PICTURE GALLERY

The English drawing-room and dining-room cannot, as in Italy, be converted into a picture gallery, and opened at all hours to the amateur and the student. The costume [*sic*] of Italy and England is totally different: we live in our best; they in their worst apartments: we like to be surrounded by the fine works of art which we may have the good fortune to possess; they very liberally consign them to the sight and free use of the public.[1]

Sir Richard Colt Hoare's interesting observation of the difference between Italian and English methods of picture display, and of the way in which this reflected differences in their social mores, dates from 1817. Gustav Waagen took up one of the same points two decades later: 'The English generally employ pictures to ornament their apartments, for which purpose the pictures of [the Dutch] school are peculiarly suitable, by their agreeable and finished execution.'[2]

Two phenomena lie behind these remarks. One was the sheer quantity of pictures imported into England between the mid-18th and the mid-19th century, above all between the 1790s and the 1820s.[3] The other was that, precisely because these hosts of pictures were distributed throughout all the various rooms, which a more lavish style of existence had brought into regular use (breaking down the old distinction between state rooms and private apartments), English houses and their collections were no longer as accessible to strangers as they had been in the past.[4] Stourhead (where there was, however, no family to accommodate) was one of the honourable exceptions: Colt Hoare's guides to the house, of 1800 and 1818, were clearly produced to enable visitors to see almost all the ground-floor rooms.[5] But elsewhere the sudden influx of treasures kept tantalisingly out of reach led, first to the establishment of annual loan exhibitions of Old Masters at the British Institution from 1815 onwards, and then to the creation of the National Gallery itself in 1824.

Even in the 18th century, the wealth of pictures that was available, and the pleasure or prestige of living with them, meant that they tended to be distributed throughout a house. This was in stark contrast with France, where painters complained that their own productions were being denatured by being relegated to serve as overdoors and overmantels in curvilinear frames. The huge plate-glass mirrors, and gilt and

Detail of Batoni, *St Paul* (54b)

pastel-painted *boiseries* or bright silks, which formed the setting of such pictures, forced French artists to adopt equally glaring and unnatural colours.[6] They were also unhappy that their works were banished from hanging next to Old Masters. Even the latter were not always admitted, as they were thought detrimental to the silk hangings,[7] and were less popular than mirrors and *pagodes* (Chinese porcelain figures).[8] Although the influential architectural theorist Jacques-François Blondel was professedly hostile to the indiscriminate use of paintings for decorative purposes, he was equally concerned to confine pictures to specific rooms set aside as cabinets or galleries, since 'one must avoid an apartment looking like a picture-dealer's shop'.[9]

The few instances of picture galleries in French *hôtels particuliers* (examples in country *châteaux* are even scarcer) thus served as a kind of quarantine for the pictures. In Britain, by contrast, they simply represented an additional form of display, and one that was often forced upon collectors by the relentless increase in the size of their collections. Neither Burghley, Houghton,[10] nor Kedleston[11] – to take three houses transformed or built to take great collections of pictures – has an actual picture gallery; the pictures were distributed throughout the house. At Petworth in the early 19th century, there was already 'an *immensity* of pictures on the ground floor of the house, and ... all the rooms above are full of them'.[12] The 3rd Earl of Egremont responded by simply enlarging piecemeal the North Gallery (originally built for the 2nd Earl's collection of Antique sculpture), in order to house just a portion of his ever-growing collections of modern sculpture and pictures.

At Stourhead in 1794–1802 Colt Hoare had added a purely functional Picture Gallery, so as to aid him in his (not entirely systematically pursued) aim of weeding out originals from copies, and first-rate pictures from the second- and third-rate, while hanging every room with pictures of a particular character. (In a number of other collections, landscape paintings seem to have been singled out in this way, but I know of no other hangs as systematically arranged by genre as Colt Hoare's.) At Knole, Charlecote, Kingston Lacy and Shugborough, the largest and highest-ceilinged room in the house, the Great Hall or the Saloon, almost automatically became the home of the bigger and more prestigious pictures, whatever their subject.

The Picture Gallery added to Attingham by Nash for the 2nd Lord Berwick in 1805–7 represents a rather different phenomenon, and one that was to be much more typical of the great 19th-century picture collections. It was an addition to the house, whose pompous architecture was intended to make a show, in exactly the same way as the 2nd Baron's open and notoriously expensive purchases of pictures at auction were. It heralded ever more splendid galleries – the majority, significantly, built in or onto town houses, where they could also be used as the settings for dazzling banquets or soirées, and impress many more people than could a gallery tucked away in the country.[13] The first was built onto Cleveland House by the Duke of Bridgewater (1795–7). This was followed by those of Thomas Hope's house in Duchess Street (1799–1804); of Sir

John Leicester's house in Hill Street (1805), and of Tabley for the same owner (1809; see cat. no.32); by a second gallery for Cleveland House, to take the Marquess of Stafford's third of the Orléans pictures, along with the third he had inherited from the Duke of Bridgewater (1805–6); by those of Grosvenor House (1807–8; enlarged 1825–7); Apsley House (1828–9); Stafford (now Lancaster) House (c.1832–5); Bridgewater House (1846–51); Somerley, Hampshire (c.1850); Dorchester House (1850–63); Dudley House (1858);[14] and Hertford House (1872–5). Catalogues were published for some of the earlier examples, to enhance their éclat, with engravings not just of the pictures, but of the galleries themselves.[15] Of all these, only Hertford House and its collection (the Wallace Collection) survives intact, and Apsley House (the Wellington Museum) and Somerley nearly so. The gallery at Attingham contains a largely different – and inferior – collection, while that of Stafford (Lancaster) House survives only as a shell; the rest – and yet others, not enumerated here – have all been demolished, and their once-great collections have been dispersed.[16]

The pictures that were hung in these halls, saloons and galleries naturally tended to be such as had been painted for galleries or for public places in the first place.[17] Even before the French Revolution, Joseph II's dissolution of religious houses had put large altarpieces on the market, particularly in the Austrian Netherlands, though the Emperor had tended to pre-empt the finest examples for his new, didactically arranged, public picture gallery in the Belvedere in Vienna.[18] But the Revolution itself dramatically increased these possibilities, both by the further wholesale repression or secularisation of religious houses throughout Europe, wherever the French or their client régimes held sway, and by the punitive taxation and other pressures that forced aristocratic families to sell their heirlooms. In this way the field of Spanish painting, which – but for Murillo – had been virtually *terra incognita* to British collectors, was at least partially opened up (e.g. cat. no.51), though it was the great Italian and Flemish pictures in Spanish collections that were more sought after (e.g. cat. no.49). Similarly, some of the historic Roman and Venetian collections yielded up their major treasures for the first time (e.g. cat. no.45), especially after Papal and Doganal export controls had been removed.

Not that picture galleries and saloons were used exclusively for the hanging of large pictures. 19th-century watercolours of the galleries at Apsley House and Somerley show smaller pictures arranged in patterns round the larger ones. In both the saloon-like Drawing Room at Kedleston and in the Picture Gallery at Stourhead, small pictures were placed in flanking 'columns' or as a bottom register in the manner of a predella, many retaining their French Rococo frames, in deliberate contrast to the more sober 'Maratta' or other frames on the big paintings.

One aspiration in having a picture gallery must also have been to emulate the *saloni* and galleries that housed the great Italian picture collections, such as those in the Palazzo Medici-Riccardi in Florence, or the Palazzo Colonna in Rome, which many of the collectors will have known from having made the

Grand Tour. Colt Hoare, indeed, was specifically reminded of this parallel on a visit to Belvoir Castle in 1800, before its devastating fire: 'I thought myself transported to some of the palaces in Italy, where a variety of pictures are collected in a long extent of rooms, unarranged, with all their antique rust and mold upon them.'[19] The Batoni *Apostles* (cat. no.54), which came out of just such a gallery in Forlì, and the set of Vernet *Times of Day* (cat. no.56) have been hung here as a *Settecento* upper register, over the *Seicento* and *Cinquecento* paintings beneath, to recall the picture-hangs seen and re-created by those who had made the Grand Tour.

The hang in this room is a mixed one, as was nearly always the case in the past with private collections of pictures (and with the National Gallery itself until 1866). The universal modern museum method of hanging chronologically – a didactic principle first introduced by Christian von Mechel in the Belvedere in Vienna in 1781 – was never adopted (though the Earl-Bishop of Bristol had intended to use the quadrant arms at Ickworth for this purpose).[20] It was also rare for any division into Schools of painting to be attempted, such as was more frequently found on the Continent. *Bienséance* was the aim, as defined by Mrs Jameson:

> The pictures should hang so as to produce a harmony in variety. Schools and artists of every style may be inter-mingled with good effect, provided that in colour they do not eclipse each other, nor produce a harsh contrast to the eye, nor in subject strike a discord in the mind or the fancy. ... It is very seldom that you can hang a modern picture near an old one, and this, in many cases, more from the contrast in tone and feeling, than the positive difference in point of value and merit. ... A private collection confined to works of one particular class – as the Queen's Gallery, or Sir Robert Peel's [both almost exclusively of Dutch pictures] – is less exciting and agreeable than one in which the schools of art are mingled; but to mingle them with judgement is the difficulty.[21]

The hanging of paintings by School became a little less unusual in the 19th century, Mrs Jameson's strictures not-withstanding. The influential collection of the Marquess of Stafford in Cleveland House was so divided, with a special 'Poussin Room' for the *Seven Sacraments*;[22] Thomas Hope added a Flemish Gallery to his original gallery in 1819, with significant differences both in its architecture and in the hanging of the pictures.[23] The two great pioneer collectors of Spanish painting, William Bankes and William Stirling, each devoted a room or rooms exclusively or almost exclusively to the Spanish School, at Kingston Lacy and at Keir.[24] More often, however, as Mrs Jameson indicates, it was Netherland-ish pictures that were so singled out. Even this was less for art historical reasons than because Dutch and Flemish pictures were generally smaller in scale, and benefited from being hung where they could be seen close to (cf. the following essay on the Cabinet). It was also sometimes because they were trophies of a Continental collection composed exclusively of pictures of these Schools. Such seems to have been the case with rooms in the London houses of two of the three purchasers of Baron

Verstolk van Stoelen's pictures, Lord Overstone and Hum-phrey St John Mildmay. But the third, Thomas Baring, though he had in 1850 'erected a well-lighted gallery, in which a large selection of his best pictures have found a place', was publicly admonished by the gallery director Waagen that: 'A stricter arrangement of the schools ... would increase the harmonious effect of the whole, and also display the strength of the collection to greater advantage.'[25]

The few collectors of modern British pictures in the early 19th century tended to hang them in separate galleries or suites of rooms, just as collections of sculpture were likewise generally housed in galleries of their own. Sir John Leicester's two galleries were exclusively devoted to English pictures. The Duke of Bedford at Woburn Abbey and James Morrison at Basildon Park created separate galleries for their collections of modern British painting; but the 3rd Earl of Egremont at Petworth, and Sir Richard Colt Hoare at Stourhead, deliber-ately mingled theirs with Old Masters. In the Music Room at Stourhead, in particular, the copy of Titian's classic *Death of St Peter Martyr* seems to have been placed there to match Calcott's and Owen's collaborative *Landscape with Diana and Actaeon*, which was given a deliberately 'Old-Masterish' lobed Kentian frame.[26]

James Morrison gave the Back Drawing Room of his London house entirely over to English watercolours, and the Octagon at Basildon Park over to modern British oils, with Constable's *The Lock* in pride of place.[27] Morrison aped the aristocratic tastes of a previous generation in his choice of Old Masters, but in buying contemporary British pictures he fore-shadowed other self-made men who were to dominate the Victorian art market.

Such pure collections of 19th-century British pictures have all either been dispersed, diminished or given *en bloc* to museums; certainly none survives in a house belonging to the National Trust. So it is perhaps appropriate that the Picture Gallery in this exhibition should be one of Old Masters only. Further, the pictures hung in it also all fall within the periods and schools deemed acceptable by what Francis Haskell has aptly called 'the Orléans generation'[28] – that of those whose taste had to some extent been formed by the 18th-century collections of the ducs d'Orléans. Before the Revolution these formed one of the only major collections of pictures in Paris open to the public, which became even more influential in England after it, when the pictures were brought here by two British consortia in the 1790s, to become the cornerstones of so many collections formed in the first half of the 19th century – which was for as long as this particular taste endured.[29]

43 ANDREA DEL SARTO (Florence 1486–1530)
The 'Fries' Madonna

Oil on panel. 104 × 76 cm (40 × 29½ in)
Ascott, Buckinghamshire

It is an indication of the fame enjoyed by Andrea del Sarto's various treatments of the themes of the Madonna and Child or the Holy Family, that, like Raphael's, each should have its own sobriquet.[1] For the same reason, most of them (including this picture) exist in numerous versions, and it is sometimes a contentious business to decide which one is the original.

Here, the name is that of the first-known, successive owners of the picture, the brothers, Counts Josef (1765–88) and Moritz (1777–1826) Fries (see HIST below). Nothing is known of its earlier history, and – before the revelation of significant *pentimenti* in the Christ Child's leg and the contours of his face by John Brealey's cleaning of the picture in 1969 – there was neither universal assent to its autograph status, nor agreement over its dating. Of those who have known the painting at first hand, H. Guinness (1899) dated it to 1517–18; Sydney Freedberg (1963), who relegated it to the status of a copy, dated the – for him – lost original to *c.*1520, between the *Charity* (1518; Louvre) and the likewise lost *Madonna di Porta a Pinti* of 1521; John Shearman (1965) to *c.*1521, around the same time as the fresco of the *Tribute to Caesar* (1521; Villa Medici, Poggio a Caiano), again by analogy with the *Madonna di Porta a Pinti*, but also with the *Pietà* (*c.*1519–20; Kunsthistorisches Museum, Vienna); and Antonio Natali and Alessandro Cecchi (1989) to around the same date, on the basis of similar comparisons. Raffaele Monti (1965), by contrast – if he has seen the painting – would even deny that a picture of this composition by Andrea has ever existed, seeing it instead as by his '*Maestro sartesco n.1*', operating in the master's workshop in the period between 1510 and 1520, and basing himself on little more than a design by the latter. Following the logic of their position, both Freedberg and Monti also dismiss as a copy or a pastiche the drawing in the Uffizi of the Virgin's sleeved left arm and hand that Berenson (who also accepted the painting) and Shearman regard as autograph.[2]

Such extreme divisions of opinion over the authorship even of the original of a Sartesque composition are almost unique. The reasons may in part reside in the work itself. If Shearman is right, it belongs to a time of transition and assimilation in Andrea's career, after his return to Florence from France in 1519, when he was responding to and participating in 'the major event in Central Italian painting in the twenties, the *rapprochement* between the schools of Rome and Florence'. At the same time, he was assimilating influences from Michelangelo's Sistine Ceiling: the pose and bulk of the Christ Child recall Michelangelo's *ignudi*. What is strikingly new, and peculiar to Andrea del Sarto, is the movement given to the figures and eyes of this traditional grouping (St John the Baptist was the patron saint of Florence, so often associated with the Madonna and Child), by the suggestion of some intruder – almost, as it were, at the spectator's elbow (so the Devil?) – come to alarm them.

The fact that the picture is tucked away in a country collection may also help to account for its neglect; for it has never been shown in a defining context. When last exhibited, in 1955, Ellis Waterhouse declared that it was 'one of the least known major Italian works in England'; and Kenneth Garlick called it 'the single most important picture [in the exhibition] ... the only picture in this country outside the National Gallery and the Wallace Collection which gives any real indication of Del Sarto's powers'.[3] But it was Goethe who, in the entry for 16 July 1787 in his *Italian Journey*, was the first to acclaim its beauty with the rapture that it deserves:

> Count [Josef] Fries buys a great deal, including a Madonna by Andrea del Sarto for 600 *zecchini*. Last March Angelica [Kauffman] had already offered 450 for it – would have given the whole sum, had her vigilant husband [Antonio Zucchi] not had some objections. Now they both regret it. It is an incredibly beautiful picture; one can't conceive of such beauty, without having seen it.[4]

HIST: Josef, Graf von Fries[5] (1765–88), Rome and Schloss Vöslau; Moritz, Graf von Fries[6] (1777–1826), Fries Palast, Josefsplatz, Vienna (first recorded there in winter of 1805/6;[7] sold by ?1824);[8] Artaria & Fontaine, Mannheim;[9] Charles William, 3rd Marquess of Londonderry[10] (1778–1854), Londonderry House, London; his son, George, Earl Vane, later 5th Marquess of Londonderry (1821–84); by whom sold to Baron Lionel de Rothschild (1808–79), by 1870;[11] thence by descent to Anthony de Rothschild (1887–1961), Ascott; by whom given to the National Trust in 1948, with the house, grounds and most of the contents of the showrooms.

ENGR: by Rafaele Morghen in Rome for Count Josef Fries (Palmerini 1824, p.138, no.124).

EXH: RA, winter 1870, no.110; *Early Italian Art*, New Galleries, 1893, no.214; *Italian Art*, Birmingham City Art Gallery, 1955, no.2.

LIT: Bertuch 1808, p.148; Pezzl 1816, 1820, 1823; Böckh 1821; Böckh 1823; Rochlitz 1828, i, p.129; Biadi 1829, p.149; Goethe 1830, p.34; Passavant 1833, p.78; Reumont 1835, p.84; Passavant 1836, p.178; Richter 1894, p.150; Guinness 1899, pp.69–70 and pl. opp. p.62; Knapp 1907, pp.118–20, fig.95, p.102; Crowe and Cavalcaselle 1914, vi, p.198, no.1; Reinach 1918, i, p.223; Knapp 1928, pp.98–9, 114, pl.80; Berenson 1932, p.18; Fraenckel 1935[1], pp.106, 166; Fraenckel 1935[2], p.474; Waterhouse 1955, p.295; Garlick 1955, p.39; Berenson 1963, p.7; *Ascott 1963*, no.36, pp.24–5, illus.; Freedberg 1963, i, pp.91–3, no.45, ii, fig.95; Shearman 1965, i, p.89, pl.85a, ii, p.247, no.58; Monti 1965, p.126, fig.350; Natali and Cecchi 1989, no.37, p.86.

44 Jacomo Palma Negreti, known as PALMA VECCHIO
(Serina *c*.1480 – Venice 1528)

Sacra Conversazione, with SS Jerome, Justina, Ursula and Bernardino of Siena

Oil on canvas. 90 × 157.5 cm (35½ × 45½ in)
Penrhyn Castle, Gwynedd

The *sacra conversazione*, or informal grouping of the Madonna and Child with saints, and sometimes donors, generally in a landscape setting, is quintessentially Venetian, and a type of picture particularly favoured by Palma Vecchio, and after him, by Bonifazio Veronese.[1] It is a curious hybrid between the altarpiece – with its grouping of saints whose presence is governed by the dedication and relics of the altar it adorns; the private devotional image of the Madonna of Humility; and – above all in scale and format – the gallery picture. Such paintings have a particular poignancy, some of which comes (as here) from the contrast of associations between those of the setting and those of the attendant saints. The landscape background has a romantic beauty that only Venetian painters could achieve. The saints' instruments of martyrdom, or marks of their austerities, suggest a very different world of pain and struggle: the world that drives us to seek solace, formerly by asking for the intercession of the Madonna and these saints, but now (more usually) by the contemplation of such limpid beauty.

On the far left St Jerome, bearded, bronzed and half-naked, holds a cross, in indication of his long period of study and penitence with the hermits in the Syrian desert, where he

was befriended by the lion. In his other hand he holds the Vulgate, his translation into Latin of the Hebrew books of the Old Testament and the Greek books of the New, which became canonical for the Catholic church. Next to him is St Justina, the patron saint of Padua, holding a martyr's palm in one hand, and with her other to her breast, from which projects the dagger with which she was stabbed to death by the Roman soldier who would not wait for her official execution by the sword. To the right of the Virgin is St Ursula, holding a banner, and cradling a model of the ship that brought her and the 10,000 virgins from Christian Britain to their doom at the hands of the heathen Huns of Cologne.[2] Finally, St Bernardino of Siena, in Franciscan brown habit, gives the Christ Child the disc inscribed with the Greek initials for Jesus's name and titles that he used as an aid to his preaching.

All these saints have Venetian connections. St Bernardino was made a patron saint of the city in 1470. St Justina was not only patron saint of the Venetian university city of Padua, but had her own church in Venice – S. Giustina (suppressed in 1810). St Jerome had under his patronage two churches, and a Confraternity with a Scuola which, after fusion with another,[3] took its name from the neighbouring church of S. Fantin. The oratory under the patronage of St Ursula (also suppressed in 1810) was famously decorated with the enchanting cycle of paintings by Carpaccio now in the Accademia. The picture was probably therefore painted for some client in or of the city.

Rylands convincingly dates it to around 1522–4, when Palma Vecchio had fully developed his easy groupings of full-length seated or kneeling figures in a landscape, with the Virgin forming the apex of the group, further set off by a tree behind her – a transmutation of the more formal cloth of state found in earlier representations. It antedates his final group of *sacre conversazioni*, in which the compositions have become asymmetrical, with the Madonna and Child displaced to one side, giving them a greater movement and *contrapposto*.[4] Its perfect equilibrium makes it all the more difficult to understand the period of disparagement that it went through after its condemnation by an anonymous critic in 1882.

The painting closest in character to this one is the ruined *Sacra Conversazione with SS Anthony of Padua, Jerome, Catherine of Alexandria and Mary Magdalene* (Hermitage).[5] Interestingly, the drawing in the British Museum that almost seems like a preliminary design for this[6] in fact in some senses stands midway between it and the Penrhyn painting. The posture of the body of the (thinner-faced) Virgin is still

Fig.17 Palma Vecchio, *Sacra Conversazione, with SS Jerome, Francis, Catherine of Alexandra and a Female Saint* (pen and brush; British Museum)

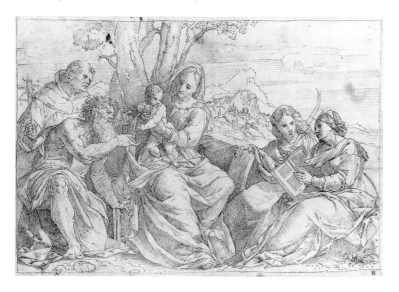

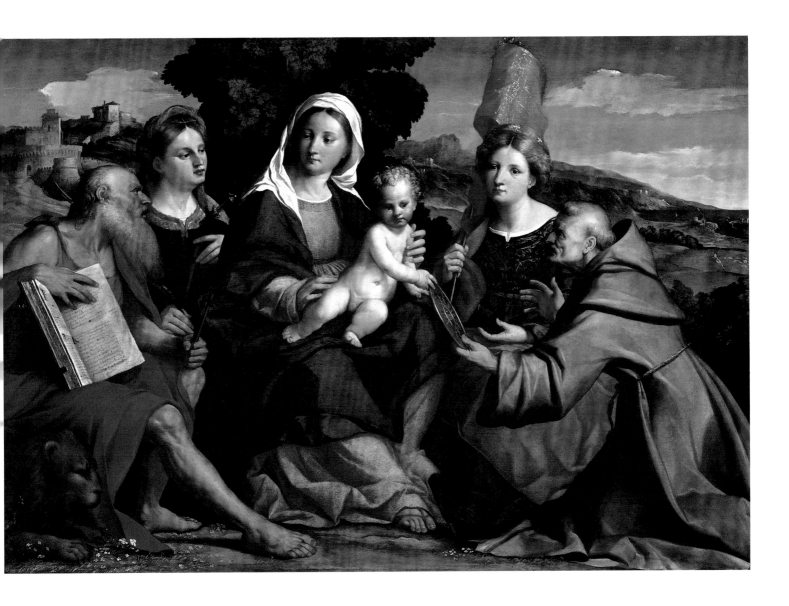

almost exactly that of the Penrhyn picture, while that of the Christ Child is very similar, but reversed. St Jerome and a Franciscan saint are common to the drawing and both paintings (though St Francis himself, rather than St Bernardino or St Anthony, is represented in the drawing). Drawing and painting both contain St Catherine. The other female saint (whose identity is unclear), seated in the foreground of the drawing and indicating a passage in a book, echoes the St Jerome performing the same action in the Penrhyn painting.[7]

HIST:[8] sold in 1838 to Prince Willem of Orange, from 1840 King Willem II of the Netherlands (1792–1849),[9] by L. J. Nieuwenhuys, for 4,000 florins; his posthumous sale, Amsterdam, 12–18 Aug 1850, lot 71 (bt in at 3,800 florins); re-offered on 5 Sept 1851 (bt in at 2,450 florins); sold privately by the heirs in 1855 to L. J. Nieuwenhuys; sold by his son C. J. Nieuwenhuys[10] to Col. the Hon. Edward Douglas-Pennant, later 1st Baron Penrhyn of Llandegai (1800–86); thence by descent to Hugh, 4th Baron Penrhyn (1894–1949), who left Penrhyn and its estates to his niece, Lady Janet Harpur, née Pelham, who, with her husband, John Harpur, thereupon assumed the name of Douglas Pennant, and in 1951 made over the castle and part of its contents in lieu of death-duties to HM Treasury, which transferred them to the National Trust.

EXH: RA, winter 1882, no.137 (as by Palma Vecchio, but when, according to Douglas-Pennant 1902, 'It was settled not to be by him').

LIT: Nieuwenhuys 1843, no.101, pp.206–7 (as by Palma Giovane); anon. review of RA winter exhibition, *The Athenaeum*, 7 Jan 1882, p.22 (doubting that by Palma Vecchio); Douglas-Pennant 1902, no.42 (saying 'Mr. W[alter] Armstrong at Penrhyn, 1898, said by Garafalo; a late and poor example'); Rylands 1988, no.61, p.229; Hinterding and Horsch 1989, p.108, no.171, and fig. on p.109; *Penrhyn Castle* 1991, p.68 and col. fig. on p.69; Rylands 1992, no.61, pp.81, 203–4, fig. on p.80.

45 Tiziano Vecellio, known as TITIAN
(Pieve di Cadore 1487/90 – Venice 1576)

?Francesco Savorgnan della Torre (1496–1547)

Oil on canvas. 126 × 97 cm (49$\frac{1}{2}$ × 38$\frac{1}{8}$ in)
Inscribed (crudely, on the back of the original canvas, and partially showing through the front): *CA ZORZI*
Kingston Lacy, Dorset

It was one of the many quirks of Kingston Lacy that, when it was left to the National Trust in 1982, this portrait was found, skied and dirty, over a door in the Saloon, so that little of its quality could be seen. It may be for that reason that, although never questioned as a Titian,[1] it has made so little noise. This is despite the fact that the picture is of striking quality, that its sitter is invested with great authority, and that it is composed of rich tones of red and purple unusual in Titian's portraits.

The anonymity of the sitter cannot have helped. When William Bankes acquired the picture from the Marescalchi collection in 1820, it was called '*un Senatore dell'antica Famiglia de' Conti Savorgnan*'.[2] When it was first exhibited at the British Institution, in 1821, it was simply as a *Portrait*. By 1856, when again shown there, it had become the *Marchese di Savorgnano*, and it was there that Waagen saw it, calling it the same, and saying that it was 'very elevated in conception, and of masterly and careful execution in bright golden tones'.[3] The cataloguer at the Royal Academy in 1870, evidently unable to read Walter Bankes's handwriting, bizarrely called it the *Marchese Tarragnio*.

It is thus not clear where Crowe and Cavalcaselle, publishing in 1877, obtained the idea that the picture was supposed to represent Girolamo Savorgnan(o) (d.1529), one of the Venetian generals who recaptured Titian's native Cadore from the Emperor Maximilian in 1508.[4] As they (followed by most other authorities) pointed out, the portrait can be dated from its style to the 1540s; so it would have to have been painted after his death, yet does not appear to be posthumous. It was a very tempting equation to make, however, since Girolamo Savorgnan's subordinate local commanders on that occasion had included Titian's cousin and his great-uncle, Tiziano and Andrea Vecellio, and because Titian had in 1537 painted a mural of this battle in the Sala del Gran Consiglio of the Doge's Palace in Venice (destr. 1577).

The sitter has since been identified, entirely plausibly, as Francesco Savorgnan.[5] He was a member of the Maggior Consiglio of Venice (which would accord with the costume), and his date of birth, 1496 – and a consequent age in his late 40s or early 50s – would exactly suit the stylistic dating of this portrait. Francesco Savorgnan was from the line of the family – 'the oldest family of the *terrafirma*' – which had been enrolled among the Venetian nobility since 1385, and

held the castles of Pizano and Zuino del Torre. His descendants had owned the palace near S. Geremia (also since known as the Palazzo Modena) until they became extinct, with the death of Senatore Marchese Antonio Savorgnan in 1810. Another branch owned a collection of over a thousand pictures, but this was not among them.

The sale of the Titian appears to have taken place before the death of the last Savorgnan, as emerges from a note made by William Bankes when he took up residence in Venice towards the end of his life:

> The Elder Schiavone (whom I consider the best colourist now in Venice) tells me that he made, and still has somewhere in his possession, a small sketch or copy of the Marquis of Savorgnan by Titian which is now at Kingston Lacy. It was at the time he copied it in the choice collection of the Avvocato Galeazzi, who sold it with three other pictures (of which one was the Judgement of Solomon by Giorgione, he cannot call to mind the remaining two) to the Conte Marescalchi for 10,000 Franks.[6]

The short-lived collection of Count Ferdinando Marescalchi (1753–1816)[7] was admired by Stendhal,[8] Byron[9] and Shelley.[10] He took advantage of his position as Minister of Foreign Affairs for the Kingdom of Italy in Paris (1802–14) to acquire works of every school from the well-supplied Paris market. He also used agents[11] and influence in Italy to buy some of the more remarkable pictures that came onto the market there, notably Correggio's early *Four Saints* (Metropolitan Museum, New York) and those sold by his heirs to Bankes, of which this Titian and Sebastiano del Piombo's *Judgement of Solomon* are the finest.[12]

HIST: presumably the Counts Savorgnan della Torre, Palazzo Savorgnan, Venice, until a little before 1797/1802, when sold by Marchese Antonio Savorgnan (d.1810); Avvocato Galeazzi, ?Ca' Zorzi, Venice; by 1813, Count Ferdinando Marescalchi (1753–1816), Palazzo Marescalchi, Bologna; acquired by William John Bankes from the executors of Count Marescalchi, 1820; by descent to H.J.R. Bankes (1902–81), by whom bequeathed, with Kingston Lacy, and the Kingston Lacy and Corfe Castle estates, to the National Trust in 1982.

EXH: BI, 1821, no.34; BI, 1856, no.31; RA, winter 1870, no.48; RA, 1960, no.83; *Genius of Venice*, RA, winter 1983, no.122; *Treasure Houses of Britain*, National Gallery of Art, Washington, 1985–6, no.498, p.561.

LIT: Waagen 1857, p.378; Crowe and Cavalcaselle 1877, ii, pp.20–21; Gronau 1904, p.279; Suida 1933, p.82; Suida 1935, p.85; Fabbro 1951, pp.185–6, fig.203; Valcanover 1960, pl.160B; Valcanover 1969, no.280; Pallucchini 1969, p.281, fig.289; Wethey 1971, ii, pp.138–9, no.94, pl.98; Gore 1986, p.307, pl.1; Preti Hamard 1995, n.31.

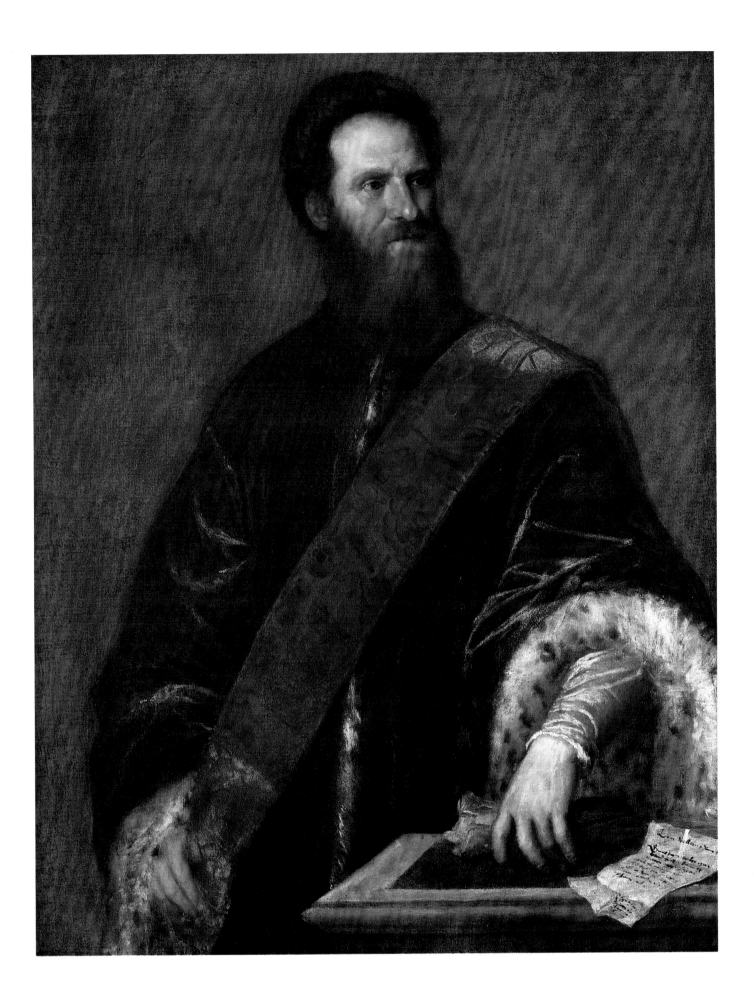

46 Attributed to Annibale CARRACCI (Bologna 1560 – Rome 1609)

The Holy Family with St Francis

Oil on canvas. 92·5 × 73 cm (36½ × 28¾ in)
Tatton Park, Cheshire

Had this picture been only a little larger, it might be hanging permanently, rather than just for the duration of this exhibition, in the National Gallery. For in the early 19th century it probably belonged to the financial genius, philanthropist and collector, John Julius Angerstein (1735–1823), 38 of whose paintings, chiefly 'large pictures of eminence', were ceded to the nation for £57,000 in 1824 by his executors to found the National Gallery.[1]

Nicholas Turner was the first to identify it as an early work by Annibale Carracci,[2] though he subsequently published it as by his cousin and teacher, Lodovico (1555–1619).[3] However, a double-sided drawing by Annibale, now in the Art Gallery of Ontario, Toronto,[4] suggests that his first thoughts were correct. The original recto of this is a study for the figure of St Jerome, in a painting dated 1583 or 1585, whose attribution has similarly oscillated between Lodovico Carracci and the young Annibale (Banco Popolare dell'Emilia, Modena):[5] the head of the saint is particularly close in character to that of St Joseph in the present picture, while his drapery is handled like that of the Madonna, and his toenails have the same claw-like character as the fingernails of St Francis. The original verso of the drawing has, however, two studies of a hand holding a violin bow, which settle the attribution of that painting, for they are for that of an angel in Annibale's signed and dated *Baptism of Christ* of 1585 in SS Gregorio e Siro, Bologna. Prior to the discovery of the drawing, this altarpiece, which Turner calls 'Annibale's most Lodovico-like work … something of an anomaly in his oeuvre', had been regarded as an ambiguous yardstick; but, by providing a basis for the attribution to Annibale of the *St Jerome* as well, the drawing shows that such was indeed Annibale's own manner around the years between 1583, when the altarpiece was commissioned, and 1585, when it was finally completed.[6]

A yet earlier altarpiece, dated to the beginning of this period, the *Crucifixion and Saints* (1583; formerly in S. Nicolò di S. Felice, and now in S. Maria della Carità, Bologna), which was Annibale's first major public commission, contains a kneeling figure of St Francis possibly drawn from the same model as the one in the present painting.[7] A number of similar depictions of the saint by Annibale also date from these years.[8]

Such a concatenation of representations of St Francis, all shown with skull and crucifix, and his introduction into the present picture with a crucifix that the Christ Child actually reaches out to touch, is unusual. To some extent, it is a reflection of the ways in which 'the Carracci Reform of Painting' was bound up with the Counter-Reformation, and

– specifically – with the idea that images should be used to promote meditation upon the central mysteries of the faith: Sin (represented by Death, in the form of a skull) and Redemption (represented by the Crucifix).[9] Time and again, St Francis is depicted as the vehicle for such notions, in a number of other paintings and engravings by Agostino and Lodovico Carracci, as well as by Annibale himself. It cannot simply have been a matter of their personal choice.

Annibale's contemporary *Crucifixion with Saints* formerly in S. Nicolò di S. Felice may provide an answer. Not only are two Franciscan saints, St Francis himself and St Bernardino, depicted with the Virgin Mary on the right hand of Christ, but the painting also stood on an altar whose patronage was transferred from the Machiavelli to the Mendicanti, i.e. to the Franciscan Friars.[10] St Francis is shown bare-footed, which might suggest that these were from the Observantine, or strict reform, branch of the Order, to which St Bernardino himself had belonged. Skull and book appear beside him, as in so many of Annibale's other representations, which also suggests that these and the crucifix were the Observantines' regular aids to meditation. The inference must surely be that altarpiece, Carracci's other portrayals of St Francis, and the present picture, in which the Christ Child touches the crucifix held by St Francis, all derive from the patronage of this branch of the Franciscan Order.[11]

HIST: ?Either: posthumous sale of M Dutartre, '*ancien Trésorier des Bâtimens*', hôtel de la Tour du Pin, Paris, 28 *ventose an* XII (19 March 1804ff.), lot 7 (as by 'Schidone' [i.e. Bartolomeo Schedoni, 1578–1615]);[12] [?Alexis Delahante] sale, Phillips, 3 March 1810, lot 64 (as by Schidone), bt in at 70 gns. ?Or: Sir Joshua Reynolds; his posthumous sale, Christie's, '11–14' [*recte* 13–17] March 1795, 4th day, lot 62 (as 'L. Carrache THE HOLY FAMILY WITH ST. FRANCIS, much in the stile of CORREGIO');[13] sold for 100 gns to Arthur Champernowne (1767–1819);[13] ?John Julius Angerstein (1735–1823). First certainly recorded in the anon. sale of remnants of his collection by his only surviving grandson, William Angerstein (1812–97) (as 'Catalogue of a Collection of Pictures, the Property of a Gentleman, removed from Blackheath' [i.e. J. J. Angerstein's former home, Woodlands]), Christie's, 20 June 1874, lot 36 (as by Schidone); one of three consecutive lots bt Waters for £9 19s 6d; sold by Waters to William Egerton, 1st Baron Egerton of Tatton (1806–83); thence by descent to Maurice Egerton, 4th Baron Egerton of Tatton (1874–1958), by whom bequeathed with the house, gardens and contents of Tatton Park to the National Trust.

EXH: ?'Ralph's exhibition' [i.e. Sir Joshua Reynolds's in aid of his servant Ralph Kirkley], 28 Haymarket, April 1791, Great Room, no.43.[14]

LIT: Brogi 1984, pp.44f., 49, n.26, pl.57; Turner 1985, pp.795–6, fig.96; exh. cat. *Ludovico Carracci*, Museo Civico Archeologico and Pinacoteca Nazionale, Bologna, 1993, and Kimbell Art Museum, Fort Worth, 1994, under no.1; Sarrazin 1994, p.178.

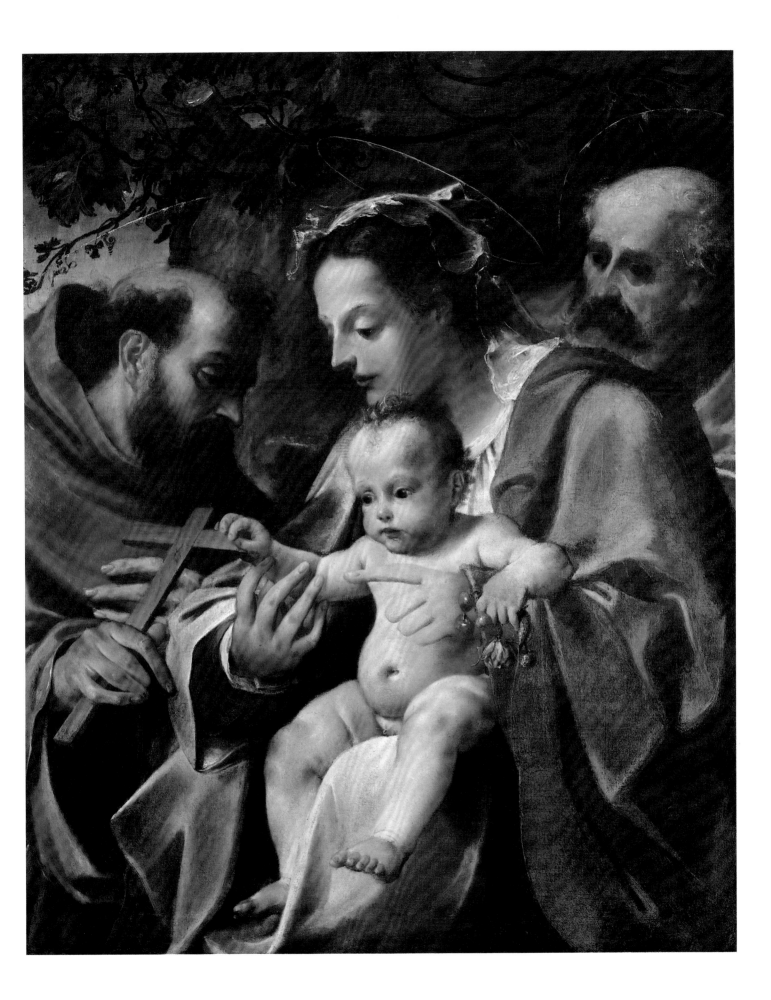

47 Bernardo STROZZI (Genoa 1581 – Venice 1644)

a *St John the Baptist interrogated about Christ*
b *Christ and the Woman of Samaria*

Oil on canvas. Each 110 × 115 cm (44 × 46 in)
Kedleston Hall, Derbyshire

Although bought, framed, hung, previously exhibited and presented here as pendants, these two pictures are not in fact a pair. They both depict interrogations concerning the nature of Christ's mission,[1] but their subjects have never traditionally been linked, nor do they balance one another compositionally or in handling. *Christ and the Woman of Samaria* has only two figures, seen close to, fully lit and rather from below, whereas *St John the Baptist interrogated* has four, slightly more distanced, in strong chiaroscuro and seen somewhat from above. In *St John the Baptist interrogated*, Strozzi's characteristic style and physiognomies are not yet fully present, and the paint is handled in more hesitant dabs, or *macchie*, compared with the more mature and fluidly painted *Christ and the Woman of Samaria*.[2]

The two pictures must therefore have been painted some distance apart in time. As its tentative handling would suggest, *St John the Baptist interrogated* is the earlier of the two, painted when Strozzi's style was not yet fully formed. Indeed Luisa Mortari was inclined to attribute it to Strozzi's circle, rather than to the artist himself.[3] Supporting the ascription to Strozzi, and a somewhat earlier dating, is its strong similarity in both handling and composition (though the figures are more spread out) to his *Act of Mercy: Giving Drink to the Thirsty*, whose prime version (Ringling Museum of Art, Sarasota) Mortari dates to c.1618–20.[4] She would seem to date *Christ and the Woman of Samaria* only a little later, whereas Michael Milkovich would date the version of it in the Bob Jones University Collection, Greenville, to 'the last Genoese years', i.e. before Strozzi's departure for Venice in late 1630 or early 1631.[5] Homan Potterton, when exhibiting the present version in 1979, preferred to date it to early in Strozzi's Venetian career.[6]

Nathaniel Curzon (about to become 5th Bt, and created 1st Lord Scarsdale in 1761) bought these two pictures at an auction of pictures assembled by the *marchand-amateur* William Kent[7] in 1758.[8] They are written into one of Robert Adam's two drawings of 1759–60 entitled '*Section of One End of the With-Drawing Room*' (i.e. Drawing Room at Kedleston), that for the south wall, as by '*Prete Genovese*' (Strozzi's sobriquet, from his initial priestly vocation).[9] The drawings include not only pictures that Curzon had inherited or bought at auction, but others that he had sent Kent to Italy to buy at source on his behalf in 1758–9.

One reason for Curzon's having dispatched Kent to Italy was the great difficulty in obtaining Italian paintings of any quality at the London auctions. The sales held in 1757–9 by

Kent, who had the capital, but not the knowledge, to buy good paintings at source, were among the few exceptions to this dearth; and Sir Nathaniel must have recognised that he had good sources of supply in Italy. Once in Italy, Kent attempted, without success, to buy pictures from the Sampieri collection in Bologna and involved himself in tortuous negotiations for pictures from the Gerini and Arnaldi collections in Florence. He was outbid by Margaret Rolle, Countess dowager of Orford, for the former, and was beaten by Henry II Hoare 'the Magnificent' to the greatest remaining prizes of the latter, which was the repository of the collection formed by the marchese Niccolò Pallavicini in Rome:[10] the *Marchese Niccolò Maria Pallavicini guided to the Temple of Virtù* by Maratta, and a pair of splendid *Landscapes* by Dughet – all three still at Stourhead.

Despite these setbacks, Kent did succeed in making two purchases in Florence which continue to adorn the same room as these Strozzis: the huge *Orlando rescuing Olympia* over the chimneypiece (attributed by Kent to Annibale Carracci); and the *Cupid Asleep on the Island of Paphos* (as a Guido Reni). However, the mixed success of Kent's efforts on Curzon's behalf in Italy combined with the failure of a sale of his own importations at Langford's seem to have finally discouraged him from dealing in paintings.[11] In his last letter to Curzon, on 20 May 1759, he resignedly says: 'I am determined never to play this game more'.

HIST: William Kent sale, London, Feb 1758, lots 36 and 35, bt for £12 and £21 by (Sir) Nathaniel Curzon (1726–1804); thence by descent, until bought with part of the contents of Kedleston, with the aid of the National Heritage Memorial Fund and the National Art-Collections Fund, in 1987, when the house and park were given to the National Trust by the present (3rd) Viscount Scarsdale.

EXH: *Works by Holbein & Other Masters*, RA, 1950–51, nos.336 (called *St John the Baptist Preaching*) and 333, pp.131–2, pl.51[b] (*Christ and the Woman of Samaria*); *Venetian Seventeenth Century Painting*, National Gallery, 1979, no.22 (*Christ and the Woman of Samaria*); *Patronage Preserved: An Exhibition of Masterpieces Saved for Country Houses*, Christie's, 1991, no.34 (only the *Christ and the Woman of Samaria* illustrated).

LIT: *Kedleston 1769*, p.5 (as Bernardo Strozzi, *Scriptural History*, and thus in succeeding edns of this gbk, and successive gbks, until 1861); Lipscombe 1802, p.110 (ditto); Matteucci 1956, p.202, fig.7; Fenyő 1958, p.146, fig.3; Mortari 1966, p.144, fig.266 (*Christ and the Woman of Samaria* alone accepted and reproduced); *Kedleston Hall*, Derby, 1977 (and subsequent edns), p.8 (as *The Incredulity of St Thomas* and *Christ and the Woman of Samaria*); Russell 1987, p.99, fig.9; *Kedleston 1988* (and subsequent edns), p.26, nos.184, 183.

a

b

48 Giovanni Francesco Barbieri, known as (IL) GUERCINO
(Cento 1591 – Bologna 1666)

An Allegory with Venus, Mars, Cupid and Time

Oil on canvas. Oval, 127 × 175 cm (50 × 69 in)
Dunham Massey, Cheshire

Guercino painted this subject twice: in the present picture
(of which there are a number of repetitions),[1] towards the
beginning of his career, around 1624–6; and again towards
the end of his career, in 1656, as one of a pair of pictures
painted for Ferdinand, Graf von Werdenberg, or Württem-
berg, to present to the Holy Roman Emperor.[2] Nobody else
appears to have done so, nor has any literary source for the
subject ever been identified. Guercino therefore probably
painted it to a programme proposed by his original patron.[3]

The theme is love and its dangerous consequences. When
Venus was dallying with Mars, she was trapped with him
under a net by her cuckolded husband, Vulcan, and
exhibited thus to all the other gods and goddesses. Here
Cupid's similar trapping under a net by Venus, and the
admonitory figure of Time, in the presence of Mars, seem to
be intended as a warning allusion to this episode. In the
inventories of Dunham Massey from 1769 onwards it was
called 'an oval Picture, representing the different stages of
human Life'. This is slightly curious, because it shows three
ages, not four (Youth is lacking, since both Venus and Mars
represent Maturity).[4]

If this picture ever had a pair, it has not been traced, but
the pendant to the Werdenberg painting, *Galatea drawn by
two Tritons, with Cupids* (Residenzgalerie, Salzburg),
illustrates another myth describing the dangers of love: the
sea-nymph Galatea was loved by the Cyclops Polyphemus
but loved the shepherd Acis, and was inconsolable after the
giant crushed him with a boulder. However, Guercino seems
not to have included Acis or to have alluded to his grim fate.
We do not know what the Werdenberg version looked like,
but it would seem from the two drawings for it to have also
been a more benign image.[5] In both, Venus holds a docile
Cupid to her breast – suckling in the one, sated and sleeping
in the other – while Time and Mars look concernedly on.
Mars and Venus were the subjects of many paintings by
Guercino (there is a fine early *Mars* at Tatton Park);[6] there is
evidently some relationship in theme between this picture –
and even in composition, in the case of the Werdenberg
version – and the *Venus, Cupid and Mars* in Modena.

The client probably specified the unusual oval format.[7]
The picture still preserves its original frame (as oval
paintings often do, because it is no light matter to make a
new frame of such a shape, to conform with some change
in fashion). This is particularly fortunate, since the self-
evidently heraldic eight-pointed stars on it help identify the
client as Tiberio Lancellotti, for whom Guercino painted a

number of pictures in Rome.[8] He came from a Roman
patrician family with a love of art. The Palazzo Lancellotti
was begun by Francesco da Volterra (c.1591) for Cardinal
Scipione Lancellotti (1526/7–98), and finished by Carlo
Maderno for his nephew, Cardinal Orazio Lancellotti (1570/
71–1620).[9] Tiberio completed the interior of his uncle's
palace with frescoes by Guercino and Lanfranco, in
quadratura settings by Agostino Tassi.[10]

We do not know whether the picture was bought by
Harry Grey, 4th Earl of Stamford (1715–68), or George
Booth, 2nd and last Earl of Warrington (1675–1758), at or
after John Blackwood's 1754 auction. It would have been a
late and uncharacteristic purchase for Lord Warrington,
who seems to have been primarily interested in native view,
animal (see cat. no.16) and portrait painting, or merely in
copies of Old Masters. On the other hand, his son-in-law
and heir, the 4th Earl of Stamford, seems to have been less of
a collector than his son, the 5th Earl (1737–1819). The 4th
Earl is better known for creating one of the great landscape
parks of the 18th century, at Enville Hall in Staffordshire,
the ancestral home to which he seems to have devoted most
of his energies, keeping Dunham Massey and its collections
distinct as a Booth property. None the less, it is surely
significant that, only four years after Blackwood's sale of
this picture, and four months before the death of his father-
in-law had given him Dunham Massey and a great increase
in wealth, the 4th Earl should have bought five pictures, four
of them Italian, at Fauquier's sale on 12 April 1758.[11]
Moreover, almost the only difference between the numbers
of paintings at Dunham Massey listed (without detail) room
by room in the posthumous inventory of the 2nd Earl of
Warrington and of those in the inventory of paintings there
taken the year after his own death, occurs over the Best, or
Great Staircase – where this *Allegory* was hanging in 1769.

HIST: Tiberio Lancellotti, Palazzo Lancellotti, Rome;[12] ?Sir Thomas
Sebright, 4th Bt (1692–1736), or ?Mr Bacon; ?their sale, London, 1737,
3rd day, lot 85 (as '*Mars, Venus, Cupid, and Time*, Emblematical');[13]
?[John] Blackwood's sale, 1754, 2nd day, lot 41 (as the same; sold for
30 gns): ?bt by Harry Grey, 4th Earl of Stamford (1715–68) – recorded
at Dunham Massey from the posthumous inventory taken in 1769
onwards (as 'an oval Picture, representing the different stages of human
Life. Guercin'); thence by descent to Sir John Foley Grey, 8th Bt,
Enville Hall, Staffs; his sale, Christie's, 1931, lot 113, bt by Roger, 10th
Earl of Stamford (1896–1976), on whose death bequeathed, with the
estate, house and contents of Dunham Massey, to the National Trust.

EXH: *Guercino in Britain*, National Gallery, 1991, no.16; *Il Guercino*,
Museo Civico Archeologico, Bologna, 1991, no.63.

LIT: Gore 1978, pp.27, 29, 31; Salerno 1988, no.109, p.191.

49 Sir Anthony VAN DYCK (Antwerp 1599 – Blackfriars 1641)

The Stoning of St Stephen

Oil on canvas. 178 × 150 cm (70 × 59 in)
Tatton Park, Cheshire

Stephen's election as the first of the seven deacons chosen by the apostles and his subsequent martyrdom by stoning are described in chapters vi and vii of the Acts of the Apostles. He was the first martyr for Christ, a man 'full of faith and power, [who] did great wonders and miracles among the people'. Brought before the Jewish council, he called his listeners 'stiffnecked and uncircumcised in heart and ears, [who] ... do always resist the Holy Ghost: as your fathers did'. He looked up and saw a vision: 'Behold, I see the heavens opened, and the Son of Man standing on the right hand of God.' Stephen was then taken out of Jerusalem and stoned. 'And he kneeled down, and cried with a loud voice, "Lord lay not this sin to their charge."' Among those standing by, approving the killing of Stephen, was Saul, who was later to be St Paul.

Van Dyck shows the moment when Stephen has fallen on his knees and calls to God to forgive his murderers. He is dressed in a red dalmatic (the vestments of a deacon) and is stoned by five men, while another looks on at the far left. In the background are two other men. The foremost, who is excitedly pointing out the scene to his companion, is the young Saul, at whose feet, in the biblical account, 'the witnesses laid down their clothes', which can be seen beneath his left foot. In the top right-hand corner angels fly down to the saint carrying wreaths and the palm of martyrdom.

All the main features of the composition – the kneeling saint with his eyes turned towards heaven, the muscular stone-throwers, the figure of the pointing Saul, and the angels descending with wreaths and palm – can be found in Rubens's great altarpiece of this subject which is now in the Musée des Beaux-Arts, Valenciennes.[1] Van Dyck has, however, reversed the composition.[2] Rubens's painting is usually dated in the period 1615–20, and may well have been painted when the young Van Dyck was in his studio.

Stylistically, Van Dyck's painting can be placed in the early years of his long stay in Italy (1621–7). Its scale and composition, and the powerful, half-naked figures of the saint's murderers strongly recall such large-scale religious paintings as *The Taking of Christ* and *The Brazen Serpent* (both Prado), painted a year or two before he travelled from Antwerp to Italy late in 1621. The head of the saint, his eyes raised with great pathos to heaven, is strikingly similar to the heads of St Rosalie, the patron saint of Palermo, whom Van Dyck painted in a number of versions during and after his stay in Sicily in 1624.[3] The angels are handled in the same manner as those who crown St Rosalie in the paintings in the Menil Collection, Houston, and the Wellington Museum,

Apsley House, London. The painting should, therefore, be dated in the period 1623–5, when Van Dyck was travelling in Italy before settling in Genoa.[4] This was a time when Van Dyck was absorbing diverse Italian influences: his study of the work of the Carracci in Bologna is revealed in the composition (which is more open than Rubens's) and in the saint's upturned face, while the broad and vigorous technique is distinctly Venetian.

Religious paintings by Van Dyck are rare in Britain. The artist's British patrons did not commission religious paintings from him, and few were collected later. *The Taking of Christ* (Corsham Court, Wilts) and *The Virgin and Child* from the Bridgewater and Sutherland collections (Fitzwilliam Museum, Cambridge) are notable exceptions.[5] *The Stoning of St Stephen*, a dramatic and powerful Counter-Reformation image from his Italian years, occupies, therefore, a particularly important place in this country's representation of the artist who changed the entire course of painting in Britain.

Christopher Brown

HIST: possibly painted for 'the Spanish chapel at Rome';[6] in the church of San Pascual Bailon, Madrid, in 1793[7] (probably presented by Don Juan Gaspar Enríquez de Cabrera, 6th Duque de Medina de Roseci and 10th Almirante de Castilla (1623–91), whose father may have bought the picture in Italy);[8] removed from the church between 1803 and 1806 by Don Manuel Godoy, Chief Minister of Charles IV and 'Prince of Peace', and hung in his palace in Madrid until his fall from power and arrest in 1808;[9] purchased in Madrid in 1808 by the painter George Augustus Wallis, acting for the art dealer William Buchanan, and brought by Wallis via Germany and France to England in 1813;[10] purchased from Buchanan by the art dealer Alexis Delahante, apparently for more than £1,000; Delahante sale, Phillips, 3 June 1814, lot 77, bt for 700 gns by Wilbraham Egerton of Tatton, MP (1781–1856); thence by direct descent to the Barons Egerton of Tatton, Tatton Park, with which left to the National Trust in 1958 by Maurice, 4th and last Baron Egerton of Tatton (1874–1958).

EXH: RA, winter 1884, no.166; RA, winter 1900, no.89; *Italian Art*, RA, winter 1960, no.51; *Van Dyck*, Agnew's, 1968, no.19.

LIT: Ponz 1793, v, p.37; Buchanan 1824, ii, pp.245, 247; Smith 1831, iii, p.100, no.354; Guiffrey 1896, pp.60–61; Cust 1900, p.240; Schaeffer 1909, no.64; Gluck 1931, p.137; Trapier 1957, p.269; Martin and Feigenbaum 1979, pp.24–5; Brown 1982, pp.78–82; Wagner 1983, ii, no.141, pp.121–3.

50 Don Diego de Silva VELÁZQUEZ (Seville 1599 – Madrid 1660)

Prince Baltasar Carlos (1629–46) as a Hunter

Oil on canvas. 154 × 90·5 cm (60½ × 35½ in), including
6·5 cm (2½ in) canvas added later on the left, and 4 cm
(1½ in) on the right
Ickworth, Suffolk

Prince Baltasar Carlos was the only and cherished son of
Philip IV of Spain by his first marriage, to Elisabeth of
France (Isabel de Borbón). He was painted at every stage of
his short life and in a variety of guises by Velázquez, but
only twice as a sportsman, at the age of six, in this painting
and that in the Prado.

The chief difference between the two pictures is one of
scale. The Prado version is of exceptional size for a whole-
length portrait of a child (191 × 103 cm; 75¼ × 40½ in). That is
because it is one of a set of three portraits whose original
purpose was to hang in the Torre de la Parada,[1] a hunting-
lodge in the grounds of El Pardo palace near Madrid. The
other two portraits are of Prince Baltasar Carlos's father,
King Philip IV,[2] and of his surviving uncle, the *Cardinal-
Infante Fernando*[3] (both in the Prado). They are of identical
height, but slightly differing widths. All three show the
sitters in the same plain hunting-costume (though the
Cardinal-Infante wears a cloak over his, and a lace collar has
been painted out), and all three include dogs, and a tree as a
foil. They stand in front of the same uncultivated hunting
terrain, which has been identified as that of the Sierra de
Guadarrama.

The portraits were painted or adapted to hang together in
the Galeria del Rey between 1634 and 1636, in the context of
five hunting scenes painted by Pieter Snayers (Prado), and
one – the so-called 'Tela Real' (Royal Hunting Enclosure) –
by Velázquez himself (with help from J.B. del Mazo;
National Gallery), with animal pictures by Frans Snyders
and Paul de Vos as overdoors.[4] Elsewhere in the Torre de la
Parada hung Velázquez's portraits of four dwarfs from the
royal households (all in the Prado; Baltasar Carlos's is
Francisco Lezcano, in the same setting of the Sierra), and –
rather strangely – his *Aesop*, *Menippus* and *Mars* (also in
the Prado).[5]

One of the most remarkable things about these royal
portraits is, as Svetlana Alpers has noted,[6] their simplicity.
The sitters' dress is plain, their guns are functional, not
elaborately decorated, and there are no boastful mounds of
game. This must be seen in the context not only of the
simplicity of Spanish royal dress in general, but of the Torre
de la Parada's function as a hunting-lodge. For in 17th-
century Spain, hunting was an exclusively noble activity,
and in the form of boar-hunting within a canvas enclosure
as shown in the 'Tela Real', an exclusively royal one.[7] In a
more public palace it might have been appropriate to
celebrate the regality of the King and other members of the

royal family by richness of costume or emblems of authority.
In the context of this hunting-lodge, to which only those of
the highest rank were admitted, omitting such trappings
underscored the fact that the mere persons of the King and
princes were exalted above all others. Hence the simplicity
of these portraits.

In the present picture, the Prince is shown with three
dogs – a partridge-dog and two Spanish greyhounds, or

Fig. 18 Velázquez, *Prince Baltasar Carlos as a Hunter* (Prado)

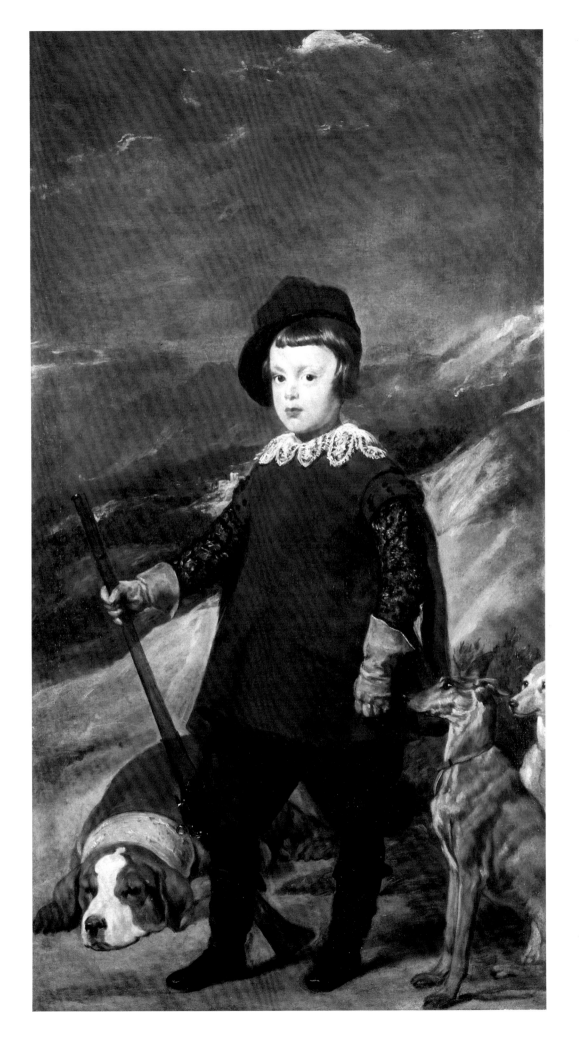

galguillos,[8] the latter a gift from the Cardinal-Infante to Baltasar Carlos, acquired from Lombardy in 1633.[9] In the Prado version, the partridge-dog and only one greyhound are shown. It has been suggested that there were once two, and that the picture has been cut down, but there is no sign of this.[10] A more logical explanation is that, between the painting of the two versions, one had died. This is, in other words, to propose that the present picture is not a mere copy of the Prado painting, as has generally been thought, but an earlier and autonomous portrait of the Prince,[11] from which an expanded variant was derived for the Torre de la Parada set. The numerous *pentimenti* in the present picture,[12] and the way in which the rifle and part of his tabard are painted over the already painted landscape, both support this argument. Moreover, the face of the Cardinal-Infante in the Torre de la Parada portrait had probably been painted before the hunting-lodge was even rebuilt, and the portrait of *Philip IV* was also reworked to suit this new context. So the Torre de la Parada portrait of *Baltasar Carlos* would have been like these in not being the first of its type.[13]

Where the present picture might have been painted for is hard to say.[14] What might be hazarded, is that it was not originally an independently framed picture. Already unusually narrow in relation to its height, even the degree of this narrowness is to some extent disguised by a slight shortening at top and bottom, and by the unfortunate later additions on either side. But these additions, which are not completely hidden by the frame, do something more material: they diminish the impression that the rest of the head and body of the second greyhound continue behind the frame (as is achieved with the single greyhound in the Torre de la Parada picture). This is an illusion that would have been even more effective if the picture were to have been set in panelling, rather than in a frame – which is also what is implied by its extreme narrowness.

There are two likely ways in which the picture may have reached Ickworth. If it was one of the many looted from Spanish palaces and religious houses by the 'King of Spain', Joseph Bonaparte, and his generals, then Frederick William, 5th Earl and 1st Marquess of Bristol (1769–1859), could have acquired it in Paris in the 1820s. Alternatively, it could have been acquired in Madrid by the 1st Marquess's third son, Lord William Hervey (1805–50), who was Secretary to the Legation in Madrid between 1830 and 1840, but this seems less plausible.[15]

HIST: ?Spanish Royal Collections; ?acquired in France by Frederick William, 5th Earl and 1st Marquess of Bristol (1769–1859); first recorded in an undated list in the Marquess's hand, drawn up *c*.1837;[16] thence by descent, until surrendered with Ickworth and the contents of the state rooms to HM Treasury, in lieu of the death-duty payable on the estate of the 4th Marquess (1863–1951), and handed over to the National Trust in 1956.

EXH: *Fair Children*, Grafton Galleries, 1895, no.71; RA, winter 1895–6, no.101; Guildhall, 1901, no.120; Courtauld Institute Galleries, 1962; *El Greco to Goya*, National Gallery, 1981, no.25 (as 'Studio of Velazquez').

LIT: Gage 1838, p.307 (as one of 'Two portraits of Spanish princes, full length, each with a dog, 5ft. by 3 wide, – Velasquez' in the Library); Justi 1903, ii, p.51; de Beruete 1906, p.57 (as 'one of the best copies of Velazquez by Mazo'); Calvert and Hartley 1908, p.215, no.157; von Loga 1913, pl.81; Stevenson 1914, p.134; Allende-Salazar 1925, pl. on p.177, and p.284; Mayer 1936, no.272, p.65 (as a studio replica); Lafuente Ferrari 1943, under no.LXVI; de Pantorba 1955, p.138; letters to *Apollo*, from Angus Bainbridge, June 1962, p.331, and from Anthony Blunt, Aug 1962, p.492 (indicating that Tomás Harris had not only identified the Ickworth picture as an original Velázquez, supported by Blunt and other scholars, but that – with greater temerity – he had advanced the idea that the painting in the Prado was a copy by Goya); López-Rey 1963, pp.70–72, 267, no.306, pl.299 (as a workshop picture); Camón Aznar 1964, i, p.564, pl. on p.565; de Pantorba 1964, p.55 (as one of three *antiche copie* of a supposedly cut-down original); Bardi 1969, p.96, no.63A; Brown 1986, p.138, pl.160 (as 'workshop of Velazquez'); exh. cat. *Velázquez*, Metropolitan Museum, New York, 1989, p.176; Prado, 1990, p.280 (as an old copy).

51 Juan Bautista Martínez del MAZO
(?Beteta c.1612/16 – Madrid 1667)
after VELÁZQUEZ (Seville 1599 – Madrid 1660)

The Household of Philip IV ('Las Meninas')

Oil on canvas. 142 × 122 cm (56 × 48 in)
Inscribed on reverse of unlined canvas: 276
Kingston Lacy, Dorset

It may seem perverse, with all the wealth of paintings in National Trust houses to choose from, to show a copy. Yet not only is the original in the Prado one of the most sublime but enigmatic paintings in the world – 'the theology of painting', as Luca Giordano called it – a painting that has never been exhibited outside its native Spain, but this half-size reduction has considerable interest and qualities of its own.[1] The presence of such a version in this exhibition will also serve as a reminder of the important role played by copies in collections in the past.

Photography has made it a great deal easier to compare versions of particular pictures, and so to separate the original from the copy. But because it is now so easy to get to know the composition of a particular painting from photographic reproductions of it, museums no longer think it necessary to exhibit painted copies. This is to ignore the vital contributions to our experience of a picture made by paint and canvas themselves, and by direct perception of scale. By preserving the older way of hanging copies and originals side by side, country house collections allow us to enjoy celebrated pictures, which we may never be able to see in the flesh.

'But where is the painting?'[2] Such is the confusion between image and reality in 'Las Meninas' that the answer to Théophile Gautier's deceptively simple question is far from straightforward. The setting is Velázquez's studio in 1656, in the 'Gallery of the Prince' (i.e. the by then deceased Baltasar Carlos, cf. cat. no.50) in the royal palace known as the Alcázar. Centre stage is the Infanta Margarita (1651–73), later to be Empress.[3] She is surrounded by '*Las Meninas*', the Portuguese term used at the Spanish Court to denote the young female attendants of a royal child. On the right are two of the royal dwarfs – Maribárbola, who was of German origin, and Nicola de Portosanto/Pertusato, who was born in Italy. The dog being kicked out of the way is reputed, by local tradition, to be a Lyme mastiff, bred at Lyme Park in Cheshire (NT). On the left, Doña Maria Augusta Sarmiento offers the Princess water, oblivious to the arrival of King Philip IV and his Queen, Mariana of Austria, to whom Doña Isabel de Velasco drops a curtsey.[4] In the original, the mirror on the back wall reveals that the royal couple are standing where we stand, and therefore seeing what we see. At the far end of the room, Don José Nieto Velázquez, 'Master of the Queen's Tapestry' and apparently no relation, appears to be drawing back a curtain, in order for the royal couple to proceed to the room beyond.[5]

According to Palomino, the King, Queen, princesses and ladies of the bedchamber all used to enjoy watching Velázquez at work.[6] Here the artist stands back from a work in progress. But what is Velázquez painting? Palomino believed he was painting the royal couple, and that the mirror reflected this painted image and not the couple themselves. There is not, however, any such portrait by Velázquez of King and Queen together, nor ever was; nor, because of the 'divinity that doth hedge a King', would any such portrait of a royal couple have been thought appropriate at the Spanish Habsburg court.[7] Instead, as the size of the canvas with its back to us tends to confirm, the artist is probably seen painting '*Las Meninas*' itself.

'*Las Meninas*' is a painting reflecting Velázquez's relationship with Philip IV and his family, and was not intended to be a public work. It was kept in the private royal apartments of the Alcázar (where it was slightly damaged in the fire of 1734), and then of the new Palacio Real. It was not on public display until transferred to the newly created Prado in 1819.[8] In all that time, just one painted copy is recorded, which could only have been made before the transfer of the original from Velázquez's studio to the royal apartments.[9] If this is that picture, as it must be, then it was painted by the one person whom Velázquez (with the permission of the King) might have authorised to make such a copy: his son-in-law and former pupil, Juan Bautista Martínez del Mazo.[10] It is first mentioned in 1677, in the collection of the famous collector and patron of Velázquez himself, Don Gaspar de Haro, 7th Marqués del Carpio, for whom it may have been painted. Although del Mazo was not recorded then as the copyist of this specific picture, he was already listed as the author of other copies of works by Titian and Velázquez from the Royal Collection in an inventory of Carpio's collection made in 1651.[11] The next record of it – again as the only existing copy – is in the collection of the statesman, scholar, poet and patron of the arts, Gaspar Melchor de Jovellanos (1744–1811). His heirs, 'in a bad moment', sold it to William Bankes, who 'was a long while in treaty for it & was obliged at last to give a high price'.[12]

One of the two most significant differences between the present reduction and the original is that the reflections of the royal couple (but not of the crimson curtain above them) are lacking from the mirror at the end of the room. The other is that Velázquez's palette is no longer set with his full

Fig.19 Detail of Velázquez, '*Las Meninas*' (Prado)

turns, is relegated to a distant vision. It is hard not to see all this as Mazo's painted commentary on '*Las Meninas*', expressing both his more traditional relationship with the royal family, as compared with that which Velázquez had enjoyed, and a very different approach to his art.

Mazo is also present in '*Las Meninas*' itself, in the form of his copies, on the far wall, of two of the paintings designed by Rubens for the Torre de la Parada (see cat. no.50): *Minerva's Punishment of Arachne*[13] and *The Judgement of Midas*.[14] Both piquantly illustrate cases of artistic hubris, with the former also showing a contest over Don José's responsibility, tapestry.

William Bankes, who had obtained the picture in 1814, considered it, like Jovellanos, to be Velázquez's original sketch, and 'the glory of my collection ... which I flatter myself will be the finest in England, tho' not a finished picture'. He entrusted it to the British Minister to the Court of Spain, Sir Henry Wellesley, no doubt for him to ship back to England with the protection of diplomatic immunity.[15] Once at Kingston Lacy it was ultimately installed, as William Bankes had always planned for it, and as shown in his own early drawings indicating how his Spanish pictures were to be hung,[16] in pride of place in the great Golden, or Spanish, Room, where, as Waagen was to say: 'I know no other collection in England containing so many valuable pictures of the Spanish school.'[17]

range of colours, but with white and red alone. Mazo would seem to be subtly acknowledging that, whereas Velázquez was painting himself in the act of painting the picture that we – but originally the royal couple – see as a completed painting, he – the copyist – was simply making a painting of a painting, with no royal presence.

That Mazo (who, incidentally, had begun his career as Painter to Prince Baltasar Carlos), did meditate upon the meaning of '*Las Meninas*' is suggested by his picture of *The Painter's Family* (Kunsthistorisches Museum, Vienna), which was probably painted shortly after Velázquez's death, when Mazo had succeeded him as *pintor de cámara*. This shows the painter's two families, by Velázquez's daughter and by his second wife, Francisca de la Vega (who is also in the picture), on a stage-like foreground, behind which a curtain is pulled back to reveal a room with an example of one of Mazo's portraits of *Philip IV* at the first level behind. To the right of that is an opening: as in Velázquez's own *Kitchen Scene* (National Gallery), there seems to be deliberate ambiguity as to whether this is an actual opening to another room, or an unframed painting on the wall feigning such an opening. Within this, the painter is at work on a portrait of a now older Infanta Margarita. Neither sitter nor royal visitors are present, but, instead, his youngest child in leading reins is restrained from rushing towards him by a thoroughly rustic nurse. Just one of the children in the foreground looks out at us, to establish contact between our two worlds. The painter, far from being highlighted, like Velázquez, as the pivot on which the whole of '*Las Meninas*'

HIST: (?painted for) Don Gaspar de Haro, Marqués del Carpio (d.1687), Jardin de San Joachim, Madrid (inventory of 15 June 1677, no.314); ibid., posthumous inventory, 1688, no.364, valued at 4,000 *reales*; taken in lieu of debts by his cousin, the Conde de Monterrey, in 1690; acquired by the medallist Pedro de Sepúlveda,[18] from an undisclosed source, for 2,500 *reales*, for Pedro Díaz de Valdés and (?Bernardo del) Campo to present to Gaspar Melchor de Jovellanos (1744–1811), at the instigation of Ceán Bermúdez, in Feb 1790 [the number 276 may have been that given to the picture in Jovellanos's collection]; bt from his heirs by William Bankes (1786–1855) by Oct 1814;[19] sent back to Kingston Lacy via Sir Henry Wellesley; thence by descent, until bequeathed to the National Trust, with the estates and contents of Kingston Lacy and Corfe Castle, by H.J.R. Bankes (1902–81).

EXH: BI, 1823, no.138 (lent by W. Bankes, as the *Infanta Margarita and Suite*, by Velázquez); BI, 1864, no.111 (as *Infanta Margaretta, etc.*, in Studio); RA, winter 1870–71, no.10 (as *Las Meninas*); RA, 1902, no.105 (as *Las Meninas*).

LIT: Ceán Bermúdez 1800, i, p.xxiv, v, p.172; Ochoa 1835, p.14 n.1; Stirling 1848, ii, p.652, iii, p.1395 (as 'A finished sketch, or small repetition'); repeated, without correction, in 2/1891, ii, pp.773–4, iv, p.1578; Stirling 1855, p.175 (as 'a fine repetition'); Waagen 1857, p.381; *The Athenaeum*, 11 June 1864, p.811; Curtis 1883, pp.14–15, no.22 (as 'An original sketch of the above with variations'); Jovellanos 1885, p.150; Justi 1888, ii, p.315–16 (as the sole known sketch for the Prado picture); Stevenson 1899, p.133; Justi 1903, i, p.xx (as the *one* original sketch by Velázquez), ii, p.296 (repeating 1st edn); Mesonero Romanos 1899, p.213; von Loga 1909/10, pp.198–9 n.1; Stevenson 1914, pp.57, 133 (as a 'large study' or 'sketch' for the Madrid picture); López-Rey 1963, no.230, p.205, pl.232 (as 'an old copy'); López-Rey 1979, p.504 (as a 17th-century copy); Maclarnon 1990, pp.114, 121, 123, 124; Harris 1990, pp.125–30 (as by Mazo, and as the picture recorded in the Carpio and Jovellanos collections).

52 REMBRANDT Harmensz. van Rijn (Leyden 1606 – Amsterdam 1669)

Catrina Hooghsaet (1607–85)

Oil on canvas. 126 × 98·5 cm (49½ × 38¾ in)
Inscribed on shield, upper left: *CATRINA HOOGH-/SAET.
OUT 50/Jaer/Rembrandt f./1657*
Penrhyn Castle, Gwynedd

The question of Rembrandt's religious affiliations, and the importance that these had for his choice and treatment of biblical subjects, has been hotly debated over the years. One of the most persistent beliefs is that he was a Mennonite, or at least closely associated with this sect.[1] The Mennonites were originally followers of Menno Simons (1496–1561), a former priest from Friesland, who had become an Anabaptist (a believer in adult baptism) and had brought together the remnants in Holland and Friesland of this hounded sect after the disastrous failure of the 'Kingdom of the Saints' in Münster in 1533–5. Their literal observance of the Bible meant that they refused to bear arms or take oaths, which effectively excluded them from civil or military office. They had preachers, but not priests, and vested authority in the congregation. Their rejection of the institutions of the state meant that – like the Quakers – many turned their unremitting concentration to business, and thus prospered and became very rich.

Catrina Hooghsaet, more commonly known as 'Trijn Jans', was a Mennonite and daughter of the compass-maker Jan Dirksz. Hooghsaet. By a second marriage in 1637, she became the wife of the dyer and Mennonite preacher Hendrick Jacobsz. Rooleeuw, whose brother, Lambert Jacobsz. (1592–1637), was an admirer, copyist and collector of Rembrandt's work. Lambert Jacobsz. was also a Mennonite preacher, whose painting of the obscure Old Testament subject *Abigail and Nabal* (Courtauld Institute)[2] is the kind of picture generally assumed to be typical of the sect's interest in the more recondite episodes of the Bible – an interest seemingly shared by Rembrandt.

It was at one time suggested that the pose of this portrait indicates that there must have been a pendant of the sitter's husband,[3] but the fact that the couple had been living apart for many years before this picture was painted renders this very unlikely.[4] It is, however, just possible that the portrait of her deceased brother that she left with this one to her three-year-old nephew was a pendant to it.[5]

What this portrait also shows is a woman of the merchant class, of great wealth and authority in her own right, as is suggested by her rich but sober dress, and by the Turkey carpet spread over the table beside her armchair. Her hair is almost entirely concealed, as was required of Protestant married women, by a head-dress held tight by *hooftijsertgen*, or 'head-irons'. This device had an unfortunate side-effect, noted by Owen Feltham five years before the portrait was painted: 'Their Ear-Wyers have so nipt in their Cheeks, that

you would think some Faiery, to do them a mischief, had pincht them behind with Tongs.'[6]

Rembrandt's actual religious affiliations are perhaps best summed up by Simon Schama:

Rembrandt came from a family in which the father was a Calvinist and the mother a practising Catholic. At different times he himself was attracted to Remonstrants, Mennonites, and to highly unorthodox sects like the Collegiants and the Waterlanders [actually a less vigorous branch of the Mennonites, to which Catrina herself belonged], whose emphasis upon extreme scriptural simplicity appealed to a Christian for whom the Bible was an anthology of human drama.[7]

He was also, however, a member of a Calvinist congregation and married a Calvinist, Saskia van Uylenburgh, in 1633; but his dealer, Saskia's uncle, Hendrik Uylenburgh, was a Mennonite, whose commissions to Rembrandt, as to a whole group of other artists, must have played an important role in their choice of novel subjects from the Bible.[8] It was probably the connection with Hendrik Uylenburgh that accounts for Rembrandt having painted a number of portraits of Mennonites during his earliest years in Amsterdam, of which the double portrait of the Mennonite preacher *Cornelis Claesz. Anslo and his wife Aaltje Gerritsdr. Schouten* (1641; Gemäldegalerie, Berlin) is both the most striking and the one which seems best to exemplify the importance that Mennonites attached to the exposition of the Bible.[9]

Rembrandt did not portray another Mennonite until 1657, with this portrait. Here it is almost as if he has taken the submissive wife of the Anslo double portrait and set her on her own, straightened her up, raised her above rather than below the same Turkey-carpeted table, and placed her two hands – one of which still clasps a handkerchief – authoritatively upon the arms of her chair, instead of submissively in her lap. For this portrait of an independent woman, he adopted the same pose (albeit in a less aggressive form) that he had previously used for male portraits, such as that of an *Unknown Man* painted in 1637 (Duke of Sutherland's collection, Mertoun, now doubted by some).[10] He was to employ it again, but to even more striking effect, because posed frontally (and with the handkerchief-holding hand drawn in towards the sitter's waist), in the memorable portrait of *Margaretha de Geer* (1583–1672) (c.1661; National Gallery), who may have lost her husband, the enormously wealthy Dordrecht merchant Jacob Jacobsz. Trip (1575–1661), shortly before.[11]

It has been suggested that there have been a number of changes to the present portrait: notably, that one of the sitter's hands was originally placed in her lap; that the parrot

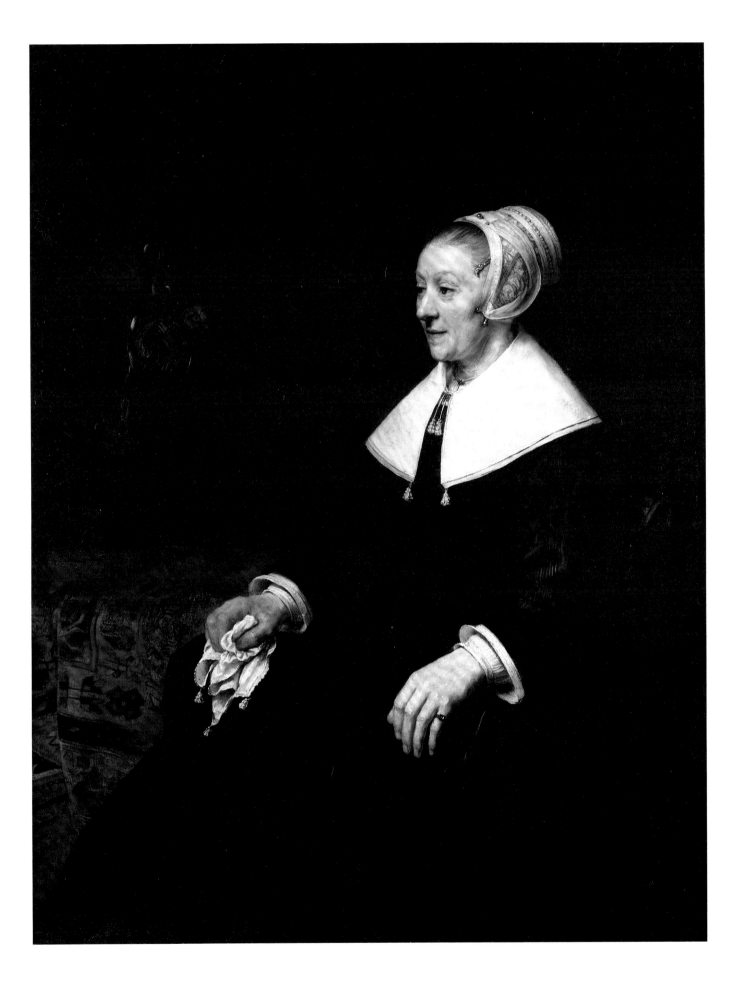

Fig. 20 Detail of the heliogravure in Bode's *Complete Work of Rembrandt* (1901)

first stood on the table; and that there was once a curtain to the left.[12] There is no real evidence of any of this, but parts of the painting have sunk in and become much less legible. A heliogravure of the painting, taken around 1900 for Wilhelm Bode's *magnum opus* on Rembrandt, reveals that the hoop in which the parrot perches hangs from the same bracket as the shield bearing the inscriptions, and that this bracket projects from the trunk of a tree that divides into two branches at the top.

What is surprising for the portrait of a Mennonite is the inclusion of a parrot at all. Not only was it a sign of luxury, but only two years earlier a sermon had been published attacking women who thought more of their parrots than the poor. Catrina Hooghsaet might almost have been the target of this sermon, since she owned a pet parrot and, in a codicil added to her will in December of the year in which this portrait was painted, left 'her little parrot with its cage' to one Giertye Crommelingh.[13] However, the bird appears oddly placed, in front of her nose, and indistinct. Equally puzzling are the inscription giving the sitter's name, which is apparently unique in Rembrandt's portraiture, and the curiously awkward way in which this is placed on a shield, and then broken between two lines.[14] Catrina Hooghsaet's gaze does not in fact require the presence of the parrot, while the tree was evidently painted so as to provide a support

both for its hoop and for the shield with the inscription. These rather provincial elements may prove to be later additions, made after the death of the sitter, when her portrait was accorded more importance as a family icon than as a painting by Rembrandt. Fortunately, the pigments with which they were painted have become more transparent with age and so less visible, so that we can simply enjoy and admire an older woman's portrait of striking dignity and self-assurance.

HIST: ?John Fane, Lord Le Despencer, 7th Earl of Westmorland (1685–1762), Mereworth Castle, Kent;[15] Sir Francis Dashwood, 2nd Bt, Lord Le Despencer (1708–81), of West Wycombe, Mereworth Castle; Sir Thomas Stapleton, 6th Bt, Lord Le Despencer (1766–1831), of Rotherfield Greys, Mereworth Castle; his posthumous sale, 1831; bt after the sale by Peacock (according to Smith 1836, but the Getty Provenance Index has been unable to trace any such sale); by 1836–42, Edmund Higginson (né Barneby; 1802–71), Saltmarshe Castle, Herefordshire;[16] offered for sale with his pictures, Christie's, 4–6 June 1846, 3rd day, lot 221, bt in at 760 gns; his sale, Christie's, 16 June 1860, lot 43, bt by Farrer for 740 gns; Col. the Hon. Edward Douglas-Pennant, 1st Baron Penrhyn of Llandegai (1800–86); thence by descent to Hugh, 4th Baron Penrhyn (1894–1949), who left Penrhyn and its estates to his niece, Lady Janet Harpur, née Pelham, who, with her husband John Harpur, thereupon assumed the name of Douglas Pennant, and in 1951 made over the castle and part of its contents in lieu of death-duties to HM Treasury, which transferred them to the National Trust.

EXH: BI, 1851, no.52 (lent by Edmund Higginson); RA, 1873, no.137 (lent by Lord Penrhyn); RA, 1899, no.75 (ditto, as *A Lady with a Parrot*); Rembrandt Tercentenary Exhibition, Leyden, 1906; Grafton Gallery, 1911, no.60 (ditto, as *Caterina Hooghsaet*); on loan to the National Museum of Wales, 1971–85; *Art in Seventeenth Century Holland*, National Gallery, 1976, no.92.

LIT: Horace Walpole to Richard Bentley, 5 Aug 1752: '. . . at Mereworth, which is so perfect in a Palladian taste, that I must own it has recovered me a little from Gothic. . . . The gallery is eighty-two feet long, hung with green velvet and pictures, among which is a fine Rembrandt . . .' (Walpole 1973, xxxv, p.143); Sprange 1780, p.293, Mereworth House, east end of Picture Gallery (as 'A Dutch Lady in a chair, by Rembrandt'); Sprange 1797, 1801, p.229; Neale 1825, ii; Smith 1836, vii, p.174, no.546 (as *Catherine Hoogh*: 'This picture, when sold, was exceedingly disguised and obscured by dirt'); Higginson 1842, no.39 (as *The Portrait of Catrina Hoogh or Hooghsat*, in the Gallery); Smith 1842, ix, p.800, no.32; Waagen 1854, ii, p.336; Vosmaer 1868, p.491; Vosmaer 1877, p.557; Dutuit 1883, no.216; Michel 1893, p.558; Michel 1894, ii, p.237; Bode 1901, vi, no.454; Douglas-Pennant 1902, no.19; Rosenberg 1904, pl. p.204; Schmidt-Degener 1906, p.272, fig. on p.269; Valentiner 1908, pl.441; Hofstede de Groot 1915, vi, p.277, no.652; Hofstede de Groot 1916, vi, p.312, no.652; Wijnman 1934, pp.90–96; Bredius 1935, no.391; Bauch 1966, no.519 (detailing supposed changes); Lecaldano 1969, no.354; Gerson 1968, no.336, pl. on p.403; Dudok van Heel 1980, p.115; Schwartz 1985, p.333, fig.385; Tümpel 1986, no.244, pp.123, 419, and col. pl. on p.281; 1993, no.244, p.419, col. pl. p.281.

53 Bartolomé Esteban MURILLO (Seville 1618–82)

Urchin mocking an Old Woman eating Polenta

Oil on canvas. 147·5 × 107 cm (58 × 42 in)
Dyrham Park, Gloucestershire

Murillo's paintings of urchins and beggar-boys had no real native, and few foreign, precursors, and form but a small part of his substantial oeuvre.[1] Yet before the Peninsular War brought large numbers of his works on the market in the early 19th century, they and his Madonnas were the subjects by which he was best known in northern Europe. Indeed they seem to have been originally painted almost entirely for a foreign clientele.[2]

The earliest of these pictures, the *Street Urchin looking for a Flea* (Louvre), is generally dated to *c*.1645–50.[3] As the subject (a boy delousing himself) indicates, Murillo began by depicting the street children of his native Seville with an unblinking naturalism, employing a sombre palette and strong chiaroscuro. The main group, to which the present picture belongs, was executed between about 1660 and about 1680. In these pictures, the mood is generally more cheerful, with smiling boys eating or playing dice. The compositions usually consist of two or three figures, often arranged in pyramidal form and psychologically contrasted, with a dog, a wicker or straw basket, and an earthenware water jug. They were painted in Murillo's later, more airy *estilo vaporoso*. This picture is unusual in that it combines the boy with an adult, who is eating polenta, and in that the boy directly addresses the spectator. This may suggest that it was intended to exemplify some Spanish proverb. It is also the only composition of which there is a second – either autograph or studio – version (Wallraf-Richartz Museum, Cologne).[4]

As Angulo Iñiguez has argued, these pictures were probably not just bought, but commissioned, by Netherlandish merchants doubling as picture dealers and collectors.[5] A key figure must have been Nicolás Omazur (1609–91 or after), an Antwerp silk merchant and poet, who was painted by Murillo (Prado), was left two small pictures in his will, and had his *Self-portrait* (National Gallery) engraved after his death.[6] Another must have been Josua van Belle (*c*.1635–1710), a Rotterdam merchant trading with Seville, whose portrait was also painted by Murillo (National Gallery of Ireland, Dublin), and whose collection still contained a picture of this character, when it was sold in 1730.[7]

Versions of Murillo's urchin pictures reached Britain via Flanders at an early date. At Dunster Castle in Somerset and Kingston Lacy in Dorset (both NT), there are copies of the *Boys eating Grapes and Watermelon* (once owned by the Antwerp Postmaster, J.B. Anthoine [d.1691]; now Alte Pinakothek, Munich) that, with a greater or lesser degree of certainty, go back to the 17th century. This suggests either that the original was within these shores before it passed to Anthoine, or that copies were supplied to England from Antwerp. The Kingston Lacy painting is arguably the first by or after Murillo to be recorded in Britain. For it was bought by Ralph Bankes by 1658/9 from a Mr Matthewes, who seems to have been a dealer specialising in Netherlandish paintings, to judge by the other five pictures that Bankes had from him.[8] The original of the *Boys eating Grapes and Watermelon* is dated variously to between 1645 and 1655,[9] so Ralph Bankes was getting a brand-new copy of a newly minted picture. The present picture might have been a similarly early import, but of an autograph work.

Who might the importer have been? In 1693 William I Blathwayt (?1649–1717), politician, collector and builder of Dyrham, bought eighteen itemised pictures, some Antwerp-related, from the painter Jan Siberechts.[10] The Murillo was not among them, but he might have acquired it in another transaction from the same source. Alternatively, he may have obtained it by purchase or bequest from his uncle, the even greater connoisseur and collector, Thomas Povey (*c*.1612/18–1700 or after).[11] Perhaps significantly in this context, Povey was involved with the colonies, trade and Tangier (the other side of the Straits of Gibraltar to Seville) during his active years, and then and afterwards was known for his stylish way of living and collections. Evelyn called him 'a nice contriver of all Elegancies'.[12] On 8 November 1693 Povey sold his nephew £500-worth of books and pictures (mostly family portraits and 'small peeces').[13] In 1700 another Povey, William Blathwayt's nephew John, wrote to old Thomas Povey to describe Dyrham inside and out, not only tactfully letting fall that 'in these several Apartments your pictures have a Great share in the Decoration',[14] but also telling him that it had been impossible to find a place where Povey's 'Great Perspective' (by Samuel van Hoogstraten) would work its full illusionistic effect. This clearly indicates that there had been some second transaction, which included the two architectural perspectives by Hoogstraten and perhaps this Murillo.

The picture was included in the third day of a sale held at the house on 18–21 November 1765, which had been forced on William III Blathwayt (1719–87) by his creditors.[15] However, his younger brother, General Wynter Blathwayt (1729–1806), appears to have bought it, so that it remained in the family, if not the house. Two other pictures of similar subjects ascribed to Murillo made a more permanent departure from Dyrham at this sale, as lots 16 and 33 on the same day: '*Two Boys and a Black Boy*, by Murelli' and '*Two Boys and a Fox*, by Murelli'. These must have been earlier replicas or copies of the two pictures now in the Dulwich Picture Gallery, which have themselves been in England since at least the 17th century.[16]

Fig.21 After Murillo, *Boys eating Grapes and Watermelon* (Kingston Lacy)

HIST: ?William I Blathwayt (1649–1717), either: ?by purchase or bequest from Thomas Povey (*c*.1612/18–1700 or after); or: ?by purchase from ?Jan Siberechts; Dyrham sale (Thomas Joye), 18–21 Nov [1765], 3rd day, lot 34: '*An old Woman and a Boy*', ditto ['Murelli']; sold for 12 gns [to ?General Wynter Blathwayt (1729–1806); left by him to] Lt-Col. George William Blathwayt (1797–1871); thence by descent until 1956, when house, garden, furniture and certain of the pictures were acquired by the National Land Fund and transferred to the National Trust.

EXH: RA, winter 1882, no.158; *Portrait Groups from National Trust Collections*, Arts Council (touring), 1960, no.4, pp.8–9; *Treasures from the National Trust*, Glynn Vivian Art Gallery, Swansea, 1971; *The Golden Age of Spanish Art*, Nottingham University, 1980, no.53; *El Greco to Goya*, National Gallery, 1981, no.47.

LIT: Fulcher 1856, p.240; anon. review of RA winter exh., *The Athenaeum*, 7 Jan 1882, p.22 (as 'a far finer and truer Murillo'); Gonse 1882, p.290; Curtis 1883, p.289, no.450; Baddeley 1916, p.551; Mayer 1923, pl. p.208, p.293 (as a copy of the picture in Cologne); Gore 1969, p.244 and fig.36; Klesse 1973, p.90 (as '*Eine qualitativ vorzügliche Replik*'); Angulo Iñiguez 1981, i, p.451, ii, no.400, pp.308–9 (as the original, of *c*.1670, of which the Cologne picture is possibly a studio copy, and that of the Duke of Wellington a '*copia de pobre calidad*'), iii, pl.449; John H. Elliott, 'Art and Decline in Seventeenth-century Spain', in exh. cat. *Murillo*, RA, 1983, p.45, fig.41.

The copy of the present painting also at Dyrham was made not from it, but probably either from the variant now in the Wallraf-Richartz Museum, Cologne,[17] or from the copy of that belonging to the Duke of Wellington.[18] It was probably acquired as a substitute for the original some time during its period of absence from the house following the 1765 sale. The Cologne and Wellington versions were not available for copying in England until the 19th century, which alone would be enough to dispose of the tenacious myth that Gainsborough came out to Dyrham from Bath to make this copy, as he died in 1788.[19] The picture in any case has none of the characteristics of his copies of Old Masters.[20] We know, however, that Gainsborough did copy and own paintings then attributed to Murillo, but all these were of religious subjects.[21] There is no record of his ever copying one of Murillo's studies of urchins and beggar-children, even though these were clearly the major influence on his own pictures of 'Cottage Children', as well as on certain of the fancy pictures of Sir Joshua Reynolds.[22]

54 Pompeo BATONI (Lucca 1708 – Rome 1787)

a *St Peter*

b *St Paul*

c *St John the Evangelist*

d *St Matthew*

Oil on canvas. Each 73 × 60·5 cm (28¾ × 23¾ in)
Basildon Park, Berkshire

Sets of the Twelve Apostles are part of the basic iconography of churches, but they more often take sculpted form, or are simply symbolised by crosses, with or without the emblems of their lives or martyrdoms.[1] It is unusual, as Francis Russell has said, that they should have been painted as a set for a private collection, and even more so that the major part of one such set should adorn an English country house.[2] Although the Apostles were among the saints that the Anglican church continued to recognise, sets of Sibyls were more common in English country houses. One reason for this was, perhaps, that religious paintings were very rarely collected in England for their content; if anything, they were collected in spite of it. Otherwise, not only the profusion of Madonnas and Saints, but also the early English taste for Murillo, with his proliferation of child-angels, would be inexplicable. Yet even in Italy, where these particular Apostles once formed part of the greatest single concentration of Batoni's work – the Merenda collection in Forlì – it was unusual to commission religious subjects specifically for a picture gallery.

Batoni, who was personally pious, responded to this commission with artistic energy. Each saint has his traditional defining attributes. St Peter appears with the two 'keys of the kingdom of heaven' offered him by Christ, and the cock that crew after he had denied Christ thrice. St Paul holds the sword with which he was martyred. Both also hold books embodying their Epistles. St Matthew, author of the first Gospel, receives divine inspiration from an angel; St John the Evangelist is shown writing his Gospel, accompanied by an eagle.

Batoni characterised the Apostles further by giving each one strongly individual physical characteristics and an emphatically differentiated pose. Russell has seen these divergences as evidence of a developing style and has proposed that the set was painted over a relatively extended period, between about 1740 and 1742–3.[3] However, as in the case of the precedents set by Rubens and Van Dyck,[4] it seems more likely that differences in character are being misinterpreted as a progression in style, and that the set was painted over a briefer span. Batoni's immediate inspiration appears to have been a set of replicas of Rubens's *Christ* and *Apostles*, executed by the artist's pupils, and retouched by him, which entered the Pallavicini collection in Rome.[5]

Count Cesare Merenda (1700–54) and his brother Fra Giuseppe (1687–1760) were Batoni's most dedicated patrons, commissioning at least 32 recorded pictures from the artist between about 1740 and 1750.[6] They came from an old patrician family of Forlì, and the collection appears to have been begun by their grandfather, Giuliano Merenda; it ultimately consisted of about 370 pictures, of every kind. Although it contained Old Masters – on whose acquisition Batoni gave advice – one of its chief strengths lay in 18th-century Roman painting. Here, the fact that Count Cesare had been a lawyer practising in Rome since 1723 was no doubt of key importance. His brother, who also functioned locally as an architect (albeit primarily on ecclesiastical commissions), designed a new gallery in the family *palazzo* in Forlì in the 1730s. It was for this that these and most of the other Batonis were intended. The Merenda *palazzo* with its gallery was destroyed by the Allied bombing of Forlì on 10 November 1944. The pictures had mostly been removed to safety to the family villa, but, deprived of their natural location, were then largely sold over the next twenty years or so.[7]

Although the Merenda *Apostles* and *God the Father* formed a set of a dozen pictures, they were incomplete as a set of Apostles.[8] Curiously, Christ and the Virgin Mary are also not represented.[9] It therefore seems highly possible that the *Virgin and Child with St John the Baptist* recorded in one of the manuscript lists of the collection, and by Marcucci in 1944, supplied images of them to the set.[10] In the absence of dimensions, we cannot know for sure; but, given what would appear to have been the very orthodox piety of the Merenda brothers, it would seem highly likely. Even in its incomplete state, however, the set makes a vivid and arresting group, represented here by two pairs of pictures: *St Peter* and *St Paul*, and two *Evangelists* – still in their original Roman 'Maratta' frames.[11]

HIST: commissioned by Count Cesare (1700–54) and Fra Giuseppe (1687–1760) Merenda, for the picture gallery of the Palazzo Merenda, Forlì, *c*.1740–43; there until 1945; Villa Merenda – Salecchi, nr. Forlì, until 1959, when sold (probably via M. & C. Sestieri, Rome) to the dealer Julius Weitzner, London; with P. & D. Colnaghi & Co., London, 1959–60; by whom sold in 1960 to Lord and Lady Iliffe; by whom presented to the National Trust in 1979.

EXH: *Allan Ramsay, his Masters and Rivals*, National Gallery of Scotland, Edinburgh, 1963, no.19 (*St John the Evangelist* only).

LIT: Calzini and Mazzatinti 1893, pp.53–4, nos.117 or 336, 119, 87, 90 (as an unidentified *Apostle* and *St Paul*, and as *St Mark* and *St John*); Casadei 1928, p.382; Marcucci 1944, pp.95 n.1 (*St Peter* unidentified, and *St Matthew* misidentified as *St Mark*), 96, fig.1 (*St John the Evangelist*); Chyurlia 1953, p.64 (repr. of *St John the Evangelist*); Russell 1980, pp.35–42, esp. figs.2, 6, 4, 5; Clark and Bowron 1985, nos.80–83, pp.27, 232–3, and pls.80–83.

a

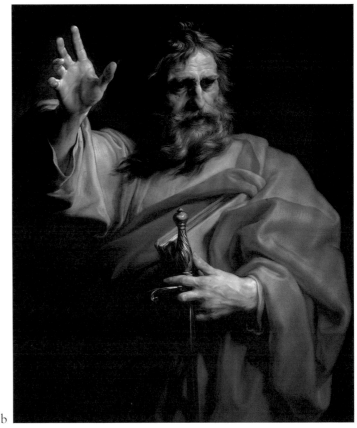

b

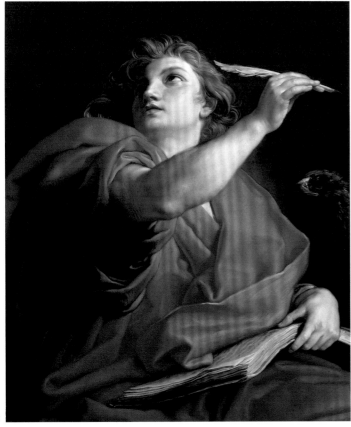

c

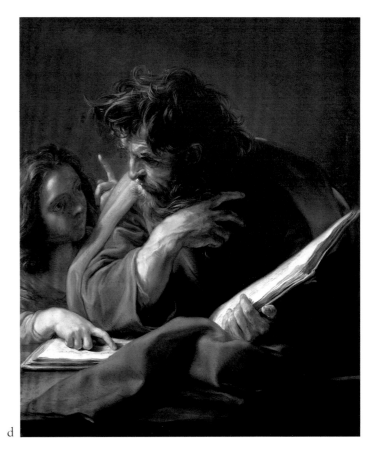

d

55 Pompeo BATONI (Lucca 1708 – Rome 1787)

a *Purity of Heart*

Oil on canvas. 98 × 74 cm (38½ × 29 in)
Signed (on base of table): *P. B. 1752*

b *Meekness*

Oil on canvas. 99 × 74 cm (39 × 29 in)
Uppark, West Sussex

Since at least about 1815, these two pictures have always hung in the Saloon at Uppark, in the same register as the overdoor portraits of Sir Harry Fetherstonhaugh and his grandparents, Christopher and Sarah Lethieullier.[1] As a result, they almost seem to take their place as additional members of the family.[2] Perhaps for this reason, and because of the traditionally Anglican upbringing of the English, their unusual imagery was at first taken for granted, and then viewed in entirely secular terms, as 'Innocence' and 'Love'.

As was first recognised by Clark and Bowron,[3] they in fact represent personifications of the Second and Fifth of the Beatitudes, from the Sermon on the Mount: 'Blessed are the meek: for they shall inherit the earth. . . . Blessed are the pure in heart: for they shall see God.'[4] These authors also saw that the personification of each Beatitude was taken from Cesare Ripa's *Iconologia* (1603): the young woman holding a lamb, signifying meekness or gentleness, for *La mansuetudine*; and the other, clutching a dove to her heart, with lilies on the table, for *La mondezza di cuore*.[5] What does not seem to have been appreciated is how rare such painted depictions of Beatitudes were at any time,[6] despite the availability of the formulae provided by Ripa, and how exceptional such single-figure personifications are in Batoni's oeuvre. Nor how curiously they consort with this artist's portraits elsewhere in the house, of Sir Matthew Fetherstonhaugh and his kin with various mythological attributes – of Adonis or Meleager, Diana, Apollo, Flora and the like.

The explanation for this unusual commission is perhaps to be found in the composition of the Fetherstonhaugh party that sat to Batoni in Rome in 1751 while on the Grand Tour. In addition to Sir Matthew and his wife, née Sarah Lethieullier, it comprised her younger brother, Benjamin, and their older half-brother, Lascelles Iremonger. But it also included Sir Matthew's younger brother, Utrick,[7] and his future wife, née Katherine Durnford, the sixth daughter of the Vicar of Harting (the parish into which Uppark fell);[8] she was travelling as Lady Fetherstonhaugh's companion. They were all painted by Batoni, among his earliest English sitters – some more than once[9] – probably in two sets, one for Sir Matthew, and one for Benjamin Lethieullier (cf. cat. no.56). Although there is nothing in his dress in Batoni's portraits to indicate that Utrick was at this time in Holy Orders, he had already been ordained deacon in 1740 and priest in 1742; in 1757 he was to be appointed Rector of Harting. By contrast, Sir Matthew's interests would appear to have been largely political, scientific and economic.[10] Utrick might therefore have suggested that this unusual commission be given to Batoni. The artist himself would probably have welcomed it, as he was personally devout; indeed, he left his family virtually destitute, despite his huge earnings from portraying travelling British *milordi* and other Grand Tourists, because of the extent of his charitable donations in his lifetime.[11]

The resulting pictures must later have presided somewhat incongruously over the revels of Sir Harry Fetherstonhaugh and his cronies. While the old story that his mistress, Emma Hart (later Lady Hamilton), danced naked on the Dining Room table is unfounded, the Prince of Wales is documented as a frequent guest, with his entourage of dogs and jockeys. Sir Matthew's other major acquisition on his travels, Luca Giordano's six canvases of the *Parable of the Prodigal Son*, would have provided a more appropriate accompaniment.[12]

One eminent scholar of the 18th century has rightly singled out *Purity of Heart* as an embodiment of 'Batoni's style at its finest', yet concluded, 'Almost nothing is said, but the means of expression are exquisitely competent.'[13] This underestimates it. For the artist has transcended Ripa's use of symbols, so as not just to characterise Purity, but actually to create a physical embodiment of it.

HIST: commissioned by ?Sir Matthew Fetherstonhaugh in Rome in 1751; thence by descent and bequest, at Uppark, until ceded to HM Treasury in partial lieu of death-duties in 1965, and transferred to the National Trust.

EXH: *Italian Art and Britain*, RA, 1960, no.128, p.60 (*Purity of Heart* only) and *Illustrated Souvenir*, pl.59 (as *Innocence (Girl with a Dove)*); *Pompeo Batoni and his British Patrons*, Kenwood, 1982, no.46 (as *Personification of 'Purity of Heart'*).

LIT: Gore 1965[4], p.1474, fig.3 (*Purity of Heart* reproduced as *Innocence*); Isa Belli Barsali, 'Batoni, Pompeo Girolamo', in *DBI*, vii, 1965, p.200; Levey 1966, p.175 and fig.174 (as *Innocence*); Clark and Bowron 1985, nos.167, 168, p.256, pls.157, 158 (as *Personifications of Purity of Heart* and of *Meekness*).

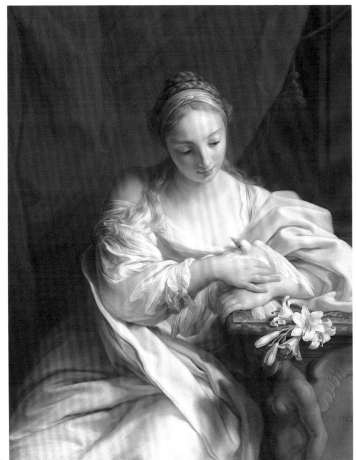

a

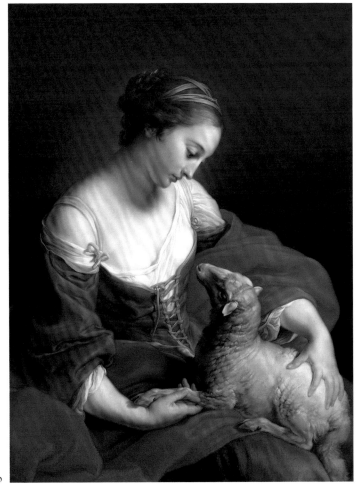

b

56 (Claude-)Joseph VERNET (Avignon 1714 – Paris 1789)

The Four Times of Day

a *Morning: A Port in Mist – Fishermen hauling in their Boat*
Signed on rock, bottom left: *Joseph Vernet f./Romae 1751*

b *Midday: A Ship Offshore, foundering in a Storm*
Signed on bale, on bottom left, together with merchants' marks: *Joseph/Vernet/Romae/1751*

c *Evening: Harbour Scene, with Boats being unloaded and Spectators*
Signed bottom right: *Joseph Vernet f. Romae/1751*

d *Night: Rocky Inlet, with Fisherfolk setting their Nets, cooking and drinking*
Signed on stern of rowing-boat: *Joseph Vernet/f. Romae/1751*

Oil on canvas. Each 99 × 134·5 cm (39 × 53 in)
Uppark, West Sussex

a

The idea of painting sets of landscapes or marines illustrating *The Four Times of Day* was an 18th-century one (cf. under cat. no.19).[1] Painters in the 17th century, if they paired landscapes at all, generally preferred to maintain a unity of mood or mode between them. Contrast was less favoured, though Poussin did on one occasion pair 'Calm' with 'Storm', while Claude sometimes set chill, grey 'Morning' off against balmy, orange 'Evening'.[2] Vernet's aim was to introduce as much variety as possible into his compositions, and to paint the quintessence of certain types of scenery rather than particular spots. The scenes are also all coastal, so as to display the effects of light and atmosphere both at sea and on land. And, as he wrote of a later set of *The Four Times of Day*, 'these pictures are made to act together [*jouer leur rolles ensemble*] and to set each other off'.[3]

The first scene, *Morning*, shows the mists gradually lifting, revealing the 16th-century lighthouse of Naples, '*la lanterna del Molo*', as fishermen haul in their boat after a night's work, and individual anglers make their catches. *Midday* has a sudden storm, of the kind that can unexpectedly develop in the Mediterranean. *Evening* shows cargo being disembarked from wherries, with spectators,

including Turks, come to enjoy the scene and the evening air. The oriental figures, the fortifications, and the grand-ducal crown over the armorial cartouche on these, are all intended to convey a suggestion of Leghorn (Livorno), the port through which most of the British entered Central Italy. *Moonlight* shows a rocky inlet, with fishermen setting their nets, and others gathered round a fire, or smoking and drinking. These were scenes that Vernet was to paint, in a kaleidoscopic variety of settings and staffage, throughout his career, but rarely again with such freshness and refinement.[4]

18th-century collectors liked to commission paintings in pairs or sets (cf. cat. nos.54, 55), as they frequently used them for overdoors, overmantels and a variety of other decorative purposes. If the requirement ever irked Vernet, as it did many of his contemporaries, he was too professional to show it. His father, Antoine Vernet, had been a decorative painter in his native Avignon, and Vernet himself had already painted a dozen overdoors for the *hôtel* of his patron, the marquise de Simiane, in Aix (1731–2), before leaving Provence in November 1734 for Rome. Here he painted almost exclusively for his compatriots and the British, and was to remain until 1752.

b

c

When Vernet began his *livre de raison* (account book)[5] in 1735, his commissions were from the first regularly for pairs of pictures – to begin with, marines, without mention of their character.[6] Sometimes just one subject was specified by the client, and the rest were left to Vernet himself: '*à ma fentesie* [*sic*]'. He probably painted his first *Four Times of Day* in 1738/9, when Paul-Hippolyte de Beauvillier, duc de Saint-Aignan (1684–1776)[7] commissioned 'an overdoor of a moonlight, to make a pendant to the three others that I have already painted for him'.[8] In 1745, for the first time, Vernet records specifically being asked to produce a set of four pictures on this theme, and then it was for an Englishman, 'M. Draik Anglois': William Drake (1723–96) of Shardeloes, Bucks,[9] who was travelling in a party in Italy in 1744–5.[10] Drake's travelling companion, James Dawkins (1722–57), also commissioned a pair of marines (representing a [morning] mist and a storm [at midday]), and a pair of landscapes (representing a sunset and a moonlight), which were clearly another treatment of the same subject.

Dawkins's and Drake's purchases were made in the very year that Vernet married an Irish woman, Virginia Cecilia Parker, daughter of Mark Parker, a captain in the Papal navy, who thereafter sometimes acted as Vernet's agent, and

also helped to swell the number of Vernet's British clients.[11]

In late 1750 'M. Latheulier' ordered a set of four marines, along with two landscapes with waterfalls, which were supposed to be completed by April 1751. That latter month 'Mons. le chevalier Featherston-Haugh' commissioned a set of four pictures – two marines and two landscapes – whose subjects were left to the artist's '*fantaisie*', but which would almost certainly have been another set of the *Times of Day*.[12] These patrons were Benjamin Lethieullier (1728/9–97) and his brother-in-law, Sir Matthew Fetherstonhaugh, 1st Bt (?1714–74), who were each making the Grand Tour between 1749 and 1752, and met up in Rome, forming the family party described in cat. no.55. In March 1752 Lethieullier commissioned a further pair of pictures, '*a ma fantasie, paysage ou marine*',[13] on behalf of his brother-in-law, no doubt so that Sir Matthew would also own six pictures by the artist. The last – and only other recorded – payment, for a 'little picture', was made by '*le frère de M. Lathullier*',[14] i.e. Benjamin's travelling companion and half-brother, Lascelles Raymond Iremonger (1718/19–93). Before the 1989 fire, there were at Uppark one set of the *Times of Day* (the pictures exhibited here) and two *River Landscapes* by Vernet, together with superb copies by Vernet's former

d

studio assistant, Charles-François Lacroix de Marseille (c.1700–82), of three of the former and one of the latter. Matching these with the complicated and poorly documented original commissions is far from easy.

It has generally been assumed that Vernet failed to complete the second set of *Times of Day* and pair of landscapes commissioned by and on behalf of Sir Matthew before leaving Rome for France in the second half of 1752; and that Lacroix was asked to step in to fill the breach with replicas.[15] However, the pictures by Lacroix at Uppark are all signed and dated 1751, like the Vernets, which they copy with such consummate fidelity that they must have been made directly from the originals, before their dispatch to England. Indeed the copies may even have been under way *before* Sir Matthew placed his order in April 1751. It therefore looks as if what we have at Uppark are Benjamin Lethieullier's original commission of 1750, together with a partial set of replicas, made not for Sir Matthew, but for Lethieullier's travelling companion, Lascelles Iremonger, who, though the older man, as a younger son did not have Benjamin's resources, and so could afford only copies.

There is no record of Vernet ever fulfilling his commission for Sir Matthew.[16] Those pictures painted for Lethieullier, including the present set, probably first hung at one of his houses, Belmont in Middlesex, or Middleton in Hampshire. If Iremonger did own the Lacroix replicas, he probably left them in 1793 to Lethieullier,[17] who would have left both sets to his nephew, Sir Harry Fetherstonhaugh, in 1797.[18]

HIST: commissioned by Benjamin Lethieullier (1728/9–97) from the artist in late 1750, to be completed by April 1751; presumably left by Lethieullier to his nephew, Sir Harry Fetherstonhaugh, 2nd Bt (1754–1846); thereafter, by descent and bequest, at Uppark, until ceded to HM Treasury in partial lieu of death-duties in 1965, and transferred to the National Trust.

EXH: *Claude-Joseph Vernet*, Kenwood, and Musée de la Marine, Paris, 1976–7, nos.29–32 (shown in Paris alone; only *Morning* and *Midday* illustrated); *Souvenirs of the Grand Tour*, Wildenstein, 1982, nos.48–51 (*Morning* and *Evening* transposed); *The Treasure Houses of Britain*, National Gallery of Art, Washington, 1985–6, nos.200 (*Morning* [as *Evening*]), 201 (*Midday*); *Patronage Preserved*, Christie's, 1991, no.19 (*Morning* and *Midday*).

LIT: Lagrange 1864, pp.333–4, 361 (transcribing Vernet's *livre de raison*: 'Ouvrages qui me sonts ordonnez': no.116; and 'Ouvrages que j'ay fait': no.42); Ingersoll-Smouse 1926, i, p.61, nos.330–31 (citing Lagrange, unaware of the pictures' whereabouts).

6

THE CABINET

'I do not care for the Teniers you mention', wrote the 4th Earl of Chesterfield in 1749 to his godson, Solomon Dayrolles, then Resident at The Hague, 'both my picture-rooms being completely filled – the great one with capital pictures, the cabinet with *bijoux*'.[1] There were few people then, and not many even in the heyday of British collecting during the next 100 years, who ordered their collections so systematically; but, as he admitted to a French correspondent, 'I have arranged the majority of my rooms [in the London house just built for him by Isaac Ware] entirely *à la Françoise*.'[2] In most English houses, the smaller pictures were either distributed throughout the rooms, or used to complement the larger pictures in saloons and picture galleries (see p.118). At exhibitions, such as those of the Royal Academy, the frequent complaint was that they were just flung up wherever there was a space for them – often in the topmost register;[3] the early 19th-century hangs at Petworth and Wentworth Castle were almost as crowded and chaotic.

The idea of segregating smaller and more precious pictures into a special room of appropriate scale probably had its immediate origin in the way in which the pioneering group of Dutch and Flemish pictures in the Orléans collection was displayed in the Palais-Royal in Paris.[4] But, further back than that, it had its roots in the Renaissance *Kunst- und Wunderkammer*, or 'cabinet of curiosities'.[5]

The Anglo-French word 'cabinet' – right from its origins in the medieval Latin, *cabana* or *capana*[6] – had a dual meaning: on the one hand, that of a small room in which such items or collections were kept (or, in French, that of the 'collection' itself); and on the other, that of the lockable piece of furniture with drawers in which precious items or collections were shut away. The Cabinet Room at Stourhead, indeed, plays on this ambiguity, taking its name from the *pietra dura* 'Cabinet of Pope Sixtus V' that still stands in it.

The first such rooms of which we know combined small size and singularity with cupboards, and were places of quiet retreat. In Francesco I de' Medici's *Studiolo* in the Palazzo Vecchio in Florence the cupboards containing the treasures were adorned with highly refined pictures, which were painted especially for it, rather than being collected at a great price.[7] Such had also been true of earlier *studioli*, whether the cupboards of treasures were fictive – as with the *intarsie* of Federigo da Montefeltro's *studioli* in the palaces of Urbino and Gubbio – or real – as with Isabella d'Este's successive *studioli* in Mantua, or Alfonso d'Este's *camerino d'alabastro* in Ferrara. One generation's commissions inevitably became

Detail of Breughel and van Balen, *The Four Elements: Fire* (60b)

the collections of succeeding generations; sheer accumulation, combined with the displacements of paintings caused by successive transformations of princely palaces and their decorative schemes, will have created pressures for rooms more specifically devoted to pictures. But it was above all the entry upon the scene of certain passionate collector-rulers anxious to possess works by past as well as present masters – especially those by such seemingly unsurpassable artists as Raphael, Dürer, Correggio, Holbein, Bruegel, Bosch and Titian – that brought pure picture galleries and cabinets into being: such men as the Grand Dukes Francesco I and Ferdinando I de' Medici of Tuscany, Duke Vincenzo I Gonzaga of Mantua, King Philip II of Spain, and the Emperor Rudolph II in Prague.[8]

In Britain, Henry, Prince of Wales (1594–1612) might have fulfilled such a role, but for his premature death. His younger brother, Charles I (1600–49), instead became the greatest collector that this country has ever seen; yet the urge to collect, the beginnings of the collections themselves, and 'the Keeper of our Cabbonett Roome', Abraham van der Doort (c.1575/80–1640), were all inherited by Charles from Henry.[9]

A 'Cabbonett Roome' was begun for Prince Henry in St James's Palace shortly before his death in November 1612, but – in view of the fact that the long gallery there had only just been wainscotted to take the collection of pictures that he was accumulating – it seems probable that it was simply intended to house coins, medals and sundry other precious items, in the 'cubboards' or 'cabbonetts' from which it took its name, with small bronzes arranged about them.[10] On his accession in 1625 Charles I broadened the scope of Van der Doort's appointment, to make him additionally Overseer, or Surveyor, of 'all our pictures of [i.e. belonging to] Us, Our Heires and Successors'. Around 1637 he also created a 'new erected Cabbonett roome' in the Privy Gallery at Whitehall, which was to contain not only all the old cupboards or cabinets holding coins, medals, miniatures and so on that had been in the previous Cabinet Room in St James's Palace, but also paintings as well.[11]

We know from Van der Doort's manuscript *Book of all such the Kings Pictures As are by his Maiest⁵. Especiall appoyntment placed at this present time remayning in Whitehall* (1638 ff.), exactly what this contained and how. There were 74 paintings, almost all measuring less than 2 ft – and mostly less than 1 ft – in any direction. The exceptions were clearly centre-pieces of extreme preciousness: Titian's *Lucretia* (at 3 ft 2 in × 2 ft 1 in, the largest picture there); Rubens's *modello* for the Banqueting House ceiling, itself deployed on the ceiling; Raphael's *Mystic Marriage of St Catherine*; and Leonardo da Vinci's *St John the Baptist*. Mingled with the pictures were six bas-reliefs in silver, hone-stone, ivory and wood. 39 other reliefs in – probably gilt – bronze, most seemingly by the Van Vianens, were either disposed in the window-bays (since they would not suffer from exposure to direct light), or as yet unplaced. Scattered through the room were 35 statuettes in bronze, terracotta and wood, and alabaster, and a silver candlestick by Christian van Vianen. The 75 miniatures were kept in cupboards, more being added between 1637 and 1639.

There were 54 books, 36 of them relating to the Order of the Garter, five relating to medals, three emblem-books, and the others chiefly bound volumes of prints and drawings. Then, kept in leather-lined drawers, there were the medals themselves, over 300 of them in gold, silver and bronze. Finally, indicating that this new 'Cabbonett Roome' still harked back to its roots in the earlier tradition of 'cabinets of curiosities', there was a whole miscellany of objects: engraved copper plates and chased silver plates, drawings, wax models, ivories, scientific instruments, crystals and 'a peece of a Lanscept [landscape] wrought in the manner as they doe make turkey Carpetts worke'.[12] Everything belonged to the realm of *artificialia*, and almost everything was figurative.

What similar cabinets there may have been in other palaces,[13] and in the houses of other collectors, we do not know, because of a lack of documentary evidence, and because most of the major collections were broken up by the Civil War and the Commonwealth, like the Royal Collections themselves. We are, however, remarkably fortunate that Ham House retains a substantial portion of a cabinet of little pictures and miniatures, installed in their original setting – the Green Closet – which may have housed some of them as early as the reign of Charles I. Regrettably, we do not in fact know what the room contained after it had been transformed for William Murray (c.1600–55), later 1st Earl of Dysart, around 1637–9, when a complete ceiling of tempera paintings by Franz I Cleyn (1583–1658) was added. Our first record of it, in what is probably his posthumous inventory of c.1655, is only one of furnishings and hangings, which were 'of greene stuffe' (always thought a good background for pictures), from which the room later took its name.[14]

By the time of the next inventory, that of 1677, the room had acquired 'two Japan Cabinetts', 'one table done with silver', 'A black Abinie [ebony] box', together with 'Nyneteine pictures with guilt frames' and 'Therttie eight of black Abinie frames'.[15] From the '*Estimate of Pictures*' drawn up separately from the inventory of 1683, we can see that this distinction between gilt and ebony frames is, in part, one between pictures proper and miniatures, although many of the former were in ebony frames too.[16] Neither here, nor anywhere else in the house, however, were there any 'curiosities'. For the fashionable Duke and Duchess of Lauderdale, who extended and refurnished the house from 1672, they were clearly an outmoded taste.

Ham is an exceptional survival, but it was also probably a rare phenomenon even in its own day. William Sanderson in his *Graphice* (1658), for instance, has a whole chapter of recommendations on where 'To place the Pictures within Doors'. However, he makes no mention of a cabinet, under that or any other name: a special small room for little, precious pictures.

In the next century, it is equally difficult – outside the context of the royal palaces – to find other instances of quite this kind. Horace Walpole's own Tribune at Strawberry Hill in Middlesex was an act of conscious but miniaturised homage to the *tribuna* of the Uffizi, but like much of what Walpole did, it was unique.[17] Indeed, in a 'Villa and Collection, in which

almost everything is diminutive',[18] it is invidious to single out any one room as a cabinet, while none was a cabinet purely of pictures. In his manuscript *Journals of Visits to Country Seats &c.*, he reports only one instance (whether by name or description), besides Ham, of a pure picture cabinet – at Stourhead – together with one late example – at Burghley – of a cabinet of curiosities. This last contained a few paintings, but many more miniatures, enamels and such items as 'a Crystal Vase adorned, in the front a cameo of Queen Elizabeth, a fine casket with cameo of Henry 8th & his three children, enameld ring, & triangular Saltseller, that were Queen Elizabeth's'.[19]

It was only what might be called the 'prodigy collections' – such as Houghton, Wilton, or Devonshire House in London – that seem to have had anything like a picture cabinet, primarily devoted to pictures and of the smaller sort.[20] Northumberland House in London contained an unusual feminine example: 'her Ladyship's closet is even a repository of curiosities, and, among other valuable things, contains so fine a collection of pictures, as to afford a most pleasing and almost endless entertainment to a connoisseur'.[21] It is also surely significant that, in order to paint a portrait of Sir Lawrence Dundas as the connoisseur of Dutch and Flemish pictures that he undoubtedly was (see cat. no.61), Zoffany had to amalgamate the hangs of two different rooms, to make him appear to be sitting in a picture cabinet in his house in Arlington Street.[22]

Henry II Hoare 'the Magnificent's' Cabinet Room at Stourhead was a classic picture cabinet, composed exclusively of pictures painted in Italy, to accord with the Italian origin of the *pietra dura* cabinet. The central painting, Poussin's *Rape of the Sabines* (Metropolitan Museum, New York), was large, but none of its satellites seems to have been. At least two of the more precious paintings in it (both still at Stourhead) were on copper: a *Flight into Egypt* by Maratta, and a *Marriage of St Catherine* then believed to be by Barocci, but in fact by Calvaert (cat. no.58). All the pictures that we know of seem to have been in particularly fine – often French – frames.

All this was, however, disrupted by Sir Richard Colt Hoare (see cat. no.11), when he rationalised the picture-hangs throughout the house around 1800, and created a larger, semi-detached picture gallery. He kept the eponymous Italian cabinet in its niche, but made no attempt to ensure that the paintings were of the same school. Instead, in his own words: 'This room is devoted exclusively to Landscapes, of which it contains a very pleasing variety.'[23] In this, he seems to have been following what might almost be regarded as an 18th-century trend within the English tradition of picture cabinets: to make them cabinets of landscapes. Thomas Coke, Earl of Leicester (1697–1759) had devoted one room of Holkham entirely to landscapes, no fewer than seven of them by Claude.[24] In the King's apartment at Buckingham Palace, one room was 'of very fine Landscapes'. And, in that most precious of all survivals, the Cabinet at Felbrigg, not only is the whole tone set by the six large oils and 26 little gouaches by G.B. Busiri (1698–1757), all of Rome and its environs, but nine of the other sixteen pictures there were landscapes as well (including cat. no.57), and the rest mostly marines and flower-pieces. At Holker Hall, the collection formed by Sir William Lowther, 3rd and last Bt (1727–53), consisted of almost nothing but landscapes.[25]

Cabinets devoted exclusively to a group of works of art in a particular medium, or by one artist,[26] seem, even in the 19th century, to have been more common than rooms hung only with cabinet pictures, and removed from other use.[27] Such was the case even following the great influx of paintings into Britain from the Continent during the French Revolution and after, and the consequent whole-hearted adoption of the French 18th-century taste for exquisitely finished Dutch and Flemish pictures of cabinet size. An important, albeit short-lived, exception was the Grand Drawing Room at Fonthill Abbey. Its name was a misnomer, as, following his ostracism (see cat. no.9), William Beckford could not entertain. Instead, it contained some of the exceptional pieces of French furniture and *objets d'art* in his collections, and many of his choicest and smaller pictures. As John Cornforth has noted, its real significance is that it broke with the tradition of hanging pictures to complement the design of a room, by situating them instead in relation to the eye of the beholder.[28]

One of the reasons for the appeal of smaller – and especially Dutch and Flemish – pictures was that they could be lived with. For Gustav Waagen, this had the same beneficent moral influence on the collecting classes as the creation of free public museums and galleries was intended to have on the population at large: 'I cannot refrain from again praising the refined taste of the English for thus adorning [with paintings] the rooms they daily occupy, by which means they enjoy, from their youth upward, the silent and slow but sure influence of works of art.'[29]

Perhaps more significant than the picture cabinet *per se* were those exceedingly select cases where everything in a collection had been so carefully chosen and placed, that, in effect, the whole house became a cabinet. Just as Strawberry Hill exemplified this in the 18th century, so the banker-poet Samuel Rogers's house in St James's Place did for the first half of the 19th century, and Sir Brinsley Ford's does in our own.[30] In praising Rogers's collection, Mrs Jameson extends the concept of the cabinet to embrace the house as a whole:

To select a cabinet of pictures which, within a small space, shall include what is at once beautiful, valuable, and rare is a matter of time as well as of taste. . . . And if few know how to select pictures, I know nothing that requires more taste, feeling and experience, than their arrangement when selected. . . . A private collection confined to works of one particular class – as the Queen's Gallery [in Buckingham Palace], or Sir Robert Peel's [in Whitehall Gardens] – is less exciting and agreeable than one in which the schools of art are mingled. . . . In short, it is the highest criterion of an exact, as well as an educated taste in art, to select a small collection of pictures of various date, style, and feeling; to hang them in the same room; and so to hang them, that neither the eye shall be offended by inharmonious propinquity, nor the mind disturbed by unfit associations.[31]

May we have achieved what she advocates, in the very different context of this exhibition!

57 Lucas van VALCKENBORCH
(Louvain *c.*1535 – Frankfurt am Main 1597)

A *View on the Meuse with Coal-miners*

Oil on panel. 31 × 44.5 cm (12¼ × 17½ in)
Inscribed on a rock bottom left: *P. BRILL*
Felbrigg Hall, Norfolk

It is ironic that the Meuse valley, one of the cradles of landscape painting in Europe, should also have been the hearth of those great landscape despoilers – coal-mining, and its associated iron and steel industries. Yet there may have been a more intimate connection between the two than might at first appear. On the one hand, mining and forging provided landscape painters with unusual and – at least in their infancy – picturesque subjects, which may have had a local appeal as landscape painting was emancipating itself from the need for religious pretexts, such as the *Flight into Egypt* or the *Temptation of St Antony*. On the other, by encouraging capital formation, mining and industry may have helped to create a clientele with excess capital to spend upon a superfluity such as art. At the same time, this new picture-buying class no doubt liked to see its familiar surroundings and activities reflected in what it bought for private enjoyment and display, rather than for religious or other public function.[1]

Until 1954 the present picture was identified as *A View on the Danube* by Paul Bril (1554–1626), whose false signature it bears, although he never worked by that river, nor ever treated it in his paintings. It was first recognised as an early work of Lucas van Valckenborch by the Rijksbureau voor Kunsthistorische Documentatie in The Hague, and published in 1954 by Jacques Stiennon.[2] It was subsequently, and plausibly, identified as a *View on the Meuse* – although whether of a single site, or of a conflation of sites, remains to be established.

After the *Bildersturm* of 1566, Valckenborch fled from Malines in the summer of 1567, going first to Liège and then to Aachen. He seems to have been so struck by the scenery around the towns on the Meuse that he recorded it in a number of pictures, painted both at the time and subsequently in Antwerp, after his temporary return to Flanders in the second half of the 1570s. These views are already recorded by Karel van Mander in his *Schilderboek* (1604), who says that the Valckenborch brothers and Hans Vredeman de Vries:

> went to Aachen and Liège, where they worked a lot from nature, since the banks of the Meuse and the environs of Liège afford many fine views. Since they were also all skilful performers on the German flute, the three of them enjoyed themselves greatly.[3]

Lucas van Valckenborch seems to have been equally struck by the region's mining industry, since he introduced miners and mines not only into his views, but also into representations of subjects such as the *Tower of Babel*, or the *Crucifixion*.[4] In the present picture, the depiction is restricted to the three miners in the foreground, one already making his way downwards with a hod on his back, towards what is possibly a line of coal-barges on the river. The composition of the landscape appears to have been more influenced by artistic precedent than by any desire for topographical precision. The setting is structured somewhat like that of the *Magdalena Poenitens* in Pieter Bruegel's set of engravings known as the *Large Landscapes*, but in reverse.[5] Although it is in no sense an imitation, Bruegel's example may have encouraged Valckenborch to exaggerate the mountainous character of the terrain.

Coal-mining and iron-founding continued to fascinate Valckenborch throughout his life, since he also included them in a number of the pictures that he produced as a court painter to the Archduke Matthias in Linz (1582–93);[6] he probably repeated some of these depictions during his last four years in Frankfurt. He was not the first artist to paint such subjects, but he did so with surprising frequency. They were already to be found in certain paintings by Herri met der Bles (*c.*1510–50/55)[7] of Bouvignes, near Dinant (also on the Meuse and a centre of metalwork), and by Lucas Gassel (*c.*1500/10–after 1568)[8] of Helmond, who operated in Brussels. Valckenborch's subsequent portrayals, particularly of ironworks, give them much greater prominence.

Like virtually every painting in the Cabinet at Felbrigg, this appears to have been acquired by William II Windham (1717–61) when on the Grand Tour (1738–42); it is described on the diagrammatic picture-hangs that he drew up in early 1752, as '*View on the Danube*, by P. Brill'.[9] The ascription to the Rome-based Bril might mean that Windham had acquired the picture in that city, but he spent much more of his time abroad in Geneva, and also seems to have bought pictures on his return through the Low Countries in 1742. The frame is one of a whole set, of differing Rococo patterns, made for this room and for the Great Parlour (now the Drawing Room), probably by the Huguenot René Duffour of Soho, better known as a supplier of papier-mâché ornament.[10] The room as a whole is an epitome of the Grand Tour, devotedly preserved (apart from its furniture) by the successive families that inhabited it.

HIST: presumably acquired by William II Windham (1717–61), first
recorded on his hanging-plan for the Cabinet at Felbrigg in 1752; thence
by descent (and once by purchase, in 1863, when John Ketton bought
the estate from the banker of the bankrupt William Frederick 'Mad'
Windham), until 1969, when estate, house and all its contents were
bequeathed to the National Trust by Robert Wyndham Ketton-Cremer
(1906–69).

EXH: *17th Century Art in Europe*, RA, 1938, no.63 (as *View on the
Danube*, by Paul Brill); *Flemish Art*, RA, 1953, no.304 (as the same);
Fine Paintings from East Anglia, Castle Museum, Norwich, 1964, no.73
(as *View on the Meuse* by Lucas van Valckenborch); *Between Renais-
sance and Baroque*, City Art Gallery, Manchester, 1965, no.230 (as the
same); *Dutch and Flemish Painting in Norfolk*, Castle Museum,
Norwich, 1988, no.38 (as the same).

LIT: Stiennon 1954, p.21, no.34 (as *Paysage rocheux*, by Lucas I van
Valckenborch); Wied 1990, pp.136–7, no.14 (as *Flusslandschaft*;
claiming that the background is overpainted, of which no indication
has emerged in conservation); *Felbrigg* 1995, p.60, no.38, and col. fig.
on p.61.

58 Denys CALVAERT (Antwerp *c.*1540 – Bologna 1619)

The Mystic Marriage of St Catherine of Alexandria

Oil on copper. 47.5 × 38 cm (18¾ × 15 in)
Stourhead, Wiltshire

The betrothal of St Catherine to the infant Christ with a ring is an essentially visual tradition. It developed out of the words – themselves taken from the ecstatic language of medieval mystics, with which, according to *The Golden Legend*, this entirely apocryphal saint is supposed to have spoken of Christ to her torturer, the Emperor Maxentius: 'He is my God, my lover, my shepherd, and my sole spouse.' She wears a crown, to denote the fact that she was supposedly the only daughter of a king called Costus. The broken wheel is emblematic of the Emperor's attempt to put her to an exemplary death by having her cut up by two countervailing wheels with blades attached to them. This was thwarted by an angel with such force that they exploded, destroying 4,000 spectators. The saint's actual martyrdom – in token of which the child-angel holds a palm frond behind her – was by decapitation.

The betrothal is here performed by the Virgin Mary, who is seated on a throne and under a baldachin, as the Queen of Heaven, and acts as St Catherine's sponsor. The Virgin's mother, St Anne, holds the Christ Child, who sits on a cloth-covered cradle that foreshadows both his tomb and the altar on which he is offered as a daily sacrifice in the Mass. Behind them is the infant St John the Baptist, clutching his emblem, the lamb, and another martyr's palm. St Joseph looks on from behind, and a glory of child-angels swoops down from above, bringing a circlet of eternity, in exchange for Catherine's earthly crown.

All this is highly Catholic imagery, making much of the very things – the cults of the Virgin, saints and angels – that the Protestant Reformers had denied. Calvaert's loving, almost playful, treatment of them seems to set his art apart from that of the next generation in Bologna, the Carracci, whose art has stronger ties with the Counter-Reformation emphasis upon the central christological mysteries of the faith promulgated by Bishop Paleotti of Bologna (see cat. no.46). The reform of painting in Bologna from the 1570s on developed in two overlapping stages, which find a parallel in the art schools established there. The first was set up by Calvaert after his return to the city from Rome in 1575, and its pupils included Guido Reni, Domenichino and Albani. The second was the so-called Accademia degli Desiderosi or Incamminati, founded by the Carracci around 1582–3, to which all three of these artists later transferred. The essential difference between the two was that Calvaert's was primarily a traditional studio, in which artists learnt to work with his methods and in his style, whereas the Carracci's was intended to take its students back to first principles – above all, back to the study of selected nature.

Calvaert, in turning himself from a Flemish into an Italian artist, went back to the same High Renaissance models as the Carracci – to Raphael and Correggio, in particular – but tended to do so in a spirit of imitation of their paintings, rather than by taking them as guides to the imitation of elevated nature. Thus, the overall idea for this composition would appear to be indebted to Raphael's *Great Madonna of François I^er* (Louvre), with further inspiration for the pose of the Christ Child from his *Madonna del Divino Amore* (Capodimonte, Naples). The delicate little features of the Virgin and of St Catherine, and the general sweetness, derive from Correggio's much-copied treatment of the subject now in Capodimonte, but then in the Farnese collections in Parma.[1]

Calvaert treated the Mystic Marriage of St Catherine in a number of paintings. That from the Sacchetti collection in the Musei Capitolini, Rome,[2] probably provides the best evidence for the dating of this picture, as it is very close in style, and bears traces of the signature and date: *DIONISI CAL ... 1590*. The composition is essentially the same, but in reverse, and restricted to the figures of the Virgin and St Catherine, St Anne, and the Christ Child, with St John the Baptist peeping from behind St Catherine, where the little angel now emerges with a palm frond. A drawing in the Louvre,[3] from the collection of Alfonso III d'Este, Duke of Modena (d.1644), brings the composition much closer to the present painting.

The Louvre drawing[4] was probably prepared, firstly for a little painting on canvas in the Auckland City Art Gallery that is modelled almost directly on it, but in reverse,[5] and then, as a further elaboration of that, for the present little painting on copper for a collector's cabinet. It seems very likely that Calvaert encountered the works of Johannes Rottenhammer (1564–1625) soon after the latter arrived in Italy in 1589, and was encouraged by them further to miniaturise and intensify the jewel-like brilliance of his colouring. A dating to between 1590 and 1595 therefore seems plausible for the present picture.

HIST: ?a collection in France; acquired by Henry II Hoare 'the Magnificent' (1705–85) – first recorded by the payment of one guinea to 'Collivo' [Collevous] for 'cleaning Barroch' on 29 April 1759;[6] then listed in the Cabinet Room by Horace Walpole in 1762 (as 'Marriage of St Catherine, by Baroccio'); thence by descent until 1946, when given to the National Trust along with the house, its grounds and the rest of the contents, by Sir Henry Hoare, 6th Bt (1865–1947).

LIT: *Stourhead* 1800, p.17 (as 'Marriage of St Catharine, by Frederico Baroccio', in the Cabinet Room); *Stourhead* 1818, p.18; Colt Hoare 1822, p.79 (as 'The Marriage of St Catharine. A beautifully high-finished picture, by Baroccio', in the Picture Gallery); Walpole 1927–8, p.41.

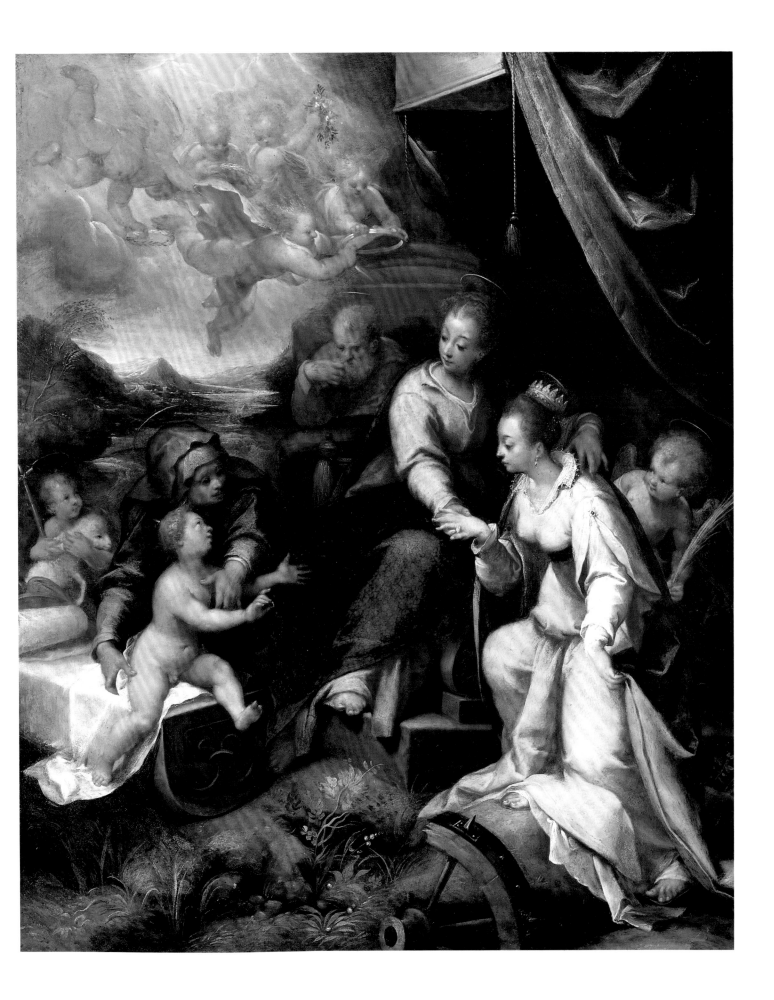

59 Adam ELSHEIMER (Frankfurt am Main 1578 – Rome 1610)

a *St John the Evangelist* e *St Peter*
b *St John the Baptist* f *St Paul*
c *St Thomas Aquinas* g *St Joseph and the Christ Child*
d *Tobias and the Angel* h *The Virgin and St Anne*

Oil on silvered copper. Each 9 × 7 cm (3½ × 2¾ in)
Petworth House, West Sussex

These eight exquisite little pictures belong among the *incunabula* of English collecting. They are identifiable with the 'Ensen Hamor – Eight little pieces' in the posthumous inventory taken in 1635 at York House, the London residence of the assassinated 1st Duke of Buckingham, the greatest collector of paintings in the country before Charles I.[1] While still in Italy, the naturalness of their observation of both human beings and landscape exercised an influence out of all proportion to their size.[2]

As at present constituted, they do not form a complete or coherent group.[3] An identically sized *St Lawrence*, also on copper (Musée Fabre, Montpellier),[4] must once have belonged to the set, as is demonstrated by a set of copies by Cornelis van Poelenburgh in the Uffizi,[5] which includes both one of it and an *Abraham and Isaac*, for which no original is known. These ten paintings are made up of natural pairs: the two *St Johns*; *St Peter* and *St Paul*; *Abraham and Isaac* and *Tobias and the Angel*; *The Virgin and St Anne* and *St Joseph and the Christ Child*; and *St Thomas Aquinas* and *St Lawrence*. Only this last pairing lacks any obvious compositional or thematic link – which might suggest that the set was originally larger still. Such is certainly the implication of a second set of copies by Poelenburgh, which still adorns a Dutch cabinet at Penshurst. These do not include an *Abraham and Isaac*, but add a *St Francis* and a *Mary Magdalene* – neither of which necessarily posits an original by Elsheimer – and a *St Catherine*, which does seem to do so.[6]

One thing is immediately conspicuous about Elsheimer's pairs of figures: that they are not affronted, but in apposition to one another. This encourages the idea that they were intended to flank, perhaps in tiered pairs, some central image or object, which may have been a statue, relief or relic, rather than another picture.[7] The identities of the figures give no very clear indication as to what this central image might have been, nor the place for which it might have been intended. The four images with two figures all include a child, which might point to an orphanage or infant school.[8] The inclusion of *St Thomas Aquinas*[9] would appear to suggest a Dominican client.

The *St Thomas Aquinas* is also more distinctively characterised than any of the other saints: not only does

he stand in front of what looks like the view of an actual church (and convent), but he holds the model of a simplified reduction of it in his left hand. A church is occasionally found as an attribute of Aquinas, sometimes balanced upon a book: it apparently denotes his proclamation as the fifth Doctor of the Western Church in 1567. He is not often portrayed on his own, rather than in the company of other Dominican saints, and never before so specific a location. These little copper panels were therefore probably painted for someone belonging to the Italian convent shown in this picture, with which Aquinas must have had some particular association. At this point, however, speculation fails. None of the places in Italy with which Aquinas was associated ever appears to have borne any resemblance to the Early Renaissance church complex shown behind him.[10] In conformity with the known facts, but against the grain of the iconographic tradition, Elsheimer has also shown Aquinas as decidedly plump: back in Italy, the saint yearned for the fresh herrings that he had enjoyed in Paris! The picture is possibly also a disguised portrait of the client, but Elsheimer may simply have been asked to make the saint look like this. It is anyway in keeping with the wonderful humanity that he has given what would normally have been remote icons.

Painted around 1605, during the final, Roman decade of Elsheimer's short life, these figures have a grandeur beyond their tiny dimensions, which looks back to the sets of saints engraved by Schongauer and Dürer.[11] But what sets them apart, even in Elsheimer's small and precious oeuvre, are the landscape backgrounds. As the late Keith Andrews observed: 'Pastoral calm, wide vistas or nature at its wildest and most mysterious: they belong to the most miraculous details that Elsheimer achieved.'[12]

The early history of these pictures is uncertain. It seems most likely that they took the same route as Elsheimer's *Story and Adoration of the True Cross* (Städelsches Kunstinstitut, Frankfurt), which was painted around the same date. That was acquired from Juan Pérez in Rome in 1619 by Cosimo II (d.1621) for the Grand-Ducal Collections in Florence, only to be sold by 1635, and reach England, already broken up, by the end of the century, if not before.[13] Poelenburgh's set of copies has been recorded in the Grand-Ducal Collections in the Uffizi since 1761, which suggests that he may have made them as replacements for the originals when they were on the point of being sold: he was in Italy between 1617 and 1625, at some point working for

Detail of *St John the Baptist* (59b)

Detail of *Tobias and the Angel* (59d)

the Grand Duke.[14] Moreover, Elsheimer's *St Lawrence* appears to have remained in the Grand-Ducal Collections until at least 1750, only to leave them under mysterious circumstances later; it was bequeathed to the city of Montpellier in 1825 by the painter F.-X. Fabre, after his retirement from Florence.[15] Whether Buckingham had acquired the other eight from Italy, or in Spain, we do not know.

The collection of Algernon, 10th Earl of Northumberland (1602–68) is the only one remaining in Britain of those formed by members of the Court of Charles I, albeit depleted, and now divided between the houses of the two successor branches of the family, the Earls of Egremont and the Dukes of Northumberland. Much of it was assembled in the troubled times of the Civil War and Commonwealth, when, as one of the few magnates on the Parliamentary side, he was in a position to acquire, when most of the Court collectors were forced to sell.[16] These Elsheimers were among the greatest prizes that he obtained as the tenant of the widowed Duchess of Buckingham at York House, from 1640 to 1647, while protecting the interests of her son, the 2nd Duke. He appears to have acquired them after Parliament ordered the sale of the pictures there, having indicated that he was prepared to accept 'some of the smaller pictures in consideration of that money' which Parliament still owed him for his earlier services to its cause.[17] As the 1671 inventory indicates, he put all eight little plates into one frame. In 1752 the 2nd Earl of Egremont had each placed in neat little Rococo frames by Joseph Duffour (cf. cat. no.57), to which they have been restored for this exhibition.[17]

HIST: first recorded as 'Ensen Hamor – Eight little pieces' in the posthumous inventory taken of George, 1st Duke of Buckingham's (1592–1628) pictures, at York House in 1635; then as 'Eight little Pictures in one Frame by Elshammer', valued at £250, in Symon Stone's posthumous inventory of Joscelyn, 11th Earl of Northumberland's (1644–70) pictures at Northumberland House, 30 June 1671 [no.40];[19] passed by the marriage in 1682 of his granddaughter, Lady Elizabeth, the last Percy heiress, to Charles, 6th Duke of Somerset (1662–1748); Algernon, 7th Duke of Somerset (1684–1750); thence to his nephew, Charles, 2nd Earl of Egremont (1710–63), on the division of the collection between him and the 7th Duke's son-in-law, Sir Hugh Smithson, later 1st Duke of Northumberland (1714–76); listed in 'My Lady's Dressing Room' in Egremont House, Piccadilly, in his posthumous inventory of 5–10 Dec 1764; thence by descent at Petworth until the death in 1952 of the 3rd Lord Leconfield, who had given Petworth to the National Trust in 1947, and whose nephew and heir, John Wyndham, 6th Lord Leconfield and 1st Lord Egremont (1920–72), arranged for the acceptance by HM Treasury of a major part of the collections in lieu of death-duties in 1956.

EXH: *Pictures from Petworth House*, Wildenstein, 1954, no.5; *Between Renaissance and Baroque*, Manchester City Art Gallery, 1965, nos.86–93.

LIT: *Petworth* 1856, p.30, nos.272–9, as in the Old Library (according to a MS annotation, transferred to the Red Library); Bode 1880, pp.58, 251, 253–4; Collins Baker 1920, pp.35–6, nos.272–9; Drost 1933, pp.58–62, nos.16–23, pls.20–27; reviewed by Martin Davies in *Burlington Magazine*, lxiv, June 1934, pp.290–91; Weizsäcker 1936, i, pp.112–14, nos.39A–H and figs.45–52; Weizsäcker 1952, pp.33–6, 220–21 nn.222, 223, nos.39A–H; Waddingham 1972, pp.605–6 and figs.17, 18 (suggesting a dating to before 1605, because of their influence on Teniers the Elder, who returned to Antwerp that year); Andrews 1977, nos.17A–H, pp.147–8, pls.53–63, col. pl.IV; Andrews 1985, nos.17A–H, pp.182–3, col. pls.67–74; Gore 1989, p.124, fig.4 (*St Thomas Aquinas*); Wood 1994, pp.283, 305 no.40, and 316 n.16.

a

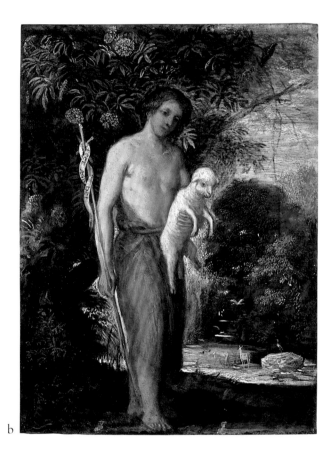

b

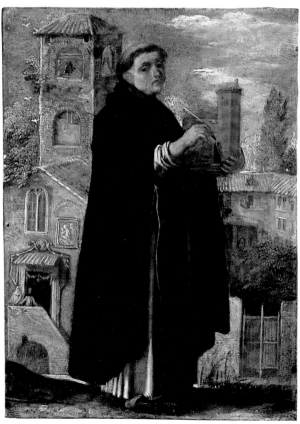

c

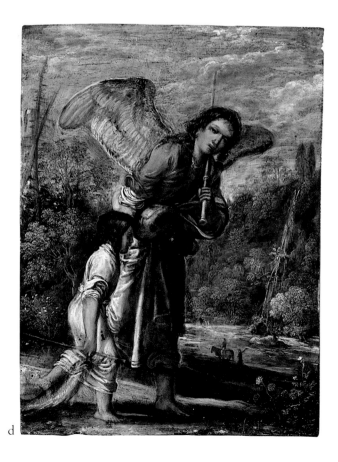

d

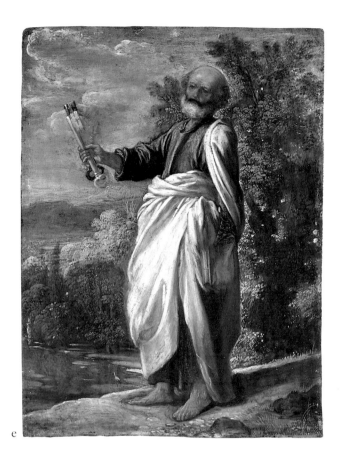

e

f

g

h

60 Jan BREUGHEL the Younger (Antwerp 1601–78) and Hendrik van BALEN the Elder (Antwerp 1575–1632)

The Four Elements

a *Air*
b *Fire*
c *Water*
d *Earth*

Oil on copper. Each 47·5 × 82·5 cm (18¾ × 32½ in)
Kingston Lacy, Dorset

The theory that the material world was composed of four elements was evolved by Empedocles (*c*.450 BC) and promulgated by Aristotle, from whom all medieval science derived. The human significance of these was enhanced by the idea that each governed one of the four humours, of which the body and temperament were supposed to be similarly formed. Hence Sir Toby Belch's question in *Twelfth Night* (Act II, Scene 3): 'Does not our lives consist of the four elements?'

This may help to account for the extraordinary variety of engravings of *The Four Elements* published in the Netherlands, which must in turn have been the immediate inspiration for the idea, though not the form, of the various depictions of them by Jan 'Velvet' Brueghel the Elder (1568–1625). As Brueghel treated them, however, they developed a new dimension, becoming pictorial encyclopaedias of the natural world.

It is no coincidence that some of Brueghel's earliest treatments of the subject should have been for his lifelong patron, Cardinal Federico Borromeo (1564–1631), Archbishop of Milan, as the Cardinal saw art primarily in mimetic terms and such pictures as a *speculum*, or a mirror held up to nature.[1] They were thus well suited to the Biblioteca Ambrosiana, which the Cardinal founded in Milan as a library and picture gallery, giving everyone access to the sources of knowledge and to some of the finest performances of art.

We can gain some idea of the evolution of Jan Brueghel the Elder's sets of *The Four Elements* from his remarkable correspondence with Cardinal Borromeo, and with the latter's right-hand man, Ercole Bianchi, who was also a collector and amateur painter. This is one of the most extensive between an artist and his patrons to have come down to us from before the 18th century.[2] In its latter stages, when Brueghel is concerned about the increasingly capricious progress through Italy, Sicily and Malta of his son, the painter of the present set of pictures, it is also one of the most personal.

The surviving correspondence only begins in 1596, and although there are gaps in it (notably between 1596 and

1605), it seems likely that the first Element, *Earth* (seized from the Ambrosiana by the French in 1796; now in the Louvre),[3] was painted before 1605. It was probably intended originally as a representation of *Paradise* or *The Garden of Eden* (as it is still more commonly called), and only subsequently pressed into service as one of the Four Elements. Alternatively, it began life as the painting of '*Animali*' that pleased the Cardinal, as Brueghel expressed himself delighted to hear on 1 February 1608, but which was sent back to him for some alteration in 1609, perhaps the addition of the little figures of God, Adam and Eve necessary to identify it as *Paradise*.[4] The first that we hear of the Elements is in connection with a painting of *Ceres*, or *Abundance*, that Brueghel announced to Cardinal Federico in a letter from Antwerp dated 8 July 1605.[5] In this, the Elements are both personified by four putti, each bearing appropriate attributes, and represented by a profusion of still-life and zoological detail.

This picture, after a little lapse of time, may have prompted Borromeo or Brueghel to suggest that he take up and multiply these details in single depictions of individual Elements. The Element of which we first hear, *Fire*, is certainly that least adequately represented in *Ceres*, since it is the one most appropriately symbolised (as here) by *artificialia*, or the works of Man, whereas the other three Elements could all be represented by *naturalia*. (Because items in cabinets of curiosities were traditionally divided into *naturalia* and *artificialia*, Cardinal Federico may very well have wished to set one off against the other, if he was already thinking of attaching his collection of pictures to his newly founded Library.) The picture (still in the Ambrosiana) is mentioned as already in progress in a letter of Brueghel's to Bianchi of 26 September 1608.[6] In contrast to the present treatment of the subject, but as in Cardinal Federico's *Earth/Paradise*, the human figures are relegated to the background; and though the picture is described as that of Vulcan's forge in the 1618 list, one is unaware of the presence of the god.

Cardinal Federico may at this stage only have wished to have an example of Brueghel's virtuosity in painting metallic and inanimate things as well as furry, feathered and leafy natural ones. He was certainly in no hurry to order a complete set of *The Four Elements*. That step was instead

a

b

taken by Bianchi, with whom Brueghel had a protracted correspondence between February 1608 and April 1611, over the slow progress of the four pictures.[7] They were in turn probably the originals for the profusion of sets or single pictures of the Elements that emanated from Jan Brueghel the Elder himself, from his son – as in the set shown here – and from a whole host of studio assistants and outside copyists.[8] The popularity of the Bianchi Elements is perhaps explained by the fact that they were 'fatte con figurini nudi' ('done with little naked figures'),[9] unlike the first two painted for Cardinal Federico, of which there are virtually no repetitions.[10]

The Cardinal's set was not completed until much later. He hesitated over commissioning a Water or an Air in 1613, finally deciding in 1614 on the former, which was finished and dispatched via Bianchi the same year.[11] The picture is still in the Ambrosiana, and reveals that the collector's world of the Earth and Fire, as painted for him, had become populated with the putti and mythological figures that characterised Bianchi's Elements. However, a grizzled old river-god takes the place of the nubile young water-nymph found in derivatives of the Bianchi Water, such as the one shown here, perhaps in deference to the kind of strictures upon the seductive dangers of nudes in painting that Borromeo was to express in his De pictura sacra (1624). In the last of his Elements for Borromeo, Air, which was not painted until 1621 (also seized by the French and now in the Louvre), Brueghel went over entirely to his mythological way of depicting them, and in this particular case, did not shrink from painting a nude for the Cardinal.[12]

Much more rigorous and scientific analysis is still required to establish precisely who painted each of the numerous sets of replicas and when. Everything said here is subject to that caution.[13] Because of its quality and closeness of handling to Jan Brueghel the Elder's other works, the present set can reasonably be attributed to Jan Breughel the Younger. The key question is whether it was painted before the artist set out on his journey to Italy in 1622, i.e. in Jan Brueghel the Elder's studio and within his lifetime.

We are fortunate that, among the unusually detailed documentation that we possess for the Brueghels, there is a partial transcription of the detailed account book that Jan Breughel the Younger kept from the moment of his abrupt return for home on hearing in Palermo of his father's death in 1625.[14] Between that date and 1632, the year of Hendrik van Balen's death, only two sets of copies of the Elements are recorded, on one of which van Balen worked. Admittedly, the portions of the account book relating to 1629 and to 1632 itself are missing, but enough survives to make it clear that Breughel the Younger and van Balen were no longer collaborating regularly on this theme. In all the finest sets of Elements, however – including the present one – the figures are by van Balen. Such sets were therefore very probably executed in Jan Brueghel the Elder's lifetime, and under his supervision, by his son. The fact that the figures in the present set are unique suggests even more strongly that it was painted before 1622.

In the case of Fire, no other version has this group of Venus arming Aeneas instead of Venus and her blacksmith husband Vulcan. (Milan was one of the chief centres for the making of fine suits of armour, which may be why Borromeo and Bianchi were particularly gratified to have these products of the furnace given most prominence in this Element.) In the case of Water and Air, no other versions have nymphs or putti in quite these poses or places. In the case of Earth, the same is true, but neither does any other version have the superb pair of leopards stretching and nuzzling. This is perhaps the most telling detail, since it suggests an alteration made at the instigation of – and possibly even by – Jan Brueghel the Elder himself, rather than by his son. These leopards were one of Brueghel the Elder's happiest inventions, though their pose may originally have been studied or invented by his much more celebrated friend and occasional collaborator, Rubens, who used it in his Nymph and Satyr with Two Leopards (Montreal Museum of Fine Arts).[15]

These pictures are not part of the historic collection of Kingston Lacy, not being recorded there before 1905. We know nothing of their earlier provenance. Since virtually no other Old Masters were added to the collection after the death of William Bankes in 1855,[16] they must have been bought by Walter Ralph Bankes's widow, née Henrietta Fraser. Her only other pictorial patronage appears to have been the commissioning of very Edwardian watercolours from Mary Gow, Mrs Sydney Prior Hall.

HIST: acquired after 1905, probably by Henrietta Fraser, Mrs Walter Ralph Bankes (d.1953); bequeathed by her son, Ralph Bankes (1902–81), to the National Trust, together with the entire estates and contents of Corfe Castle and Kingston Lacy.

LIT: *Kingston Lacy* 1986, p.24; 1994, p.58.

c

d

61 David TENIERS the Younger (Antwerp 1610 – Brussels 1690)

The Card Players

Oil on panel. 46 × 58.5 cm (18 × 23 in)
Signed bottom left: *D. TENIERS. F.*
Polesden Lacey, Surrey

The indoor tavern scene is one of the quintessentially Dutch types of picture, yet also one of the most surprising, when viewed in the context of traditional pictorial themes. It represented a turning to the activities of the everyday life of common people, as decisive in its day as that of the Impressionists in the 19th century, but with barely any precedent save the art of Pieter Bruegel. It is therefore a little disconcerting that the genre should have been invented, not by a Dutchman, but around 1625 by one Fleming, Adriaen Brouwer (1606–38) from Oudenaarde, and that it should have been taken up and given some of its finest expression by another, David Teniers of Antwerp.

Brouwer's innovation, by comparison with such precursors as David Vinckboons (1576–1632) or Adriaen van der Venne (1589–1662), was to show boors rather than gentlefolk, and to depict them indoors, in taverns or simple interiors, rather than cavorting in the open – and with less supercilious or satirical intent. His paintings always have more movement than Teniers's – brawls are frequent – and the interiors are more cramped; but he put all the essential elements in place. As time went on, he restricted the tonal range of his pictures to a limited palette of browns and greys, against which only the odd cap or blouse stands out as a note of lively colour.[1]

Teniers introduced a greater element of spaciousness and calm; more minutely particularised figures, often of slightly higher social status; an increased emphasis upon still-life elements; and a lighter, blonder colouring, with the background colour of the walls tending more towards silvery grey than brown. The impression conveyed, as in the tavern pictures of his contemporary in Holland, Adriaen van Ostade (cf. cat. no.62), is of simple enjoyment of such things as ale, tobacco and cards, and of cheerfulness. One can see why their works were so sought after for the prime collectors' cabinets in Holland and in France in the 18th century. By contrast, these collectors neglected Brouwer, whose works had, however, been particularly popular in his own lifetime among fellow-artists: Rubens owned no fewer than seventeen of his paintings, and Rembrandt six, a copy and a sketchbook.[2]

Teniers's earliest pictures of the kind date from 1633; tellingly, they were often misattributed in the past to Brouwer.[3] The importance that he ascribed to them can be gauged from the fact that in the earliest of his 'Gallery Interior' pictures, of 1635 (private collection),[4] he places one of them in the foreground, the foremost of a group of five of his own pictures being examined by two youthful connois-

seurs. His *Backgammon Players* (also at Polesden Lacey) must date to only two or three years after these, yet it shows the artist already distinctively and recognisably himself.[5]

The present painting is also a relatively early work, datable to the early or mid-1640s, as are four other pictures of card players; one of these, '*Le bonnet blanc*' of 1644 (private collection), was so celebrated that it simply took its name from the most distinctive note of colour in the painting.[6] All of these are situated in the same L-shaped space, with the game of cards taking place in the well-illuminated, transverse, stage-like section at the front. Figures sit at fireplaces in the darker section going back at a right-angle from this. Three of them have a niche containing a carafe of wine (almost like a secular equivalent of the piscina in a church). All four have an opening high up in a wall, two with an earthenware pot in, and two with an onlooker (in the Louvre's picture, a crone, as here) peering at the card players, with a window behind. This last feature, which almost amounts to a signature of Teniers's tavern scenes, seems first to appear in a painting of 1635 in a private collection in Madrid.[7] All but '*Le bonnet blanc*' (which has them on the left-hand side only) have groups of still-life elements, including a trestle bench and a pitcher with a handle in both foreground corners.

The left-hand card player appears to be painted from the same model as the one in a similar position in the National Gallery's picture, and in turn to be the same as (if slightly older than) the man having his foot dressed in *The Village Doctor's* (1636; Szépmüvészeti Museum, Budapest).[8] The other card player, by contrast, does not appear to recur in any other painting by Teniers, and is unusual in looking out at us, as if to draw us in to the picture. He also wears slightly smarter clothes, with ribbons on his shoes and knickerbockers, and a broad linen collar. One might almost expect him to be a self-portrait, but he bears no resemblance to Teniers; he certainly has the particularity of a portrait, however: perhaps he was a fellow-artist or connoisseur.

One of the greatest connoisseurs that this country has known was responsible for importing this picture to England: Sir Lawrence Dundas, 1st Bt, of Aske (*c*.1710–81). Tantalisingly, it is just off-screen in Zoffany's celebrated conversation-piece of him in a composite interior of his house in Arlington Street (Marquess of Zetland).[9] Its factitious pendant is the lower of the two pictures visible on the right-hand wall.[10] They were two of no fewer than ten paintings by Teniers bought for Dundas in Paris by the dealer, and later auctioneer, John Greenwood in 1763, four of which came from 'ye Marquis of Gravelle, who is changing his fine flemish Masters for to place ye Taudry french ones'.[11]

Its roll-call of owners thereafter is almost as distinguished.

The most notable was William Wells (1768–1847), better known for his patronage of living artists (particularly Landseer), and for the gardens at Redleaf, his house near Penshurst (which reputedly introduced crazy paving to Britain).[12] His 17th-century Dutch and Flemish 'low-life' pictures, including four more by Teniers, chimed perfectly with his acquisition of Wilkie's *Distraining for Rent* and of a sketch for his *The Village Festival*. The most elusive owner is George Field, whose extraordinarily rich loan of *objets d'art* and furniture to Marlborough House (the temporary home of the future Victoria & Albert Museum) in 1856 also comprised a 'Collection of twenty-five Dutch and Flemish cabinet pictures', including this and one other Teniers.[13]

This picture is at Polesden Lacey because it is one of many fine Dutch works inherited by Mrs Greville (see cat. no.15) from her father, the brewery millionaire William McEwan (1827–1913). Teniers was the only artist he represented by more than one painting – and then by three, two of which (whether consciously acquired as such) are tavern scenes.[14]

HIST: ?[Louis-Robert Malet, comte] de Graville (1698–1776), from whom bt with the *Journeymen Carpenters* by Sir Lawrence Dundas, 1st Bt (c.1710–81); the posthumous sale of his collection, Greenwood's, Leicester Square, 29–31 May 1794, 2nd day, lot 35; Edward Coxe[15] (d.1814), of Hampstead; his sale, Peter Coxe's, 23–5 April 1807, 2nd day, lot 66 (bt by Birch or Hammond); (by 1821) William Wells, of Redleaf (1768–1847); his sale, Christie's, 12–13 May 1848, 2nd day, lot 108; George Field, of Ashhurst Park, Tunbridge Wells, by 1856; his sale, Christie's, 10 June 1893, lot 35; bt Lesser Adrian Lesser, by whom sold the same year to William McEwan, MP (1827–1913); by whom bequeathed to his daughter Margaret, Mrs the Hon. Ronald Greville (d.1942); by whom bequeathed, along with Polesden Lacey, the contents of her house in Charles Street, London, and the rest of her collections, to the National Trust in 1942.

EXH: BI, 1821, no.12; 1843, no.74; 1851, no.63; Marlborough House, 1856; *Art Treasures Exhibition*, Manchester, 1857, no.1028; BI, 1865, no.11; RA, winter 1871, no.122.

LIT: Smith 1831, iii, no.353, p.353; Waagen 1854, ii, p.335; Waagen 1857, p.192; *Polesden Lacey* 1964, no.59, p.28; Sutton 1967, p.212, appendix 7(xv).

62 Adriaen van OSTADE (Haarlem 1610–85)
Boors merrymaking outside an Inn

Oil on canvas. 47·5 × 38 cm (18¾ × 15 in)
Signed on table bottom left: *A V* [in ligature]
Ostade 167[0 or 9]
Ascott, Buckinghamshire

Haarlem was second only to Amsterdam in the number and quality of the artists who were born or settled there in the 17th century. At first sight, this might seem surprising, as although Haarlem was one of the historic cities of Holland, it was not a great trading or administrative centre, neither was it the seat of a university. It owed its prosperity to linen-weaving and brewing.[1] In 1583, however, two artists displaced from the Southern Netherlands by the religious and political upheavals of the period, Karel van Mander and Hendrik Goltzius, had come together with Cornelis van Haarlem to found an informal 'academy' in the city.[2] The Haarlem painters' guild, like that of Delft – another city productive of artists – retained its vitality in the 17th century, undergoing a significant reform in 1631.[3] The quality of artistic training, and the emphasis on craft specialisation and standards that these two phenomena imply, may help to account for the extraordinary variety of branches of painting that Haarlem-based artists mastered: landscape[4] (Jacob van Ruisdael),[5] portraiture (Frans Hals), history painting (Salomon de Bray), still-life (Willem Claesz. Heda) and church interiors (Pieter Saenredam).

One of the most influential of the incomers, Adriaen Brouwer (Oudenarde 1606–Antwerp 1638), introduced yet another speciality: interior scenes of low life. He was reputedly a pupil of Frans Hals when he first went to Haarlem (though there is conflicting evidence as to whether this was before or after the first record of him in Holland, which was in Amsterdam in 1625). If this is true, and if it was after 1625, it is just possible that he was a fellow-pupil of Ostade's, whom Houbraken asserts to have studied with Hals around 1627. But since Pieter Nootmans was already hailing Brouwer – with whatever exaggeration – as 'world-famous' in March of that year, any co-pupillage would have to have been earlier than that. There is, however, no evidence that Ostade was as precocious as Brouwer, since the first record of him as an artist dates only from 1632, albeit already on a commission outside Haarlem. Ostade's earliest identifiable paintings[6] are unthinkable without Brouwer, and it was not until the 1640s that he began to develop his own distinctive themes and manner. From the outset, however, his touch was more precise, and his figures were more individualised, than those of Brouwer.[7] In the later 1630s he had already begun to paint outdoor scenes, and in the 1640s his tavern scenes too developed a new spaciousness, with a more affectionate and detailed portrayal of their protagonists and clutter.

The present picture is – or was – dated 1670.[8] It used sometimes to be maintained that Ostade's powers declined from around 1670,[9] but there is no real indication of this. Once he had established what he wanted to say, and the means of saying it, his powers of both invention and observation – since he persisted in drawing figures from the life right up until the last – enabled him to make ever fresh variations on his chosen themes.[10]

Dancing outside a tavern is the pretext for the present picture. Ostade seems to present this as an innocent enough occupation. Part of the charm of his pictures is, indeed, that he does not caricature his protagonists' faces by making them grimace (though he does obviously select 'boor' types of face), or moralise in a heavy-handed way. None the less, there are plenty of activities condemned by the censorious on display: dancing – condemned by preachers as a 'vain, rash, unchaste' activity;[11] drinking – and with abandon, as exemplified by the man in the doorway raising his glass, and the other with a whole flagon in his hands, slumped by the table; smoking, which was almost invariably associated in its pernicious effects with drinking,[12] since, as Constantijn Huygens humorously observed, each inexorably drove in-dulgers to the other;[13] card playing; and that most depraved of musical instruments, the hurdy-gurdy.

All these would alone be enough to indicate that the picture might have been expected to evoke a self-righteous glow (unless it aroused complicity!) in its owner. But, over and above these, there are the distant view of the church and church-goers, and the flag over the tavern door (instead of where it should be, on the church tower). All imply a corruption of the original occasion for a day off work, to celebrate a church festival[14] – a corruption, moreover, that is being extended to the goggling young children.

HIST: Count van Wassenaar-Obdam (1692–1766); his sale, The Hague, 19 Aug 1750, lot 39 (bt by Brouwer); by 1829, in the collection of Jonkheer Willem van Loon (1794–1847);[15] his widow, Agatha Winter Jonkvrouw van Loon (1793–1877); by whose children sold to Baron Lionel de Rothschild (1808–79), who hung it at 148 Piccadilly; by inheritance to his son, Leopold de Rothschild (1845–1917),[16] by whom kept at Gunnersbury Park; his son, Anthony de Rothschild (1887–1961), by whom kept at Ascott, and given with the house, grounds and most of the contents of the showrooms to the National Trust in 1949.

EXH: *Dutch Pictures: 1450–1750*, RA, 1952–3, no.484.

LIT: Hoet 1752, ii, p.292, no.39; Smith 1829, i, p.163, no.202; Smith 1842, ix, p.109, no.101; Hofstede de Groot 1910, iii, p.387, no.800; *Ascott* 1963, no.1, p.8; Schnackenburg 1981, i, p.142, under no.305.

63 Ludolf DE JONGH (?Rotterdam 1616 – Hillegersberg 1679)

A Lady receiving a Letter

Oil on canvas. 58·5 × 72·5 cm (23 × 28 in)
Signed (on the painting of *Diana and Actaeon* behind):
L.C.D. Jonge
Ascott, Buckinghamshire

This has a double title to be in an exhibition of paintings from National Trust houses. It once belonged to the choice collection of pictures, furniture and objects in the *goût* Beckford (see cat. no.9) put together by George Lucy (1789–1845) of Charlecote in Warwickshire, which, in the words of his widow, 'bespeak him to have been a man of polished mind and refined taste'.[1] And it was later acquired by Baron Lionel de Rothschild (1808–79), the great collector of the English branch of the Rothschild family[2] (cf. cat. nos.39, 40, 41, 43, 62), the only remnants of whose collection to survive as a collection do so at Ascott.

Both George Lucy and Lionel de Rothschild, however, thought that they were buying a picture by a much more celebrated artist than Ludolf de Jongh: Pieter de Hooch (Rotterdam 1629–Amsterdam 1684). Indeed, in the 19th century de Hooch's works were prized much more highly than Vermeer's. Only when the picture had been cleaned and the painted-over signature on it discovered, prior to its exhibition at the Royal Academy in 1938, was the actual artist revealed.[3]

In aesthetic terms, the deception was not, however, a grave one. Although de Jongh was over ten years older than de Hooch, and had begun by serving as a model for him, in this and a handful of other pictures he was patently influenced by the younger man, and in them he is inspired to attain some of de Hooch's best qualities. By capturing simple, everyday actions in the geometrically defined setting of a courtyard, garden or room, within which each figure and object is illuminated by precise lighting, he creates a sense of timelessness that confers on these seemingly banal scenes a quality of universality.

Pieter de Hooch's earliest dated courtyard scenes are the two of 1658, with variants of the same setting, in the National Gallery[4] and recently sold from the Byng collection at Wrotham Park, Middlesex.[5] 1658 is also the date on three of de Hooch's earliest room scenes: the *Card Players* (Royal Collection),[6] the *Girl drinking with Two Men* (Louvre)[7] and the *Soldier paying a Hostess* (Marquess of Bute).[8] At this period, de Jongh was still painting the tavern and guard-room scenes which may have inspired de Hooch. Such scenes are obviously also interiors, but they lack the oblong, box-like geometrical space, the precisely described fall of light, and the stillness, all of which set de Hooch's classic interiors apart from previous representations of the kind. Yet in one of them, the *Tavern Scene* of 1658 (Groninger Museum, Groningen),[9] de Jongh can be seen modifying his earlier

formulae so as to adopt these very characteristics. In it, however, as in the present picture, de Jongh has retained one restless element that seems to have been something of a favourite with him, but which was avoided by de Hooch – a pair of gambolling dogs.

This treatment of people in interiors was not restricted to Rotterdam artists such as de Hooch and de Jongh; indeed, it became particularly popular in Delft and Amsterdam, where de Hooch worked from 1652. De Hooch's brother-in-law, Hendrik van der Burgh (Naaldwijk 1627–?Delft or Leyden after 1669), and the Flemish musician and artist Pieter Janssens Elinga (Bruges 1623–Amsterdam before 1682), who became a citizen of Amsterdam in 1657, imitated them most consistently; but Vermeer (Delft 1632–75) was also influenced by them in some of his earlier pictures; and even Emanuel de Witte[10] (Alkmaar c.1617–Amsterdam 1692) and Samuel van Hoogstraten[11] (Dordrecht 1627–78) passingly adopted aspects of the same formula. By contrast, another Rotterdam artist, Jacob Ochtervelt (1634–82), treated 'entrance hall' scenes very differently: adopting an upright format, and reducing the setting so as to focus almost exclusively upon the figures.[12]

In the 19th century almost all Dutch pictures of this kind – even patent brothel scenes – were generally viewed as illustrating the innocent diversions of upper-class company. In the case of the present picture, which is set in the well-lit focal entrance hall, or *voorhuis*, of a grand house,[13] the woman darning linen, and the servant bringing more down the stairs, do indeed appear to establish this as a virtuous domestic scene. They are there, however, as a kind of counterpoint to the central event: the richly dressed page delivering some oral message in connection with the opened letter held by the mistress of the house. As nearly always in such pictures, the letter must be a love-letter. Any doubt on this point is settled by the theme of the picture prominently displayed upon the end wall, *Diana and Actaeon*, which makes a familar allusion to cuckoldry, the graphic symbol of which was a set of horns on the betrayed husband's head.[14] (Actaeon was transformed into a stag and then hunted to death by his own hounds for spying Diana naked.) That an amorous encounter is being plotted is also suggested by the dogs in the foreground. The clock (an interesting early example of a pendulum bracket-clock) on the wall is a traditional *memento mori* – though the *voorhuis* was also the natural place for it to be installed.

HIST: unknown collection, Paris; Thomas Thompson Martin[15] (c.1770–
1826); sold by him in 1826 to George Lucy (1789–1845) of Charlecote
for £250; thence by descent to Henry Spencer Lucy (1830–89); by whom
sold c.1875 to Baron Lionel de Rothschild (1808–79);[16] by whom hung
in the Baron's Room at 148 Piccadilly; thence by descent to Anthony de
Rothschild (1887–1961), Ascott; by whom given to the National Trust
with the house, grounds and most of the contents of the showrooms in
1949.

EXH: *Pictures, chiefly by the Old Masters of the Italian, Flemish, and
Spanish Schools*, Society of Arts, Birmingham, 1833, no.67 (as by P. de
Hooge); *17th Century Art in Europe*, RA, 1938, no.248, p.104, pl.59
(as by de Jongh).

LIT: Smith 1833, iv, p.228, no.32 (as by Peter de Hooge); Lucy 1862,
p.166; Hofstede de Groot 1907, i, p.538, no.230 (as by de Hooch,
repeating Smith); Waterhouse 1938, pl.V[b] (as by de Jongh); *Ascott*
1963, no.28, p.18, pl.; Kuretsky 1979, p.34, fig.119; Sutton 1980, pp.30,
65 n.11.

64 Gerard TER BORCH (Zwolle 1617 – Deventer 1681)

An Officer making his Bow to a Lady

Oil on canvas. 76 × 68 cm (30 × 26¾ in)
Polesden Lacey, Surrey

Exactly what is going on in this picture is a little ambiguous. The officer – representative of a notoriously licentious crew – is holding the exquisitely dressed young woman's hand by her be-ringed fingers.[1] They are being watched from behind a table by an old widow, whose placing and look suggest a procuress, while a cavalier at the same table plays a theorbo or lute – always an instrument with erotic overtones[2] (despite sometimes being called a *guitarre angélique* in 18th-century sale catalogues). Refined and respectable though everything looks, all the indications point to this being, if not an actual brothel, a place of illicit assignations.

Ter Borch's scenes containing fine young women with officers, in particular, all seem to carry such connotations.[3] Even more piquantly, perhaps, the young woman in this and many other pictures of the kind appears to be an idealised and time-frozen likeness of Gerard's unmarried half-sister, Gesina ter Borch (1631–90), who was herself an occasional painter, but primarily a draughtswoman, watercolourist and versifier. It was her great merit to have carefully kept in albums all the drawings by her brother and the other artist members of her family that she could gather, and to have bequeathed them to her niece, from whom they descended intact, and are now largely in the Rijksprentenkabinet in Amsterdam.[4]

We have three likenesses of Gesina ter Borch from these albums, two of them from around 1659–60: an oval head-and-shoulders watercolour-cum-gouache *Self-portrait* in a cartouche,[5] and a watercolour copy of a lost three-quarter-length oil painting apparently by Gerard.[6] But for the darker colour of her hair, the shared likeness – particularly of the *Self-portrait* – with the protagonist in this and other paintings is striking. However, if one were being pedantic, one would have to admit that the resemblance of the *Self-portrait* to the eponymous young woman of '*Curiosity*' (Metropolitan Museum, New York)[7] is greater still. Whoever the original model for the young woman in the present picture was, she first appears in the tondo of a *Young Woman at a Toilet-table* (private collection), which is datable stylistically to c.1648–9.[8] Like Bonnard's wife in his paintings, her appearance changes not at all thereafter – save to keep up with fashions in hair-style and dress. It seems more plausible, therefore, that these depictions derived from an internalised image of someone close to the artist, than that they were painted from an actual model. The model also first appears too early to have been Gerard's wife, the widowed Geertruyt Matthijs of Deventer, whom he married only in 1654.[9] The present picture is dated by common consent to around 1662, when Gesina would have been over

30, and would evidently have looked older than the young woman here.

Ter Borch's pictures, more than any others, have been taken to epitomise the refinement of Dutch upper-class life and manners in the 17th century. Yet not only was he in fact depicting episodes of a more equivocal character, but he also spent his whole career, not in a centre of court or city life, such as The Hague or Amsterdam, but in the provincial towns of Zwolle, and – from 1654 – Deventer, in the province of Overijssel.[10] Zwolle was, admittedly, its capital, and Deventer a prosperous manufacturing centre of which Ter Borch became a *gemeensman* on the Council in 1666; but it is, none the less, rather as if the image of Restoration England had been set by an artist working in Devizes.

A fine interior and furniture such as he portrays here could no doubt have been found in Overijssel, but it must be remembered that Ter Borch was constantly travelling to greater centres, such as Amsterdam, Haarlem, The Hague (and even, in his youth, London). He probably made his scenes of seduction and procurement more acceptable as pictures to be hung on respectable walls by removing them to finer locations than those in which they would have actually taken place. The brothels described in contemporary police reports would certainly appear to have been infinitely more sordid places.[11] It is not a 19th-century Englishman, however, but a Dutchman and an American, writing in the late 20th century, who say of Ter Borch's treatment of such equivocal scenes: 'Psychologically and pictorially he has a gentleman's touch and delicacy.'[12]

HIST: posthumous sale of Johan Aegidiusz. van der Marck, Burgomaster of Leyden, Amsterdam, 25 Sept ff. 1773, lot 326; posthumous sale of Jan Jacob de Bruijn, Amsterdam, 12 Sept 1798, lot 8; James Craufurd (d.1816), Rotterdam; his anon. sale of 'Private Property consigned from Abroad', Christie's, 26 April 1806, lot 11;[13] bt for 240 gns by George Granville, 2nd Marquess of Stafford (1758–1833; cr. 1st Duke of Sutherland, 1833), and installed in the Cabinet of Cleveland House, St James's, London;[14] after 1833, 2nd Duke of Sutherland, Stafford House, London;[15] [?sold privately to] Yolande Duvernay, Mrs Lyne Stephens, Lynford Hall, Norfolk,[16] and Roehampton Grove; her posthumous sale, Christie's, 11 May 1895, lot 347; bt Lesser Adrian Lesser, by whom sold in 1896 to William McEwan, MP (1827–1913); by descent to his daughter, Margaret, Mrs the Hon. Ronald Greville (d.1942); by whom bequeathed, along with Polesden Lacey and the contents of her house in Charles Street, London, and the rest of her collections, to the National Trust in 1942.

EXH: *Woman and Child in Art*, Grosvenor Galleries, 1913, no.62; *Dutch Art 1450–1900*, RA, winter 1929, no.228 (*Commem. Cat.*, p.137); on loan to National Gallery, 1943–4; *Dutch Paintings of the 17th Century*, Arts Council travelling exh., 1945, no.37; *Dutch Cabinet Pictures of the 17th Century*, Birmingham Art Gallery, 1950, no.61; *Dutch Pictures: 1450–1750*, RA, 1952–3, no.398; *Dutch Painting in the*

Golden Age, Metropolitan Museum, New York, Toledo Museum, Toronto Gallery, 1954, no.12; *Dutch Genre Painting*, Arts Council (Wales), 1958, no.38; *Art in Seventeenth Century Holland*, National Gallery, 1976, no.13; *Treasures Houses of Britain*, National Gallery of Art, Washington, 1985–6, no.293; *Dutch Art in the 17th Century*, Birmingham City Art Gallery, 1989, no.40.

LIT: Britton 1808, p.143, no.249; Ottley and Tomkins 1818, iii, class iii, no.71, p.100, pl.28 (over a Cabinet door); Buchanan 1824, ii, p.183; Smith 1833, iv, pp.130–31, no.41; Waagen 1838, ii, p.253; Waagen 1854, ii, p.71; Hofstede de Groot 1913, v, no.164, p.60; Gudlaugsson 1960, no.187, i, pp.132–3, pl.187 on p.330; ii, pp.183–4; *Polesden Lacey* 1964, no.50, p.26, pl.6; Lloyd Williams 1994, p.51, col. pl.III.

65 Gabriel METSU (Leyden 1629–67)

'Le corset bleu'

Oil on panel. 41 × 30 cm (16 × 12 in)
Signed at the bottom of the sheet of music: *G. Metsu*
Upton House, Warwickshire

As with the Ter Borch (cat. no.64), the content of this picture is perhaps not quite as straightforward as it looks. The association of a young cavalier and an elegant woman with music and a glass of wine – evidently being drunk by the latter – was, in the context of Dutch painting, clearly intended to hint at amorous activity. This message is reinforced by the footwarmer, which usually alludes to the warmth of passion,[1] prominently placed half under the young woman's skirt. Other elements of the picture can be interpreted in similar terms: the dog, both embodiment of lechery and emblem of fidelity, seemingly taking alarm for that of his mistress; and the phallic projection of the sword-hilt. But it is difficult to know at what point such readings say more about the mind of the commentator than about the intentions of the artist!

At around the period that this picture was painted, in the mid-1660s, Metsu had anyway achieved a state of aesthetic equilibrium in his pictures, such that all those elements and implications seem peripheral. Like de Hooch and Ter Borch in these years – and he seems to have been influenced by both – the chief emphasis is upon the understated interplay between the protagonists. With Metsu, as with Ter Borch, we are further invited to relish the sheen of satin, and the richness and variety in the texture and colour of velvet, fur and table-carpet. In the case of Metsu, however, there is a greater complexity and interpenetration of elements, which makes their successful resolution in pictures like this all the more satisfying.

The curious phenomenon that many of the most cele-brated Dutch pictures bear French titles has a relatively simple explanation. The collecting of fine Dutch pictures outside the United Provinces began in France before the middle of the 18th century, when this painting probably acquired what would appear to be its original French Rococo frame. It was in France that many of them were first engraved, receiving titles either through this process or through their fame among connoisseurs – as *'Le corset bleu'* did when it was in the celebrated collection of Randon de Boisset. Often, it is the single most striking feature within a painting that provides the name – in this case, the woman's brilliant blue fur-trimmed jacket. Such titles were often retained when, as in this case, they found their way to richer or more eager collectors in Britain in the disturbed years of the French Revolution and after.

Thanks to the 18th-century love of pairs and pendants (cf. cat. nos.19, 42, 55, 56), from the moment that this picture was first recorded in a French collection, it had been given a factitious companion, showing a young woman in a scarlet jacket breaking off from drawing a plaster cast of a putto by Duquesnoy to caress a dog, subsequently entitled – inevitably – *'Le corset rouge'* (?baron Edmond de Rothschild, Prégny). Although sundered again after they reached England in the 19th century, when subsequently the present picture had passed into the hands of Alfred de Rothschild, it acquired another false pendant, this time showing a young woman in a scarlet jacket drawing the plaster bust – rather than the whole figure – of a putto (National Gallery), which was, confusingly, also given the title *'Le corset rouge'*. Alfred de Rothschild's hope that his collection would be kept together as an 'heirloom' was disappointed, so on his death the two pictures again went their separate ways. Each was, however, to be presented to a public collection in England, by Viscounts Bearsted and Rothermere respectively, within a decade of one another; and so it is that, for the duration of this exhibition at least, they are both hanging in the National Gallery.

HIST: ?Lambert Witsen sale, Amsterdam, 25 May 1746, lot 5;[2] bt [?Jan Mauritz] Quinkhard (1688–1772); Pierre-Louis Randon de Boisset (1708–76), Paris;[3] his posthumous sale held by Pierre Remy and others at his house in rue Neuve des Capucines, 27 Feb ff. 1777, lot 81; bt by de Morimières or Perrin (with *'Le corset rouge'*);[4] Destouches sale, Paris, 21 March 1794, lot 42; bt by J.-B.-P. Le Brun (with *'Le corset rouge'*); Le comte Wautier sale, Paris, 9 June ff. 1797, lot 11; bt by Le Rouge (with *'Le corset rouge'*); G. Robit[5] sale, Paris, 21 May 1801, lot 70; bt by Lafontaine for Michael Bryan (with lots 71, 72, *'Le corset rouge'* and *The Cello-player* [Royal Collection]), on behalf of George Hibbert, MP (1757–1837), Clapham, to whom sold for 700 gns;[6] his sale, Christie's, 13 June 1829, lot 65; with Joseph Neeld (1789–1856), Grittleton House, Wilts, by 1831; with Sir John Neeld, 1st Bt (1805–91), in 1878; probably sold during the winter of 1878–9 to Baron Lionel de Rothschild (1808–79); by division in 1882 to his son, Alfred de Rothschild[7] (1842–1918), by whom ?originally kept at Halton, Bucks, but by 1903 at 1 Seamore Place; by him bequeathed to Almina, Countess of Carnarvon (1876/7–1969);[8] by whom sold to Knoedler, London; by whom sold in 1924 to the Hon. Walter Samuel, later 2nd Viscount Bearsted (1882–1948); by whom given to the Trust in 1948.

EXH: Mr Bryan's Gallery, 88 and 118 Pall Mall, 1801–2, no.23 (as *'Le Corset Blue'* [*sic*]); BI, 1815, no.74; BI, 1831, no.76; RA, winter 1878, no.119; *Dutch Old Masters*, Manchester Art Gallery, 1919, no.37; *Oud-Hollandsche en Vlaamsche Meesters*, Kleycamp Galleries, The Hague, 1927, no.29; *Dutch Art*, RA, winter 1929, no.234; *Masterpieces of Dutch Painting of the 17th Century*, Slatter Galleries, London, 1945, no.13; *Some Dutch Cabinet Pictures of the 17th Century*, Birmingham Art Gallery, 1950, no.40; *The Bearsted Collection*, Whitechapel Art Gallery, 1955, no.34 (pl.xxxvi in catalogue).

LIT: ?Hoet 1752, ii, p.186; Buchanan 1824, ii, pp.54–5, no.70, p.67, no.23; Smith 1833, iv, p.77, no.8; Waagen 1854, ii, p.246; Blanc 1857, i, p.356; Davis 1884, i, no.19; Erskine 1902, p.74; Cust 1905, i (under 'Metsu'); Hofstede de Groot 1907, i, no.149; *Upton* 1974, no.120, pp.34–5, pl.IIIc; Robinson 1974, p.85 n.103, fig.203 (dating to 1660s).

66 Jan STEEN (Leyden 1625/6–79)

'The Burgomaster of Delft'

Oil on canvas. 82·5 × 68·5 cm (32½ × 27 in)
Signed on the bottom step: *J Steen/1655*
[the *J* and *S* in ligature]
Penrhyn Castle, Gwynedd

Much has been done in recent years to bring Dutch painting into the discourse of high art.[1] The reputation of Jan Steen in particular has been thought to need rescuing from Sir Joshua Reynolds's notorious claim that it was only his schooling in the 'inferior' practice of genre painting that had prevented him from attaining greatness,[2] by a whole monograph devoted to his religious and historical paintings alone.[3] Arguably, however, that is the wrong way to set about demonstrating that Steen is a major painter. Instead, there is a case for saying that it is in paintings such as *'The Burgomaster of Delft'* that Steen raises genre painting to the dignity of great art.

The subject of the present painting is less easy to establish than it might seem; that is one reason why its traditional – but possibly inaccurate – title has been retained. Indeed, its enigma is surely part of its appeal. At a quick glance, it appears to show a prosperous Dutch burgher with his daughter on the steps of their house, considering a plea for alms from an old beggarwoman and her son. Such a subject was not uncommon in the 1650s.[4]

Simon Schama has made this picture immeasurably better known, by making it not only the cover picture, but almost the eponym, of *The Embarrassment of Riches*.[5] He has argued that the man and girl's apparent unresponsiveness to the beggarwoman's plea should be seen in conjunction with the piece of paper that he holds in his hand. This, he suggests, is her licence of residence in Delft, giving her permission to beg within the city boundaries, which the man is considering.

But is she actually a beggarwoman at all? She and the boy are, though poorly, solidly dressed – not in rags; they are both shod, not barefoot; she wears clean linen, and her bonnet even has a fur trim to it. She carries a basket over her arm – a battered version of the little plaited straw baskets that sitters in portraits of a slightly earlier period sport as if they were Gucci bags. The boy is holding his hat, not out for alms, but respectfully in front of his chest. Nor is the woman actually extending her hand with the palm flat upwards, to receive a coin. She is tilting it, as if showing something she holds, and one can, indeed, make out something reddish hanging from her hand. Whatever it is, it has evidently come from her basket: she is not begging, but offering something for sale. Is it some sprig of a plant? (one is irresistibly reminded of gypsies hawking heather on the London Underground). Or is it a poor little arrangement of threads, or some other fairing?

Whatever the offering, it may explain the apparent disdainfulness of the young girl, as it is scarcely likely to have any appeal for someone such as her, decked out in her finery. It is, by contrast, hard to imagine that anyone would have had his daughter painted turning her back upon a case deserving of charity. Once interpreted as a scene of wares – however slight – offered for sale on the *stoep*, or doorstep, the picture also takes its place more easily, though still idiosyncratically, within the burgeoning tradition of doorstep and entrance hall scenes, and depictions of purchases made at the threshold of a house.[6]

Of course, such an interpretation does not entirely alter the meaning of the picture, nor subvert its relevance to Schama's book. For, while the book – in this a true product of the 1980s – is more concerned with the spending than the getting of wealth, the way in which the picture contrasts the ease of the patricians with the homespun deference of the woman and child could be taken as an illustration of the operation of the Calvinist work ethic: it is the business of the poor to get their living, not to depend upon charity, while the prosperity of the rich is a just reward for their labours.[7]

If the picture is seen in this light, there is less reason to doubt that it is a disguised portrait. In this, it would be a precedent for other genre pictures with the same primary purpose.[8] Regrettably, we do not know the identity of the sitters. Hofstede de Groot, who expressed understandable scepticism over the painting's traditional title, said that if it were of the Burgomaster of Delft in 1655, he would be

Detail of cat. no.66

Detail of cat. no.66

Gerard Briel(l) van Welhoeck (1593–1665; Burgomaster, from 1640), with his daughter Anna, who was born in 1638 and married Adriaan Bogaert van Beloys in 1656.[9] As Christopher Brown has said, however, he bears no resemblance to the one known portrait of Briel.[10] No one seems so far to have tried to see whether it does not show another Burgomaster, or to discover the owner of the particular house shown on the Oude Delft Canal. (On the right can be seen the Oude Kerk and on the left the Delflands Huis and the Prinsenhof; Steen himself owned a brewery on this canal between 1654, when he arrived in the city, and 1657.) The deliberate contrivance of showing the arms of the city of Delft on the bridge would certainly seem to suggest that the sitter was a civic official. The curious inclusion of the man in an old-fashioned cartwheel ruff above them might even suggest that he was the sitter's father, and that he had earlier occupied the same office.

No wife is included in the picture. Since the painting itself hardly implies a pendant, in which she would have figured, she must have been dead. Christopher Brown has suggested[11] that the limpid glass vase containing flowers – or, more precisely, perhaps, the conspicuously blown tulip within it – might be intended as an evocation of her. Placed unnaturally where it is, on the outside sill, and above the daughter, this seems very probable.[12]

HIST: posthumous sale of E.M. Engelberts, Protestant Minister of Hoorn, and Jan Tersteeg, Amsterdam, 13 June ff. 1808, lot 142 (as 'een Burgemeester van Delft ... in de stijl van G. Metzu geschilderd'), bt by L.J. Nieuwenhuys for 750 florins; sale of 'Pictures recently imported' (by Alexis Delahante),[13] Phillips, London, 10 May 1811, lot 46 (as The Burgomaster of Delft and his Daughter with a Mendicant Asking Alms), bt in at 84 gns; sale of 'A[lexis] Delahante, Esq. [d.1837], returning to Paris', Phillips, 3–4 June 1814, lot 18 (as The Burgomaster of Delft), bt for 59 gns by Griffiths or Griffin; sold at an unknown date (probably not until 1855 or after) by C.J. Nieuwenhuys to Col. Edward Douglas-Pennant, later 1st Baron Penrhyn of Llandegai (1800–86); thence by descent to Hugh, 4th Baron Penrhyn (1894–1949), who left Penrhyn and its estates to his niece, Lady Janet Harpur, née Pelham, who, with her husband John Harpur, thereupon assumed the name of Douglas Pennant, and in 1951 made over the castle and part of its contents in lieu of death-duties to HM Treasury, which transferred them to the National Trust.

EXH: RA, 1882, no.238; Old Masters in Aid of the National Arts-Collection Fund, Grafton Gallery, 1911, no.95; Vermeer – oorsprong en invloed, Museum Boymans, Rotterdam, 1935, no.78a; Dutch Pictures: 1450–1750, RA, 1952–3, no.544; Dutch Genre Painting, Aberystwyth, etc. (Arts Council), 1958, no.4; Art in Seventeenth Century Holland, National Gallery, 1976, no.103; The Treasure Houses of Britain, National Gallery of Art, Washington, 1985–6, no.294.

LIT: Douglas-Pennant 1902, no.24; Hofstede de Groot 1907, i, p.241, no.878 (as the So-Called 'Portrait of the Burgomaster of Delft and his Daughter'); Bredius 1927, p.70, pl.95; Trautscholdt 1937, p.509; de Groot 1952; Martin 1954, p.15, fig.15; Kirschbaum 1977, p.39; exh. cat. Masters of Seventeenth Century Dutch Genre Painting, Philadelphia Museum of Art, etc., 1984, p.xlviii, fig.77; Haak 1984, p.428, fig.936 (as a portrait and 'undoubtedly a commission'); Schama 1987, pp.573–5, fig.297 and cover.

67 Philips WOUWERMAN(S) (Haarlem 1619–68)

The Conversion of St Hubert

Oil on canvas. 96·5 × 84 cm (38 × 33 in)
Signed: on rock, bottom right: *PHILIPS* (in monogram)
W/1660
Penrhyn Castle, Gwynedd

The episode in the legend of St Hubert (d.727) shown in this picture is one that was first borrowed and applied to him in the 15th century from that of St Eustace. Wouwermans has here paid his own tribute to that borrowing by adapting the group of dogs, and perhaps even taking the – for him – unwonted upright format, from Dürer's celebrated engraving of the Latin saint.

As applied to St Hubert, the story told of a young man leading a worldly and dissolute life, in the course of which, one Good Friday morning, he was out hunting. When he had the stag at bay, a luminous cross suddenly appeared between its horns, and it turned to him and spoke: 'Why are you pursuing me? I am Jesus, whom you honour without being aware of it.' When the astonished Hubert asked what to do, he was told to seek instruction and guidance from St Lambert, Bishop of Tongeren/Maastricht (*c*.635–*c*.700). Having done so, and become a Christian priest, he ultimately succeeded Lambert as Bishop; around 715 he translated the latter's relics and his see to Liège.

Fig.22 Albrecht Dürer,
St Eustace
(engraving, *c*.1501)

In 825 a portion of St Hubert's own relics was moved to the abbey of Andage (later renamed Saint-Hubert) in the forests of the Ardennes. This being great hunting-country, he became the patron saint of hunting (and also the saint with prophylactic powers against rabies: a special bread used to be baked, called 'St Hubert's Bread', eating which was supposed to be protection against the contagion). It was thus natural that the most striking hagiographical legend associated with the chase should have been assumed into his *vita*.

Wouwermans painted landscapes peopled by horses and riders, often in the form of hunts, skirmishes, fairs, riding-schools, and parties or halts at an inn. Although the old bit of dealers' patter that his 'signature' is a white horse is untrue, one generally forms a focal point in his pictures. His subject-matter, combined with his exquisite finish, contrived to make him one of the most popular artists with aristocratic collectors in the 18th and 19th centuries – a taste that his prolific output also made it feasible to gratify. His paintings have fallen out of fashion in our own time, but there are still more pictures in Great Britain by or ascribed to him than by any other Dutch artist save Willem van de Velde the Younger.[1]

Quite why Wouwermans should have chosen St Hubert for the subject of the present picture is still obscure. The picture is first mentioned in 1782/3, when it was said to have been painted for an unnamed predecessor of the then Catholic priest of Haarlem, with his features borrowed for the figure of St Hubert.[2] Seven years later, Samuel Ireland had picked up a whole story about it. After saying that Wouwermans, like Berchem, had early on lived from hand to mouth, always in hock to the picture dealers, who were thus able to get paintings out of him for a pittance, he goes on:

Happily, however, in his ripe years, he was relieved from his indigence and dependence on picture-dealers, by a Catholic priest (he being himself of the Romish church)[3] who lent him six hundred guilders, which sum, though but small, enabled him to increase his price to double what he had been usually paid, and he became soon after possessed of sufficient wealth to give his daughter, as a portion in marriage, twenty thousand guilders. In return for his confessor's liberality, he painted his portrait in small, kneeling before his horse, in the character of St. Hubert, which he presented to him, and with it the sum so graciously lent. The picture should be noticed by every Connoisseur who passes through this city: the drawing and colouring are in his best stile, and the picture is exquisitely finished: it may be termed a chef d'oeuvre, where the superiority of the work vies with the gratitude of the artist, and may be found in a chapel near the house where Wouwermans resided, situated in the Bakenessegragt.[4]

In 1816 Roeland van Eijnden and Adriaan van der Willigen gave the name of the priest as Cornelis Catsz.,[5] but Wouwermans scarcely ever painted portraits, and it may be doubted whether the present picture really contains one.[6] He did, however, paint a number of biblical subjects such as the Conversion of Saul,[7] in which horses took a necessary part. But many – such as the Preaching of St John the Baptist (Gemäldegalerie, Dresden) or his favourite theme, The Annunciation to the Shepherds[8] – have horses rather unwontedly introduced into them.

The present picture was painted relatively late in Wouwermans's career. Two similarly late works, The Christian Knight with Time and Death of 1655[9] and St Michael triumphing over Evil and Death (1662; Museum of Fine Arts, Boston),[10] are uncharacteristic – but seemingly very personal – representations which tend to suggest that Wouwermans turned to a Catholic-influenced religiosity, very possibly under his wife's influence. By contrast, here the artist maintains his traditional balance between the scale of the landscape and the figural elements – and includes a characteristically *con brio* passage of the hunt following furiously behind, in the background. The result is at once a harmonious whole, and a painting of unique character within the artist's oeuvre.

HIST: reputedly painted in gratitude for a timely loan from Cornelis Catsz., priest of the Catholic chapel (over the Kwakebrug on the Bakenessegracht), Haarlem; with his successor, J.B. Schuyt, in 1782/3; sold to the dealer Cornelis Sebille Roos (1754–1820), Amsterdam, in 1804;[11] acquired by the dealer L.J. Nieuwenhuys in 1817; sold by him in May 1823 to Prince Willem of Orange, subsequently King Willem II of the Netherlands (1792–1849; succ. 1840),[12] in Brussels, with a Seascape by Ludolf Bakhuysen, for 26,000 francs; his posthumous sale, Gothic Hall, The Hague, 12 Aug ff. 1850, lot 92, bt back by L.J. Nieuwenhuys for 3,000 florins; sold to Friedrich, Baron von Mecklenburg;[13] his posthumous sale, 11 Dec 1854, lot 30, bt C.J. Nieuwenhuys for 7,200 francs; sold to Col. Edward Douglas-Pennant, later 1st Baron Penrhyn of Llandegai (1800–86) for £600 in 1855; thence by descent to Hugh, 4th Baron Penrhyn (1894–1949), who left Penrhyn and its estates to his niece, Lady Janet Harpur, née Pelham, who, with her husband John Harpur, thereupon assumed the name of Douglas Pennant, and in 1951 made over the castle and part of its contents in lieu of death-duties to HM Treasury, which transferred them to the National Trust.

LIT: van Eynden 1787, p.133; Ireland 1790, i, pp.114–15; van Eijnden and van der Willigen 1816, i, pp.404–5; Smith 1829, i, pp.289–90, no.323; Nieuwenhuys 1837; Nieuwenhuys 1843, no.78, pp.166–7; Douglas-Pennant 1902, no.17; Moes 1905, ii, p.367, no.7106; Hofstede de Groot 1909, ii, pp.263–4, no.27, and pp.265–6, no.38; Hinterding and Horsch 1989, p.10 n.20, p.86, no.92, with fig. of line engraving; Duparc 1993, pp.278, 286 n.136, fig.34.

68 Frans van MIERIS the Elder (Leyden 1635–81)

The Artist as Virtuoso at his Easel

Oil on panel. Originally 17.5 × 13.5 cm (7 × 5¼ in);
with additions 19.5 × 15.5 cm (7¾ × 6 in)
Signed below architrave of plinth: *F. van Mieris. f.*
Inscribed, as if incised on the frieze: *ÆTAT. 32 Anno. 1667*
Polesden Lacey, Surrey

Frans van Mieris was a prolific painter of self-portraits –
indeed, in Holland in the 17th century, second only to
Rembrandt[1] – which is all the more surprising in view of his
minute and painstaking technique. No more than in the case
of Rembrandt, however, can they necessarily be regarded as
evidence of repeated introspection. Mieris's self-portraits
show him to have been as interested in depicting his own
epidermis and disguises as in all the other surfaces that his
other paintings lovingly describe. Since these self-portraits
were themselves equally marketable commodities,[2] some of
them also reveal him to have been concerned to present an
image of himself to his clients at the same time.

Here, for instance, the gold-braided velvet cap and the
satin gown proclaim the painter to be a person of wealth and
elegance. That he can wear such clothes, while holding a
palette and fine brushes, further conveys the message that his
practice of his art is itself so refined that it does not threaten
this gentlemanly status. The book indicates that his is a
learned profession, the drawing of a seated nude at his elbow
that its real processes take place first in the mind, through
disegno, which will shortly fill the blank panel on his easel.[3]

The gesture of leaning with an elbow upon a parapet had
already been adopted from Titian's so-called '*Portrait of
Ariosto*' (National Gallery) by Rembrandt for a *Self-portrait*
of 1640 (ibid.).[4] It not only contributes to the same effect,
but also provides an elegant resolution to the traditional
artist's dilemma, of how to portray his right arm, when it is
actually the one that he is painting with, while his left arm
(which is what he sees reflected by the mirror in reverse, as if
it were his right arm) is in repose.[5] One would like to think
that Mieris knew Rembrandt's 1640 *Self-portrait*,[6] rather
than just the *Self-portrait* etching of the previous year, since
it is unusually finished for that artist at this date, and could
have helped to inspire this particular self-portrait's unusual
degree of finish and directness.

But whereas Rembrandt simply shows himself, leaning
upon a parapet, Mieris includes all the already-mentioned
subsidiary details. In thus aspiring to deliver a message
about his art, this *Self-portrait* has more intellectual affinity
with Rembrandt's exceptional self-portraits from the
beginning and end of his career: *The Painter in his Studio*
(Museum of Fine Arts, Boston)[7] and the *Self-portrait
holding Palette, Brushes and Mahlstick* (Kenwood).[8] It is
perhaps even more closely related to Bartholomeus van der
Helst's posthumous 1654 portrait of *Paulus Potter*

(Mauritshuis, The Hague),[9] showing him similarly sitting
before a blank canvas on his easel, holding a palette, brushes
and mahlstick. (Unusually, Mieris omitted a mahlstick,
perhaps to indicate the faultless perfection of his art, to
produce which not even his hand needed steadying.)[10] The
greater prominence and illusionistic effect given to the
parapet, with its seemingly incised inscription, owes most
to Mieris's former master, Gerrit Dou (1613–75).[11]

It is just possible that the *ÆTAT. 32* inscribed on this and
the *Self-portrait* drawing in the British Museum[12] might
explain the multiplication of self-portraits by Mieris in
1667.[13] At that time Christ was thought to have been born in
AD 1, and crucified in AD 33: AD 33, in which he became 32,
was thus the last of his life. It was, therefore, for anyone of
a reflective inclination (which Mieris may well have been,
despite – or because of – being a drunkard), a year in which
to take particular stock of one's life. Without going so far as
to portray himself *as* Christ,[14] Mieris may have felt it a
particularly appropriate time to record his own image in
various different guises. At the same time, his popularity
was such that he would have had no difficulty in selling
the results.

HIST: posthumous sale of [Abel-François Poisson], marquis de
[Marigny, and finally de] Ménars[15] (1725–81), held by F. Basan & F.C.
Joullain in his *hôtel* in the Place des Victoires, Paris, 18 March 1782, lot
58 (6½ *pouces* × 5 *pouces* [= 17.5 × 13.5 cm]); bt by Louis-Marie Le Bas
de Courmont de Pomponne (1714–94) for 1221 *livres*;[16] Jonkheer Johan
II Goll van Franckenstein[17] (1756–1821); by descent to his son,
Jonkheer Pieter Hendrik Goll van Franckenstein (1787–1832), after
whose death auctioned by the widow of C.S. Roos, at *het Huis met de
Hoofden* on the Keizersgracht, Amsterdam, by 1 July ff. 1833, lot 51
(19 × 16 cm), bt by Woodin for 470 florins; Charles Heusch, London, by
1835–40; by descent to F. Heusch, ibid.; John III Walter[18] (1818–94),
Bear Wood, Berks, by 1857; his second (but eldest surviving) son,
Arthur Fraser Walter (1846–1910), London; presumably sold privately
to L. Neumann, 11 Grosvenor Square, London; his sale, Christie's,
4 July 1919, lot 10, bt by Agnew's for 700 gns, on behalf of Mrs the
Hon. Ronald Greville (d.1942); by whom bequeathed along with
Polesden Lacey, the contents of her house in Charles Street, London,
and the rest of her collections, to the National Trust in 1942.

EXH: BI, 1840, no.88; RA, winter 1882, no.110; *Dutch Pictures: 1450–
1750*, RA, 1952–3, no.535; *De Hollandse fijnschilders*, Rijksmuseum,
Amsterdam, 1989, no.17.

LIT: Smith 1829, i, p.72, no.39; Smith 1842, ix, p.41, no.23; Waagen
1854, ii, p.252; Waagen 1857, p.297; Moes 1905, ii, p.102, no.5060.7;
Hofstede de Groot 1928, x, no.256, pp.68–9 (wrongly stating that
engraved by Blootelinck); van Hall 1963, p.211, no.16; *Polesden Lacey*
1964, no.60, pp.28–9; Naumann 1978, pp.3–4, 18 nn.5–8, fig.1;
Naumann 1981, i, col. pl. opp. p.68, pp.70–72, 130–32; ii, no.66,
pp.81–2, pl.66.

69 Attributed to Godfried SCHALCKEN
(Made, nr Dordrecht, 1643 – The Hague 1706)
Boys flying Kites

Oil on panel. 44·5 × 34·5 cm (17½ × 13½ in)
Upton House, Warwickshire

The portrayal of children was one of the great strengths of Dutch 17th-century painting. Unlike the naked putti of Italian art, whose bodies form half-abstract arabesques, they appear clothed, actual and, above all, childish. Here, kite-flying – and perhaps even the dragonfly! – may carry some message of frivolity and transience taken from emblem-books, but that is not the point of the picture. It is, instead, just what it purports to be: the pure celebration of a favourite pastime of young boys.

As such, it seems to belong to a small group of pictures showing boys enjoying themselves, all of which appear to be by the same hand. The two with the greatest affinity with the present picture are the *Boys swimming from a Boat* (Louvre)[1] and *The Pancake-maker* (Museum of Fine Arts, Boston),[2] which is also on panel, and almost exactly of a size with it. The boys in all three pictures share generically related, somewhat fleshy, features, which are cast half into shadow by a similar broad-rimmed hat in the same, rather striking, way. Both the Louvre and the Boston pictures have at various times been attributed to Nicolaes Maes (Dordrecht 1634–Amsterdam 1693), but each is now demoted to an un-named 'Follower of Maes'.[3] The Louvre painting has the tantalising remains of a signature, beginning with a capital 'S'. This has in the past been taken to stand either for Samuel van Hoogstraten (Dordrecht 1627–78), or for Godfried Schalcken.

The attribution of the present picture to Schalcken was first suggested to the 2nd Lord Bearsted by Sir Alec Martin of Christie's, on the strength of comparisons with the signed panel of a *Young Boy fishing* (Staatliche Museen, Berlin).[4] The latter might also seem to belong to the group, but, like many of Schalcken's pictures, it is painted in a much finer, less obviously brushed, technique (which may partly be explained by its smaller size – 31 × 25 cm). The large, almost out-of-scale, yellow flags are, however, strikingly similar, with a butterfly poised on the end of a flower, just as the dragonfly hovers on the tip of one of their leaves here.

Whether or not one accepts the attribution of the present picture to Schalcken, it must be significant that all the attributions proposed for it and the other pictures in the group have been to Dordrecht artists. None of the three remained working there throughout his life, however, which may have some bearing upon who might have influenced whom, and when.

Samuel van Hoogstraten was the eldest of the three, and nothing in his signed or securely documented work[5] links

him convincingly with this group of paintings. He left for Vienna for the first time in 1651, travelled much thereafter, but was fixed in Dordrecht from 1656 to 1662. Nicolaes Maes first went to Amsterdam to study painting between around 1650 and 1653, and settled permanently there in 1673. The Schalcken family moved from nearby Made to Dordrecht itself in 1654; two years after this, Godfried was placed as an apprentice with Hoogstraten, and remained so until the latter left for London in 1662. After a probable three years perfecting his art with Gerrit Dou in Leyden, he returned to Dordrecht, not to leave again until 1691.

According to the late Thierry Beherman, Schalcken's earliest work was *The Young Musicians* (Narodowe Museum, Poznań), which is signed with the apparent date of 1663, one year after his departure for Leyden to become a pupil of Dou.[6] Unsurprisingly, both handling and composition already strongly reflect the influence of his new master; but it is surely significant that that, his first secure work, should be a study of boys enjoying themselves, as in the group of pictures that we have been studying, and that it too should include one in a wide-brimmed hat of the same type. Schalcken was evidently a precocious and versatile artist, and it does not seem unreasonable to propose the Upton, Boston and Louvre paintings as examples of his earliest manner, after he had been taught by Hoogstraten, but before he had come under the influence of Dou and his *fijnschilderij*; whereas the *Young Boy fishing* (unconvincingly dated by Beherman to *c.*1670–75) would be a work of *c.*1662–3, already reflecting that influence.

Recent cleaning of the picture has made more evident what seems to be some deliberate heraldry in the kites – even echoed, perhaps, in the costumes – though it has not yet proved possible to identify the tinctures and charges as those of a family or city in the Netherlands.[7]

HIST: Jean-Gilles-Marie-Joseph Schamp d'Aveschoot[8] (1765–1839), Ghent; his sale, Ghent, 14 Sept 1840, lot 116 (as by Dierck Maes), bt by Mme Durray of London for 630 francs; bt after the sale by Henry Hucks Gibbs,[9] cr. 1st Baron Aldenham 1896 (1819–1907); Alban George Gibbs, 2nd Baron Aldenham (1846–1936); his posthumous sale, Sotheby's, 24 Feb 1937, lot 115 (as by Nicolaes Maes); bt by Pawsey & Payne, probably on behalf of Walter Samuel, 2nd Viscount Bearsted (1882–1948); by whom given to the National Trust in 1948.

EXH: BFAC, 1932–3, no.1 (as by Nicolaes Maes); *The Bearsted Collection*, Whitechapel Gallery, 1955, no.37 (as by Schalcken).

LIT: *Upton* 1950, p.30, no.129; *Upton* 1964, p.39, no.129 (as by Schalcken); Sumowski 1983, iii, no.1365, p.2021, pl. on p.2091 (as by Maes); Beherman 1988, no.296, pp.346–7, fig. 296 (as by Maes, and possibly an Allegory of Air, or illustration of a proverb).

70 Giuseppe (Bartolomeo) CHIARI (Rome 1654–1727)

The Rest on the Flight, with Angels

Oil on canvas. 66 × 49·5 cm (26 × 19½ in)
Inscribed on the stretcher: *Lady Crewe*
Calke Abbey, Derbyshire

This painting is something of a double revelation. Not only has it not as yet been seen by the public at Calke (a house popularly, but erroneously, thought to have no decent pictures),[1] because it had been removed from what would seem to have been its proper place in the Boudoir before the house passed to the National Trust; but conservation of it for this exhibition has revealed a whole host of angels that had previously been painted over. Evidently, orthodox Anglican tastes could accommodate themselves to the decidedly Catholic imagery of the Christ Child on the Flight into Egypt being served by angels with a basket of nails, prefiguring those that would fasten him to the Cross, a toy version of which he holds in his other hand. But the host of other angels and cherubim must have been too much to take.

Chiari is an artist whose name is not infrequently found in 18th-century sale catalogues and inventories in England.[2] As Carlo Maratta's chief artistic heir, his name was probably often used for paintings that lacked the sanction for an ascription to the master.[3] With time, and without any longer the constraint of the knowledge acquired through visits to the studios of Maratta's epigoni in Rome, owners, collectors and dealers tended to promote the works of these followers to the status of those by the master. Thus over-promoted, many have since been dispatched to the saleroom, disbelieved, exported to America, and have only then recovered their true names.[4]

On 20 July 1726 the *abate* Giuseppe Gentili wrote from Rome to the great statesman, builder and collector, Lothar Franz von Schönborn, Archbishop-Elector of Mainz, giving his assessment of the Roman artistic scene:

> After the death of Carlo Maratti [in 1713] there are now no longer in Rome any such signal painters, who can hold their own against the celebrated masters of the past, as in the succession from Raphael to Michelangelo to Andrea Sacchi to Guido Reni, and so on. But still, there is no lack of excellent painters, and those with the greatest celebrity and esteem are Giuseppe Chiari, Francesco Trevisani, Sebastiano Conca, Cavaliere Odatti [Odazzi], all 'heroic' history-painters.[5]

The late Rudolf Wittkower called Chiari simply 'the most faithful' of Maratta's pupils.[6]

In all his paintings Chiari, indeed, loyally adopts Maratta's physical types and modes of composition; but, in keeping with 18th-century taste, he makes his figures more slender and gracile. All rough edges are smoothed away, and a sweetness bordering upon the saccharine pervades the whole. With a style that is less a development than an inherited mantle, it is difficult to chart any clear stylistic progression in his works. However, it would probably be fair to assume that robuster, more *mouvementés* pictures, such as two paintings of *The Rest on the Flight* (Bob Jones University Art Museum, Greenville, and Nelson-Atkins Museum, Kansas City) date from earlier in Chiari's career. The calmer, more graceful compositions, such as that of the present picture and the version in the Statens Museum for Kunst, Copenhagen,[7] probably date from later on in it. Their structure of interlocking triangles is almost too reminiscent of Raphael's *Canigiani Holy Family* (Alte Pinakothek, Munich), while the arcade recalls that at the back of Annibale Carracci's *Madonna and Child with St Francis in Ecstasy* (National Gallery of Canada, Ottawa). It was this increased note of Raphaelesque classicism that made this composition such an acceptable model for Lorenzo Masucci (d.1785) later in the century, when the currents of Neo-classicism were beginning to stir. He employed it, with very little change, for an altarpiece in S. Maria dell'Orazione e Morte in Rome, towards the middle of the 18th century.[8]

A little confusingly, Chiari seems to have made reductions of his earlier pictures in his later manner.[9] In doing this, he was perhaps responding to the relative lack of commissions for new altarpieces in Rome, and to the novel market for smaller and more collectable pictures opening up with the increased influx of young men on the Grand Tour. Even in the present case, where the Calke and Copenhagen pictures both appear to date from later in Chiari's career, it is by no means self-evident which is the prime version: both may be reductions of an unidentified altarpiece, made for sale to a foreign collector or a Grand Tourist.[10]

The ultimate buyer in this case was probably Sir Henry Harpur, 7th Bt (1763–1819), who later took the name of Crewe and became the first of the Harpur Crewe recluses; his French tutor on the Grand Tour had noted his pupil's serious inclinations.[11] He may even have had the excess of angels painted out, to avoid upsetting his pious and Evangelical mother. But these would seem to have been minor improprieties when compared with the major ones of taking and living with a former lady's maid as his mistress, and then compounding the mischief by marrying her! His widow's name appears to be that inscribed on the back of the picture, to judge by her style and its apparent date.

HIST: ?bt in Rome by Sir Henry Harpur, 7th Bt (1763–1819); ?his widow, Nanette Hawkins, Lady Crewe (1765/6–1827); by descent at Calke to Henry Harpur-Crewe (né Jenney; 1921–91), by whom given, with the house, estate and collections, to the National Trust in 1985.

71 Jean-Siméon CHARDIN (Paris 1699–1779)
'La gouvernante'

Oil on canvas. 46·5 × 38·5 cm (18¼ × 15¼ in)
?Signed (above middle panel of left door): *chardin*
Tatton Park, Cheshire

> Chardin always preferred depicting women to men, and children to adults. What he wishes to convey, he does less by the expression that he gives to the faces – which varies little – or by the look – an indefinable combination of abstraction and attention – of his characters, than through the stance and posture of their always quite immobile bodies. Avoiding both sentimentality and story-telling, Chardin – better than any other painter – gives expression to that tender but pure dialogue that takes place between adult and child.[1]

In these words Pierre Rosenberg has come as close as anyone to seizing the essence of Chardin's quietly compelling pictures of women and children. As he points out, this particular composition was the first in which Chardin depicted, not a housemaid occupied in some task or a child alone, but a woman of higher social status in actual dialogue with a young boy.[2] (The 18th-century French use of the word *gouvernante* was subtly different from that of the English 'governess'; it could also, as here, denote a 'housekeeper'.)[3] She has put aside her workbasket to brush his three-cornered hat, breaking off from the task to address him, possibly with a reprimand. The boy, who is evidently off to school – his parcel of schoolbooks under his arm, his shuttlecock, battledore and playing-cards abandoned on the floor – stands respectfully in front of her, as if listening to what she has to say, but actually lost in his own thoughts.

The room where this takes place has a fine parquet floor *à la française*, but plain, old-fashioned panelling, rather than up-to-date *boiseries*, upon the walls. The chair that the *gouvernante* sits on, though richly upholstered, also harks back to the previous century; as does the tapestried room beyond, glimpsed through the half-open door. The most modern note is struck by the curvilinear *table à quadrille*, or gaming-table. It is on such tables that Chardin's children so often build their houses of cards: the cards here have also obviously been put to the same use.[4]

Even critics of the Salon of 1739, in which the prime version of this picture was exhibited, differed in their interpretations of it: for most of them, the *gouvernante* was scolding the child, though many of them went on unwarrantably to assume that this was for untidiness, or for dirtying his hat. The chevalier de Neufville de Brunhaubois-Montador, however, thought that she was hearing his lesson.[5] This was an opinion shared by Watteau's picture dealer Edmé Gersaint, who described the woman as the boy's mother,[6] even while citing the engraving by François-Bernard Lépicié (which is titled *La gouvernante*),[7] when he catalogued the version in the posthumous sale of the chevalier Antoine de la Roque in May 1745.

If there is a moral, it is that implicit in so many depictions of childhood. The left-hand side of the picture contrasts the boy and his carefree pursuit of games and play, with the right-hand side occupied by the *gouvernante*, who has put aside one piece of work to take up another. The tension of this picture lies in the contrast between these two sides. The bound-up schoolbooks project from under the boy's arm, forming the liaison between the two spheres, while the soft, mingled colours of the tapestry glimpsed through the open door behind him also suggest the little paradise of childish freedom still to be enjoyed.

The prime version of this picture (1738; National Gallery of Canada, Ottawa) was apparently painted for Jean de Jullienne, the great collector and publisher of Watteau's works.[8] There is, however, evidence for the existence in the 18th century of at least two other autograph versions. One was in the posthumous inventory of Chardin's effects, and then in the sale of them of 6 March ff. 1780. The other was that in the La Roque sale, where it was described by Gersaint as '*une copie, retouchée dans plusieurs parties par Chardin*'. This did not mean a copy produced by another hand or in Chardin's studio, which he had retouched, but an autograph replica, slightly altered by the artist.[9]

Cleaning (by Keith Laing, in 1994–5) has not only confirmed the picture's autograph status, but has also revealed what seem to be the faint traces of a signature. There are also undoubted *pentimenti* – and slight differences from the Ottawa version – at the ends of the racket and shuttlecock, and in the playing-cards, in the back line of the boy's coat and the shape of his pigtail, and also in the skein of blue wool. Traces of added pigment on the boy's coat and on the wall have almost exactly the same composition and solubility as what is beneath them, strongly suggesting that this is the La Roque version, retouched by the artist, just as Gersaint described.[10]

HIST: ?posthumous sale of Antoine, chevalier de la Roque (1672–1744), Paris, May 1745, lot 190, paired with a version of *La pourvoyeuse*[11] (sold together to 'Colins' for 164 *livres*); ?sale held by 'Dr' Robert Bragge (d.1778), London, 15–16 Feb 1749/50, 1st day, lot 35 (sold for 18 gns);[12] Sir George Warrender, 4th Bt (1782–1849), of Lochend, East Lothian, and Cliveden; his sale, Christie's, 3 June 1837, lot 5; bt Wilbraham Egerton, MP (1781–1856); by descent to Maurice, 4th Baron Egerton (1874–1958), by whom left to the National Trust.

EXH: City Art Gallery, Manchester, 1960, no.127.

LIT: exh. cat. *Chardin*, Grand Palais, Paris, etc., 1979, under no.83, pp.260–63; Rosenberg 1983, no.117A; Conisbee 1986, p.152, col. pl.145.

72 François BOUCHER (Paris 1703–70)

'La vie champêtre'

Oil on canvas. 61 × 48 cm (24¼ × 19 in)
Belton House, Lincolnshire

Quite unlike the sentimental pastorals and nude mythologies with which Boucher later made his name, this picture is one of those he painted at the beginning of his career. The genre here is Dutch. Into a setting that owes something to the rural scenes with ruins by the italianate school of Dutch land-scapists, Boucher has inserted figures indebted to his imitations of Abraham Bloemaert's studies from everyday life.[1] The sleeping harvester, in particular, is almost a quotation from Bloemaert's *Pastoral Scene with Tobias and the Angel* (Staatliche Museen, Berlin).[2] Untypical though it is, this is the earliest painting by Boucher to reach England that still remains here.[3]

The brushwork of this picture, and even more the types of the figures in the middle plane, associate it with such paintings as *La fontaine* (J.B. Speed Art Museum, Louisville),[4] *Noah entering the Ark* and *The Sacrifice of Noah* (both private collection, Fort Worth),[5] and – slightly more distantly – with early pastoral landscapes such as *Rustic Scene with a Mother spinning*[6] (last recorded in the Frey collection in Paris in 1953), *Landscape with Bathers in a Moat*[7] (last recorded in a private collection in Paris in 1966) and *Crossing the Ford* (auctioned at Avranches in 1995).[8]

All but the last of these have the slumped figure of a peasant acting as a *repoussoir* in the foreground, and one can well believe that, if these were not derived directly from drawings by Bloemaert, they were at least inspired by such. In the three last, the landscape predominates over the figures and is characterised by exaggeratedly plunging effects of perspective recession, and by vegetation of almost demented vitality (partially inspired by Boucher's teacher, François Lemoine). In *La fontaine*, as in the present picture, it is the figures that predominate over the setting, and the distortions of perspective and foliage are less extreme. The concen-tration upon a group of rustics, without the introduction of any erotic or sentimental note, while not reducing them to mere staffage in a landscape, sets these works apart from the themes of Boucher's maturity. The brushwork and the treatment of drapery have also shed the mannerism of Boucher's earliest pictures, without acquiring the summary quality of those that he painted after his return from Italy in 1730/31. It is most probable, therefore, that either they just antedate his journey there in 1728, or that they are examples of the '*tableaux précieux à la manière des Flamands*' that Papillon de la Ferté asserts Boucher did in Rome.[9] Boucher's etchings after Bloemaert provide additional support for this latter dating. Although these were published as late as 1735, the drawings from which they were done seem to have been available to Boucher for some time before, and appear to have come from a larger group that had circulated among Boucher and his fellow students in Rome.[10]

At this period in his life, when he needed funds to get to Rome and to support his stay there at his own expense,[11] Boucher seems to have turned out pictures, etchings and drawings for engravings at a furious rate. Probably unable, as yet, to take on studio assistance, he seems to have simplified the task for himself, not only by repeating whole compositions with minimal variations, but by re-employing elements – particularly figures and animals – from one painting in another. His dexterity in this respect also meant that he was invited to enliven landscapes by other – sometimes earlier – artists with these. His ability to compose at the point of his brush meant that he often introduced small modifications in the process. So the sleeping young man (but without his guitar), together with a pissing cow (borrowed from the landscape engraved as *Le berger napolitain*), two sheep and a herdswoman, were added to a *Landscape with Ruins*, doubtfully ascribed to J.-B. Lallemand (1716–1803).[12] The cow recurs, with minor variations, among Boucher's additions to a *Landscape Capriccio with Ruins* by Jacques de Lajoue (1687–1761).[13] The motif of the young man behind a mule laden with a brass cauldron and earthenware pitcher – which is what prompted the advertisement of the engraving after the painting to say that it was 'entirely painted in the style of Benedetto Castiglione' – is employed, in variant forms, in at least two other early pictures.[14]

HIST: sale held by Andrew Hay, London, [14–15 Feb] 1744/5, 2nd day, lot 33, *A Harvest with Fig⁵., a Man Sleeping*, bt for £15 by Peters; sale held by 'Dr' Bragge, 1756, 2nd day, lot 32 (as *A Harvest*), bought for £13 2s 6d by 'Banks': i.e. Sir Henry Bankes (1711–74);[15] his collection, Wimbledon; whence inherited by his daughter, Frances, Lady Cust (from 1776, Lady Brownlow), and brought to Belton; thence by descent, until sold at Christie's, 3 May 1929, lot 1, bt by 'Smith'; Frank T. Sabin, London, 1935; with Fröhlich, London, in 1946; Dr Ernst Sklarz, London; from whom it passed to his widow, Mrs Martha Sklarz (d.1993), Kew, who bequeathed it to the National Trust, so that it should be returned to Belton.

ENGR: by Elisabeth Lépicié, 1741.

EXH: *French and Venetian XVIIIth Century Paintings*, Frank T. Sabin, London, 1935, no.6; *European Masters of the Eighteenth Century*, RA, 1954–5, no.474; *François Boucher*, Metropolitan Museum, New York, etc., 1985–6, no.9.

LIT (on the painting, not the engraving): Voss 1953, p.85, fig.39 (dating it to *c*.1740); Ananoff and Wildenstein 1976, no.55, i, pp.191–2, fig.278 (dating it to 1730); Ananoff and Wildenstein 1980, no.55; Jean-Richard 1978, p.332, under no.1382; Laing 1986, p.1567, fig.1 on p.1566; *Belton* 1992, p.38.

NOTES

Introduction

1. Cf. *The Times*, 17 July 1894, p.12.
2. Darley 1990, p.5.
3. In 1907 the Trust did acquire a fair-sized house, Barrington Court in Somerset, parts of which were being used as a cider store, but it became such a liability that it probably set back any idea of the Trust owning and managing substantial houses for a generation.
4. *National Trust Act 1937*, Section 3(b).
5. For the bare facts of this, cf. esp. Lees-Milne 1976 7, but for the vivid reality, see the same author's inimitable *Diaries* (published between 1975 and 1985), and Lees-Milne 1992, with a chapter on Lord Lothian and Blickling.
6. For what might be called a 'hare-and-tortoise' view of the changing relationship between the NACF and NT over the years, see Rees 1995.
7. Cf. exh. cat. *A Gift to the Nation: The Fine and Decorative Art Collections of Ernest E. Cook*, Holburne Museum, Bath, 1991.
8. David Lindsay, Lord Balniel, and ultimately 28th Earl of Crawford and 11th Earl of Balcarres. His *ur*-great-uncle, Sir Coutts Lindsay, 2nd Bt, founded the Grosvenor and New Galleries. The latter's younger brother, Col. Robert Lindsay, VC, created Lord Wantage, married the only surviving daughter of Lord Overstone, whose distinguished collection (the Loyd Collection) he inherited, but also enhanced. Their younger daughter married R.S. Holford (see cat. no.29). The prodigious Holford Collection was catalogued after Lord Wantage's death with the aid of his nephew by marriage, Robert Benson, who published another catalogue of it just prior to its breakup, and who had a distinguished collection of Early Italian paintings of his own.

The Wantages' elder daughter married Alexander, 25th Earl of Crawford and 8th Earl of Balcarres (David Crawford's great-grandfather), who not only created the Lindsay Library, but also wrote *Sketches of the History of Christian Art* (1847). Their eldest son, Ludovic, 26th and 9th Earl, though primarily an astronomer, both made selective disposals from and expanded the Library – notably with documents relating to the French Revolution, but also with manuscripts (now in the John Rylands Library, Manchester), a philatelic library (bequeathed to the British Museum) and a series of English and Oriental manuscripts illustrating the history of hand-writing (left to the Free Library of Wigan).
He published a number of volumes in successive issues of the *Bibliotheca Lindesiana* (1883–1913). His eldest son, David, 27th and 10th Earl (David Crawford's father), was an active Conservative politician, but also had a fine collection of pictures at 7 Audley Square, partly inherited and partly acquired. He wrote pioneering studies of *Donatello* (1903) and *The Evolution of Italian Sculpture* (1909). As intensely public-spirited as his son, he was the chairman, president, or trustee, of numerous societies and public bodies concerned with books and art. He wrote the high-minded entry on 'Museums of Art' for the ninth edition of the *Encyclopaedia Britannica* (1911).

9. For his own account of his – particularly significant – role at Petworth, see Blunt 1980.
10. See Gore 1993.
11. Editorial by Neil MacGregor, *Burlington Magazine*, cxxviii, June 1986, p.391.

Catalogue no.1

1. Johnson 1934, iii, p.161 (entry for 19 Sept 1777).
2. Bray 1778, p.72. Bray's visit to Derbyshire is datable by his (sole) entry in his diary for 1775, under 28 Sept (cf. Bray 1938, p.17).
3. *Journal of a Tour into Derbyshire in the Year 1793*, Cambridge University Library, Add. MSS 5804, ff.8–9, reprinted in Plumptre 1992, p.62. I am grateful to Richard Garnett for transcribing the Plumptre reference.
4. Verney 1894, iii, p.406; 1899, iv, p.353.
5. There is, however, at Petworth a very battered pastel painted by George Chace in 1811, of *Mrs Purser*: 'Housekeeper for nearly forty years to Petworth'. Quite exceptionally, Edward Blore actually depicts a housekeeper expounding the beauties of the Great Chamber at Canons Ashby, Northants, to a trio of tourists around 1825 (British Museum, reproduced on the cover of NT gbk to *Canons Ashby*).
6. Walpole 1980, xl, p.318; 1941, ix, p.4.
7. Including Lord Lumley in the 16th century and Lord Wharton in the 17th century, but the practice did not become more general till the later 18th century. Walpole was perfectly prepared to spring up a ladder, to put identities upon his friends' collections of portraits.
8. Leslie Harris (1978[2], p.217) found that 200 were printed in 1769, at a cost of £8 1s.

The Portrait Gallery

1. Colt Hoare 1822, p.70.
2. The Great Dining Room at Chatsworth is hung almost exclusively with 17th-century whole-lengths, as is the State Dining Room at Woburn with those by or after Van Dyck, and as was the Dining Room in Earl de Grey's house in St James's Square (Waagen 1854, ii, p.84).
3. See Prinz 1970 and Coope 1984, the latter especially for the development of the distinctively English phenomenon and term 'long gallery'. William Sanderson in his *Graphice* (1658, p.27) already recommends that: '*Graver* stories; *Histories*, your best figures and rarest worke becomes [Long] Galleries; here you Walk, Judge, Examine, Censure.' The moment of transition from the old Long Gallery to the new Saloon hung with pictures is perfectly caught by the Duke of Buckingham's demolition of Arlington House, and construction of Buckingham House (now Palace) in 1703–5. In 1705 he wrote: 'I am oftner missing a pretty gallery in the old house I pulled down, than pleased with a *Salon* which I built in its stead, tho' a thousand times better in all manner of respects' (Buckingham 1726, ii, p.220).
4. Such is the inference to be drawn from the listing of pictures in the Gallery in the inventory attached to Bess of Hardwick's will of 1601 (cf. Boynton 1971, p.29).
5. William, 5th Duke of Devonshire, KG (1748–1811), inherited in 1764. Horace Walpole, who had visited Hardwick in 1760, describes the Gallery as having 'bad tapestry, & worse pictures, mentioned in her [Bess of Hardwick's] Will', implying that nothing had changed. It is not until the description in *The Topographer*, iii/v, Nov 1790, p.328, that it is said that: 'When we saw it [the Gallery], the tapestry was taken down, and the numerous portraits with which it used to be hung, set aside, in order to repair it, in doing which we were informed the strictest attention was to be paid to replacing every thing in its old style.' The 1792 inventory reveals 65 pictures in what was now called the Long Gallery – some 17th-century three-quarter-lengths – as against the 38, mostly small ones, there in 1601.
6. Ter Kuile 1969, nos.1, 2, pp.13, 43–6, and figs.11, 12; exh. cat. *The Age of Charles I*, Tate Gallery, 1972, nos.1, 2; exh. cat. *The Treasure Houses of Britain*, National Gallery of Art, Washington, 1985–6, nos.49, 50.
7. Dale 1901, p.42; Millar 1994, esp. p.521. Euston Hall, built for the Earl of Arlington only a little, if at all, later, *c*.1670, is likewise described by Celia Fiennes in 1698 as having 'a long gallery hung with pictures at length' (i.e. with whole-lengths; cf. Fiennes 1982, p.139).
8. '*Les Peintres de Portraits sont aujourd'hui plus communs et plus mauvais à Londres qu'ils ne l'ont jamais été*' (Le Blanc 1745, p.209).
9. It was, however, very tempting to borrow his *Archbishop Vernon-Harcourt* from Sudbury, to show how Lawrence could make even an ecclesiastic *salonfähig*.
10. Two exceptions should perhaps be mentioned, though neither is on view, and only the first was both commissioned by the sitter, and of an actual donor: Sir John Lavery's *Walter, 2nd Viscount Bearsted* (formerly hung at Upton House); and Graham Sutherland's *The Hon. Edward ('Eddy') Sackville-West*, which hangs in the private apartments at Knole.
11. Cf. exh. cat. *Sickert: Paintings*, RA and Van Gogh Museum, Amsterdam, 1992–3, no.117 (also illustrating the portrait of *Lord Faringdon*); and Lees-Milne 1992, p.57.

Catalogue no.2

1. For Sir Anthony and Sir Robert especially, see *The Three Brothers*, 1825, and Sidney Lee in the *DNB*.
2. Vaes 1924, p.202.
3. Cust 1902, pls.xxi, xxii, and Adriani 1940, p.23, and pls.60v–63.
4. Fuller 1952, p.572.
5. The portraits could hardly have remained in England, as there was no Shirley seat here (Wiston having been sold to Cranfield in 1622), and Robert's only son, Henry, having predeceased him. If they had stayed in England, they would surely have been copied or engraved. The version of *Lady Shirley* recorded by William

Bathoe as having been in Charles I's collection (from George Vertue's transcription of the Ashmolean MS of Abraham van der Doort's inventory; see Bathoe 1757, p.163, no.18) seems to have been Gheeraerts's portrait of *?Anne Vavasour as 'Virgo persica'* (Hampton Court, no.299); Van Dyck's name was probably speculatively inserted by Vertue as an annotation. Hollar's engraving of her is after another portrait. One of the portraits of Sir Robert that the *DNB* reports as being in S. Maria della Scala may have been a copy of it made in Rome.

6. Bellori 1672, p.255.

Catalogue no. 3

1. Sanderson 1658, p.39.
2. Any more than is that of her cousin, *Sir John Suckling* (Frick Collection, New York), as compared with that of *Lord Wharton* (National Gallery of Art, Washington).
3. From George Wither's '*Ah me! Am I the Swaine*', 1622.
4. No record of the marriage itself has been found, but Vicary Gibbs implies that 1637 is the date given in a belated bill for the fees, dated 26 Jan 1640, while the future 6th Earl was born on 24 Jan 1637/8 (*Complete Peerage*, iv, 1916, p.54 and note e).
5. Recently rediscovered in the archives of the National Portrait Gallery by Jacob Simon, to whom I am most grateful for communicating a transcript of it.
6. What is apparently the best version of this, from the Breadalbane collection, was last sold at Christie's, 24 April 1987, lot 72. In this the sitter holds a lute, her playing of which was celebrated in a poem by Edmund Waller.
7. 1606–49; Vaduz, Prince of Liechtenstein; cf. exh. cat. *Anthony van Dyck*, National Gallery of Art, Washington, 1990–91, no.87.
8. Cf. Laing and Strachey 1994, p.8, fig.9.
9. Cf. Millar 1963, no.180.

Catalogue no. 4

1. North 1890, i, p.170.
2. Powis Castle. It is possibly a slightly later variant of a portrait with a garden setting and no coronet (sold at Christie's, 27 Feb 1970, lot 101; and subsequently at Sotheby's, 14 July 1993, lot 13). Wright also apparently painted her sister, Lady Anne (if the portrait at Powis believed to be of her is not actually of Lady Powis mourning her). He certainly painted the latter's husband, Henry, ultimately 6th Duke of Norfolk (one of Wright's portraits of him is also at Powis).
3. Huysmans's portrait of Catherine in the Royal Collection has an almost identical Cupid.
4. Such is the grandeur of this portrait that the sitter has been taken for one of these two Queens. Her features bear no relation whatsoever to those of Catherine, but those of Mary of Modena do for a moment give one pause. Mary appears most similar in the mezzotints after lost portraits by Kneller and Largillierre of precisely this epoch (as witness the hair-style), but in neither does she have the pronouncedly beaky nose of this sitter – the feature that most characterises Wright's portraits of Lady Powis.
5. Cf. Torrington 1934, i, pp.137–8; 1936, iii, pp.295–6.

Catalogue no. 5

1. Sandrart 1925, p.376.
2. Cf. Aldo Rizzi in *Mostra del Bombelli e del Carneo*, Chiesa di S. Francesco, Udine, 1964, esp. pp.xxxiv–vii; Rizzi, *DBI*, xi, 1969, pp.381–91; Pallucchini 1981, i, pp.305–9, ii, figs.1035–50.
3. Exh. cat. cit., no.1; Pallucchini 1981, ii, fig.1035.
4. Palazzo Ducale, Venice; cf. Ivanoff 1954, pp.276–8.
5. Cf. Jaffé 1966, pp.114–27.
6. Sumptuously commemorated by his Chief Steward, the painter John Michael Wright, in *An Account of His Excellence Roger Earl of Castlemaine's Embassy*, 1688. Almost inevitably, perhaps, the picture came to be regarded as a portrait of Castlemaine with and by Wright. But the painter was not with the Irish peer on his first Italian journey, nor ever his secretary, and the portrait is clearly not the work of a British artist, nor even of one operating in Britain. What is not yet clear is whether the name given to the secretary in the National Portrait Exhibition in 1866, Nicholas Wright, represents a garbling of the painter's name, or a record of the secretary's true name.
7. See n.6 above.

Catalogue no. 6

1. The elder daughter, according to Dugdale (*Visitation of Shropshire*, 1668, fol.101) and her tomb; but more probably the younger, if one considers the implications of her sister's earlier marriage and marriage settlement.
2. Royal Avenor and then Clerk Comptroller of the Board of Green Cloth (whose portrait by Huysmans is also at Belton).
3. For a description of this, as well as for other details about Lady Brownlow, see Cust 1909, pp.171–8, esp. pp.173–4.
4. The drawing for this monument is in the Victoria & Albert Museum (inv. no.D.1104–1898). It was one of 44 drawings ascribed to Caius Gabriel Cibber when acquired by the museum, but has subsequently been attributed to William Stanton, the builder of Belton, by John Physick (1969, pp.32–3). Stanton was responsible for a number of these drawings and had carved the tomb of Sir John (d.1679) and Lady Brownlow at Belton, and that to the 3rd Earl Rivers at Macclesfield (d.1694; erected 1696), father of the 4th Earl, whose then mistress was Dorothy's sister, Anne. However, he did not supply his name as the author of this tomb to John Le Neve for his *Monumenta Anglicana* (1717–19). Geoffrey Fisher (oral information) has included this in a very convincing group of monuments and drawings that he has attributed to Thomas Stayner (c.1668–1731).
5. D.A., in William Hone, *The Year Book*, 1832, col.554.
6. For which, see Holmes 1993, esp. ch.4.

Catalogue no. 7

1. Leslie and Taylor 1865, i, p.9.
2. Ibid., ii, p.440.
3. Graves and Cronin 1899–1901, ii, pp.726–7; *Saltram* 1967, no.30, pp.21–2, pl.IIb, no.119.

4. Graves and Cronin 1899–1901, ii, p.732; *Saltram* 1967, no.13.
5. The present picture; and with her son: Graves and Cronin 1899–1901, ii, pp.729–30; *Saltram* 1967, no.6.
6. Graves and Cronin 1899–1901, ii, p.730–31; *Saltram* 1967, no.18; exh. cat. *Reynolds*, RA, 1986, no.111, p.283, col. pl.
7. *Saltram* 1967, nos.64, 66, 120, 121, 122, 125 (not all of these are prime versions).
8. Graves and Cronin 1899–1901, i, p.59; *Saltram* 1967, no.22.
9. *Saltram* 1967, no.12. It had been engraved by Boydell when in Reynolds's collection.
10. *Saltram* 1967, no.108 (unjustifiably doubting the inscribed date); Roworth 1992, p.18, fig.2.
11. From the original MS of Reynolds's obituary of 'the Hon.^ble M^rs Parker', British Library, Add. MSS 48 252, fol.15, published in *The Public Advertiser*, 29 Dec 1775, reprinted in *The Gentleman's Magazine*, xlvi, 1 Feb 1776, p.75, and quoted in Lummis and Marsh 1990, p.70.
12. British Library, Add. MSS 48218, quoted in Lummis and Marsh 1990, p.72.
13. Ibid., quoted in *Saltram* 1967, p.32.
14. Ibid., quoted in Graves and Cronin 1899–1901, ii, p.729.
15. See Lummis and Marsh 1990, pp.75–6. Reynolds was also, consciously or unconsciously, echoing an action already employed by Kneller in his portrait of *Margaret Cocks, Countess of Hardwicke* of 1716 (Stewart 1983, no.343, p.109, pl.78). He may have known Kneller's portrait from the prime version then at Wimpole, Cambs (private collection, UK), or from one of the repetitions or studio copies now at Antony, Cornwall, and Hatfield, Herts.
16. See n.11 above.
17. Unfortunately, there is no record of the picture in Reynolds's ledger books. Not (so far as we know) because it was painted *gratis* for a friend, but because the first page for the letter 'P', which would have recorded any payments, is missing. According to Graves and Cronin, that page was torn out by Reynolds's niece, Theophila Gwatkin, in 1844, and sent to Benjamin Robert Haydon to refute Sir Martin Archer Shee's assertion that no such ledger book existed. That, however, is a confusion with Mrs Gwatkin's tearing out and loan to Haydon of a page of Reynolds's secret memoranda of his painting practices, for that purpose (Haydon 1963, pp.573, 579).

Catalogue no. 8

1. Hervey 1954, p.294.
2. See French 1988, esp. pp.26–9, 36 and 67–9 for pose, attributes, and Aileen Ribeiro's comprehensive description of Commodore Howe's almost identical uniform.
3. Hervey 1954.
4. This had already been commemorated in a portrait of him by Reynolds given to Bury St Edmunds, for which he was MP in 1757–63 and 1768–75 (Manor House Museum, ibid.).
5. A framed and glazed drawing of the hull of HMS *Dragon* was lot 132 in the sale of 17 May 1827 (see HIST).
6. Hervey's flight prevented him from returning to Paris with his naval uniform and a drawing of his ship, as promised, for Gravelot to finish the

conversation-piece that he had begun in collaboration with J.E. Liotard (also now at Ickworth, completed by an English hand). Yet he may have renewed the liaison much later: cf. the letter from J.-J. Vial in Nice to Liotard of 14 Dec 1775, passing on the Earl's invitation to him to come to Nice to complete his portrait, and to paint him with a lady whom he had painted many times before (Loche and Röthlisberger 1978, p.100, under no.119).

7. He gave Pembroke a portrait of himself by Reynolds in 1763 (Wilton House).

8. Reynolds painted two portraits of her for Lord Bristol in 1781: one in the Wallace Collection and the other (appropriately, as *Circe*) in the Smith College Museum of Art, Northampton, MA.

9. Walpole 1939, p.66.

10. Fulcher 1856, pp.61, 185.

Catalogue no.9

1. Ward and Roberts 1904, ii, p.9 (with wrong dimensions).

2. He suppressed all but six copies of the latter before publication, only republishing them in 1834, with considerable excisions, in combination with his letters from Spain and Portugal.

3. Written in French (like Wilde's *Salomé*), but first published in English, without authorisation, as an anonymous translation (like Macpherson's *Ossian*), purportedly from the Arabic, in 1786.

4. Melville 1910, p.105 [letter of 2 April 1781, from Paris].

5. For an excellent account of Beckford as a collector, which none the less sweeps the pictures into a paragraph, see Wainwright 1989, pp.108–46.

6. Hazlitt 1903, ix, pp.58–60; cf. Jones 1978.

7. Romney's earlier *William Beckford as a Boy of about Thirteen* (present whereabouts unknown; Tipping 1919, pp.515–16, fig.1) has a similarly placed teazle, in front of a rough-hewn rock with a circlet of ivy on it, on which the pensive boy leans. Since these are clearly intended to suggest the memory of his recently deceased father, 'Alderman' Beckford (d.1770), it is very possible that teazle and relief are meant to perform the same function here. My thanks to David Cross on these points.

Catalogue no.10

1. Waterhouse 1953[1], 2/1962, p.214. This is considerably toned down in his entry on Hoppner in Waterhouse 1981, p.181.

2. Anglesey 1961, p.151, quoting a letter from Thomas, 2nd Baron Graves, to the Dowager Countess of Uxbridge.

3. Beechey had chosen to show his own wife cradling their sleeping child only a year or so before, in even more naturalistic fashion. By contrast, Benjamin West's *Jocosa, Lady Cust with her sleeping Niece Caroline* of c.1770 had been a modern-dress reworking of Annibale Carracci's *Il silenzio*.

4. See Anglesey 1955, pp.187–219.

Catalogue no.11

1. There are suggestive echoes of Van Dyck's *William, 1st Earl of Denbigh, with an Indian Boy* (National Gallery). The significance of the boy

and his gesture in this picture is still uncertain (cf. Martin 1970, pp.52–5, and exh. cat. *Van Dyck in England*, National Portrait Gallery, 1982, no.16). However, it is at least arguable that he might be summoning Denbigh to think of returning home, in the middle of his long tour of the East 'to better my understanding'.

2. Farington viii, pp.2940–41 (8 Jan 1807).

3. According to an uncertainly dated letter from Colt Hoare to the Earl of Ailesbury (Woodbridge 1970, p.153 n.) and Woodforde's notebook (private collection, England).

4. He made a tour of northern England in 1800 and another of Ireland in 1806 – the only one he published himself (see Colt Hoare 1983).

5. Woodbridge 1970, pp.184, 194–234, 251–67; Colt Hoare 1983, pp.17, 25–30.

6. He was careful to distinguish these from his grandfather's acquisitions, in the unprecedentedly systematic arrangement and account of the collection at Stourhead given in the first volume of *Modern Wiltshire*.

7. He obtained a series of fancy pictures from Thomson, and gave particular encouragement to Louis Ducros, Francis Nicholson, and J.J. Rouby. He also played an active part at the British Institution, and wrote an introduction to William Carey's catalogue of the collection of his friend and fellow-patron, Sir John Leicester (1810). His commissions to and purchases from artists were considerably influenced by (and in the case of Northcote's *The Dumb Alphabet*, actually taken over from) the latter. His taste was never adventurous, however, and, after a sneering attack on his 'patronage' in *The Annals of the Fine Arts* in 1817, he desisted altogether (cf. Woodbridge 1970, pp.235–49).

Catalogue no.12

1. Redgrave 1947, pp.239–40.

2. *DNB*, xlii, p.457.

3. Simon 1987, p.214.

4. Allen 1991.

5. Farington 1982, x, p.3833 (24 Dec 1810).

6. Exh. cat., York City Art Gallery, 1994, no.13.

7. Rowell 1993, pp.29–36.

8. Creevey 1948, pp.291–2.

9. She is mentioned in a letter from William Eliot (later 2nd Earl of St Germains) to Lady Harrowby of 21 July 1808 (Aspinall 1969, vi, p.282, n.2).

10. Parry 1930, pp.259, 263.

11. The most promising candidate, Letitia Anne Hoare, Mrs Sage (active 1773–1817), 'The First [English] Female Aerial Traveller', was called Mrs Robinson when she reappeared as dresser and wardrobe-keeper to Charles Dibdin Jr in 1804, but must be ruled out by age (cf. Highfill et al. 1991, pp.167–9).

12. Creevey 1948, p.292. One further candidate, Catherine Skinner, Mrs William Robinson (1768–1843), sister of the Jamaican Journal writer, Maria, Lady Nugent, is eliminated by John Downman's very different likeness of her (British Museum Print Room, Butleigh Court sketchbook, 4th ser., iii, fol.8).

Catalogue no.13

1. Bucklow 1993, pp.364.

2. There are five portraits of the 3rd Earl by

Phillips at Petworth alone, as well as those by his mother, and by William Hoare of Bath, John Lucas and George Clint, showing him from boyhood to old age. Significantly, there is none by any of the fashionable artists of the day, despite his great enthusiasm for the works of Reynolds, and although Beechey was a regular houseguest. He did, however, get Romney and Hoppner to portray his mistress (later wife) and illegitimate children.

3. The 3rd Earl himself had hung in this position Reynolds's *Death of Cardinal Beaufort* (see no.15).

4. The picture shown is actually Phillips's own copy of 1819 (Collins Baker 1920, no.59) of a portrait he had painted in 1810 (Royal College of Surgeons).

5. Egremont 1985, p.286.

6. Collins Baker 1920, no.30.

7. Butlin and Joll 1984, no.18, i, p.17, ii, pl.14.

8. Collins Baker 1920, no.34.

9. Creevey 1948, p.293.

10. Leslie 1860, i, p.80.

11. Petworth, no.97. It can be seen, once by daylight, and in the other being viewed there by moonlight coming through the lunettes (blocked up by the time of Phillips's painting), in two of Turner's gouaches (Butlin et al. 1989, pls.43, 44).

12. Petworth, no.115.

13. Until 1993 it stood in the Audit Room, the room that would have been the Carew Gallery, had the sculptor not been so greedy, or desperate, for cash.

14. Dogs feature in virtually every portrait of him, but, oddly, they were eliminated from the version that the 3rd Earl retained of Turner's *View out from the House over the Park at Petworth*. In the original version, which Creevey saw installed in the panelling of the Carved Room at Petworth in 1828 (Creevey 1948, p.293), but which is now in the Tate Gallery (Butlin and Joll 1984, no.283, i, pp.165–6, ii, pl.285), a whole troupe of them stream behind him, as he stands to contemplate the sunset. One sculpted by Carew in the pose of *The Dog of Alcibiades*, stands in the lake, where he drowned.

15. The substitution is evident from the Phillips having the same number as the Reynolds, with the addition of an asterisk, and is indicated on two diagrams of the changing hangs at Petworth made not many years after the 3rd Earl's death. Its dispatch to Cockermouth in 1861, and substitution by another whole-length of the 3rd Earl, by George Clint, is revealed by a MS addition to a copy of the 1856 catalogue in the possession of Lord Egremont. Collins Baker's allocation of the wrong number to this picture, which was that of another Phillips of the 3rd Earl acquired from the Polwarth sale in 1912, is responsible for its true identity having remained unrealised for so long.

Catalogue no.14

1. Although his mother was the daughter of a Rev. George Watts, there was no connection with the painter's family.

2. He was described by Ellen Twisleton as 'not one of the souls that Nature tried her finest touch on. At the bottom of everything, there is a little coarse commonplaceness about him' (Twisleton 1928, p.248).

3. Darley 1990, pp.108, 124–5.

4. Watts 1912, i, p.160.

5. Barrington 1905, p.2 (these *Reminiscences* are dedicated 'To the memory of Janie Senior').

6. Stirling 1924, p.220.

7. Blunt 1975, p.99.

8. Barrington 1905, p.3.

9. Ibid., pl. opp. p.4.

10. Ibid., p.7. Around the same time he painted a whole-length of her sister-in-law, *Miss Senior*, 'surrounded in her portrait by the beautiful sky and the grand laurel leaves, put in as the grand Venetians would have painted them', and a portrait of her mother, *Mrs Hughes*. He later painted her only son, *Walter Senior*, as a gift for her, just two years before she died (ibid., pp.3, 9n., pl. opp. p.8; Watts 1912, i, p.296).

11. He used Holman Hunt as the model for King Ina, in the mural of *Justice* that he painted between 1853 and 1859 in Lincoln's Inn. It was executed in true fresco, as Pre-Raphaelites recommended.

12. Ibid., i, p.174.

13. Ibid., i, p.175.

14. Watts's *Annals*, quoted Blunt 1975, p.102.

Catalogue no.15

1. There is no biography of her – in part, at least, because she had all her personal papers destroyed after her death; but see Masters 1989, pp.86–107.

2. There is no life of McEwan, but see the excellent résumé of him as a businessman and as a collector in Lloyd Williams 1994. His daughter was to have both him and herself painted by more conventional foreign artists, he by Benjamin Constant, in 1900, she by Hermann Schmiechen in 1909 (his portrait, *Polesden Lacey* 1971, p.14, no.5; hers destroyed there by fire in 1961). According to Mrs Greville's MS list of her pictures, it was painted from six sittings at the Savoy Hotel.

3. Lees-Milne 1975, p.147.

4. By Constant and Walter Ouless respectively (*Polesden Lacey* 1976, p.25).

5. Lady Greville's memoirs, *Vignettes of Memory* (1927), make only one mention of her son as an adult, and none of her upstart daughter-in-law.

6. Channon 1993, p.264.

7. The Grevilles had originally taken Reigate Priory from Lady Henry Somerset. Polesden was bought from the executors of Sir Clinton Dawkins, who had only just had Sir Ambrose Poynter make substantial alterations to the modest villa built by Thomas Cubitt for Joseph Bonsor (which had itself replaced the Carolean house belonging to Sheridan).

8. Clark 1974, pp.269–70.

9. Channon 1993, p.336.

10. Lees-Milne 1975, pp.112–13; Lees-Milne 1977, p.168.

Conversation-pieces, Narrative Painting and Sporting Art

1. Johnson 1787, xi, p.208.

2. Pevsner 1956, p.22; 1964, p.31.

3. Farington 1982, vii, p.2594 (24 July 1805). Fuseli saved his hypothesis only by claiming that '*Historical painting*, viz: matter of fact, they may encourage'.

4. It was thought to be a masterly stroke of ingratiation with his host country when the German ambassador created a canine cemetery between his embassy and Carlton House Terrace steps.

5. At Lyme Park there is one of the rare examples of the near life-size portrayals that preceded Wootton and Seymour's horse-paintings, by the Master I H, dated 1666 (Millar 1995, pp.9–10, fig.6).

6. *Conversation Pieces* is dedicated to Sir Philip Sassoon, 'to whom the conversation piece, and Zoffany, more especially, are deeply indebted'. Sir Philip also owned one of the supreme French examples of the genre, J.-F. De Troy's *A Reading of Molière*, which was sold from Houghton Hall in 1994.

7. Praz 1971 is marvellously stimulating, but savours very much of the period when it was written, in its overdone insistence upon the conversation-piece's bourgeois roots.

8. Ireland 1798, iii, pp.25–6.

9. Pevsner 1964, p.35.

10. For the role that Kathleen Newton played in Tissot's life and art, see Wentworth 1984, pp.125–53. For the deliberate ambiguity of his subjects, see Malcolm Warner's essay in exh. cat. *James Tissot*, Barbican Art Gallery, 1984, pp.32–6.

11. Reviewing a posthumous exhibition of Alma-Tadema's pictures, Roger Fry maintained that the artist had 'undoubtedly conveyed the information that the people of that interesting and remote period [i.e. the Roman Empire] had their furniture, clothes, even their splendid marble villas made of highly scented soap' (quoted by Bell 1968, p.79).

12. For a useful list of mid-Victorian collections described by F.G. Stephens in *The Athenaeum*, and their subsequent fate, see Macleod 1986.

13. Indeed, the first known manifestation of such an interest is for a picture that got away, but which, had it been secured, would have been one of the masterpieces of the collection, Luis Paret's *Paseo in Front of the Botanical Gardens in Madrid* – a remarkable purchase for an Englishman to have contemplated in 1932 (letters of 14 and 26 June 1932 to George Bambridge, from Jage Bull, of the Danish Legation in Madrid).

Catalogue no.16

1. I am grateful to David Hancock, Director of Shugborough, and author of *The Heritage of the Dog*, for this information.

2. Laing 1990, cover and pp.62–5, esp. pp.63–4, fig.1.

3. When Hogarth advertised the loss of his dog in 1730, he called it: 'A light-colour'd Dutch dog, with a black Muzzle, and answers to the Name of Pugg' (Paulson 1991, pp.203, 222–4). This coincides with the first appearance – almost as a signature – of the first true pugs in his pictures. Yet the Chelsea porcelain pug believed to be his later dog Trump, modelled by Roubiliac, has more of the mastiff-like characteristics of the dog shown here.

4. Arnold-Forster 1950, p.115. Katherine was great-granddaughter of 'Old' Sir George Booth, 1st Bt, 'flower of Cheshire', and first builder of the present house of Dunham Massey. I am

grateful to Mr and Mrs Arnold-Forster for a transcript of this document.

5. Laing 1990, p.62.

6. Vertue ii, p.141.

7. Vertue i, p.117; v, p.14. The subsequent fate of Sotheby's Knyffs does not seem to be known.

8. Honour 1954.

9. Yale 1985, p.136, fig. p.137.

Catalogue no.17

1. The young artist bears little resemblance to Mercier as shown in Faber's mezzotint of his lost *Self-portrait at an Easel* (exh. cat. *Philippe Mercier*, 1969, frontispiece), but that dates from a decade later. There is more resemblance to his image in the lost *Mercier Family Portrait* that he himself etched (ibid., no.3); but, though evidently done a year or two before the present painting, the artist looks more youthful in the latter.

2. To his chagrin, as the holder of an Irish peerage and to avoid problems of precedence, Tyrconnel was given the ribbon the day after the English peers and their sons, on 28 May 1725. His and his wife's identities are secure; theirs and those of the other participants were first set down over a century later, in an undated note by a Lady Brownlow (almost certainly the widow of the 1st Baron) tucked into the Hon. Elizabeth Cust's MS catalogue of the pictures at Belton. Lady Elizabeth Cust (1909, pp.191–2) has the same cast, but with the roles differently allocated.

3. Sotheby's Monaco, 2 Dec 1989, lot 172; exh. *Dessins anciens*, Haboldt & Co., Paris, 1990–91, no.21.

4. Either alone or with the Schutz brothers (for whom, see cat. no.18). Cf. exh. cat. cit., 1969, pp.11, 25–6; Ingamells and Raines 1976–8, pp.3–4; and Rorschach 1989–90, pp.5–6.

5. The Hon. Elizabeth Cust, MS catalogue of the pictures at Belton, c.1805–6, no.220 (ascribed to Liotard); Cust 1909, p.208; Rorschach 1989–90, p.53, no.36.

6. MS in the Belton Archives, Lincolnshire RO. In view of the absence otherwise of the present painting from any of the lists of Lord Tyrconnel's pictures, it is just possible that it was meant by this rather elliptical designation.

7. Cust 1909, pp.231–2.

Catalogue no.18

1. Ingamells and Raines 1976–8, pp.3, 8–9 n.7.

2. Vertue ii, p.72.

3. NPG 1556: cf. Kerslake 1977, i, pp.338–40, ii, pl.950; see also exh. cat. *Philippe Mercier*, 1969, no.24; Ingamells and Raines 1976–8, p.22, no.39.

4. Millar 1963, no.522, i, pp.174–5, ii, pl.184; exh. cat. cit., no.26; Ingamells and Raines 1978, p.22, no.40. There are grounds for doubting the location of the room at Hampton Court suggested by these and Edward Croft-Murray (1970, ii, p.255), and (by implication) by Michael Levey (1964, p.91). Contrary to what is maintained by Kimerly Rorschach (1989–90, pp.7, 42 n.14), nor does the view through the window bear any resemblance to the setting of the Prince's Carlton House. The painting by Pellegrini seen on the wall is from a set first recorded at Kensington Palace, and it was there that Hervey records the Prince playing the cello to all and sundry.

5. Inv. no.1905–4–14–43; cf. Edwards 1948, p.311, fig.4, though his judgement that 'no hint of the artist's subservience to Watteau survives' in it is incomprehensible, when the outer figures are borrowed directly from his compositions. A *terminus ante quem* for it is suggested by the related engraved frontispiece to one of the volumes of *The British Musical Miscellany, or The Delightful Grove*, published by Walsh around 1732 (Hammelmann 1968, p.1053, fig.4).

6. Egmont 1920, i, pp.290, 412.

7. Hervey 1931, i, p.310. The discrepancy over what instrument the Prince played is odd. Egmont was a good enough musician to have a 'concert', and so to have distinguished between a bass-viol and cello (but see also Hervey 1931, i, p.195).

8. Mercier painted two further portraits of Princess Anne, both of which have disappeared, though the first, a standing three-quarter-length in the Prince's hunting livery, is visible as the overmantel in Charles Philips's *Frederick, Prince of Wales, with the Knights of the Round Table in the Blue Room at Kew House* of 1732 (Millar 1963, no.533, i, p.177, ii, pl.207).

9. Egmont 1920, i, p.454.

10. Hervey 1931, i, p.273.

11. Cf. exh. cat. *Handel*, National Portrait Gallery, 1985–6, p.143.

12. This is also Kimerly Rorschach's view (1989–90, p.7).

13. This identification is based on Lord Egmont's remark about her competence as a harpsichordist; all he actually said, however, was: 'She sings fairly and accompanies her voice with the thorough bass on the harpsichord at sight' (Egmont 1920, i, p.466: entry for 19 Dec 1733), which does not necessarily suggest competence to chamber music standard. We have no evidence for her sisters' comparative accomplishments. Indeed, in the related drawing bearing Thomas Worlidge's initials in the Royal Collection at Windsor, this figure is seen sketching, rather than playing the harpsichord (Edwards 1948, p.12, fig.5). In a painting of Frederick with four of his sisters (now at Wilhelmsthal), which has been mistakenly attributed to Charles Philips (Rorschach 1989–90, p.57, no.104), but is more probably by Enoch Seeman, Anne would appear to be the one in the centre playing the mandora, while Amelia plays the harpsichord, and Caroline paints, with Mary (later Landgravine of Hesse-Cassel) looking on.

14. Apparently given to Col. Johann Schutz (d.1773), Keeper of the Privy Purse and Master of the Robes to Frederick. Shotover House passed to the descendants of his brother, Augustus, Baron Schutz, Keeper of the Privy Purse and Master of the Robes to George II, through his marriage to Penelope Madan, lady-in-waiting to Queen Caroline, the ward of the childless General Tyrrell of Shotover (see Ingamells and Raines 1976–8, p.31, no.85). The two brothers had previously commissioned Mercier's earliest surviving conversation-piece – indeed earliest surviving English portrait altogether – which appears to have been conceived in part as an affirmation of loyalty to the Protestant Succession and the Hanoverian dynasty (exh. cat. cit., no.11; Ingamells and Raines 1976–8, p.31, no.85).

Catalogue no.19

1. The earliest Netherlandish tradition of allegories and personifications, over which so much ink has been spilt (Shesgreen 1983; swallowed whole by Paulson 1992, ii, pp.135–6, 413 nn.17–18), was effectively dead by the end of the 17th century.

2. Cf. Goodman-Soellner 1977, pp.41–58.

3. Felton 1785, p.28, purporting to quote Nichols, though the reference has not been found.

4. Fielding 1974, i, p.66.

5. Vertue iii, p.30.

6. Nichols 1782, p.209; expanded by Lichtenberg 1794, pp.62–3; trans. in Lichtenberg 1966, pp.279–80.

7. Cf. Lane 1895, pp.29, 30, 51, 59. Hogarth was absolutely up-to-the-minute, because the second lodge had moved itself from the Star & Garter in St Martin's Lane to the Earl Cardigan, or Cardigan's Head, as recently as 1738–9.

8. As identified by John Nichols in Nichols 1781, p.100; but see also Paulson 1992, ii, pp.131–4, for detailed documentation of De Veil's role as a magistrate involved in suppressing the illegal sale of gin.

9. This pictorial *topos* carried its own freight of moralising implications (Białostocki 1966 and exh. cat. *El Greco: Mystery and Illumination*, National Gallery of Scotland, Edinburgh, 1989.

10. See Paulson 1992, ii, pp.229–39 for an excellent account of the auction and its context.

11. Vertue iii, p.124.

Catalogue no.20

1. Walpole 1927–8, p.44; visit of July 1762. Walpole was describing what he categorised as a copy of the picture, then belonging to Stephen Fox (see below). The copy may be by Ranelagh Barrett, whom he specifically credits with two other copies there, while the late Earl of Ilchester – who may well have been drawing on some unspecified document – further credits him with this one.

2. Vertue iii, p.57.

3. For Hervey, see Halsband 1973.

4. *Essays*, 1885, quoted in Colvin 1976, v, p.75.

5. The Garter was also added to the Richardson portrait of him owned by Lord Holland, which has a label on the back inscribed: 'It is a very good picture, altered as to the dress by Lord Holland, who loved and still loves his friend Charles Spencer better than any man living' (Ilchester 1937, p.39).

6. Halsband 1973, p.91.

7. For Villemin as the butt of jokes, see the quotation from the Melbury game-book of 20 Sept 1736 in Ilchester 1920, i, p.50.

8. Desaguliers obtained one benefice in 1720, Stanmore Parva in Middlesex, from the Duke of Chandos, to whom he had become chaplain in 1714. George I rewarded him with Bridgham in Norfolk, worth just £70 p.a., which George II subsequently exchanged for Little Warley in Essex, but he never seems to have been prosperous.

9. Calvert 1907, pp.12, 20–31.

10. Calvert 1907, pp.106–7; Paulson 1991, i, pp.114–19; Paulson 1992, ii, pp.56–60.

11. Hervey, if not himself a Mason, reported with amused tolerance on their reception in a letter to Henry Fox the next day (Ilchester 1950, p.45).

12. Hogarth had already introduced him as the preacher in the Masonic-symboled *The Sleeping Congregation* of 1736 (Paulson 1991, i, pp.97–103, fig.40). Even the motif of the toppling chair may be Hogarth's way of alluding to another of Desaguliers's main scientific interests: balance, to which Lecture III in the second volume of his *A Course of Experimental Philosophy* (1744) was devoted.

13. Some or all of the protagonists did spend some time together at Maddington in September 1738, though this was followed by a temporary estrangement between Hervey and their host, and in turn by a permanent breach between Hervey and Henry Fox some time after the autumn of 1739 (Ilchester 1920, i, pp.51, 85; Halsband 1973, p.250).

14. The interpretations by Paulson (1992, ii, pp.174–6) and Campbell (1990, pp.281–97) are anachronistic in spirit and mistaken in detail.

Catalogue no.21

1. Cf. D'Oench 1980, esp. pp.21–2.

2. D'Oench 1980, no.30, p.59, pl.30 (dating the picture rather too late for the sitter's age and representation *in statu pupillari*).

3. Exh. cat. *Robert Adam and Kedleston*, NT, 1987, p.9.

4. Harris 1978².

5. In December 1758 Robert Adam was claiming, with only slight exaggeration, that 'the proud Grecian has not seen Sir Nathaniel these two years', and would not surrender the drawings (Watkin 1982, p.34).

6. Instead Curzon sent Kent on a picture-buying expedition to Italy, in 1758–9, which resulted in a somewhat mixed bag of paintings, primarily from the collection of the Marchese Arnaldi in Florence (previously in that of the Marchese Niccolò Pallavicini in Rome; cf. Rudolph 1995). Nor did he commission any further history pictures, apart from a scene from the *Decameron* by Henry Robert Morland that was later adjudged indecent, and replaced by William Hamilton's *Ruth and Boaz*. Instead, he obtained sets of decorative paintings from William Hamilton and Biagio Rebecca.

7. Brettingham's design for the central hall, like Adam's after him, envisaged all the niches in the long walls being occupied by classical statues or casts, but, in the event, eight were left vacant. Some of the casts, and the only two Antique marbles, were instead supplied by Joseph Wilton (Kenworthy-Browne 1993).

8. Exh. cat. cit., p.74. See also Hardy 1978.

Catalogue no.22

1. Cf. esp. *The Atholl Family* (1767; Duke of Atholl).

2. Oliver 1894, i, pp.cxxi, cxl; Oliver 1899, iii, pp.318–9.

3. Curiously, it can only have been a little later, around 1768/9, that he painted the first of at least two versions of *A Porter with a Hare* (exh. Society of Arts, 1769), in which the label on the dead hare, showing where the illiterate porter was to deliver it, is addressed to Zoffany himself

(Manners and Williamson 1920, pp.19–20, pl. opp.; exh. cat. *Johan Zoffany*, National Portrait Gallery, 1976, nos.45, 46).

4. Reynolds painted a head-and-shoulders portrait of Frances around this time (also at Kingston Lacy). For their two families, see Oliver 1894, iii, pp.256–64.

5. Namier and Brooke 1964, iii, pp.657–8.

6. Mcnaghten 1955, pp.19–20; 1958, pp.58–61.

7. Garlick 1989, no.679, illus. p.258.

8. There are paired examples of it and the Borghese Vase in alabaster in the Great Hall at Houghton, and in bronze in the Entrance Hall at Osterley (Haskell and Penny 1981, no.82, p.316, fig.167).

9. In consequence of this error, a curious attempt was made to pass off as this picture (at Christie's, 15 April 1994, lot 10) one of Thomas and Catherine Banks, and their son, the fanciful genealogist Thomas Christopher Banks (1765–1854), which is probably the only known portrait by Biagio Rebecca.

Catalogue no.23

1. I am most grateful to Dr Catherine Wills for this and the following equine information.

2. The others are '*Jason*' *with a Groom*, '*Pilot*' *with Jockey up* and '*Juniper*' *held by a Groom, with the Doncaster Cup displayed*.

3. Beard and Gilbert 1986, p.922. William Marlow also gave Vials's as his contact address, between 1763 and 1778, as Lucy Wood has kindly pointed out to me.

4. *Epochs of the Arts*, 1813, p.169.

Catalogue no.24

1. David Alexander has discovered Paye's true place and year of birth (not Boxley in Kent, as previously thought), and that his second name was his mother's. I am indebted to him for this and much other information exploited in this entry.

2. One of the better-known examples is Watteau's drawing, possibly of the French engraver Bernard Baron, in the British Museum.

3. A half-length derivative variant of it, without hands or setting, was presented to the Royal College of Surgeons by Francis Wingrave in 1800 (Le Fanu 1960, no.192, p.62, pl.34).

4. The print is unusually large, and rare. The only example known to David Alexander and me is in the Portrait folders in the British Museum Print Room.

5. *Literary Gazette*, 26 Jan 1822, p.60; partially reproduced by the *New Monthly Magazine*, vi/15, 1 March 1822, pp.137–8. Also cf. obituary by 'D' in 'Neglected Biography. No.1. – R.M. Paye', *Library of the Fine Arts*, iii/13, Feb 1832, pp.95–101, esp. p.96.

6. Clayton 1913, p.231, fig. p.232. Paye had moved from Swallow Street to Broad Street by 1784, when he shared lodgings with Wolcot.

7. Paye's anonymous obituarist in the *Literary Gazette* (see n.5 above) comments on his unsociability, which had the consequence that 'he was taken up and set down again, precariously employed . . .'.

8. When Paye showed the picture in 1783, his adjacently numbered exhibit was *An Old Woman at work in a Window*, which sounds

almost like a pendant to it, and is the one recorded in the *Library of the Fine Arts* (see n.5 above) as being sold some time subsequently, after it had passed out of his hands, as 'a fine Netherlandish work'. Similarly, a picture of his wife and family modelling *The Widow's Cruse* was displayed at a prominent dealer's as a Velázquez, and the present picture was bought by Neeld as by Wright of Derby.

9. Haskell and Penny 1981, no.67, pp.280–82; exh. cat. *Wright of Derby*, Tate Gallery, etc., 1990, no.23.

10. In 1827 Neeld inherited the then astonishing sum of £1 million from his great-uncle, Philip Rundell (1746–1827), who had founded the goldsmiths Rundell, Bridge & Rundell, one of the most successful such firms that this country has ever seen. This enabled him to commission Henry Clutton and then James Thompson to build Grittleton and furnish it with contemporary British sculpture on a lavish scale (Read 1982, pp.140–41, figs.170–74). For his picture collection, see Waagen 1854, ii, pp.243–8.

Catalogue no.25

1. Waterson (1980, pp.10, 58) points, however, to what may be a significant regional grouping of such portraits.

2. *John Meller's Negro Coachboy* has traditionally been dated to the early 18th century (Waterson 1980, pp.30–33, fig.24), but it probably also belongs to the late 18th century. It too may be the work of John Walters, albeit possibly copying some decayed earlier original: hence its difference in format from the latter's portraits of living servants.

3. Cf. Waterson 1980. Waterson had the original idea of presenting Erddig through the history of its servants, just as he had the idea of introducing visitors to the outbuildings and servants' quarters before the family rooms.

4. 4 Feb 1771: Clwyd RO, Erddig MSS D/E/563. Quoted Waterson 1980, p.47.

5. Significant by her absence is the most famous of all the servants of the Yorke family, Betty Ratcliffe (c.1735–1810), lady's maid and governess, but ultimately companion to Philip Yorke's mother, and the maker of numerous 'curiosities' out of cut-paper, mother-of-pearl, mica, etc., religiously preserved by the Yorkes ever since. But, as an 'upper servant', she came into a quite different category, and would have been painted for the family by a proper portrait painter, if at all (Waterson 1978¹).

6. There is not even a portrait of Simon II as an adult. The anonymous portrait of his wife and child, of c.1815, is by an inferior artist to that of these portraits. Might they be earlier performances by Henry Spurrier Parkman (1810 or 1814–64), author of *Thomas Lewis, Huntsman at Cefn Mably* (1841) and *Mr Dorrington, Keeper at Halswell* (National Museum of Wales)? But not only would these indicate a falling-off in quality since the Erddig portraits, but Parkman appears to have been Bristol-born or bred, only painting the huntsman of Cefn Mably, because it, like Halswell, was a Kemeys-Tynte estate, not because he had a practice in Wales.

7. For what follows, see Waterson 1980, pp.55–64, 82–6, 110, 231.

8. 17 March 1685/6: D/E/1542 (17).

9. James Wyatt had advised upon alterations to Erddig in 1773–4 (D/E/284), and designed a tower and monument for Marchwiel church; but it is more probably his carpenter-architect brother, Samuel, then employed in building Kinmel Park nearby, who is intended here.

10. Waterson 1980, fig.38.

11. D/E/1542 (332).

Catalogue no.26

1. The 1924 catalogue of the National Gallery, Millbank (i.e. Tate Gallery), improbably suggests that the baby was painted first and the mother added (p.173).

2. Horsley 1903, p.276.

3. Lang 1897, ii, p.343; quoted in exh. cat. *Sir Edwin Landseer*, 1981–2, p.17.

4. This, and much of the other information in this entry, is a patchwork based on Richard Ormond's original research, as incorporated in his admirably informative exh. cat. cit.

5. Landseer painted both straight portraits of Lady Louisa and Lady Rachel Russell, and subject-pictures using them openly as his models. Those of Lady Louisa include *Lady Louisa Russell feeding a Donkey* (drawing of 1825; etched by Jessica Landseer, 1826), *Cottage Industry* (1831; Duke of Abercorn; first engraved by F.C. Lewis) and *Twelfth Night* (1836; first engraved by J.H. Robinson); and of Lady Rachel, *Little Red Riding Hood* (1831; first engraved by J.H. Robinson), *Actress at the Duke's* (1832; engraved by C. Rolls) and *Pets* (1832; engraved by W.H. Watt; variant etched as *Lady Rachel Russell with a Pet Fawn* by the Duchess, who etched other works by Landseer too).

6. He first painted the Duchess in 1823 for a portrait engraved in *The Keepsake*.

7. For a contrary view, see Lennie 1976, pp.28–30.

8. As witness his relationship with his aunt, Barbara Potts; the Queen's dresser and confidante, Marianne Skerrett; and his guardian once his mind had gone, Mrs Pritchard.

9. An unfinished painting on copper (Tate Gallery, inv.3008; Graves 1876, no.206), in which he created a rudimentary setting for the figures, and added a large bloodhound to the left. It was engraved by J. Thomson for the *Book of Beauty* in 1837.

10. Collection Marquess of Northampton; exh. cat. cit., p.17, fig.19.

11. Exh. cat. cit., no.40.; Parkinson 1990, p.139.

12. Exh. cat. cit., no.39.

Catalogue no.27

1. Dafforne 1872, pp.97–9.

2. *The Times*, 18 May 1859, p.12, quoted in Rosemary Treble's excellent entry on *The General Post Office* in exh. cat. *Great Victorian Pictures*, Arts Council, Leeds City Art Gallery, etc., 1978, no.21, to which this entry owes a large debt.

3. *The Athenaeum*, 21 May 1859, p.682, quoted ibid.

4. *Punch*, 16 June 1860, p.247, quoted ibid.

5. Disraeli 1853, book IV, ch.i, p.140.

6. Cf. exh. cat. *George Elgar Hicks*, Geffrye Museum, 1982, no.16, and 'Notebooks', pp.54–6.

Catalogue no. 28

1. The full signature, *J. J. Tissot/69*, appears on a contemporary photograph preserved in Tissot's own albums, according to exh. cat. *Tissot*, 1984, p.102, and Wentworth 1984, n.83.
2. *Antique Collector*, June 1984, reprinted in exh. cat. cit., pp.8–9.
3. Goncourt, vi, 1935, p.143, entry for 28 May 1882: 'Il me dit aimer l'Angleterre, Londres, l'odeur du charbon de terre, parce que ça sent la bataille de la vie ...'.
4. Exh. cat. cit., no.30, p.104, col. pl.11.
5. Exh. cats. *Master Drawings from the National Portrait Gallery, London*, Art Services International, 1993, no.65; *Vanity Fair*, National Portrait Gallery, 1976.
6. Naylor 1965 (making disappointing use of Bowles's since-vanished papers).
7. José de Murrieta (created Marqués de Santurce in 1877) had already attempted to sell *On the Thames* at Christie's in 1873.
8. Cf. *Survey of London* 1973, pp.165–6. The subsequent sales of their collection in the 1890s (after the Argentine had declared bankruptcy) show that they afterwards preferred Alma-Tadema to Tissot. Their country house, Wadhurst Park in Sussex, was sold to Julius Drewe, founder of the Home & Colonial Stores, with much of its furniture, which can now be seen at Castle Drogo, the mock-medieval castle in Devon that Drewe commissioned from Lutyens (now also NT).
9. A drawing for the woman with a pistol is in a private collection in London.

Topographical Landscape

1. Lomazzo 1598, Book III, p.94. Haydocke uses the word three times on this one page, but not elsewhere, in the context of a discussion of *trompe-l'oeil* painting. The discussion of 'Diverse Kindes of Landskips' was to have been in 'the sixth booke of Practise', but though its headings are all set out in the table of contents, regrettably, it was never actually printed.
2. Vitruvius 1960, pp.210–11. I have made small amendments to the translation.
3. Pliny 1968, pp.346–7.
4. All of what follows is heavily indebted to Gombrich 1966, pp.107–21. See also, for England, the immensely rich and detailed Ogden 1955.
5. Tiraboschi, *Storia della letteratura italiana*, Florence, 1712, vii, p.1722, as quoted and translated from the Latin by Gombrich 1966, pp.113–14, 151, nn.32–3.
6. I take the phrase from one of the categories and chapter headings of Clark 1949.
7. Van Mander 1994, i, fol.233r, pp.190–91.
8. Norgate 1919, pp.45–6; quoted by Gombrich 1966, pp.107, 116.
9. Norgate 1919, p.42. Landscape was, however, accepted in England earlier than this. The Ogdens (1955, pp.5–6) neatly pinpoint the moment: '[In] the first printed book in English to deal directly with landscape, Henry Peacham's *The Art of Drawing with the Pen and Limning in Watercolours* (1606), he says: "Seldome it is drawne by it selfe, but in respect & for the sake of something els, wherfore it falleth out among those thing[s] which we call *Parerga*", but in the next (1612) edition, he substitutes "If" for "Seldome", showing that he and his readers were now familiar with landscape painting as an independent art, even if as a subordinate one within the hierarchy of painting, for which he now goes on to prescribe "General Rules for Landtskip".'
10. Harris 1985, pp.10–11; Croft-Murray 1962, i, p.207[b]. It would be intriguing if the *View of the Old Palace of Greenwich* at Kingston Lacy, now revealed as the earliest complete view of that building (cf. exh. cat. *Henry VIII: A European Court in England*, National Maritime Museum, Greenwich, 1991, pp.20–21, fig.1) were to turn out to be by Portman. All the more so, as it probably goes back to the collection of Ralph Bankes, who at one point owned some pictures from Charles I's collection. Cf. Ogden 1955, pp.72–3, 99–100, for the later development of landscape overmantels in the 17th century.
11. *Walpole Society*, xliii, 1972, p.278. This 'gelderps man' may have been responsible for the view of Hatfield – one of the earliest 'country house views' – in the background of Geldorp's portrait of *William, 2nd Earl of Salisbury* of 1626 (cf. Auerbach and Kingsley Adams 1971, cat.82, pp.84–6, col.pl.X).
12. Not only did Stalbemt paint two views of Greenwich that were in Charles I's collection, one of which survives in the Royal Collections, but he also provided drawings for Keirincx to work from (*Walpole Society*, xxxvii, 1960, pp.160, 195; xliii, 1972, pp.66, 276).
13. Sanderson 1658, pp.27, 26.
14. E.g. de Lairesse 1707; cf. the Eng. trans. by 'John Frederick Fritsch, *Painter*', 1738, p.292: '*over the Chimney I propose a Piece with Figures . . . for, what Business can a Landskip have there, the Horizon whereof ought to be without, nay, much lower than the picture? Wherefore, in so principal a Place nothing would be seen but Sky.*'
15. For Svetlana Alpers, there was even a strong 'mapping impulse' behind the Dutch topographical painting that none the less ranked then, as it ranks now, as art (Alpers 1983, pp.119–68). A singular exception among the inventories is that of *c.*1758 of Dunham Massey, in which the only 'Picktures' to have their subjects described are three *Views* of Dunham itself.
16. The idea has been taken over somewhat uncritically from Marxist-inspired English literary theory, most notoriously in David Solkin's exhibition and its catalogue, *Richard Wilson: The Landscape of Reaction*, Tate Gallery, 1982–3.
17. Cf. Klingender 1947, pp.74–7, figs.12, 13, 23.
18. Cited in exh. cat. *Pre-Raphaelites: Painters and Patrons in the North East*, Laing Art Gallery, Newcastle, 1989, no.43, p.78.

Catalogue no. 29

1. Cf. exh. cat. *De zichtbaere Werelt*, Dordrechts Museum, 1992–3, p.132.
2. Despite all John Loughman's researches into picture ownership in 17th-century Dordrecht. An 18th-century Dutch copy of the left-hand side of the picture (particularly admired by Van Gogh; now on loan from the City of Amsterdam to the Rijksmuseum) suggests that it may already have been cut up into two – more sellable – pictures of conventional format, before it left Holland.

3. *Ascott* 1963, p.7.
4. Colebrooke was a banker and merchant who had been educated at Leyden, and may have got his hands on the picture or pictures through his Dutch connections. It may be significant that the other Cuyp in Colebrooke's forced sale in 1774 was a *View of Nijmegen* that had Horace Walpole in raptures, but whose exact identity and earlier history are equally mysterious (see exh. cat. *The Treasure Houses of Britain*, National Gallery of Art, Washington, 1985–6, no.316, and Reiss 1975, no.103, p.142). For Colebrooke to have owned two topographical Cuyps of such exceptional beauty suggests a very special source for them.
5. George III's former Prime Minister and the outstanding collector of Dutch pictures in Britain in the second half of the 18th century, at his houses of Luton Hoo, Beds (Waagen 1854, iii, pp.474–85), and Highcliffe, Hants (Russell 1984). By 1764 he owned the great *River Landscape* (National Gallery) which Benjamin West told Farington was the first Cuyp known in England. Most of the pictures in the sale of the widow of his third and favourite son, General Sir Charles Stuart (1753–1801), seem originally to have belonged to him.
6. Holford had inherited £1 million from his uncle in 1838, in addition to his own already substantial fortune. Through his marriage to Mary-Anne Lindsay, he became brother-in-law to a whole nexus of aesthetes, collectors and art historians: Sir Coutts Lindsay, Lord Wantage, and Alexander, Earl of Crawford and Balcarres. Encouraged by William Buchanan, he had already began collecting pictures in 1839, and was to assemble one of the greatest 19th-century collections of paintings and illuminated manuscripts (Waagen 1854, iii, pp.193–222; Holford 1927). It was kept in the palatial residences built for him by Lewis Vulliamy – Westonbirt, Glos, and Dorchester House, London. The Cuyp hung beside the chimneypiece in the Green Drawing Room at Dorchester House (see Sebag-Montefiore 1988, fig. on p.53).
7. Anthony de Rothschild evidently had a particular fondness for Cuyp, since he also bought the *Landscape with a Horseman on a Road* which had at one point belonged to Baron Lionel, and owned – and may have bought – the *Peasant Boy with Cattle and Sheep* (also at Ascott), which, though generally ignored in the literature, may be a perfectly genuine picture disfigured by overpaint.

Catalogue no. 30

1. Bellotto was so successful that it was Canaletto who was regarded as the impostor when he arrived in England in 1746 (Vertue iii, pp.149, 151).
2. Links 1973, p.108.
3. Kozakiewicz 1972, no.101. It is first recorded in the collection of the great collector and connoisseur George Agar-Ellis, 1st Baron Dover (1797–1833), but with no indication as to its previous provenance.
4. Unlike the *View of the Campidoglio* (Petworth), which is probably the picture that was included in the exhibition held on the façade of the Scuola di S. Rocco in Venice in 1743, in the hope of attracting a buyer. A pair of *Views of*

Turin had been commissioned by Carlo Emanuele III of Savoy in 1745. Bellotto's celebrated later depictions of Dresden and of castles and palaces in Saxony were painted for Augustus III of Saxony-Poland, or for his powerful first minister, Heinrich, Count Brühl.

5. Kozakiewicz (1972, no.100) implausibly described this as the *Vorzeichnung* (preparatory drawing) for the present picture, but it, and two similarly inscribed drawings for a pair of the Milanese pictures, are evidently subsequent *ricordi*. For a juster assessment by Penelope Brownell, and two large reproductions, one with superimposed perspectival lines, see exh. cat. *Bernardo Bellotto: Verona e le città europee*, Museo di Castelvecchio, Verona, 1990, no.36, pp.128–9 and fig. on p.34.

6. Sir Brinsley Ford's forthcoming *Dictionary of British Travellers in Italy in the 18th Century*, edited by John Ingamells, may enable us to pinpoint a likely client whose movements took him through Verona at the same time as Bellotto.

7. Along with a third Italian picture, *Capriccio with the Lock at Dolo*, signed and dated 1748 (Kozakiewicz 1972, nos.99, 102, 107). Giorgio Marini has suggested that this may have been a judicious act of flattery of the new director of the royal gallery in Dresden, the Veronese Pietro Guarienti (*c*.1700–53). Guarienti already knew Bellotto and may have incited the King to invite him to Saxony (in default of Canaletto, who had gone to England); in 1753 he published an encomium on Bellotto in his updated edition of Orlandi's *Abecedario pittorico* (1753, p.101), claiming (somewhat outdatedly) that only great connoisseurs could distinguish his work from his uncle's (exh. cat. *The Glory of Venice*, 1994–5, p.429, col.1).

8. Exh. cat. cit., 1994–5, no.254, pp.362–5, 428–9.

9. Murray 1962, p.44, no.85. This emerged, ascribed to Marlow, in the so-called Tracy Park Heirlooms sale, held by Mrs Arthington-Davy, through Rogers, Chapman & Thomas, 17 July 1929, lot 164. It was not bought by Lord Lee of Fareham until 1945.

10. Walpole 1967, xxiii, pp.298–9 and n.11. Walpole himself believed the copyist to be Mortimer. The two pictues were lots 54 and 55 on the 2nd day, and were bought by [?General] Grey and [Gilbert Fane] Flem[m]ing, for £280 10s and £260 10s respectively. The latter – no doubt the genuine Bellotto now in Edinburgh – was bought by Lord Cadogan at Flemming's sale at Christie's, 22 March 1777, lot 48.

11. Many of the pictures were hung in the recently created Ballroom when the 2nd Lord Clive went to India, as Governor of Madras, in 1798. After his return, he made Powis over to his son and took most of the pictures with him to Walcot in Shropshire. Thereafter, they were divided between his two sons, and the Powis portion led a somewhat peripatetic existence between the family's various houses. In this century, with Walcot demolished and the house in Berkeley Square given up, almost all of them have been sold. Various inventories record the presence of the picture in London or at Powis: 'List of Lord Clive's Pictures, with their sizes', 1771–4 [Berkeley Square], Dining Parlour: 'Cannalletti A View in Verona H.64″ W.103″';

Inventory of Pictures, Prints & Drawings, 17 March 1775 [Berkeley Square], Dining Parlour: 'A View in Verona. Canaletti, cost £147'; List of Pictures, 20 [?28] Sept 1776 [Berkeley Square], 'Room over the Library: fronting the Window': the same; 'Catalogue of a Collection of Pictures in the Gallery at Powis Castle belonging to ... Lord Clive', Sept 1798, no.2: 'View of the City of Verona, in Italy, Canaletti'; two picture-hanging plans of the Ballroom there, undated, but *c*.1800; finally, a photograph illustrating an article by Christopher Hussey in *Country Life*, 2 Jan 1937, shows the picture hanging in the drawing room in 45 Berkeley Square.

Catalogue no. 31

1. The murals found at Pompeii were first published in the volumes simply entitled *Le antichità di Ercolano esposte*, 1757–92.

2. For the excavations of Herculaneum, see Ruggiero 1885; and Fausto Zevi, 'Gli scavi di Ercolano', in exh. cat. *Civiltà del'700 a Napoli*, Naples, 1979–80, ii, pp.58–68. See also Bologna 1979.

3. De Saint-Non 1782, ii, ch.7, p.3, ch.8, opp. p.54. He had gathered the material for this publication in the 1770s.

4. Cf. exh. cat. *Travels in Italy*, Whitworth Art Gallery, Manchester, 1988, no.48.

5. Cf. Thomas 1952–5, pp.13–28.

6. Cf. van Heel and van Oudeheusden 1988, pp.36–7; Wegner 1992, pp.66–96; Wegner and Krönig 1994, pp.158–9; exh. cat. *German Printmaking in the Age of Goethe*, British Museum, 1994, no.80. The two undated gouaches of Pompeii in the Kupferstichkabinett in Berlin (Nordhoff and Reimer 1994, nos.346 and 347) may be survivors of the original set. Four autograph replicas, dated 1793 and 1794, are in the Museums of Weimar and Leipzig, and in a private collection (Nordhoff and Reimer 1994, nos.235, 236, 249 and 237).

7. A *View of Pompeii* and a *Lake Avernus*, only slightly smaller than the present picture (100 × 135 cm), were among the nine pictures that King Friedrich Wilhelm II of Prussia's mistress, the Gräfin Lichtenau, bought or commissioned on behalf of the King when in Italy in 1796 – six of them views of Naples and its environs. These were installed in a room in the Marmorpalais at Potsdam, but have been missing since World War II. I am most grateful to Dr Reinhard Wegner for telling me that the *View of Pompeii*, whose appearance is known only from a photo of the room in Poensgen 1937, seems to show a different composition.

8. One of the other paintings by Hackert at Attingham (probably from a group acquired by the future 3rd Lord Berwick in Naples as late as 1827) is signed *Philippe Hackert 1799* – no doubt because it was painted while he was still in Naples, working under French protection.

Catalogue no. 32

1. For Sir John Leicester as collector and patron, see Hall 1962, Whittingham 1986, and exh. cat. *Paintings from Tabley*, Heim Gallery, London, 1989.

2. It is not a pendant: they do not seem to have been intended to hang together, and never did.

3. Farington 1982, ix, pp.3397–8.

4. Butlin and Joll 1984, no.208, i, p.127, ii, pl.206.

5. Exh. cat. *Paintings from Tabley*, no.20.

6. See the table and comments in Joll 1977.

7. See Youngblood 1983 and Butlin et al. 1989.

Catalogue no. 33

1. See exh. cat. *D'outre-Manche: L'art britannique dans les collections publiques françaises*, Louvre, 1994.

2. Jean-Charles, called Charles, baron Rivet (1800–72) was also the intimate friend of Delacroix, who at one point wanted to make him his heir. Subsequently a politician, at this period Rivet frequented the studios of both Delacroix and Bonington in Paris, and had them to stay at his family château at Mantes. He was Bonington's companion on, and probably financed, his visit to North Italy in 1826. The letters he wrote during that journey are a precious source for our knowledge of Bonington's personality. He and his descendants owned – and some still own – a variety of works by Bonington. A set of soft-ground etchings of ten of them – including the present picture as no.9 – were made by Charles Damour, and published as *Oeuvres inédites de Bonington* in 1852.

3. Dubuisson and Hughes 1924, pp.119–20, giving a fairly faithful translation of the story as originally told in Dubuisson 1909, pp.385–6, n.1. Auguste, comte de Forbin (1777–1841), as a friend and former fellow-pupil of Granet, also had quite different aesthetic values to Bonington and Rivet.

4. Damour added legs to the horse in his etching.

5. Delacroix 1951, pp.324–5, entry for 31 Dec 1856; cf. Delacroix 1895, iii, p.188.

6. Indeed, this title seems to have been used for the first time when the picture was exhibited at Agnew's in 1962, in a geographically impossible yoking of the Somme with Normandy.

7. Dubuisson 1909, pp.384–6, fig.; Dubuisson and Hughes 1924, p.118 (in the pl. opp. p.120 it is admittedly just called *Coast Scene*).

8. Exh. cat. *Bonington*, 1991–2, no.9.

9. Exh. cat. cit., nos.49, 50, 76, 110, 120.

10. Exh. cat. cit., no.119. It is tentatively identified with a painting in [Sir Henry] Webb's sale in Paris on 23–4 May 1837, called *Le port de Saint-Valéry (Somme), bateaux, pêcheurs sur le rivage*. But it should be noted that the two sketches (whether or not they are both by Bonington) that can be associated with this picture and that belonged to baron Rivet's daughter, are both baldly captioned *Coast Scene* in Dubuisson and Hughes 1924 (pl. opp. p.56).

11. Exh. cat. cit., no.26 and cover. Plausibly identified both with the exhibit with which Bonington won a gold medal at the Salon of 1824 – *Marine. Des pêcheurs débarquent leur poisson* – and with the painting which had acquired this title by the time that it was in H. A. J. Munro of Novar's sale in 1857.

12. Exh. cat. cit., no.31. Evidently related to one that was also shown at the 1824 Salon, as *Étude de Flandre*, which has plausibly been identified with the *Shipping on the Canal at Calais: Morning* (sold in [Sir Henry] Webb's sale in Paris, 23–4 May 1837, lot 7).

Catalogue no. 34

1. North 1946, p.66.
2. Pennant 1781, ii, p.284; see also Pennant 1810, iii, pp.85–7, esp. p.87. In the first edition (1781) he makes no reference to any quarrying, and dismisses the slates in a sentence.
3. Cf. Klingender 1968, esp. ch.5.
4. Bingley 1798, i, p.179.
5. Pückler-Muskau 1832, pp.46–9.
6. Quoted by gracious permission of Her Majesty the Queen. I am grateful to Delia, Lady Millar, for finding and communicating this reference to me.
7. Unlike his son-in-law, Edward Douglas-Pennant, 1st Baron Penrhyn (for whom, see the *Penrhyn* entry in the Gazetteer), to whom he is, however, supposed to have bequeathed the task of filling his great pile with a worthy collection of pictures.
8. Klingender 1968, p.82, fig.11. In 1848 Hawkins went on to exhibit a picture called *The Great Bangor Slate Quarries, N. Wales* at the Royal Academy. The slate quarries at Bangor were of no particular consequence, but since Bangor was the port from which most of the Penrhyn slate was trans-shipped and so sometimes took its name, it seems possible that this also depicted the Penrhyn quarry. It is not known what, if any, relation Henry Hawkins was to the G. Hawkins who was entrusted with the more exalted task of executing a set of lithographs of the interiors and exterior of Penrhyn Castle for Col. Douglas-Pennant, published in 1846.
9. I owe this observation to Jonathan Marsden.

Catalogue no. 35

1. Reduced version, also 1881; Manchester City Art Gallery. Even the urbane Kenneth Clark lost his cool when analysing the – to him – spurious appeal of this picture, describing the supposed photographic truth of it as a 'squalid claim' (Clark 1956, pp.100–1).
2. For the construction and history of the canal, see Williams 1898 and Leech 1907.
3. See Leader's obituary in *The Times*, 23 March 1923, p.15; and Reynolds 1973, no.288, pp.179–81 and pl.219; esp. p.181 re Williams's copy, which is itself untraced. Leader himself owned a small study of *Willy Lott's Cottage* (Ipswich Museums and Galleries), which he had bought in or after 1885, and which was in his widow's sale at Christie's, 8 April 1927, lot 34 (exh. cat. *Constable*, Tate Gallery, 1991, no.62).
4. For the similar *Churchyard, Bettws-y-Coed* (1863; Guildhall Art Gallery), see exh. cat. *Landscape in Britain 1850–1950*, Arts Council, Hayward Gallery, etc., 1983, no.36.
5. See the excellent entry written around this last by Rosemary Treble, in exh. cat. *Great Victorian Pictures*, Arts Council, Leeds City Art Gallery, etc., 1978, no.27.
6. Saint 1976, p.429.
7. Lusk 1901, p.23, who suggests that the subject was originally tackled on Leader Williams's recommendation. This would seem to be borne out by the fact that the artist owned not only the sketch of the present picture, but what is really an autonomous version of it, midway in size between the two (see p.96 and n.10). The four-year interval between the cutting of this section

of the canal and the present version suggests that it was the intermediate version that encouraged Lord Egerton to commission his own.
8. Hodgson 1887, pp.89–90.
9. Obituary in *The Times* (see n.3).
10. Leader's first sketch and his intermediate version were bought by Maurice, 4th and last Baron Egerton of Tatton, after Leader's widow's sale (Christie's, 8 April 1927, lots 59 [bt Sampson for 17 gns] and 51 [bt in at 22 gns]).
11. Leech 1907, ii, pp.22, 34, 54, pl. opp. p.20.

Ideal Landscape

1. Gainsborough 1963, pp.87–91, letter 42, c.1764.
2. Fuseli 1820, p.179. In the list of those he exonerated from this charge of 'mapwork', Wilson's is the only English name.
3. Reynolds 1975, p.250.
4. Quoted by Whitley 1915, p.369.
5. Whitley 1928, i, p.381; Benjamin West seems to have been unconsciously recalling Wilson's criticisms of Gainsborough, when he similarly dismissed A.W. Callcott's trees as like '*fried parsley*' (Farington 1982, viii: 5 May 1807). Wilson was equally dismissive of the landscapes of the more popular and fashionable George Barrett as '*Spinach and Eggs*'.
6. Leonardo da Vinci 1956, pp.50–51, 59; Cozens first explained his method, which he claims to have lit upon independently of Leonardo's *Treatise*, in his *Essay to Facilitate the Inventing of Landskips, Intended for Students in the Art*, 1759 (cf. Sloan 1986, pp.30–35).
7. Leonardo da Vinci 1956, p.50. The heading of the section in which this passage is contained indicates that Leonardo intended these stains only as aids to invention, not as something to be literally transcribed. In later reporting the contemptuous view of landscape painting held by Botticelli, who said that all that was necessary was to fling a spongeful of colours against a wall, Leonardo drily notes that the uninspiring consequences of such an approach can be seen in that painter's own works.
8. The rooms or cabinets of landscapes detailed on p.157 all seem to have been of such foreign examples.
9. The most vivid illustration of this is Wilson's *View of the Ruined Arch in Kew Gardens* (Sir Brinsley Ford collection), which passed for over a century as a *View in the Garden of the Villa Borghese*, deceiving even Kenneth Clark, as Douglas Cooper pointed out with a certain relish (Cooper 1948).
10. Hayes 1982, ii, no.126, pp.485–7, with illus. With the typically perverse English urge to see everything in terms of topography, it has often been impossibly identified as a view of *Mettingham Castle*.
11. Hayes 1982, ii, no.118, p.468 and pl.
12. Letter to C.R. Leslie, 1834, quoted by Hayes 1982, i, p.293, and linked, as by most commentators, with his no.115, ii, p.463, pl. on p.462, rather than with the other autograph Gainsborough landscape, still in the private collection at Petworth (his no.178, pp.560–61 and illus.).
13. Hayes 1982, ii, no.2, pp.327–8 and illus.
14. Hayes 1982, ii, no.107, p.452, pl. opp. p.451; Chapel 1982, no.24, pp.92–3 and pl.62.
15. Butlin and Joll 1984, no.226, pp.135–6, pl.51.

16. Butlin and Joll 1984, no.53, pp.41–2, pl.63.
17. Reynolds called More 'the best painter of air since Claude' (Whitley 1928, ii, p.200). The Earl-Bishop of Bristol may have commissioned as many as a dozen landscapes in oil, half a dozen in watercolour, and a self-portrait from him (Andrew 1993, pp.135–9, 170, 171, 173, 179, 180, 182, 185–9). Most seem to have been destroyed when Downhill was burnt in 1851, but in 1994 the National Trust acquired from the Marquess of Bristol, and transferred to the public rooms at Ickworth, More's *Landscape with Cicero, his Friends and a Distant View of his Villa* (1780; Andrew 1993, cat. B28, i, p.187, fig.133).
18. Cornforth 1991.
19. The *Liber Veritatis* was itself in English possession (that of the Dukes of Devonshire) and engraved by Richard Earlom, almost like some stud-book of the pictures' pedigrees.
20. It may also be worth recalling, as an illustration of the terrible haemorrhages from British collections, above all since World War II, that only 59 of these are still in collections in the United Kingdom; and – as a warning for the future – that only 28 of these are secure in public collections.
21. See the judicious remarks in Hussey 1927, *passim*, esp. pp.138–9; see also Manwaring 1925 and Howard 1969; for the particular case of Stourhead, see Woodbridge 1970, esp. pp.30–33.
22. In exh. cat. *Claude: The Poetic Landscape*, National Gallery, 1994, nos.36, 56.
23. Cf. the analysis of the inventories of the Stadhouder's residences, and the valuations put on the stock of the Amsterdam dealer Johannes de Renialme, cited by Peter Sutton in exh. cat. *Masters of 17th-century Dutch Landscape Painting*, Museum of Fine Arts, Boston, etc., 1987, pp.4–5; and Simon Schama's essay, ibid., which brilliantly reaffirms the novelty of the 'native' Dutch approach to landscape, while noting the appeal of the italianate painters, and particularly Cuyp (pp.80–82), both to the Dutch and to the English landed gentry.
24. De Lairesse 1707, i, p.344; quoted in translation in exh. cat. cit., 1987, p.4. De Lairesse was writing this, however, at a time when the chief Dutch practitioners of landscape painting – Isaac de Moucheron, Jacob de Heusch or the Glaubers (fine examples of whose work are at Felbrigg and Erddig) – had gone over to an 'international' style with none of this specificity.
25. Cf. esp. Noel Desenfans's remarks (1802, ii, pp.141–3), as quoted in Cook 1914, pp.5–6; and exh. cat. *Aelbert Cuyp in British Collections*, National Gallery, 1973. Observations on the preferences and shifts in the British taste for Dutch landscape painters are also contained in: Christopher Wright, 'Van Goyen: A History of British Taste', in exh. cat. *Jan van Goyen*, Alan Jacobs Gallery, London, 1976; Christopher Brown, *Scholars of Nature: The Collecting of Dutch Paintings in Britain 1610–1857*, exh. cat., Ferens Art Gallery, Hull, 1981; and Julia Lloyd Williams, 'Dutch Art and Scotland', in exh. cat. *Dutch Art and Scotland: A Reflection of Taste*, National Gallery of Scotland, Edinburgh, 1992. The lovely and recently cleaned *Evening Landscape* by Cuyp at Kedleston was bought at a sale of 'Dr' Bragge's in 1759, and is thus perhaps the first identified picture of his to have entered

a British collection. Yet Richard Wilson could tell Beechey (so presumably when at the Royal Academy, between 1776 and 1781) that Cuyp's merits had yet to be discovered (Whitley 1928, i, p.380).

Catalogue no. 36

1. Freedberg 1975, p.657.
2. De Hollanda 1928, 1st Dialogue, p.16.
3. Cf. Mayer 1910.
4. Baglione 1642, pl. p.297.
5. Faggin 1965 made a useful start towards establishing a chronology, which Berger 1993 continues. The latter, however, deals exclusively with easel paintings, discusses only those few works she illustrates, and had seen only about half of the pictures she adjudges authentic.
6. De Maere and Wabbes 1994, p.172.
7. Faggin 1965, cat.47, pp.23, 32, pl.30.
8. Faggin 1965, cat.44, pp.25, 32, pl.43a.
9. Exh. cat. *Ideal and Classical Landscape*, National Museum of Wales, Cardiff, 1960, no.17; exh. cat. *Fine Paintings from East Anglia*, Castle Museum, Norwich, 1964, no.7; sold by Graham Baron Ash, Christie's, 4 Nov 1967, lot 168, bt by Colnaghi's; with the Leger Gallery in 1978.
10. Inv. no.449. Berger 1993, pp.161–4, 196, and pl.22.
11. The duc de Valentinois (1689–1751) lived in the hôtel de Matignon (now the residence of the Prime Minister of France), which had largely been completed and decorated for his father, the comte de Thorigny (cf. exh. cat. *La rue de Varenne*, Musée Rodin, Paris, 1981, pp.27–37). The duke's collections, especially of *objets d'art*, were some of the most sumptuous of their day, while 'the Schools of Italy, Flanders & France make up the profusion of pictures to be seen there'. Unfortunately, his confessor, the Théatine Father d'Héricourt, 'pointed out to him, with justice, that many of his pictures, though of a great price, were not to be tolerated in the house of a Christian, because of the indecency and immodesty of the figures in them; & in consequence, the pictures were destroyed' (*Mémorial de Paris*, ibid., 1749, i, pp.214–15; *Mémoires du duc de Luynes*, Paris, 1863, ix, p.85: both quoted in Duvaux 1965, i, pp.xxi, cccxxvi). This picture and *Le repas italien* by Lancret (the latter acquired by Frederick the Great; cf. Wildenstein 1924, no.77 and exh. cat. cit., 1981, p.36) must have been among those sold privately soon after his death. The remainder was not dispersed at auction until 15 *messidor l'an* XI (4 July 1803).

The painting has been revealed by restoration to be too small for its frame, after the removal of the overpaint disguising its enlargement – which was probably carried out so as to make it an exact pendant of the *View of Tivoli with St Peter's in the Distance* ascribed to Claude (not otherwise recorded) that was the next lot in Bragge's auction.

A good portrait of *Marie de Bourbon* (sold Phillips, 6 April 1995, lot 22) is inscribed on the back of the panel: *ce tableau apartient/a M. le duc de/Valentinois 1716/N⁰. 2*; and the *Valley Landscape* by Breenbergh in the Dulwich Picture Gallery has a similar inscription with the date 1725 (no.338; Murray 1980, p.32 and pl.).

The late and much regretted Bruno Pons informed me in April 1995 that the posthumous inventory taken in the hôtel de Matignon on 6 May 1751 reveals that the duc de Valentinois owned six paintings ascribed to Bril, but he was unable to pinpoint this one.
12. Cf. Lippincott 1983; and Pears 1988 (the allusions to the disposals of the 2nd Earl's pictures in the notes on p.261 of this are incomplete and, in some cases, inaccurate).
13. Other pictures, probably including La Hyre's superb *Departure of Abraham* (Hermitage), left the collection in ways that have yet to be established. Thirteen of the finest pictures at Petworth, including Chardin's *La mère laborieuse*, which had been bought by the 2nd Earl at a sale held by the engraver-dealer Thomas Major in 1758, were winkled out of it by a fox-hunting colonel, probably working on behalf of the dealer Arthur Sulley, in 1927.
14. Bought at another sale of 'Dr' Bragge's, 18–19 Feb 1756, 2nd day, lot 71.
15. Bought at John de Pesters's sale, 1–2 April 1757, 2nd day, lot 31.

Catalogue no. 37

1. Genesis, xxix, 16–20.
2. Cf. Pigler 1974, i, p.67 – who, however, curiously omits all three Claudes. See also Hendrik ter Brugghen's treatment of the subject in the National Gallery.
3. Cf. exh. cat. by Humphrey Wine, *Claude: The Poetic Landscape*, National Gallery, 1994, p.81.
4. This cavalier approach to the Bible was in spite of the commission for the Hermitage picture having come from a dignitary of the church, Henri van Halmale, Dean of Antwerp Cathedral. It is also clear from the letter that Claude wrote accompanying two preliminary drawings of the composition that the choice of subject was his own (Röthlisberger 1968, nos.962–3, i, pp.357–8, pls. in ii). It is outdone, however, by the painting known as 'The Mill' (1648; *LV* 113; National Gallery), onto which, after the picture had been completed for the duc de Bouillon instead of its original commissioner, Cardinal Camillo Pamphilj, Claude painted an inscription quite arbitrarily identifying it as an episode in the life of Jacob's father, the *Marriage of Isaac with Rebecca*, which is not described in the Bible at all. The significance of this once again remains elusive.
5. Exh. cat. cit, 1994, p.80, no.29.
6. It might have been truer to say that the parallel was with the failure of Laban to keep faith, save that there would then have been a pointless prolepsis in showing the beginning rather than the dénouement of the story.
7. The third was a little painting on copper, of a *Coast Scene with the Embarkation of St Paul for Rome* (1655; *LV* 132; Birmingham Museum and Art Gallery). Cardelli also owned two 'smaller pictures with woods and three animals' that are not recorded in the *Liber Veritatis* (cf. Röthlisberger 1961, pp.312–13; exh. cat. *Claude Lorrain*, National Gallery of Art, Washington, 1982–3, p.453).
8. Boisclair 1986, pp.54, 70 n.100, 145, 215, 346.
9. Parry or Perry Walton (d.1702) was a painter (his only identified work is a still-life in the Dulwich Picture Gallery; cf. exh. cat.

Mr Cartwright's Pictures, ibid., 1987–8, no.76) and 'Repairer of the King's Pictures', who also restored and supplied frames for all the Van Dycks at Petworth (Jackson-Stops 1980). Grinling Gibbons's contribution to Petworth needs no reminder.
10. The sale was advertised in the *London Gazette*, no.2136, 6–10 May 1686; the only surviving copies of the catalogue are in the Bodleian Library, Oxford (Ashm. H 24 [140]) and the British Library (Bagford Collection: Harleian MSS 5947, no.120); Woodward 1963, pp.250–52.
11. The 'Pictures Appras'd att Petworth by Mr. Symon Stone the 30th. of July 1671', however, include, as no.98, 'A Landskipp Gloudilloraigne' (valued quite high, at £30), which must be a garbling of Claude Lorraine (Wood 1994, pp.307, 323 n.219).
12. Gayer's name was inscribed against no.67 (a version of which is, by coincidence, also at Petworth) in the index to the *Liber Veritatis* compiled by Claude's heirs, and by a later hand on the back of the *Liber Veritatis* drawings of this picture and of no.67 – the only Englishman's name so to appear. He is an intriguing figure, who deserves further investigation. One of the sons of a former Lord Mayor of London, Sir John Gayer (d.1649), who instituted the so-called 'Lion Sermon', he seems to have become an early *marchand-amateur*, trafficking between England and Italy. A strong supporter of the Stuarts, he became a Jacobite, and was forced to flee to Italy after the discovery of the Duke of Berwick's plot in 1696. His association with Grinling Gibbons and Parry Walton in the Banqueting House sale is a hypothesis, but the two latter must have had an agent in Italy who obtained the pictures, his name is attached to the Claudes, and he owned two carvings by Gibbons, and, like the sculptor, was associated with St James's, Piccadilly.
13. The other picture was bought by a Mr Huckle – possibly the James Huckle of 'Upper Molesy in the County of Surry Gent' who was to marry Kneller's illegitimate daughter around 1706/7, or his father. This prompt division of the two paintings shows how little regard was paid to their pairing.

Catalogue no. 38

1. Cf. Palumbo-Fossati 1982, pp.36, 49, 86–9, pls.75–9.
2. Young 1770, iii, p.101. He further makes the interesting remark, apropos the 'vails' normally paid to servants by visitors: 'Sir *Walter Blackett's* is the only place I have viewed, as a stranger, where no fees were taken' (p.102).
3. Mariette 1857/8, iv, p.88. Claude was not French by birth or training: Lorraine was annexed to France only in 1766.
4. Letter of 1987.
5. Engraved by Vivares when in Dr Chauncey's collection. Cf. Coural 1990, pp.307–9. This, the only serious published study on the artist, is also a distillation of the author's *thèse de 3ᵉ cycle* for the Sorbonne on the artist, which it would be good to have published in its entirety. Her assumption that Dr Chauncey's Patel remained in England until it was acquired by the Louvre in 1989 is, however, incorrect, since it was sold at Bukowski's, Stockholm, 7–9 May 1941, lot 116, as by the non-existent Benoît Patel.

6. Coural 1990, figs.3, 4, 5.

7. Anon. sale, Hôtel Drouot, Paris, 4 March 1931, lot 81, bt by A.P. de Mirimonde, by whom bequeathed in 1985 to the Réunion des Musées Nationaux, and allocated to the Musée de Tours (cf. exh. cat. *La collection A.P. de Mirimonde*, Louvre, 1987, pp.60–61). Crampton sale, Christie's, 16 May 1923, lot 156 (acquired by the Louvre in 1936).

8. Cf. exh. cat. *Le Cabinet de l'Amour de l'hôtel Lambert*, Louvre, 1972.

9. There is no proper study of Patel the Younger, but see the useful entry on the *Landscapes of the Months* of 1699 in exh. cat. (by Pierre Rosenberg and Marion C. Stewart) *French Paintings 1500–1825*, San Francisco Fine Arts Museum, 1987, pp.74–8.

10. Mariette 1857/8, IV, p.89.

11. Sotheby's, 13 Dec 1978, lot 82. Coural (1990, pp.308, 309 n.20) accepts the reattribution to Patel the Elder, but calls it, impossibly, *The Death of Hippolytus(?)*.

12. Other examples include the *River Landscape with Classical Ruins and Figures and Animals crossing a Bridge*, which was in the Camperdown sale at Christie's in 1921 as simply by 'Patel', but was sold again there on 28 June 1974 as by Patel the Younger; and the *Landscape with Classical Ruins and Herdsfolk*, advertised by the Pulitzer Gallery, London, in 1966 as by the Elder, but sold at Sotheby's on 16 Feb 1983 as by the Younger; and finally, the *Landscape with Classical Ruins and Goatherds* that was ascribed to the Elder when in the Ford collection, but which in the Gaekwad of Baroda's collection has been ascribed to both Younger and Elder (Dibdin 1920, p.14).

13. Cf. Petrusevich 1990, no.81.

14. There are also two Patel the Elders (one doubtful) at the Fitzwilliam Museum, Cambridge, and others at Glasgow and Sheffield (cf. the listing in exh. cat. *Masterpieces of Reality: French 17th Century Painting*, Leicestershire Museum and Art Gallery, Leicester, 1985–6, pp.127–8, at which the last was exhibited, no.59, pl.59). The *Landscape with Jephthah and his Daughter* acquired by the Birmingham City Museum and Art Gallery as by Patel the Elder in 1967 is, however, more probably by Henri Mauperché (exh. cat. cit., no.58, pp.121–2, pl.58). The *Landscape with Cybele, and Atys changed into a Pine Tree* at Philipps House, Dinton, Wilts (NT), is signed and dated by Pierre-Antoine Patel, 1703.

Catalogue no.39

1. Of the four large landscapes by Pijnacker once at Attingham (NT), there is only one survivor there now; the others were sold by the 6th Lord Berwick, Christie's, 8–10 Feb 1862.

2. The picture was correctly ascribed to Asselijn in the lists of Baron Lionel de Rothschild's paintings, but was described as by Romeyn by the time of its transfer to the National Trust. The mistake was corrected in *Ascott* 1963, but the Courtauld photograph has always been filed in the Romeyn box, which may account for the picture's apparently being unknown to, and thus omitted from, Steland-Stief's catalogue raisonné of 1971, whose foreword (p.6) reveals it actually to have been completed in 1963.

3. One of the few pictures of his that does take a wider view is the *Landscape with Cattle* sold at Lempertz, Cologne, 21 May 1970, lot 150.

4. A point made by Peter Sutton in exh. cat. *Masters of 17th-Century Dutch Landscape Painting*, Boston Museum of Fine Arts etc., 1987, p.43. Cf. the paintings in the Louvre (inv. no.985; Steland-Stief 1971, no.186, pp.77, 155, dated to c.1649; Steland-Stief 1980, fig.12, p.221); the Musées Royaux, Brussels (Steland-Stief 1971, no.124, pp.74, 143, pl.xlvii, dated to 1647; Steland-Stief 1980, fig.29, p.234); and the Steengracht sale at Petit, Paris, 9 June 1913, lot 1 (Steland-Stief 1971, no.111, pp.73, 141, pl.xlvi, dated to 1646/7); and the drawing in the Fitzwilliam Museum, Cambridge (Steland-Stief 1980, fig.52, p.249).

5. Save that in the far distance, whose form is very similar to that of the ruin in the distance of the Brussels picture.

6. Steland-Stief 1971, no.101, pp.74–5, 139, pl.xlviii, dated to c.1648.

7. Steland-Stief 1971, no.138, pp.93–4, 146, pl.lxv; Steland-Stief 1980, fig.45, p.245; exh. cat. cit., 1987, no.2, dated to c.1649.

8. Steland-Stief 1971, no.53, pp.89–90, 131–2, pl.lxi, dated to c.1650, and noting the influence of J.B. Weenix on the setting; also Steland-Stief 1980, fig.46, p.245. A good copy is in the Herzog Anton Ulrich-Museum, Braunschweig, variously attributed to Weenix himself, to Frederick Moucheron, or to Willem Schellinks (cf. Klessmann 1983, p.16, no.366).

9. *Ascott* 1963, p.26, no.45, as 'Attributed to Jan Asselyn'.

10. Steland-Stief 1971, no.15, pp.94, 125, pl.lxvi, dated after 1646; Steland-Stief 1980, fig.48, p.247, calling it 'eine Arbeit der Spätzeit'.

11. Cf. exh. cat. cit., 1987, no.4.

12. I am most grateful to Michael Hall for this information, which comes from a list of Baron Lionel's pictures drawn up not long before his death, in the archives of N.M. Rothschild & Sons Ltd (for which, see Hall 1994², p.268). The picture is not mentioned by Waagen, probably because it was only acquired by Baron Lionel some time after his visit to England in 1851; he also never visited Gunnersbury.

Catalogue no.40

1. Hofstede de Groot lists 850 paintings by him, which is a considerable number, even allowing for misattributions.

2. Ilse von Sick (Sick 1930) made the first, albeit summary, attempt at a chronology, followed by Eckhard Schaar in 1958, the published version of whose thesis is regrettably not illustrated, and more schematic.

3. *Ascott* 1963, no.3; also from the collection of Baron Lionel de Rothschild, who acquired it from C.J. Nieuwenhuys, who had in turn bought it at Thomas French's sale at Christie's, 12 May 1855, lot 4 (information from Michael Hall).

4. Cf. Haak 1984, p.383, fig.813.

5. White 1982, no.17, p.20, pl.16.

6. Cf. exh. cat. *Nederlandse 17ᵉ eeuwse italianiserende landschapschilders*, Centraal-museum, Utrecht, 1965, no.78, pp.155–6, pl.81.

7. There is a rare exception, dated 1673, in the Royal Collection: *A Mountainous Landscape with Herdsmen driving Cattle down a Road*.

8. It may be indicative that Schaar 1958 does not include it in his section on 'Der Weg in ansteigenden Gelände' in Berchem's pictures of the 1650s (p.55–6).

9. Cf. exh. cat. *Seventeenth-century Dutch Drawings: A Selection from the Maida and George Abrams Collection*, Rijksprentenkabinet, Amsterdam, 1991, no.74.

10. A similar adaptation of this figure of a gentleman-sportsman to that of a rustic is found in a drawing, known only from a copy in the Hamburg Kunsthalle, that was in turn used in the *Italian Landscape at Sunset* of c.1655–65 (on loan from the Netherlands State Office of Fine Arts to the Boymans-van Beuningen Museum, Rotterdam). Cf. exh. cat. *Between Fantasy and Reality: 17th Century Dutch Landscape Painting*, Tokyo Station Gallery, etc., 1993, no.73, p.218, col. pl. p.123.

11. Though Baron Leopold was from the English branch of the family, his title and his particle – a translation of the German 'von' – came from the Austrian barony conferred upon his father in 1822, which Lionel was permitted to accept and transmit to his male heirs by royal licence of 1838 (cf. Hall 1994²).

12. Waagen 1854, ii, p.129.

13. This is his first recorded purchase. Perhaps to compensate in some little way for the sale to Catherine the Great of the Walpole Collection from Houghton by the 3rd Earl of Orford of the 1st creation in 1779, he acquired some fine Flemish and Dutch 17th-century pictures. These included Rubens's 'Rainbow' Landscape from the Balbi Collection (now Wallace Collection), a superb *Extensive Landscape with Windmill* of 1655 by Philips Koninck (Firle Place, Sussex) and the present picture. Waagen described this Berchem, when at Wolterton Hall, Norfolk, as: 'A rocky landscape, with a procession of shepherds and animals. In his late cool and heavy manner. Inscribed' (Waagen 1854, iii, p.434). For the 3rd Earl of Orford as a collector, see Moore 1988, pp.64–5.

14. Patteson had begun to collect Dutch and Flemish pictures when travelling on the Continent in 1778–9, and added to them by purchases through agents thereafter. Through marriage he also acquired the collection of Dr Cox Macro (1683–1767), which included a whole group of canvases by the Flemish emigré Pieter Tillemans (1684–1734); his wife, Elizabeth Staniforth (1760–1838), was Cox Macro's niece and heir. The failure in 1819 of a London bank with which Patteson was associated, coming on top of a number of unsuccessful business ventures by his own firm, Patteson & Iselin, and the ruinous expenses of parliamentary cam-paigns, brought him to the verge of bankruptcy. One of the first things to be sacrificed was his bought picture collection. The title-page of the sale catalogue singles out the present picture as 'a beautiful CABINET JEWEL by Berghem, of the highest Class'. On Patteson, see Moore 1988, pp.40–47, 119–27.

15. Hüsgen 1780. For Goethe's account of the taste for art in his native city, see *Dichtung und Wahrheit* (1811–33) and his advertisement for *Über Kunst und Alterthum in den Rhein- und Maingegenden* (1816).

16. Heuberger 1994, esp. *A European Family*, pp.3–33, and *Essays*, pp.221–86.

Catalogue no.41

1. Hofstede de Groot 1912, iv, p.351; this author found it impossible, however, to accept the internal and external evidence for this picture's dating so late in the artist's career.
2. Hofstede de Groot 1912, iv, no.181; Broulhiet 1938, no.268, p.413, pl. p.236.
3. Hofstede de Groot 1912, iv, no.184.
4. No.995; Hofstede de Groot 1912, iv, no.162; Broulhiet 1938, no.269; MacLaren and Brown 1991, p.182, pl.162.
5. Hofstede de Groot 1912, iv, no.114; Broulhiet 1938, no.209, p.404, pl. p.206.
6. Hofstede de Groot 1912, iv, nos.172, 46; Broulhiet 1938, nos.192, 197; for the Elkins picture (first recorded as having long been in the family possession of Sir Richard Ford), cf. exh. cat. *Masters of 17th Century Dutch Landscape Painting*, Boston Museum of Fine Arts etc., 1987, no.44.
7. Hofstede de Groot 1912, iv, no.121; Broulhiet 1938, no.189, p.401, pl. p.196.
8. Hofstede de Groot 1912, iv, no.42; Broulhiet 1938, no.193; Davidson 1968, i, pp.222–4.
9. Hofstede de Groot 1912, iv, no.118; Broulhiet 1938, no.208; Gerson and Goodison 1960, i, no.49, p.62, pl.32.
10. Hofstede de Groot 1912, iv, no.78; Broulhiet 1938, no.274; White 1982, no.67, p.50, pl.55.
11. Alexander Baring, Lord Ashburton had formed a distinguished collection of pictures, which was housed in part in his great Neoclassical mansion, The Grange, Hants. The bulk of the finest pieces of his collection were kept in his London mansion, Bath House, 82 Piccadilly, which was remodelled for him by Henry Harrison in 1821 (Waagen 1854, ii, pp.97–112).

His grandson, Alexander, 4th Baron Ashburton, appears to have been making disposals from the collection even before the great Barings crash of 1893.

Catalogue no.42

1. MS cited by Coekelberghs 1976, p.52.
2. Exh. cat. *Painting in Italy in the Eighteenth Century: Rococo to Romanticism*, Art Institute of Chicago etc., 1970–71, p.182.
3. Busiri Vici 1974, nos.65, 66, pls.65, 66, col. fig.32, and figs.112, 113, 119, esp. pl.65 and figs.112, 119.
4. Busiri Vici 1974, nos.58–60, pls.58–60, and col. figs.122–4, esp. pl.58 and fig.123.
5. Busiri Vici 1974, nos.204, 205, pls.204, 205, and col. figs.117, 118, esp. pl.204 and fig.118.
6. The *Notamento de' quadri incassati*, in *Cassa Lettera E*, nos.7–10: 'Quattro paesi di figura ovale: pal[mi]. 3½ p[er]. 2¾ di Lucatelli [*sic*] (li detti paesi sono al Nº di 6 simili, una [deg]li altri 2 sono notati [*sic*] in altre casse)'; another in the same case, no.16; the sixth in *Cassa Lettera F*, no.8.

The Picture Gallery

1. Colt Hoare 1817, no.4, p.16.
2. Waagen 1838, i, p.56; repeated in Waagen 1854, i, p.26, with the only difference that 'school' was made plural, so as to cover both Flemish and Dutch pictures.

3. Thomas Winstanley gives a vivid picture of the whole Continent being scoured for pictures after the Revolution, which were then imported by the boat-load (cited in Herrmann 1972, pp.199–200); though William Buchanan, smarting under the failure of his own later speculations, claimed that the opportunities for acquiring 'works of art of a *high class*' had passed (Buchanan 1824, ii, pp.372–7). Even as late as 1836 – but before the crucial switch of middle-class patronage to contemporary British artists – an astonishing 10,421 pictures were imported into England, without counting those from France (Customs records cited by the *Art-Union*, 1839, p.104; quoted by Haskell 1976, p.81, n.57).
4. This inaccessibility extended even to the grounds. At Penrhyn, Prince Pückler-Muskau noted that the portcullises on the neo-Norman gates were 'no inapt symbol . . . of the illiberality of the present race of Englishmen, who shut their parks and gardens more closely than we do our sitting-rooms' (Pückler-Muskau 1832, i, p.43). Waagen's records of his various tours between 1835 and 1857 bring home how crucial the letter of introduction had become. In some houses, housekeepers (see cat. no.1) might still show round visitors without these, if only as a useful source of income, but such visits were hasty and perfunctory.
5. There were also certain signal metropolitan exceptions, such as Thomas Hope's galleries and the Stafford Gallery in Cleveland House.
6. There is an extensive polemical literature on this topic, but see esp. La Font de Saint Yenne 1747; Le Blanc 1747, pp.136–7 (blaming the vanity of women!); Gougenot 1748, pp.136–8; Le Blanc 1753, pp.154–5.
7. La Font de Saint Yenne 1747, p.21.
8. Gougenot 1748, p.37.
9. *L'architecture françoise*, Paris, 1752, i, p.119.
10. It must be remembered, however, that Sir Robert Walpole kept many of his prime pictures in London, at 10 Downing Street and in his house at Chelsea, and that a 'Green-house' at Houghton had to be hastily converted into a picture gallery after his resignation in 1742/3 (Walpole 1752, p.76).
11. Cf. exh. cat. *Robert Adam and Kedleston*, National Trust, 1987, esp. p.12.
12. Creevey 1948, p.292.
13. How greatly such galleries went against the grain, particularly in the country house, can be gauged from the disapproval of that social barometer, Robert Kerr (quoted in cat. no.68, n.18). Kerr was, however, equally convinced 'that a valuable collection ought to be properly displayed – not merely put up on the walls of the Family rooms at hazard'. His preferred solutions were a 'Cortile' or a 'Gallery-Corridor'.
14. Previously, Lord Ward (created Earl of Dudley in 1860) had taken the Egyptian Hall to show off his acquisitions (cf. Haskell 1976, p.97); just as Sir Richard Wallace was to show his treasures off at the Bethnal Green Museum, while he was rebuilding Hertford House (1872–5).
15. They were mostly separate publications, with texts by John Britton, William Young Ottley, William Carey or John Young; but some of these collections appeared in

C.M. Westmacott's compendium, *British Galleries of Painting and Sculpture*, 1824.
16. For an excellent conspectus of most of these private galleries, tied into a survey of the development of museological methods of display, see exh. cat. *Palaces of Art: Art Galleries in Britain 1790–1990*, Dulwich Picture Gallery, 1991–2.
17. It was the want of such pictures that was particularly felt in London before the building of most of the great galleries, and that made the acquisition of John Julius Angerstein's pictures (themselves, paradoxically, squeezed into the rooms of a house in Pall Mall) as the cornerstones of the projected National Gallery seem so desirable. Hence Lord Liverpool's letter to Elizabeth, Duchess of Devonshire, of 19 Sept 1823: 'The great object is large pictures of eminence. Small pictures are as well dispersed in private collections, but there are scarcely any houses in London capable of containing large pictures, and the consequence is that they are either not bought, or are sent to great houses in the country, where few can see them' (quoted by Whitley 1930, p.66).
18. See the very interesting series of letters from Sir Joshua Reynolds to the Duke of Rutland in 1785, about his (only moderately successful) expedition to Brussels to buy pictures from an auction of those from 66 suppressed religious houses, on his own and the Duke's account (Herrmann 1972, pp.112–16). The catalogue of Schamp d'Aveschoot's posthumous sale in Ghent in 1840 (cf. cat. no.69) says in the *Avertissement* that: 'Most of his major acquisitions were made directly from the monks'. An unpublished notebook apparently records his visiting all the suppressed monasteries, buying, selling, exchanging, and having his purchases cleaned and restored (*Biographie nationale de Belgique*, 1911–13, xxi, p.583).
19. Colt Hoare 1983, p.120.
20. See the Earl-Bishop's letter to his daughter, Lady Elizabeth Foster, from Naples, 6 March 1796, quoted on p.230 (Childe-Pemberton 1925, ii, pp.497–8). Cf. also his letters to Prof. John Symonds from Pyrmont, 16 July, 5 Oct 1796 (ibid., pp.505–6, 518–19).
21. Jameson 1844, pp.384–5.
22. Cf. Britton 1808.
23. Views of the two are instructively juxtaposed in Herrmann 1972, pls.18, 19. The hang in the Flemish Gallery was tighter and more patterned, the pictures were hung invisibly, flush with the walls – not on chains and canted forward – and there was no sculpture commingled.
24. For the Golden – or Spanish – Room at Kingston Lacy, see pp.138 and 203. At Keir, less romantically, the Billiard Room and Staircase were hung almost exclusively with Spanish pictures (Waagen 1857, pp.449–50).
25. Waagen 1857, pp.130–32, 136–40 (for the Library and Small Drawing Room at 2 Carlton Gardens); pp.154–7 (for the Drawing Room at 46 Berkeley Square); and Waagen 1854, ii, pp.175–6 (for Thomas Baring's acquisitions and picture gallery).
26. Cf. exh. cat. *Augustus Wall Callcott*, Tate Gallery, 1981, p.35, fig.4. Although the landscape is compositionally closer to Dughet's *Landscape with Elijah and the Angel* (National Gallery; but

then in the Hart Davis collection), as suggested there by David Blayney Brown, subject and collaboration point equally forcefully to the *Landscape with Diana and Actaeon* by Dughet and Maratta, then more freely visible at Devonshire House (Boisclair 1986, no.164, pp.223–4, fig.202).

27. Waagen 1854, ii, pp.263; Waagen 1857, pp.112–13, 301–4.

28. Haskell 1976, pp.71, 96.

29. The French, Dutch and German pictures in the Orléans collection were sold directly by Philippe-Egalité in 1792 to Thomas More Slade, who was in partnership with Lord Kinnaird and Messrs Morland & Hammersley. These pictures were exhibited for sale by private contract at the so-called European Museum in 1793. The Italian pictures took a more tortuous route to England, where they were bought by a consortium consisting of the Duke of Bridgewater, his nephew, Earl Gower (subsequently Marquess of Stafford, to whom the Duke was also to leave his share of the collection), and the Earl of Carlisle, using the dealer Michael Bryan as their agent and adjudicator. After selecting which pictures each wished to retain for his own collection, the whole lot were exhibited at Bryan's Rooms in Pall Mall for six months from December 1798, over which period the remainder were sold by private contract. The receipts from these sales and the gate were such that the trio effectively got their pictures for nothing. For further details, see esp. Buchanan 1824, i, pp.11–216, Waagen 1854, i, pp.18–21, ii, pp.485–503, and Stryenski 1913. For the surprisingly abrupt eclipse of the taste of the 'Orléans generation' between 1840 and 1850, see Haskell 1976, p.81.

Catalogue no.43

1. Such sobriquets denote either its original location, or the most illustrious collection through which it has passed, or some distinctive feature in it: e.g. the *Madonna di Porta a Pinti* (the original fresco was the centrepiece of a tabernacle in Florence, and has perished; one of the innumerable copies has served as an overmantel in the Queen's Bedchamber at Ham House since the 17th century); the *Madonna Corsini* (acquired from the collection of the Duke of Buckingham by the 10th Earl of Northumberland, and still in that of Lord Egremont at Petworth); or the *Madonna del Sacco* (Chiostro dei Morti, SS Annunziata, Florence; so named from the great bolster on which St Joseph rests; a graphite drawing of this by David Paton has also been at Ham since before 1683).

2. Uffizi, no.6432F: Freedberg 1963, pp.92–3; Monti 1965, fig.351; Shearman 1965, i, pl.85b, ii, p.354. Anna Maria Petrioli Tofani included the drawing, with a ringing affirmation of its authenticity, in exh. cat. *Andrea del Sarto 1486–1530: Dipinti e disegni a Firenze*, Palazzo Pitti, Florence, 1986–7, no.30, p.236.

3. Garlick 1955, p.39.

4. Letter of 16 July 1787; Goethe 1830, xxix, p.34.

5. The considerably older of the two sons of the immensely rich banker, merchant and manufacturer, Johann, Reichsgraf von Fries (1719–85), founder of the family bank and himself something of a connoisseur. From 1785

to 1787 he was in Rome, where he was painted by Angelica Kauffman beside the model of the *Theseus and the Minotaur* that Canova carved for him and which was subsequently also sold to Lord Londonderry. He preened himself on his connoisseurship, which was in fact very slender – so much so that his combination of pretension and gullibility gave rise to the expression in Rome 'E un secondo conte di Fries' (Gorani 1793, ii, pp.242–8).

6. He also showed an interest in art from an early age, buying massively. He and his wife, Theresa, née Princess Hohenlohe-Waldenburg, kept a celebrated *salon* in their palace on the Josefsplatz in Vienna, frequented by artists, writers and participants in the Congress of Vienna, which actually met in it.

His outgoings outran even his enormous income, however, and between 1815 and 1819 the bank ran at a loss. In 1819 his wife died. From that point on he seems to have begun to sell things, at first privately, and then by anonymous auctions of pictures, prints and books, in Amsterdam and Vienna in 1824 and 1825. The next year Fries & Co. declared bankruptcy; Count Moritz's English partner, Mr Parish, drowned himself in the Danube; certain pictures were sold at auction, by Artaria in Vienna, by Nöe in Paris, and twelve at Christie's; and he himself died in Paris. In 1828 the remains of the by then utterly depleted collection were sold in Vienna (cf. Lugt 1921, no.2903, pp.535–6). Sir Thomas Lawrence was given first pick of Fries's drawings by one of his English creditors, W. Mellish.

7. As the picture engraved by Raphael Morghen (Bertuch 1808, p.148). Rochlitz (1828, i, p.129) describes Fries's innovatory – one might say Biedermeier – hanging of his pictures, with a good distance between them, and with the small ones in little shadow-boxes, to kill distracting reflections.

8. It does not feature in the list of 42 major pictures from the collection that Count Moritz received permission to export in February 1824 (Frimmel 1913, pp.422–4), suggesting that by that date it had already been sold.

9. This was the great picture-dealing branch of the Artaria print-publishing family (for which, see esp. Tenner 1966, pp.126–59). Hoser makes it clear that it was the Mannheim rather than the Vienna branch of the family that, with M. Nöe of Paris, acted as middleman over the disposal of the Fries pictures (Hoser 1846, p.xxi, note b). According to Palmerini's catalogue of Morghen's engravings, which was published in 1824, at the very moment when the painting was on the market: 'Count de Fries owns the picture, and owned the copper-plate, which he has now ceded to Artaria of Mannheim, who have had it printed in Paris' (Palmerini 1824, p.138, no.124). In other words, Moritz, Count Fries handed over the plate that had been privately engraved for his brother Josef in Rome by Morghen (corresponding to its first state, which bears the name of artist and engraver, but no more). Artaria used it to puff the picture for sale in Paris, the then centre of the European art market (corresponding to the second state of the print, to which the name and arms of Fries as owner have been added). I am most grateful to Antony Griffiths

for finding and showing to me in the Print Room of the British Museum these two states of the print, still in the volumes originally formed by Morghen's 'intimate friend, Signor Paruti of Venice', complete with complementary volumes of explanatory text – apparently the very ones on which Palmerini drew.

In fact, however, the sale was to be made, not in Paris, but to Lord Londonderry, when back in London.

10. Biadi mentions what was apparently the present picture as '*Attualmente nella collezione di Lord Castlereagh in Londra*' in 1829 (Biadi 1829, p.149). Charles William, Baron Stewart, later 3rd Marquess of Londonderry, was never in fact Lord Castlereagh; this must be a confusion with his better-known half-brother, the statesman ultimately 2nd Marquess of Londonderry (1769–1822). Stewart served as ambassador in Vienna (1814–22) and is specifically named as a direct buyer from Count Moritz (Hoser 1846, p.xxi, note b), but that is unlikely in this case, since he had returned to London some two years before the sale took place. Theodor von Frimmel (1913, i, pp.422, 432–3) categorically states that the picture had passed into the hands of the Sektionsrat im K.K. Ministerium für Kultus und Unterricht, Dr Carl Lind, but what he saw was actually a partial version of the lost *Madonna Barbadori* (Freedberg 1963, no.41; Shearman 1965, no.49).

11. To judge from notes made at Ascott on 9 October 1937 by H. Isherwood Kay of the National Gallery, there appears to have been evidence that the picture was sold to Baron Lionel by the 5th Marquess of Londonderry when he was Earl Vane, i.e. after 1854. Baron Lionel lent it to the Winter Exhibition at the Royal Academy in 1870.

Catalogue no.44

1. Cf. Rylands 1992, ch.4, pp.67–88, and esp. the pungent n.2 on p.86, for Bonifazio. For the development of the *sacra conversazione* in the particular context of the Venetian altarpiece, see Humfrey 1993, pp.12–13, 184–8, 201–17, 232–47, 304–10.

2. Philip Rylands, evidently working from a photograph after seeing the picture in the flesh, mistook the ship for a book, and thought that, to be St Ursula's, the banner should have had a red cross on a white ground – in token of the Resurrection – so could not identify this saint (Rylands 1992, no.61, p.203).

3. It was fused with the Confraternity of S. Maria della Giustizia.

4. See Humfrey 1993, pp.212–16, 238–45, 304–10, for the earlier development of such asymmetry and then *contrapposto* in *sacre conversazioni* altarpieces. Palma was himself in arrear of such developments.

5. Rylands 1992, no.62, p.204.

6. Rylands 1992, no.D6, pp.253, 115–16, and fig. on p.118.

7. A book is an unusual attribute for a female saint, unless she is the founder of a religious Order, and it is the book of her Rule – but then she is generally shown in the habit of that Order. This saint wears none; could she be, in place of St Jerome, one of the holy and learned women who followed him to Bethlehem: St Paula or her

daughter, St Eustochium? If so, more probably the former, since she seems to be an older woman; otherwise, perhaps St Anne, who is often shown teaching the Virgin to read, and is also shown as an older woman, though not usually on her own.

8. The early history of the picture is not known, nor can anything usefully be deduced from the copy that is first recorded in the sale at the Galleria Sangiorgi in Rome in 1899, as coming from the collection of marchese Alessandro Pallavicini dei duchi Grimaldi, in the Palazzo Pallavicini Grimaldi in Genoa (sale of 29 Nov–2 Dec 1899, lot 226; Rylands 1992, p.204).

9. On Willem II's collection, see Hinterding and Horsch 1989.

10. C. J. Nieuwenhuys had previously made two catalogues of Willem II's collection. For his role as adviser to Col. Douglas-Pennant and the creation of the collection at Penrhyn, see *Penrhyn Castle* 1991, pp.36–40.

Catalogue no.45

1. It was, however, omitted by Hans Tietze from both editions of his monograph on Titian (1936 and 1950), no doubt because he could neither see the picture nor obtain a photograph of it.

2. So worded in the unsigned and undated certificate of early 1820 for this, the *Venus/Omnia Vanitas* and the Canaletto. In the MS *Catalogo* of Feb 1813 (see n.7), it is just called: 'Ritratto in tela quasi intera d'uno della antica figura dei Savergnan, gia appartenente al Conte Antonio ultimo superstite'.

3. Waagen 1857, p.378.

4. Crowe and Cavalcaselle 1877, i, pp.99ff.; ii, pp.20–21. The painting must then have been encrusted with varnish, as they describe Savorgnan as wearing 'a dark *green* pelisse'!

5. This was established by a member of another line of the Savorgnan family, Count Fulvio Bonati Savorgnan d'Osoppo, whose findings were published by Celso Fabbro (1951, pp.185–6).

6. Bankes Papers, Dorset R.O. Bankes's informant was probably Natale Schiavone (1777–1858), who did not return to Venice from his training in Florence until 1797, and was then in Trieste from 1802 to 1816, thus circumscribing quite a narrow interval during which he could have made these sketches.

7. Although the *Nota dei quadri componenti la Galleria del fu conte Ferdinando Marescalchi* (1824) in the Muñoz papers in the Archiginnasio in Bologna has long been known, serious study of the collection has only begun with Proni's publication of an earlier *Catalogo dei quadri esistenti nella Galleria di Sua Eccellenza il Signor Conte de' Marescalchi Ministro delle Relazioni Estere del Regno d'Italia* in the Mezzofanti papers, Bologna (1988, pp.33–41). She, however, dates it (p.33 n.2) much too late, to after 1824. The correct date, 1813, has been established by Monica Preti Hamard (1995). I am most grateful to the latter for giving me advance sight of this article, for alerting me to Monica Proni's, and for sharing her thoughts over the paintings acquired from the collection by William Bankes.

8. Stendhal wove memories of seeing it in 1811 into *Rome, Naples et Florence, en 1817*, remarking, 'The pictures in one of these apartments are all chef-d'oeuvres' (entry for 4 May 1817; Stendhal 1818, pp.174–5). Stendhal claims to have gone to the Palazzo Marescalchi in pursuit of seven or eight pretty Polish women being given an art-historical course there.

9. Byron urged Bankes to buy the *Judgement of Solomon*: 'I know nothing of pictures myself, and care almost as little: but to me there are none like the Venetian – above all, Giorgione. I remember well his Judgement of Solomon in the Marescalchi in Bologna. The real mother is beautiful, exquisitely beautiful. Buy her, by all means, if you can' (letter from Ravenna, 26 Feb 1820; Byron 1977, vii, p.45).

10. Letter to Thomas Love Peacock, 9 Nov 1818 (Shelley 1909, ii, pp.636–7). I owe this reference to Zeri and Gardner 1986, p.9, refs.

11. For this network of agents, see Preti Hamard (1995, n.57). With regard to Venice in particular, Marescalchi's wife's mother was a Grimani, and he was a great friend of Leopoldo Cicognara, Director of the Accademia from 1808 (ibid., nn.36–7).

12. The Bankes papers include the following: a receipt from Count Carlo Marescalchi's agents for 575 [luigi] romani for the *Judgement of Solomon*, dated 11 Jan 1820; a faint pencil note by Bankes on the back of this, of the Velázquez *Cardinal Massimi* and two other pictures that he did not buy after all, along with further notes of things seen in the Palazzo Ercolani; and an unsigned and undated certificate for the *Judgement of Solomon*, with more pencil notes by Bankes on the back of it. These evidently allude to five more prospective acquisitions, only two of which he seems to have bought – the would-be Titian *Venus/Omnia Vanitas* and Canaletto of *Venice under an Approaching Storm* (of which, however, there is no subsequent record) – and an unsigned and undated certificate for the present picture, the Canaletto, and the *Venus/Omnia Vanitas*. In the Piancastelli papers in the Biblioteca Communale di Forli, there is a note of 20 Jan 1820 recording the sale to W. J. Bankes of the two Titians, the Canaletto and the 'Giorgione', but as yet no mention of the Velázquez. Interestingly, another, much more extensive, list of 105 paintings on offer from the Marescalchi collection, not previously identified as such, and unsigned and undated, but datable to c.1820, is among the Berwick papers (cf. cat. no.42). For some reason, the Hon. William Noel-Hill, later 3rd Lord Berwick, seems to have bought nothing from it.

Catalogue no.46

1. For Angerstein and his collection, see the excellent catalogue of the exhibition held at his former suburban villa, *John Julius Angerstein and the Woodlands: 1774–1974*, Woodlands Art Gallery, Blackheath, 1974. For details of the transactions through which first the key pictures of the collection, as selected for advertisement in John Young's *Catalogue* of July 1823, and then the remainder of the lease of his London house, 100 Pall Mall, were acquired for the nation, see Whitley 1930, pp.64–76, 220–23, 269.

2. Letter of 1 May 1980.

3. Turner 1985, where he said that his opinion was supported – on the basis of a photograph – by Denis Mahon, Michael Jaffé, Juergen Winkelmann and Mario Di Giampaolo (although an undated note by this last on the mount of the Photographic Survey photo in the Witt Library ascribes it to Agostino Carracci). Alessandro Brogi's article of the previous year (Brogi 1984), attributing it (in ignorance of either Nicholas Turner's original opinion or its reversal) to Annibale, seemed rather outgunned. Nicholas Turner (oral opinion, March 1995) persists in his attribution to Lodovico, kindly drawing my attention to two paintings of *The Mystic Marriage of St Catherine* by or attributed to him respectively – the first including a St Francis – in exh. cat. *Ludovico Carracci*, Bologna and Fort Worth, 1993–4 (nos.12, 1), in neither of which, however, do I find the types or the handling as close as in the paintings by Annibale cited here. Béatrice Sarrazin has already drawn attention to the affinities between the Tatton painting and the *Holy Family* recently acquired by the museum of Nantes (Sarrazin 1994, cat.127, pp.178–9, as Annibale (?) Carracci). The Christ Child is indeed particularly close, but other aspects of that picture are more suggestive of Lodovico Carracci.

4. Exh. cat. *Italian Drawings 1500–1800*, Kate Ganz Ltd, 1987, no.14.

5. Exh. cat. *Italian Paintings & Sculpture*, Heim, 1966, no.1 (as by Annibale); Posner 1971, ii, p.77 (as by Lodovico); Malafarina 1976, no.166 (as by Lodovico); exh. cat. *Selected Baroque Paintings from the Italian Banks*, National Gallery of Art, Washington, 1990, pp.16–19 (exhibited as by Annibale).

6. For the progress of the SS Gregorio e Siro picture, cf. esp. exh. cat. *Bologna 1584: Gli esordi dei Carracci e gli affreschi di Palazzo Fava*, Pinacoteca Nazionale, Bologna, 1984, no.106.

7. Posner 1971, ii, no.6, p.4; Malafarina 1976, no.6, p.88, col. pls.I, II; exh. cat. *The Age of Correggio and the Carracci*, National Gallery of Art, Washington, etc., 1986–7, no.87.

8. The half-length *St Francis meditating upon a Crucifix laid on a Skull* (Galleria Capitolina, Rome; Posner 1971, ii, no.20, p.11; Malafarina 1976, no.21), the *Head of St Francis holding a Skull and Crucifix* (Galleria Borghese, Rome; Posner 1971, ii, no.28, p.14; Malafarina 1976, no.27), the half-length *St Francis displaying the Crucifix with Skull and Books* (Galleria dell'Accademia, Venice; Posner 1971, ii, no.29, p.15; Malafarina 1976, no.28), and the recently discovered oblong *St Francis adoring the Crucifix, with Skull and Book* (exh. cat. *Treasures of Italian Art*, Walpole Gallery, 1988, no.12, previously sold at Sotheby's Monaco, 20 June 1987, lot 313, as by Lodovico Carracci).

9. Gabriele Paleotti (1521/2–97), to whom the Council of Trent had delegated the task of drawing up guidelines for the production of art, was both a Bolognese, and Cardinal-Archbishop of Bologna (Boschloo 1974, esp. i, chs.7 and 8, pp.121–55).

10. Masini 1666, i, p.343 (still calling it the Altar de' Machiavelli; Fanti 1981, p.115, no.17.

11. Although images by the Carracci were included in exh. cat. *L'immagine di San Francesco nella Controriforma*, Rome Calcografia, 1982–3 (e.g. nos.23–5, 102), no consideration was given to their exceptional degree of involvement with this saint's imagery.

12. If the name under which the picture was sold in 1874 – 'Schidone' – was that under which it had been acquired and featured in the Angerstein collection thereafter, as seems most probable, then this is the only serious candidate among the Schedonis auctioned during J. J. Angerstein's active years as a collector (i.e. from c.1789 until his retirement from business in 1811). If the details in the Dutartre sale catalogue are exact, however, this was both slightly smaller than the present picture, at 30 × 24 *pouces* (81 × 65 cm), and a little different in composition: 'the Infant Jesus extends his arms to a Religious [only identified as St Francis in the Delahante sale] *prostrated* before him'.

13. This alternative provenance assumes that the present painting was already recognised as a Carracci. It also depends on the picture that was bought by the dealer George Yates at Champernowne's posthumous sale in 1820 being a copy, since Angerstein would be unlikely to have acquired the present painting at so late a date. Certainly, the 1820 sale catalogue made no mention of the picture's illustrious provenance from Reynolds, and it made only half the price fetched by that in the latter's posthumous sale in 1795.

14. Graves and Cronin 1899–1901, iv, p.1603.

Catalogue no.47

1. When John the Baptist preached the baptism of repentance by water around the Jordan, he was asked if he was the Christ. He responded: 'One mightier than I cometh, the latchet of whose shoes I am not worthy to unloose: he shall baptise you with the Holy Ghost and with fire' (Luke, ii, 15–16). Christ's invitation to a woman of Samaria (whose inhabitants the Jews considered outcasts) to give him water, and his readiness to talk to her and instruct her, surprised her and shocked his disciples. She was, however, the first to whom he revealed himself as the Messiah, and in doing so he indicated that his mission was not to the Jews alone (John, iv, 5–30).

2. Closer inspection also reveals differences in the execution of the two frames.

3. The attribution was evidently not made from personal inspection, since she situates both paintings in London (Mortari 1966, p.144).

4. Of which Mortari lists four other autograph versions (Mortari 1966, pp.38, 89, 155, 167, 172, 174, figs.278–81, 283, 286). Another was sold at Christie's, 9 Dec 1988, lot 22. Cf. exh. cat. *Bernardo Strozzi: Paintings & Drawings*, University Art Library, Binghamton, NY, 1967, no.12.

5. Mortari 1966, pp.38, 136–7, 144, and figs.275, 276; exh. cat. cit., no.26. The drawing in Budapest that Fenyő connected with this painting, Mortari rightly identifies as for a quite distinct composition (Fenyő 1958, p.146, fig.3; Mortari 1966, pp.144, 219, fig.472). Mortari hesitates whether to make the freer and much more lyrical treatment of the subject (in the collection of Dr D. Hannema, Het Nijenhuis, Heino) one of Strozzi's last Genoese works, or one of the earliest Venetian ones, so strongly does it seem to her to reflect the influence (to which Fenyő had already drawn attention) of such Venetian artists as Palma Giovane (Mortari 1966, pp.38, 138, fig.311).

6. Cf. exh. cat. *Venetian Seventeenth Century Painting*, National Gallery, 1979, no.22.

7. For Kent, see esp. Fleming 1958, p.227, and exh. cat. *Drawings by Guercino from British Collections*, British Museum, 1991, pp.20–21.

8. According to a bill in the Kedleston archives. A complete catalogue of this sale has not yet been located. Houlditch's transcription, in the second of his two volumes of London sale transcriptions (1711–59; National Art Library, 86.00.18, 19), is unusual in noting only five lots from the sale, three of which were, however, bought by Curzon (only one of which is now at Kedleston); it is hard to see why he should have omitted the rest of Curzon's purchases. Leslie Harris succeeded in pinpointing the Strozzis by matching up the bill for the lots bought at the sale (which have their number only), with prices subsequently put against pictures by the 2nd Lord Scarsdale. I am most grateful to him for this and much other information from the Kedleston archives, which he has put into order over the last 30 years.

9. Cf. exh. cat. *Robert Adam and Kedleston* (by Leslie Harris and Gervase Jackson-Stops), Heinz Gallery, RIBA, 1987. This particular drawing is not included in the catalogue, but Adam's design for the ceiling of the Drawing Room, signed and dated 1759, is no.24. His *Section of the Chimney Side of the WithDrawing Room* is signed and dated 1760. Adam's drawings are very functional, compared with Stuart's appealing watercolours for a State Room (cat. nos.11–14).

10. On Pallavicini (1650–1714), see Rudolph 1995 (forthcoming). Stella Rudolph's research into the Pallavicini and Arnaldi collections has enabled her to identify a number of previously unsuspected paintings at Kedleston as coming from this source, as well as revealing the full importance of Pallavicini himself.

11. Kent continued to deal in drawings. In early 1761 James Adam wrote to his brother Robert to say that Kent had bought the collection of drawings formed by Baron Stosch (Fleming 1966, p.279). And he returned from Florence to London with the remarkable album of drawings by Fra Bartolomeo that had belonged to the virtuoso and collector Francesco Gabburri (1675–1742); this was sold at Sotheby's, 20 Nov 1957.

Catalogue no.48

1. Salerno (1988, p.191, no.109) lists four, of which the only one in a public collection is in the Hermitage. Another was sold at the Hôtel des Ventes at Vannes, on 4 Dec 1992, with a bizarre ascription to the Circle of Adriaen van der Werff (*Gazette de l'Hôtel Drouot*, 13 Nov 1992, no.41, p.xxii). A copy ascribed to Mattia Preti was among the pictures sent back from Italy by the 3rd Lord Berwick in 1833 (Berwick Papers, Shropshire RO). See also n.4.

2. Cf. Malvasia 1841, ii, pp.270, 337. The present picture was painted before Guercino began his celebrated *Libro dei conti*, or Account Book. The 1656 version is recorded there, however, as '*A Venus with Mars, Cupid, and Time*' – save that in the original Italian, the name 'Love' is – as always – used instead of 'Cupid'. The identity of the client has yet to be fathomed: the old family of the Werdenbergs was by now extinct, while the comital line of the Dukes of

Württemberg took its title from Mompelgard/Montbéliard.

3. The fact that he painted the second version for a remote client in a foreign country might suggest that there was a – probably Latin – source that would have been recognised by any European with a good education.

4. The 1737 sale through which it passed had in fact also included a painting ascribed to Guercino specifically called *The Four Ages*, which is not identifiable with any known picture by him. The version in Richard Cosway's sale in 1791 was similarly called '*The Four Stages of Human Life*'.

5. Istituto Nazionale per la Grafica, Rome, inv. F.N.119 (22556) and Gabinetto dei Disegni, Civiche Raccolte d'Arte, Milan, inv. B–1415–2, 3896–2, cf. exh. cat. *Il Guercino: disegni*, Museo Civico Archeologico, Bologna, 1991 [1992], nos.148–9.

6. Exh. cat. *Il Guercino[: dipinti]*, Museo Civico Archeologico, Bologna, 2/1992, no.69.

7. Tiberio Lancellotti also owned the tondo of the *Rest on the Flight* imported into England by Buchanan in 1804 and now in the Cleveland Museum of Art, whose unusual shape has been accounted for by the suggestion that it was painted as the pendant of some Renaissance tondo in his collection (exh. cat. *Il Guercino: Dipinti*, Palazzo dell'Archiginnasio, Bologna, 1968, no.56, p.140).

8. Malvasia 1841, ii, p.261. The arms of the Lancellotti are *azure, five mullets* [stars], *or, with in chief a label with four pendants gules* (cf. Salerno 1988, p.168, no.84; exh. cat. *Il Guercino[: dipinti]*, Museo Civico Archeologico, Bologna, etc., 1991, pp.xlviii–1 and n.46, and col. pl. p.lii). Diane de Grazia made the connection with the three three-dimensional stars painted by Guercino on a ceiling of the Palazzo Lancellotti. Her observation is reported only in the second edition of this catalogue, in the entry on this picture, on p.182.

9. Cf. Blunt 1982, p.182. The door of the palace, also commissioned by Cardinal Orazio, was designed by Domenichino – his only executed work in architecture. The two panels from keyboard instruments painted by Annibale Carracci (one in the Angerstein purchase that founded the National Gallery, and the other left to it by Holwell-Carr) were left by Fulvio Orsini (d.1600) to Orazio Lancellotti (inv. nos.93–4; Levey 1971, pp.65–7).

10. Tassi had delegated much of the work in the palace to others, and is said to have ensured that his 'friends' Guercino and Lanfranco were well paid (according to Passeri 1934, pp.120–21, but note the caution expressed in exh. cat. *Il Guercino[: dipinti]*, 1991, p.1, n.47). The Abate Lancellotti who wrote in *L'Hoggidi* (Venice, 1627) an enthusiastic account of artistic patronage in Rome under the Barberini (cited by Haskell 1971, p.3, n.1) was probably also a relative.

11. Houlditch transcriptions, National Art Library, ii, pp.91–3, lots 9, 22, 28, 38.

12. Given the easy later circumstances of the family (Tiberio bought a fief in Naples, which was raised in the 18th century, first to a marquisate and then to a principality), it is hard to see why this picture should have already been

sold some time before 1737, while Guercino's *Rest on the Flight* (now Cleveland Museum of Art) apparently remained in the collection until 1804. Although not mentioned there by Ramdohr in 1787, Irvine does seem to have procured both the latter and the Annibale Carracci painted keyboard panels from the Palazzo Lancellotti, if not directly (cf. Buchanan 1824, ii, p.155; and Brigstocke 1982, p.340).

13. This auction, which contained a quite exceptional number of superior-sounding Italian pictures for any sale in London before the end of the 18th century, may have included a core of paintings from the Lancellotti collection. In that case, the other Guercinos in the sale could make up the *altri quadri* mentioned by Malvasia (1841, ii, p.261) as painted for Tiberio Lancellotti. They were an '*Abraham Sacrificing Isaac*', '*The Four Ages*' and '*His Ritratto, by Himself*'. None is readily identifiable with any painting known today. As cited by Richard Houlditch (transcriptions, pp.99–108), they are lot 89 on the 1st day, and lots 75 and 94 on the 2nd day. The sale is identified as that of Sir Thomas Sebright and a Mr Bacon. The latter is not readily identifiable, but the former was most probably the just-deceased 4th Baronet (1692–1736), whose portrait was included among the whole-lengths painted by William Aikman for Lord Hobart at Blickling, apparently because he was a bibliophile; he has not – before now – been noted as a picture collector.

Catalogue no.49

This catalogue entry is based, in the first place, on notes made by St John Gore and Alastair Laing. I am also indebted to Burton Fredericksen and Maria Gilbert at the Provenance Index, Getty Art History Information Program, Santa Monica, and to my colleague Gabriele Finaldi at the National Gallery.

1. For Rubens's altarpiece, see Vlieghe 1973, no.146, pp.150–52.
2. For other examples of Van Dyck's creative use of compositions by Rubens at this period of his career, see Brown 1994.
3. For a discussion of this group of paintings, see Martin and Feigenbaum 1979, pp.125–31; and Brown 1982, pp.78–82.
4. Cust (1900, p.240) states that the picture was painted in 1623 for the Chiesa degli Spagnoli in Rome, but this appears to have no foundation other than Smith's catalogue entry.
5. Copies of the Prado *Taking of Christ* are at Kingston Lacy and Calke Abbey.
6. According to the catalogue of Delahante's sale in 1814, the painting 'is one of two illustrated [*sic*] pictures painted at Venice by the immortal artist, for the Spanish chapel at Rome'. It is, however, not recorded either in S. Giacomo degli Spagnoli or S. Maria di Monserrato, the principal churches of the Spanish community in Rome, or in any other church in Titi 1674, or any other 17th-century guidebook to the city. It is possible that it was in the private chapel of the Spanish ambassador, but no description of a Spanish ambassador's residence is known before the acquisition of the Palazzo di Spagna (formerly the Palazzo Monaldeschi) in the Piazza di Spagna, by the Count of Onate for use as the embassy in 1647.

7. Ponz 1793, v, p.37.
8. He inherited his father's collection, of which an inventory was made on the latter's death in 1647 that mentions the *St Rosalie*, but not this picture, unless it is the large *St Stephen* (n.459), having temporarily lost its attribution (see Fernández Duro 1902). The 9th Almirante purchased paintings in Rome (where he was ambassador) and Naples, and it seems likely that the Van Dyck was among them. The 10th Almirante was himself an artist and collector, founded the church of S. Pascual Bailon in 1683 and endowed it with a number of his pictures.
9. Wagner 1983, ii, no.141, pp.121–3. With thanks to William Jordan for making this unpublished thesis available to me.
10. On the morning of the sale, Murat, commander of the French forces that had just occupied Madrid, sequestered some of the best pictures and had them sent to Naples (Buchanan 1824, ii, p.227). Wallis, however, managed to buy 24 pictures from the Godoy and other collections, and brought them to England. The Van Dyck, described as 'A celebrated picture of the Martyrdom of St. Stephen, from the collection of the Prince of Peace – 800 guineas', was among them (Buchanan 1824, ii, p.245). In an open letter of 29 October 1813 (Buchanan 1824, ii, pp.238–41), Buchanan offered the whole group for 20,000 guineas. Although it included such masterpieces as Raphael's *Madonna della Tenda* (Alte Pinakothek, Munich), Correggio's *Madonna of the Basket* and Velázquez's *Rokeby Venus* (both National Gallery), he could not find a single buyer. See also Brigstocke 1982, p.18.

Catalogue no.50

1. The Torre de la Parada is best known for the set of some 60 Ovidian mythological scenes that Rubens designed for it, and for the 50 or so hunting and animal pictures that Snyders painted for it or delegated to Paul de Vos (Alpers 1971, pp.37–41, 116–28, with the rectifications suggested by Held 1980, i, pp.251–5; see also Robels 1989, pp.99–104).
2. Inv.1184. For the most recent discussion of this cf. exh. cat. *Velázquez*, Metropolitan Museum, New York, 1989, no.20, and Prado, 1990, no.43.
3. Inv.1186; cf. exh. cat. *Velázquez*, Prado, 1990, no.44.
4. Alpers 1971, pp.101ff.; for the portraits, see esp. pp.106, 108, 127–8, figs.32–7. The Cardinal-Infante left Madrid for the last time for Barcelona in April 1632 (though he did not leave Spain, to become Governor of the Spanish Netherlands, until 1634, never to return). As the Torre de la Parada was not built till 1635–6, it seems reasonable to suggest that his picture was originally painted with some other destination in mind. So too, perhaps, was the King's: hence the changes later made to both of them (see below). That would leave only the *Prince Baltasar Carlos*, whose inscription identifies it as having been painted when he was six (i.e. between October 1635 and October 1636), as having been specifically painted for the Torre de la Parada (no explanation has been adduced for why it alone should be inscribed).
5. Exh. cat. cit., 1990, nos.52–5 (the royal dwarfs), nos.49–51 (the classical figures).

6. Alpers 1971, pp.127–8.
7. MacLaren and Braham 1970, pp.102–3; Gállego 1968, part II, ch.2, p.220; Alpers 1971, pp.101–4.
8. According to David Hancock (letter of 28 Feb 1995), to whom I am most grateful for his help in identifying the dogs in this set of portraits, the dog lying down, called a *Hühnerhund* by Justi, is most probably a Navarrese partridge-dog.
9. Justi 1903, i, p.340; ii, p.51.
10. Nor is there any reason for that portrait alone of the three to have been so treated (and why eliminate a whole dog from the right, when on the left only landscape need have been sacrificed?). The painting is already within 4 cm of the width of the portrait of the *Cardinal-Infante Fernando*, who, as an adult, requires more space to move in. The King's portrait is 19 cm wider still, but that befits his status. Even were the Prado picture to have been 4 cm wider, it would not have been enough to accommodate a second dog.
11. The picture has never received its due in print since Justi 1903 (see LIT). It has suffered from past overcleaning and flattening by hot-lining, and has an area of damage in the tabard, but its true character and quality were revealed after it was cleaned by Horace Buttery in 1961–2. Moreover, it, and not the Prado version, was the pattern for the numerous copies (one formerly at Attingham) and variants of the type.
12. The 1961–2 cleaning revealed *pentimenti* visible to the naked eye (the picture has yet to be x-rayed) in the shape of the cap, the bottom left-hand corner of the hem of the tabard, and in the placing of the Prince's left leg and foot. The Prado painting has only one possible *pentimento*, an adjustment to the height of the Prince's right arm (cf. Garrido Pérez 1992, pp.402–9; I am grateful to Zahira Veliz, who prepared the present painting for exhibition, for this reference, as for the benefit of much discussion about the physical characteristics of the Ickworth picture).
13. The face-mask in the Ickworth and Prado portraits is identical, although the x-ray of the latter (see n.12) appears to show that the face was freshly worked on top of a more generalised mask. The Prado painting has an added strip of canvas at the top, considered by Carmen Garrido Pérez to be virtually contemporaneous, showing that even this required adjustment to make it conform to the other two portraits and their hastily run-up setting.
14. Other versions of the *Philip IV* and the *Cardinal-Infante* in hunting-costume, ascribed to Velázquez himself, were recorded at the Alcázar in 1686 and 1701 (Bottineau 1956 and 1958, p.453; Fernández Bayton 1981, ii, p.174; my thanks to Gabriele Finaldi for these references). They were probably destroyed, or irreparably damaged, by the fire there in 1734. The Alcázar inventories record no portrait of Baltasar Carlos; even if one had existed, it would presumably have been on the scale of the original, or larger, to match the other versions of the '*Tela Real*' and the portraits of the King and Cardinal-Infante (MacLaren and Braham 1970, pp.104–5).
15. A Velázquez would probably have outstripped the resources of a younger son; and he was too junior in the embassy to have been given one by the King (as an earlier Minister, Sir

Henry Wellesley, had been given the '*Tela Real*' by Ferdinand VII).

16. It refers to the 1st Marquess's portrait by Lawrence (of 1827) as 'painted 10 years previously'. The picture does not appear in William Seguier's MS *Catalogue & Valuation of Pictures, the Property of the Earl of Bristol at the Warehouse of Mess*^{rs} *France & Banting, James Street, Haymarket, taken April 19th 1819*, before Ickworth had been made habitable.

Catalogue no. 51

1. Palomino [1724] 1987, p.166. The picture has the visible qualities of a sketch, with handling ranging from quite finished faces (e.g. Velázquez's) to parts left unfinished (e.g. the door frame), but is painted over a squared-down grid and a considerable amount of underdrawing.

2. 'Où donc est le tableau?' (Gautier 1864, p.280).

3. On the first occasion on which Velázquez's picture was inventoried – significantly, by Mazo himself (Orso 1993, p.8) – in the Alcázar in 1666, it was actually just called a portrait of 'the Lady Empress with her ladies and a female dwarf'.

4. The fundamental work on the identity of those portrayed is Sánchez Cantón 1943.

5. He had been worsted by Velázquez in 1652 in his application for the post of *Aposentador*, or Chamberlain of the Royal Palace, and was only at some subsequent point compensated with the title of *Aposentador de la Reina*. For the pictorial significance and the origins of this figure, see Chastel 1963, pp.141–5; reprinted in Chastel 1978, ii, pp.145–55 and col. pl.

6. Palomino 1724, iii, ch.VII; 1987, pp.164–6.

7. I did not see the perspectival reconstruction by Philip Troutman at the Slade Art School in December 1992, which purported to demonstrate that it *is* a portrait of the royal couple that is reflected in the mirror, but – as with all cases of 'pictures within pictures' – the fictive element must be taken into account.

8. Even the former owner of this picture, a powerful minister, Gaspar Melchor de Jovellanos, said that he had only seen the original once or twice in passing.

9. Only Goya made a rare etching of it, which, like his preparatory drawing (owned by Céan Bermúdez), was almost as prized by collectors as if it were the original.

10. See the compelling arguments for this, and the convincing reconstruction of the picture's provenance, in Harris 1990, pp.125–30.

11. For the collections of Don Gaspar de Haro, see Pita Andrade 1952; and M. Burke, *Private Collections of Italian Art in Seventeenth-century Spain*, PhD diss., New York University, 1984, cited by Harris 1990.

12. Stirling 1848, iii, p.1387; Harris 1990; and see n.19 below.

13. The final painting is lost, and we do not know who executed it.

14. The final painting was executed by Jordaens; both it and Mazo's copy are in the Prado, inv. nos.1551, 1712.

15. Maclarnon 1990 and William Bankes's letter to his father from Cairo, 3 Sept 1815, ibid., appendix II, p.124. Wellesley, later Lord Cowley, himself owned one of the rare examples of Goya's etching of '*Las Meninas*'.

16. Maclarnon 1990, p.114, figs.47–8.

17. Waagen 1857, p.383.

18. This complicated story was unearthed by Nigel Glendinning, and supplied to Enriqueta Harris (1990, p.129).

19. See William Bankes's letter to his father, Henry Bankes, from Alicante, 17–20 Oct 1814 (Dorset RO; published by Maclarnon 1990, appendix I, p.123).

Catalogue no. 52

1. It is traceable to some misinformation given to the Florentine art historian Baldinucci by Rembrandt's onetime Danish pupil, Eberhard Keil (Baldinucci 1686, p.78). This seems first to have been picked up by a theologian, K. Vos, who argued (*De gids*, iii, 1909, pp.49ff.) that Rembrandt was a Mennonite, but belonged – like Anslo and Catrina Hooghsaet – to the more liberal 'Waterland' branch of the sect. For a positive, but measured, assertion of Rembrandt's affiliation with the Mennonites, cf. Rosenberg 1964, pp.180–84, 354–5, nn.12–24.

2. Princes Gate 1961, iii, p.4 and pl.ii; exh. cat. *The Princes Gate Collection*, Courtauld Institute Galleries, 1981, no.32, p.21.

3. Wijnman 1934, pp.90–96.

4. Cf. Dudok van Heel 1980, p.115.

5. For the provisions of Catrina Hooghsaet's will, see Wijnman 1959.

6. Feltham 1652, p.50. I am indebted to Aileen Ribeiro for this reference, as for many of these costume notes. Catrina left her golden 'ear-irons' to Marritje Dircksdr. Hooghsaet. They are an indication that she belonged to the 'Waterland' congregation, but she respected the Mennonites' ban on lace and cuffs. For this and much other information, I owe a great debt to Marieke de Winkel, chapter 8 of whose thesis, *Het Kostuum bij Rembrandt* (University of Amsterdam, 1993, pp.105–11), is devoted to the dress of the Mennonites, with particular attention to that of Catrina Hooghsaet.

7. Schama 1987, p.122.

8. Tümpel 1986, pp.80, 91, 99, 109, 116, 119, 123, 381 n.103.

9. It has even been claimed, thanks to the presence of the snuffers beside the douted candle in it, that it is an illustration of *correctio fraterna*, the Mennonites' practice of 'brotherly admonition', based upon Matthew, xxvii, 15–20 (Klamt 1975, pp.155–65; cited by Pieter van Thiel, exh. cat. *Rembrandt: The Master and his Workshop*, National Gallery, 1991–2, p.225).

10. Bredius 1935, no.214; but doubted by Gerson 1969, no.187, and Tümpel 1986, no.A90.

11. Exh. cat. *Art in the Making: Rembrandt*, National Gallery, no.17 (and see no.16 for the Trips). X-rays reveal that she too was at one point painted with both hands on the chair-arms.

12. Cf. Bauch 1966, no.519.

13. Wijnman 1959, cited by exh. cat. *Bilder vom alten Menschen*, Herzog Anton Ulrich-Museum, Braunschweig, 1993, no.55, whence my remarks on the significance of parrots are also taken. My thanks to Marieke de Winkel for this reference.

14. Before the picture was cleaned, there was for a long time uncertainty as to whether the sitter's name was really Hooghsaet or Hoogh – the latter reading even giving rise to the notion that she was the mother or wife of Pieter de Hooch!

15. It seems to have formed part of a remarkable, but little-known, collection of paintings put together by the future 7th Earl, which was subsequently treated as a Le Despencer heirloom. The 7th Earl had Colen Campbell rebuild the Le Despencer house, Mereworth, c.1722–3, which was not only a pioneering Palladian building, one of the four English emulations of the Villa Rotonda, but was also adorned within by stucco by Artari and Bagutti, and by a whole set of painted ceilings by the Venetian Francesco Sleter (1685–1775). Artari, Bagutti and Sleter had previously worked at the Duke of Chandos's prodigy-house, Canons; the collection at Mereworth included sketches for Chandos's town house in St James's Square by Bellucci, and it would appear that the splendour of the interiors and collections of Canons and Chandos House were the inspiration of those at Mereworth, despite their very different exteriors.

16. Higginson's collection, which was particularly strong in Dutch pictures, was one of the finest to be assembled in Britain in the 19th century, but is little known, because of its two-stage dispersal within his own lifetime, with no more than a privately printed and unillustrated catalogue to commemorate it. Saltmarshe itself, rebuilt in castle style c.1840, was demolished in 1955, and an old photograph of the former picture gallery shows dim equine replacements for the departed glories on the dramatically papered walls (Reid 1980, ii, p.55).

Higginson's finances may have had their ups and downs, since, only four years after publishing his *Descriptive Catalogue* of the collection in 1842, he had a sale at Christie's comprising 231 lots, in which many of the finest pictures were sold for vast sums, including two pictures now in the Wallace Collection, Murillo's *Adoration of the Shepherds* (2,875 gns) and Rubens's *Holy Family* (2,360 gns), but this Rembrandt failed to reach its reserve. According to Redford (1888, i, p.136), he decided to sell, having become terrified that his collection would be destroyed by fire, after an alarm when his dining-room table-cloth caught light! (I am grateful to Charles-Sebag Montefiore for this reference, from his draft entry on Higginson in his projected *Dictionary of the British as Collectors*, as I am for much more information from his great library and store of knowledge of British private collections than is separately acknowledged in my various entries.) The sale of 1860 comprised only 46 lots, but still of considerable quality. Between the sales, in 1849, Higginson presented a painted version of Baldassare Peruzzi's *Adoration of the Magi* (sometimes identified with the one that Vasari says Girolamo de Treviso painted) to the National Gallery.

Catalogue no. 53

1. Angulo Iñiguez 1981, i, pp.203–4, 441–57; and Angulo Iñiguez in exh. cat. *Bartolomé Esteban Murillo*, RA, 1983, p.26.

2. None is recorded in Seville before the mid-18th century and Palomino makes no mention of them in his life of the artist (Palomino [1724] 1987, pp.280–86). He says only that Murillo 'did many paintings for private houses, but very few

of them remain, for foreigners have taken advantage of the opportunities offered by these calamitous times to take them out of Spain'. He had already said that Murillo's strength in 'colour' rather than in 'drawing' made him more sought after even than Titian or Van Dyck outside Spain, since that was what laymen responded to most.

3. Angulo Iñiguez 1981, no.390; ii, pp.303–4; iii, col. pl.428.

4. Inv.2541; Klesse 1973, pp.89–91, pl.84; Angulo Iñiguez 1981, ii, p.309 (as possible studio replica).

5. Of the five such pictures in the Alte Pinakothek, Munich, two appear to have been acquired by the Elector Max Emanuel when he was Statthalter of the Spanish Netherlands: one from the estate of the Antwerp Postmaster, J.B. Anthoine (d.1691), the other in a group of 101 pictures that he bought in 1698 from Gisbert van Colen, a merchant who dealt in every sort of goods throughout Europe (Krempel 1976, i, p.221–38, esp. 222–3, 224, 236, 237 n.28); one came from the Mannheim Gallery, which was a collection of primarily Netherlandish paintings put together by the Elector Palatine Carl III Philip (1661–1742) and his successor Carl Theodor (1724–99); the other two were bought by the Elector Max III Joseph of Bavaria from the estate of the Munich Privy Councillor Franz Joseph von Dufresne in 1768.

6. MacLaren and Braham 1970, repr. 1988, pp.71–4, esp. n.4; Angulo Iñiguez 1981, no.416, ii, pp.326–7; iii, col. pl.464; exh. cat. cit., 1983, no.63.

7. Angulo Iñiguez 1981, i, p.144; ii, no.406, pp.314–15; iii, pl.462; exh. cat. cit., 1983, no.62.

8. It is named in the second and third of the lists of his small collection of pictures at Gray's Inn, which Bankes drew up in 1658/9 and on 23 Dec 1659, respectively (Laing 1993, pp.122, 123). In the first it is listed simply as: '2 Boyes Eating Grapes on a large knee Cloth', valued surprisingly high, at £15. In the second it is a little more expansively called: '2 Spanish Boyes Eating Grapes A Coppy mr matthewes £15.00.00' – still without any artist's name, but with the name of the vendor.

9. Angulo Iñiguez 1981, no.388; ii, pp.302–3; iii, col. pl.440.

10. Bill in the Dyrham archives, Glos RO.

11. For Povey, see Jacobson 1932, esp. pp.43–9, DNB entry by Edward Irving Carlyle, and Pepys 1983, x, pp.344–5.

12. Entry for 29 Feb 1676. Cf. Evelyn 1955, iv, p.84. See also the entry for 1 July 1664 (iii, p.375).

13. Dyrham archives, Glos RO, D1799/E247.

14. Dyrham archives, Glos RO, D1799/E420, letter from Whitehall dated 5 Dec 1700, quoted in Dyrham Park 1981, pp.57–8.

15. The only copy of the catalogue is in the British Museum Library (s.c. 1360); it is not listed in Lugt. Tentatively dated to 1717 in the Library's catalogue, the true date was established by Owen Justice from a payment in the Methuen archives for the portrait of Elizabeth I and Death mentioned as at Dyrham by Vertue.

16. Murray 1980, p.85 and pl.; exh. cat. cit., nos.67, 68. These were the 'boyes of Morella the Spaniard' which were bought by Sidney, 1st Earl

of Godolphin (1645–1712) at the sale of the sequestrated pictures of the exiled John, 1st Earl/ Duke of Melfort (1649–1714), at the Banqueting House, Whitehall, on 22 June 1693, 'for 80 ginnies, deare enough', as recorded by Evelyn (1955, v, p.145 and n.2: entry for 21 June 1693). They were lots 58 and 59 in the belated sale at Christie's of the pictures from Godolphin House on 6 June 1803, when they were bought by Baker and George Augustus Wallis, respectively, acting – or so the auctioneer thought – on the instructions of the 3rd Earl of Egremont. Whatever happened, they must soon have been sold on, since they feature in Desenfans's insurance list of 6 July 1804. By coincidence, what were probably the copies from the Dyrham sale of 1765 remained obstinately unsold in the running sale by contract at the so-called European Museum between at least June 1803 and December 1806.

17. First recorded in Cadiz, where Antonio Ponz saw it around 1776 in the substantial collection of Don Sebastian Martinez (Ponz 1794, xviii, pp.21–2, no.47). Only in England between the sale of the Marquis de Salamanca in Paris, 3–6 June 1867, and that of the Earl of Dudley, Christie's, 25 June 1892.

18. First discovered by Captain Edward Davies in the collection of Don Manuel de Leyra in Cadiz in 1809 (Davies 1819, pp.xciv, 97n.).

19. The story was apparently first published by G.W. Fulcher (2/1856, p.240).

20. There is a firm letter to this effect from Ellis Waterhouse to Ralph [?Edwards], dated 2 July 1958, in the National Trust's archives.

21. He copied Abraham and Isaac, then belonging to the Cartwrights of Aynho, Northants (Angulo Iñiguez 1981, no.90; ii, p.101; iii, pl.52; Waterhouse 1958, repr. 1966, p.125, no.1024). He owned the St John the Baptist in the Wilderness (National Gallery), now given to a follower (MacLaren and Braham 1970, pp.80–81).

22. Ellis Waterhouse, 'Murillo and Eighteenth-century Painting outside Spain', in exh. cat. cit., pp.70–71, fig.75.

Catalogue no.54

1. Cf. Laing 1984, pp.65–83, with further references.

2. Russell 1980, pp.35–42. The partial set of (five) Apostles by Van Dyck formerly at Althorp should none the less be remembered.

3. Clark and Bowron, while accepting the idea of such a timespan and its date-range, do not in practice suggest particular placings for any individual Apostle within the period of c.1740 to c.1743, contenting themselves instead with listing and illustrating them simply in alphabetical order (Clark and Bowron 1985, nos.74–85, pp.27, 231–3, pls.73–85).

4. Rubens painted a set of Apostles for the Duke of Lerma around 1611–12, and Van Dyck another for a Guilliam Verhagen around 1620–21 (cf. Roland 1984, pp.211–23; exh. cat. Anthony Van Dyck, National Gallery of Art, Washington, 1990–91, nos.19, 20), for which there were precedents (Urbach 1983, pp.5–22).

5. Zeri 1959, nos.431–3, pp.233–7 and pls. Already owned by G.B. Pallavicini in Antwerp in 1665, they are first recorded in Rome in the collection of Cardinal Lazzaro Pallavicini in 1679. Batoni painted a Visitation for the

collection about the very period of his Apostles (Zeri 1959, no.20, p.35, pl.). The Pallavicini Rubenses seem a more likely source than the incomplete set of full-length Apostles painted by Andrea Sacchi and Carlo Maratta for the Barberini, as proposed by Russell and by Clark and Bowron.

6. It suggests a closer than usual rapport between artist and clients that no fewer than three of Batoni's pictures in the brothers' collection were sketches (Clark and Bowron 1985, nos.37, 40, 111), one for a painting of which they also owned the larger version (Clark and Bowron 1985, no.112, which has the dimensions of a house-altar). Batoni also painted two variants of a Holy Family for them, presumably one each (Clark and Bowron 1985, nos.53, 54). He was even prepared to improve the Christ and the Woman of Samaria by his former teacher, Agostino Masucci, by repainting a face in it (Clark and Bowron 1985, no.128).

7. Many of them were sold through the Rome gallery of M.& C. Sestieri. St Andrew was sold to the Art Institute of Chicago; St Bartholomew to Tony Clark; St James the Less to Morris Kaplan in Chicago; but the main group of seven Apostles (St James the Greater, St John the Evangelist, St Matthew, St Paul, St Peter, St Philip and St Thomas) and God the Father were acquired by the dealer Julius Weitzner in London. All but one of these (St James the Greater, which he sold to the Bob Jones University Collection, Greenville, SC) were in turn acquired by Colnaghi's and sold to Lord and Lady Iliffe, as was St James the Less, when it reappeared on the market in 1968.

8. Other Apostles are named by Egidio Calzini in his guide to Forlì in 1893 (Calzini and Mazzatinti 1893, pp.53–4; cf. also Calzini 1896, pp.129–30, 138–9) and by Luisa Marcucci in 1944 (1944, pp.95–105, esp. list p.95 n.1). These, however, seem to have been simple misnomers, since the total number of Apostles is the same, as it is in two MS house lists of the collection.

9. Russell suggested that the Ecce Homo still in the possession of Count Cesare Merenda Farneti at Forlì was the pendant of God the Father, outside the series, but he was unaware that it is barely half the size of God the Father and all the Apostles, or that it was singled out, as a picture on its own, as a special legacy from Count Cesare Merenda to his friar-brother (Clark and Bowron 1985, no.75, p.231, pl.74).

10. There was, however, a separate picture of St John the Baptist on his own that might otherwise have formed part of the set (Clark and Bowron 1985, under 'Untraced Paintings', p.368).

11. 'Con cornice cimaso dorata' was how that on the Ecce Homo was described in Count Cesare's will in 1754.

Catalogue no.55

1. They are shown in these positions in hanging plans of c.1820 that were destroyed in the fire of 1989, but which had, fortunately, been photographed by the Furniture Department of the Victoria & Albert Museum.

2. On the embossed picture-guide produced at the behest of Sir Harry Fetherstonhaugh's widow for the Salon, they are called '"Love" and "Innocence" (Portraits) Pompeo Battoni'.

3. Exh. cat. Pompeo Batoni, 1982, no.46.

4. Matthew, v, 5, 8.

5. Ripa 1603: '*Fanciulla, che tenga fra le braccia in atto di accarezzare un picciolo & mansueto agnello*' (p.37). Not to be confused with the secular virtue of *Mansuetudine*, whose symbol is '*Donna coronata d'olivo, con un Elefante accanto, sopra del quale posi la man destra*' (ibid., p.304). Yet for the Fifth Beatitude, Batoni preferred the secular personification of *Purità*, '*Giovanetta, vestita di bianco, con una Colomba in mano*' (ibid., p.421), to that specifically for this Beatitude, '*Una donna, che sparga lagrime di pianto, sopra un cuore che tiene in mano*' (ibid., p.39), which may have seemed altogether too extravagant and lachrymose to the English. He added the Madonna's lilies for good measure. *Innocenza*, on the other hand, has a personi-fication of its own: '*Verginella, vestita di bianco in capo tiene una ghirlanda di fiori, con un'Agnello in braccio*' (ibid., p.235).

6. The only post-medieval painted depiction of the full set of eight Beatitudes known to this writer was that by Eustache Le Sueur for the chapel in the *hôtel* of président Brissonnet in Paris, of which just two, *Justice* and *Meekness* (shown as a seated young woman, feeding a lamb with its paws in her lap), survive: cf. Mérot 1987, nos.100–3, pp.244–8, figs.317, 318. It would be interesting to know whether Brissonnet had Jansenist leanings to account for such unusual imagery. Occasional instances of single Beatitudes occur: e.g. Biliverti's *Meekness* (Kunsthistorisches Museum, Vienna) and another, of uncertain attribution, which has been in the Pitti Gallery, Florence, since at least 1663 (Iahn-Rusconi 1937, p.263, no.420). But it does not, by and large, seem to have been a part of the Bible of which the post-Tridentine Catholic Church encouraged visual representation.

7. For whom, see John and Yenn 1922, pt.1, iii, p.135. Sir Matthew wrote in Oct 1753 to Horace Mann: 'My bro! that was abroad with me has married Miss Durnford (*un mariage d'Amour*). I hope they will be happy, tho' Prudence [not a Virtue painted by Batoni!] was a little neglected' (PRO SP105/310). I am most grateful to John Ingamells for this reference.

8. Traditionally called Charlotte, but, as Lynn Allen pointed out in a letter of 7 Sept 1982, Charlotte married Robert Raynor of Docking, Norfolk, whereas Katherine married Utrick Fetherstonhaugh. Clark and Bowron (1985) call Dr Durnford Rector of Harting, but this he cannot have been, since Utrick succeeded to the rectorship, whereas Dr Durnford went on, as vicar, to tutor the young Harry Fetherstonhaugh (b.1754; cf. Meade-Fetherstonhaugh and Warner 1964, p.37).

9. Clark and Bowron 1985, nos.154–63, pp.252–4, pls.144–53.

10. He was MP successively for Morpeth (1755–61) and Newcastle (1761–74), Fellow of the Royal Society, and towards the end of his life took an active interest in the Grand Ohio Company and its attempt to found a colony to be called Vandalia (1769–75), in honour of which he got Henry Keene to build a folly called the Vandalian Tower at Uppark.

11. Clark and Bowron 1985, pp.19–22.

12. They each have a purity of style and content that makes them far more convincing harbingers of Neo-classicism than either Batoni's own, more conventional, history-pictures and altarpieces, or Vien's earliest *goût grec Maidens* and *Priestesses*, which actually postdate them by a whole decade (Gaehtgens and Lugand 1988, nos.175–87).

13. Levey 1966, p.175 and pl.111, p.174 (still under the illusion that it represented *Innocence*).

Catalogue no.56

1. The idea was sometimes even projected back retrospectively onto works of the past – most famously onto the four landscapes (which actually form two pairs of pendants) painted by Claude for Henri van Halmale, Dean of Antwerp Cathedral, now in the Hermitage (*Liber Veritatis*, nos.154, 160, 169, 181).

2. For Poussin's *Calm* (Sudeley Castle Trustees) and *Storm* (Musée des Beaux-Arts, Rouen), see exh. cats. *Nicolas Poussin*, Grand Palais, Paris, 1994, nos.200, 201, and RA, 1995, nos.73, 74. His swan-song, the set of *Four Seasons* (Louvre), is also a set of *Four Times of Day*, along with many other layers of meaning.

3. Guiffrey 1893, p.50: 13 May 1762, Vernet to Marigny (quoted in exh. cat. *Claude-Joseph Vernet*, Kenwood, 1976, introduction, n.p.).

4. For a still fresh, but terrestrial, set of *Times of Day*, painted a little later, for the marquis de Villette in 1757 (though there are some discrepancies from that commission in the set as at present constituted), cf. exh. cat. *Claude to Corot: The Development of Landscape Painting in France*, Colnaghi, New York, 1990, nos.31A–D.

5. Vernet began an irregular account of '*Ouvrages qui me sont ordonnez*' in 1735, but only started keeping a list of '*Ouvrages que j'ay fait*' some time later. Lagrange transcribed and published both, and did his best to collate the two, but their inconsistencies, and his ignorance of Vernet's English clients and their intercon-nections, sometimes defeated him. They are in the Musée Calvet, Avignon.

6. In this, Vernet was already operating more systematically than his teacher and precursor as a French marine painter in Rome, Adrien Manglard (1695–1760). Manglard's only pairings of pictures appear to be of 'calms' with 'storms', with the time of day playing only a subsidiary role (Maddalo 1982, nos.31, 38 and nos.34, 39).

7. For whom and whose collections, see Le Moël and Rosenberg 1969.

8. Lagrange 1864, p.322, no.5: '*un dessus de porte en clair de l'une [sic] pour faire pendant aux trois autres que je luy ay deja fait*'. The two of these others included in Saint-Aignan's sale (17 June 1776, lots 57, 59; the latter resold at Sotheby's, 19 April 1989, lot 60) were of *Fishing-boats in a [Morning] Mist*, and a *Port of Neptune [at Sunset] with Passengers Disembarking*, which makes it clear that Vernet intended to round off a set of *Times of Day*. Even more significantly, the *Morning Mist* was described in the sale as 'the 1st painting by Vernet of this kind'. Although this no doubt refers to Vernet's portrayal of this particular atmospheric effect, it also almost necessarily implies that it was also the first time that he had been able to paint the *Four Times of Day*, by broadening his range of effects in this way.

In 1742 he likewise painted for a certain Mme de Seignon a pair of marines of a *Sunset* and a *Moonlight*, as pendants to two other pictures that he had painted previously – either before he had begun the *livre de raison*, or that he had failed to record (Lagrange 1864, p.323, no.10). In 1743 he painted just two *Times of Day* for a certain M. Moulon: a *[Morning] Mist* and a *Sunset over a Calm [Sea]* (Lagrange 1864, p.324, no.25).

9. They were described at Shardeloes by Thomas Jones in 1774 as 'four very capital pictures of Vernet, which were painted for Mr. Drake during his residence at Rome – when Vernet was a Young Man, rising in reputation, and Conse-quently in his best manner' (Jones 1946–8, p.33). They were sold at Christie's, 25 July 1952, lot 131, and the set was subsequently broken up. Cf. exh. cat. *Claude-Joseph Vernet*, Kenwood, 1976, nos.14 (*Misty Morning*) and 87 (engr. of *Evening*).

10. The party also included the Jacobite scholar Edward Holdsworth, as Drake's 'monitor', and Holdsworth's friend Dr Thomas Townson, as tutor to the dissipated James Dawkins; three members of the group were painted together in a conversation-piece by the emigré artist and dealer James Russel in 1744 (exh. cat. *British Artists in Rome: 1700–1800*, Kenwood, 1974, no.100; repr. in Ford 1974, p.404; cf. also Russel 1748, letter XXXVI, and Markham 1984, pp.290–91, n.g).

11. In 1749 Robert Wood (?1717–71), Dawkins's future companion in the 'discovery' of Palmyra, ordered four oval marines as overdoors on behalf of Joseph Leeson, later Lord Milltown (1701–83), at Russborough (exh. cat. cit., 1974, nos. 25–8; s. and d. 1750). John Bouverie ordered a set of four marines early in 1750, along with two landscapes with waterfalls. In May 1745 he had travelled from Rome to Venice with Russel and Dawkins, to meet up with Drake, Holdsworth and Townson (Russel 1748, pp.241–2). Immedi-ately after this commission he was to leave for Asia Minor with Wood and Dawkins, only to die at Magnesia in September. Bouverie has recently been identified as a pioneering collector of Guercino drawings (cf. exh. cat. *Drawings by Guercino from British Collections*, British Museum, 1991, pp.21–6, 28–32, nn.53–102).

12. Lagrange 1864, p.335, no.125.

13. Lagrange 1864, p.336, no.135.

14. Lagrange 1864, p.261, no.45.

15. Sir Matthew's pictures were originally to have been handed over to a certain '*M. Girardin, medecin*', and the payment to have been made by the banker '*M. Belloni*' (could he have been related to the Don Pietro Belloni who was then making scagliola table-tops for Sir Matthew?). That some slippage took place is indicated by what must be the later remark in Vernet's list of addresses (in which Sir Matthew's name occurs after two in Marseilles), written some time after his return to the South of France in October 1753: '*M. Reynier à Aix est celuy qui est chargé de retirer et payer les tableaux de M. Fetheston*' (Lagrange 1864, p.438).

16. There is no record of any payment for the pictures in Vernet's list of '*Argent que je reçois*'; nor did Horace Walpole note any such things on his visit to Uppark on 16 August 1770 (Walpole 1927–8, p.68). Not from brevity, since he did find

time to note 'four wax basreliefs coloured, and done at Naples'.

17. An indication of the closeness between Lascelles Iremonger and Benjamin Lethieullier is that a uniform tablet to the latter is included among those to the Iremongers in the family mausoleum at Wherwell.

18. The alternative hypothesis, that the Vernets hung in Sir Matthew's town house (now Dover House, Whitehall), and only came down to Uppark when Sir Harry sold this to the Duke of York in 1787, is wanting in the crucial evidence that Vernet ever executed his commission from Sir Matthew (see nn.15 and 16).

The Cabinet

1. Letter of 31 March 1748/9; cf. Chesterfield 1892, iii, p.316, cited in exh. cat. *The Treasure Houses of Britain*, National Gallery of Art, Washington, 1985–6, p.354 (but calling Dayrolles a dealer). Chesterfield wanted the pictures for Chesterfield House, into which he had only just moved, rather than for the Ranger's House, Blackheath, onto which he was shortly to build a picture gallery, but where he was then only living out the fag-end of his brother's lease. A distinctive picture gallery was – in contrast to a picture cabinet – the more customary English way of having a special room for displaying pictures, of every size. Isaac Ware (1756, Book III, ch.xxviii, pp.333–4) said that a picture gallery was 'only a part of great houses' and that 'the first question . . . is, whether the proprietor desire to have one or two?' – claiming, quite arbitrarily, that if there was only one it had to be in the centre of the house. Illustrating instead Chesterfield House as an example of a house with two (pl.60; cf. ch.xl, pp.433–4), he reveals – rather surprisingly, in view of Lord Chesterfield's letter – that the 'two additional rooms' for pictures were of the same size.

2. Letter to Mme la marquise de Monconseil, 30 July 1748; ibid., p.294.

3. Cf. the *Morning Chronicle*'s attack on the Hanging Committee of the RA in 1829, quoted in Whitley 1930, p.163.

4. Cf. M.L.R., *Les curiositez de Paris*, Paris, 1742, i, pp.168–81; and the plans in Blondel 1752–6, ii, Book V, ch.ix, pl.3.

5. The classic work on these is still Schlosser 1908; but cf. also Scheicher 1979; Impey and MacGregor 1985; Pomian 1978.

6. Cf. Latham 1965, pp.61–2, under *cabana*; Imbs 1971–83, iv, pp.1104–7, under *cabine* and *cabinet*. The OED (1989, pp.748–9), under 'cabinet', continues to cite 19th-century French etymological dictionaries in support of its statement that the French word *cabinet* derives from the Italian word *gabinetto*, when the reverse is in fact the case.

7. Cf. for this precursor in type of the cabinet, Liebenwein 1977.

8. Cf. Pelli 1779; Berti 1967; Heikamp 1963; Luzio 1913; exh. cat. *Splendours of the Gonzaga*, Victoria & Albert Museum, 1981; Zarco Cuevas 1930; Sánchez Cantón 1956–9; Bauer and Haupt 1976; and the analysis of this by Eliška Fučikova, 'The Collection of Rudolf II at Prague: Cabinet of Curiosities or Scientific Museum', in Impey and MacGregor 1985, pp.47–53. See also Ronald

Lightbown, 'Charles I and the Tradition of Princely Collecting', in MacGregor 1989, pp.53–72.

9. Cf. Strong 1986, esp. pp.184–200.

10. We know of Prince Henry's 'Cabbonett Roome' only from Van der Doort's references to it: primarily his marginal note that Prince Henry had 'promised him that when the Cabbonett roome Should be done that he Should have the keeping of all his Meddals', but also his preamble to King Charles, that 'yor pictures and rarities wch you had kept at St Jameses in the Cabbonett roome' had been transported to the new one at Whitehall, and his statement about the 'fower speckled wooden drawers' from the cupboards in it, both of which indicate that it was subsequently completed for Charles when he was Prince of Wales (cf. Van der Doort 1958–60, pp.154, 76, 138). The King's Works were responsible for the transformation of the long gallery, which is recorded by a specific bill, but the work on the 'Cabbonett' would appear to be buried in the unitemised £1,586 7s 10d spent by the Prince's Works between 1 Aug 1611 and 30 Nov 1612 (cf. Colvin 1982, iv, pp.245–6).

11. Cf. Van der Doort 1958–60, pp.xiii–xvii, 76–156. It is worth noting that the King's Chair Room seems to have served as a previous, and then as a subsidiary, cabinet in Whitehall Palace.

12. This kind of hybrid between picture cabinet and cabinet of curiosities can be seen in a number of the 17th-century Flemish paintings of collectors' cabinets, even if none of these can be taken as a veristic depiction of any particular cabinet (cf. esp. Spelt-Holterhoff 1957; with the corrections and analysis of Zaremba Filipczak 1987). Charles I actually had one of these in the King's Chair Room at Whitehall, which may still be in the Royal Collections (cf. Van der Doort 1958–60, pp.65, 232, no.17).

13. Queen Henrietta Maria's 'little roome betweene the 2. Gallories at Sommersett house', to which Charles I sent three miniatures from 'the Cabonnett roome' in St James's Palace (Van der Doort 1958–60, p.123), sounds very like one of these.

14. Thornton and Tomlin 1980.

15. Thornton and Tomlin 1980, pp.127–32.

16. By 1679–83 this had fallen to 53 pictures, which – to judge by the 1679 inventory and the subsequent emendations to it, comprised only 12 pictures in gilt frames, 40 in black ebony frames, and 'One picture with a Round carv'd frame'; by 1683 itself the total number of pictures and miniatures had dropped back further, to 51.

17. The plate in the *Description of Strawberry-Hill* is labelled *The Cabinet*, leaving it ambiguous (as at Stourhead) as to whether this refers to the room itself, or to the most conspicuous item of furniture in it, the 'cabinet of enamels and miniatures', designed by him.

18. Walpole 1784, Preface, p.i.

19. Walpole 1927–8, p.59. It should be remembered, however, that Walpole's *Journals* are primarily of visits outside London. After the publication of Dodsley 1761 and Martyn 1767, he would have felt less need to describe the collections they list, some of which (e.g. the London ones of John Barnard and Charles Jennens) are the most likely to have had picture cabinets.

20. Houghton Hall's is the only one of these to be called 'The Cabinet', and the explanatory text even says: '*Note*, That all the Pictures in this Room, except the Portraits, that have not the Sizes set down [which were mostly those in focal positions], are very small' (Walpole 1752, p.65). At Wilton, the room was called 'The Closet', or 'The Closet within the Corner Room' (cf. Cowdry 1752, pp.78–87; Kennedy 1758, pp.85–93), and again, by no means every picture was small. At Devonshire House, the Little Dressing Room seems in effect to have been a picture cabinet (Martyn 1767, i, pp.26–9).

21. Dodsley 1761, v, p.58; cf. Martyn 1767, i, p.112: 'The Dutchess of Northumberland's closet is a repository of curiosities, and contains a fine collection of pictures.'

22. Cf. exh. cat. *Johan Zoffany*, National Portrait Gallery, 1976, no.56; *The Treasure Houses of Britain*, National Gallery of Art, Washington, 1985–6, no.281.

23. Colt Hoare 1822, p.76.

24. Cf. Cornforth 1991.

25. Described by Waagen (1857, pp.421–6), after it had passed by inheritance to the Cavendish Earls of Burlington.

26. Instances of these were, or had been: the 'Raphael-ware Closet' at Narford Hall (which went back to the early 18th century); the 'Titian Room' at Blenheim; Sir Robert Walpole's 'Maratta Room' (which included Marattesques) at Houghton; the Canaletto Rooms at Woburn Abbey and Dalkeith; the 'Hogarth Room' at Erlestoke Park; the small room devoted to Van Dyck's oil sketches for the *Iconography* at Montagu House; a cabinet devoted to Thomas Stothard in Samuel Rogers's collection; B.G. Windus's library in Tottenham hung with 50 of Turner's finished watercolours; the room dedicated to copies of Raphael at Apsley House; the Dining Room at Bowood (in which pictures by Eastlake and Stanfield were actually let into the walls, 18th-century fashion, like the thirteen Angelica Kauffmans in the Dining Room of Sir Culling Eardley's Belvedere); the cabinet of Limoges enamels at Warwick Castle, and a similar cabinet at Chatsworth; and, of course, the Golden, or Spanish, Room at Kingston Lacy.

27. The very few examples of this kind of traditional picture cabinet detailed by Waagen were all in the very grandest or most select collections: at Stafford House (Waagen 1854, ii, p.73); in the Hope house in Duchess Street in London (Waagen 1854, ii, pp.114–24); at Hamilton Palace (Waagen 1854, iii, pp.302–3); and the Marchioness of Exeter's Boudoir at Burghley (Waagen 1854, iii, pp.408–9; though this must also have been used as a room). The many houses where in 1854 he enumerates paintings by school rather than by location may be concealing further instances, however. Yet in the Supplement of 1857, every single collection is detailed as hung – generally with the schools of painting all mingled – in the main rooms of the houses, including (particularly in Scotland) the Billiard Room.

28. Cornforth 1978, p.114; Wainwright 1989, pp.140–42.

29. Waagen 1854, iii, p.7 – stimulated by his experience of the Early Italian paintings in Earl

Cowper's collection at Panshanger in 1835 (cf. Waagen 1838, iii, p.3). Significantly, even the picture gallery added by William Atkinson for the larger pictures in 1821–2, with three skylights, was called, and used as, a drawing-room (Lasdun 1981, pp.80–82).

30. A case of a slightly different kind – a private museum, indeed – is Sir John Soane's Museum at 12–14 Lincoln's Inn Fields, in London. Soane created the Picture Room in 1824, and designed the ingenious hinged panels on three walls, which open to reveal further pictures. The hang includes Hogarth's *Rake's Progress* and *Election* series, with other oils, watercolours and drawings, primarily architectural, by Soane and his contemporaries. The character of the whole, however, is as summed up by Waagen (1854, ii, p.320): 'The principal part of this strange collection may be compared to a mine with numerous veins, in which, instead of metallic ore, you find works of art.'

31. Jameson 1844, pp.383–6. Although Mrs Jameson, in advocating Samuel Rogers's collection as a model for smaller cabinets, appears to be implying that the pictures in it only occupied one room, this was not so. Charles Sumner in a letter to G.S. Hilliard of Jan 1839, says: 'You have often heard of Rogers's house. It is not large, but the few rooms – two drawing-rooms and a dining-room only – are filled with the most costly paintings. . . . I should think there were about thirty in all [a grave underestimate]; perhaps you will not see in the world another such collection in so small a space' (quoted by Clayden 1887, p.450). See also the description of it by Waagen (1854, ii, pp.73–82), and the recollection of it by Lady Dorothy Nevill (1906, pp.47–8). An anonymous watercolour of the Dining Room, in which the poet's celebrated breakfasts were held, shows a rich – but not overcrowded – hang of well-known pictures from a variety of schools (Cornforth 1978, p.131, pl.165).

Catalogue no. 57

1. For the depiction of iron foundries in art, see Evrard 1955; for the depiction of mining, particularly by Valckenborch and his contemporaries, see Winkelmann 1958, esp. pp.86–8, col. pls.43–5, pls.53–4.
2. Stiennon 1954, p.21, no.34.
3. Van Mander 1885, ii, pp.47–8. For particular examples, cf. Wied 1990, nos.2, 3, 8, 11, 14 (this picture), 18, 23, 27, 30, 40, 41, 42, etc.
4. Mining and/or iron foundries feature in most of the landscapes enumerated in n.3 above. They, or figures associated with them, also appear in Wied 1990, nos.6, 7, 66, 82.
5. Cf. Hollstein 1949–, iii, p.256.
6. While in Linz he seems to have taken fresh inspiration from the iron foundries of Styria (Wied 1990, p.15, col.1).
7. Herri met der Bles's *Landscape with Mines and Forges* exists in a number of versions, of which the prime one would seem to be that in the Uffizi (cf. Winkelmann 1958, pp.84–6, pl.43); others are in the galleries of Prague, Vienna, Budapest and Graz.
8. Notably the signed and dated painting of 1544 in the Musées Royaux, Brussels (Winkelmann 1958, p.86, pl.44).

9. For William II Windham, his Grand Tour, and his Cabinet, see Ketton-Cremer 1962, pp.112–58; Hawcroft 1958; *Felbrigg Hall* 1995 (with plan for the picture-hang of the chimneypiece wall, p.58).
10. There are also some papier-mâché frames at Felbrigg. It is possible that René Duffour supplied these, and that the carved frames were made *in situ* by Thomas Quintin, who is documented as working at Felbrigg on architectural carvings and gilding between March 1751 and May 1753; but the pictures were sent down from London in July 1752, so this is unlikely. Cf. the carved frames made by Joseph Duffour for the Elsheimers (cat. no.59) in 1752. René Duffour appears to have been the son of Joseph Duffour, frame-maker to Frederick, Prince of Wales, and subsequently to have changed his name to Stone, since by about 1765 a René Stone was working from what had been the Duffours' address, at the Golden Head in Berwick Street, Soho (cf. Beard 1981, p.257; exh. cat. *The Quiet Conquest: The Huguenots 1685 to 1985*, Museum of London, 1985, p.202, no.292).

Catalogue no. 58

1. It is the painting's Correggiesque qualities that account for its old ascription to Federico Barocci. However, Barocci was always monumental, even on a small scale, whereas Calvaert perpetually seems small and precious, even on a large one.
2. Inv. no.99; cf. exh. cat. *Le siècle de Bruegel*, Musées Royaux des Beaux-Arts, Brussels, 1963, no.253; Bruno 1978, no.80, pp.36–7.
3. Inv. 19.836; cf. *Revue de l'art*, xlv/4, Oct 1928, fig. p.164; exh. cat. *Le seizième siècle européen: Dessins du Louvre*, Louvre, 1965, no.196.
4. It was exhibited in 1965 as a study for the Capitoline painting, but this last was probably created first, as a domestic altarpiece (it is on canvas, and measures 70 × 94 cm).
5. Originally ascribed to F. Mazzola (i.e. Parmigianino), but attributed to Pietro Faccini when presented by Mr J. Yock in 1960 (cf. Tomory 1962, no.8). The faces of the Virgin and St Catherine are more italianate – and the latter more Parmigianinesque – than those habitual with Calvaert, so that the attribution may not be entirely wide of the mark: (cf. esp. *The Mystic Marriage with St Jerome* in the Pinacoteca Capitolina, Rome; Bruno 1978, no.124, pp.57–8). Calvaert may have delegated some or all of the painting to a pupil (surely not Faccini; could it have been Reni?) – hence its being on a lowlier support. (Malvasia lists a painting of this subject by Reni in the Bonfiglioli collection, Bologna, as one of his earliest works.) On Calvaert's use of reversal to generate new compositions, see Kloek 1993.
6. Hoare almost certainly acquired it from France (probably via an auction in London), to judge by its superb French Rococo frame. Unlike many owners, he seems to have made a point of retaining good French frames on his pictures rather than reframing them uniformly with the rest of the collection: e.g. on two paintings by Poussin, *The Choice of Hercules* (still at Stourhead) and *The Rape of the Sabines* (sold in the Heirlooms sale of 1883; now in the Metropolitan Museum, New York). So did his successor, Colt Hoare (cat. no.9), who, when he

placed the present picture and a number of others like a predella in his new Picture Gallery in 1802, seems deliberately to have set off their lively Rococo frames, as grace-notes to the more sober Maratta-type frames of the larger paintings.

Catalogue no. 59

1. Cf. Davies 1907, p.382.
2. Waddingham (1972) and Andrews (1977 and 1985) have drawn attention to echoes of specific landscapes in pictures of this set upon Teniers the Elder and Claude.
3. For the fullest discussion of the whole group, copies of individual pictures, etc., see Andrews 1977 and 1985.
4. Fabre 1914, p.232, no.835 (indicated as part of Fabre's original donation of his works of art and library in Florence to the commune of Montpellier in 1825).
5. Cf. Uffizi 1979, pp.417–18, nos.P1203, 1204; Schaar 1959, pp.34–5.
6. The Penshurst cabinet has been published in *Country Life*, 23 March 1912, p.438, but never properly studied. I am most grateful to Lord and Lady De L'Isle for having given me ample opportunity to study it. In the original commission to Elsheimer, a *St Francis* might well have been paired with the *St Thomas Aquinas*, as representatives of the two great Mendicant Orders, the Franciscans and the Dominicans, but that would have left *St Lawrence* without a counterpart. The obvious one would have been *St Stephen*, the other deacon and proto-martyr, but we know of neither original nor copy of this saint by Elsheimer. Nor do the two female saints make an immediately obvious pairing. It is, therefore, perhaps safest to take only the set of Poelenburgh copies in the Uffizi as reflections of Elsheimer's originals. The additional saints on the Penshurst cabinet that do not appear to presuppose originals by Elsheimer may have been introduced to suit its particular function and client.
7. As is the case with the reconstituted group of pictures of *The Story of the True Cross*, set around *The Adoration of the Cross* (Städelsches Kunstinstitut, Frankfurt). The Penshurst cabinet, from the imagery of its silver reliefs and gilt bronzes, would seem originally to have been centred upon some three-dimensional image of Christ's Passion.
8. It is also interesting, but inconclusive, that Elsheimer should have made one of his rare etchings of just the *St Joseph and the Christ Child* (Hollstein 1949–, vi, p.147, no.8; Andrews 1977, no.57, p.201, pl.7). But – contrary to what Andrews maintains – none of Hollar's etchings is after a picture in this set, but – at best – after versions or variants of the *St John the Evangelist* and *St Lawrence* available to him in Antwerp in 1650 (Pennington 1982, nos.168, 170; Weizsäcker 1936, figs.53, 54).
9. Previously called *St Dominic*, but rightly identified by Andrews (1977): the star on his breast and the model church are the usual attributes of St Thomas Aquinas, the quill pen takes the place of the usual book, but these both obviously refer to his writings.
10. It is not Roccasecca, where Aquinas was born; not Montecassino, where he was sent as a child with the prospect of becoming abbot; not

Anagni, nor Orvieto, nor Viterbo, at all of which he taught; not S. Domenico in Naples, where he worked on the *Summa Theologica*, and the crucifix miraculously addressed him; nor, finally, the Cistercian abbey of Fossanova, where he died, on his way to the Council of Lyons, as Andrews has suggested (1977, p.148). The Dominican nun and novice (?) on the steps appear to indicate a convent. If the *St Lawrence* was not originally paired with a painting of the other proto-martyr, St Stephen (for the existence of which there is no evidence), his inclusion in the set may reflect the church's dedication.

11. Did Rubens have a memory of the *St Joseph and the Christ Child* in his mind when he painted *The Return from Egypt* (Wadsworth Atheneum, Hartford, CT) for Archduke Albert around 1614 (Jaffé 1989, no.231)?

12. Andrews 1977, p.30.

13. For the reconstruction of this tabernacle, see Andrews 1977, no.16.

14. Cf. Schaar 1959, pp.26–8, 40 n.50.

15. It is recorded in the 1704 inventory of the Uffizi, and by C.-N. Cochin (1769, ii, p.9): 'Un autre petit tableau représentant un diacre, par *Adam Helsemer*; cette figure est très spirituellement touchée, le visage est un peu de couleur semblable à celle de la faïance'.

16. For excellent and thorough documentation of Northumberland's collecting and collections, see Wood 1994; on Van Dyck's collections and their dispersal, for what Northumberland obtained from these and how, see Wood 1990 and Brown and Ramsay 1990.

17. Cf. Stoye 1989, pp.215–30.

18. Joseph Duffour's bill is in the Petworth archives (PHA 3131). He charged £12: 'For Carven 8 little frames Gilt in Burnish'd Gold att 30 shillings each' (20 Aug 1752).

19. Cf. Wood 1994, pp.283, 305, no.[40], and p.316 n.16.

Catalogue no.60

1. See esp. Borromeo 1624 and 1625; Bedoni 1983.

2. Published, with a commentary and some facsimiles, by Crivelli 1868.

3. Inv.1092. Cf. Ertz 1979, no.342, pp.364, 374–6, 614–15, fig.315.

4. Crivelli 1868, pp.92, 131; Bedoni 1983, pp.114, 120, 156 n.128, pl.51. Bedoni can hardly be right in saying that Brueghel turned it into an allegory of *Earth* at that time, since it is the 'animali' that already define it as such.

5. Crivelli 1868, pp.50–51. The picture is one of those listed as the second of two sets of '*Sei pezzi di paesini dipinti sopra il rame*' in the lists annexed to the original act of foundation of the Pinacoteca Ambrosiana of 1618, of which it still forms a part (cf. Falchetti 1969, pp.298, 137, fig. p.138). Ertz (1979, p.363, fig.434) quite arbitrarily dismisses this as a later substitution; but, since he neither argues his case nor offers any explanation of how or why such a thing could have taken place, his opinion can be discounted. It is, however, probable that the figures are by Hendrik van Balen, though neither the letter nor the list mentions it.

6. Crivelli 1868, pp.110–12; Falchetti 1969, pp.298, 131; Ertz 1979, no.190, pp.364, 374–6, 589, fig.445.

7. Crivelli 1868, pp.98–184; Ertz (1979, esp. pp.363–5) completely fails to grasp this crucial distinction between the set of *Elements* that Brueghel executed in one fell swoop for Bianchi (whom he fails to mention at all in this context), and those painted singly, over two decades, for Borromeo, so that his attempted classification of them is riddled with flaws.

8. For this to have been possible, the artist must have retained a master set in Antwerp – and it was perhaps the need to paint this set, in addition to the one commissioned by Bianchi, at a time when he was much employed by the Archduke Albert and Archduchess Isabella, that helps to account for his delays in completing Bianchi's commission.

9. Crivelli 1868, letter of 4 July 1609, pp.139–40. In this, Brueghel says that he has already begun *Air* and *Fire*, but that he cannot use two *paisetto* [*sic* – i.e. really landsca*pes*] that Bianchi has sent him for *Earth* and *Water* because of this fact. Bianchi must have hoped that Brueghel was simply going to enrich the landscape which Bianchi (or perhaps another artist) had painted with still-life details and creatures, but they clearly did not lend themselves to the inclusion of mythological or allegorical figures as well.

10. What has happened to Bianchi's originals is far from clear. Crivelli thought (it is not quite clear on what evidence) that they had passed to the duca di Melzi, in his *palazzo* in the via Cavalchina in Milan, and that afterwards two had been sent to the Villa Melzi, and two had vanished without trace (Crivelli 1868, pp.151–2). The Melzi set, however, had been acquired by Count Giacomo Melzi d'Eril (1721–1802) from Count Firmian in 1782, and was ascribed to Jan Breughel the Younger in the first printed catalogue of the Melzi d'Eril collection around 1802. When catalogued a century later at the Villa di Bellagio, it was as by Jan Breughel the Elder, but it was admitted that *Air* and *Water* seemed to be by an inferior hand (cf. Carotti 1901, p.171, nos.55–8, and p.111).

A better-founded account was given to Gabburri by the great connoisseur and collector of Old Master drawings, Padre Sebastiano Resta, in 1704. He said that all eleven of Bianchi's Brueghels had been acquired by the Governor of Milan, the marchese di Cavacena, who sent them to his master, Philip IV of Spain; the King then distributed them all as presents to ladies of the court, from one of whom five or six were acquired by the Patriarch Girolamo Colonna (1604–66), who had shown them to him in Rome. After that the trail runs into the sand (Bedoni 1983, pp.146–7). Whatever the truth of the matter, the prior existence of the Bianchi set, whose gestation gave Brueghel so much trouble in Milan, tends to support Ertz's contention that the well-known set in the Doria-Pamphilj Gallery (already recorded in the Palazzo Pamphilj in the Piazza Navona in Rome in 1666) is composed of – at best – autograph replicas (Safarik and Torselli 1982, nos.21–4, as by Jan Breughel the Elder and Hendrik van Balen; inv. nos.322, 328, 332, 348; Bedoni 1983, pp.68–73, pls.26–7; Ertz 1979, nos.248–51, pp.370–71, pls.439–42). It is just possible that the signed and dated (1611) version of *Earth* on its own, which first came to light in an auction at Cologne in 1952 (exh. cat.

Jan Brueghel the Elder, Brod Gallery, London, 1979, no.28), is a solitary survivor of the original series for Bianchi.

11. Crivelli 1868, letters of 19 April 1613, 24 Dec 1614, 13 March 1616, pp.203–4, 220–21, 223: the reference to '*il quadro de pesci*' in this last must be to the *Element of Water*, since there is no record of Brueghel ever having done a simple still-life of fish for Borromeo, Bianchi or anyone else. Crivelli was still able to read the date on *Water* as 1614.

12. Crivelli 1868, pp.238 (Bedoni 1983, pp.133, 135–6, rightly corrects the date of this letter from 1616 to 1621, which is that found on the picture) and 271–4.

13. Ertz (1984, nos.193–6, 190–201, 197, pp.68–9, 357–65, with figs. and col. pls.39–44) singles out two sets of *Elements* (one originally in Archduke Leopold Wilhelm's collection, now in the Musée des Beaux-Arts, Lyons; the other in a private collection) and a single *Fire* (private collection) that he singles out as by Jan Breughel the Younger, but without any argument for his case. A very full listing of other versions is to be found in exh. cat. *Le siècle de Rubens dans les collections publiques françaises*, Grand Palais, Paris, 1977–8, under nos.14 (*Fire*) and 15 (*Water*). A poor set of copies of all four *Elements* is at Saltram; an *Air*, probably by Jan Breughel the Younger and Hendrik van Balen, is at Stourhead.

14. Vaes 1926, reprinted from this in a German translation in Ertz 1984.

15. Called *Pan and Syrinx* or *The Age of Gold* and ascribed to Martin de Vos when in the Orléans collection (cf. Held 1973; Jaffé 1989, no.289 bis). This was offered to Sir Dudley Carleton in 1618 – but may well have been painted some time before – with the statement that the leopards were 'done from the life. . . . An original by my hand, all save the beautiful landscape, done by a good man for that speciality', which certainly implies that the leopards were Rubens's own invention. Yet the earliest version of Brueghel's own *Animals preparing to enter the Ark* (Getty Museum, Malibu), which includes not only them, but a pair of lions that feature in Rubens's *Daniel in the Lion's Den* (offered to Carleton on the same occasion) is signed and dated as early as 1613 (exh. cat. *Jan Brueghel the Elder*, Brod Gallery, London, 1979, no.29, pp.96–7, and cover detail).

16. The exception is the Zurbaran studio version of *St Elizabeth of Portugal*, which Walter Ralph Bankes bought as an inadequate substitute for the Velázquez *Philip IV* sold to Otto Gutekunst of Colnaghi's in 1896, and earmarked by the latter and Berenson for Isabella Stewart Gardner.

Catalogue no.61

1. In one picture in particular, the *Scene in a Tavern* (Johnson Collection, Philadelphia Museum of Art), Brouwer anticipated Teniers very closely: the setting is more spacious and L-shaped; the protagonists – including a more distant group in front of a fireplace – have calmed down; still-life elements are introduced (notably an arrangement of logs in the right-hand corner, a toss-pot and a flagon, glass and cloth upon a very Teniers-type table); and a drawing of a peasant's head is stuck up on the wall.

2. Rosenberg, Slive and ter Kuile 1977, p.183.

3. E.g. Koninklijk Museum voor Schone Kunsten, Antwerp (inv. no.5043), and Gemälde-galerie, Kassel (inv. GK139): exh. cat. *David Teniers the Younger*, Koninklijk Museum, Antwerp, 1991, nos.1, 3. Teniers was even asked to make a copy of a Brouwer in the artist's own lifetime, since demand for his works exceeded the supply; and we have a number of drawn copies of Brouwer's paintings by him (cf. exh. cat. *Teniers*, no.109).

4. Exh. cat. cit., no.11.

5. Unfortunately, this panel was expanded a little later, to make it conform to the classic type of Teniers tavern interior (perhaps even to make it, as it now serves for the present picture, the pendant to another such painting), and the instability of the joints make it unsuitable to lend (*Polesden Lacey* 1964, p.28, no.58; exh. cat. *Teniers*, p.18, fig.5, and p.56).

6. Exh. cat. *Teniers*, no.33; the others (some-what arbitrarily selected) are an undated picture also in a private collection (ibid., no.34), a painting of 1645 in the Louvre (ibid., fig.34a), and an undated picture in the National Gallery (inv.2600; cf. Martin 1970, pp.269–71, who adduces good grounds for suggesting that this picture may be earlier still, from towards the end of the 1630s).

7. Exh. cat. *Teniers*, no.12. This too, however, appears to be a feature that Teniers derived from Brouwer: see the example in the latter's *Tavern Scene with a Sexual Assault* in the Bacon collection at Raveningham Hall (exh. cat. *The Age of Rubens*, Museum of Fine Arts, Boston, 1993, no.65).

8. Exh. cat. *Teniers*, no.14.

9. Exh. cat. *Johan Zoffany*, National Portrait Gallery, 1976–7, no.56, with a detailed consideration of the composite setting; cf. Francis Russell, in exh. cat. *The Treasure Houses of Britain*, National Gallery of Art, Washington, 1985–6, no.281. For Dundas as a patron and collector, see the issue of *Apollo* dedicated to him, Sept 1967, pp.168–225.

10. The two paintings, in more elaborate versions of the frame on the present picture (which is probably a later dealer's imitation), are *Corps-de-garde* (Dulwich Picture Gallery; inv. no.54; Murray 1980, p.125 and pl.) and, below, *Journeyman Carpenters* (in the collection of the Dukes of Newcastle at Clumber until 1938; last sold at Sotheby's, 21 April 1982, lot 65). The former was from the De Neville collection in Amsterdam, which – *pace* Russell – makes it more likely that its and the matching frames on this wall were carved for Dundas, rather than that de Graville's Tenierses should have retained theirs. The posthumous sale of Dundas's collection by his son (created Baron Dundas of Aske in August), at Greenwood's on 29–31 May 1794, contained fifteen paintings by Teniers, almost all pictures of some consequence. Desenfans's collection now at Dulwich is probably the only British one ever to have had more, but not of so consistently high a level.

11. Sutton 1967, pp.209–10, with the invoice on p.212, appendix 7(xv). This letter calls the vendor the 'Marquis of Gravelle'; the catalogue of Dundas's sale says 'the Marquis de Graville'. The only plausible candidate for either appears to be Louis-Robert Malet de Graville (1698–1776), whose family *seigneurie* of Graville carried with it the right to the title of *marquis*, but who had originally called himself the marquis de Valsemé, and, after 1730, comte de Graville. He not only fought with the French army in Flanders between 1743 and 1749, but was appointed Governor of Dunquerque in 1758. He was thus well placed to acquire pictures by Teniers, whether as the spoils of war, or as legitimate purchases in peacetime.

12. Wells had a distinguished collection of Old Masters. He sold his Van Dyck *Head of Charles I in Three Positions* to the Prince Regent, and bequeathed Reni's *Coronation of the Virgin* to the National Gallery, but it was as 'one of the richest and most choice collections of the Dutch masters' in England that Passavant singled it out for encomium (1836, ii, pp.71–2).

13. *Fourth Report*, 1857, pp.81–2. My thanks to Clive Wainwright for this reference.

14. Cf. Lloyd Williams 1994.

15. Edward Coxe was the brother of the auctioneer Peter Coxe. His sale contained pictures of remarkably high quality, which fetched good prices (Fredericksen 1990, ii, pt. 1, p.25, no.483).

Catalogue no.62

1. See exh. cat. *Haarlem: The Seventeenth Century*, Jane Voorhees Zimmerli Art Museum, Rutgers, NJ, 1983. For the specific case of landscape, see Christopher Brown's catalogue, cited in n.4 below. Christopher Wright's 1989 Birmingham exhibition, *Dutch Painting in the Seventeenth Century: Images of a Golden Age in British Collections*, was also organised by centres of production, and contains a useful overview of Haarlem's contribution, pp.80–104, as does Haak 1984, pp.166–72, 179–87, 229–61, 377–94.

2. For a useful summary of this issue, see Rosenberg, Slive and ter Kuile 1979, pp.23, 429–30, n.23, and the essays by E. Haverkamp-Begemann and F.F. Hofrichter in exh. cat. cit., 1983, esp. pp.1–3, 36–7.

3. For two differing interpretations of this, see Taverner 1972–3; and Alpers 1983, pp.113–14; see also the essay by J.J. Temminck in exh. cat. cit., 1983, pp.17–26.

4. In this context, see esp. Christopher Brown's pioneering exhibition at the National Gallery in 1986, *Dutch Landscape: The Early Years: Haarlem and Amsterdam 1590–1650*, esp. pp.21–2, 24–34, 57–62, 63–71, 131–85, 199–220.

5. Ruisdael's productions even included a topographical speciality known as 'haarlempjes'. As this term suggests, he had in fact left Haarlem to settle in Amsterdam, where he is first recorded in 1657, and where these – to Amsterdam burghers – 'foreign' views, with their novel panoramic effects (some of which may in fact depict Alkmaar), were probably all painted between about 1669 and 1675 (cf. esp. exh. cat. *Masters of 17th-century Dutch Landscape Painting*, Museum of Fine Arts, Boston, etc., 1987–8, esp. pp.49–53, 437–8, 463–5).

6. Schnackenburg 1970.

7. A good early example is the *Drinkers and Fighting Children* of 1634 in the Sarah Campbell Blaffer Foundation (cf. Wright 1981, pp.136–7; and exh. cat. *Masters of Seventeenth Century Dutch Genre Painting*, Philadelphia Museum of Art, etc., 1984, no.89).

8. So read by Smith and by Waagen. Schnackenburg (1981, i, p.142, no.305; ii, pl.42, fig.305) also prefers the date of 1670 for the picture, and for the drawing for the *Dancing Couple* in the British Museum (inv.1836.8.11.431; there is a copy in the Musée des Beaux-Arts, Besançon).

9. Hofstede de Groot 1910, iii, p.141.

10. His *Couple of Boors dancing in a Tavern* amply demonstrates this: besides a finished watercolour of 1673 (Teylers Museum, Haarlem), there are variant oil paintings of 1673 (last seen at auction in Paris in 1931) and 1675 (in the Harold Samuel Collection, Mansion House, London). So does the *Interior of an Inn with Boors Playing Cards* (?1674; also at Ascott), which shows no falling off as compared, for instance, with the *Boors before a Tavern Fireplace* (1668; Polesden Lacey).

11. Cf. Sutton 1992, p.146 n.10.

12. Cf. Brouwer's *Boors Smoking* (exh. cat. cit., 1984, no.21) and Jan Jansz. van de Velde III's variations on his *Still-life with Pipes and Glasses* (Sutton 1992, no.75).

13. Exh. cat. *Adriaen van Ostade: Etchings of Peasant Life in Holland's Golden Age*, Georgia Museum of Art, University of Georgia, 1994, pp.68–9.

14. Just as in Ostade's etchings of *The Fiddler and the Hurdy-gurdy Boy* and *The Village Festival under the Great Tree*; the latter has a similar couple dancing outside the door of the tavern (exh. cat. cit., 1994, nos.108–10 and 113–14).

15. Van Loon's collection comprised some 82 Dutch and Flemish 17th-century paintings, largely acquired at auction or by private purchase. When his widow died, their nine surviving children appear to have made a private offer of the collection to the Rothschilds, who bought it *en bloc*. This itself was not unusual in the context of the time; what was unusual for the Rothschilds, is that it was divided between members of the English and the French branches of the family. The lion's share seems to have gone to Baron Lionel, and the rest to baron Edmond, though one or two pictures seem to have been sold or given away.

16. Baron Lionel's collection was divided among his three sons, Nathaniel (subsequently created Lord Rothschild), Leopold and Alfred, in 1882 on the basis of a list – and, presumably, valuations – drawn up by the art dealers Frederick & Charles Davis of 47 Pall Mall. Charles Davis went on to write the – entirely anodyne – text of the catalogue of Alfred de Rothschild's collection in 1884.

Catalogue no.63

1. Lucy 1862, pp.128–31, at the beginning of a list of everything that he bought at the Fonthill sale, totalling £3,431 10s 6d. The words were taken from his obituary in the *Warwickshire Standard* for 5 July 1845 (quoted ibid., p.162).

2. Cf. Hall 1994², esp. pp.266–72.

3. R.E. Fleischer lists a number of instances of false de Hooch signatures on de Jongh's paintings (1978, p.63 n.16). On 27 Jan 1827 the dealer Thomas Emmerson wrote to Lucy: 'I

made inquiry in Paris about your picture by De Hooge, which you had from Thompson Martin, and I find it came from there, and was considered remarkably fine. I always considered it so; and you will be pleased to know that it is a picture which is not known on the market, and has never been hackneyed about' (Lucy 1862, p.166) – which is precisely what it must have been, for de Jongh's signature to have been concealed. Emmerson (d.1855) held a number of sales between May 1829 and May 1854. Posthumous sales of his pictures were held at Christie's on 17 Feb and 23–4 March 1855 and on 21–31 May 1856. There were no fewer than three de Hoochs in his first sale, of 1–2 May 1829 at Phillips. In 1823 he himself had sold to Lucy a pair of Wouwermans (sold to Lionel de Rothschild in 1875) and Teniers's so-called *Wedding of the Artist* (1651), and in 1824 the Hobbema that he called a '*View near Haarlem*' (Metropolitan Museum, New York), both of which were also to be acquired by Baron Lionel, but at an unknown date. In 1826 he acted for him in getting Domenichino's *St Cecilia* at Lord Radstock's sale.

4. Sutton 1980, no.34, pp.84–5, col. pl.IX, pl.33.

5. Sutton 1980, no.33, p.84, col. pl.VIII, pl.32, and in exh. cat. *Masters of Seventeenth Century Dutch Genre Painting*, Philadelphia Museum of Art, etc., 1984, no.53. The one in the Royal Collection can probably be dated a year earlier, thanks to the date of 1657 on one of the copies of it (Sutton 1980, no.36, p.86, pls.39, 37).

6. Sutton 1980, no.28, pp.81–2, col. pl.VI, pl.26.

7. Sutton 1980, no.26, p.81, pl.23.

8. Sutton 1980, no.27, p.81, pls.24–5.

9. Exh. cat. cit., 1984, p.224, fig.1.

10. E.g. *Interior with a View down an Enfilade and a Woman at a Clavichord* (Boymans-van Beuningen Museum, Rotterdam).

11. E.g. in his *trompe-l'oeil* peepshow box (National Gallery) and *View down an Enfilade* (1662; Dyrham Park).

12. Cf. Kuretsky 1979, esp. ch.2, pp.34–9, figs.121–35. The author actually adduces the present painting to illustrate the difference of approach (p.34, fig.119).

13. Cf. Zumthor 1962, pp.37–8, cited by Kuretsky 1979, pp.34, 39 n.2.

14. Susan Kuretsky interprets the subject of the painting on the wall simply as a parallel eruption of a male 'into this peaceful sphere of feminine activity' to that of the page in the actual picture (1979, p.34).

15. This *marchand-amateur*'s posthumous sale of somewhat miscellaneous pictures removed from his residence, Whitehall House, was held by Foster at the Egyptian Hall on 5 May 1827, with subsequent sales held by Phillips on 6 May 1830 and 26 Feb 1831.

16. Family tradition has it that, in Mary Lucy's old age, her second and surviving son, Spencer, introduced Baron Lionel de Rothschild's agent to the house before his mother was up in the morning, so as to value her late husband's acquisitions and close a deal, before she could veto their being sold (Fairfax-Lucy 1977, inside back cover). She and her eldest son, Fulke (1824–48), had always set their face against the facile solution of selling off George Lucy's costly acquisitions to expunge his debts, as her brother recommended (Fairfax-Lucy 1983, p.75).

Catalogue no.64

1. He is *not* putting a ring on her finger, as the catalogue of the 1974 *Ter Borch* exhibition would have it, nor are they dancing, as Gudlaugsson proposed (1960, no.187), with sublime disregard for the impossibility of cutting any sort of figure on the dance-floor in spurs.

2. Cf. Mirimonde 1966–7, *passim*.

3. E.g. *The Greeting* (National Gallery of Art, Washington; Gudlaugsson 1960, no.139); *The Visit* (Bührle Collection, Zurich; Gudlaugsson 1960, no.149); *L'instruction paternelle* (Gudlaugsson 1960, no.110); *Le galant militaire* (Louvre; Gudlaugsson 1960, no.189).

4. For Gesina as draughtswoman and custodian of the family drawings, see Gudlaugsson 1960, ii, pp.37–9; and exh. cat. *Ter Borch*, 1974, pp.226–41.

5. Exh. cat. cit., no.110.

6. Gudlaugsson 1960, no.171. He also discusses and illustrates a later *Self-portrait* in oils by her (Armand Hammer collection; Gudlaugsson 1960, ii, p.286 n.5, pl.xxiii, fig.4).

7. Gudlaugsson 1960, no.164; exh. cat. cit., no.44.

8. Gudlaugsson 1960, no.77; exh. cat. cit., no.19.

9. She seems more likely to be the woman who appears both in a portrait in the Hage collection in Nivaa that first surfaced in Deventer in 1901 (Gudlaugsson 1960, no.108, i, pp.94–6, pl. p.265; ii, pp.114–15) and in a number of genre pieces – notably the *Horse in its Stall* (J. Paul Getty Museum, Malibu; Gudlaugsson 1960, no.109; cf. also nos.95, 96, 98, 112, 113). The sitter in the first two of these is surely the same in the others, and so not, as Gudlaugsson and the 1974 exhibition catalogue would have it, ter Borch's stepmother putting in a belated appearance?

10. For these, see Haak 1984, pp.394–401.

11. Cf. the vivid section on brothels in Schama 1987, pp.467–80.

12. Rosenberg, Slive and ter Kuile 1979, p.219. Cf. 'The gentleman . . . makes his bow with the easy gracefulness of a person long used to mix in polished society' (Ottley and Tomkins 1818, iii, p.100).

13. Fredericksen 1990, ii, pt. 1, pp.9–10; pt 2, p.988. Craufurd (called Crawford by Buchanan 1824) was a Scottish merchant who had become Consul in Rotterdam in 1802. He dealt in pictures from the first – if he is the same Craufurd who was serving as Dundas's agent and banker in Rotterdam in 1762–3 (cf. Sutton 1967, pp.207–9).

14. 'The richest nobleman in England', he had already bought a one-third share, and inherited another third, of the Italian pictures in the Orléans collection. He hung the picture at Stafford (formerly Cleveland) House. The picture gallery built onto this in 1805–6 by C.H. Tatham was the first to be opened to the public – a most important event, in the absence of any National Gallery until 1824; even after that, until at least the opening of Wilkins's purpose-built edifice in Trafalgar Square in 1837, and the demolition of Cleveland House to make way for Sir Charles Barry's palatial Bridgewater House in 1846, the national collection was dwarfed in quantity, quality, and installation by this great private one (cf. exh. cat. *Palaces of Art: Art Galleries in Britain 1790–1990*, Dulwich Art Gallery, 1991–2).

15. Soon after the death of the 1st Duke of Sutherland in 1833, the 2nd Duke removed the Gower/Stafford/Sutherland pictures to the as yet incomplete Stafford (formerly York, and now Lancaster) House, since, by the will of the 3rd and last Duke of Bridgewater, his estates, houses (which included Cleveland House) and collections then passed to the 1st Duke of Sutherland's second son (cr. Earl of Ellesmere in 1846), and the Sutherland pictures had to find a new home.

16. A ballet dancer of international repute, before her marriage to the heir of a rich Lisbon merchant. For Lynford Hall, the neo-Jacobean pile built for them by William Burn in 1856–61, see Girouard 1979, p.412, and Sayer 1981, p.155.

Catalogue no.65

1. Such footwarmers appear with greater frequency in paintings of this kind than verisimilitude would seem to warrant. Three particularly flagrant examples occur in pictures with strong erotic implications in *Masters of Seventeenth Century Dutch Genre Painting*, Philadelphia Museum of Art, etc., 1984, nos.77, 68, 80: Jan Miense Molenaer's *The Duet* (Kress Collection, Seattle Museum of Art), Cornelis de Man's *The Chess-players* (Szépmüveszeti Museum, Budapest) and Michiel van Musscher's *Doctor taking a Young Woman's Pulse* (private collection, USA). Although Peter Sutton adduces the text to Roemer Visscher's emblem of a footwarmer in his *Sinnepoppen* (1614) to suggest that its meaning was more innocuous, its very nickname, used as the title of the emblem – *mignon des dames* – subverts his argument. As Colin Eisler pointed out (1977, p.136 n.3), its conspicuous deployment in Jan Steen's *Man offering a Woman an Oyster* (National Gallery) is patently suggestive of the supposedly aphrodisiac effects of oysters.

2. Hofstede de Groot (1907, i, no.149) suggests that this, or the *Man and Woman seated by a Pair of Virginals* (National Gallery) may have been the picture in the Witsen sale. The dimensions more or less agree, but the description, while sufficient to eliminate the National Gallery picture – in which little music-making is taking place, and in which the woman is not, as here, wearing a satin skirt – is not extensive enough to clinch the identification: 'A Young Woman wearing a satin dress, who is making music with a man . . . by Gabriel Metzu; 1 foot 4½ inches [high] × 1 f. 1 in.' ('Een Juffer met een satyne kleed aan, die met een Heer Musiceert, teder en puyk door Gabriël Metzu; h. l v[oet] 4 en een half d[uim], br. 1 v. 1 duim') (cf. Hoet 1752, ii, p.186). MacLaren (1960, p.243) refutes the identification of the National Gallery picture (inv.839) with that in the Witsen sale.

3. The *receveur général des finances de Lyon* and a noted collector – above all of the drawings of Boucher, with whom he made a journey to Holland in 1766 (cf. exh. cat. *Fragonard*, Grand Palais, Paris, and Metropolitan Museum, New York, 1987–8, p.178). According to the posthumous tribute paid to him by his friend and fellow-collector, Jean-Gaspard de Sireu(i)l, in the *avertissement* to the catalogue of his sale: 'It was on this tour that he acquired the liveliest taste for the Flemish & Dutch School. When a picture was known to have a great reputation, he acquired it,

paying like a prince. It is no exaggeration to say that the most precious pictures of Flanders and Holland are to be found in his *Cabinet*. He took M. Remy [the auctioneer]'s advice on all his acquisitions. It was M. Boucher who introduced them' (*Catalogue* of the Randon de Boisset sale, 27 Feb 1777, pp.ix–x; cf. the 'Éloge de M. de Boisset', *Almanach des artistes*, 1777, pp.155–6; quoted in Duvaux 1873, p.ccc).

4. From at least 1777, it was artificially paired with this factitiously enlarged panel of different date, known from the epoch of its arrival in England as 'Le corset rouge'. But whereas both the French and English catalogues called the present painting the *chef d'oeuvre* of Metsu, and it was taken for 700 guineas, 'Le corset rouge' was taken for only 400 guineas.

5. A collector who had profited from the upheavals of the French Revolution to put together a remarkable collection of pictures, primarily 17th-century Netherlandish and Italian, but including a number of Poussins.

6. The dealer Michael Bryan repeated his tactics over the acquisition and disposal of the Italian pictures from the Orléans collection. He persuaded two keen collectors with fortunes from the West Indies, Sir Simon Clarke, 9th Bt (1764–1832), and George Hibbert, MP, to stake him for the acquisition of over 50 of the best pictures at the auction of the Robit collection in Paris. Each then selected those that he most wanted, taking turns; Hibbert took 'Le corset bleu', and Clarke 'Le corset rouge'. All the pictures, together with many from other sources, were exhibited for sale by private treaty at Bryan's gallery and the former premises of the Royal Academy in Pall Mall, over the winter of 1801–2. Those not pre-empted by Clarke and Hibbert or otherwise sold, together with other pictures that they had acquired as a speculation from the Orléans and other collections, were auctioned off at Christie's on 14 and 15 May 1802 (cf. Buchanan 1824, ii, pp.35–72; Brigstocke 1982, pp.292–3, 462, 465, 468; Fredericksen 1988, i, p.12, no.62; p.20, no.111; and p.456).

7. Alfred de Rothschild was the only one of Baron Lionel's sons actively to enlarge upon the share of his father's pictures that he had inherited, although, in the preface to Charles Davis's *Description* of his collection in July 1884, he touchingly said: 'The principal objects, and those which, needless to say, I most prize, I inherited from my dearly beloved father.' His particular predilection was for 18th-century French pictures and furniture, but it was perfectly in keeping with the taste of that period, as of his family, that he should have acquired fine 17th-century Dutch paintings as well. In 1907 he made an *en bloc* purchase of 27 pictures from the 5th Lord Ashburton via Agnew, including another painting by Metsu, of a young woman in a red jacket drawing the bust of a putto. He hung it as a pendant to 'Le corset bleu', under the misappropriated title of 'Le corset rouge', perhaps under the misapprehension that it was that picture. The real 'Corset rouge' had been bought by Nieuwenhuys at the posthumous sale of Sir Simon Clarke, Christie's, 8 and 9 May 1840, 2nd day, lot 104. When John Smith wrote (1842, ix, p.527, no.36), it had been acquired by baron James de Rothschild. Not apparently

recorded since, it has probably passed by descent to baron Edmond de Rothschild. Alfred de Rothschild's so-called 'Corset rouge' was described as hanging as a pendant to the 'Corset bleu' by Mrs Erskine in 1902, and was lot 77 in the Countess of Carnarvon's sale at Christie's on 22 May 1925. It was given to the National Gallery in 1940 by Viscount Rothermere.

8. The bequest to her of 1 Seamore Place and all its contents led to the false assumption that she was the illegitimate daughter of Alfred de Rothschild, who requested 'that she will regard them as heirlooms'. However, after her husband's death and her remarriage in 1923, she sold them off privately through Knoedler's and Duveen, and the remainder at Christie's (sale on 19–22 May 1925).

Catalogue no.66

1. Cf. esp. exh. cat. *Tot lering en vermaak*, Rijksmuseum, Amsterdam, 1976; exh. cat. *Die Sprache der Bilder*, Herzog Anton Ulrich-Museum, Braunschweig, 1978; exh. cat. *Gods, Saints & Heroes: Dutch Painting in the Age of Rembrandt*, National Gallery of Art, Washington, etc., 1980–81.

2. Reynolds 1975, pp.109–10. Despite owning Steen's *Banquet of Antony and Cleopatra*, Reynolds also criticised his forays into history painting: 'Artists … who, though excellent in the lower class of art … attempt grave and great subjects … become perfectly ridiculous' (p.236).

3. Kirschenbaum 1977.

4. There is a painting by Gabriel Metsu in Kassel of *A Young Woman giving Alms to a Boy* (Hofstede de Groot 1907, i, no.109, pp.283–4; cf. Robinson 1974, p.32, fig.45), and another by Nicolas Maes of 1659 of *A Young Woman with her Maid giving Alms to a Boy* (E. Haab-Escher collection, Zurich; Robinson 1974, p.32, fig.46; Sumowski 1983, iii, no.1381). (Both show, as here, a church in the distance, as if to underline the Christian duty of giving.) A signed picture of 1656 by Nicolaes Maes shows *A Man inside the Door of his House giving Alms to a Boy* (Michael Hornstein collection, Montreal; Sumowski 1983, iii, no.1359; Robinson 1974, p.32, fig.47). Somewhat later, Jan van der Heyden even introduced a vignette of the owner of a grand classical country house confronted by a mother with a child on her back begging for alms as he comes out of the pedimented gateway to it (*Architectural Capriccio*, National Gallery of Art, Washington; Wagner 1971, no.151, p.101; Schama 1987, p.573, fig.296). Later still, Matthijs Naiveu showed a beggar-boy being given alms within the threshold of *The Draper's* (1709; Stedelijk Museum 'De Lakenhal', Leyden; cf. exh. cat. *Masters of Seventeenth Century Dutch Genre Painting*, Philadelphia Museum of Art, etc., 1984, no.81).

5. Schama 1987, pp.573–5.

6. The prime painter of purchases inside the outer doorway to the entrance hall was Jacob Ochtervelt (1634–82; cf. Kuretsky 1979, esp. ch.2, pp.34–9). No painter made a similarly distinct genre of doorstep scenes, though they occur in the works of several, particularly Nicolaes Maes. For the door as threshold, see Schama 1987, pp.570ff.

7. Cf. Tawney 1948, pp.122–3, 172, 229–30, 239–51, 260–70. Tawney's over-arching thesis may have been exploded long since, but his evidence on these particular points remains compelling.

8. E.g. Steen's own *Poultry Yard* (1660; Mauritshuis, The Hague), in which the figure of the girl around whom the whole painting revolves is a portrait of either Jacoba Maria van Wassenaer or Bernardina Margriet van Raesfeld (cf. exh. cat. *Art in Seventeenth Century Holland*, National Gallery, 1976, no.105, p.84 and cover); or Emmanuel de Witte's *Fish-market* (c.1661–3; National Gallery), in which the woman with her daughter bargaining for fish is Adriana van Heusden (cf. MacLaren and Brown 1991, pp.489–92, pl.412).

9. Hofstede de Groot 1907, i, no.878, p.241. It is unclear why Hofstede de Groot should have singled out this particular candidate, when there were four Burgomasters at a time in Delft (information from Drs. Shaffers-Bodenhausen, letter of 3 July 1995).

10. Exh. cat. *Art in Seventeenth Century Holland*, National Gallery, 1976, no.103; Moes 1897, i, p.128, no.1112, lists a portrait of — Briel van Welhoeck of 1654, which was auctioned at The Hague on 22 Nov 1886. This may have been the half-length by Anthonie Palamedes of 1654 in the John E. Stillwell sale, Anderson Galleries, New York, 1 Feb 1927, lot 221. (My thanks to Drs. Schaffers-Bodenhausen for this point.)

11. In conversation with the author in 1990. As a variation of the same symbolic use of tulips, he drew my attention to Rubens's 'Four Philosophers' in the Palazzo Pitti, Florence, in which the two blown tulips of the four in the glass vase stand for the two dead members of the group. *Symbolique & botanique: Le sens caché des fleurs dans la peinture au XVIIᵉ siècle* (Trianon de Bagatelle, Paris, 1989) included an *Allegory of Death* attributed to Rachel Ruysch (Musée Jeanne d'Aboville, La Fère), containing a whole bed of blown tulips in a broken urn, along with other symbols of mortality (no.17). *Les vanités dans la peinture au XVIIᵉ siècle* (Petit Palais, Paris, and Musée des Beaux-Arts, Caen, 1990–91) has instances of tulips associated with skulls (fig.1 on p.56, no.F.49 and no.O.1), but tends to suggest that these are an allusion to the vanity of 'tulipomania' (cf. also no.O.23). What may be true is that this specific flower was deliberately chosen as a symbol of loss through death because of its very preciousness.

12. In a letter of 25 March 1611 to Ercole Bianchi, Jan Brueghel the Elder writes of painting a large flowerpiece as a memorial to a dead child (Crivelli 1868, pp.166–7).

13. The *émigré* Delahante was the son-in-law of the harp- and piano-maker, collector and dealer Sébastien Érard, and himself a dealer of great discrimination, who operated in England (still contriving to import pictures from the occupied Continent) during his two decades of exile. With the death of his wife in 1813, and the Restoration of the Bourbons in 1814, he finally acted on his decision to return to France, selling many of his paintings at Phillips's before he went (cf. Buchanan 1824, ii, pp.190–95; Haskell 1979, p.26 n.10; Fredericksen 1993, iii, pt.1, p.70).

Catalogue no.67

1. Cf. Wright 1989, checklist on pp.267–9.
2. Van Eynden 1787, p.133.
3. This is not true: it was Wouwermans's wife who was Catholic, with whom he had run away to Hamburg to marry, while still under age.
4. Ireland 1790, i, pp.114–15.
5. Van Eijnden and van der Willigen 1816, i, pp.404–5.
6. It is not impossible, however, that the head of St Hubert may represent a likeness of Cornelis Catz (1612–71), taken at a younger age than that used by Johannes Visscher for the posthumous engraving of him (Hollstein 1992, p.92, no.128; my thanks to Drs. Schaffers-Bodenhausen for drawing my attention to this).
7. Hofstede de Groot (1909, ii, p.262, no.22) records a panel of this subject that passed through an Amsterdam sale in 1804.
8. Hofstede de Groot 1909, ii, pp.258–61, nos.10–18.
9. Formerly on the art market. Note again the inspiration from a print by Dürer (Duparc 1993, pp.275–6, fig.29).
10. Duparc 1993, pp.278–9, fig.35 and cover.
11. Lugt 1921, p.400, no.2145.
12. Willem II put together one of the more remarkable collections of the 19th century, amounting almost to a representative history of art. Very regrettably, however, the Dutch state was not prepared, and his successor and heirs were unable, to acquire or keep his collection. It was sold at successive auctions to pay off his great debts (Hinterding and Horsch 1989).
13. Mecklenburg is listed by Waagen (1839, p.780) as having a fine collection of Dutch and Flemish pictures. Three of these are now in the Wallace Collection – one of them a *Horse Fair* by Wouwermans of such covetable quality that, on the baron's sudden death in June 1854, while staying in the 4th Marquess of Hertford's *hôtel* in the rue Laffitte, the latter immediately adverted to the likelihood of his pictures coming onto the market, since he had died intestate. Cf. Hertford Mawson 1981, no.44 (letter of 27 June 1854), p.58.

Catalogue no.68

1. Rembrandt's painted self-portraits number 50 or more. According to Naumann (1981, i, p.126), Mieris painted 31 surviving self-portraits. Another thirteen pure self-portraits are known from mentions only (Naumann 1981, ii, pp.214–17, among nos.D.142–D.166). Van Hall (1963, pp.210–14, nos.1–48) lists 45 original self-portraits in various media.
2. Naumann (1981, i, pp.27–8, 126) argues this not only from the two that Mieris painted for Cosimo III's Gallery of Self-portraits (which could be regarded as a special case), but from the fact that the *Self-portrait* that Cosimo had originally wanted was no longer available. Christopher Wright (1982, pp.13–14) makes the point that not a single one of Rembrandt's self-portraits was listed in the inventory taken after his declaration of insolvency in 1656 (but this may be because *all* family portraits were excluded).
3. These last points were first made by Naumann (1978, pp.3–4). The entry in exh. cat.

De Hollandse fijnschilders, 1989, no.17 (which I am most grateful to Anne Rowell for translating for me), by contrast, takes a sceptical view of any attempt to read significance into this self-portrait.
4. As also noted by Naumann (1978, p.4; 1981, i, p.71).
5. For an excellent illustration of this process, see Johann Gumpp's *Self-portrait* of 1646 in the Uffizi (exh. cat. *Painters by Painters*, National Academy of Design, New York, 1988, no.17).
6. Mieris may have known the '*Ariosto*' from the painted, drawn and engraved copies of it that had been made by Sandrart and Reinier van Persijn when it was in Amsterdam between 1636 and 1641 (cf. exh. cat. *Second Sight: Titian and Rembrandt*, National Gallery, 1980). Current opinion favours the very plausible hypothesis that the original is itself a self-portrait. Mieris would certainly have known Rembrandt's *Self-portrait* etching of 1639 (Bartsch, no.21; White and Boon 1969, B21, i, pp.9–10; ii, pl. p.10; Wright 1982, pl.61) and possibly one or more of the self-portraits by Rembrandt's pupils inspired by his painted *Self-portrait* (listed in MacLaren and Brown 1991, p.340).
7. Exh. cat. *Rembrandt: The Master and his Workshop*, National Gallery, 1992, no.3.
8. Exh. cat. *Rembrandt*, 1992, no.49; exh. cat. *Face to Face: Three Centuries of Artists' Self-portraiture*, Walker Art Gallery, Liverpool, 1994–5, no.16.
9. A relationship already pointed out by Naumann (1978, p.4, p.18 n.6; 1981, i, p.71).
10. Yet in the *Self-portrait* of 1676–9 that he painted at Cosimo III's request, to show himself painting, or in the act of 'showing some small work with tiny figures … which would demonstrate both the excellence and the refinement of his art', he appears with a mahlstick and palette before his easel, but with no brushes (Naumann 1981, cat.111, i, pp.125–6; ii, pp.117–18, pl.111; exh. cat. *Painters by Painters*, no.19).
11. But Dou's own mature self-portraits all have much more elaborate settings and paraphernalia than Mieris's (cf. Martin 1913, frontispiece and pls.16–21: not all authentic).
12. Engraved by Abraham Blooteling (Naumann 1978, no.13, pp.27–8, pl.23, fig.18; Hollstein, no.185).
13. It was also the year of his disguised *Self-portrait as a Soldier* formerly in the Gemäldegalerie in Dresden (destroyed in World War II; Naumann 1981, cat.68).
14. As Dürer did in his celebrated *Self-portrait* of 1500 (when he was 28 – the age at which Jesus is supposed to have begun his ministry) in the Alte Pinakothek in Munich.
15. Better known as the marquis de Marigny; not only did he inherit much of the collection of his sister, Mme de Pompadour, but he was a connoisseur and collector in his own right. Her taste in painting, however, was primarily for François Boucher and Carle Van Loo; whereas his was more for Vernet and Greuze, and for the latter's Dutch genre precursors.
16. At this sale de Courmont bought five other pictures (three Dutch, and two 18th-century French, all probably characterised by high finish) and a gilt-bronze firedog. His fine collection of

pictures was sequestrated during the Revolution, but later returned to his widow, who put them up for auction in 1795, the year after he had been guillotined. (The Mieris, however, was not included in the sale.) According to his step-grandson, Edmond de Goncourt, de Courmont was 'one of the great and passionate collectors of the 18th century', to whom 'certain of the fine Dutch pictures of the Louvre' had once belonged (cf. Goncourt 1881, i, p.354, cited by Launay 1991, pp.39, 147 n.2).
17. The second in three generations of remarkable collectors of 'one of the finest collections of paintings and drawing that Holland has ever had' (Lugt 1921, no.2987, pp.559–60). Its prime strengths were Dutch, and above all in drawings, of which it ultimately contained 5,000–6,000 sheets (including a *Self-portrait* drawing by Mieris). These were made accessible every Tuesday evening, and visitors were offered refreshments, or even invited to supper. There were also 89 paintings, exclusively by the best Dutch and Flemish masters.
18. John Walter, chief proprietor of *The Times*, owned a significant collection of primarily Dutch and Flemish pictures, as can be gathered from his loans to the British Institution and then to the Royal Academy. It had evidently been started at Bear Wood by his father, John II Walter (1776–1847), who, it was said, 'has a very well chosen, though not a large, collection of pictures, near Reading' (Sarsfield Taylor 1841, ii, p.406). Its full scope is, however, difficult to establish, since no catalogue was published, and by the time that the remnants were auctioned off by his grandson John IV Walter at Christie's (19 June 1937, lots 79–88), a number of private sales must have taken place, including that of this picture. (His son Arthur Fraser Walter appears previously to have made his own additions to the collection, including that of Lievens's *Magus at a Table* now at Upton House, around 1903.) The house that Robert Kerr rebuilt for John III Walter at Bear Wood between 1865 and 1874, at the astonishing cost of £120,000, included a top-lit picture gallery, as a concourse in the centre of the house, around which all the main rooms were set; for, according to Kerr: 'to attach such a Gallery to the house as a mere show-place, is an idea wanting in that domesticity of motive which ought to pervade everything connected with a private dwelling' (Kerr 1871, p.456, pl.40; quoted by Girouard 1979, p.271, fig.21).

Catalogue no.69

1. R.F. 2132; cf. Demonts 1922, p.164 (as Dordrecht School, probably by Samuel van Hoogstraten or the young Godfried Schalcken). Cf. also Rivière 1919, i, pl.22; Sumowski 1983, iii, no.1363 (as by Nicolaes Maes).
2. Inv.57.199; cf. Sumowski 1983, iii, no.1364.
3. Nicolaes Maes's *The Hurdy-gurdy Player* (Dordrechts Museum) includes a number of boys with broad-rimmed hats like those in the present picture, but it only serves to point up the differences between his more Rembrandt-inspired manner and that of the present artist (Sumowski 1983, iii, no.1360; exh. cat. *De zichtbaere werelt*, Dordrechts Museum, 1992–3, no.63).

4. Letter of 13 April 1937. The Berlin picture (inv.837) was first recorded in the sale of Joseph Sonsot in Brussels (20 July 1739, lot 48) and was later at Sans Souci (Beherman 1988, no.157, pp.250–51). Neither Peter Sutton nor William Robinson (letters of 28 Feb and 4 April 1995) believe the present picture or the other two in the group to be by the same hand as the *Young Boy Fishing*. My thanks to them both for sharing their thoughts with me.

5. For which, cf. Roscam Abbing 1993.

6. Beherman 1988, no.235, pp.37, 323, fig.208a on p.304.

7. The tinctures and charges of the main kite, reading downwards, are: *tierced in fess: gules; argent, charged with a mullet gules; and vert, charged with a mullet argent.* The same arrangement of colours, but without the stars (because it is so distant), can be seen on the furthest kite; the main kite-flyer wears a bottle-green sash of the same hue as the band on the kite, and a collar-bow and cuff-trimmings of a similar red. My thanks to Karen Schaffers-Bodenhausen (letter of 10 May 1995), who has been unable to find either a civic or a personal coat of arms corresponding to this in the heraldic collections of the Centraal Bureau voor Genealogie.

8. He was the fourth in a Ghent dynasty of officials and collectors, whose collection was sufficiently celebrated to be referred to, like that of the Dukes of Sutherland, as a private museum (*Biographie nationale [de Belgique]*, Brussels, xxi, 1911–13, cols.580–87). Unlike the latter, however, it was monotonous in character, being almost exclusively composed of 17th-century Netherlandish pictures. The 250 or so lots in his posthumous sale included no fewer than 58 pictures attributed to Rubens, including *The Miracle of St Benedict* (which he had acquired directly from the dissolved Abbey of Afflighem), 22 Van Dycks – mostly portraits, including that of the *Abbé Scaglia*; nine Rembrandts, including a version of *Christ on Lake Genessaret*; and so on. No fewer than 55 of the pictures were bought by or for British collectors, sixteen of them – unusually – by a woman, a Mme Durray from London, including the present painting.

The sale also included two pictures ascribed to Schalcken: a typical-sounding *Pretty Woman lit by a Candle* (lot 31, bt Tencé, and not identified since; it had purportedly been bought in Paris in 1811; Beherman 1988, p.401, no.225) and a *Portrait of a Little Child in a Bonnet and Ribbons* (lot 53, bt Tardieu) that is so uncharacteristic of Schalcken that it has been doubted, despite the signature. The latter is probably the picture that once belonged to the great connoisseur Vitale Bloch (who does not seem to have doubted it), which last appeared at Christie's, 30 March 1979, lot 125 (Beherman 1988, pp.222–3, no.127). The features of this child, allowing for its still being more of an infant, are not dissimilar to those of the boy in the present group of pictures.

9. Merchant banker (in the family firm), philologist, Tory politician and devout Anglican, Gibbs must have acquired this picture while still an undergraduate at Oxford. He annotated his copy of the sale catalogue (in the RKHD): 'Very pretty but it will fetch more than I like to give for it – *spera que se podria tomar a vente – vrai tableau*'; and – evidently reflecting some transaction with Mme Durray after the sale: 'Bought – *fünf und zwanzig*'. My thanks to Gosem Dullaart for xeroxes of the relevant pages.

Catalogue no.70

1. Portraits and horse-paintings (see cat. no.23) aside, exceptions to this careless condemnation must include a predella panel of *The Annunciation* by an artist close to Lorenzo di Credi, a Vasarian *Holy Family* painted on slate, a *Coriolanus pleaded with by his Womenfolk* by Amigoni, a *David and the Shewbread* by Jan de Bray, a *SS Benedict, Scholastica and Companions* attributable to J.-B. de Champaigne, a set of four *Views of Naples* by Gabriele Ricciardelli, and what may be an autograph version of Batoni's much-repeated *Head of the Virgin*.

2. Chiari probably also painted the *Madonna showing the Christ Child a Cross*, likewise at Calke.

3. At Kedleston, for instance, one of the many versions of a Reni-esque *Flight into Egypt* (of which it is far from certain that there ever was an original by Guido himself) has been ascribed to Chiari ever since the first catalogue of the collection, of 1769.

4. Two such cases have happened not long since with other small paintings of *The Rest on the Flight* by Chiari. One, which enjoyed some celebrity as a Maratta when it was in the Leuchtenberg collection in the 19th century, was sold as such by Christie's (14 Dec 1979, lot 88), and was only identified as a Chiari, by Edgar Peters Bowron, when it was given by Robert Bloch to the Nelson-Atkins Museum in Kansas City (cf. exh. cat. *Baroque Paintings from the Bob Jones University Collection*, North Carolina Museum of Art, Raleigh, 1984, p.46, n.5). Another, which was in the celebrated Miles collection at Leigh Court in Somerset as a Maratta, was exported at some point to South America, and only sold under its correct name by Sotheby Parke Bernet, New York, 9 June 1983, lot 148.

5. Von Freeden 1955, ii, letter 1378, p.1041.

6. Wittkower 1973, p.467.

7. Roughly the same size as the present picture, it was acquired from the estate of Princess Charlotte Amalie in 1783, along with a pendant of the *Adoration of the Shepherds*, both with an ascription to Maratta. Olsen 1961, p.71.

8. Cf. Hager 1964, p.87, fig.23; Sestieri 1994, i, p.125, iii, fig.735; what would appear to be the *modello* for it was auctioned at Sotheby's Monaco, 30 June 1995, lot 28. It is signed in full, which, not unnaturally, led Hermann Voss, who first published the Copenhagen picture, to attribute it to Lorenzo Masucci too (Voss 1924, p.612, pl.369a; still so attributed by Rudolph 1983, no.470, and by Sestieri 1994, i, p.125). With more knowledge of the distinction in execution between generations of *barochetto* artists in Rome, Tony Clark at first reattributed the Copenhagen picture and its pendant to Lorenzo's father, Agostino Masucci (1692–1768), despite the fact that this artist's signed and dated altarpiece of the *Annunciation* of 1748 in the same museum betrays a rather different hand (letter of 15 Feb 1959; cited in Olsen 1961, p.76, pls.LXXVIIIb and a). Upon further reflection, however, he realised that Lorenzo Masucci had not been using a painting by his father as the model for his altarpiece, but one by his father's teacher, Giuseppe Chiari (cf. Kerber 1968, p.82, n.61, quoting an undated letter from Clark). The Copenhagen picture he related in turn to a horizontal *Rest on the Flight* in the Bob Jones University Art Museum, whose traditional ascription to Chiari has rightly never been questioned.

9. Such would appear to be the case with the two small pictures of the *Adoration of the Magi* and the *Birth of the Virgin* at Belton. Although at first sight they would appear to be *modelletti* for Chiari's two earliest recorded autonomous works, the commission he took over from Niccolò Berrettoni for the two altarpieces in the Cappella Marcaccioni in S. Maria del Suffragio in Rome (Schleier 1973), they may in fact be later reductions. They are first listed in the Drawing Room of Tyrconnel's Arlington St house in the 1738 inventory.

10. There are three variant versions of the Bob Jones *Rest on the Flight* that may represent similar instances of Chiari recycling his compositions for the market, but which, from the change towards a blonder tonality and in the character of the Madonna's face, just may be by his pupil, Agostino Masucci. All three are upright: one, reduced to the figures of the Madonna, Christ Child and John the Baptist, without any angels, and with Joseph reading instead of unloading the ass, is at Burghley House, Northants. What would appear to be a copy of this is at Belton. A third, with St Joseph again unloading the ass as in the Bob Jones picture, but with the upper half of the Virgin's body in an altered pose, and a quite different crew of angels, was sold at Phillips, 6 April 1995, lot 205, with an attribution to the 'Circle of Lorenzo Masucci'.

11. Colvin 1985, p.48.

Catalogue no.71

1. Exh. cat. *Chardin*, 1979, p.263, col.1.

2. As C.-N. Cochin *fils* had already noted (Cochin 1780, quoted in exh. cat. cit., p.202, col.2).

3. It is clearly, for instance, a housekeeper who is shown warning the adult lovers in the picture by J.-F. De Troy engraved by Cochin *père* as *La gouvernante fidèle* (Victoria & Albert Museum; cf. Kauffmann 1973, p.276, no.342). The 'false friend' translation – in this context – as 'governess' somewhat undermines Ella Snoep-Rietsma's discussion of the composition (1973, pp.186–8; repr. in Snoep-Rietsma 1975). Some of the critics of the picture in the Salon were, however, under the same impression, since they talked of '*sa gouvernante*' in relation to the boy.

4. It is in keeping with the ambiguity over the exact status of the *gouvernante*, that it is unclear whether this combination of richness with unfashionability expresses the general character of a solid bourgeois interior, or that of the kinds of room to which children and upper servants were relegated.

5. *Description raisonnée des tableaux exposés au Louvre: Lettre à Madame la marquise de S.P.R.,*

9 Sept 1739, quoted in exh. cat. cit., 1979, p.262, col.1.

6. The Goncourts also saw her as a mother, but of the lower middle class (Goncourt 1958, p.128). Mariette 1851/3–59/60 similarly calls the woman in *La bonne éducation* (1749) 'une mère ou gouvernante'; and Count Tessin called the woman in his *La toilette du matin* (which is the feminine counterpart of the present picture) 'En gouvernante', when most critics called her the little girl's mother (Grate 1994, p.93).

7. Lépicié added the following quatrain to his engraving after the Ottawa version, although this will have been his own interpretation, not the artist's:

Malgré le Minois hippocrite
Et l'air soumis de cet Enfant
Je gagerois qu'il prémédite
De retourner à son Volant.

(Despite this child's submissive air
And his hypocritical little look
I'll bet his mind's already there –
Back to playing with his shuttlecock.)

8. Cf. exh. cat. cit., no.83; Rosenberg 1983, no.117A; Conisbee 1986, p.162, col. pl.145 and pl.158.

9. Rosenberg had already suggested at the time of the Chardin exhibition that the present picture, which he knew only from a photograph, but which appeared to him to be 'de qualité plus qu'honorable' (exh. cat. cit., p.262), might be that of the La Roque sale. After seeing it subsequently in the flesh, but before cleaning, he was happy to pronounce it autograph (visit of 18 Sept 1990).

10. See Report C774, dated March 1995, of the analysis carried out by Libby Sheldon of UCL Painting Analysis Ltd. The double ground (grey over red) also conforms with Chardin's practice (cf. Merrill 1981, pp.123–8; cited and confirmed by Joseph Fronek, in 'The Materials and Technique of the Los Angeles *Soap Bubbles*', in Conisbee 1990, pp.23–5).

11. There are at least three autograph versions. Rosenberg (exh. cat. cit., no.80, pp.253–4) has given good grounds for maintaining that the La Roque picture was that signed and dated 1738 now at Schloss Charlottenburg in Berlin, which is recorded as having been bought in Paris in 1746 for Frederick the Great, along with an untraced version of *La ratisseuse*.

La gouvernante was in no way the pendant of *La pourvoyeuse*, which makes it all the less likely that there was a significant difference in perceived quality between the two. The La Roque sale included no fewer than eight other Chardins, six of them in pairs. Two pairs were acquired for Crown Prince Adolphus Frederick of Sweden (Grate 1994, nos.102–5); even in the case of one of these, one painting, *La fontaine*, is on panel, signed and dated (1733), whereas the other, *La blanchisseuse*, is on canvas, and signed, but not dated – suggesting that it too, unlike its pendant, is not the prime version. La Roque was not only the subject of one of Watteau's rare portraits, and a discriminating collector of contemporary French art, but the editor of the *Mercure de France*, which he used to publicise its engraved manifestations in particular.

12. Like the Boucher (cat. no.72), it would appear to have been imported soon after it was painted. It is perhaps significant that all but two of the nineteen sales of paintings (sometimes recurrences of the same pictures) by Chardin in England before 1760 were of genre subjects such as this (Raines 1984, pp.182–3). His quiet still-lifes never found a ready reception here; his understated depictions of middle-class domesticity, by contrast, clearly struck some answering chord. The engraving of *La gouvernante* was even copied in the vignette on a Battersea enamel box (Tuck Collection, Musée du Petit Palais, Paris).

Catalogue no.72

1. Shoolman Slatkin 1976, pp.247–60, pls.1–15.
2. Rosenberg, Slive and ter Kuile 1977, pl.193; for the copy of Abraham Bloemaert's drawing for this figure, the offset in Darmstadt of which bears an early ascription to Subleyras, see exh. cat. *Les collections du comte d'Orsay: Dessins du Musée du Louvre*, Louvre, Cabinet des Dessins, 1983, no.100. From a study by Abraham Bloemaert (or from the engraving of this by Frederick Bloemaert) for the *Pastoral Scene with Tobias*, Boucher was to borrow the figure of the boy standing with a basket, both in his *Capriccio View of the Farnese Gardens* (1734; Metropolitan Museum, New York; exh. cat. *François Boucher*, Metropolitan Museum, New York, etc., 1985–6, no.23), and in the tenth etching of his *Livre d'étude d'après les desseins originaux de Blomart* (Jean-Richard 1978, no.184).
3. What may have been the earliest arrival of all, engraved by Vivarès as *The Handsom Cook Maid*, and published by J. Johnson as a glass engraving entitled *Eggs in Danger*, is now in the Musée Cognacq-Jay in Paris (Burollet 1980, no.10). The advertisement in the April 1735 *Mercure de France* for Aveline's engraving of it states that it had been 'acquired by an English gentleman who has taken it to London'.
4. Ananoff and Wildenstein 1976, no.46; engraved by Jean Pelletier, cf. Jean-Richard 1978, no.1453.
5. Exh. cat. *François Boucher*, nos.10, 11.
6. Voss 1953, p.82, fig.45; Ananoff and Wildenstein 1976, no.50.
7. Voss 1953, p.82, fig.37; Ananoff and Wildenstein 1976, no.72.
8. Voss 1953, p.82, fig.38.
9. De la Ferté 1776, ii, p.657. *La fontaine* was also said to have been painted after Boucher's return from Rome, but only by the catalogue of the fourth sale in which it appeared, that of M. Bourlat de Montredon (Paris, 17 March ff. 1778, lot 15). The catalogue also mistitled it *Bergers à la fontaine*, thus confusing it with a different early painting, engraved by Fessard, rather than by Pelletier.
10. This would at any rate appear to be the explanation of the two sheets of copies of Bloemaert drawings among the three *fonds d'ateliers* of French artists in Rome acquired by the comte d'Orsay and now in the Louvre (cf. exh. cat. cit., 1983, nos.99, 100). The sheet with the figure of the sleeping peasant boy may indeed be, as its offset in Darmstadt is inscribed, by Subleyras; but the sheet with the two figures of seated women has every appearance of being by Natoire. Boucher's copy of the larger of these two figures, inscribed as by 'vateau', was included in a sale of items belonging to descendants of Bouchardon, held at Troyes, 17 May 1987.
11. In 1723 Boucher had won the *premier prix* awarded by the Académie Royale de Peinture et de Sculpture, but the favouritism exercised by the *Surintendant des Bâtiments du Roi*, the duc d'Antin, had deprived him of the three years' study in Rome that normally came with the award.
12. The whole picture was ascribed to Lallemand when it was put up for auction at Brest on 25 Oct 1994, but it looked earlier. Lallemand, who certainly seems to have worked for Boucher when he first arrived in Paris from Dijon, only came in 1744 – too late for Boucher to have been inserting figures such as this into any pictures of his.
13. Last sold at the Hôtel Drouot, Paris, 18 Dec 1991, lot 60, as entirely by Lajoue (cf. Roland Michel 1984, no.P92, p.106, fig.107, also as entirely by Lajoue). The first record of it, however – in an age when figure-painting was given primacy over landscape – is in the Silvestre sale in Paris, 16 Nov ff. 1778, lot 53, when it was wholly ascribed to Boucher: it is identifiable thanks to the little sketch of it by Gabriel de Saint-Aubin in his copy of the catalogue, now in the Bibliothèque de l'Institut, Paris.
14. The lost early painting engraved by Elisabeth Cousinet Lempereur as *Départ de Jacob* (a thoroughly Castiglione subject, albeit only doubtfully the actual pretext of the picture; Jean-Richard 1978, no.1375), and one of c.1735/6, with the mule alone, last recorded with Leonard Koetser in 1954 (Ananoff and Wildenstein 1976, no.54) and engraved with a rocaille surround by Huquier as *Pastorale* (Jean-Richard 1978, no.1089).
15. His name appears to be decipherable, together with the numbers N.13 and H.R.6, on an old label on the back of the picture, one of those with details of attribution and provenance affixed by Elisabeth Cust to the pictures at Belton House, which correspond with the entries in the first manuscript catalogue of the collection drawn up by her in 1805–6 (cf. Russell 1984). Sir Henry Bankes was no relation of the Bankes family at Kingston Lacy, but a City merchant (a member of the Grocers' Company), who became Sheriff of London and was knighted in 1762. He put together a good little collection of pictures, not depending purely upon the London salerooms, but himself making a buying trip to Antwerp in 1754, where his best purchase still at Belton was a head of *Jan van den Wouwer* ('Woverius') very close to Van Dyck. He kept his collection at his villa in Wimbledon. It came to Belton through the marriage of his only daughter, Frances (1756–1847), to Sir Brownlow Cust, 7th Bt, created Baron Brownlow in 1776.

GAZETTEER

Anglesey Abbey (Cambridgeshire)
33

The house and collections are essentially the creation of one man, **Urban Huttleston Broughton, 1st Lord Fairhaven** (1896–1966). He was one of those collectors whose instincts are obsessive, tending to buy things for groups and sets, rather than singly. He also liked his pictures to have an illustrious lineage.

Lord Fairhaven was named after his maternal grandfather, Henry Huttleston Rogers, one of the founders of Standard Oil. His father made a second fortune as a mining and railway engineer in the United States between 1887 and 1912, when he returned to England, settling at Park Close, Englefield Green, near Windsor Castle. While serving in the 1st Life Guards during the First World War and until 1924, Huttleston Broughton was also stationed at Windsor. The experience seems to have encouraged him to begin buying views of the castle in the 1920s. He eventually assembled over 100 paintings, 150 water-colours and drawings, and 500 engravings, recording the development of Windsor over three and a half centuries. The earliest MS catalogue of his collection, produced in 1920, suggests that he began more simply, but in the same documentary fashion, with paintings and prints of the Life Guards. He was painted in his ceremonial Guards uniform, half-length, by Oswald Birley in 1925.

In 1926 Huttleston Broughton and his younger brother Henry bought Anglesey Abbey and had Sidney Parvin restore the former Augustinian priory in a conservative, but opulent, style. On his marriage in 1932, Henry Broughton ceded the house to his brother, who in March 1929 received the peerage intended for their father (d. January 1929). Lord Fairhaven's taste seems to have been formed partly by his mother, to whom he was devoted. In 1923 she had bought Constable's *Embarkation of George IV to open Waterloo Bridge in 1817*, which now forms the centre-piece of the Library, added to the house by Parvin in 1937–8, with elmwood bookshelves cut from the piles of the demolished bridge. Lord Fairhaven had a nostalgic enthusiasm for late 18th- and early 19th-century Britain, the world evoked by the sumptuously bound colour-plate books of that period which fill the Library. In his preface to William Gaunt's and F. Gordon Roe's *Etty and the Nude* (1943), he wrote: 'For too long has everything foreign been praised and sought-after, often to the passing over of our own very fine artists.' His collection of 20 Etty oil studies and sketches hangs in the Library

Corridor. He had a special fondness for landscape painting (of which cat. no.33 is the outstanding example), and also bought works that reflected his passion for racing (Wootton's *Newmarket Heath*) and shooting. After the war, he expanded his horizons to include such Old Masters of the first rank as Cuyp's *St Philip baptising the Eunuch* and the two Altieri Claudes that had once belonged to William Beckford (see cat. no.19), which he bought, along with a third Claude, at the Duke of Kent's posthumous sale in 1947. His taste in 20th-century art was predictably conservative: e.g. Alfred Munnings's study for *The Royal Family returning from Ascot Races*. In 1955–6 Sir Albert Richardson built the two-storey Gallery to display his paintings and silver.

Lord Fairhaven also created one of the most famous 20th-century gardens, on 90 acres of unpromisingly flat Cambridgeshire farmland. Scattered through this is a very interesting collection of sculpture, including the superb set of urns made for Wanstead House in Essex by Scheemakers and Delvaux. He also made the only collection of small bronzes to have come to the Trust.

LIT: Fairhaven Papers, Cambs RO; on the views of Windsor, see Bunt 1949; on garden sculpture, see Roper 1964; Hall 1994[1].

Ascott (Buckinghamshire)
29, 39, 40, 41, 43, 62, 63

Ascott preserves only a fraction of the collection of 119 pictures, primarily Dutch and Flemish 17th-century cabinet pieces, formed by **Baron Lionel de Rothschild** – that inherited by his grandson **Anthony de Rothschild** in 1917. Although small, this is the only portion of Baron Lionel's collection to survive intact, and reflects its original character and quality. Anthony added and bought back a number of primarily British paintings, but is best known for his superb collection of Ming and Kangxi porcelain.

Baron Lionel (1808–79) was the eldest son of Nathan Mayer, who founded the English branch of the Rothschild bank. He had a Continental taste for highly finished Dutch and Flemish cabinet pictures in perfect condition, which was shared by another successful banker, Sir Thomas Baring, 2nd Bt, whose brother Alexander, later 1st Lord Ashburton, also first imported the Hobbema (cat. no.41) to Britain. He seems to have made two substantial purchases *en bloc*: one of a group of Dutch pictures (including two Adriaen van Ostades), from the heir of Charles Heusch in London (in 1854–7), on his own account; the other in partnership with his

French cousin, baron Edmond de Rothschild, of the Dutch collection of Jonkheer Willem van Loon in Amsterdam (in 1878). From the latter came the Ostade shown here (cat. no.62). His finest Italian picture, the 'Fries' *Madonna* (cat. no.43), was bought privately from the future 5th Marquess of Londonderry, but came originally from the collection of the eponymous head of the Austrian banking-house. He also acquired a number of Dutch paintings, including the de Jongh (cat. no.63), privately from the son of George Lucy of Charlecote. Baron Lionel also took up the British practice of buying glamorous British full-length portraits by the great names of the later 18th century: hence Reynolds's *Miss Meyer as 'Hebe'*, and the Gainsborough called *'The Duchess of Richmond'*.

He went to contemporary artists only for portraiture. In 1835 he sat for a small three-quarter-length portrait (National Portrait Gallery) to Moritz Daniel Oppenheim, a painter much employed by the Frankfurt branch of the Rothschild family, as artist, teacher and adviser. Oppenheim also devoted a pair of pictures to the legend of the foundation of the Rothschild family fortunes. In 1841 the newly fashionable Francis Grant painted Lionel and his brothers riding to hounds in the Vale of Aylesbury, where the family built a group of country houses from 1836, and had founded a pack a little before. Lionel kept his pictures at 149 Piccadilly and Gunnersbury Park. In 1882 his collection was divided among his three sons, Nathaniel (created 1st Lord Rothschild), Leopold and Alfred – of whom only the last was a sub-stantial collector in his own right.

Baron Leopold (1845–1917), who had Ascott enlarged and transformed by George Devey in 1874–80, was more interested in the gardens at Ascott and Gunnersbury and in the turf than in pictures, but none the less made a number of purchases, including Stubbs's *Five Mares*, and Boucher's four ovals of *The Arts*.

Ascott and a third of Baron Leopold's pictures passed to his youngest son, **Anthony de Rothschild** (1887–1961), who added or recovered no fewer than three works by Cuyp (including cat. no.29). Stubbs's *Pumpkin* and *Two Horses in a Paddock* came into the collection in 1926 as wedding presents from his uncle, James de Rothschild of Waddesdon. He shared the family fascination with 18th-century British portraiture, buying Gains-borough's *The Hon. Thomas Needham* from Agnew's in 1928, but also acquiring Turner's *Cicero at his Villa at Tusculum* the same year.

Anthony de Rothschild presented Van Dyck's *The Abbé Scaglia adoring the Madonna and Child* to the National Gallery in 1937. He gave Ascott and most of its collections to the National Trust in 1950.

LIT: notebook of Baron Lionel's pictures, 1878–9 (with supplementary notes), and list of division between Nathaniel, Leopold and Alfred, March 1882, Rothschild Archive, N.M. Rothschild & Sons; Lees-Milne 1950, p.257; *Ascott* 1963; Gore 1969, pp.239–40; Hall 1994[2].

Attingham Park (Shropshire)

31, 42

Attingham still preserves the fragments of two separate collections, those of **the 2nd Lord Berwick**, and of his brother, **the 3rd Lord Berwick**, both in part formed in Italy.

Thomas, 2nd Lord Berwick (1770–1832) made the Grand Tour of Italy in 1792–4. His companion on the trip, the Rev. Edward Clarke, also advised on the acquisition of items for Attingham (previously called Tern Hall), which had recently been rebuilt by his father, the 1st Lord Berwick (1745–89). Clarke wrote from Rome in 1792 that the 2nd Baron 'has left me to follow my own taste in painting and sculpture'. Hence the large *Cupid's Wound* (1793) and *Bacchus and Ariadne* (1794) commissioned in Rome from Angelica Kauffman, who also painted a full-length portrait of Berwick in 1794. Robert Fagan's grisailles after or simulating Antique reliefs in the Entrance Hall and Outer Library were probably also commissioned at this time. On his return, Berwick continued to buy pictures through London dealers, paying high prices for Old Masters from the Orléans collection, including a purported Raphael of *St John in the Wilderness*, for 1,500 gns, and Titian's *Rape of Europa* (Isabella Stewart Gardner Museum, Boston), for 700 gns. He also bought a Murillo *Virgin and Child* (Metropolitan Museum, New York) from the collection of the Marqués de Santiago in Madrid for £2,500, and Maso da San Friano's altarpiece of *The Visitation* (Fitzwilliam Museum, Cambridge; on loan to Trinity Hall chapel). Exactly how and when he acquired the Hackerts (see cat. no.31) is unclear. To display his collection, he had a splendid top-lit Picture Gallery added to Attingham by John Nash in 1805–7. In 1810 he admitted to his brother not 'having the resolution to abstain from *Building* and Picture buying'. When the final crash came, it resulted in a sale of 45 major paintings at Phillips in London on 7 June 1825, and a sixteen-day sale of the contents of Attingham, held at the house by John Robins from 30 July 1827, followed by another in July–August 1829. The 2nd Baron spent the rest of his life in retirement in Italy.

The family portraits and nineteen other pictures were retained by William Noel-Hill, the future **3rd Lord Berwick (1773–1842)**. The 3rd Baron assembled a large collection of his own, while serving as Ambassador to the Court of Sardinia in Cagliari and Turin (1808–24), and to the Kingdom of the Two Sicilies in Naples (1824–33). He bought Van Dyck's *Balbi Children* (National Gallery) and

Sebastiano del Piombo's *Cardinal Sauli and Companions* (National Gallery of Art, Washington) from the Balbi sisters, and Salvator Rosa's *Expulsion of the Money-changers* from the Marchese Nicolo Cattaneo Grillo dal Portelle, all in Genoa; and four large altarpieces by Giaquinto (all now in North American collections) and the Orizzontes (cat. no.42), in Naples. A further group of four Hackerts was acquired in Naples in 1827, together with other paintings by French artists based in Italy during the Revolution, such as Simon Denis, Jean-Pierre Péquignot, Pierre-Athanase Chauvin and Jules-César Van Loo, most of which have been unfashionable ever since and so have escaped being sold. The 3rd Baron hung some of these pictures at his own house, Redrice near Andover in Hampshire, until he inherited Attingham on his brother's death.

The Attingham collections were depleted by further sales: at Winstanley's in Liverpool on 29 October 1839, when Luca Giordano's *Dionysius, former Tyrant of Syracuse as a Schoolmaster* (Walker Art Gallery, Liverpool) was separated from its pendant, *The Murder of Archimedes at Syracuse* (still at Attingham); at Christie's on 30 May 1840; and at Phillips on 7 July 1842. Other major pictures, including *The Balbi Children*, seem to have been sold privately, through Samuel Woodburn, with the important library.

William, 6th Lord Berwick (1802–82), who succeeded in 1862, bought pictures to fill the gaps in the Picture Gallery, but was then forced to consign a group of three fine Pynackers (a fourth remains in the Gallery) to Christie's in 1862 and another 55 pictures in 1864. Lesser sales have been held this century. Despite this succession of losses, much still remains, nicely complemented by such Neo-classical works as the *Venus* after Canova and *Caroline Murat, Queen of Naples* in the manner of François Gérard, which were bought in 1926 and 1927 respectively by the 8th Lord Berwick with the encouragement of his wife. Teresa, Lady Berwick brought a further dash of Italian culture to Attingham: her parents, Costanza Mazini and the artist William Hulton, lived in the Palazzo Donà near S. Maria Formosa in Venice and were friends of Sickert, who painted Lady Berwick in 1933 as a *Lady in Blue*.

LIT: Berwick Papers, Shropshire RO; *Attingham*; on Clarke, see Clarke 1824; on Teresa, Lady Berwick, see Waterson 1981, pp.43–68; Lees-Milne 1950, pp.250–52; Gore 1969, p.240; *Attingham Park* 1992, pp.43–55.

Basildon Park (Berkshire)

54

Basildon is unusual among National Trust houses in not being dominated by portraits, having passed by sale through three different families, with periods of neglect between.

During the Victorian and Edwardian eras, it contained a substantial part of one of the most distinguished collections put together in Britain in the second quarter of the 19th century, that of **James Morrison**. This has now completely gone, but has been replaced since 1954 by a very different collection, chiefly of 18th-century Italian pictures, chosen by **Langton, 2nd Baron, and Renée, Lady Iliffe** to suit the Palladian character of the house.

Sir Francis Sykes, Bt (1732–1804), the builder of Basildon, was a nabob who had made a fortune as Resident of Murshidabad. Having returned to England in 1768 and settled near his friend Warren Hastings in Berkshire, he commissioned Carr of York to build the house in 1776. Theodore de Bruyn painted classical insets in grisaille (now gone) in the Dining Room in 1783–4, but most of the principal rooms do not seem to have been completed by Sykes's death. The next two generations succeeded in dissipating his fortune in short order. Sir Francis Sykes, 3rd Bt (1799–1843) was painted c.1837 by Maclise (private collection) descending a staircase in medieval armour and carrying a jousting lance; his wife Henrietta, who also appears in the picture, was successively the mistress of Disraeli and Maclise. Basildon was let from c.1820 and finally sold in 1838.

The purchaser was **James Morrison, MP (1789–1857)**, who had made a fortune from his drapery business. He seems to have started collecting in the 1820s with contemporary British pictures. His first success was Constable's *The Lock* (Thyssen-Bornemisza collection, Madrid), which he bought on the first day of the 1824 RA exhibition against considerable competition. Three years later he acquired Wilkie's *The Confessional* (National Gallery of Scotland, Edinburgh) direct from the artist, and Turner's *Pope's Villa at Twickenham* (exh. 1808) at Lord de Tabley's sale (see cat. no.32).

Morrison's collection was transformed in 1838, when he went into partnership with the dealer William Buchanan to buy the late Edward Gray of Haringey's Dutch pictures *en bloc*. He took for himself Rembrandt's *Hendrickje Stoffels* (National Gallery), Hobbema's *Wooded Landscape* (National Gallery of Scotland), and an Adriaen van Ostade *Tavern Scene*, among others. His two principal French pictures, Claude's *Adoration of the Golden Calf* (Manchester City Art Gallery) and Poussin's *Triumph of Pan* (National Gallery), were both purchased in 1850.

By the 1830s, Morrison already owned Balham Hill, 57 Upper Harley St and one of the surviving pavilions of Fonthill Splendens in Wiltshire, but wanted somewhere larger to display the best of his collections. 'What a casket to enclose pictorial gems!' he exclaimed when he first saw Basildon; and that, after the still uncompleted interior had been remodelled by his friend, the architect J.B. Papworth, is what it became. When Waagen visited in 1857,

Turner's *Thomson's Aeolian Harp* hung in the Staircase Hall. His other modern British pictures were concentrated in the Octagon Drawing Room, four of the grander Old Masters in the Library, and the smaller, primarily Netherlandish, pictures more profusely in the Oak Room.

After Morrison's death in 1857, Basildon passed to his widow, and then to their eldest son, Charles, who introduced some of his father's London pictures. The Morrisons gave up Basildon in 1910, and the picture collection was reunited for the last time at the Grosvenor Gallery in 1914–15. Some items survive at Sudeley Castle in Gloucestershire, but many of the best pieces have been sold in recent years.

Basildon remained largely empty and unloved until 1952, when it was rescued by **Lord and Lady Iliffe**. With the help of the architect Winton Aldridge, they restored the semi-derelict house to Carr's original conception, introducing appropriate old furniture and fittings from the sale of Ashburnham Place in Sussex, and Carr's demolished Panton Hall, Lincs. They also found themselves collecting Italian or italianate pictures of an appropriate scale, primarily of the *Settecento*. These were mostly bought from, or with the advice of, Agnew's and Colnaghi's; the latter was one of the pioneering dealers to promote the taste for paintings and drawings of this period in the Anglo-Saxon world after World War II. The Octagon Drawing Room became an italianate *tribuna* for the Batoni *Apostles* (cat. no.54) and biblical and mythological scenes by Pittoni. Works elsewhere in the house include Charles de la Fosse's *Rinaldo and Armida* and *Rape of Europa*, which were supplied to Montagu House (later the British Museum) in London *c.*1689–90, and Sebastiano Galeotti's *Rebecca at the Well*. Lord Iliffe sat to Graham Sutherland and bought all his preliminary designs and studies for the tapestry of *Christ in Glory* in the new Coventry Cathedral. A selection from the Herbert Art Gallery in Coventry, to which he gave them, has been loaned back to the house.

LIT: Morrison Papers, Lord Margadale collection; on Morrison, see Gatty 1976; on his pictures at Basildon, see Waagen 1854, iii, p.134, and 1857, pp.300–12; on his Upper Harley St pictures, see Waagen 1854, ii, pp.260–63, and 1857, pp.105–13; exh. cat. *Pictures from Basildon Park*, Grosvenor Gallery, 1914–15; *sale*: (at the house) 26 Oct ff. 1920.

Belton House (Lincolnshire)
6, 17, 72

Belton today contains a large and distinguished group of family portraits, the best dating from the late 17th century. It has also been home, in whole or part, to three important collections of Old Masters, made by **Viscount Tyrconnel**, **Sir Henry Bankes** and **Sir Abraham Hume** (the last two through

inheritance). However, only remnants of these survive at Belton.

The inventory of 'Young' Sir John Brownlow 3rd Bt's (1659–97) new house made in 1688 lists 175 pictures, chiefly family portraits, but including 'Eight and Twentie pictures of Kings and Queens' in the Marble Hall. The Brownlows sat to most of the leading late 17th-century painters – Lely, Wissing, Riley and Closterman, Tilson, and Kneller (cat. no.6) – often for full-length portraits, a set of which is now incorporated into the panelling in the Saloon.

Apart from commissioning *The Belton Conversation-piece* (cat. no.17) from Mercier, **Viscount Tyrconnel** (1690–1754) collected pictures in a somewhat haphazard fashion. His taste does not seem to have been particularly enterprising, but is probably very representative of what it was possible to acquire in the early 18th century from 'Picture Marchants in London' (who included a Count Viani): a miscellaneous mixture of Dutch, Flemish and Italian flower-pieces, views, and religious and historical painting. Two of the most interesting to remain at Belton are Chiari's *ricordi* of his two early altarpieces in S. Maria del Suffragio in Rome (see cat. no.70). Many are distinguished by fine English 18th-century gilt carved-wood frames. In a way that was characteristic of the time, however, the Old Masters formed the bulk of the 152 pictures that are recorded as having hung in Tyrconnel's London home in 1738, whereas the 196 pictures recorded at Belton in 1737 chiefly comprised family portraits, most of which had been inherited. The London pictures were inventoried again on his death in 1754, after which they were moved to Belton by his sister and heir, Anne, Lady Cust. She had considered commissioning an ambitious conversation-piece of her family from Hogarth in 1741, but settled for the cheaper Enoch Seeman.

In 1774 Frances, Lady Brownlow inherited the collection of primarily French and Flemish paintings made by her father, **Sir Henry Bankes** (1714–74), a London merchant who seems to have bought a number of them while travelling in Flanders in 1754, but otherwise at London auctions. The finest of the latter now at Belton is Boucher's *La vie champêtre* (cat. no.72), bought in 1756.

The last and best collection to come to the family was that of the 1st Earl Brownlow's father-in-law, **Sir Abraham Hume** (1749–1838). Through Hume, who had married the sister of the last two Earls of Bridgewater, the Brownlows also inherited Ashridge Park, Herts (where most of his pictures were kept), but not the matchless Old Master collection of the last Duke of Bridgewater, which went to the Leveson-Gowers. Hume was a founder-subscriber and director of the British Institution, set up in 1806, and a friend of Reynolds, who painted him three times and left him whichever of his Claudes he wanted. He published the first serious study of Titian,

anonymously in 1829, and was also an occasional artist. As a result, he had a particular taste for oil sketches. Hume bought Italian pictures chiefly, at first through the dealer Robert Patoun and then through the Venice-based dealer Giovanni Maria Sasso: in 1786 Giovanni Bellini's *Portrait of a Condottiere* (sold in 1923; National Gallery of Art, Washington); in 1787 the *Madonna and Child* attributed to Fra Bartolomeo (still at Belton). In 1799 he acquired Titian's *Death of Actaeon* (sold in 1919; National Gallery). His Northern pictures were fewer, but equally distinguished, including Rembrandt's *Aristotle contemplating the Bust of Homer* (sold in 1893; Metropolitan Museum, New York), and a whole group of Cuyps, including *The Maas at Dordrecht* (National Gallery of Art, Washington).

The 3rd Earl Brownlow commissioned Leighton's soulful full-length portrait of his wife Adelaide, who bequeathed to the National Gallery a fragment of Pesellino's dismembered Pistoia altarpiece on her death in 1917; Lord Brownlow had been a trustee since 1897. He also acquired the remarkable ensemble of huge paintings by Melchior d'Hondecoeter, all but one of which have survived in the Dining Room at Belton, despite the sales of many of the best paintings from there and Ashridge in 1923 and 1929.

LIT: Brownlow Papers, Lincs RO; the Hon. Elizabeth Cust compiled a MS catalogue in 1805–6 (with revisions and additions up to 1851) and fixed labels with inventory numbers and details of attribution and provenance to the backs of the pictures then in the house; for Hume's collection, see MS catalogue in the National Art Library, Hume 1824, Waagen 1838, ii, pp.201 ff., Waagen 1854, ii, pp.313–16, and Sutton 1982, pp.396–8; on the Hondecoeters, see Laing 1991[2]; *Belton* 1992, pp.36–40; *sales*: Christie's, 4 May 1923, lots 1–187; Christie's, 3 May 1929, lots 1–27; Christie's, 30 April–2 May 1984, lots 540–729 (with essay by Francis Russell on collection).

Calke Abbey (Derbyshire)
23, 70

Although the Harpurs were among the richest families in Derbyshire in the 18th century, and the 5th, 6th and 7th baronets made the Grand Tour, the family's enthusiasm for paintings, with which the house is densely hung, outran its taste. Those that they (and in particular **Sir Harry Harpur, 6th Bt**) commissioned were primarily of Calke and its inhabitants, both human and animal. When they bought, they seem to have done so cheaply and locally, with the possible exception of **Sir Henry Harpur Crewe, 7th Bt**. None the less, Calke contains a surprising number of interesting pictures.

Sir John Harpur, 4th Bt (1680–1741), the builder of the house, commissioned several portraits of his immediate family, including

the two double portraits of his children by Charles D'Agar and John Verelst. The marriage of Sir Henry Harpur, 5th Bt (1708–48), to Lady Caroline Manners, daughter of the 2nd Duke of Rutland, brought portraits of her relatives into the house. In the same way, the Greville relations of the 6th Baronet's wife, Frances, are commemorated in a number of portraits in the Drawing Room. Tilly Kettle's superb full-length portrait of Lady Frances and her son Henry (the future 'isolated baronet'), painted c.1766, occupies pride of place over the chimneypiece in the Saloon, which contains family and other portraits spanning the period from 1669 to 1828.

Sir Harry Harpur, 6th Bt (1739–89), began Calke's fine collection of animal pictures, commissioning portraits of four of his most successful racehorses from Gilpin in 1774 (cat. no.23), and employing Sartorius. While staying at the Black Bear (now Bear Hotel) in Devizes in the 1770s, he was taken with the drawing skills of the innkeeper's son, the young Thomas Lawrence. He commissioned pastel portraits of himself and his son (still at Calke) and offered to pay for the boy to study painting in Italy, an offer turned down by Lawrence senior. Ricciardelli's four panoramic views of Naples and its environs (dated 1747) are said to have been bought by Sir Henry Harpur Crewe, 7th Bt (1763–1819), who may also have bought Madonnas by Batoni and Chiari, and cat. no.70, when in Italy in the mid-1770s.

The bulk of the collection was put together in the early 19th century by Sir George Harpur Crewe, 8th Bt (1795–1844), who bought more animal pictures by Landseer and John Ferneley senior, together with a few Old Masters, mainly Dutch or would-be Dutch 17th-century pieces. Sir John Harpur Crewe, 9th Bt (1824–86), commissioned the most important and largest animal picture in the house, Ferneley's *Council of Horses* (1850), which is set in the ancient Calke Park. The collection remains very much as hung by Sir John in the late 19th century.

LIT: Harpur-Crewe Papers, Derbys RO; Isabel Crewe compiled a MS list of the pictures in 1883; Colvin 1985; *Calke Abbey* 1989, pp.28–31; on the horse pictures, see Wills 1989; *sale*: Christie's, 1929 (but unsold and returned to the house).

Cliveden (Buckinghamshire)
18

Cliveden has belonged at various periods to four great collecting families, the **Buckinghams, Sutherlands, Westminsters** and **Astors.** But as a Thames-side villa, it was always a secondary residence, and so never seems to have housed their picture collections. Successive changes of ownership and two fires have disturbed the important accumulation of garden sculpture much less.

George, 2nd Duke of Buckingham (1628–87), builder of the first house, was the son of one of the outstanding early 17th-century virtuosi, who had rapidly filled York House with a spectacular collection of 16th-century Venetian paintings, and also owned the Elsheimers (cat. no.59). The 2nd Duke was painted as a child by Van Dyck (Royal Collection) and as an adult by J. M. Wright (1669; private collection) and Peter Lely (c.1675; National Portrait Gallery), among others. The next owner, the 1st Earl of Orkney (1666–1737), modernised the garden and the house, but we know frustratingly little about how he or Frederick, Prince of Wales (1707–51; tenant, 1737–51) furnished it. Whatever pictures they may have left behind would have been destroyed in the fire of 1795.

Sir George Warrender, 4th Bt (1782–1849), who bought Cliveden in 1824 and rebuilt it, owned an eclectic group of pictures, including Chardin's *La gouvernante* (cat. no.71), but his chief interest in life was food. **George, 2nd Duke of Sutherland** (1786–1861) bought and, after the fire of 1849, rebuilt the house, but seems always to have kept his best pictures at Stafford House in London and Trentham Hall in Staffordshire. The pictures he hung here were largely by contemporary artists, to judge from a list of those removed on the Duchess's death in 1868 (Staffs RO, D593 R/3/2/9/14). They included F.-X. Winterhalter's full-length of her (1849; Dunrobin Castle, Sutherland) and sixteen views of Italy commissioned from William Leighton Leitch, which hung on the stairs. The ceiling above was decorated by A.L. Hervieu with portraits of the Duchess's children as the Seasons, almost the only element of her decorative schemes to survive in the house. The Duke introduced some important sculpture to the grounds, including Thorvaldsen's *Mercury and Argus* (1818) and Princess Marie d'Orléans's *Joan of Arc* (c.1838). The Duchess's son-in-law and successor at Cliveden, **Hugh Lupus, 1st Duke of Westminster** (1825–99), owned another outstanding collection, which was primarily kept in specially designed galleries at Grosvenor House in London.

William Waldorf, 1st Viscount Astor (1848–1919) embellished Cliveden with classical sarcophagi and other sculpture from Italy (the huge bronze group of *The Rape of Proserpina* attributed to Vincenzo de' Rossi) and France (two *Nymphes de Diane* from Marly). He also commissioned two neo-Baroque fountains from Thomas Waldo Story. The small picture collection consisted mainly of portraits of former inhabitants (hence cat. no.18). He was painted by Hubert von Herkomer, and his daughter-in-law, Nancy Astor, in a delicious three-quarter-length painted by J.S. Sargent in 1908.

LIT: Sutherland Papers, Staffs RO; Gore 1969, pp.242–3; Boström 1990; Boström 1991; *Cliveden* 1994; Crathorne 1995.

Dunham Massey (Cheshire)
16, 48

This collection consists primarily of portraits, of the Booths, the Greys and their animals, together with an unusual series of bird's-eye views of the house and park. The **4th, 5th and 6th Earls of Stamford** were the principal collectors, acquiring important contemporary Grand Tour pictures in the late 18th century. The Guercino (cat. no.48) is a rare surviving Old Master; there are copies of Titian's *Vendramin Family* (by Francis Harding) and Rubens's *Apollo expelling the Forces of Darkness*, and a very early one of Holbein's *Duchess of Milan*.

The Booths played a leading part in the upheavals of the Civil War and Commonwealth, and many of the protagonists of the period are depicted – a number in copies after Van Dyck. Sir George Booth, 1st Baron Delamer (1622–84) sat to Lely (version at Dunham; original in the Bodleian Library, Oxford), and the south front he added to the Tudor house is recorded in a bird's-eye view by Adriaen Van Diest (dated 1697). His son, Henry, 1st Earl of Warrington (1651–94), neglected the house and its collection, being lucky to survive implication in conspiracies against Charles II and James II. His most important addition was a portrait of himself, three-quarter-length in armour, by Kneller.

George, 2nd Earl of Warrington (1675–1758) was the first serious collector in the family, but his real passions were for walnut and mahogany furniture and for silver by the finest early 18th-century Huguenot goldsmiths. He began the tradition of commissioning portraits of the family's dogs with Jan Wyck's '*Old Vertue*' (cat. no.16), painted around 1700. He also remodelled the Tudor long gallery, which became the Great Gallery, but it seems never to have been used as a showplace for important paintings. Pictures from his collection are distinguished by early 18th-century black and gold frames similar to earlier ones in the Royal and Spencer collections. Dahl painted the 2nd Earl with his daughter and heir, Mary (1704–72).

Lady Mary's husband, **Harry Grey, 4th Earl of Stamford** (1715–68), sat to Reynolds, perhaps in 1756, and is recorded as buying Italian pictures (which may have included cat. no.48) in 1758. However, he spent most of his life at Enville Hall, the Greys' historic Staffordshire seat, leaving his wife to manage Dunham. So it was probably she who commissioned John Harris to paint four views of Dunham c.1750. Around this date Harris also painted three views of the Peak District, two of which remain in the house. The two portraits of *A Great Dane Called 'Turpin'* by Thomas Stringer, a local Knutsford painter, date from 1778, when he was also paid for restoring pictures in the collection.

George, Lord Grey of Groby, later 5th Earl of Stamford (1737–1819), was painted as a Cambridge MA by Francis Cotes c.1758, and

later by West and Romney. The 5th Earl and his friend and neighbour, Sir Henry Mainwaring, 4th Bt, then made the Grand Tour of Italy, sitting to Mengs (in Rome in 1760) and Batoni respectively. They each commissioned a major picture of *Aeneas and Achates* from Nathaniel Dance (Tate Gallery; and Mere Hall sale, Christie's, 1994). Dance also painted a double portrait of the pair, a miniature copy of which, by Mengs's sister, is at Dunham. Their amusements were commemorated more informally by Thomas Patch in his earliest caricatures of Anglo-Florentine society – *A Punch Party* (dated 1760) and *Antiquaries at Pola*. A set of seven small anonymous watercolours record the 5th Earl's landscaping of the park at Dunham in the late 18th century.

George, 6th Earl of Stamford (1765–1845) made the Grand Tour in 1788, and also returned with pictures, most notably three watercolours by Ducros, which he bought in Rome. Two years later he was painted full-length by Romney, who had earlier painted a pair of smaller portraits of his parents.

The 9th Earl and Countess of Stamford rehung the collection as part of their substantial Edwardian redecoration of the house, which was undertaken with the advice of the furniture historian Percy Macquoid. Many of the Grey portraits now at Dunham were hung at Enville during the 19th century. They were bought back for the house by the 10th Earl of Stamford at the Foley-Grey sales of 1928 and 1931, and subsequently.

LIT: Stamford Papers, John Rylands Library, University of Manchester (regular inventories from 1769); on the Grand Tour pictures, see Gore 1978; on the bird's-eye views, see Harris 1978[1]; on the animal pictures, see Laing 1990; *Dunham Massey* 1981, pp.48–63.

Dyrham Park (Gloucestershire)
53

The bulk and the best of the pictures are Dutch or Flemish and date from the later 17th century. Most were introduced by **William I Blathwayt**, the builder of the house (between 1692 and 1704), many of them having initially been acquired by his uncle, **Thomas Povey**. These pictures underline the essentially unchanged 'Dutch William' character of Dyrham, with its blue-and-white Delftware, architectural panelling, Flemish verdure tapestries and leather hangings.

When George Vertue's brother visited Dyrham in 1745, he singled out the allegorical portrait of *Elizabeth I and Death* (now Corsham Court, Wilts). How this reached the house is not clear, but now almost nothing of Tudor Dyrham survives. Indeed there is little from before 1688, when **William I Blathwayt (?1649–1717)** came into Dyrham through his wife, Mary Wynter (1650–91), who was painted by Michael Dahl. This picture now hangs in the Great Hall, with most of the

family portraits, including another by Dahl of her husband.

Blathwayt's uncle, **Thomas Povey (?1618–?1700)**, who sat to John Michael Wright in 1658, was Treasurer to the Duke of York in 1660 and much involved in trade with the colonies. Pepys ridiculed his muddle-headedness, but enjoyed his hospitality, commenting particularly on his illusionistic murals and paintings by Robert Streater and Samuel van Hoogstraten. Two such views by the latter now at Dyrham, of an arcaded courtyard and down a corridor (dated 1662), almost certainly came from Povey's collection. In 1693 Blathwayt ('a very proper handsome person, and very dextrous in buisinesse', according to Evelyn) bought 112 pictures from his uncle to furnish his rising house, including William Shepherd's portrait of the playwright *William Killigrew* (dated 1650). In the same year he also purchased eighteen paintings from the Antwerp artist Jan Siberechts, including the *Façade of the Jesuit Church at Antwerp*, attributed to Anton Gheringh, two harbour scenes by Hendrik van Minderhout and two animal hunts by or after Snyders. Among the other Dutch pictures is an unusually large group of fowl-pieces by Hondecoeter and his imitators, and landscapes and flower-pieces by lesser 17th-century artists, many in their original plain black frames, some serving as overdoors or overmantels. The Murillo (cat. no.53) stands apart, both for its quality and as the sole surviving member of a trio of pictures by or after this artist once in the collection.

In 1704 Blathwayt's young sons, William II and John (a musical prodigy, who had already been painted by William Sonmans in 1702; Music Faculty, Oxford), set out on the Grand Tour with a Huguenot tutor, M. Patron de Blainville, who kept an extensive journal of their travels (published in part, in English translation, in 1743–5; his surviving letters to their father and their accounts in 1985). In Rome in 1707 the brothers were painted by the painter-dealer Edward Gouge.

William III Blathwayt was forced by his creditors to put part of the collection up for sale at the house in 1765, but he or his relatives seem to have bought in a fair amount of it. The last major addition to the collection was made by Col. George Blathwayt in 1845: five large canvases, which had been painted by Andrea Casali for Fonthill Splendens in Wiltshire, and were bought from the Theatre Royal, Bath, to set into the ceilings of the Great Hall and the two principal staircases. A Hobbema was sold in 1901 and more of William I Blathwayt's pictures in 1956. To make up for these losses, Dutch pictures bequeathed to the Trust by Joan Evans and Helen Lowenthal have been introduced.

LIT: Blathwayt Papers, Glos RO; the 1710 inventory is published in Walton 1986; for the Blathwayt brothers' Grand Tour, see de Blainville 1743–5 and Ford 1975–6; Gore 1969, pp.243–4.

Erddig (Clwyd)
25

The family historian, Albinia Cust, concluded, rightly: 'The Squires of Erddig were not Art collectors in the strict meaning of the term.' Apart from the famous series of servant portraits begun for **Philip I Yorke** (for details of which, see cat. no.25), they commissioned little, and the best of the non-portrait works came by inheritance. They were, however, obstinate in hanging on to their possessions.

Joshua Edisbury, the builder of the house in 1683, had little left to spend on pictures, and whatever he may have bought was dispersed with his bankruptcy. His successor, John Meller, commissioned *trompe-l'oeil* architectural views from Sir James Thornhill for the garden of his London house *c*.1712. There is a plan dated 10 July 1721 for hanging pictures at Erddig (Clwyd RO, D/E/279), but the inventory of 1726 (D/E/280) reveals that there were few in the house at this date, and certainly nothing to match Meller's superb furniture. When John Loveday visited in 1732, he noted 'an excellent picture of yᵉ Virgin & Babe', 'a good Picture of a jocose Frier' and 'Above Stairs a Gallery hung wᵗʰ yᵉ Sibylls, all lengths [twelve in all, sold by Philip I in 1787, because wrecks]'.

In 1770 **Philip I Yorke (1743–1804)** inherited from his uncle, James Hutton, a small collection, which included a Snyders studio still-life and other 17th-century, mainly Flemish, landscapes and flower-pieces. The collection seems to have been formed by James's father, Matthew Hutton, and had hung previously in his London house in Park Lane. Philip I probably acquired a number of the other Old Masters in the Drawing Room.

Around the time of his marriage in 1770 Philip I commissioned a portrait of his first wife, Elizabeth, from Francis Cotes. In 1780 he sat to Gainsborough, who was also paid 5 guineas for 'new dressing' an earlier portrait of Meller. He also commissioned the first of the servant portraits, from a Denbigh artist, John Walters, between 1791 and 1796. The full-lengths by Kneller and another hand of *Judge Jeffreys* and his brother came from Acton Park, Wrexham.

Simon II Yorke had the paintings cleaned and revarnished around 1820 (undated list, D/E/288) and had engravings made of some of the earlier family portraits, but added little to the collection of significance beyond more servant portraits. Further inventories made in 1835 (D/E/293), 1894 (D/E/2328) and 1922 (D/E/313) tell a similar story of little change.

LIT: Yorke Papers, Clwyd RO (catalogued in 4 vols); apart from the inventories noted above, there are a picture list (undated, but after 1905; D/E/2331), TS notes on the portraits in the Gallery by E.E. Cope (1910; D/E/310), and an incomplete TS list (1917; D/E/312); Cust 1914; for the portraits, see Steegman 1957, pp.94–8; on the servant portraits in particular, see Waterson 1980, *passim*; *Erddig* 1995.

Felbrigg Hall (Norfolk)
57

The Windhams and their successors at Felbrigg are represented in an extensive line of family portraits, which include a good late 17th-century group. The most important collector in the family was **William II Windham**, whose Grand Tour acquisitions in the mid-18th century still hang very much as he intended in the Drawing Room and Cabinet – a precious survival. They consist primarily of 18th-century Italian landscapes and Dutch 17th-century marines.

In October 1688 William I Windham (1647–89) paid two shillings 'for lyne to hang the piktures in the new parlour [now Drawing Room]' in the west wing he had just added to the house built by his grandfather, Sir John Wyndham, in 1621–4. He and his wife Katherine Ashe both sat to Lely, who also painted her father and sister. Their son and heir Ashe Windham and his fiancée Hester Buckworth were painted by Kneller.

William II Windham (1717–61) was a man of many talents: linguist, mathematician, wood-turner, bookbinder, draughtsman, collector. In 1738–42 he made the Grand Tour with his tutor Benjamin Stillingfleet and lived in Geneva with a group of like-minded and high-spirited friends nicknamed 'the Common Room'. He was painted in his youth in pastel by Barthélemy du Pan, in a charmingly relaxed double portrait c.1745 by Francis Hayman with his great friend David Garrick (private collection), and full-length, as a hussar, apparently by another friend, the gentleman-painter James 'Count' Dagnia. In the 1750s he had James Paine transform his grandfather's west wing to display the pictures he had bought and commissioned during his Grand Tour. The Drawing Room still contains the cream of his marine pictures, including the large pair of *The Battle of the Texel* by the Van de Veldes, facing Samuel Scott's two views of the Thames. Four 'Landskips by [Jean-Baptiste L']Allemand' were listed in this room in 1764, of which three remain in the house. The adjoining Cabinet, the climax of the suite, is principally hung with landscapes (including cat. no.57), notably six large oils and 26 smaller gouaches of classical sites in and around Rome by Giovanni Battista Busiri, but also two pairs of classicising oils by J. B. Huysmans and Johannes Glauber, as well as another large marine, by Simon de Vlieger, and a miscellany of flower-pieces and genre pictures. The arrangement follows diagrams he had himself drawn up, which are still preserved among the archives – the earliest such surviving hang to be documented in this way. He gave the pictures in these two rooms their own distinct patterns of Rococo gilt frame, probably carved by the Huguenot René Duffour of Soho, who may also have modelled the papier-mâché frames on other pictures in the house. The 17th-century portraits of William II's parents and grandparents were concentrated in the new Dining Room, the oval overdoors being placed within elaborate fixed plaster frames by Joseph Rose the Elder. The chimneypiece is flanked by bronzed plaster busts on brackets of classical worthies by John Cheere; Paine devised a similar arrangement for the Stair Hall.

William III Windham (1750–1810) devoted his life to national politics, and made few changes to Felbrigg or its collections. His secretary, the future landscape gardener Humphry Repton, sketched him at the outset of his career, delivering the Norfolk Petition in 1778. He was painted in oils in 1788 by Reynolds – a portrait (now in the National Portrait Gallery) which he exchanged for one by the same artist of his closest friend George Cholmondeley; he also sat in 1803 to Lawrence (a good copy by Jackson in the Drawing Room). William III's adoptive heir, né William Lukin, appears in a delightful conversation-piece with his brothers about to set out from Felbrigg Parsonage for a day's shooting, painted in 1803 by William Redmore Bigg. On an extended visit to Belgium in 1820–21 Vice-Admiral Lukin bought marine pictures by Abraham Storck and Ludolf Bakhuysen, which were further to enrich Felbrigg's collection of marines, when he finally moved into the house in 1824. In 1842 his son, William Howe Wyndham, remodelled the Great Hall in neo-Jacobean style, at the same time introducing a good group of Neo-classical marble busts and bronzes after the Antique. He may also have acquired 'The Headless Lady', a fragment of a 4th-century BC Athenian grave monument.

Despite the bankruptcy of 'Mad Windham', the subsequent sale of the house in 1863 to John Ketton, and the negligence of his son Robert Ketton in the early 20th century, little of importance was lost. The portraits on the stairs came from Beeston Regis, the Norfolk seat of the Cremer family, in 1924, when Wyndham Cremer Cremer inherited Felbrigg from his uncle. They appear to derive from several sources and to depict members of the interrelated Cremer, Green and Woodrow families. Wyndham Cremer's eldest surviving son, **Robert Wyndham Ketton-Cremer (1906–69)**, set himself the task of saving Felbrigg: to raise much-needed funds, he was obliged to sell one of the Van de Veldes to the National Maritime Museum in 1934 (now kindly returned on loan). His history of Felbrigg has become a classic, and he also wrote a pioneering life of Horace Walpole, and elegant essays on Norfolk personalities.

LIT: Windham Papers, Norfolk RO (damaged by fire in 1994); the picture diagrams of the Cabinet remain in the house; on Felbrigg, see Ketton-Cremer 1962 and *Felbrigg Hall* 1980 and 1995; on William II Windham's foreign acquisitions, see Moore 1985, pp.40–47, 122–32; on the Cabinet, see Hawcroft 1958; on the Dutch and Flemish pictures, see Moore 1988, pp.103–6; on the marine pictures, see Waterson 1986[1] and 1986[2].

Ickworth (Suffolk)
8, 20, 50

The Herveys were a family of diarists. Appropriately, therefore, their surviving collection at Ickworth consists almost entirely of portraits. The Velázquez (cat. no.50), and the 18th-century (e.g. cat. nos.8 and 20) and early 19th-century English examples, commissioned between the times of **John, 1st Earl of Bristol** and **Frederick, 1st Marquess of Bristol**, are of the highest quality. Little, if anything, of the various collections of Old Masters, contemporary painting and sculpture assembled by **Frederick, 4th Earl of Bristol** ever reached the house.

The earliest family portrait, dated 1564, is of *Francis Hervey* (d.1602) in his uniform as one of Elizabeth I's Band of Gentlemen Pensioners, but the collection really begins with **John, 1st Earl of Bristol (1665–1751)**. In the 1730s he patronised a local Bury St Edmunds artist, John Fayram, but in 1742 he sat to the fashionable visitor, Jean-Baptiste Van Loo. Van Loo had painted his eldest surviving son, the courtier, politician and memoir-writer **John, Lord Hervey (1696–1743)**, in the previous year, full-length and holding his purse of office as Lord Privy Seal. Lord Hervey had also had himself sculpted in Rome in 1729 (terracotta, and marble copy at Ickworth; original marble at Melbury). A more unusual portrayal of him is in Hogarth's *Hervey Conversation-piece* (cat. no.20), which celebrates Hervey's and the Foxes' circle of friends in relaxed, but enigmatic, fashion. The *Classical Landscape* by Gaspard Dughet was engraved as in his collection in 1741. Zoffany painted the small full-length of his eldest son, the delicate George, 2nd Earl of Bristol (1721–75), as Lord Keeper of the Privy Seal, between 1768 and 1770, and ovals of his younger sons William and Frederick (later 4th Earl) as Royal Chaplain, as well as some of the set of paintings of his four daughters. The curious conversation-piece of *Captain Augustus Hervey (later 3rd Earl of Bristol) Home from the Sea* was commissioned by Lady Hervey when the family was in Paris in 1750, from Gravelot and Liotard, but was subsequently finished by other hands. Around 1767 the future 3rd Earl was painted again, by Gainsborough (cat. no.8), who also depicted his illegitimate son (in a small octagonal canvas), and his nephew, *John Augustus, Lord Hervey* (life-size full-length).

The 'Earl-Bishop' – **Frederick, 4th Earl of Bristol and Bishop of Derry (1730–1803)** – was a capricious eccentric and obsessive traveller, and by far the most ambitious collector in the family. He formed his collection primarily in Italy, professing to desire 'to have few pictures but choice ones', but in fact buying and commissioning indiscriminately. In the 1790s, possibly under German influence, through his liaison with the King of Prussia's mistress, Countess von Lichtenau, he conceived the idea of

shaping his collection on historical lines. He wrote to his daughter, Lady Elizabeth Foster, in 1796: 'What say you to my idea of a gallery of German painters from Albert Dürer to Angelica Kauffmann, and [Italian painters] from Cimabué to Pompeio Battoni, each divided by pillasters into their respective schools – Venetian for colouring, Bologna for composition, Florence for designs, Rome for sentiment, & Naples for nothing at all?' Although he was ahead of his time in buying 'primitives', he later referred to them as 'all that old pedantry of painting'.

The Earl-Bishop was a liberal but erratic patron of contemporary artists in Rome and Naples, sitting to Angelica Kauffman, Batoni, Hugh Douglas Hamilton and Mme Vigée-le Brun, whose self-portrait is also at Ickworth. He also commissioned landscapes from Thomas Jones, Philip Hackert and Jacob More, and history pictures from Benvenuti, Cammuccini, Guy Head, F.-X. Fabre and others. In sculpture, the gigantic marble *Fury of Athamas* was commissioned in 1790 from Flaxman, who gratefully noted that the Earl-Bishop had 'reanimated the fainting body of Art in Rome', but also that he had barely recovered his own outlay on the marble. When the Earl-Bishop was arrested by the invading French forces and his collections were confiscated in 1798, 343 artists signed a petition for their return. This was done, but after his death, parts were taken in settlement of his debts and others auctioned off in Rome.

The Earl-Bishop's three chief houses were all designed specifically to display his collections. His first favourite was his '*Tusculum*', Downhill in Co. Londonderry (begun c.1775; burnt out in 1851), where the cream of the collection was concentrated in the gallery in the west wing and in the library beyond. Only the Mussenden Temple (NT) survives, a rotunda built in honour of a cousin, Frideswide Mussenden, with whom he was in love. Ballyscullion, also in Co. Londonderry (begun in 1787; dismantled in 1813), was the model for Ickworth, combining a central rotunda with quadrant wings designed to serve as galleries. In 1794 he wrote of the former: 'Young Geniusses who cannot afford to travel into Italy may come into my house & There copy the best masters.' Ickworth, begun in 1795/6, was incomplete when the Earl-Bishop died, and only made habitable for the 1st Marquess between 1821 and 1832. It received none of the Earl-Bishop's later collections, as he disinherited his son for preferring to marry a 'penniless Irishwoman' to an illegitimate daughter of the King of Prussia, leaving all his personalty instead to the brother of the deceased Mrs Mussenden. Most of the works of art relating to the Earl-Bishop have been bought back since, out of what survived the fire at Downhill.

Benjamin West's fifth autograph version (dated 1779) of his *Death of Wolfe* is first recorded in 1804 in the collection of **Frederick, 1st Marquess of Bristol (1769–1859)**, who may have bought it because the 1st Earl's grandson, Captain Hervey Smyth, who was Wolfe's ADC, plays a prominent role in the drama. The 1st Marquess also seems to have acquired the damaged, but still impressive, *Head of an Unknown Man*, generally accepted as by Titian, together with the small, but important, group of Spanish pictures at Ickworth (see cat. no.50), and the Spanish copy of Domenichino's vast *Last Communion of St Jerome*, painted in 1808 in Paris, where he probably acquired them, as he recovered *The Fury of Athamas*.

In 1879 the 3rd Marquess had J.D. Crace decorate the Pompeian Room with murals based on the classical wall-paintings discovered in 1777 at the Villa Negroni on the Esquiline Hill in Rome and later purchased by the Earl-Bishop with a view to installing them at Downhill, though their ultimate fate is unknown. Crace used as his source the engravings made from copies of them by Mengs and others. Many of the better pictures were accepted by HM Treasury in lieu of death-duties in 1956; the remainder have mostly been sold piecemeal since.

LIT: Hervey Papers, Suffolk RO, Bury St Edmunds; Gage 1834; Willoughby 1906; for the 1st Earl's collections, see Hervey 1894; on the Earl-Bishop, see Childe-Pemberton 1924, Ford 1974, Fothergill 1974 and Figgis 1993; Gore 1964[4] and 1964[5]; Gore 1969, pp.245–6; *Ickworth* 1979.

Kedleston Hall (Derbyshire)
1, 21, 47

The present house was designed from the first around pictures belonging to **Sir Nathaniel Curzon, 5th Bt**, who acquired most of them in the London salerooms or from Italy. Like Robert Adam's house, the collection has a strongly Italian flavour, but includes a superb Cuyp, an outstanding de Momper and a remarkable large Salomon Koninck of *Daniel expounding Nebuchadnezzar's Dream*.

The outbuildings of the old house, and the short-lived house built by Francis Smith of Warwick c.1700 for Sir Nathaniel Curzon, 2nd Bt, are depicted in an anonymous oil. Among the pictures that came from the latter are a group of decorative paintings by Adriaen van Diest, and a pair of pictures of Alexander the Great, optimistically ascribed to Veronese in the 1740s. The most impressive of the earlier portraits are a group of Lely full-lengths painted for Philip, 4th Lord Wharton, of *The Duke and Duchess of York*, *The 1st Duke of Ormonde*, *The 1st Earl of St Albans*, and *The 1st Earl of Arlington*, all in Garter robes, which were bought by Sir Nathaniel Curzon, 4th Bt (1676–1758), at Sir William Stanhope's sale in 1733. This Sir Nathaniel sat with his wife Mary to Jonathan Richardson the Elder between 1727 and 1730, to celebrate the birth of a healthy male heir, the future 1st Baron Scarsdale (their first son, John, who had died in 1720, appears in the clouds).

Sir Nathaniel Curzon, 5th Bt, 1st Baron Scarsdale (1726–1804) visited the Low Countries and northern France briefly in 1749, but despite his fascination with ancient Rome seems never to have made the Grand Tour of Italy. Devis's conversation-piece of him with his young wife, Lady Caroline Colyear (cat. no.21), shows the relative *naïveté* of his taste in the early 1750s. In April 1756 he made the first payment for Gavin Hamilton's pioneering Neo-classical *Venus ushering Paris to Helen*, but Hamilton was associated with one of his discarded architects, James 'Athenian' Stuart, and he neither commissioned anything more from him, nor bought any pictures or Antique sculpture through him.

Sir Nathaniel had already begun to buy Old Masters, including a Claude and a purported Rembrandt (now ascribed to Bol), from the collector John Barnard c.1754 (both sold in 1930, but the latter recovered in 1987). In February 1757 he bought Luca Giordano's huge *Triumph of Bacchus*, and Benedetto Luti's almost equally large *Cain and Abel* and *Christ in the House of Simon Levi*, at a sale of pictures imported from Italy by the dealer William Kent, and then in 1758–9 sent Kent to Italy to buy more. His purchases there, which included the purported Carracci *Orlando delivering Olympia from the Sea-monster* and Reni *Cupid asleep on Cyprus*, were primarily made from the collection of the Marchese Arnaldi in Florence. Cuyp's beautiful *Evening Landscape* (fig.16) came from 'Dr' Bragge's sale in London in 1759.

Sir Nathaniel took particular care in choosing Old Masters of the right size, character and subject-matter to suit the new house which he had begun building in 1759, and many are an integral part of the designs for the interiors that Stuart, and then Adam, drew up for the principal rooms. The east side of the main block was given over to the Old Masters, in general spaciously arranged in fixed and uniform plasterwork frames that harmonised with the rest of Adam's decorative scheme. Portraits were con-centrated in the State Apartment on the west side, and later in the Family Corridor. Decorative painting and casts of famous Antique statues, acquired chiefly through Matthew Brettingham the Younger, took the place of easel paintings in the two axial rooms, which have the strongest classical character: in the Marble Hall there are circular paintings after Domenichino and Gravelot incorporated into the overmantels and, above, simulated reliefs of scenes from Homer and of Roman life; in the Saloon, capriccios of Roman ruins by William Hamilton, between *trompe-l'oeil* imitations of reliefs with episodes from English medieval history by Biagio Rebecca, after compositions by Kauffman and Cipriani.

Because so many of Scarsdale's pictures were set in fixed frames, his heirs had little reason to alter their arrangement, and only sales of some of the free-framed paintings

have upset it since: notably the Claude, a disputed Poussin of equally debatable subject (Toledo Museum of Art), and Guido Reni's *Bacchus and Ariadne* (Los Angeles County Museum of Art). Most subsequent Curzons have added little to the collection, bar portraits.

George Nathaniel Curzon, successively Baron (1898), Earl (1911) and Marquess (1921) Curzon (1859–1925), belonged in his youth to the intellectual and aesthetic world of the 'Souls'. His wife said, only half in jest, that he would spend £10,000 on a painting, but not buy a new dressing-gown. As an historian, he had a particular predilection for English portraits (most of which were sold after his death). He also accumulated Eastern works of art during his tours in 1887, 1890 and 1894, and while Viceroy of India (1899–1905). He left the finest Indian items from his collection to the Victoria & Albert Museum, but the Indian museum that he created at Kedleston with the advice of the V & A survives largely intact, in cases of its design.

Lord Curzon commissioned twelve sketches of his first wife, Mary Leiter, from Franz von Lenbach. He himself reputedly disliked being painted, but did sit to Herkomer, Logsdail and Sargent (1914; Royal Geographical Society), who also painted his second wife, Grace Duggan; and to Philip de László (All Souls College, Oxford), who also painted his second wife, and his mistress, the novelist Elinor Glyn (private collection). He rescued Bodiam and Tattershall Castles and donated them to the Trust, while India owes the Ancient Monument Preservation Agency to him.

LIT: Curzon Papers, Kedleston and India Office Library; Martyn 1767, ii, pp.62–3; *Kedleston 1769, c.1787, c.1790, 1849, 1861*; Waagen 1854, ii, pp.390–94; Walpole 1927–8, pp.64–5 (visit in Sept 1768); Harris 1978[2]; exh. cat. *Robert Adam and Kedleston*, 1987; *Kedleston* 1988, rev. 1993; on the sculpture, see Kenworthy-Browne 1993.

Kingston Lacy (Dorset)
22, 45, 51, 60

The picture collection at Kingston Lacy – originally known as Kingston Hall (designed by Roger Pratt, and built in 1663–5) – has at its core what is arguably the earliest surviving and continuously recorded gentry collection in the United Kingdom. The prime collectors were two squires: **Sir Ralph Bankes** in the mid-17th century and **William Bankes** in the first part of the 19th century; but some interesting additions were made by **Henry II Bankes**, before and after 1800. Only three significant pictures have left the house since 1855: Velázquez's *Philip IV* (sold in 1896 by Gutekunst and Berenson to Isabella Stewart Gardner, and now in her Museum in Boston); a portrait of the poet *Francisco Quevedo*, considered by some also to be an autograph Velázquez (bought by Paul Wallraf in 1938 and now in the collection of Sra. Xavier de

Salas, Spain); and a study in oils for the head of Edward Altham's *Self-portrait*, traditionally ascribed to Salvator Rosa (disappeared some time after 1905; recovered in 1995).

Chief Justice Sir John Bankes's eldest son, John (1626–56), was painted with his tutor, Sir Maurice Williams, in the only identified portrait by Franz Cleyn the Elder. His younger brother, **Sir Ralph Bankes** (?1631–77), seems to have started collecting pictures when he was in Italy in the mid-1650s with the youngest son, Jerome (who had his portrait painted by Stanzione). They were originally housed in his chambers in Gray's Inn, since the family's then seat, Corfe Castle, which his father had acquired from the proceeds of the law, had been sequestered and slighted, after his mother's heroic defence of it during the Civil War. Three lists of this early collection survive: the first (1656/8), in a commonplace book of Ralph's in the Library at Kingston Lacy, containing just fifteen paintings; the second (1658/9), containing eighteen pictures; and the third, dated 23 December 1659, with 37 pictures – 21 of which are certainly, and another two or three probably, at Kingston Lacy today (these last two lists are on deposit in the Dorset RO).

The character of these first pictures was eclectic, the present survivors ranging from a pair of large mythologies by Sébastien Bourdon, and a large italianate landscape bought, or even commissioned, via Lely from Nicolaes Berchem in 1655, to a little still-life by Van Son. Five pictures from Charles I's collection had to be handed back at the Restoration. But there was also a copy of a Dou, now in the Royal Collection but then in Lely's, together with a *Magdalen* by Lely, a copy of the portrait of a 'Beauty' by him, and his portrait of the copyist *N. Wray*. This last foreshadows the superb set of portraits by Lely, not only of Sir Ralph's family and friends, but of the notorious *Lady Cullen*, of which Reynolds was to say in 1762: 'I never had fully appreciated Sir Peter Lely till I had seen these portraits.' Sir Ralph clearly went on to buy many more, though less distinguished, pictures, but there is unfortunately no further record of the collection till a cleaning list by George Dowdney of 1731, followed by full MS lists, by location, of 1762–4, and of 1772, revised in 1775, by which time the collection had grown to some 150 pictures.

Henry II Bankes (1757–1834) sat to Batoni and bought a purported Domenichino copy of Raphael's *Stoning of St Stephen* from the Barberini Collection on the Grand Tour in 1779, but chiefly relished contemporary English portraiture, Old Master drawings, and prints. His drawings, unusually for the time, were framed and hung, and one of three surviving picture-bats of c.1800 shows their arrangement, mingled with cabinet paintings, and pastel copies by members of his family.

His son, **William Bankes** (1786–1855), bought the most important pictures in the collection during his extended and uncon-

ventional Grand Tour of 1812–20, in two bouts, before succeeding to Kingston Hall, which he proceeded to transform into Kingston Lacy, originally by using Charles Barry as his architect, but then by instructions from his enforced exile in France and Italy from 1841 onwards, even though he knew that he could never return there.

His first campaign of collecting was in Spain in the wake of the Peninsular War, in 1812–15, when he sought to build up a representative collection of Spanish painting, for which he subsequently created the celebrated 'Golden Room' at Kingston Lacy. The most interesting of these was J.-B. del Mazo's sketch-copy of Velázquez's '*Las Meninas*' (cat. no.51). The best picture that he acquired, under romantic circumstances, was not Spanish, but the 'Raphael' *Holy Family*, formerly in the collections of the Gonzagas and Charles I, and later in the Escorial.

William Bankes's second round of acquisitions was made when passing through Italy during his return from Egypt (where he had done pioneering work of exploring, recording and collecting), in 1819–20, when he bought a superb group of pictures from the Marescalchi collection in Bologna, including Sebastiano del Piombo's unfinished *Judgement of Solomon*, Titian's *Savorgnan* (cat. no.45), and – ironically, his best Spanish painting – Velázquez's portrait of the great connoisseur, *Cardinal Massimi*.

After his return to England, and later in exile, Bankes's chief interest was in acquiring large pictures for decorative purposes, including two *Animal Combats* by Snyders from the Leganés collection in the Altamira sale in London in 1827, and the elements of whole Venetian *Cinquecento* ceilings. But he also acquired the two magnificent early Rubens portraits in the Saloon from Genoa in 1840. A further distinctive acquisition was that of 50 of Henry Bone's enamel copies of 16th- and early 17th-century English portraits.

William Bankes had a particular interest in bronze sculpture, in the execution of which he regarded the French as vastly superior to the British. He introduced Baron Carlo Marochetti to this country, by procuring for him the commission for Glasgow's equestrian statue of *Wellington* (1840–44), and employed him to create a kind of pantheon of the Bankes family in the Civil War on the stairs at Kingston Lacy (1841–55). When in exile, he was a pioneering collector of Venetian *Cinquecento* bronzes.

The subsequent history of the collection is mainly one of devoted preservation – other than the three seemingly arbitrary disposals listed above – culminating in the munificent bequest of the two estates of Kingston Lacy and Corfe Castle, and all the collections, to the National Trust by Ralph Bankes in 1981. The one good, if somewhat out of character, acquisition was that of the set of *The Four Elements* on copper, by Jan Breughel the Younger and Hendrik van Balen (cat. no.60).

LIT: Bankes Papers, Dorset RO; no printed catalogue was ever produced; Waagen 1857, pp.374–83; *Kingston Lacy* 1986; Cornforth 1986; Gore 1986; on the Spanish paintings, see Maclarnon 1990; on Marochetti, see Ward-Jackson 1990; on Lely and Sir Ralph Bankes, see Laing 1993[1]; *Kingston Lacy* 1994, esp. pp.37–43.

Knole (Kent)

3

Knole has one of the most interesting collections of portraits in Britain, as befits a house of such age, size and historical resonance. They comprise not simply like-nesses of the Sackvilles and the families they married into over four centuries, but also a gallery of 16th-century worthies, and portraits of 17th- and 18th-century writers. These last were acquired by **Charles, 6th Earl of Dorset** and **John Frederick, 3rd Duke of Dorset**, who were the principal Sackville collectors.

In 1566 Queen Elizabeth gave Knole to her cousin, **Thomas, 1st Earl of Dorset (1536–1608)**, who remodelled it in 1603–8, and had the Great Staircase and the Cartoon Gallery painted by Paul Isaacson and others. The 1st Earl was painted in 1601 in a three-quarter-length attributed to John de Critz, in his robes and holding his staff of office as Lord Treasurer. Lady Margaret Howard, wife of the 2nd Earl, probably collected the core of the group of portraits of celebrated 16th-century figures that has long hung in the Brown Gallery. Portraits of English sovereigns were added to these when they were given matching ribboned frames in the late 18th century.

Van Dyck's full-length of *Frances Cranfield* (cat. no.3) was probably painted shortly before her marriage in 1637 to Richard, 5th Earl of Dorset (1622–77). In 1674 their son, the future 6th Earl, inherited through the death of her brother, the 3rd Earl of Middlesex, the Cranfield estates and chattels, which included two Mytens full-lengths of her father, the Lord Treasurer Lionel, 1st Earl of Middlesex, and probably others by the artist and his studio, including that of the Venetian ambassador *Niccolò Molino* (1622) and the *James VI and I*, which is in a superb contemporary frame. When the 6th Earl gave up the Middlesex seat, Copt Hall, in 1700/1, six wagon loads of chattels were brought to Knole, including the copies of the Raphael Cartoons from Franz Cleyn's workshop that had been used at the Mortlake tapestry works.

Charles, 6th Earl of Dorset (1638–1706) sat for a full-length in 1694 and for a Kit-cat portrait (c.1697; National Portrait Gallery; on loan to Beningbrough, Yorks) to Kneller, who also painted a charming whole-length of his two legitimate children with a fawn, and a three-quarter-length of his illegitimate daughter, *Lady Shannon*. Praised by Pope as 'The grace of courts, the Muses' pride, patron of arts', he collected the portraits of his

literary friends by Kneller, Riley, Dahl and others that hang in the Poets' Parlour in the private apartments.

The installation of Lionel, 7th Earl and 1st Duke of Dorset (1687–1765) as Lord Warden of the Cinque Ports is celebrated in John Wootton's sizeable view of the ceremony at Dover (dated 1727), which hangs over the Great Hall fireplace in an elaborate Kentian frame adorned with the Sackville arms and vair. 'Thoroughly unsatisfactory' was Vita Sackville-West's verdict on Charles, 2nd Duke of Dorset (1711–69), but, for all his dissipation, he was not an uncultured man. The paintings he commissioned serve chiefly to record his passion for music, which he did much to promote in London in the early 18th century: hence the portrait of *Handel* (private apartments). The full-length of him as 'a Roman Consul returning from the Army' by Franz Ferdinand Richter recorded a Christmas masquerade in Florence in 1738, and served as the model for George Knapton when he painted him in similar guise in one of his portraits of the founder-members of the Society of Dilettanti (Brooks's). The finest portrait of him, however, is a pastel by Rosalba Carriera (private apartments).

His grandson, **John Frederick, 3rd Duke of Dorset (1745–99)**, was an altogether more active and interesting collector. In 1770 he made the Grand Tour: a notebook survives which contains *An Account of the Number and Value of the Pictures, Busts etc.* that he purchased in Rome that year. Through the dealer and cultural go-between Thomas Jenkins, then at the height of his influence in Rome, the 3rd Duke bought a number of pictures, including *The Virgin and Child with St Francis and St Jerome* (then attributed to Perugino, now to the workshop of Francesco Francia) and a Flemish bandit scene (then given to Salvator Rosa), but also Old Master drawings (largely sold at Christie's, 1 April 1987). Jenkins's great rival, James Byres, gave the 3rd Duke as a present Teniers's *A Hurdy-gurdy Player* and *Le Marchand de Ratafia* (private apartments). The 3rd Duke's note-book also records purchases made in Venice in 1771 from Count Vitturi, and in 1774–5, following his return to London; Garofalo's *Judith with the Head of Holofernes* and ?Schedoni's *St Peter Delivered from Prison* were both sent to him from Rome by Jenkins in 1775. Many of these are hung today in Lady Betty Germain's Dressing Room. The note-book contains a list, dated 1778, of the pictures kept at Knole and in his London house, 38 Grosvenor Square (now the Indo-nesian Embassy), which had been embellished for him by John Johnson, probably in 1776.

The 3rd Duke was also an imaginative patron of contemporary artists, particularly Reynolds, who became a friend. In 1769 he sat for the full-length which Walpole described in 1780 as 'extremely like, but the colouring much gone already'. He commissioned a number of fancy pictures, including *Cupid as*

Link Boy (Albright-Knox Art Gallery, Buffalo, NY) and *Mercury as Cut Purse* (Buscot Park, Oxfordshire), which connive in the Duke's rakish private life. Reynolds also painted his mistress, *Giannetta Baccelli* (private apartments), who was painted again by Gainsborough, c.1782 (Tate Gallery), and who was the reputed model for a plaster nude by Locatelli now at the foot of the Great Staircase. He also acquired from Reynolds portraits of his Chinese page, *Wang-y-Tong* (1777), and of a number of his literary and theatrical acquaintances, such as *Dr Johnson* and *Oliver Goldsmith*. The ambitious history painting *Ugolino and his Children in the Dungeon*, bought in 1775, is one of eleven works by Reynolds still in the house, many now in the Reynolds Room; until the late 19th century, there were almost twice that number. The 3rd Duke was a pall-bearer at Reynolds's funeral. His wife, Lady Arabella Cope, was painted at length in 1790 by Hoppner, who also depicted their three children together (Metropolitan Museum, New York); after she had been widowed, she sat to Mme Vigée-le Brun, in 1803.

George Sandars's full-length of the short-lived 4th Duke effectively marks the end of both the male line of the Sackvilles and the long line of Knole portraits. As at first a subsidiary seat of the Earls successively of Plymouth, Amherst and de la Warr, and then the seat of younger sons of the last, Knole was no longer ducal in either its pretensions or its resources, and heirlooms were sold to keep house and estate going. In 1911 Gainsborough's *A Beggar Boy and Girl* (*Thomas and Elizabeth Linley*) (c.1768; Clark Art Institute, Williamstown, MA) and the exceptional medieval tapestries of the *Seven Deadly Sins* were bought by J.P. Morgan, whose mistress Lady Sackville became in the year before his death (1912–13), just after death had ended her *amitié amoureuse* with 'Seery' Scott, who had left her the substantial residue of the Wallace Collection still in France. After winning the notorious court-case that the bequest provoked, she promptly sold it to the dealer Jacques Seligmann, sight unseen.

There is, however, one significant and worthy postscript. In 1953–4 the future 5th Lord Sackville, better known as the man of letters Eddy Sackville-West, was painted by Graham Sutherland in a seated full-length (private apartments) that touchingly distils the Sackville melancholia.

LIT: Sackville Papers, Kent RO; the pictures at Knole were described in *The Ambulator*, 1774, and a list published in the *Tunbridge Wells Guide*, 1786, pp.186–97; Willis 1795; Bridgman 1817 (with room-by-room listing of pictures); Brady 1839; Mackie 1858; Sackville 1906; Sackville-West 1922; Walpole 1927–8, p.77 (visit on 30 Aug 1780); Phillips 1929; Vertue ii, 1932, pp.50–51; iv, 1936, pp.18, 123–4; Lees-Milne 1950, pp.245–6; Gore 1965[2] and 1965[3]; Gore 1969, pp.246–7.

Penrhyn Castle (Gwynedd)
34, 44, 52, 66, 67

Apart from some earlier family and other portraits, the oil paintings at Penrhyn were almost entirely bought by one man, **Col. Edward Gordon Douglas-Pennant, 1st Baron Penrhyn of Llandegai** (1800–86). It is a rare example in Britain of a 19th-century collection that has survived virtually intact, *in situ* and in family ownership.

The Douglas-Pennants descend from the Earls of Morton (hence a copy of Van Dyck's lost *Countess of Morton*), the Earls of Portmore (Ramsay's fine *Viscount Milsington*), the Dawkinses (Brompton's huge *Dawkins Family*, on loan) and the Pennants, a City family of West Indian nabobs (the set of watercolours of Jamaica by George Robertson). In the 19th century their wealth came from their Welsh estates (of which G.F. Robson painted the set of eight huge watercolours), above all from the Penrhyn slate quarries (cf. cat. no.34).

According to Lord Penrhyn's daughter, Adela, 'Mr Dawkins-Pennant [the rebuilder of the castle] . . . had expressly desired that a good collection of pictures should be made at Penrhyn by his heirs, and my Father took pains to carry out his wishes.' Although Col. Douglas-Pennant inherited in 1840, he began slowly, acquiring J.R. Herbert's *St John the Baptist preaching to Herod* only in 1848 and Dieric Bouts's *St Luke painting the Madonna and Child* around 1850. He subsequently recanted his taste for the primitive, whether in its original or revived Victorian form.

After this false start, he seems to have begun again in 1855, when he bought three or four Old Masters from the Belgian dealer C.J. Nieuwenhuys (1799–1883). While still a young man, Nieuwenhuys wrote a catalogue of the collection of Prince Willem of Orange (later King Willem II of the Netherlands), which his father, L.J. Nieuwenhuys, had played a significant part in forming (cf. cat. nos.44, 67). He was sent by his father to England, and in time became Lord Penrhyn's chief adviser and source of pictures. Lord Penrhyn began buying in earnest in the 1860s and seems to have had a particular fondness for three kinds of picture: Dutch 17th-century, especially large landscapes and dignified figural subjects (cat. nos.52, 66, 67); Venetian 16th-century *sacre conversazioni* (cat. no.44); and Spanish 17th-century works (he had served in Portugal and visited Spain as a young man), including a huge *Kitchen Scene* recently revealed to be by Antonio de Pereda. He bought little from contemporary artists, and that mainly portraits or landscapes with personal associations like F.R. Lee's *The River Ogwen at Cochwillan Mill* and three ambitious watercolours by Carl Haag.

According to Lord Penrhyn's granddaughter, Alice Douglas-Pennant, who catalogued the collection, he was constantly rearranging his pictures. Smaller, more delicate pictures that would have been lost amid the neo-Norman vastness of Penrhyn were kept in the family's London home. Portraits were relegated to the upper floors of the castle to make room for his new purchases, which were concentrated in the Dining Room, Breakfast Room and Lord and Lady Penrhyn's Sitting Rooms. In 1899 the 2nd Lord Penrhyn had the pictures cleaned and rehung by Sir Walter Armstrong, Director of the National Gallery – Spanish, Italian and English in the Dining Room, Dutch primarily in the Breakfast Room.

LIT: Douglas Pennant Papers, University College of North Wales, Bangor; almost the only source of information on the pictures is Douglas-Pennant 1902; on the portraits, see Steegman 1957, pp.57–61, pl.10; Gore 1969, p.248; *Penrhyn Castle* 1991, pp.36–40; Laing 1992.

Petworth House (West Sussex)
2, 12, 13, 32, 36, 37, 59

It is only right that Petworth should be represented in this exhibition by more paintings than any other house, as it contains by far the richest and most historic collection in the care of the National Trust. The central figures in its creation were **the 10th Earl of Northumberland** and – to a lesser extent – **the 6th Duke of Somerset** in the 17th century, and **the 2nd and 3rd Earls of Egremont**, from the mid-18th century to 1837. All four were active as both patrons and collectors.

Algernon, 10th Earl of Northumberland (1602–68) had the taste for Venetian *Cinquecento* painting typical of the courtier-collectors of his day, but was also one of the most discriminating collectors of Van Dyck's portraits. The 1671 inventory of his collection (see below) lists seventeen original Van Dycks and four copies. These include the haunting, posthumous portrait he commissioned in 1633 of his father, the 'Wizard' 9th Earl. The 10th Earl himself seems to have sat only once to Van Dyck, for the family group painted *c.*1634 (at Petworth), but this provided the face-mask for the half- and full-lengths of him as Lord High Admiral (Duke of Northumberland), which were to inspire naval portraits by Reynolds and Gainsborough (see cat. no.8). He was also one of the earliest patrons of Lely, commissioning the pair of portraits of *Charles I with James, Duke of York* (Syon House, Middlesex) and *The Youngest Children of Charles I* in 1647, while the children were in his and his sister's custody.

As one of the few leading peers to side with Parliament, the 10th Earl was able to continue acquiring during the Civil War and Commonwealth. His collection was recorded in part at Suffolk (later Northumberland) House, in his lifetime, by Richard Symonds in 1652, and in full after the death of his short-lived son, Joscelyn (1644–70), 11th Earl, in a 'Note of the Pictures at Northumberland House, taken and appraised by Mr. Symon Stone the 30th of June 1671', and in lists of the fewer pictures at Petworth (30 July), and at Syon (10 July). These three lists describe about 150 pictures, valued at £4,260 10s. By far the highest value – £1,000 – was put on Titian's *Vendramin Family* (National Gallery), which the 10th Earl had bought from Van Dyck's executors in 1645/6.

Titian's damaged *Mars and Venus* (repainted between 1652 and 1671 as a *Nymph and Faun*) and *Man in a Black Plumed Hat* are now both at Petworth, while his influential *Cardinal d'Armagnac and his Secretary* is in the Northumberland collection. Northumberland probably acquired the two compositions of the *Madonna and Child with St John and Angels* by Andrea del Sarto (Lord Egremont) from the 2nd Duke of Buckingham, whose London house, York House, had been sequestrated by Parliament, but leaving Northumberland as its tenant. From the same source came the little Elsheimers (cat. no.59), which were the most highly valued among his Northern pictures. Besides the Van Dycks, they included departed paintings by Holbein, Claude (possibly the first to reach England) and Dou, and a *St Sebastian* by Gerard Seghers still at Petworth. There were five still-lifes by Juan Fernández and three by De Heem.

Charles, the 'Proud' 6th Duke of Somerset (1662–1748), came into Petworth by marrying Lady Elizabeth Percy, the only child and heir of the 11th and last Earl of Northumberland. He devoted most of his energies to rebuilding Petworth, from 1688, commissioning Laguerre to decorate the Grand Staircase after the fire in 1714/15, with murals of *The Story of Prometheus*, *The Muses* and *The Duchess of Somerset riding in Triumph*. He also had Dahl paint portraits of ladies of the court of Queen Anne, which after the fire were let into the panelling in the Beauty Room, below copies of capriccios by Polidoro in the Royal Collection from the 10th Earl of Northumberland's collection. The 6th Duke collected comparatively few Old Masters, the great exception being his Claude (cat. no.37), which he bought at or after an auction held in 1686 by his frame supplier (*inter alia* for the Van Dycks), Parry Walton, and Grinling Gibbons, whose limewood carvings represent the summit of his achievement and of the 6th Duke's artistic patronage. In the 1690s he bid successfully for a purported Guercino at Edward Le Davis's sale, but refused to take delivery of it when the auctioneer attempted to charge him a price that took account of the devaluation of the currency since the sale. Closterman, who had painted full-lengths of him and his wife, and was acting as his adviser at the sale, bought the picture on his own account, which so enraged the 'Proud' Duke that he ceased to employ the artist in any capacity, and may have been put off collecting Old Masters altogether. On the death of his son, the 7th Duke, in 1750, the collections

were divided between the latter's nephew, the 2nd Earl of Egremont, and the Duke's daughter Elizabeth, through whose husband, the 2nd Earl and future 1st Duke of Northumberland, her portion has descended and is now concentrated at Alnwick and Syon.

Charles, 2nd Earl of Egremont (1710–63) made the Grand Tour of Germany, France and Italy in 1728–30 with George Lyttelton and Henry Bathurst. His taste for Italian pictures was probably formed during this trip, and it may have encouraged him to buy the Bellotto (long called Canaletto) *View of the Campidoglio*; but he also owned earlier works, including a Bronzino portrait. His highly important collection of Antique sculpture was chiefly assembled in 1758–63, through Matthew Brettingham the Younger and Gavin Hamilton in Rome, and was intended to be displayed in the North Gallery (built in 1754–63 by the elder Brettingham), though much of it had not been unpacked when he died.

The 2nd Earl bought most of his pictures at the newly burgeoning London auctions. The survivors range from Massys's *Card Players, or The Prodigal Son*, to numerous 17th-century landscapes by Bril (cat. no.36), Berchem, Calvaert, Ruysdael, Van Goyen, Van der Velde and others. His French pictures included Bourdon's *Joseph sold by his Brethren* and Barbault's *La fille dotée* (Lord Egremont); among those now gone are La Hire's *The Departure of Abraham* (Hermitage) and Chardin's *La mère laborieuse* (private collection, USA). Most of these pictures he kept at Egremont House in London (now the Naval & Military Club), but the majority were sold for paltry sums by his son, the 3rd Earl, at Christie's, on 7–8 March 1794 (141 lots), when he gave up the house.

George, 3rd Earl of Egremont (1751–1837) is justly famous as the great patron and collector of Turner, who stayed at Petworth for long periods in the late 1820s and 1830s (for further details, see cat. no.32). But this was only one aspect of his role as patron of modern British art from the early 1800s to the 1830s. He seems at first only to have collected paintings by the classic 18th-century English painters. He claimed to admire Hogarth above all other British artists, owning his *Mary Woffington as Mary, Queen of Scots* (1759; Lord Egremont) as well as copies of his works. He purchased landscapes by Wilson and Gainsborough, numerous portraits by Reynolds, as well as his *Death of Cardinal Beaufort* and the huge, unfinished and bitumen-wrecked *Macbeth and the Witches* from the Boydell Gallery, which became the centre-piece of the hang in the Square Dining Room. His wife commissioned two pictures from William Blake. He also bought works by Fuseli, Wilkie, William Hilton, A.W. Callcott, B.R. Haydon and Washington Allston, but his particular favourites (beside Turner) were James Northcote, C.R. Leslie and George Clint. The 3rd Earl's preferred portraitist was Thomas Phillips, who was kept busy (see cat. no.13).

The 3rd Earl was rare among aristocratic collectors in also commissioning monumental sculpture, but almost unique in doing so from British sculptors at home. For him Flaxman carved his first marble statue since the 1790s, the *Pastoral Apollo* (1813–24), and his last monumental work, the *St Michael overcoming Satan* (1819–26), which, with the Irishman J.E. Carew's *Vulcan, Venus and Cupid* and *Prometheus and Pandora*, and other works by the latter, are now placed with figures and groups by Rossi and Sir Richard Westmacott, and the 2nd Earl's Antique statuary, amid the modern pictures in the North Gallery (extended in 1824 and 1826–7; restored in 1991–3).

Thirteen major pictures were sold to a plausible dealer in 1927, but the collection has otherwise changed remarkably little since the 3rd Earl's death in 1837. Thomas Phillips's young son drew up an inventory of the collection in 1835 (National Art Library, MS 86 FF 67). In the Petworth archives are notebooks containing diagrams of the picture-hang, c.1840–41 (PHA 7518), sketches of the pictures cleaned by H.R. Bolton in 1856 (PHA 7527), and sketches of them made by 'A.E.K.', c.1841–3, to accompany the anonymous 1856 catalogue (PHA 7519). The pictures were thinned out, when the Treasury rejected a number from those offered in lieu of death-duties, and were rehung by Anthony Blunt in 1952–3, divided into type room by room. With the help of Lord and Lady Egremont, they are currently being re-arranged to give the hangs the more crowded character they had in the early 19th century.

LIT: Egremont Papers, Petworth (with W. Sussex RO; catalogue, 1968); inventories and catalogues: Phillips 1835 (MS in the National Art Library); Waagen 1854, iii, pp.31–43; *Petworth* 1856; Collins Baker 1920; on the 10th Earl of Northumberland, see Wood 1994; on Turner at Petworth, see Joll 1977, Youngblood 1983 and Butlin et al. 1989; on the Antique sculpture, see Michaelis 1877 (revisions by Vermeule 1955, 1956) and Wyndham 1915; on the 3rd Earl as a patron of sculpture, see Kenworthy-Browne 1977; see also Gore 1969, pp.248–50; Gore 1977; Blunt 1980; Jackson-Stops 1980; Gore 1989; Rowell 1993.

Plas Newydd (Isle of Anglesey)
10

Plas Newydd, or 'New Mansion', was the seat successively of the Griffith, Bagenal and Bayly families. By his marriage in 1737 to Caroline Paget, Sir Nicholas Bayly, 2nd Bt, inherited the barony, heirlooms and houses of the Pagets, notably their principal residence at Beaudesert in Staffordshire. When that was abandoned after the First World War, many of the Paget pictures were moved to Plas Newydd. The **6th Marquess** commissioned

Rex Whistler's huge architectural capriccio in the Dining Room. Of the very few Old Masters in the house, the best is Snyders's *A Butcher's Stall*.

William, 1st Lord Paget (1505/6–63), one of Henry VIII's 'new men' and the founder of that family's fortunes, was painted by an unknown, but impressive, Flemish artist, probably in 1556. Three versions of this, of different dates, are in the Entrance Hall. There is also a fine full-length Van Dyck, probably of the widowed Duchess of Buckingham. The sequence of family portraits does not pick up again until c.1700. The 9th Baron, Henry, 1st Earl of Uxbridge (1744–1812), sat to Romney for a three-quarter-length portrait, which shows him clutching a sample of copper ore from the Parys mines, from which the family was to derive much of its wealth. The next generation favoured Hoppner, who painted **Henry, 1st Marquess of Anglesey (1768–1854)**, his first wife, Lady Caroline Villiers, his sister, Lady Caroline Capel (cat. no.10), and his brother, Arthur. Lord Anglesey also acquired records of his distinguished military career, such as Denis Dighton's furiously animated *Battle of Waterloo*, and portraits of his military superiors: *George IV*, in field marshal's uniform, from Lawrence's studio, c.1814, and *The Duke of Wellington*, commissioned from John Lucas, 1840–42. This last was intended for 'an excellent and most prominent place' at Beaudesert; most of the earlier family portraits would originally have been shown there, or at Uxbridge House, Piccadilly (now Royal Bank of Scotland), rather than at Plas Newydd, which, with its park, was transformed between 1793 and the 1820s. John 'Warwick' Smith was asked to paint watercolour views of the house and its surroundings c.1800. It is also full of 19th-century marine pictures, which reflect its position on the Menai Strait.

The theatrical extravagances of the 'Dancing' 5th Marquess (1875–1905) forced a 40-day succession of sales in 1904–5, in which much was lost. The house was brought back to life in the 1920s and 1930s by **the 6th Marquess (1885–1947)** and his wife, **Lady Marjorie Manners (1883–1946)**, who was painted by James Jebusa Shannon, an artist much favoured by the Manners family. They altered the Saloon to take four enormous pastoral scenes by the Flemish artist B.P. Ommeganck (dated 1789). They were also friends and generous patrons of Rex Whistler, who was commissioned in 1936 to paint his longest mural, for the Dining Room. This panoramic capriccio stylishly conjures up an Italian seaport amid the mountains of Snowdonia, which can be seen through the windows opposite. The adjoining Rex Whistler Museum illustrates his range as decorative artist, portrait painter, book illustrator, stage designer and amateur architect; many of the exhibits have been loaned to the National Trust by his brother, Laurence Whistler.

LIT: Anglesey Papers, University College of North Wales, Bangor; on Whistler, see Hussey 1946 and Jackson-Stops 1977; for the portraits, see Neale 1822, v, and Steegman 1957, pp.26–35, frontispiece, pls.5–8; *Plas Newydd* 1992; *sales*: Christie's, 30 Nov–1 Dec, 12–13 Dec 1904, 24 Feb 1905, et al. (over 17,000 lots in all).

Polesden Lacey (Surrey)
15, 61, 64, 68

Polesden Lacey, which **Dame Margaret (formerly Mrs Ronald) Greville** left to the National Trust in 1942, with the stipulation that 'a Picture and Art Gallery' be created there, and in memory of her father, **William McEwan**, was the first bequest accepted by the Trust because of the merits of the collections rather than of the house and grounds. Most of the better 17th-century Dutch and Flemish pictures, which form one major part of the collection, were bought by McEwan. Mrs Greville followed her father in this, as she did in buying Raeburns; but whereas he may have done so because the artist was a fellow-Scot, she seems to have been following a typical *goût Duveen* that also embraced Early Flemish and Italian painting.

William McEwan, MP (1827–1913), made his fortune from the brewery he founded in Edinburgh in 1856 (now part of Scottish & Newcastle). Like the slightly older William Armstrong of Cragside in Northumberland (also NT), he was a generous local benefactor, who does not seem to have begun seriously collecting pictures on his own account until late in life, when in semi-retirement. He first seems to have been inspired to do so after acquiring Frans Hals's *Dutch Lady* and *Dutch Gentleman* in 1885, and Rembrandt's *Woman in Bed* in 1892, for the National Gallery of Scotland. He appears to have preferred 17th-century Dutch and Flemish cabinet pictures, particularly genre scenes and coastal and river views. Of the 36 Dutch and Flemish pictures now at Polesden Lacey (not all on view), sixteen were inherited from McEwan. Their high quality is probably explained by the fact that he bought everything from or through a reliable dealer who himself had a taste for these kinds of picture, Lesser Adrian Lesser (active 1874–99), the first four all from the sale of Henry Bingham Mildmay. If any personal taste at all is visible, it is for Teniers, three of whose works were bought in one transaction from Lesser in 1894 (cf. cat. no.61). Nor, in view of the small number of paintings involved, is it really accurate to talk of a 'collection'. He seems to have ceased buying altogether after Lesser retired in 1899. McEwan also paid for the building of Edinburgh University's graduation hall and for its decoration with murals and mosaics on allegorical themes in an Early Renaissance style by William Mainwaring Palin (1894–7). He sat for portraits by Benjamin Constant (1900) and Walter Ouless (1901).

Mrs Ronald Greville (d.1942) expanded the collection that she inherited from her father with further purchases, many of them from or through Agnew's. They were combined with porcelain, good majolica, furniture and silver to create a luxurious setting for her role as a society hostess. She continued to buy Dutch pictures, evidently favouring portraits, especially classic British images in the Duveen taste of children (perhaps because she had none of her own): e.g. Lawrence's *The Masters Pattison*. She also acquired two artist's self-portraits, by Frans van Mieris (cat. no.68) and Jonathan Richardson the Elder. Again in keeping with the *goût Duveen*, she bought examples of Early Italian, French and German panel painting. Two such pictures, by or attributed to Corneille de Lyon, came from houses that are now in the care of the National Trust, Petworth and Belton. Her most appealing purchases of this kind, the still enigmatic predella panel of *The Miracle of Our Lady of the Snow*, and Benedetto Diana's *Meeting of Joachim and Anna*, were made through the art historian Tancred Borenius.

LIT: William McEwan's early notebooks and letters are in the Scottish Brewing Archive, University of Glasgow; a notebook in which Mrs Greville recorded brief details of her and her father's purchases survives at Polesden Lacey; *Polesden Lacey* 1964; Gore 1969, pp.250–51; for McEwan's Dutch pictures, see exh. cat. *Dutch Art and Scotland*, National Gallery of Scotland, Edinburgh, 1992, p.174; and as a collector and benefactor, see Lloyd Williams 1994.

Powis Castle (Powys)
4, 5, 30

Powis contains late 17th- and early 18th-century murals by Verrio, Lanscroon and others, apparently commissioned by the **1st** and **2nd Marquess/Dukes of Powis**, and a long run of family portraits (including those of **the Herberts of Chirbury**), chiefly of the 17th and late 18th century. Most of the few surviving subject-paintings came into the family through the marriage in 1784 of the heiress of the Herbert Earls of Powis with the son of **Clive of India**, Edward, 1st Earl of Powis of the 3rd creation.

William Herbert, 3rd Lord Powis, 1st Marquess/Duke of Powis (c.1626–96) had Antonio Verrio paint the ceiling of the new Grand Staircase some time between 1674 and 1685 with what seems to represent a glorification of Charles II's Catholic queen, Catherine of Braganza, based on Veronese's *Apotheosis of Venice* (Doge's Palace). Such a borrowing may derive from his cousin, the Earl of Castlemaine's, sojourn in the city (see cat. no.5). The 1st Marquess/Duke and two of his daughters were painted in exile in France, probably by François de Troy. His wife, Lady Elizabeth Somerset, had already been painted by John Michael Wright (fig.3), and on an altogether grander scale by Jacob Huysmans

(cat. no.4). The Staircase walls were painted with mythologies and allegories by Lanscroon for **William, 2nd Marquess/Duke of Powis (c.1665–1745)**, after his partial recovery of his estates in 1705.

With the extinction of the male line of the Powis Herberts in 1748, the castle passed by marriage to a descendant of their distant kinsmen, **the Herberts of Chirbury**, Henry, 1st Lord Herbert of Chirbury and 1st Earl of Powis of the 2nd creation (1703–72), which brought to Powis a host of images of the poet, historian, philosopher and autobiographer, Edward, 1st Lord Herbert of Chirbury (1582–1648), including an exquisite miniature by Isaac Oliver, a bronze bust by Hubert Le Sueur, and the whole-length described in his autobiography (the Larkin of him is at Charlecote). The 1st Earl's son, George, 2nd Earl of Powis (1755–1801), made the Grand Tour of Italy in 1775–6 with the gentleman-connoisseur and painter William Patoun (see below), and sat to Batoni in Rome in 1776. Thereafter he preferred metropolitan life and neglected Powis and its family portraits, which accounts for their patchy survival.

The meteoric collecting career of the greatest of the Nabobs, **Robert Clive of India (1725–74)**, began somewhat hesitantly two years after his final return from the East, in February 1769, when he bought a few minor items, through his architect William Chambers, from a group of pictures imported by Richard Ansell and consigned to James Christie's first important auction. He had the self-confidence of the self-made man and the means to indulge it (over £500,000 in 1770), although he acknowledged that he was not an expert, and took advice from Patoun, the painter Benjamin West, and his secretary Henry Strachey. He kept his pictures at his London house, now 46 Berkeley Square, though intending them for Claremont in Surrey. He only began buying in earnest in February 1771 with the purchase of eighteen pictures from another Ansell consignment to Christie's, including a Dolci *Madonna and Child* (untraced) for 520 gns. After much haggling, he acquired seven pictures from Sir James Wright, including Veronese's *The Visitation* (Barber Institute, Birmingham) and a supposed Tintoretto *Madonna and Child with Saints* now attributed to L'Aliense.

Early in 1773 Henry II Hoare 'the Magnificent' of Stourhead negotiated the sale to him of two Vernet marines, which had originally been ordered by the King of Poland. Clive also commissioned from West a series of huge canvases depicting the key events in his conquest of India for the eating-room at Claremont (a version of *Lord Clive receiving the Grant of the Diwani from the Great Mogul* is now on loan from the India Office Library to Powis). Otherwise, he seems to have shown little interest in contemporary art, declaring 'he would only purchase the works of the Old Masters and leave his son to encourage the moderns'. His best Old Masters

were bought in rapid succession in 1773: the Bellotto (cat. no.30), Poussin's *Landscape with the Funeral of Phocion* (Earl of Plymouth; on loan to the National Museum of Wales, Cardiff) and *The Finding of Moses* (National Gallery, and National Museum of Wales), and Claude's *Landscape with the Reconciliation of Cephalus and Procris* (Earl of Plymouth). He toured France and Italy during the winter of 1773–4 with Patoun, buying in Rome a purported Tintoretto *Assumption* from Thomas Jenkins and Antique sculpture, including a *Boy with a Bird* and a *Cat and Snake*, for which he was prepared to pay '*Coute qui coute* [*sic*]'; the following year he committed suicide.

Clive had sat to Nathaniel Dance (Powis), and apparently for a '*Family Piece*' (untraced) by Gainsborough, who certainly painted a whole-length of his son as a boy. The 1st Earl of Powis (1754–1839) had himself, his family and friends painted in a set of oval pastels by Hugh Douglas Hamilton. His children were done in the same medium and format by their governess, Anna Tonelli, daughter of the Florentine miniature-painter Nistri. When he went to India, as Governor of Madras, in 1798, much of his father's collection was hung in the recently adapted Ballroom at Powis. After his return in 1804, when he brought back further Eastern trophies to add to those collected by his father and his wife (now forming the Clive Museum), he made Powis over to his son, and took most of the pictures to Walcot in Shropshire; thereafter, they were divided between his two sons (from whom the Earls of Powis and Plymouth descend). Much of the Powis portion has since been further dispersed or sold: the principal works still at Powis are the Bellotto, Brescianino's *Madonna and Child* (engraved as a Fra Bartolomeo when in Clive's possession), and Jan Weenix's vast *Landscape with Huntsman and Dead Game*.

LIT: Powis Papers, National Library of Wales, Aberystwyth, India Office Library, London, and Shropshire RO; Loveday 1890, pp.15–16 (visit on 22 May 1732); Steegman 1957, pp.261–72; Gore 1969, pp.251–2; *Powis Castle* 1987, 1989; on Clive of India as collector, see Bence-Jones 1971; the European works of art in the Clive Museum are nos.210–48 in Archer et al. 1987, pp.132–43.

Saltram (Devon)
7

John Parker, 1st Lord Boringdon (1734–88) was responsible for introducing to Saltram most of the best pictures, whether by purchase or commission. Little has been added since, though much has been subtracted.

The most impressive of the early family portraits is Marcus Gheeraerts's full-length of *Sir Thomas Parker* (1594–1630). Three generations later, Lady Catherine Parker was painted by Thomas Hudson in the manner of Rubens's *Helène Fourment*, but it is with her

son, Lord Boringdon, who inherited Saltram in 1768, that the collection really begins. He was, above all, a close friend and generous patron of Reynolds. (For details of this fruitful relationship and the artist's paintings still at Saltram, see cat. no.7.)

In 1764 Boringdon made the Grand Tour of Italy with his first wife, visiting Rome and Naples, where he met and sat to Angelica Kauffman. When Kauffman later moved to England, he obtained from her a *Self-portrait*, a *Neapolitan Woman* and a series of large paintings with subjects taken from mythology and classical and British history. He also acquired her portrait of their mutual friend, Reynolds (1767), in Van Dyck dress. The history paintings were bought specifically to hang in the Saloon, the climax of the new apartments created by Robert Adam. Kauffman's future husband Antonio Zucchi supplied the ceiling roundels (taken from classical mythology) in this room, and the overdoors and ceiling lunettes (with appropriate images of Antique authors) in the Library (later converted into the Dining Room). She also sold Boringdon volumes of engravings and one of Old Master drawings, in which a rare study for a *Deposition* by Perugino has recently been discovered.

Boringdon seems to have bought mementoes of his Italian tour: Ricciardelli's four *Views of Naples*, Hackert's *Caserta* (cf. cat. no.31) and a pair of *Classical Ruins* attributed to Codazzi. He also turned to Reynolds for advice in buying Old Masters; indeed, his version of Guercino's *Madonna and Child with the Infant St John* came from Reynolds's collection. To furnish the Saloon as Adam suggested, he bought copies of celebrated Old Masters, the overmantel a fine early replica of Titian's *The Andrians* (original in Prado). Smaller, classicising landscapes in the manner of Gaspard Dughet, Locatelli, Salvator Rosa and Borgognone are now densely hung in the Morning Room and Velvet Dressing Room, alongside Italian history pictures, and a number of Dutch and Flemish genre paintings: the best are Guido Reni's *St Faith*, a *Holy Family with the Infant Baptist* by Lubin Baugin (framed as a pendant to Reynolds's Guercino, so probably also from him), Pietro de' Pietris's *Diana Bathing*, Egbert van Heemskerk's *Puritan Meeting* and Pieter de Hooch's late *Tavern Scene*. Elsewhere in the house the most important pictures are Sammacchini's *Madonna and Child in Glory* (a cut-down altarpiece from S. Maria della Morte in Bologna) and Rubens's head of *Vincenzo II Gonzaga* (from Charles I's collection).

Boringdon's son, the 1st Earl of Morley (1772–1840), was more interested in politics than collecting, but his second wife, Frances Talbot (1782–1857), specialised in copying Old Masters: examples of her watercolours are grouped in the Boudoir, of her oils, in the Velvet Drawing Room. The 2nd Earl (1810–64) bought Vanvitelli's *Ponte Rotto* in Rome,

but little else, as his father's debts forced him to sell the family's London house and move out of Saltram. Although the 3rd Earl (1843–1905) married a daughter of the immensely wealthy collector R.S. Holford (see cat. no.29), he had to retrench still further, selling Reynolds's *Mrs Abington as 'Miss Prue'* (1771; Yale Center for British Art) and *Kitty Fisher in the Character of Cleopatra* (c.1759; Iveagh Bequest, Kenwood) by auction in 1876, and Van Dyck's *'Bolingbroke Family'* (Detroit Institute of Arts) in 1883. In 1926 the 4th Earl (1877–1951) inherited Dorchester House and Westonbirt (but not their collections) from Sir George Holford, and decided to sell both in order to preserve the historic family seat at Saltram. In 1957 the 5th Earl (1878–1962) transferred the house to the National Trust and sold the pictures in most of the upstairs rooms to provide Saltram with a partial endowment.

LIT: Morley Papers, Devon RO, Plymouth; for an outline list of the collection, see Anon. 1819, rev. 1844; Gore 1966[2]; Gore 1969, pp.252–3; *Saltram* 1967, 1977; Russell 1995; *sales*: Christie's, 29 April 1876, 3 June 1876.

Shugborough (Staffordshire)
26

The Ansons were modest squires, until the naval career and prizes of George, Admiral Lord Anson (1697–1762) enabled his elder brother, **Thomas Anson**, from 1744 to expand the family seat, and then, with his legacy in 1762, to form sizeable collections of Old Master paintings and Antique sculpture, and a great library. These were almost entirely dispersed in 1842 by a catastrophic pair of sales, from which the family portraits and **the 1st Earl of Lichfield's** sporting pictures were withdrawn at the last minute, and a few survivors bought in.

Thomas Anson (1695–1773) made the Grand Tour in 1724–5, and was a founder-member of the Society of Dilettanti (1732). He had a three-quarter-length of his brother in his peer's robes (painted after 1747 in oils by Hoare of Bath) installed as an overmantel in his newly created Drawing Room (now Dining Room), which was embellished with stucco by Francesco Vassalli, and with huge inset architectural capriccios by Bolognese *quadraturisti* (c.1748). The Admiral was painted more than once by Reynolds (a version was bought for Shugborough in 1871). Lord Anson's death in 1762 gave his brother massively increased resources with which to stud the park with a whole variety of structures, some inspired by Stuart and Revett's *Antiquities of Athens* (1762). In 1768–75 Nicholas Dall painted a set of half a dozen views of the house, the park and its buildings, and a nearby property, and executed decorative paintings for the Library and Orangery (destroyed).

Thomas Anson bought about 120 pictures, over a hundred pieces of sculpture, and numerous medals, chiefly through Sir John Dick, British Consul in Leghorn (Livorno). Some of the landscapes he acquired at auction in Britain, notably a Claude from Dr Richard Mead's sale in 1754, appear to have been of higher quality. These all went in the 1842 sales; the few survivors now mostly hang in the Red Drawing Room and on the stairs. They include an *Immaculata* (1731) by Miguel Jacinto Meléndez, a curiously doctored version of Honthorst's *Angel appearing to St Peter*, and a decorative Zuccarelli.

Admiral Lord Anson had no children, and Thomas Anson never married, so at his death everything passed to his sister's son, George Adams, who took the name of Anson. His son, Thomas, created Viscount Anson in 1806, got Samuel Wyatt to start transforming the house from the moment he succeeded in 1789. The extravagance of his son, also **Thomas (1795–1854)**, created **Earl of Lichfield** in 1831, led to the 1842 sales. Part of his undoing was a passion for sport, racing and farming, as recorded in works by Sir Francis Grant (*A Shooting Party at Ranton Abbey*, 1840), William Webb (*Lord Anson's Hunt*) and Thomas Weaver (sundry horses and goats' heads). The final crash resulted in a seven-day sale of the contents of 15 St James's Square, and a fourteen-day sale of those of Shugborough. He and his wife went abroad to economise until 1847, and after their return lived primarily at Ranton. Their eldest son, Thomas, 2nd Earl of Lichfield (1825–92) and his wife (the baby in cat. no.26) moved back into Shugborough and refurnished it.

LIT: Anson Papers, Staffs RO; Gore 1969, p.253; *Shugborough* 1989; on the capriccios, see Laing 1993[2]; *sale*: by George Robins at the house, 1–6, 8–13, 15, 16 Aug 1842 (MS copy of the catalogue in William Salt Library, Stafford).

Stourhead (Wiltshire)

11, 58

Appropriately for a Palladian house famed for its gardens, Stourhead is rich in Italian pictures, both originals and old copies, and in landscapes in particular. These were primarily collected from the mid-18th to the early 19th century, by **Henry II Hoare 'the Magnificent'** and **Sir Richard Colt Hoare**. Despite a disastrous Heirlooms sale in 1883, and a fire in 1902, the house still contains many good Old Masters, as well as albums of Colt Hoare's own views of Italy, and several pictures commissioned by him to demonstrate that the modern British School was a worthy heir to the Italian masters.

Before 1741, when **Henry II Hoare 'the Magnificent'** (1705–85) moved into the house built by his father in 1721–5, the collection had consisted of little more than recent family portraits, by Dahl and Richardson, among

others. Hoare himself sat to Dahl in 1726 for a life-size portrait astride a horse painted by Wootton, who also painted for him *The Bloody-shouldered Arabian*, a *Hunting Group* and a number of landscapes (all but the last still at Stourhead). He created the gardens in the arcadian image of Claude and the Poussins, and turned to Horace Mann to secure him an original Claude landscape 'at almost any price'. Hoare had at first to be content with the two large landscapes by Gaspard Poussin (Dughet), which Mann bought in 1758 from the Arnaldi collection in Florence (cf. Sir Nathaniel Curzon at Kedleston), and replicas of the Pamphilj Claudes. He fared better with Nicolas Poussin: *Hercules between Virtue and Vice*, bought at the Duke of Chandos's sale in 1747, and *The Rape of the Sabines* (Metropolitan Museum, New York), by 1762. He also bought Maratta's *Marchese Niccolò Maria Pallavicini conducted to the Temple of Virtù* from the Arnaldi collection in 1758, and having failed to get a picture by Cignani as a pendant, he turned to Mengs for an *Octavius Caesar and Cleopatra* which was commissioned via Thomas Jenkins and John Plimmer in Rome in 1759. He was an enthusiastic purchaser of the works of modern artists in Rome and elsewhere, buying a pair of large biblical subjects by Imperiali, and paintings by Sebastiano Ricci, Panini, Trevisani, Conca, Orizzonte and Vernet. More unusually, he also bought a whole group of paintings by Louis Lagrenée. The focus of the house, the Saloon, was largely hung with copies of Veronese and the classic *Seicento* masters.

This classic taste also extended to sculpture, in which he particularly favoured Rysbrack, who made the statue of *Hercules* in the Pantheon, several busts, and sold him a number of his terracotta *modelli*. William Hoare of Bath (a relation only by marriage) painted a quantity of portraits, fancy pictures, and a large copy of a Rubens at Wilton in pastel for him, as well as a series of pastels of the children of Hoare's nephew, Sir Richard Hoare, 1st Bt, for the latter. Through this artist he was one of the first to buy a subject-picture by Gainsborough, *Peasants going to Market: Early Morning* (sold in 1883; ex-Royal Holloway College). In his later years Hoare became increasingly gloomy about the state of the world and less active as a collector (though he initiated the family's patronage of Samuel Woodforde), making over Stourhead to his favourite grandson in 1783.

According to **Sir Richard Colt Hoare, 2nd Bt (1758–1838)**, 'an early habit of application to business induced me to have recourse to the pen and pencil'. Having been taught by John 'Warwick' Smith and Carlo Labruzzi, he became a talented topographical draughts-man, illustrating his own extensive travels in Italy. As well as portraits (cat. no.11) and fancy pictures, Samuel Woodforde painted copies of two figure groups in Poussin's *Rape*

of the Sabines, and of Raphael's *Parnassus*, for the Library that Colt Hoare added to the house c.1800. Austere in his personal habits and antiquarian in his interests, Colt Hoare had the contemporary fondness for sentiment and melodrama, which was gratified by paintings such as Henry Thomson's *Distress at Sea* (1804) and *by Land* (1811). He was, however, equally interested in collecting watercolours, acquiring two sets of ten watercolours apiece of Salisbury Cathedral and its environs from Turner between 1795 and c.1800 (all since sold). He got Francis Nicholson and J.C. Buckler to paint a series of views of the house and grounds, in 1813–14 and 1824 respectively, and Nicholson to paint *Stonehenge* and a watercolour copy of Loutherbourg's *An Avalanche*, which belonged to his friend and fellow-collector, Sir John Leicester. Nicholson also did a view of the Library showing the group of Canaletto drawings of the *Ceremonies of the Doge* he had unearthed in Venice in 1787 (all sold in 1883). He bought thirteen large highly finished watercolours from Louis Ducros, whom he believed had raised the technique to the status of oil painting, and which he framed and hung as such. He was also proud of having introduced Ducros' work to Turner, but commissioned only one oil from the latter – *Lake Avernus: Aeneas and the Cumaean Sibyl* (1814–15; Yale Center for British Art), after a drawing of his own and as a pendant to Richard Wilson's *Lake Nemi, with Diana and Callisto* (sold in 1883; on loan).

Colt Hoare's principal Old Master was Cigoli's huge altarpiece of *The Adoration of the Magi*, from the demolished church of S. Pietro Maggiore in Florence, which he bought in 1790 and which he had framed by Chippendale the Younger as the centre-piece of the Picture Gallery that he had built by c.1802 to display the best of the collection. He listed 53 paintings here in 1822 and was careful to distinguish his own acquisitions from those of his grandfather.

He was unusually systematic in hanging and framing the whole of his collection, devoting each room to a particular medium and category of painting. The visitor was first confronted with family portraits in the Entrance Hall, then by a mixture of British fancy pictures, Old Masters and copies of these, in the Music Room. The Dining Room was largely given over to pastels, many of them portraits; and the South Apartment beyond was entirely hung with sepia wash copies by J.J. Rouby and Jacob Seydelmann. More of these adorned the so-called Italian Room on the other side of the Staircase (to which lesser pictures were relegated), and beyond this was the climax of the collection, three rooms linked by a continuous wall-to-wall Brussels carpet: the Cabinet, which was now entirely given over to landscapes; the Ante-Room; and the Picture Gallery itself. Drawings and watercolours were in the Column Room and North Apartment, and

could be seen only by special application. The Saloon retained its large copies of the classics.

Colt Hoare's son predeceased him, leaving only a daughter, so Stourhead and its collections went to his half-brother and his descendants. Augusta East, Lady Hoare (d.1903), wife of the 5th Baronet (1824–94), was a friend of Leighton, who painted an idealised, but penetrating, portrait of this unhappy woman, in Paris in 1858, and of her daughter, 'Gussy', in profile, in 1860. Her husband's improvidence led to the sale of 1883, which included Rembrandt's magical nocturne of *The Flight into Egypt* (National Gallery of Ireland, Dublin), Fra Bartolomeo's *Holy Family* (National Gallery) and Dolci's *Salome* (Glasgow Art Gallery), and Colt Hoare's incomparable library of topographical and archaeological books (six volumes of his own drawings and watercolours were bought back later). Henry Hoare, 6th Bt (1865–1947), repaired some of the gaps left by the sale with pictures from Wavendon in Buckinghamshire. His wife, née Alda Weston, commissioned St George Hare to paint her husband (in 1907), her (in 1910) and their son (posthumously); the Hoares also acquired two watercolour subject-pictures, together with mildly titillating fancy pictures in oils. Having lost their only son in the First World War, and with the approach of the Second, they determined in 1938 to secure Stourhead by giving it to the National Trust, this taking effect in 1946. About 1960 Anthony Blunt weeded out and rehung the pictures in the Picture Gallery, which was redecorated in 1993–4 and, with the Music Room, rehung broadly following Colt Hoare's hang (allowing for losses and additions in and after 1883). In 1994–5 the St George Hares were placed in the re-Edwardianised Saloon.

LIT: Hoare Papers, Wilts RO; *Stourhead* 1800, 1818, 1822; Colt Hoare 1822; Waagen 1854, iii, pp.172–3; Sweetman 1901; Hazlitt 1903, ix, pp.55–6; Walpole 1927–8, pp.41–3 (visit in July 1762); Lees-Milne 1950, pp.248–50; Gore 1964[1] and 1964[2]; Gore 1969, pp.253–5; Woodbridge 1970; *Stourhead* 1981 (picture list); Cornforth 1994; *sales*: Christie's, 2 June 1883 (the pictures comprised 69 lots); Sotheby's, 30 July–6 Aug 1883 (books and prints, including albums of drawings and watercolours – 1,971 lots in all); Sotheby's, 9 Dec 1887 (remaining portion of the library).

Tatton Park (Cheshire)
35, 46, 49, 71

The key figure in the formation of the collection was **Wilbraham Egerton** in the first half of the 19th century. His son, William, 1st Lord Egerton, and his grandson and namesake, **Wilbraham, Earl Egerton**, added a number of mostly lesser pictures in the second half of the century. They shared a taste for 17th-century Italian Baroque painting, but also bought an eclectic mixture of Flemish primitives, Venetian *Cinquecento*, Dutch 17th-century genre, and sundry portraits, most notably the set of *Cheshire Gentlemen*.

In 1729 Samuel Egerton (1711–80) was apprenticed by his uncle, Samuel Hill of Shenstone (whose heir he ultimately became), as a clerk to Hill's business partner in Venice, Joseph Smith, already Canaletto's great promoter among British collectors. The two *Views of Venice* by Canaletto had been ordered by Hill when he was in Venice, but were only completed, after much gingerly chivvying by Smith and Egerton, in 1731. While in Venice Egerton was painted at length by Bartolomeo Nazzari. Hill had previously been active in buying pictures elsewhere in Italy, but had difficulty in extracting good paintings, writing from Rome in 1728: 'No man here parts with a picture or statue till he has sold his wife and every thing else yt can bring him any money.'

Wilbraham Egerton (1781–1856), who inherited Tatton in 1806, bought at auction, with a preference for large Baroque pictures, of the kind that the French Revolution had released onto the market in large quantities in Italy and Spain in the early 19th century. His outstanding purchase was Van Dyck's *Stoning of St Stephen* (cat. no.49); but he also bought two Guercinos, *Absalom and Tamar* (from Sir George Warrender's sale, like cat. no.71) and *Mars*; a major Dughet *Landscape* from the Falconieri and Radstock collections; and Poussin's (sadly wrecked) *Noah's Sacrifice* from the Cassiano dal Pozzo and Corsini collections. His 17th-century Dutch pictures included an italianate landscape by Berchem and peasant scenes by Bega and Koninck. More unusual for the period was his purchase in the Low Countries in 1816 of a pair of Early Netherlandish panel paintings, the two *Heads of Nicodemus* and *Joseph of Arimathea* derived from Rogier van der Weyden's *Descent from the Cross* (Prado). His Chardin, *La gouvernante* (cat. no.71), had been among the earliest works by this artist to reach Britain, and stands alone in the collection. The Egertons sat to none of the great 18th-century English portrait painters, but there is a good group of early 19th-century portraits in the Dining Room. Wilbraham Egerton's most important portrait commission was *The Cheshire Hunt*, painted in 1839 by the local sporting artist Henry Calvert, which dominates the Entrance Hall.

In 1869 his son, William, 1st Lord Egerton (1806–83), acquired and hung *The Cheshire Gentlemen* round the top of the Staircase at Tatton. This group of local gentry had met in 1715 at Ashley Hall, Cheshire (from which the pictures had been removed) to decide whom to support during the Jacobite rising. They chose the winning side, and celebrated their good judgement and fortune by commissioning these ten full-length portraits in 1720. Their painter has yet to be established. At the sale of remnants of the Angerstein collection in 1894, Lord Egerton bought Annibale Carracci's *Holy Family* (cat. no.46) – albeit as the work of a lesser master – and a *Venus finding the Dead Adonis* attributable to Antonio Carracci.

Wilbraham, 2nd Baron Egerton (1832–1909), who succeeded to Tatton in 1883, and was created **Earl Egerton** in 1887, had appeared as a small boy in *The Cheshire Hunt*. He bought a number of minor Italian Baroque pictures, including the little painting on copper of *St Hyacinthus in Adoration before a Vision of the Madonna* (stolen in 1986). He probably also bought the early *Cinquecento* paintings, which have suffered from over-cleaning. No fewer than three versions of Leader's *Manchester Ship Canal* (including cat. no.35) commemorate Earl Egerton's support for this major local project.

LIT: Egerton Papers, Cheshire RO, and John Rylands Library, Manchester; Chaloner 1950; Gore 1964[3], pp.692–4; Gore 1969, p.255.

Uppark (West Sussex)
55, 56

Uppark is, in large part, a rare survival of a Grand Tour collection, put together between 1748 and 1752 by **Sir Matthew Fetherstonhaugh** and his wife's brother, **Benjamin Lethieullier**, with a sprinkling of earlier portraits and Dutch and Flemish pictures probably collected by the former. The Batonis (e.g. cat. no.55) and Vernets (e.g. cat. no.56) have no equal as a group in Britain.

Ford Grey, 1st Earl of Tankerville (1655–1701), the builder of the house, sat to Peter Lely for the portrait now at Audley End, Essex. The 1st Earl's grandson, Charles, 2nd Earl of Tankerville of the 2nd creation (1697–1753), commissioned Pieter Tillemans in the 1720s to paint views of the house, and of the Downs towards South Harting.

In 1746 **Sir Matthew Fetherstonhaugh, 1st Bt** (1714–74) married Sarah Lethieullier (1722–88), who came from a rich and cultivated Huguenot family that included the antiquary Smart Lethieullier. She was herself an amateur artist, painting the exquisite watercolours on vellum of flora and fauna in the Red Drawing Room. Sir Matthew and his wife were painted in pastel by William Hoare of Bath and in small-scale oils by Arthur Devis, the latter as part of two sets of Lethieullier and Iremonger kin (dated 1748 and 1749), one of which was probably commissioned by Lady Fetherstonhaugh. In 1748 Sir Matthew was buying pictures in the Austrian Netherlands, possibly including the Snyders *Larder with Dead Game*, and other Dutch and Flemish works still in the house. Between 1749 and 1752 two family parties made the Grand Tour, meeting up in Rome and Naples in 1751. In Rome Sir Matthew and his brother-in-law, **Benjamin Lethieullier** (1728/9–97), commissioned portraits and allegories (cat. no.55) from Pompeo Batoni,

and a number of pictures from Vernet, including two sets of the *Four Times of Day* (the executed one being cat. no.56) and a set of replicas from Lacroix de Marseille. Other sets included eight studio versions of Canaletto's Venetian views (four destroyed in 1989), five views of Naples by Tommaso Ruiz, four pastoral landscapes by Zuccarelli, and four by Orizzonte, and six large pictures depicting episodes from the *Parable of the Prodigal Son* by Luca Giordano.

When Walpole visited Uppark in 1770, he noted 'no tolerable pictures' apart from portraits by Batoni, which suggests that the best of Sir Matthew's other Grand Tour acquisitions were then hung in his London house (now the Scottish Office), which had been built for him by James Paine in 1754–8. Shortly after Walpole's visit, two of the Giordanos, with Nathaniel Dance's full-length portraits of *George III* and *Queen Charlotte* (exh. RA, 1769), were placed in the Saloon in fixed plaster frames, as part of the redecoration of the room, probably again to designs by Paine. Sir Matthew's account book (1747–67), the principal evidence for his purchases, was destroyed by the fire in 1989, but a partial transcript survives.

Sir Harry Fetherstonhaugh, Bt (1754–1846), sat to Nathaniel Dance as a boy, in a portrait inspired by Batoni's portraits of his father and uncle as classic hunters. When he made the Grand Tour in 1776, he was also painted by Batoni, but in a larger-scale three-quarter-length. He became a friend of the Prince of Wales, the most voracious British picture collector of the age, and seems to have acted as one of his artistic advisers. However, he was less interested in paintings than in sculpture and the decorative arts, particularly French Empire furniture and porcelain. It was probably when his uncle Benjamin Lethieullier died in 1797 that Sir Harry inherited a number of the pictures that would have been hanging in his two country houses, Belmont in Middlesex, and Middleton in Hampshire (including cat. no.56, and possibly cat. no.55).

Comparison between picture-diagrams of *c*.1815 and the 1874 inventory reveals how little the arrangement was altered during the 19th century. The essentially conservative attitude of subsequent owners brought few further changes or additions to the collection. Of the pictures shown in the public rooms, the 1989 fire destroyed only François Musin's large *Battle of Trafalgar*, acquired by Admiral Meade-Fetherstonhaugh in the 1930s. However, from the family's private collection on the upper floors, which included important components of the original collection, only one trifling work was saved.

LIT: Fetherstonhaugh Papers, W. Sussex RO (which include the 1722 and 1874 inventories; those papers retained in the house were destroyed in 1989); Walpole 1927–8, p.68 (visit on 16 Aug 1770); Nares 1956; Gore 1965⁴; Gore 1969, p.256; *Uppark* 1995.

Upton House (Warwickshire)
9, 19, 24, 65, 69

In 1927 Upton became home to the burgeoning collections of **the 2nd Viscount Bearsted**. From a house bought and adapted to take, in the first instance, his father's fine but conventional collection of English 18th-century portraits and Dutch *petits-maîtres*, together with the beginnings of his own collection of English sporting pictures and paintings of rural life, it developed into the unusual phenomenon of an art gallery in a country house, containing English 18th-century conversation-pieces and narrative pictures, a roomful of Greuzes, Dutch 17th-century paintings, Early Flemish and Italian paintings, and Sèvres and Chelsea porcelain.

Upton was bought in 1757 by the banker Francis Child (1735–63), who kept his pictures at Osterley Park in Middlesex, using Upton merely as a hunting-lodge. Around 1803 Anthony Devis was commissioned to paint a pair of views of Upton, one of which was bought for the house by the National Trust in 1949. The Earls of Jersey succeeded by marriage to the Child inheritance in 1804 and themselves owned an important picture collection (the larger pictures from Osterley were destroyed by fire in 1949). But they lived mostly at Osterley, and at Middleton Park in Oxfordshire, and Upton was let or empty for much of the 19th century.

Its purchaser in 1927, **Walter Samuel, 2nd Viscount Bearsted (1882–1948)**, was the only son of Sir Marcus Samuel, 1st Viscount Bearsted (1853–1927), founder of the Shell Transport & Trading Co. Ltd in 1897, and its chairman until 1921. In 1895 the latter bought The Mote near Maidstone in Kent, which had been rebuilt in 1793–1801 by D. A. Alexander for the future 1st Earl of Romney, whose wife sat to Reynolds (exh. RA, 1777) and later to Gainsborough, who also painted their offspring, *The Marsham Children* (1787). None of these pictures came with the house, but the 1st Lord Bearsted bought comparable replacements, such as Romney's *William Beckford* (cat. no.9) and Reynolds's double portrait of *The Earl and Countess of Ely*, as well as a number of 19th-century pictures by such artists as Millais, Leighton and Watts, five of which he gave to the Guildhall Museum; the one survivor in the collection, Burne-Jones's *Love among the Ruins* (1894), is on loan to Wightwick Manor (q.v.).

The 2nd Viscount and his wife Dorothy were both painted at length by Lavery (family collection) during the First World War, in which he won the MC, but he only rarely bought subject-pictures by contemporary artists – though James Pryde was one exception. After his father's death in 1927, Lord Bearsted decided to sell The Mote, having given the park to the citizens of Maidstone and his father's collection of Japanese prints and *objets d'art* to the local museum. He bought Upton, which was

modernised for him by Morley Horder, because it offered better hunting-country and more space for his growing collections. Even so, in 1936 Trenwith Wills had to convert the racquets court into a top-lit Picture Gallery for his 15th- and 16th-century paintings. Other pictures were hung at 1 Carlton Gardens (now the official residence of the Foreign Secretary) and later in the Albany.

The 2nd Viscount shared his father's taste for the English 18th century, but from the start avoided swagger portraits, preferring a more intimate kind of painting, illustrative of English life. His first recorded purchases, in 1919, were of Stubbs's *Haymakers*, *Reapers* and *Labourers*, from the collection of Sir Walter Gilbey, Bt, the author of the first serious study of the artist, and father of Arthur Gilbey, pioneer collector of fishing pictures (cf. Wimpole Hall). He bought at first from Knoedler's, but increasingly from a variety of smaller dealers in London and on the Continent, and from *marchand-amateurs* such as Langton Douglas. He also bid at Christie's, advised by Sir Alec Martin of that house.

His English conversation-pieces and narrative pictures were sometimes by celebrated names such as Arthur Devis (*The Harthals Family*, bt 1928; and *The Edgar Children*, bt 1929) and Hogarth (cat. no.19). But just as often they were works by obscure artists, such as Robert West's *Smith Family* or J(ames?) Cole's *Flute-player*. It is in these and still anonymous pictures such as the *Francis(?) Popham fishing* or the '*Mr Poyntz of Bath*' *changing a Gun* that much of the charm and strength of this part of the collections lies.

He also began acquiring Early Nether-landish and Italian, and Dutch 17th-century pictures. Here, his touch was less sure, for several reasons. He disdained buying from Duveen (who, with all his roguery, did have the best pictures). Despite his immense wealth, he was not prepared to pay the dizzy sums offered by the American 'squillionaires' (Andrew Mellon outbid him for Cuyp's magnificent *The Maas at Dordrecht* in the second Brownlow sale in 1929). In this field, he was also susceptible to the lure of a great name. Not one of his three 'Rembrandts' has stood the test of time: the *Magus at an Altar* is the best – an early Rembrandtian Lievens, of which Rembrandt himself owned an example. His collection does not therefore match up to those that were being formed by the great American industrialists and bankers, and likewise being donated to public institutions. There are, nevertheless, masterpieces among the Dutch pictures at Upton: Metsu's '*Le corset bleu*' (cat. no.65), Flinck's enchanting *Child holding a Dog*, Jacob van Ruisdael's *Le coup de soleil*, Steen's '*The Tired Traveller*' and Saenredam's *Interior of the Church of St Catherine, Utrecht*.

Lord Bearsted's real distinction lay in his eye for the striking and unusual – for what was simply excellent on its own terms: first

and foremost, the utterly untypical, but deeply moving, *Death of the Virgin* by Pieter Bruegel, which once belonged to Rubens; the two panels by the maverick Jan Provost, particularly the hallucinatory *Nocturnal Nativity*; or the exquisite little *El Espolio* by El Greco, from the collection of Don Gaspar de Haro y Guzman, Marqués del Carpio (cf. cat. no.51); or even Paret's *View of El Astillero at Olaveaga* and the *Boys Flying Kites* attributed to Schalcken (cat. no.69). Of the pictures from his collection not included in his munificent donation to the National Trust in 1948, the masterpiece is Greuze's *Little Girl clutching a Spaniel* that once belonged to another great collector, the duc de Choiseul.

The 2nd Viscount Bearsted's position as a collector, civic benefactor and City magnate drew him into the museum world: he was a trustee of the National Gallery (1936–43; chairman, 1942–3), the Tate Gallery (1946–8) and the Whitechapel Art Gallery (1944–8), where the collection was exhibited in 1955.

LIT: Bearsted Papers, Warwicks RO; *Upton* 1950 (the basis for the 1955 Whitechapel exh. cat.); Lees-Milne 1950, pp.255–6; *Upton* 1964; Gore 1969, pp.256–8.

Wallington (Northumberland)
38

Wallington contains one of the most complex and appealing schemes of mid-Victorian mural decoration to survive in Britain, which was commissioned by **Sir Walter Calverley Trevelyan** and his first wife, **Pauline**. There are fairly complete, but confusing, lines of family portraits, beginning in, and strongest for, the late 17th century, with one or two highlights later, but they are rivalled in interest by the cabinet of curiosities created in the late 18th century by Dame Jane Wilson, of Charlton House, Greenwich, and by the collection of porcelain she initiated, which had to be bought back by her grandson, Sir Walter.

Although built by the Blackett magnates of Newcastle, Wallington as we see it today is essentially the creation of Sir Walter Calverley Blackett, 2nd Bt (1707–77). Born Walter Calverley, he married the illegitimate daughter of his uncle, the last of the Blackett baronets of Wallington, took his name, and set about transforming the house (to designs by Daniel Garrett, and with superb Rococo stucco by Pietro Lafranchini) and the gardens, turning barren moorland into 'a noble and well-ordered estate'. Arthur Young mentioned only five pictures after his visit in 1768, but included the Patel (cat. no.38) and Wootton's 'grotesque enough' *Dancing Dogs* of 1759; according to one of Sir Walter's contemporaries: 'His fondness for his little Dogs is quite ridiculous & Childish.' He sat for several portraits by Reynolds (a whole-length, c.1759–61, at Wallington; another, of 1760, in Newcastle Infirmary).

He is reputed to have been so angered by Young's satirical allusion to Gainsborough's portrait of his niece, Sukey Trevelyan, as 'the *portrait of a hat and ruffles*', that he got another artist (family tradition says Reynolds) to paint these out – as can indeed be seen.

Sir John Trevelyan, 4th Bt (1734–1828), inherited Wallington in 1777, but continued at the ancient family seat, Nettlecombe in Somerset. Romney's robustly English whole-length of him was bought for Wallington by the National Trust from Nettlecombe in 1991, with help from the NACF and the family. He handed Wallington over to his son, another John, later 5th Bt (1761–1846), on the latter's marriage to the great heiress Maria Wilson in 1791. The second Sir John was an amateur artist, making the Grand Tour and recording its sites in watercolours (but more often copied from other artists than of his own composition), and he put together a collection of Dutch Old Masters (since dispersed).

Sir Walter Calverley Trevelyan, 6th Bt (1797–1879), was the first member of the family to live exclusively at Wallington, but its mid-Victorian embellishment probably owes more to his wife, **Pauline Jermyn (1816–66)**, who was a gifted painter and encourager of talent. During their extended honeymoon in Italy in the 1840s she persuaded him to buy a number of important Early Italian pictures, including the *Madonna and Child Enthroned* by Piero della Francesca (Clark Art Institute, Williamstown, MA). She became a close friend of Ruskin, who fostered her taste for the Pre-Raphaelite in art. In 1856 the Trevelyans commissioned William Bell Scott, director of the School of Design in Newcastle, to decorate the Central Hall at Wallington, which John Dobson had created out of the open courtyard of the 17th-century house. His brief was 'to illuminate the history and worthies of Northumbria'. He filled the lower register with scenes ranging in time from the building of Hadrian's Wall to mid-19th century industrial Newcastle, all painted with Pre-Raphaelite finish and intense colour. Each of the piers between was decorated with closely observed plants by Pauline's friends, including Ruskin, who is said to have been so piqued when she corrected him on a point of botanical detail that he left his unfinished. Above are medallion portraits of famous Northumbrians, and in the first-floor spandrels a frieze depicting the battle of Otterburn, from the most famous of the Border ballads, *Chevy Chase*. The scheme is complemented by ideal and portrait sculpture in the round and in relief commissioned from the Pre-Raphaelite sculptors Alexander Munro and Thomas Woolner.

After Calverley Trevelyan's death in 1879, all the chattels (including the Early Italian pictures, which were sold) went to his nephew, Alfred, while the house and the family portraits passed to George Otto Trevelyan. George Otto and his wife Caroline partially made up for these losses by buying

furniture from the Duveens of Hull, and some comparable Early Italian pictures, of which only the *Madonna and Child* from the studio of Francesco Francia (bought in 1899) survives at Wallington, together with some lesser works by contemporaries such as Burne-Jones, Leighton and Watts.

Wallington was the second major house and estate pledged to the National Trust, deeded by Sir Charles Trevelyan, 3rd Bt (1870–1958), in 1941, as a matter of Socialist principle.

LIT: Blackett Papers, Northumb RO; Trevelyan Papers, Robinson Library, University of Newcastle; Pauline Trevelyan's diaries and many of her sketchbooks are in Kansas University Library; Young 1770; Gore 1969, p.258; on Walter Calverley and Pauline Trevelyan as patrons, see Trevelyan 1977 and 1978, and exh. cat. *Pre-Raphaelites: Patrons and Painters in the North-East*, Laing Art Gallery, Newcastle, 1989; *Wallington* 1994.

Wightwick Manor (Staffordshire)
14

Theodore Mander, a Wolverhampton paint-manufacturer, and his wife Flora commissioned Edward Ould to build the house in black-and-white 'Old English' style in 1887 (extended in 1893). They decorated it with Morris & Co. furnishings, Kempe stained glass and De Morgan tiles, but had more conventional late Victorian tastes in painting, buying chiefly English and Continental views. An exception was the small, early Italian *Virgin and Child* in the manner of Raffaellino del Garbo.

Their eldest son, Sir Geoffrey Mander, MP, succeeded in 1900; in 1930 he married, as his second wife, Rosalie Glynn Grylls. She persuaded him to give Wightwick to the National Trust in 1937, as its first endowed and furnished house, and the first acquired under the Country Houses Scheme, despite it being less than a decade older than the Trust itself. With time, however, even the survival of a house of this date with all its furnishings has become a rarity, while **Lady Mander (1905–88)**, who was a moving force in Pre-Raphaelite studies, made it into a unique centre of documentation of this movement, both by what she herself collected, or supported the National Trust in acquiring, and by what she encouraged her friends (sometimes descendants of the artists) to give or place on loan. Her *Portrait of Rossetti* was published in 1964.

The first major acquisition, in 1937, was a portrait begun by Rossetti of his mistress, *Janey Morris*, and completed after his death by Ford Madox Brown. The collection is particularly strong in portrait drawings, and includes Millais' small study in oil, *Effie Ruskin: The Foxglove*. Perhaps the most important picture in the house, apart from the Watts (cat. no.14), is Burne-Jones's late *Love among the Ruins* (1894; acquired by the 1st

Viscount Bearsted, and on loan from Upton). Associates of the Pre-Raphaelites, such as Frederick Sandys, G. P. Boyce, Simeon Solomon, Marie Spartali Stillman, Henry Treffry Dunn and George Howard are also represented.

Lady Mander was painted in academic dress by Feliks Topolski, who was befriended by her husband after he came to England as a refugee from Poland in 1940. Always a proud Cornishwoman, she left a *Self-portrait* by Opie (the 'Cornish Wonder') and his double portrait of his wife, *Amelia Alderson*, to the National Trust (Trerice).

LIT: Lees-Milne 1950, p.254; on the 'Pre-Raphaeladies', see Carter 1969; Gore 1969, p.258; *Wightwick Manor* 1993, pp.39–40; Stephen Ponder is preparing a catalogue of the collection.

Wimpole Hall (Cambridgeshire)
27, 28

Wimpole has been the home of two major historic collections: the first of every kind of literary item and *objet de virtù*, formed on a prodigious scale by **Edward Harley**; the second, above all of historic portraits, begun by the great Lord Chancellor, **Philip Yorke, 1st Earl of Hardwicke**. It now houses the lesser, but in its own way distinctive and pioneering, collection of narrative pictures and conversation-pieces formed by **Capt. George Bambridge**, together with the portraits of figures associated with Wimpole primarily bought by his widow, **Elsie**, who gave the estate, house and collections to the National Trust in 1976.

Edward, Lord Harley, 2nd Earl of Oxford (1689–1741) transformed the library of books and manuscripts (the latter acquired for the British Museum in 1753) begun by his father into perhaps the greatest ever formed in these islands, and had James Gibbs build the Library at Wimpole to take part of it. He was also a major patron of portrait painters, poets and scholars, particularly Michael Dahl, as Vertue noted in 1737: 'My good Lord Oxford has at heart the promoting of . . . Mr Dhal for face painting'. His sale included no fewer than eighteen portraits by the artist. He also commissioned over 40 horse and animal paintings, views and classical capriccios from John Wootton, and had James Thornhill decorate the Chapel at Wimpole with an altarpiece of *The Adoration of the Magi* and *trompe-l'oeil* decoration incorporating gilded 'statues' of the Four Doctors of the Church (completed in 1724). He bought Old Masters direct from Italy, from 1715 onwards through the Scottish painter-dealer Andrew Hay.

He died heavily in debt in 1741, forcing his widow, née Lady Henrietta Cavendish-Holles, to disperse his collection, which included some 300 (primarily Italian Baroque) Old Masters and portraits of famous persons, in a six-day sale held in March 1741/2. However,

'all the family pictures of the Cavendishes, Holles', Pierponts, Harleys, etc., Noblemen, Ladys and gentlemen in any ways related, my lady reserved for her own use not to be sold'. She also took with her to the houses of her daughter, Margaret, Duchess of Portland (Matthew Prior's 'noble, lovely, little Peggy'), Bulstrode Park in Buckinghamshire, and Welbeck Abbey in Nottinghamshire, almost all the Wootton animal pictures, eleven of which have been kindly lent back to the house by her descendant, Lady Anne Cavendish-Bentinck.

The Lord Chancellor, **Philip Yorke, 1st Earl of Hardwicke** (1690–1764), who bought Wimpole in 1740, also acquired some of Harley's historical portraits, including Kneller's whole-length of *Bishop Burnet* (still at Wimpole) to add to his own expanding collection of these. The grander examples probably hung with his Old Masters in the Gallery created by Henry Flitcroft in 1742. The latter included works by Titian, Rubens, Cuyp and Teniers. The 2nd Earl ('a bookish man, conversant only with parsons', according to Walpole) acquired superb pictures through his wife, Jemima, Marchioness Grey, granddaughter and heir of Henry, Duke of Kent, but kept them in the last's former house, 4 St James's Square. He sat to Gainsborough (1763; private collection), but was put off buying his landscapes (see p.99). He commissioned portraits of his wife (1741) from Allan Ramsay, who had painted his father at length (formerly Wrest Park, Beds). Reynolds painted his daughters (c.1761; Cleveland Museum of Art; oil sketch stolen from Wimpole in 1976), recommended an Italian restorer, Biondi, to clean his pictures, and wrote to him of the failure of 'our scheme of ornamenting St Paul's with Pictures'. The 2nd Earl was particularly fond of the work of Angelica Kauffman. He bought Wright of Derby's *Earthstopper on the Banks of the Derwent* (1773; Derby Art Gallery), but gave the artist only 50 guineas for it, and expected the frame to be thrown in free.

Soane created the Yellow Drawing Room for the 3rd Earl to display the best of the Hardwicke collection, but, curiously, it does not seem to have been used for this purpose. Elsewhere, Flemish and Dutch pictures predominated, also with a bias towards portraits of famous men, particularly lawyers. In 1880, thanks to the extravagance of Charles, 5th Earl of Hardwicke (the original 'Champagne Charlie'), 200 of these pictures, including many family portraits, were prepared for auction by Christie's, but at the last minute the sale was cancelled, and they seem to have been bought by other members of the family or sold privately, to dealers such as Charles and Asher Wertheimer, with the remainder put up at Christie's in 1888.

Wimpole never became the main seat of the Agar-Robartes family, whose family bank, as Lord Hardwicke's chief creditors, acquired the house in 1894, and when they left in

1936, they took whatever pictures they had introduced, together with one or two belonging to Wimpole, to Lanhydrock in Cornwall. The Bambridges had, therefore, to introduce their own. **Capt. George Bambridge** (1892–1943) had been a diplomat and seems to have begun modestly, collecting prints, particularly coaching and military subjects, whose portability and small scale suited his itinerant way of life and limited quarters. The 1930 exhibition of *English Conversation Pieces* appears to have sparked an interest in this new field of collecting, but he was not able to start buying seriously until he left the Diplomatic Service in 1933, and his wife, Rudyard Kipling's daughter, had inherited the royalties from her father's books in 1936. He had tried, but failed, to buy Luis Paret's *Paseo outside the Botanical Gardens, Madrid* in 1932. He bought the Hicks (cat. no.27) and two Tissots (including cat. no.28) in 1937. A Devis conversation-piece and two English fishing scenes from the sale of Arthur N. Gilbey's (cf. Upton) unique collection of angling pictures followed in 1940. Most unusually, he also bought Continental examples: Quinart and Lecomte's *The duc de Berry shooting an Eagle in the Forest of Fontainebleau* (1818; from the collection of the duchesse de Berry; bt c.1938), and Charles Thévenin's architectural view of the Neo-classical *Cotton Mill, House and Wharf of Richard-Lenoir* (1809; bt 1941). He was equally prepared to buy appealing anonymous works, such as the *Interior of Pattison's Shoe-shop* (c.1825; bt 1941). His finest and most fascinating purchase was probably W. E. Witherington's *A Modern Picture Gallery* (1824; bt 1941), which is both an anthology, and a plea for the patronage of contemporary British art, painted in the year of the foundation of the National Gallery.

Tragically, George Bambridge died in 1943 at only 51, just when he was making some of his best purchases in the salerooms, in the market from which most buyers were kept away by World War II. His widow, **Elsie** (1896–1976), continued to collect, but mainly works that reflected her passion for Wimpole. These included portraits of former owners, bought mainly through Leggatt Bros., but also Tilly Kettle's charming *Master George Graham* (1774), perhaps both on account of its Anglo-Indian and Cambridgeshire associations, and because of the children the Bambridges never had.

LIT: Harley and Hardwicke Papers, British Library; Bambridge Papers, Wimpole and Cambs RO; on Harley, see Vertue i–vi, *passim*; on Harley and Hay, see Pears 1988, pp.78–83; on Thornhill, see Allen 1985; on the 2nd Earl of Hardwicke's London pictures, see Walpole 1927–8, pp.39–40; on the 4th Earl's collection at Wimpole, see Waagen 1857, pp.518–23; on the Bambridge collection, see Laing 1991[1]; *Wimpole* 1991, pp.45–8; *sales*: 8 March ff. 1741/2; Christie's, 7 Aug 1880 (but see above); Christie's, 30 June 1888.

BIBLIOGRAPHY

Published in London, unless otherwise indicated.

Adriani 1940 G. Adriani ed., *Anton van Dyck, Italienisches Skizzenbuch*, Vienna, 1940.

Allen 1985 Brian Allen, 'Thornhill at Wimpole', *Apollo*, cxxii, Sept 1985, pp.204–11.

Allen 1991 Brian Allen et al., *The British Portrait*, Woodbridge, 1991.

Allende-Salazar 1925 Juan Allende-Salazar, *Velázquez*, Berlin and Leipzig, 1925.

Alpers 1971 Svetlana Alpers, *Corpus Rubenianum Ludwig Burchard*, ix: *The Decoration of the Torre de la Parada*, London and New York, 1971.

Alpers 1983 *The Art of Describing*, Chicago, 1983.

Ananoff and Wildenstein 1976 Alexandre Ananoff and Daniel Wildenstein, *François Boucher*, Lausanne and Paris, 1976, 2 vols.

Ananoff and Wildenstein 1980 *L'opera completa di Boucher*, Milan, 1980.

Andrew 1993 Patricia R. Andrew, 'Jacob More: Biography and a Checklist of Works', *Walpole Society*, lv, [1989/90] 1993, pp.105–96, figs.57–142.

Andrews 1977, 1985 Keith Andrews, *Adam Elsheimer*, Oxford, 1977; trans., Munich, rev. 1985.

Anglesey 1955 The [7th] Marquess of Anglesey ed., *The Capel Letters: 1814–1817*, 1955.

Anglesey 1961 *One-Leg*, 1961.

Angulo Iñiguez 1981 Diego Angulo Iñiguez, *Murillo*, Madrid, 1981, 3 vols.

Anon. 1819 Anon., *Catalogue of the Pictures, Casts and Busts Belonging to the Earl of Morley*, Plymouth, 1819, repr. 1844.

Anon. 1832 Anon., 'Neglected Biography. No.1. – R.M.Paye', *Library of the Fine Arts*, iii/13, Feb 1832, pp.95–101.

Anon. 1886 Anon., 'Attingham Hall', *Eddowes Salopian Journal*, 26 May, 2 June 1886; repr. in *The County Seats of Shropshire*, pt.2.

Antal 1962 Frederick Antal, *Hogarth and his Place in European Art*, 1962.

Archer et al. 1987 Mildred Archer, Christopher Rowell and Robert Skelton, *Treasures from India*, 1987.

Armstrong 1898 Sir W. Armstrong, *Gainsborough*, 1898.

Arnold-Forster 1950 Mary Arnold-Forster, *Basset Down*, 1950.

Ascott 1963 F. St John Gore et al., *The Ascott Collection*, NT, 1963; rev. 1974, repr. 1980.

Aspinall 1967–71 A. Aspinall ed., *The Correspondence of George, Prince of Wales*, 1967–71, 8 vols.

Attingham Anon., *Descriptive Catalogue of Paintings and Engravings. Attingham House, Shropshire*, n.d. [?1842–61].

Attingham Park 1992 *Attingham Park*, NT gbk, 1992.

Auerbach and Kingsley Adams 1971 E. Auerbach and C. Kingsley Adams, *Paintings & Sculpture at Hatfield House*, 1971.

Baddeley 1916 St Clair Baddeley, 'Dyrham, Gloucestershire', *Country Life*, 4 Nov 1916, pp.546–52.

Baglione 1642 Giovanni Baglione, *Le vite de' pittori, scultori, et architetti ... del 1572 ... a ... 1642*, Rome, 1642.

Baldinucci 1686 Filippo Baldinucci, *Cominciamento e progresso dell'arte dell'intagliare in rame*, Florence, 1686.

Bardi 1969 P.M. Bardi, *Tout l'oeuvre peint de Velázquez*, Paris, 1969.

Barnes and Wheelock 1994 Susan J. Barnes and Arthur K. Wheelock Jr ed., *Van Dyck 350*, Washington, 1994.

Barrington 1905 Mrs Russell Barrington, *G.F. Watts: Reminiscences*, 1905.

Bathoe 1757 *A Catalogue and Description of King Charles the First's Capital Collection*, 1757, published by William Bathoe.

Bauch 1966 Kurt Bauch, *Rembrandt: Gemälde*, Berlin, 1966.

Bauer and Haupt 1976 R. Bauer and H. Haupt, 'Das Kunstkammerinventar Kaiser Rudolphs II, 1607–11', *Jahrbuch der Kunsthistorischen Sammlungen in Wien*, lxxii, 1976.

Beard 1981 Geoffrey Beard, *Craftsmen and Interior Decoration in England 1660–1820*, Edinburgh, 1981.

Beard and Gilbert 1986 Geoffrey Beard and Christopher Gilbert ed., *Dictionary of English Furniture Makers 1660–1840*, 1986.

Beckett 1949 R.B. Beckett, *Hogarth*, 1949.

Bedoni 1983 Stefania Bedoni, *Jan Brueghel in Italia e il collezionismo del seicento*, Florence and Milan, 1983.

Beherman 1988 Thierry Beherman, *Godfried Schalcken*, Paris, 1988.

Bell 1905 M. Bell, *Watts*, 1905.

Bell 1968 Quentin Bell, *Bloomsbury*, 1968.

Bellori 1672 G.P. Bellori, *Le vite de' pittori, scultori, ed architetti moderni*, Rome, 1672.

Belton 1992 A. Tinniswood et al., *Belton House*, NT gbk, 1992.

Bence-Jones 1971 Mark Bence-Jones, 'The Taste of a Nabob: Clive of India as Builder and Collector', *Country Life*, 18, 25 Nov 1971, pp.1366–8, 1446–8.

Berenson 1932, 1957, 1963 B. Berenson, *Italian Pictures of the Renaissance*, Oxford, 1932; *Venetian School*, 1957; *Florentine School*, 1993.

Berger 1993 Andrea Berger, *Die Tafelgemälde Paul Brils*, Münster and Hamburg, 1993.

Berti 1967 L. Berti, *Il Principe dello Studiolo: Francesco I de' Medici e la fine del Rinascimento Fiorentino*, Florence, 1967.

Bertuch 1808 K. Bertuch, *Bemerkungen auf einer Reise aus Thüringen nach Wien im Winter 1805 bis 1806*, Weimar, 1808.

Biadi 1829 Luigi Biadi, *Notizie inedite della vita d'Andrea del Sarto*, Florence, 1829.

Białostocki 1966 Jan Białostocki, 'Puer sufflans ignes', *Arte in Europa: Scritti di storia dell'arte in onore di Eduardo Arslan*, 1966, i, pp.591–5.

Bingley 1798 Rev. William Bingley, *Excursions in North Wales*, 1798, 2 vols.

Blanc 1857, 1861 Charles Blanc, *Le trésor de la curiosité*, Paris, 1857; *Les trésors de la curiosité*, 1861.

Blondel 1752–6 J.-F. Blondel, *L'architecture françoise*, Paris, 1752–6, 3 vols.

Blunt 1975 Wilfrid Blunt, 'England's Michelangelo', 1975.

Blunt 1980 A. Blunt, 'Petworth Rehung', *National Trust Studies*, 1980, pp.119–32.

Blunt 1982 *Guide to Baroque Rome*, 1982.

Böckh 1821 F.H. Böckh, *Wiens lebende Schriftsteller*, Vienna, 1821.

Böckh 1823 *Merkwürdigkeiten der Haupt- und Residenz-Stadt Wien*, Vienna, 1823.

Bode 1880 Wilhelm Bode, 'Adam Elsheimer, der Römischer Maler Deutsche Nation', *Jahrbuch der Königlich Preussischen Kunstsammlungen*, i, 1880, pp.51–78, 245–62.

Bode 1897–1906 *The Complete Work of Rembrandt*, Paris, 1897–1906, 8 vols.

Bode 1906 *Rembrandt und seine Zeitgenossen*, Leipzig, 1906.

Boisclair 1986 Marie-Nicole Boisclair, *Gaspard Dughet*, Paris, 1986.

Bologna 1979 F. Bologna, *La parola del passato: Studi su Ercolano & Pompei*, 1979.

Borromeo 1624 Federico Borromeo, *De pictura sacra libri duo*, Milan, 1624; ed. C. Castiglione, Sora, 1932.

Borromeo 1625 *Musæum*, Milan, 1625; Italian trans. by L. Graselli, Milan, 1909.

Boschloo 1974 A.W.A. Boschloo, *Annibale Carracci in Bologna: Visible Reality in Art after the Council of Trent*, The Hague, 1974.

Boström 1990 A. Boström, 'A Rediscovered Florentine Bronze Group of the Rape of Proserpina, at Cliveden', *Burlington Magazine*, cxxii, Dec 1990, pp.829–40.

Boström 1991 'Sculpture at Cliveden', *Apollo*, cxxxiv, Aug 1991, pp.94–103.

Bottineau 1956, 1958 Yves Bottineau, *Bulletin hispanique*, Bordeaux, 1956, 1958.

Boynton 1971 Lindsay Boynton ed., 'The Hardwick Hall Inventory of 1601', *Furniture History*, vii, 1971, pp.1–40.

Brady 1839 John Henry Brady, *The Visitor's Guide to Knole ...*, Sevenoaks, 1839.

Bray 1778 William Bray, *Sketch of a Tour into Derbyshire and Yorkshire*, 1778.

Bray 1938 F.E. Bray, 'Extracts from the Diary of William Bray, the Surrey Historian,

1756–1800', *Surrey Archaeological Collections*, xlvi, 1938, pp.26–58.

Bredius 1927 A. Bredius, *Jan Steen*, Amsterdam, [1927].

Bredius 1935, 1969 *Rembrandt: Sämtliche Gemälde*, Vienna, 1935, rev. by H. Gerson as *Rembrandt: The Complete Edition of the Paintings*, London and New York, 3/1969.

Bridgman 1817 John Bridgman, *An Historical and Topographical Sketch of Knole*, 1817.

Brigstocke 1982 Hugh Brigstocke, *William Buchanan and the 19th-century Art Trade*, 1982.

Britton 1808 John Britton, *Catalogue Raisonné of the Pictures Belonging to the Most Honourable the Marquess of Stafford in the Gallery of Cleveland House*, 1808.

Brogi 1984 Alessandro Brogi, 'Aggiunti al giovane Annibale Carracci', *Paragone*, xxxv, July 1984, pp.44ff.

Broulhiet 1938 Georges Broulhiet, *Meindert Hobbema*, Paris, 1938.

Brown 1982 Christopher Brown, *Van Dyck*, Oxford, 1982.

Brown 1986 Jonathan Brown, *Velázquez: Painter and Courtier*, New Haven, 1986.

Brown 1994 Christopher Brown, 'Anthony van Dyck at Work: "The Taking of Christ" and "Samson and Delilah"', *Wallraf-Richartz-Jahrbuch*, lv, 1994, pp.43–54.

Brown and Ramsay 1990 Christopher Brown and Nigel Ramsay, 'Van Dyck's Collection: Some New Documents', *Burlington Magazine*, cxxxii, Oct 1990, pp.704–10.

Bruno 1978 R. Bruno, *Roma: Pinacoteca Capitolina*, Bologna, 1978.

Bryan 1801–2 Michael Bryan, *Catalogue of the Robit Collection*, 1801–2.

Buchanan 1824 William Buchanan, *Memoirs of Painting*, 1824, 2 vols.

Buckingham 1726 *The Works of John Sheffield, ... Duke of Buckingham*, 1726.

Bucklow 1993 Spike Bucklow, 'The 3rd Earl of Egremont, a Patron and his Portrait: New Light on Petworth', *Apollo*, June 1993, pp.363–6.

Bunt 1949 C. Bunt, *Windsor Castle through Three Centuries*, Leigh-on-Sea, 1949.

Burollet 1980 T. Burollet, *Musée Cognacq-Jay: Peintures et dessins*, Paris, 1980.

Busiri Vici 1974 A. Busiri Vici, *Jan Frans Van Bloemen "Orizzonte" e l'origine del paesaggio romano settecentesco*, Rome, 1974.

Butlin and Joll 1984 Martin Butlin and Evelyn Joll, *The Paintings of J.M.W. Turner*, New Haven and London, 1977, rev. 1984, 2 vols.

Butlin et al. 1989 M. Butlin, M. Luther and I. Warrell, *Turner at Petworth*, 1989.

Byron 1973–81 L.A. Marchand ed., *Byron's Letters and Journals*, 1973–81, 11 vols.

Calke Abbey 1989 Howard Colvin et al., *Calke Abbey*, NT gbk, 1989.

Calvert 1907 Albert E. Calvert, *The Grand Lodge of England*, 1907.

Calvert and Hartley 1908 A.F. Calvert and C.G. Hartley, *Velázquez*, 1908.

Calzini 1896 Egidio Calzini, 'La Galleria Merenda in Forlì e le pitture del Batoni in

essa contenute', *Arte e storia*, xv/17–18, 10, 30 Sept 1896.

Calzini and Mazzatinti 1893 E. Calzini and G. Mazzatinti, *Guida di Forlì*, Forlì, 1893.

Camón Aznar 1964 José Camón Aznar, *Velázquez*, Madrid, 1964, 2 vols.

Campbell 1990 Jill Campbell, 'Politics and Sexuality in Portraits of John, Lord Hervey', *Word and Image*, vi/4, Oct–Dec 1990, pp.281–97.

Carey 1819[1] [William Carey], *A Catalogue of Pictures by British Artists, in the Collection of Sir John Leicester, Bart.*, 1819.

Carey 1819[2] William Carey, *A Descriptive Catalogue of a Collection of Paintings by British Artists, in the Possession of Sir John Fleming Leicester, Bart.*, 1819.

Carotti 1901 Giulio Carotti, *Capi d'arti appartenenti a S.E. la Duchessa Joséphine Melzi d'Eril Barbò*, Bergamo, 1901.

Carter 1969 Ernestine Carter, 'The Pre-Raphaeladies', *Sunday Times*, 5 Oct 1969.

Casadei 1928 Ettore Casadei, *La città di Forlì e i suoi dintorni*, Forlì, 1928.

Céan Bermúdez 1800 J.A. Céan Bermúdez, *Diccionario historico de los más ilustres profesores de las bellas artes en España*, Madrid, 1800, 6 vols.

Chaloner 1950 W.H. Chaloner, 'The Egertons in Italy and the Netherlands 1729–1734', *Bulletin of the John Rylands Library*, xxxii/2, March 1950, pp.157–70.

Channon 1993 Robert Rhodes James ed., *'Chips': The Diaries of Sir Henry Channon*, 1967, pbk 1993.

Chapel 1982 Jeannie Chapel, *Victorian Taste: The Complete Catalogue of Paintings at the Royal Holloway College*, 1982.

Chapman 1930 G. Chapman, *A Bibliography of William Beckford of Fonthill*, 1930.

Chastel 1963 André Chastel, 'La figure dans l'encadrement de la porte chez Velázquez', *Actes du colloque Velázquez*, 1963.

Chastel 1978 *Fables, formes, figures*, Paris, 1978.

Chesterfield 1892 Lord Mahon ed., *The Letters of Philip Dormer Stanhope, Earl of Chesterfield*, 1892.

Childe-Pemberton 1924 William S. Childe-Pemberton, *The Earl-Bishop*, 1924, 2 vols.

Chyurlia 1953 Roberta Chyurlia, 'Pompeo Batoni o del classicismo settecentesco', *Emporium*, cxvii, 1953, pp.56–67.

Clark 1949, 1956 Kenneth Clark, *Landscape into Art*, 1949, repr. 1956.

Clark 1974 *Another Part of the Wood*, 1974.

Clark and Bowron 1985 Anthony M. Clark and Edgar Peters Bowron, *Pompeo Batoni*, Oxford, 1985.

Clarke 1824 W. Otter, *The Life and Remains of Edward Daniel Clarke*, 1824.

Clayden 1887 P.W. Clayden, *The Early Life of Samuel Rogers*, 1887.

Clayton 1913 E.W. Clayton, 'Richard Morton Paye', *Connoisseur*, xxxvii, 1913, pp.231–2.

Clifford 1977–8 T. Clifford, 'Cigoli's Adoration of the Magi at Stourhead', *National Trust Year-Book*, 1977–8, pp.1–17.

Cliveden 1994 Jonathan Marsden et al., *Cliveden*, NT gbk, 1994.

Cochin 1769 C.-N. Cochin, *Voyage d'Italie*, Paris, 1769, 3 vols.

Cochin 1780 *Essai sur la vie de Chardin*, Paris, 1780.

Coekelberghs 1976 Denis Coekelberghs, *Les peintres belges à Rome de 1700 à 1830*, Brussels and Rome, 1976.

Collins Baker 1912 C.H. Collins Baker, *Lely and the Stuart Portrait Painters*, 1912, 2 vols.

Collins Baker 1920 *Catalogue of the Petworth Collection of Pictures*, 1920.

Colt Hoare 1817 Richard Colt Hoare, 'On the Conduct of the Directors of the British Institution', *Annals of the Fine Arts*, ii, 1817.

Colt Hoare 1822 *The History of Modern Wiltshire: The Hundred of Mere*, 1822.

Colt Hoare 1983 M.W. Thompson ed., *The Journeys of Sir Richard Colt Hoare through Wales and England 1793–1810*, Gloucester, 1983.

Colvin 1963–82 H.M. Colvin ed., *The History of the King's Works*, i, ii, 1963; iii, 1975; iv, 1982; v, 1976; vi, 1973.

Colvin 1985 *Calke Abbey, Derbyshire: A Hidden House Revealed*, 1985.

Conisbee 1986 Philip Conisbee, *Chardin*, Oxford, 1986.

Conisbee 1990 *'Soap Bubbles' by Jean Siméon Chardin*, Los Angeles County Museum of Art, 1990.

Cook 1914 Sir Edward Cook, *Catalogue of the Pictures in the Gallery of Alleyn's College of God's Gift at Dulwich*, 1914.

Coope 1984 Rosalys Coope, 'The Gallery in England: Names and Meanings', *Design and Practice in British Architecture: Studies in Architectural History Presented to Howard Colvin, Architectural History*, xxvii, 1984, pp.446–55.

Cooper 1948 Douglas Cooper, 'Richard Wilson's Views of Kew', *Burlington Magazine*, xc, Dec 1948, pp.346–8.

Cornforth 1962 John Cornforth, 'An English Influence on French Art: The Work of R.P. Bonington', *Country Life*, 1 March 1962, pp.448–9.

Cornforth 1978 *English Interiors 1790–1848: The Quest for Comfort*, 1978.

Cornforth 1986 'Kingston Lacy Revisited', *Country Life*, 17, 24 April, 5, 12 June 1986, pp.1016–19, 1123–7, 1576–80, 1674–7.

Cornforth 1991 'Subtle Sequence Reconstructed', *Country Life*, 13 June 1991, pp.168–71.

Cornforth 1994 'Stourhead, Wiltshire', *Country Life*, 8 Sept 1994, pp.64–7.

Coural 1990 Natalie Coural, 'Le paysage avec ruines et pasteurs de Pierre Patel (1605–1676)', *Revue de Louvre*, no.4, 1990, pp.307–9.

Cowdry 1752 Richard Cowdry, *A Description of the Pictures, Statues, Bustos, and Other Curiosities at the Earl of Pembroke's House at Wilton* [1751], 2/1752.

Crathorne 1995 James Crathorne, *Cliveden*, 1995.

Creevey 1948 John Gore ed., *Creevey*, 1948.

Crivelli 1868 Giovanni Crivelli, *Giovanni Brueghel: Pittor fiammingo, o sue lettere e quadretti esistenti presso l'Ambrosiana*, Milan, 1868.

Croft-Murray 1962, 1970 Edward Croft-Murray, *Decorative Painting in England 1537–1837*, 1962, 2 vols; repr. 1970.

Crowe and Cavalcaselle 1877 J. A. Crowe and G. B. Cavalcaselle, *Titian: His Life and Times*, 1877, 2 vols.

CS J. Chaloner Smith, *British Mezzotinto Portraits*, 1878–83, 4 vols.

Curtis 1883 Charles B. Curtis, *Velazquez and Murillo*, London and New York, 1883

Cust 1900 L. Cust, *Anthony Van Dyck*, 1900.

Cust 1902 *A Description of the Sketchbook . . . in Chatsworth*, 1902.

Cust 1905 *The Royal Collection of Paintings, Buckingham Palace*, 1905, 2 vols.

Cust 1909 Lady Elizabeth Cust, *Records of the Cust Family: Series II: The Brownlows of Belton, 1550–1779*, 1909.

Cust 1914 Albinia Lucy Cust, *Chronicles of Erthig on the Dyke*, 1914, 2 vols.

Dafforne 1872 J. Dafforne, 'British Artists: Their Style and Character. No.CIV – George Elgar Hicks', *Art-Journal*, 1 April 1872, pp.97–9.

Dale 1901 Bryan Dale, *The Good Lord Wharton*, 1901.

Dallaway 1819 J. Dallaway, *The Parochial Topography of the Western Division of the County of Sussex*, ii, pt.1, 1819.

Darley 1990 G. Darley, *Octavia Hill*, 1990.

Davidson 1968 [Bernice Davidson], *Paintings in the Frick Collection*, 1968, 2 vols.

Davies 1819 Edward Davies, *The Life of Bartolomé E. Murillo*, 1819.

Davies 1907 Randall Davies, 'An Inventory of the Duke of Buckingham's Pictures, etc., at York House in 1635', *Burlington Magazine*, x, March 1907, pp.376–82.

Davis 1884 Charles Davis, *A Description of the Works of Art Forming the Collection of Alfred de Rothschild*, 1884, 2 vols.

DBI Dizionario biografico degli italiani, Rome, 1960–.

De Beruete 1906 Aureliano de Beruete, *Velázquez*, rev. edn, trans. Hugh E. Poynter, 1906.

De Blainville 1743–5 M. de Blainville, *Travels through Holland, Germany, Switzerland, and Other Parts of Europe . . .* , ed. Daniel Soyer, 1743–5, 3 vols.

De Groot 1952 C. W. de Groot, *Jan Steen: Beeld in woord*, Utrecht, 1952.

De Hollanda 1928 Francisco de Hollanda, *Four Dialogues on Painting*, trans. Aubrey Bell, 1928.

Delacroix 1895 *Journal de Eugène Delacroix*, ed. P. Flat and R. Piot, Paris, 1895, 3 vols.

Delacroix 1951 *The Journal of Eugène Delacroix*, ed. Herbert Wellington, trans. Lucy Norton, 1951.

De la Ferté 1776 Denis Pierre P[apillon] d[e]

l[a] F[erté], *Extrait des différens ouvrages publiés sur la vie des peintres*, Paris, 1776, 2 vols.

De Lairesse 1707 Gerard de Lairesse, *Het groot schilderboek*, Amsterdam, 1707.

De Maere and Wabbes 1994 J. de Maere and M. Wabbes, *Illustrated Dictionary of 17th Century Flemish Painters*, Brussels, 1994.

Demonts 1922 L. Demonts, *Catalogue des peintures exposées dans les galleries du Musée du Louvre, iii: Écoles flamande, hollandaise, allemande et anglaise*, Paris, 1922.

De Pantorba 1955 Bernardino de Pantorba, *La vida y obra de Velázquez*, Madrid, 1955.

De Pantorba 1964 *Tutta la pittura de Velazquez*, Milan, 1964.

De Saint-Non 1781–6 Abbé de Saint-Non, *Voyage pittoresque ou description des Royaumes de Naples et de Sicilie*, Paris, 1781–6.

Desenfans 1802 Noel Desenfans, *Descriptive Catalogue . . . of some pictures . . . purchased for . . . the late King of Poland*, 1802, 2 vols.

Dibdin 1920 E. Rimbault Dibdin, 'The State Gallery of H. H. the Maharja Gaekwar of Baroda, G.C.S.I. Part III – Continental Schools', *Connoisseur*, lvii, May 1920, pp.14–15.

Disraeli 1853 Benjamin Disraeli, *Vivian Grey*, 1825–6, repr. 1853.

DNB Dictionary of National Biography, 1882–.

Dodsley 1761 James and Robert Dodsley, *London and its Environs Described*, 1761.

D'Oench 1980 Ellen G. D'Oench, *The Conversation-piece: Arthur Devis and his Contemporaries*, New Haven, 1980.

Douglas-Pennant 1902 Hon. Alice Douglas-Pennant, *Catalogue of the Pictures at Penrhyn Castle and Mortimer House in 1901*, 1902.

Drost 1933 Willi Drost, *Adam Elsheimer und sein Kreis*, Potsdam, 1933.

Dubuisson 1909 A. Dubuisson, 'Richard Parkes Bonington', pt. II, *Revue de l'art ancien et moderne*, xxvi, Nov 1909.

Dubuisson and Hughes 1924 A. Dubuisson and C. E. Hughes, *Richard Parkes Bonington: His Life and Work*, 1924.

Dudok van Heel 1980 S. A. C. Dudok van Heel, *Doopsgezinde bijdragen*, n.s. vi, 1980.

Dunham Massey 1981, 1986 *Dunham Massey*, NT gbk, 1981, 1986.

Duparc 1993 F. J. Duparc, 'Philips Wouwerman, 1619–1668', *Oud Holland*, cvii/3, 1993, pp.257–86.

Dutuit 1883 E. Dutuit, *L'oeuvre complet de Rembrandt*, Paris, 1883.

Duvaux 1873, 1965 Louis Courajod ed., *Livre-journal de Lazare Duvaux*, Paris, 1873, repr. 1965.

Dyrham Park 1981 *Dyrham Park*, NT gbk, 1981.

Edwards 1948 Ralph Edwards, 'Mercier's Music Party', *Burlington Magazine*, xc, Nov 1948, pp.308–12.

Edwards 1954 *Early Conversation Pieces*, 1954.

Egmont 1920 *Diary of Viscount Percival, afterward First Earl of Egmont*, Historical MSS Commission, 1920.

Egremont 1985 Max Egremont, 'The Third Earl of Egremont and his Friends', *Apollo*, cxx, Oct 1985, pp.280–87.

Eisler 1977 Colin Eisler, *Paintings from the Samuel H. Kress Collection: European Schools Excluding Italian*, Oxford, 1977.

Erddig 1995 Oliver Garnett et al., *Erddig*, NT gbk, 1995.

Erskine 1902 Mrs Steuart Erskine, 'The Collection of Alfred de Rothschild in Seamore Place', *Connoisseur*, iii, June 1902, pp.71–9.

Ertz 1979 Klaus Ertz, *Jan Brueghel der Ältere*, Cologne, 1979.

Ertz 1984 *Jan Breughel the Younger*, Freren, 1984.

Evelyn 1955 E. S. de Beer ed., *The Diary of John Evelyn*, Oxford, 1955, 6 vols.

Evrard 1955 René Evrard, *Les artistes et les usines à fer*, Liège, 1955.

Fabbro 1951 C. Fabbro, 'Un ritratto inedito di Tiziano', *Arte veneta*, v, 1951, pp.185–6.

Fabre 1914 *Catalogue des peintures et sculptures exposées dans les galeries du Musée Fabre de la Ville de Montpellier*, 2/1914.

Faggin 1965 Giorgio T. Faggin, 'Per Paolo Bril', *Paragone*, xvi/185, 1965, pp.21–35.

Fairfax-Lucy 1958, 1977 Alice Fairfax-Lucy, *Charlecote and the Lucys: The Chronicle of an English Family*, Oxford, 1958; Norwich, 1977; pbk 1990.

Fairfax-Lucy 1983 *Mistress of Charlecote: The Memoirs of Mary Elizabeth Lucy*, 1983, pbk 1985.

Falchetti 1969 Antonia Falchetti, *La Pinacoteca Ambrosiana*, Milan, 1969.

Fanti 1981 Mario Fanti et al., *S. Maria della Carità in Bologna: Storia e arte*, Bologna, 1981.

Farington 1978–84 Angus McIntyre, Kenneth Garlick, Kathryn Cave ed., *The Diary of Joseph Farington*, 1978–84, 16 vols.

Fawkes 1814 W. Fawkes, *Catalogue Raisonné of the British Institution*, 1815.

Felbrigg 1980, 1995 *Felbrigg Hall*, NT gbks by Gervase Jackson-Stops, and John Maddison, 1980, 1995.

Feltham 1652 Owen Feltham, *A Brief Character of the Low Countries . . .* , 1652.

Felton 1785 [W. Felton], *An Explanation of Several of Mr. Hogarth's Prints*, 1785.

Fenyő 1958 I. Fenyő, 'Contributo ai rapporti artistici tra Palma il Giovane e Bernardo Strozzi', *Acta historiae artium academiae scientiarum hungariae*, v, 1958, pp.143–50.

Fernández Bayton 1981 Gloria Fernández Bayton, *Inventarios reales: Testamentaria del Rey Carlos II, 1701–1703*, Madrid, 1981.

Fernández Duro 1902 C. Fernández Duro, *El último Almirante de Castilla, Don Juan Tomás Enriquez de Cabrera*, Madrid, 1902.

Fielding 1974 Henry Fielding, *The History of Tom Jones, a Foundling*, 1749, ed. Fredson Bowers, Oxford, 1974.

Fiennes 1982 Christopher Morris ed., *The Illustrated Journeys of Celia Fiennes*, 1982.

Figgis 1993 Nicola F. Figgis, 'The Roman Property of Frederick Augustus Hervey, 4th Earl of Bristol and Bishop of Derry (1730–1803)', *Walpole Society*, lv, [1989–90] 1993, pp.77–103.

Fleischer 1978 R.E. Fleischer, 'Ludolf de Jongh and the Early Work of Pieter de Hooch', *Oud Holland*, xcii, 1978, pp.49–67.

Fleming 1958 John Fleming, 'Mr Kent, Art Dealer, and the Fra Bartolommeo Drawings', *Connoisseur*, cxli, March 1958, p.227.

Ford 1974 Brinsley Ford, 'The Earl Bishop, an Eccentric and Capricious Patron of the Arts', *Apollo*, xcix, June 1974, pp.426–34.

Ford 1975–6 'The Blathwayt Brothers of Dyrham in Italy on the Grand Tour', *The National Trust Year-Book*, 1975–6, pp.19–31.

Fothergill 1974 Brian Fothergill, *The Mitred Earl: An Eighteenth-century Eccentric*, 1974.

Fourth Report 1857 [*Parliamentary Papers*], *Fourth Report of the Department of Science and Art*, 1857.

Fraenckel 1935[1] I. Fraenckel, *Andrea del Sarto*, 1935.

Fraenckel 1935[2] 'Andrea del Sarto', Thieme-Becker, *Künstler-Lexikon*, Leipzig, 1935, xxix, pp.473–5.

Fredericksen 1988– Burton Fredericksen ed., *The Index of Paintings Sold in the British Isles during the Nineteenth Century*, Oxford, 1988–.

Freedberg 1963 S.J. Freedberg, *Andrea del Sarto*, Cambridge, MA, 1963, 2 vols.

Freedberg 1975 *Painting in Italy, 1500–1600*, Harmondsworth, 1975.

French 1988 Anne French ed., *The Earl and Countess of Howe by Gainsborough*, Iveagh Bequest, 1988.

Frimmel 1913, 1914 Theodor von Frimmel, *Lexikon der Wiener Gemälde-Sammlungen*, Munich, i, 1913; ii, 1914.

Fritzsche 1936 H. Fritzsche, *Bernardo Bellotto genannt Canaletto*, Magdeburg, 1936.

Fulcher 1856 G.W. Fulcher, *Life of Thomas Gainsborough R.A.*, 1856.

Fuller 1952 Thomas Fuller, *The Worthies of England* [1662], ed. J. Freeman, 1952.

Fuseli 1820 H. Fuseli, *Lectures on Painting Delivered at the Royal Academy*, 1820.

Gaehtgens and Lugand 1988 Thomas W. Gaehtgens and Jacques Lugand, *Joseph-Marie Vien*, Paris, 1988.

Gage 1838 John Gage, *The History and Antiquities of Suffolk: Thingoe Hundred*, 1838.

Gainsborough 1963 *The Letters of Thomas Gainsborough*, ed. Mary Woodall, rev. 1963.

Gállego 1968 Julián Gállego, *Vision et symboles dans la peinture espagnol du siècle d'or*, Paris, 1968.

Garlick 1955 Kenneth Garlick, 'Italian Art in Birmingham', *Connoisseur*, cxxxvi, July 1955, pp.35–9.

Garlick 1989 *Sir Thomas Lawrence*, Oxford, 1989.

Garrido Pérez 1992 Carmen Garrido Pérez, *Velázquez: Tecnico y evolucion*, Madrid, 1992.

Gatty 1976 R. Gatty, *Portrait of a Merchant Prince: James Morrison 1798–1857*, 1976.

Gautier 1864 Théophile Gautier, *Les dieux et les demi-dieux de la peinture*, Paris, 1864.

Gerson 1969 H. Gerson, *Rembrandt: Gemälde*, Gütersloh, 1969.

Girouard 1979 Mark Girouard, *The Victorian Country House*, New Haven, 1979.

Glück 1931 G. Glück ed., *Van Dyck*, New York, 2/1931.

Goethe 1830 J.W. von Goethe, *Die italienische Reise: Zweyter Römischer Aufenthalt*, in *Goethe's Werke: Vollständige Ausgabe letzter Hand*, Stuttgart and Tübingen, xxix, 1830; trans. as *Italian Journey, 1786–1788*, 1962, repr. 1970.

Gombrich 1966 Ernst Gombrich, 'The Renaissance Theory of Art and the Rise of Landscape', *Norm and Form*, 1966.

Goncourt 1881 Edmond de Goncourt, *La maison d'un artiste*, Paris, 1881, 2 vols.

Goncourt 1888–96 Edmond and Jules de Goncourt, *Journal*, Paris, 9 vols.

Goncourt 1958 *L'art du xviiie siècle*, Paris, 1860; trans. by Robin Ironside as *French XVIII Century Painters*, 1958.

Gonse 1882 L. Gonse, 'Exposition de maîtres anciens à la "Royal Academy" de Londres', *Gazette des Beaux-Arts*, xxv, March 1882, pp.288–91.

Goodison 1960 J.W. Goodison, *Catalogue of the Paintings, I: Dutch and Flemish, &c.*, Fitzwilliam Museum, Cambridge, 1960.

Goodman-Soellner 1977 Elise Goodman-Soellner, 'Boucher's *Madame de Pompadour at her Toilette*', *Simiolus*, xvii/1, 1977, pp.41–58.

Gorani 1793 J. Gorani, *Mémoires secrets et critiques des cours, des gouvernmens, et des moeurs des principaux états de l'Italie*, Paris, 1793, 3 vols.

Gore 1964[1] F. St John Gore, 'Prince of Georgian Collectors: The Hoares of Stourhead – I', *Country Life*, 30 Jan 1964, pp.210–12.

Gore 1964[2] 'A Worthy Heir to Greatness: The Hoares of Stourhead – II', *Country Life*, 6 Feb 1964, pp.278–80.

Gore 1964[3] 'From Venice to the Cheshire Hunt: Paintings at Tatton Park', *Country Life*, 17 Sept 1964, pp.692–4.

Gore 1964[4] 'An English Family at Home and Abroad: The Pictures at Ickworth House, Suffolk – I', *Country Life*, 3 Dec 1964, pp.1508–12.

Gore 1964[5] 'Gainsborough, Titian and Velazquez: The Pictures at Ickworth House, Suffolk – II', *Country Life*, 10 Dec 1964, pp.1654–6.

Gore 1965[1] 'An Edwardian Collection', *Country Life*, 10 June 1965, pp.1410–12.

Gore 1965[2] 'The Paintings of the Early Sackvilles: The Collection at Knole – I', *Country Life*, 7 Oct 1965, pp.886–8.

Gore 1965[3] 'Paintings Bought by a Duke: The Collection at Knole – II', *Country Life*, 14 Oct 1965, pp.972–4.

Gore 1965[4] 'A Grand-Tour Collection', *Country Life*, 2 Dec 1965, pp.1474–9.

Gore 1966[1] 'Buscot Park: The English Pictures', *Connoisseur*, clxi, Jan 1966, pp.2–6.

Gore 1966[2] 'A Patron of Portrait and Landscape: The Picture Collection at Saltram House, Devon', *Country Life*, 2 June 1966, pp.1386–8.

Gore 1969 'Pictures in National Trust Houses', supplement to *Burlington Magazine*, cxi, April 1969, pp.239–58.

Gore 1977 'Three Centuries of Discrimination', *Apollo*, cv, May 1977, pp.346–52.

Gore 1978 'Portraits and the Grand Tour', *Apollo*, cviii, July 1978, pp.24–31.

Gore 1986 'The Bankes Collection at Kingston Lacy', *Apollo*, cxxiii, May 1986, pp.302–12.

Gore 1989 'The Background to the Inventories Recording the Acquisitions of the 10th Earl of Northumberland and of the 2nd Earl of Egremont', in *The Fashioning and Functioning of the British Country House*, ed. Gervase Jackson-Stops, Washington, 1989, pp.121–31.

Gore 1993 '*Solvitur Ambulando*: The "Travels and Trials" of a National Trust Adviser', *Apollo*, cxxxvii, April 1993, pp.209–16.

Gougenot 1748 [L'abbé Gougenot], *Lettre sur la peinture, sculpture, et architecture, à M.****, Paris, 1748.

Grate 1994 P. Grate, *French Paintings II*, Swedish National Art Museums, Stockholm, 1994.

Graves 1876 Algernon Graves, *Catalogue of the Works of the late Sir Edwin Landseer, R.A.*, [1876].

Graves and Cronin 1899–1901 A. Graves and W.V. Cronin, *A History of the Works of Sir Joshua Reynolds*, 1899–1901, 4 vols.

Gronau 1904 G. Gronau, *Titian*, 1904.

Gudlaugsson 1959–60 S.J. Gudlaugsson, *Geraert ter Borch*, The Hague, 1959–60, 2 vols.

Guiffrey 1893 J. Guiffrey, 'Correspondance de Joseph Vernet avec le Directeur des Bâtiments sur la collection des Ports de France, et avec d'autres personnes sur divers objets, 1756–87', *Nouvelles archives de l'art français*, 3rd series, ix, 1893, pp.1–99.

Guiffrey 1896 *Sir Anthony Van Dyck*, 1896.

Guinness 1899 H. Guinness, *Andrea del Sarto*, 1899.

Haak 1984 Bob Haak, *The Golden Age: Dutch Painters of the 17th Century*, New York, 1984.

Hager 1964 Hellmut Hager, *S. Maria dell'Orazione e Morte*, Rome, 1964.

Hall 1962 D. Hall, 'The Tabley House Papers', *Walpole Society*, xxxviii, 1962, pp.59–122.

Hall 1994[1] Michael Hall, 'Anglesey Abbey, Cambridgeshire', *Country Life*, 9 June 1994, pp.102–7.

Hall 1994[2] Michael Hall, 'The English Rothschilds as Collectors', in Heuberger 1994.

Halsband 1973 Robert Halsband, *Lord Hervey: Eighteenth-century Courtier*, Oxford, 1973.

Hammelman 1968 H. A. Hammelman, 'Music-making at Home', *Country Life*, 24 Oct 1968, pp.1052–3.

Hardwick 1989 M. Girouard, *Hardwick Hall*, NT gbk, 1989.

Hardy 1978 John Hardy, 'Robert Adam and the Furnishing of Kedleston Hall', *Connoisseur*, cxcviii, July 1978, pp.196–207.

Hare W. L. Hare, *Watts*, n.d.

Harris 1978[1] John Harris, 'A Bird's-eye View of Dunham Massey', *Apollo*, cviii, July 1978, pp.4–11.

Harris 1978[2] Leslie Harris, 'The Picture Collection at Kedleston Hall', *Connoisseur*, cxcviii, July 1978, pp.208–17.

Harris 1985 John Harris, *The Artist and the Country House*, 1985.

Harris 1990 Enriqueta Harris, '"Las Meninas" at Kingston Lacy', *Burlington Magazine*, cxxxii, Feb 1990, pp.125–30.

Haskell 1971 Francis Haskell, *Patrons and Painters*, New York and London, 1963, repr. 1971.

Haskell 1976 *Rediscoveries in Art*, 1976.

Haskell and Penny 1981 Francis Haskell and Nicholas Penny, *Taste and the Antique*, New Haven and London, 1981.

Hawcroft 1958 Francis Hawcroft, 'The "Cabinet" at Felbrigg', *Connoisseur*, cxli, June 1958, pp.216–17.

Haydon 1963 W.B. Pope ed., *The Diary of Benjamin Robert Haydon*, Cambridge, MA, 1963.

Hayes 1969 John Hayes, 'English Painting and the Rococo', *Apollo*, xc, Aug 1969, pp.114–25.

Hayes 1982 *The Landscape Paintings of Thomas Gainsborough*, 1982, 2 vols.

Hazlitt 1902–6 A.R. Waller and A. Glover, *The Collected Works of William Hazlitt*, 1902–6, 13 vols.

Heikamp 1963 Detlef Heikamp, 'Zur Geschichte der Uffizien: Tribuna und der Kunstschränke in Florenz und Deutschland', *Zeitschrift für Kunstgeschichte*, xxvi, 1963, pts.3, 4, pp.193–268.

Held 1973 Julius Held, 'P.P. Rubens: The Leopards: "Originale de mia Mano"', Luneburg, 1970; repr. as a supplement to *Burlington Magazine*, cxv, May 1973.

Held 1980 *The Oil Sketches of Peter Paul Rubens*, Princeton, 1980, 2 vols.

Hertford Mawson 1981 John Ingamells ed., *The Hertford Mawson Letters*, 1981.

Herrmann 1972 Frank Herrmann, *The English as Collectors*, 1972.

Hervey 1894 S.H.A. Hervey, *Diary of John Hervey, 1st Earl of Bristol*, Wells, 1894.

Hervey 1931 Romney Sedgwick ed., *Some Materials towards Memoirs of the Reign of King George II, by John, Lord Hervey*, 1931, 3 vols.

Hervey 1954 David Erskine ed., *Augustus Hervey's Journal*, 1954.

Heuberger 1994 Georg Heuberger ed., *The Rothschilds*, Sigmaringen and Woodbridge, 1994, 2 vols: *A European Family* and *Essays on the History of a European Family*.

Higginson 1842 *A Descriptive Catalogue of the Gallery of Pictures Collected by Edmund Higginson, Esq.*, 1842.

Highfill et al. 1991 *A Biographical Dictionary of Actors, Actresses . . .*, xiii, 1991, ed. P.H. Highfill et al.

Hinterding and Horsch 1989 Erik Hinterding and Femy Horsch, '"A Small but Choice Collection": The Art Gallery of King Willem II of the Netherlands (1792–1849)', *Simiolus*, xix, no.1/2, 1989, pp.4–122.

Hodgson 1887 J.E. Hodgson, *Fifty Years of British Art*, 1887.

Hoet 1752 Gerard Hoet, *Catalogus of naamlyst van schilderyen*, The Hague, 1752, 2 vols.

Hofstede de Groot 1908–27 C. Hofstede de Groot, *A Catalogue Raisonné of the Most Eminent Dutch Painters of the Seventeenth Century . . .*, 1908–27, 8 vols.

Holford 1927 *Catalogue of the Holford Collection, Dorchester House*, ed. R.H. Benson, 1927, 2 vols.

Hollstein 1949– F.W.H. Hollstein, *Dutch and Flemish Etchings, Engravings and Woodcuts*, Amsterdam, 1949–.

Holmes 1993 Richard Holmes, *Dr Johnson and Mr Savage*, 1993.

Honour 1954 Hugh Honour, 'Leonard Knyff', *Burlington Magazine*, xcvi, Nov 1954, pp.337–8.

Horsley 1903 J.C. Horsley, *Recollections of a Royal Academician*, ed. Mrs Edmund Helps, 1903.

Hoser 1846 J.K.E. Hoser, *Catalogue raisonné, oder beschreibendes Verzeichnis der . . . Hoser'schen Gemälde-Sammlungen*, Prague, 1846.

Howard 1969 Deborah Howard, 'Some Eighteenth-century English Followers of Claude', *Burlington Magazine*, cxi, Dec 1969, pp.726–32.

Hume 1824 [Sir Abraham Hume], *A Descriptive Catalogue of a Collection of Pictures . . .*, 1824.

Humfrey 1993 Peter Humfrey, *The Altarpiece in Renaissance Venice*, New Haven, 1993.

Hüsgen 1780 R. Hüsgen, *Nachrichten von Frankfurter Künstlern und Kunstsachen*, Frankfurt am Main, 1780; as *Artistisches Magazin*, 2/1790.

Hussey 1925 Christopher Hussey, 'The Pictures at Petworth', *Country Life*, 12 Dec 1925, pp.899ff.

Hussey 1927 *The Picturesque*, 1927, repr. 1967.

Hussey 1946 'The Rex Whistler Room at Plas Newydd', *Country Life*, 22 Feb 1946, pp.342ff.

Iahn-Rusconi 1937 A. Iahn-Rusconi, *La R. Galleria Pitti in Firenze*, Rome, 1937.

Ickworth 1979 Gervase Jackson-Stops et al., *Ickworth*, NT gbk, 1979.

Ilchester 1920 The Earl of Ilchester, *Henry Fox, 1st Lord Holland: His Family and Relations*, i, 1920.

Ilchester 1937 *The Home of the Hollands, 1605–1820*, 1937.

Ilchester 1950 The Earl of Ilchester ed., *Lord Hervey and his Friends, 1726–38*, 1950.

Imbs 1971–83 Paul Imbs ed., *Trésor de la langue françoise*, Paris, 1971–83.

Impey and MacGregor 1985 O. Impey and A. MacGregor ed., *The Origins of Museums: The Cabinet of Curiosities in Sixteenth- and Seventeenth-century Europe*, Oxford, 1985.

Ingamells 1974 J. Ingamells, 'An Existence à la Watteau', *Country Life*, 7 Feb 1974, p.257.

Ingamells 1976 'A Hanoverian Party on a Terrace by Philip Mercier', *Burlington Magazine*, cxviii, July 1976, pp.511–15.

Ingamells and Raines 1976–8 John Ingamells and Robert Raines, 'A Catalogue of the Paintings, Drawings and Etchings of Philip Mercier', *Walpole Society*, xlvi, 1976–8 [1978], pp.1–70.

Ingersoll-Smouse 1926 Florence Ingersoll-Smouse, *Joseph Vernet: Peintre de marine*, Paris, 1926.

Ireland 1790 Samuel Ireland, *A Picturesque Tour through Holland, Brabant, and Part of France; Made in the Autumn of 1789*, 1790.

Ireland 1798 John Ireland, *Hogarth Illustrated*, 1798.

Ivanoff 1954 Nicola Ivanoff, 'I ritratti dell' Avogaria', *Arte veneta*, viii [1954], pp.276–8.

Jackson-Stops 1977 Gervase Jackson-Stops, 'Rex Whistler at Plas Newydd', *Country Life*, 4 Aug 1977, pp.18ff.

Jackson-Stops 1980 'Bordering on Works of Art' and 'Great Carvings for a Connoisseur': 'Picture Frames at Petworth – I, II', *Country Life*, 4, 25 Sept 1980, pp.798–9, 1030–32.

Jackson-Stops 1992 *An English Arcadia*, 1992.

Jacobson 1932 Gertrude Jacobson, *William Blathwayt*, New Haven, 1932.

Jaffé 1966 Michael Jaffé, 'The Picture of the Secretary of Titian', *Burlington Magazine*, cviii, March 1966, pp.114–27.

Jaffé 1989 *Rubens: Catalogo completo*, Milan, 1989.

Jameson 1844 Anna Jameson, *Companion to the Most Celebrated Private Galleries of Art in London*, 1844.

Jean-Richard 1978 Pierrette Jean-Richard, *L'oeuvre gravé de François Boucher dans la Collection Edmond de Rothschild, Inventaire générale des gravures: École française I*, Paris, 1978.

Johnson 1787 *The Works of Samuel Johnson, LL.D*, ed. Sir John Hawkins, 1787, 11 vols.

Johnson 1934–50 G.B. Hill ed., rev. L.F. Powell, *Boswell's Life of Johnson*, 1934–50, 6 vols.

Joll 1977 Evelyn Joll, 'Painter and Patron: Turner and the Third Earl of Egremont', *Apollo*, cv, May 1977, pp.374–80.

Jones 1946–8 A.P. Oppé ed., 'Memoirs of Thomas Jones', *Walpole Society*, xxxii, 1946–8, pp.1–162.

Jones 1978 Stanley Jones, 'The Fonthill Abbey Picture: Two Additions to the Hazlitt Canon', *Journal of the Warburg and Courtauld Institutes*, xli, 1978, pp.278–96.

Jovellanos 1885 G.M. Jovellanos, 'Reflexiones y conjeturas sobra el bozeto original del cuadro llamado *La Familia*' [1789], in J. Somoza, *Jovellanos: Nuevos datos para su biografía*, Madrid, 1885.

Justi 1888, 1903 Carl Justi, *Diego Velazquez und sein Jahrhundert*, Bonn, 1888, 2 vols, 2/1903.

Kauffmann 1973 C.M. Kauffmann, *Victoria & Albert Museum: Catalogue of Foreign Paintings*, i: *Before 1800*, 1973.

Kedleston 1769 *Catalogue of the Pictures, Statues, &c. at Kedleston* [1769].

Kedleston 1849, 1856 Anon., *Catalogue of the Pictures, Statues &c. at Kedleston*, 1849, 1856.

Kedleston 1988 Gervase Jackson-Stops et al., *Kedleston Hall*, NT gbk, 1988, rev. 1993.

Kennedy 1758 James Kennedy, *A New Description of the Pictures . . . at . . . Wilton*, Salisbury, 1758.

Kenworthy-Browne 1977 John Kenworthy-Browne, 'The Third Earl of Egremont and Neo-classical Sculpture', *Apollo*, cv, May 1977, pp.367–73.

Kenworthy-Browne 1993 'Designing around the Statues: Matthew Brettingham's Casts at Kedleston', *Apollo*, cxxxvii, April 1993, pp.248–52.

Kerber 1968 Bernard Kerber, 'Giuseppe Bartolomeo Chiari', *Art Bulletin*, l/1, March 1968, pp.75ff.

Kerr 1871 Robert Kerr, *The Gentleman's House*, rev. 3/1871.

Kerslake 1977 J. Kerslake, *National Portrait Gallery: Early Georgian Portraits*, 1977.

Ketton-Cremer 1962 R.W. Ketton-Cremer, *Felbrigg: The Story of a House*, 1962.

Kingston Lacy 1986, 1994 Anthony Mitchell et al., *Kingston Lacy*, NT gbks, 1986, 1994.

Kirschbaum 1977 Baruch D. Kirschbaum, *The Religious and Historical Paintings of Jan Steen*, Oxford, 1977.

Kitson 1978 Michael Kitson, *Claude Lorrain: Liber Veritatis*, British Museum, 1978.

Klamt 1975 J.-C. Klamt, 'Ut magis luceat: Eine Miszelle zu Rembrandts "Anslo"', *Jahrbuch der Berliner Museen*, xvii, 1975, pp.155–65.

Klesse 1973 Brigitte Klesse, *Katalog der italienischen, französischen und spanischen Gemälde bis 1800 im Wallraf-Richartz-Museum*, Cologne, 1973.

Klessmann 1983 Rüdiger Klessmann, *Die höllandischen Gemälde,* Herzog Anton Ulrich-Museum, Braunschweig, 1983.

Klingender 1947, 1968 F.D. Klingender, *Art and the Industrial Revolution*, 1947, rev. 1968.

Kloek 1993 Wouter T. Kloek, 'Calvaerts oefeningen met spiegelbeeldigheid', *Oud Holland*, cvii/1, 1993, pp.59–74.

Knapp 1907, 1928 Fritz Knapp, *Andrea del Sarto*, Bielefeld and Leipzig, 1907, 2/1928.

Koch 1834 J.A. Koch, *Moderne Kunstchronik . . .*, Karlsruhe, 1834.

Kozakiewicz 1972 S. Kozakiewicz, *Bernardo Bellotto*, Recklinghausen, 1972, 2 vols.

Krempel 1976 Ulla Krempel, 'Max Emmanuel als Gemäldesammler', in *Kurfürst Max Emmanuel: Bayern und Europa um 1700*, ed. Hubert Glaser, Munich, 1976.

Kuretsky 1979 Susan Donahue Kuretsky, *The Paintings of Jacob Ochtervelt (1634–1682)*, Oxford, 1979.

La Font de Saint Yenne 1747 [La Font de Saint Yenne], *Reflexions sur quelques causes de l'état présent de la peinture en France*, The Hague, 1747.

Lafuente Ferrari 1943 Enrique Lafuente Ferrari, *Velázquez: Complete Edition*, 1943.

Lagrange 1864 Louis Lagrange, *Les Vernet: Joseph Vernet et la peinture au XVIIIe siècle*, Paris, 1864.

Laing 1984 Alastair Laing, 'Baroque Sculpture in a Neo-Baroque Setting', in *The London Oratory: Centenary 1884–1984*, ed. Michael Napier and Alastair Laing, 1984, pp.65–83.

Laing 1986 'Playful Perfection: Boucher in Britain', *Country Life*, 5 June 1986, pp.1566–8.

Laing 1990 'Sensible, Sincere Creatures', *Country Life*, 8 Feb 1990, pp.62–5.

Laing 1991[1] 'Every Picture Tells a Story', *Country Life*, 21 March 1991, pp.110–13.

Laing 1991[2] 'Whence This Clutch of Four?', *Country Life*, 13 June 1991, pp.172–3.

Laing 1992 'Quarry of Old Masters', *Country Life*, 19 March 1992, pp.66–9.

Laing 1993[1] 'Sir Peter Lely and Sir Ralph Bankes', in *Art and Patronage in the Caroline Courts*, ed. David Howarth, Cambridge, 1993, pp.107–31.

Laing 1993[2] 'O Tempera, O Mores! The Ruin Paintings in the Dining Room at Shugborough', *Apollo*, cxxxvii, April 1993, pp.227–32.

Laing and Hirst 1986 Keith Laing and Michael Hirst, 'The Kingston Lacy Judgement of Solomon', *Burlington Magazine*, cxxviii, April 1986, pp.273–86.

Laing and Strachey 1994 Alastair Laing and Nino Strachey, 'The Duke and Duchess of Lauderdale's Pictures at Ham House', *Apollo*, cxxxix, May 1994.

Lane 1895 J. Lane, *Masonic Records 1717–1894: Being Lists of All the Lodges*, 1895.

Lang 1897 Andrew Lang, *The Life and Letters of John Gibson Lockhart*, 1897, 2 vols.

Larsen 1980 E. Larsen, *L'opera completa di Van Dyck*, Milan, 1980, 2 vols.

Larsen 1988 *The Paintings of Anthony van Dyck*, Freren, 1988, 2 vols.

Lasdun 1981 Susan Lasdun, *Victorians at Home*, 1981.

Latham 1965 R.E. Latham, *Revised Medieval Latin Word-list*, 1965.

Launay 1991 Elisabeth Launay, *Les frères Goncourt collectionneurs de dessins*, Paris, 1991.

Laver 1936 James Laver, *Vulgar Society: The Romantic Career of Tissot*, 1936.

Leach 1988 Peter Leach, *James Paine*, 1988.

Le Blanc 1745 L'abbé J.-B. Le Blanc, *Lettres d'un françois*, The Hague, 1745.

Le Blanc 1747 [L'abbé J.-B. Le Blanc], *Lettre sur l'exposition des ouvrages de peinture, sculpture, &c. de l'année 1747*, Paris, 1747.

Le Blanc 1753 *Observations sur les ouvrages . . . exposés au Salon du Louvre en l'année 1753*, Paris, 1753.

Lecaldano 1969 Paolo Lecaldano, *L'opera pittorica completa di Rembrandt*, Milan, 1969.

Leech 1907 Sir Bosdin Leech, *History of the Manchester Ship Canal*, Manchester and London, 1907, 2 vols.

Lees-Milne 1950 James Lees-Milne, 'National Trust Collections', in *The Nation's Pictures*, ed. A. Blunt and M. Whinney, 1950.

Lees-Milne 1975 *Ancestral Voices*, 1975.

Lees-Milne 1976–7 'The Early Years of the Country Houses Scheme', *The National Trust Year-Book*, 1976–7, pp.81–7.

Lees-Milne 1977 *Prophesying Peace*, 1977.

Lees-Milne 1992 *People and Places*, 1992.

Le Fanu 1960 William Le Fanu, *A Catalogue of the Portraits and Other Paintings, Drawings and Sculpture in the Royal College of Surgeons of England*, 1960.

Le Moël and Rosenberg 1969 M. Le Moël and P. Rosenberg, 'La collection de tableaux du duc de Saint-Aignan et le catalogue de sa vente illustré par Gabriel de Saint-Aubin', *Revue de l'art*, no.6, 1969, pp.51–67.

Lennie 1976 Campbell Lennie, *Landseer: The Victorian Paragon*, 1976.

Leonardo da Vinci 1956 Leonardo da Vinci, *Trattato della pittura*, trans. and ed. A. Philip McMahon as *Treatise on Painting*, Princeton, 1956.

Leslie 1860 Tom Taylor ed., *Autobiographical Recollections by the late Charles Robert Leslie, R.A.*, 1860, 2 vols.

Leslie and Taylor 1865 C.R. Leslie and T. Taylor, *The Life and Times of Sir Joshua Reynolds*, 1865, 2 vols.

Levey 1964 Michael Levey, *The Later Italian Pictures in the Royal Collection*, 1964.

Levey 1966 *Rococo to Revolution: Major Trends in Eighteenth Century Painting*, 1966.

Levey 1971 *The Seventeenth and Eighteenth Century Italian Schools: The National Gallery*, 1971.

Lichtenberg 1794 G.C. Lichtenberg, *Ausführliche Erklärung der Hogarthischen Kupferstiche, Erste Lieferung*, Göttingen, 1794.

Lichtenberg 1966 Innes and Gustav Herden ed., *Lichtenberg's Commentaries on Hogarth's Engravings*, 1966.

Liebenwein 1977 W. Liebenwein, *Studiolo: Die Entstehung eines Raumtyps und seine Entwicklung bis um 1600*, Berlin, 1977.

Links 1973 J.G. Links, 'Bellotto Problems', *Apollo*, xcvii, Jan 1973, pp.107–10.

Lippincott 1983 Louise Lippincott, *Selling Art in Georgian London: The Rise of Arthur Pond*, New Haven and London, 1983.

Lipscombe 1802 George Lipscombe, *A Description of Matlock Bath*, Birmingham, 1802.

Lloyd Williams 1994 Julia Lloyd Williams, 'Ale, Altruism and Art', *Apollo*, cxxxix, May 1994, pp.47–53.

Loche and Röthlisberger 1978 Renée Loche and Marcel Röthlisberger, *L'opera completa di Liotard*, 1978.

Lomazzo 1598 G.P. Lomazzo, *Trattato dell'arte delle pittura, scultura et architettura*, Milan, 1584; trans. as *A Tracte Containing the Artes of Curious Paintinge, Carvinge & Buildinge*, 1598, repr. 1970.

López-Rey 1963 José López-Rey, *Velázquez: A Catalogue Raisonné of his Oeuvre*, 1963.

López-Rey 1979 *Velázquez*, Lausanne and Paris, 1979.

Loveday 1890 John Loveday, *Diary of a Tour in 1732*, ed. J. Loveday, Edinburgh, 1890.

Lucy 1862 Mary Elizabeth Lucy, *Biography of the Lucy Family*, 1862.

Lugt 1921 Frits Lugt, *Les marques de collections de dessins & d'estampes*, Amsterdam, 1921.

Lummis and Marsh 1990 Trevor Lummis and Jan Marsh, *The Woman's Domain*, 1990, pp.63–90 [on Theresa and Anne Robinson].

Lusk 1901 Lewis Lusk, 'The Life & Work of B.W. Leader, R.A.', *The Art Annual*, 1901 [Christmas number of *The Art-Journal*].

Luzio 1913 A. Luzio, *La galleria dei Gonzaga venduta all'Inghilterra*, Milan, 1913.

MacGregor 1989 Arthur MacGregor ed., *The Late King's Goods*, 1989.

McKay and Roberts 1909 W. McKay and W. Roberts, *John Hoppner, R.A.*, 1909, 2/1914.

Mackie 1858 Samuel Joseph Mackie, *Knole House: Its State Rooms, Pictures and Antiquities*, [1858?].

MacLaren 1960 Neil MacLaren, *National Gallery Catalogues: The Dutch School*, 1960.

MacLaren and Braham 1970 Neil MacLaren, rev. by Allan Braham, *National Gallery Catalogues: The Spanish School*, 1970, repr. 1988.

MacLaren and Brown 1991 Neil MacLaren, rev. by C. Brown, *The Dutch School 1600–1900: The National Gallery*, 1991.

Maclarnon 1986 Kathleen Maclarnon, 'W.J. Bankes in Egypt', *Apollo*, cxxiv, Aug 1986, pp.116–20.

Maclarnon 1990 'William Bankes and his Collection of Spanish Paintings at Kingston Lacy', *Burlington Magazine*, cxxxii, Feb 1990, pp.114–25.

Macleod 1986 Dianne Sachko Macleod, 'Mid-Victorian Patronage of the Arts: F.G. Stephens's "The Private Collections of England"', *Burlington Magazine*, cxxviii, Aug 1986, pp.597–607.

Mcnaghten 1955 Angus Mcnaghten, *Family Roundabout*, Edinburgh, 1955.

Mcnaghten 1958 *Family Quest*, Cambridge, 1958.

Maddalo 1982 Silvia Maddalo, *Adrien Manglard*, Rome, 1982.

Malafarina 1976 Gianfranco Malafarina, *L'opera completa di Annibale Carracci*, Milan, 1976.

Malvasia 1841 C.C. Malvasia, *Felsina pittrice* [1678], ed. Giampetrino Zanotti, Bologna, 1841, 2 vols.

Manners and Williamson 1920 Lady Victoria Manners and Dr G.C. Williamson, *John Zoffany, R.A.: His Life and Works. 1735–1810*, 1920.

Manwaring 1925 E.W. Manwaring, *Italian Landscape in Eighteenth-century England*, New York, 1925; repr. London, 1965.

Marcucci 1944 Luisa Marcucci, 'Pompeo Batoni a Forlì', *Emporium*, xcix, 1944, pp.95–105.

Mariette 1851/3–59/60 Pierre-Jean Mariette, *Abecedario*, Paris, 1851/3–59/60, 6 vols, ed. P. de Chennevières and A. de Montaiglon.

Markham 1984 Sarah Markham, *John Loveday of Caversham*, Wilton, 1984.

Martin 1913 Willem Martin, *Gerard Dou: Des Meisters Gemälde*, Stuttgart and Berlin, 1913.

Martin 1954 *Jan Steen*, Amsterdam, 1954.

Martin 1970 Gregory Martin, *National Gallery Catalogues: The Flemish School circa 1600–circa 1900*, 1970.

Martin and Feigenbaum 1979 J.R. Martin and G. Feigenbaum, *Van Dyck as a Religious Artist*, Princeton, 1979.

Martyn 1767 Thomas Martyn, *The English Connoisseur*, Dublin, 1767.

Masini 1666 Antonio de Paolo Masini, *Bologna perlustrata*, Bologna, 3/1666.

Masters 1989 Brian Masters, *Great Hostesses*, 1982, pbk 1989.

Matteucci 1956 A.M. Matteucci, 'Note all'attività genovese di B. Strozzi', *Emporium*, 1956, pp.195–204.

Mayer 1910 Anton Mayer, *Das Leben und die Werke der Brüder Matthaeus und Paul Bril*, Leipzig, 1910.

Mayer 1913, 1923 August L. Mayer, *Murillo*, Stuttgart and Berlin, 1913, 2/1923.

Mayer 1936 *Velazquez: A Catalogue Raisonné of the Pictures and Drawings*, 1936.

Meade-Fetherstonhaugh and Warner 1964 Margaret Meade-Fetherstonhaugh and Oliver Warner, *Uppark and its People*, 1964.

Melville 1910 Lewis Melville, *The Life and Letters of William Beckford of Fonthill*, 1910.

Mérot 1987 Alain Mérot, *Eustache Le Sueur*, Paris, 1987.

Merrill 1981 Ross Merrill, 'A Step towards Revising our Perception of Chardin', *Pre-prints of Papers Presented at the Ninth Annual Meeting of the American Institute for Conservation of Historic and Artistic Works*, Philadelphia, PA, Washington, 1981.

Mesonero Romanos 1899 Manuel Mesonero Romanos, *Velázquez fuera del Museo del Prado*, Madrid, 1899.

Meyer 1985 Arlene Meyer, 'Wootton at Wimpole', *Apollo*, cxxii, Sept 1985, pp.212–19.

Michaelis 1877 A. Michaelis, *Ancient Marbles in Great Britain*, 1882.

Michel 1893, 1894 Emile Michel, *Rembrandt: Sa vie, ses oeuvres et son temps*, Paris, 1893; Eng. trans. 1894, 2 vols.

Millar 1963 O. Millar, *Tudor, Stuart and Early Georgian Pictures in the Collection of Her Majesty the Queen*, Oxford, 1963.

Millar 1994 'Philip, Lord Wharton, and his Collection of Portraits', *Burlington Magazine*, cxxxvi, Aug 1994, pp.517–30.

Millar 1995 'The Painter "IH" at Lyme Park', *Apollo*, cxli, April 1995, pp.8–11.

Mirimonde 1966–7 A. de Mirimonde, 'La musique dans les allégories de l'amour, I: Vénus; II: Eros', *Gazette des Beaux-Arts*, lxviii, Nov 1966, pp.265–90; lxix, May–June 1967, pp.319–46.

Moes 1897–1905 E.W. Moes, *Iconographia Batava*, Amsterdam, 1897–1905, 2 vols.

Monti 1965 Raffaele Monti, *Andrea del Sarto*, Milan, 1965.

Moore 1985 Andrew W. Moore, *Norfolk and the Grand Tour*, 1985.

Moore 1988 *Dutch and Flemish Painting in Norfolk*, 1988.

Mortari 1966 Luisa Mortari, *Bernardo Strozzi*, Rome, 1966.

Murray 1962 [Peter Murray], *Catalogue of the Lee Collection, Courtauld Institute of Art*, rev. 1962.

Murray 1980 *The Dulwich Picture Gallery: A Catalogue*, 1980.

Namier and Brooke 1964 Sir Lewis Namier and John Brooke, *The House of Commons 1754–1790*, 1964, 3 vols.

Nares 1956 Gordon Nares, 'The Treasures of Uppark', *Country Life Annual*, 1956, pp.40–45.

Natali and Cecchi 1989 Antonio Natali and Alessandro Cecchi, *Andrea del Sarto*, Florence, 1989.

Naumann 1978 Otto Naumann, 'Frans van Mieris as a Draughtsman', *Master Drawings*, xvi/1, spring 1978, pp.3–34.

Naumann 1981 *Frans van Mieris (1635–1681) the Elder*, Doornspijk, 1981, 2 vols.

Naylor 1965 Leonard E. Naylor, *The Irrepressible Victorian*, 1965.

Neale 1818–23, 1824–9 J.P. Neale, *Views of the Seats of Noblemen and Gentlemen*, 1818–23, 6 vols; 2nd series, 1824–9.

Nevill 1906 Lady Dorothy Nevill, *Reminiscences*, 1906.

Nichols 1781, 1782, 1785 John Nichols, *Biographical Anecdotes of William Hogarth and a Catalogue of his Works*, 1781, rev. 1782, rev. 1785.

Nichols and Steevens 1808, 1810, 1817 J. Nichols and G. Steevens, *The Genuine Works of William Hogarth*, i, 1808; ii, 1810; iii, 1817.

Nieuwenhuys 1843 C. J. Nieuwenhuys, *Description de la galerie des tableaux de S.M. Le Roi des Pays-Bays*, 1/1837; Brussels, 1843.

Nordhoff and Reimer 1994 C. Nordhoff and H. Reimer, *Jakob Philipp Hackert 1737–1807: Verzeichnis seiner Werke*, Berlin, 1994, 2 vols.

Norgate 1919 E. Norgate, *Miniatura, or the Art of Limning*, ed. M. Hardie, Oxford, 1919.

North 1890 Roger North, *The Life of the Right Hon. Francis North, Lord Guildford*, ed. Augustus Jessop, 1890.

North 1946 F. J. North, *Slates of Wales*, 1927, 3/1946.

Ochoa 1835 E[ugenio de] O[choa], 'Velázquez', *El artista*, i, 1835, pp.13–15.

Ogden 1955 Henry and Margaret Ogden, *English Taste in Landscape in the Seventeenth Century*, Ann Arbor, 1955.

Oliver 1894, 1899 Vere Langford Oliver, *The History of the Island of Antigua*, i, 1894; iii, 1899.

Olsen 1961 H. Olsen, *Italian Paintings and Sculpture in Denmark*, Copenhagen, 1961.

Orso 1993 Steven N. Orso, *Velázquez, Los Borrachos, and Painting at the Court of Philip IV*, Cambridge, 1993.

Ottley and Tomkins 1818 William Young Ottley and Peltro Williams Tomkins, *Engravings of the Most Noble The Marquess of Stafford's Collection of Pictures in London . . .* , 1818, 4 vols.

Pallucchini 1969 Rodolfo Pallucchini, *Tiziano*, Florence, 1969, 2 vols.

Pallucchini 1981 *La pittura veneziana del seicento*, Milan, 1981, 2 vols.

Palmerini 1824 N. Palmerini, *Opere d'intaglio del Cav. Raffaello Morghen*, Florence, 1824.

Palomino 1724, 1987 Acisclo Antonio Palomino de Castro y Velasco, *El museo pictórico y escala óptica*, ii, pt.3: *El Parnaso español pintoresco laureado*, Madrid, 1724; trans. Nina Ayala Mallory, Cambridge, 1987.

Palumbo-Fossati 1982 Carlo Palumbo-Fossati, *Gli stuccatori ticinesi Lafranchini in Inghilterra e in Irlanda nel secolo XVIII*, Lugano, 1982.

Parkinson 1990 Ronald Parkinson, *Catalogue of British Oil Paintings 1820–1860*, Victoria & Albert Museum, 1990.

Parry 1930 E. Parry, *Queen Caroline*, 1930.

Pasquin 1794 'Anthony Pasquin' [John Williams], *A Liberal Critique on the Present Exhibition for 1794*, 1794.

Passavant 1833 J. D. Passavant, *Kunstreise durch England und Belgien*, Frankfurt am Main, 1833.

Passavant 1836 *Tour of a German Artist in England*, trans. Elizabeth Rigby, 1836, 2 vols; repr. Wakefield, 1978.

Passeri 1934 G. B. Passeri, *Vite de' pittori, scultori e architetti dall'anno 1641 fino all'anno 1673*, Rome, 1722, ed. J. Hess, Leipzig and Vienna, 1934.

Paulson 1965, 1970, 1989 Ronald Paulson, *Hogarth's Graphic Works*, New Haven, 1965, 2 vols; rev. 1970, rev. 1989.

Paulson 1971 *Hogarth: His Life, Art and Times*, New Haven, 1971, 2 vols.

Paulson 1991, 1992 *Hogarth*, New Brunswick, i, 1991; ii, 1992.

Pears 1988 Iain Pears, *The Discovery of Painting: The Growth of Interest in the Arts in England 1680–1768*, New Haven, 1988.

Pelli 1779 Giuseppe Pelli [later Bencivenni], *Saggio istorico della Reale Galleria di Firenze*, Florence, 1779.

Pennant 1778–81, 1810 Thomas Pennant, *A Tour in Wales*, 1778–81, 1st collected edn as *Tours in Wales*, 1810, 3 vols.

Pennington 1982 Richard Pennington, *A Descriptive Catalogue of the Etched Work of Wenceslaus Hollar 1607–1677*, Cambridge, 1982.

Penrhyn Castle 1991 Jonathan Marsden et al., *Penrhyn Castle*, NT gbk, 1991.

Pepys 1970–83 Robert Latham and William Matthews ed., *The Diary of Samuel Pepys*, 1970–83, 11 vols.

Petrusevich 1990 Nadezhda Petrusevich, *Five Hundred Years of French Painting*, Leningrad, 1990.

Petworth 1856 Anon., *Catalogue of Pictures in Petworth House, Sussex*, 1856.

Pevsner 1956, 1964 Nikolaus Pevsner, *The Englishness of English Art*, 1956, 2/1964.

Pezzl 1816, 1820, 1823 J. Pezzl, *Beschreibung von Wien*, Vienna, 1816, 1820, 1823.

Phillips 1929 Charles James Phillips, *History of the Sackville Family*, 1929, 2 vols.

Physick 1969 John Physick, *Designs for English Sculpture 1680–1860*, Victoria & Albert Museum, 1969.

Pigler 1974 A. Pigler, *Barockthemen*, 2/1974, 2 vols.

Pita Andrade 1952 J. M. Pita Andrade, 'Los cuadros de Velázquez y Mazo que poseyó el septimo Marqués del Carpio', *Archivo español de arte*, 1952.

Plas Newydd 1992 Jonathan Marsden et al., *Plas Newydd*, NT gbk, 1992.

Pliny 1968 Pliny, *Natural History*, trans. by H. Rackham, Cambridge, MA, 1968.

Plumptre 1992 Ian Ousbie ed., *James Plumptre's Britain: The Journals of a Tourist in the 1790s*, 1992.

Poensgen 1937 Georg Poensgen, *Das Marmorpalais und der Neue Garten zu Potsdam*, Berlin, 1937.

Polesden Lacey 1964, 1976 F. St John Gore, *Polesden Lacey*, NT, 1964, 1976.

Pomian 1978 Krzysztof Pomian, *Collectionneurs, amateurs et curieux: Paris, Venise: XVI^e–XVIII^e siècle*, Paris, 1979, trans. as *Collectors and Curiosities*, Cambridge, 1990.

Ponz 1772– A. Ponz, *Viage de España*, Madrid, 1772–83, 12 vols; 2/1776–92, 18 vols; 3/1787–94, 18 vols.

Posner 1971 Donald Posner, *Annibale Carracci: A Study in the Reform of Italian Painting around 1590*, 1971, 2 vols.

Powis Castle 1987, 1989 *Powis Castle*, NT gbk, 1987, 1989.

Praz 1971 M. Praz, *Conversation Pieces*, 1971.

Preti Hamard 1995 Monica Preti Hamard, 'La quadreria di Ferdinando Marescalchi (1753–1816) attraverso il suo carteggio inedito con Francesco Rosaspina', *Atti e memorie dell' Accademia Clementina*, Bologna, nos.33/4, 1995, pp.181–200.

Princes Gate 1961 *Paintings and Drawings of Continental Schools other than Flemish and Italian at 56 Princes Gate London SW7*, 1961.

Prinz 1970 Wolfgang Prinz, *Die Entstehung der Galerie in Frankreich*, Berlin, 1970.

Proni 1988 Monica Proni, 'Per la ricostruzione della quadreria del Conte Ferdinando Marescalchi (1753–1816)', *Antologia di belle arte*, xxxiii–xxxiv, 1988, pp.33–41.

Pückler-Muskau 1832 Prince Hermann von Pückler-Muskau, *Briefe eines Verstorbenen* [1829–31]; trans. as *Tour in England, Ireland and France in the Years 1828 & 1829 . . . by a German Prince*, 1832, 4 vols.

Raines 1984 Robert Raines, 'Repertoire des tableaux de Lancret, Pater et Chardin dans les ventes anglaises avant 1760', *Archives de l'art français*, xxvi, 1984, pp.177–83.

Read 1982 B. Read, *Victorian Sculpture*, 1982.

Redford 1888 George Redford, *Art Sales*, 1888.

Redgrave 1947 R. and S. Redgrave, *A Century of British Painters* [1890], 2/1947.

Rees 1995 H. Rees, *The Art Quarterly of the NACF*, no.22, summer 1995, pp.20–23.

Reid 1980 Peter Reid, *Burke's and Savill's Guide to Country Houses*, ii: *Herefordshire*, 1980.

Reinach 1905–23 S. Reinach, *Répertoire de peintures*, 1905–23, 6 vols.

Reiss 1975 S. Reiss, *Aelbert Cuyp*, 1975.

Reumont 1835 A. Reumont, *Andrea del Sarto*, Leipzig, 1835.

Reynolds 1975 Joshua Reynolds, *Discourses on Art*, ed. Robert Wark, New Haven and London [1959], repr. 1975.

Reynolds 1973 Graham Reynolds, *Victoria & Albert Museum: Catalogue of the Constable Collection*, 1973.

Richter 1894 J. P. Richter, 'Die Winterausstellungen der Royal Academy und der New Gallery in London', *Zeitschrift für bildende Kunst*, v, 1894, pp.145–51.

Ripa 1603 Cesare Ripa, *Iconologia*, Rome, 1603.

Rivière 1919, 1920 Henri Rivière ed., *Les accroissements des Musées nationaux français: Le Musée du Louvre depuis 1914*, Paris, i, 1919, ii, 1920.

Robels 1989 Hella Robels, *Frans Snyders*, Munich, 1989.

Robinson 1974 F. M. Robinson, *Gabriel Metsu (1629–1667)*, New York, 1974.

Rochlitz 1828 F. Rochlitz, *Für ruhige Stunden*, Leipzig, 1828, 2 vols.

Roland 1984 Margaret Roland, 'Van Dyck's Early Workshop: The "Apostles" Series and the "Drunken Silenus"', *Art Bulletin*, lxvi, June 1984, pp.211–23.

Roland Michel 1984 M. Roland Michel, *Lajoüe et l'art rocaille*, Neuilly, 1984.

Roper 1964 L. Roper, *The Gardens of Anglesey Abbey, Cambridgeshire*, 1964.

Rorschach 1989–90 Kimerly Rorschach, 'Frederick, Prince of Wales as Collector and Patron', *Walpole Society*, lv, 1989–90 [1993], pp.1–76.

Roscam Abbing 1993 Michiel Roscam Abbing, *De schilder & schrijver Samuel van Hoogstraten 1627–78: Eigentijdse bronnen & oeuvre van gesigneerde schilderijen*, Leyden, 1993.

Rosenberg 1904 Adolf Rosenberg, *Rembrandt: Des Meisters Gemälde*, Stuttgart and Leipzig, 1904.

Rosenberg 1964 Jakob Rosenberg, *Rembrandt: Life and Work*, rev. 1964.

Rosenberg 1983 Pierre Rosenberg, *Tout l'oeuvre peint de Chardin*, Paris, 1983.

Rosenberg, Slive and ter Kuile 1977, 1979 Jakob Rosenberg, Seymour Slive and E. H. ter Kuile, *Dutch Art and Architecture 1600–1800*, Harmondsworth, 1977, 3/1979.

Röthlisberger 1961 Marcel Röthlisberger, *Claude: The Paintings*, New Haven and London, 1961, 2 vols.

Röthlisberger 1968 *Claude Lorrain: The Drawings*, Berkeley, 1968, 2 vols.

Röthlisberger 1977, 1986 *Tout l'oeuvre peint de Claude Lorrain*, Paris, 1977, rev. 1986.

Rowbottom 1970 M. Rowbottom, 'John Theophilus Desaguliers', *Proceedings of the Huguenot Society of London*, xx, 1965–70, pp.196–218.

Rowell 1993 C. Rowell, 'The North Gallery at Petworth: An Historical Re-appraisal', *Apollo*, cxxxviii, July 1993, pp.29–36.

Roworth 1992 Wendy W. Roworth ed., *Angelica Kauffman*, Brighton, 1992.

Rudolph 1983 Stella Rudolph, *La pittura del '700 a Roma*, Milan, 1983.

Rudolph 1995 *Niccolò Maria Pallavicini: L'ascesa al Tempio della Virtù attraverso il mecenatismo*, Rome, 1995.

Ruggiero 1885 M. Ruggiero, *Storia degli scavi di Ercolano*, Naples, 1885.

Russel 1748 [James Russel], *Letters from a Young Painter Abroad to his Friends in England*, 1748.

Russell 1975–6 F. Russell, 'The Stourhead Batoni and Other Copies after Reni', *National Trust Year-Book*, 1975–6, pp.109–11.

Russell 1980 'Batoni at Basildon Park', *National Trust Studies, 1981*, 1980, pp.35–42.

Russell 1984 'Engagements at Sea: The 3rd Earl of Bute's Picture Collection at High-cliffe', *Country Life*, 26 Jan 1984, pp.226–8.

Russell 1987 'Securing the Future', *Country Life*, 23 July 1987, pp.96–9.

Russell 1990 M. Russell, *Dutch Crossing*, xl, 1990, p.41.

Russell 1995 Francis Russell, 'An Overlooked Perugino Drawing at Saltram', *Apollo*, cxli, April 1995, pp.12–14.

Rylands 1988 Philip Rylands, *Palma Vecchio: L'opera completa*, Milan, 1988.

Rylands 1992 *Palma Vecchio*, Cambridge, 1992.

Sackville 1906 Lionel, Baron Sackville, *Knole House: Its State Rooms, Pictures and Antiquities*, Sevenoaks, 1906.

Sackville-West 1922 Vita Sackville-West, *Knole and the Sackvilles*, 1922.

Safarik and Torselli 1982 Eduard A. Safarik and Giorgio Torselli, *La Galleria Doria Pamphilj a Roma*, Rome, 1982.

Saint 1976 Andrew Saint, *Richard Norman Shaw*, 1976.

Salerno 1988 Luigi Salerno, *I dipinti del Guercino*, Rome, 1988.

Saltram 1967, 1977 F. St John Gore, *The Saltram Collection*, NT gbk, 1967, 1977.

Sánchez Cantón 1943 F. J. Sánchez Cantón, *Las Meninas y sus personajes*, Barcelona, 1943.

Sánchez Cantón 1956–9 F. J. Sánchez Cantón ed., *Inventarios reales: Bienes muebles que pertenecieron a Felippe II*, Archivio Documental Espanol, x, Madrid, 1956–9, 2 vols.

Sanderson 1658 W. Sanderson, *Graphice*, 1658.

Sandrart 1925 J. von Sandrart, *Academia picturae eruditiae* [1683], ed. A. R. Peltzer, Munich, 1925.

Sarrazin 1994 B. Sarrazin, *Catalogue raisonné des peintures italiennes du Musée des Beaux-Arts de Nantes, xiiiᵉ–xviiiᵉ siècle*, Nantes and Paris, 1994.

Sarsfield Taylor 1841 W. B. Sarsfield Taylor, *The Origin, Progress, and Present Condition of the Fine Arts in Great Britain and Ireland*, 1841.

Sayer 1981 Michael Sayer et al., *Burke's & Savill's Guide to Country Houses*, 1981.

Schaar 1958 Eckhard Schaar, *Studien zu Nicolaes Berchem*, Cologne, 1958.

Schaar 1959 'Poelenburgh und Breenbergh in Italian, und ein Bild Elsheimers', *Mitteilungen des Kunsthistorischen Institutes in Florenz*, ix/1, Aug 1959, pp.25–54.

Schaeffer 1909 E. Schaeffer, *Van Dyck*, Stuttgart and Leipzig, 1909.

Schama 1987 Simon Schama, *The Embarrassment of Riches*, 1987.

Scheicher 1979 E. Scheicher, *Die Kunst- und Wunderkammern der Habsburger*, Vienna, 1979.

Schleier 1973 Erich Schleier, '"Die Anbetung der Könige" von Giuseppe Chiari', *Berliner Museen Berichte*, xxxiii/1, 1973, pp.58–67.

Schlosser 1908 Julius von Schlosser, *Die Kunst- und Wunderkammern der Spätrenaissance*, Leipzig, 1908.

Schmidt-Degener 1906 F. Schmidt-Degener, 'Le troisième centenaire de Rembrandt en Hollande', *Gazette des Beaux-Arts*, xxxvi, Oct 1906, pp.265–80.

Schnackenburg 1970 B. Schnackenburg, 'Die Anfänge des Bauerninteriors bei Adriaen van Ostade', *Oud Holland*, lxxxv, 1970, pp.158–69.

Schnackenburg 1981 *Adriaen van Ostade. Isack van Ostade: Zeichnungen und Aquarelle*, Hamburg, 1981, 2 vols.

Schwartz 1985 G. Schwartz, *Rembrandt: His Life, his Paintings*, Harmondsworth, 1985.

Sebag-Montefiore 1988 Charles Sebag-Montefiore, 'Three Lost Collections of London', *NACF Magazine*, no.38, Christmas 1988, pp.50–56.

Sestieri 1994 G. Sestieri, *Repertorio della pittura romana della fine del seicento e del settecento*, Turin, 1994, 3 vols.

Shearman 1965 J. Shearman, *Andrea del Sarto*, 1965, 2 vols.

Shelley 1909 Roger Ingpen ed., *The Letters of Percy Bysshe Shelley*, 1909, 2 vols.

Shesgreen 1983 Sean Shesgreen, *Hogarth and the Times of Day Tradition*, Ithaca, 1983.

Shirley 1940 A. Shirley, *Bonington*, 1940.

Shoolman Slatkin 1976 Regina Shoolman Slatkin, 'Abraham Bloemaert and François Boucher: Affinity and Relationship', *Master Drawings*, xiv/3, autumn 1976, pp.247–60.

Shugborough 1989 John Martin Robinson et al., *Shugborough*, NT gbk, 1989.

Sick 1930 Ilse von Sick, *Nicolaes Berchem: Ein Vorlaüfer des Rokoko*, Berlin, 1930.

Simon 1987 Robin Simon, *The Portrait in Britain and America*, Oxford, 1987.

Sitwell 1937 Sacheverell Sitwell, *Narrative Pictures*, 1937.

Sketchley 1904 R. Sketchley, *Watts*, 1904.

Skipton 1905 H. Skipton, *John Hoppner*, 1905.

Sloan 1986 Kim Sloan, *Alexander and John Robert Cozens: The Poetry of Landscape*, New Haven and London, 1986.

Smith 1829–42 J. Smith, *A Catalogue Raisonné of the Works of the Most Eminent Dutch, Flemish and French Painters*, 1829–42, 9 vols.

Snoep-Rietsma 1973 Ella Snoep-Rietsma, 'Chardin and the Bourgeois Ideals of his Time: 2', *Nederlands kunsthistorisch jaarboek*, no.24, 1973, pp.147–243.

Snoep-Rietsma 1975 *Verschuivende betekenissen*, 1975.

Spelt-Holterhoff 1957 S. Spelt-Holterhoff, *Les peintres flamands de cabinets d'amateurs au xviiᵉ siècle*, Brussels, 1957.

Sprange 1780, 1797, 1801 J. Sprange, *The Tunbridge Wells Guide*, Tunbridge Wells, 1780, 1797, 1801.

Steegman 1957 John Steegman, *A Survey of Portraits in Welsh Houses*, i: *Houses in North Wales*, Cardiff, 1957.

Steland-Stief 1971 Anne Charlotte Steland-Stief, *Jan Asselijn, nach 1610 bis 1652*, Amsterdam, 1971.

Steland-Stief 1980 'Zum zeichnerischen Werk des Jan Asselijn: Neue Funde und Forschungsperspektiven', *Oud Holland*, xciv, 1980, pp.213–58.

Stendhal 1818 'Count de Stendhal', *Rome, Naples et Florence en 1817*, trans. 2/1818.

Stevenson 1895, 1899 R. A. M. Stevenson, *The Art of Velasquez*, 1895, 2/1899.

Stevenson 1914 *Velasquez*, 1914.

Stewart 1983 J. Douglas Stewart, *Sir Godfrey Kneller and the English Baroque Portrait*, Oxford, 1983.

Stiennon 1954 Jacques Stiennon, *Les sites Mosans de Lucas I et Martin I van Valckenborch*, Liège, 1954.

Stirling 1848, 1891 W. Stirling, *Annals of the Artists of Spain*, 1848, 3 vols; 2/1891, 4 vols.

Stirling 1855 *Velazquez and his Works*, 1855.

Stirling 1924 A. M. W. Stirling, *Life's Little Day*, 1924.

Stourhead **1800, 1818, 1822** [Sir Richard Colt Hoare], *A Description of the House and Gardens at Stourhead . . .* , Salisbury, 1800, Bath, 1818, rev. 1822.

Stourhead **1981** *Stourhead*, NT gbk, 1981.

Stoye 1989 John Stoye, *English Travellers Abroad 1604–1667*, New Haven, rev. 1989.

Strong 1986 R. Strong, *Henry, Prince of Wales and England's Lost Renaissance*, 1986.

Stryenski 1913 C. Stryenski, *La galerie du Régent Philippe, Duc d'Orléans*, Paris, 1913.

Suida 1933, 1935 W. Suida, *Tiziano*, Rome, 1933; French trans., 1935.

Sumowski 1983– Werner Sumowski, *Gemälde der Rembrandt Schüler*, Landau, 1983–.

Survey of London **1973** *Survey of London*, xxxviii: *Northern Kensington*, 1973.

Sutton 1962 Denys Sutton, 'Bonington, A Radical Lyricist', *Apollo*, lxxvi, March 1962, pp.58–62.

Sutton 1967 'The Dundas Pictures', *Apollo*, lxxxvi, Sept 1967, pp.204–13.

Sutton 1980 Peter C. Sutton, *Pieter de Hooch*, Oxford, 1980.

Sutton 1992 *Dutch and Flemish Seventeenth-century Paintings: The Harold Samuel Collection*, Cambridge, 1992.

Sweetman 1901 G. Sweetman, *Guide to Stourhead*, Wincanton, 1901.

Taverner 1972–3 E. Taverner, 'Salomon de Bray and the Reorganisation of the Haarlem Guild of St Luke in 1631', *Simiolus*, vi, 1972–3, pp.50–66.

Tawney 1948 R. J. Tawney, *Religion and the Rise of Capitalism*, [1926], repr. 1948.

Tenner 1966 Helmut Tenner, *Mannheimer Kunstsammler und Kunsthändler*, Heidelberg, 1966.

Ter Kuile 1969 O. ter Kuile, 'Daniel Mijtens "His Majesties Picture-Drawer"', *Nederlands kunsthistorisch jaarboek*, xx, 1969, pp.1–106.

Thomas 1952–5 Hylton A. Thomas, 'Piranesi and Pompeii', *Kunstmuseets Årsskrift*, xxxix–xlii, 1952–5, pp.13–28.

Thornton and Tomlin 1980 Peter Thornton and Maurice Tomlin, 'The Furnishing and Decoration of Ham House', *Furniture History*, xvi, 1980, pp.1–194.

Tikkanen 1913 J. J. Tikkanen, *Studien über den Ausdruck in Kunst*, i: *Zwei Gebärde mit dem Zeigefinger*, Helsinki, 1913.

Tinniswood 1989 A. Tinniswood, *A History of Country House Visiting*, Oxford, 1989.

Tipping 1919 H. Avray Tipping, 'The Hamilton Palace Collection of Pictures – II', *Country Life*, 25 Oct 1919, pp.514–17.

Titi 1674 F. Titi, *Studio di pittura, scoltura et architettura nelle chiese di Roma*, Rome, 1674.

Tomory 1962 P. A. Tomory, *Art in Italy 1500–1800*, Auckland, 1962.

Torrington 1934–6 C. Bruyn Andrews ed.,

The Torrington Diaries, 1934–6, 4 vols.

Trapier 1957 E. du G. Trapier, 'The School of Madrid and Van Dyck', *Burlington Magazine*, lxxxxix, Aug 1957, pp.265–73.

Trautscholdt 1937 E. Trautscholdt, 'Jan Steen', Thieme-Becker, *Künstler-Lexikon*, Leipzig, 1937, xxxi, pp.509–15.

Trevelyan 1977 Raleigh Trevelyan, 'William Bell Scott and Wallington', *Apollo*, cv, Feb 1977, pp.117–20.

Trevelyan 1978 *A Pre-Raphaelite Circle*, 1978.

Tümpel 1986, 1993 Christian Tümpel, *Rembrandt: Mythus und Methode*, Königstein im Taunus, 1986; trans. as *Rembrandt: All Paintings in Colour*, Antwerp, 1993.

Turner 1942 W. Turner, *English Music*, 1942.

Turner 1985 Nicholas Turner, 'Two Paintings Attributed to Lodovico Carracci', *Burlington Magazine*, Nov 1985, pp.795–6.

Twisleton 1928 *Letters of the Hon. Mrs Edward Twisleton written to her family, 1852–1862*, 1928.

Uffizi 1979 *Uffizi: Catalogo generale*, Florence, 1979.

Uppark **1995** Christopher Rowell et al., *Uppark*, NT gbk, 1995.

Upton **1950** The 2nd Viscount Bearsted, *Catalogue of Pictures and Porcelain at Upton House, Banbury*, NT, 1950.

Upton **1964** F. St John Gore, *The Bearsted Collection: Pictures*, NT, 1964.

Urbach 1983 Susan Urbach, 'Preliminary Remarks on the Sources of the Apostles Series of Rubens and Van Dyck', *Revue d'art canadienne/Canadian Art Review*, x, 1983, pp.5–22.

Vaes 1924 Maurice Vaes, 'Le séjour de Van Dyck en Italie (mi-novembre 1621– Automne 1627)', *Bulletin de l'institut historique belge de Rome*, fasc.iv, 1924, pp.163–234.

Vaes 1926 'Le journal de Jean Brueghel II', *Bulletin de l'institut historique belge de Rome*, vi, 1926, pp.163–222.

Valcanover 1960 F. Valcanover, *Tutta la pittura di Tiziano*, Milan, 1960.

Valcanover 1969 *L'opera completa di Tiziano*, Milan, 1969.

Valentiner 1908 W. R. Valentiner, *Rembrandt: Des Meisters Gemälde*, Stuttgart, 3/1908.

Van den Wijngaert 1943 F. van den Wijngaert, *Anton van Dyck*, Antwerp, 1943.

Van der Doort 1958–60 Oliver Millar ed., 'Abraham van der Doort's Catalogue of the Collections of Charles I', *Walpole Society*, xxxvii, 1958–60 [1960].

Van Eijnden and van der Willigen 1816 Roeland van Eijnden and Adriaan van der Willigen, *Geschiedenis der vaderlandsche schilderkunst*, Haarlem, 1816, 4 vols.

Van Eynden 1787 Roeland van Eynden, 'Verhandeling over den nationaalen smaak van de Hollandse school in de teken en schilder-kunst' [1782/3], *Verhandeling, uitgegeeven door Teyler's Tweede Genootschap*, Haarlem, 1787, v.

Van Hall 1963 H. van Hall, *Portretten van*

Nederlandse beeldende kunstenaars, Amsterdam, 1963.

Van Heel and van Oudeheusden 1988 Jos van Heel and Marion van Oudeheusden ed., *Brieven van Jakob Philipp Hackert an Johan Meerman uit de jaren 1779–1804*, The Hague, 1988.

Van Mander 1885 *Le livre des peintres de Carel van Mander*, trans. Henri Hymans, Paris, 1885, 2 vols.

Van Mander 1994 Karel van Mander, *The Lives of the Illustrious Netherlandish and German Painters*, from 1st edn of the *Schilderboek*, 1603–4, ed. Hessel Miedema, Doornspijk, 1994, 1 vol. published so far.

Van Puyvelde 1950 Léo van Puyvelde, *La peinture flamande à Rome*, Brussels, 1950.

Vermeule 1955, 1956 C. Vermeule, 'Michaelis Notes', *American Journal of Archaeology*, lix, 1955, lx, 1956.

Verney 1892–9 F. P., Lady and Margaret M. Verney ed., *Memoirs of the Verney Family*, 1892–9, 4 vols.

Vertue i–vi George Vertue, *Notebooks*, Walpole Society, xviii, 1930 [i]; xx, 1932 [ii]; xxii, 1934 [iii]; xxiv, 1936 [iv]; xxvi, 1938 [v]; xxix, 1947 [index]; xxx, 1955 [vi].

Vitruvius 1960 Vitruvius, *The Ten Books of Architecture*, trans. by Morris Hicky Morgan [1914], New York, 1960.

Vlieghe 1973 H. Vlieghe, *Corpus Rubenianum Ludwig Burchard*, viii: *Saints*, London and New York, 1973.

Von Erffa and Staley 1986 Helmut von Erffa and Allen Staley, *The Paintings of Benjamin West*, 1986.

Von Freeden 1955 Max H. von Freeden ed., *Quellen zur Geschichte des Barocks in Franken unter dem Einfluss des Hauses Schönborn*, Würzburg, i, 1931, ii, 1955.

Von Hadeln 1930 D. von Hadeln, *Die Zeichnungen von Antonio Canal genannt Canaletto*, Vienna, 1930; trans. 1939.

Von Loga 1909–10 Valerian von Loga, 'Las Meninas: Ein Beitrag zur Ikonographie des Hauses Habsburg', *Jahrbuch der Kunsthistorischen Sammlungen des Allerhöchstes Kaiserhauses*, xxviii, 1909/10, pp.171–99.

Von Loga 1913 *Velázquez*, Stuttgart, 1913.

Vosmaer 1868, 1877 C. Vosmaer, *Rembrandt*, The Hague, 1868; French trans., The Hague, 1877.

Voss 1924 Hermann Voss, *Die Malerei des Barock in Rom*, Berlin, 1924.

Voss 1953 'François Boucher's Early Development', *Burlington Magazine*, xcv, March 1953, pp.82–5.

Waagen 1838 Gustav Waagen, *Works of Art and Artists in England*, 1838, 3 vols.

Waagen 1839 *Kunstwerke und Künstler in Paris*, Berlin, 1839.

Waagen 1854 *Treasures of Art in Great Britain*, 1854, 3 vols.

Waagen 1857 *Galleries and Cabinets of Art in Great Britain*, 1857.

Waddingham 1972 Malcolm Waddingham, 'Elsheimer Revised', *Burlington Magazine*, cxiv, Sept 1972, pp.600–11.

Wagner 1971 Helga Wagner, *Jan van der Heyden 1637–1712*, Amsterdam and Haarlem, 1971.

Wagner 1983 I. J. R. Wagner, *Manuel Godoy: Patron de las artes y colleccionista*, unpublished thesis, Madrid, 1983.

Wainwright 1989 Clive Wainwright, *The Romantic Interior: The British Collector at Home 1750–1850*, New Haven, 1989.

Wallington **1994** Raleigh Trevelyan et al., *Wallington*, NT gbk, 1994.

Walpole 1752 Horace Walpole, *Aedes Walpolianae*, 1752.

Walpole 1784 *A Description of the Villa of Mr. Horace Walpole . . . at Strawberry-Hill . . .*, 1784.

Walpole 1828 *Anecdotes of Painting*, 1762–71, 5 vols; ed. James Dalloway, 1828.

Walpole 1927–8 Paget Toynbee ed., 'Horace Walpole's Journals of Visits to Country Seats, &c.', *Walpole Society*, xvi, 1927–8 [1928], pp.9–80.

Walpole 1937–81 W.S. Lewis et al. ed., *The Yale Edition of Horace Walpole's Correspondence*, New Haven, 1937–81, 42 vols.

Walpole 1939 'Notes by Horace Walpole on Exhibitions', *Walpole Society*, xxvii, 1938–9 [1939], p.55–88.

Walton 1986 Karin-M. Walton, 'An Inventory of 1710 from Dyrham Park', *Furniture History*, xxii, 1986, pp.25–76.

Ward and Roberts 1904 H. Ward and W. Roberts, *Romney*, 1904, 2 vols.

Ward-Jackson 1990 Philip Ward-Jackson, 'Expiatory Monuments by Carlo Marochetti in Dorset and the Isle of Wight', *Journal of the Warburg and Courtauld Institutes*, liii, 1990, pp.266–80.

Ware 1756 Isaac Ware, *A Complete Body of Architecture*, 1756.

Waterhouse 1938 E.K. Waterhouse, 'Seventeenth-century Art in Europe at Burlington House – The Paintings', *Burlington Magazine*, lxxii, Jan 1938, pp.3–13.

Waterhouse 1941 *Reynolds*, 1941.

Waterhouse 1953¹, 1962 *Painting in Britain: 1530–1790*, Harmondsworth, 1953, 2/1962.

Waterhouse 1953² 'Preliminary Check List of Portraits by Thomas Gainsborough', *Walpole Society*, xxxiii, 1948–50 [1953].

Waterhouse 1955 *Burlington Magazine*, xcvii, Sept 1955, pp.292–5.

Waterhouse 1958 *Gainsborough*, 1958, repr. 1966.

Waterhouse 1973 *Reynolds*, 1973.

Waterhouse 1981 *The Dictionary of British 18th-century Painters*, Woodbridge, 1981.

Waterson 1976 Merlin Waterson, 'Chips off a Welsh Block', *Country Life*, 19 Feb 1976, pp.412–13.

Waterson 1978¹ 'Elizabeth Ratcliffe: An Artistic Lady's Maid', *Apollo*, cviii, July 1978, pp.56–63.

Waterson 1978² 'Woods and Woodmen of Erddig', *Country Life*, 5 Oct 1978, pp.1034–6.

Waterson 1980 *The Servants' Hall*, 1980.

Waterson 1981 'Lady Berwick, Attingham and Italy', *National Trust Studies*, 1981, pp.43–68.

Waterson 1986¹ 'The Shipwright Squire? Marine Pictures at Felbrigg, Norfolk', *Country Life*, 7 Aug 1986, pp.438–40.

Waterson 1986² 'Brigantines and Battle-pieces: Marine Pictures at Felbrigg – II', *Country Life*, 18 Sept 1986, pp.904–6.

Watkin 1982 David Watkin, *Athenian Stuart: Pioneer of the Greek Revival*, 1982.

Watts 1912 M.S. Watts, *George Frederic Watts: The Annals of an Artist's Life*, 1912, 3 vols.

Wegner 1992 Reinhard Wegner, 'Pompeij in Ansichten Jakob Philipp Hackerts', *Zeitschrift für Kunstgeschichte*, lxi/1, 1992, pp.66–96.

Wegner and Krönig 1994 Reinhard Wegner and Wolfgang Krönig, *Jakob Philipp Hackert*, Cologne, 1994.

Weizsäcker 1936, 1952 Heinrich Weizsäcker, *Adam Elsheimer, der Maler von Frankfurt*, Berlin, 1936, 2 vols; catalogue and sources ed. H. Möhle, 1952.

Wentworth 1984 Michael Wentworth, *James Tissot*, Oxford, 1984.

West and Pantini 1904 W.K. West and R. Pantini, *G.F. Watts*, 1904.

Wethey 1971 H.E. Wethey, *The Paintings of Titian*, ii: *The Portraits*, 1971.

White 1982 Christopher White, *The Dutch Pictures in the Collection of Her Majesty the Queen*, Cambridge, 1982.

White and Boon 1969 Christopher White and Karel G. Boon, *Rembrandt's Etchings*, Amsterdam, etc., 1969, 2 vols.

Whitley 1915 W.T. Whitley, *Thomas Gainsborough*, 1915.

Whitley 1928 *Artists and their Friends in England 1700–1799*, 1928, 2 vols.

Whitley 1930 *Art in England: 1821–1837*, Cambridge, 1930.

Whittingham 1986 Selby Whittingham, 'A Most Liberal Patron: Sir John Fleming Leicester Bart., 1st Baron de Tabley, 1762–1827', *Turner Studies*, vi/2, winter 1986, pp.24–36.

Wied 1990 Alexander Wied, *Lucas und Marten van Valckenborch*, Freren, 1990.

Wightwick Manor **1993** Stephen Ponder, *Wightwick Manor*, NT gbk, 1993.

Wijnman 1934 H.F. Wijnman, 'Een drietal portretten van Rembrandt', *Jaarboek van het Genootschap Amstelodamum*, xxxi, 1934, pp.81–96.

Wijnman 1959 *Uit de kring van Rembrandt en Vondel: Verzamelde studies over hun leven en omgeving*, Amsterdam, 1959.

Wildenstein 1924 Georges Wildenstein, *Lancret*, Paris, 1924.

Williams 1898 Sir Edward Leader Williams, *The Manchester Ship Canal*, Institution of Civil Engineers, Paper no.3046, 1898.

Willis 1795 [H.N. Willis], *Biographical Sketches of Eminent Persons, whose Persons Form Part of the Duke of Dorset's Collection at Knole*, 1795.

Willoughby 1906 Leonard Willoughby, 'The Marquess of Bristol's Collection at Ickworth', *Connoisseur*, xiv, April, xv, May, June 1906, pp.203–10, 3–10, 84–90.

Wills 1989 Catherine Wills, 'Stable Ancestry', *Country Life*, 9 March 1989, pp.146–51.

Wilson 1992 John Human Wilson, *The Life and Work of John Hoppner*, Courtauld Institute diss., June 1992.

Wimpole **1991** David Souden et al., *Wimpole Hall*, NT gbk, 1991.

Winkelmann 1958 Heinrich Winkelmann et al., *Der Bergbau in der Kunst*, Essen, 1958.

Wittkower 1958, 1973 Rudolf Wittkower, *Art and Architecture in Italy 1600–1750*, Harmondsworth, rev. 1958, 3/1973.

Wood 1990 Jeremy Wood, 'Van Dyck's "Cabinet de Titien": The Contents and Dispersal of his Collection', *Burlington Magazine*, cxxxii, Oct 1990, pp.680–95.

Wood 1994 'Van Dyck and the Earl of Northumberland: Taste and Collecting in Stuart England', in Barnes and Wheelock 1994, pp.281–324.

Woodbridge 1970 Kenneth Woodbridge, *Landscape and Antiquity: Aspects of English Culture at Stourhead 1718 to 1838*, Oxford, 1970.

Woodward 1963 John Woodward, 'Paintings by Dolci and Claude for Birmingham', *Apollo*, lxxvii, March 1963, pp.250–52.

Wright 1981 Christopher Wright, *A Golden Age of Painting*, San Antonio, 1981.

Wright 1982 *Rembrandt: Self-portraits*, 1982.

Wright 1985¹ *The French Paintings of the Seventeenth Century*, 1985.

Wright 1985² *Masterpieces of Reality*, Leicestershire Museum, 1985.

Wyndham 1915 Margaret Wyndham, *Catalogue of the Collection of Greek and Roman Antiquities in the Possession of Lord Leconfield*, 1915.

Yale 1985 *A Concise Catalogue of the Yale Center for British Art*, New Haven, 1985.

Young 1770 A. Young, *A Six Months Tour through the North of England*, 1770, 4 vols.

Young 1821 John Young, *A Catalogue of Pictures by British Artists, in the Possession of Sir John Fleming Leicester, Bart.*, 1821.

Youngblood 1983 Patrick Youngblood, 'That House of Art: Turner at Petworth', *Turner Studies*, ii/2, 1983, pp.16–33.

Zarco Cuevas 1930 R.P. Fr. Julián Zarco Cuevas, *Inventario de las alliajas, pinturas y objetos de valor y curiosidad donados por Felipe II al monasterio de El Escorial (1571–1598)*, Madrid, 1930.

Zaremba Filipczak 1987 Zirka Zaremba Filipczak, *Picturing Art in Antwerp 1550–1700*, Princeton, 1987.

Zeri 1959 Federico Zeri, *La Galleria Pallavicini in Roma*, Florence, 1959.

Zeri and Gardner 1986 Federico Zeri and Elizabeth Gardner, *Italian Paintings: North Italian School: Metropolitan Museum of Art*, New York, 1986.

Zumthor 1962 Paul Zumthor, *Daily Life in Rembrandt's Holland*, 1962.

INDEX